VISION AND TEXTUALITY

Also by Stephen Melville

PHILOSOPHY BESIDE ITSELF: On Deconstruction and Modernism

Also by Bill Readings

INTRODUCING LYOTARD: Art and Politics
POSTMODERNISM ACROSS THE AGES: Essays for a
 Postmodernity that Wasn't Born Yesterday (*co-editor with
 Bennet Schaber*)

VISION AND TEXTUALITY

Edited by

Stephen Melville

and

Bill Readings

Duke University Press, Durham
1995

First published 1995 in the USA by
DUKE UNIVERSITY PRESS
Durham, North Carolina 27708
and in Great Britain by
MACMILLAN PRESS LTD
Houndmills, Basingstoke, Hampshire RG21 2XS

ISBN 0–8223–1630–7 hardcover
ISBN 0–8223–1644–7 pbk.

Library of Congress Cataloging-in-Publication Data
Vision and textuality / edited by Stephen Melville and Bill Readings.
p. cm.
Includes index.
ISBN 0–8223–1630–7. — ISBN 0–8223–1644–7 (pbk.)
1. Art—Historiography. 2. Literature—History and criticism–
–Theory, etc. 3. Art and literature. 4. Influence (Literary,
artistic, etc.) I. Melville, Stephen W. II. Readings, Bill, 1960–
1994.
N380.V58 1995
707' .2—dc20 94–39995
 CIP

Printed in Hong Kong

In memory of Louis Marin

Contents

List of Illustrations

Acknowledgements

The lecture series from which this book proceeds was originally sponsored by the Ray Smith Endowment for the Humanities and the Office of the Vice President for Research and Graduate Affairs at Syracuse University, along with the Kress Foundation. Further financial support came from the School of Visual and Performing Arts and the Departments of English and Fine Arts at the University of Syracuse. Diane Elam also made a major culinary contribution to the success of the series.

The production of this volume was made possible by grants from the Québec Fonds pour la formation des chercheurs et l'aide à la recherche (FCAR) and the Canadian Conseil de la Recherche en Sciences Humaines (CRSH/SSHRC). We are particularly grateful to Gilles Dupuis for his editorial work.

Portions of Mieke Bal's essay have appeared in different form in her book *Reading Rembrandt: Beyond the Word\Image Opposition* (Cambridge: Cambridge University Press, 1991). A shorter version of John Bender's essay, 'Impersonal Violence: The Penetrating Gaze and the Field of Narration in *Caleb Williams'* appears in Polhemus and Henkle (eds.), *Critical Reconstructions: The Relationship of Fiction and Life*, published by Stanford University Press (1994). We are grateful to Cambridge University Press for permission to reproduce Norman Bryson's essay form a volume edited by S. Goldhill and R. Osborne. Michael Ann Holly's essay originally appeared in *Critical Inquiry* 16 (Winter 1990): 371–96. We are grateful to the following institutions for permission to reproduce works from their collections:

The Arts Council of Great Britain, London, for *On the Insistence of the Letter* by Mary Kelly.

The Arts Institute of Chicago, for *Female Nude Seated* (Benesch 1122) by Rembrandt van Rijn.

The Brera Gallery, Milan, for *Marriage of the Virgin* by Raphael.

The British Museum, London for *Female Nude Seated* (Benesch 21) by Rembrandt van Rijn, *The Four Stages of Cruelty* by William Hogarth and *Young Woman with Binoculars* by Edgar Degas.

Civiche Raccolte d'Arte, Castello Sforzesco, Milan, for *Girodet painting Pygmalion and Galatea* by Adèle Chavassieu.

The Collection Sirot-Angel for *Morisot's Studio* (Anonymous).

Galleria Nazionale delle Marche, Palazzo Ducale, Urbino, for *The Flagellation of Christ* by Piero della Francesca.

Gemäldegalerie, Dresden, for *Sleeping Venus* by Giorgione da Castelfranco.

Hessisches Landesmuseum, Darmstadt, for *Auschwitz* by Joseph Beuys.

Kunsthistorisches Museum, Wien, for *The Martyrdom of the Ten Thousand*, by Albrecht Dürer.

Kupferstichkabinett, Berlin, for *Woman Standing Up* (Benesch 590) by Rembrandt van Rijn.

Meso di Capodimonte, Napoli, for *Judith Beheading Holophernes* (Benesch 897) by Rembrandt van Rijn.

The Metropolitan Museum of Art, New York, for *The Toilet of Bathsheba* by Rembrandt van Rijn.

Musée des Beaux Arts, Nantes, for *The Corn Sifters* by Gustave Courbet.

Musée d'Orsay, Paris, for *Olympia* by Édouard Manet.

Musée Fabre, Montpellier, for *The Meeting, or Bonjour, Monsieur Courbet* by Gustave Courbet.

Museo del Prado, Madrid, for *The Fable of Arachne* and *Las Meninas* by Diego Velazquez.

The Museum of Fine Arts, Boston, for *Woman in Black* by Mary Cassatt.

The Museum of Modern Art, New York, for *The False Mirror* by René Magritte.

The National Gallery, London, for *The Arnolfini Wedding* by Jean van Eyck and *The Young Schoolmistress* by Jean-Baptiste Siméon Chardin.

The National Gallery of Art, Washington DC, for numerous installations and exhibits.

Neue Gallery, Aachen, for *Cafe Deutschland I* by Jorg Immendorf.

Rijksmuseum Kroeller-Mueller, for *Peasant Woman Stooping Seen from Behind and from the Side* by Vincent van Gogh.

Rijksprentenkabinet, Amsterdam, for *Female Nude Seated* (Benesch 1142) by Rembrandt van Rijn.

Scuola di San Giorgio degli Schiavoni, Venezia, for *Sant'Agostino nello Studio* by Vittore Carpaccio.

Städelsches Kunstinstitut, Frankfurt am Main, for *The Blinding of Samson* by Rembrandt van Rijn.

State Hermitage Museum, Saint Petersburg, for *Danae* (Bredius 474) by Rembrandt van Rijn.

The Tate Gallery, London, for *The Meeting, or Have a Nice Day, Mr Hockney* by Peter Balke.

Teyler Museum, Haarlem, for *Joseph and Potiphar's Wife* by Rembrandt van Rijn.

The Uffizi Gallery, Firenze, for *Adoration of the Magi* by Sandro Botticelli, *Crowning of the Virgin* by Fra Filippo Lippi and *Venus of Urbino* by Titian.

Ulli Knecht collection, Stuttgart, for *Let's go to the 38th Party Conference* by Jorg Immendorf.

The Vatican Museum, Rome, for *School of Athens* by Raphael.

The Wellcome Trust, London, for *Anatomy of the Human Gravid Uterus* by William Hunter, *Myologie complette en couleur et grandeur naturelle* by Gautier d'Agoty and *Wax female figure with moveable parts*.

Notes on Contributors

Mieke Bal is Professor of the Theory of Literature at the University of Amsterdam, and Adjunct Visiting Professor of Visual and Cultural Studies, University of Rochester. Her interests include narrative theory, semiotics, and cultural studies, in particular the relations between discourse and image. Her most recent book is *Reading 'Rembrandt': Beyond the Word-Image Opposition* (1991). She is currently preparing a book on images in Proust.

John Bender is Professor of English and Comparative Literature at Stanford University. He is the author of *Spenser and Literary Pictorialism* (1972) and *Imagining the Penitentiary: Fiction and the Architecture of the Mind in Eighteenth century England* (Chicago, 1987), which was awarded the Gottschalk Prize by the American Society for Eighteenth-Century Studies. He is co-editor of *The Ends of Rhetoric: History, Theory, Practice* (1990) and of *Chronotypes: The Construction of Time* (1991).

Norman Bryson teaches art history at Harvard University. He is the author of *Word and Image: French Painting of the Ancien Régime* (1981) and *Looking at the Overlooked: Four Essays on Still Life Painting* (1990).

Victor Burgin teaches in the Art History and History of Consciousness programmes at the University of California at Santa Cruz. He is the author of *The End of Art Theory: Criticism and Postmodernity* (Humanities Press International, 1986), and editor of *Thinking Photography* (1982) and *Formations of Fantasy* (1986).

Thomas Crow is Professor of Art History at Sussex University. He is the author of *Painters and Public Life in Eighteenth Century Paris* (1985).

Peter de Bolla teaches English at King's College, Cambridge. He is the author of *The Discourse of the Sublime* (1989) and *Harold Bloom: Towards Historical Rhetorics* (1988).

Hal Foster is Professor of Art History and Comparative Literature at Cornell University. He is the author of *Recodings* (Bay Press 1985), and *Compulsive Beauty* (1993). He is the editor of *The Anti-Aesthetic: Essays on Postmodern Culture* (1983), *Discussions in Contemporary Culture* (1987), and *Vision and Visuality* (1988).

Michael Ann Holly is Professor of Art History and Visual and Cultural Studies at the University of Rochester. She is the author of *Panofsky and the Foundations of Art History* (1984) and co-editor of *Visual Theory* (1992) and *Visual Culture* (1994).

Martin Jay is Professor of History at UC, Berkeley. He is the author of *The Dialectical Imagination* (1973), *Marxism and Totality* (1984), *Adorno* (Harvard 1984), *Permanent Exiles* (1985), *Fin-de-Siècle Socialism* (1988), *Force Fields* (1992) and *Downcast Eyes* (1993).

Rosalind Krauss is professor of Art History at Columbia University. Co-founder and co-editor of *October* magazine, her books include *Passages in Modern Sculpture* (1977), *The Originality of the Avant Garde and Other Modernist Myths* (1985) and *The Optical Unconscious* (1993).

Françoise Lucbert works in Comparative Literature and Art History at the Université de Montréal. She is the author of essays on French symbolist art criticism and fin-de-siècle painting.

The late **Louis Marin** taught at the Ecole des Hautes Etudes en Sciences Sociales and Johns Hopkins University. Among his books are *Etudes Sémiologigues: Ecriture, Peinture* (1971), *Utopics, Spatial Plays* (1982), *La Critique du Discours* (1975), *Le Récit est un Piège* (1977), *Détruire la Peinture* (1977), *La Voix Excommuniée* (1978), *The Portrait of the King* (1988), *Food for Thought* (1988), *Opacité de la Peinture* (1989).

Stephen Melville teaches Art History at Ohio State University, Columbus. He is the author of *Philosophy Beside Itself*.

Griselda Pollock is Professor of Social and Critical History of Art at The University of Leeds. Her books include *Old Mistresses* (1981), *Framing Feminism* (1987), *Vision and Difference* (1988), and *Avant-Garde Gambits: Gender and the Colour of Art History*.

Bill Readings was Associate Professor of Comparative Literature at the Université de Montréal until his untimely death in 1994, as this book went to press. He taught in Switzerland and the United States and published on philosophy, literary theory, renaissance studies and art history. He was the author of *Introducing Lyotard: Art and Politics* and editor, with Bennet Schaber, of *Postmodernism Across the Ages*.

Irit Rogoff teaches critical theory and visual culture at the University of California – Davis. She is the editor of *The Divided Heritage – Problems in German Modernism* (1991) and of *Museum Culture* (1994) and author of the forthcoming *Terra Infirma – Geographies and Identities*.

Bennet Schaber teaches English at SUNY, Oswego. He is the co-editor of *Postmodernism Across the Ages* (1993), and author of a forthcoming study of Chaucer.

John Tagg is Professor of Art History at SUNY, Binghamton. He is the author of *The Burden of Representation* (1988), and editor of *The Cultural Politics of 'Postmodernism'* (1989).

PART I

Chapter One
General Introduction
Stephen Melville and Bill Readings

INSTITUTIONS I

How to Make this Book Work

The studies collected here spring, for the most part, from a series of lectures held under the title 'Vision and Textuality' at Syracuse University during the winter and spring of 1991. Funding for the series was the now-standard patchwork, with crucial initial support coming from the Kress Foundation and the Department of English, with further support coming from the Ray Smith Endowment in the Humanities, administered by the College of Arts and Sciences, and from the University's Vice-President for Research and Graduate Affairs as well as the Department of Fine Arts and The School of Visual and Performing Arts.

Most of the contributions that appear here were presented, in a sometimes significantly different order, as public lectures, while also serving as the backbone of a graduate seminar offered under the auspices of an English Department that was at that time very much in the midst of reconstituting itself as a 'Department of English and Textual Studies' with an undergraduate curriculum organized under the headings of 'History', 'Politics' and 'Theory', and with courses titled thematically rather than by author or period.

These are institutional facts, facts which offer a certain number of ways to locate or imagine the work represented here within the context of the modern research university, or at least within the context of one particular such university which is no doubt neither wholly typical nor wholly unique. This volume will appear in a larger field – on a bookshelf or in a classroom – that is not simply empty. It will find itself more or less alongside other, related collections: books like Brian Wallis's *Art After Modernism*, Rees and Borzello's *The New Art History*, the Brunette and Wills collection devoted to deconstruction and the visual arts, the Bryson – Holly – Moxey volumes on visual theory, and so on.[1] On a nearby shelf or in a related course, there will perhaps be various instances of the rapidly proliferating discourse on 'theory' and architecture; and on other nearby shelves, in other classrooms, there may be other

3

collections that touch on art barely or not at all but which nonetheless form part of its field. These too are institutional facts, if more diffuse ones, and they too offer a way of imagining both the location of the work represented here and the forces that have allowed it to emerge into print.

If we choose to open this introduction by dwelling at greater length and in greater detail than is usual on these dimensions of the volume, it is because it no longer seems possible simply to pass by in silence the intimate embrace of intellectual work and 'professional activity' that characterizes the contemporary American university; this collection may or may not end by exerting certain intellectual effects, but it will certainly exert institutional effects, such as gaining institutional capital for some of its participants, testifying for (or against) the strength of a certain market, fuelling (or quenching) certain desires for curricular or institutional transformation, and so on.

In this context, it is tempting to read the poster that announced the series (see Illustration 1) as not only graphically divided, between 'vision' and 'textuality', photomontage and prose, typographic references to the art of Barbara Kruger and something like mere type, but also as torn between a certain surrender to professional recognizability and a certain resistance to such recognition. It is this tension that will now appear to drive the extraordinary amount of prose on the poster. Paragraphs variously assert the nature and timeliness of the issues to be explored and tie each pair of lectures to those that precede and follow it so as both to locate the lectures in a certain relation to modernist claims for the specificity of visual and textual mediums, and present them as a certain ordered undoing of that specificity; an undoing that moves from disciplinary self-reflection through psychoanalysis, semiotics, political critique and questions of postmodernism to an appealingly (perhaps appallingly) open closing question: 'How have the disciplines of the humanities been transformed under the pressure of contemporary French thought?' This trajectory is as good a candidate as any to represent both 'the new art history' and 'textual or cultural studies' as they are taking shape in Britain and the USA, and we suppose that is some part at least of what this volume must mean to do. The question of what it means to do *that* nonetheless remains open, and so does the question of what it is to introduce such a representation. If it is important at this conjuncture not to present the work of theory outside the field of its institutionalization, how are we to do so? To ask this is to pose, in the most basic way, the question of contemporary intellectual agency that animates all the interdisciplinary inquiries in this volume. How can one answer it without providing just another professional rationale? The various facts of location, circumstance and contiguity adduced to this point are perhaps best taken as a measure of the oddness of the interdisciplinary encounter enacted in these pages – an encounter that does not take the form of an exchange between two more or less stable and self-regulating bodies of knowledge, the one presumably embodied in the departments of English and the other in departments of Art History.

What unfolds in these pages is – at a minimum – not a matter of two interlocutors, distinguished as 'art historian' and 'literary critic', each with a solid idea of what he or she does, looking for either common ground or points of essential divergence. One can perhaps conceive of such a conversation ('So we both interpret …' 'Indeed, but from a different standpoint …' and so on), but

the institutional space in which it might take place (what in an English University would be called the Common Room, a term significantly lacking from the discourse of the contemporary American University) is no longer at the centre of the intellectual life of the University. While it is tempting to

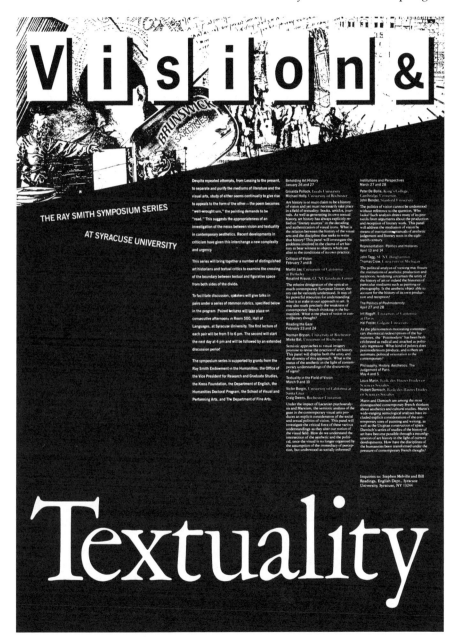

1 Poster for Vision and Textuality Conference, 1989

attribute the absence of this space to the collapse of a range of social hierarchies and exclusions that have seemed to support it in the past, the deep structure of this shift has also to do with the development of the University as a late modern institution: bureaucratization and specialization do not require a 'culture club', merely the intensified performance of discrete roles. The sensed need for an overall rationale for humanistic inquiry has been displaced by the desire for increased performance in a variety of fields organized solely by their submission to a central, necessarily empty and formal, standard of performance.[2]

The mode of interdisciplinary engagement that arises in such a context is not modelled on humanistic conversation, but is rather provoked by a crisis arising within what are now discrete fields of inquiry; this crisis is one which the interdisciplinary question may either seek to prevent or to exacerbate. The understanding of interdisciplinarity as an attempt to exacerbate rather than resolve the disorder of disciplines is a question posed against the bureaucratic internalization of the issue of performance. It asks: how can intellectual work do something other than simply fulfil arbitrary, internally determined, performance indicators? How can it be more (or less) than a unit of professional currency? This question of intellectual agency is one that each discipline must ask of itself. It is a pragmatic question in that it does not have any one answer but must be taken up each time circumstantially.

The asking of such a question involves a divided relation to something called 'theory'. On the one hand, 'theory' offers us a way of taking stock of our activity, reflecting upon the nature of what we do rather than routinely following the paths prescribed by our particular professional field. In this sense, the question of theory is posed against the automatic self-reproduction of institutional structures and systems of behaviour. On the other hand, there is always reason to place 'theory' itself in question as an attempt to ground and unify the field of inquiry in a way that speeds the process of professionalization, securing the autonomy of what we do and allowing us to improve 'performance'. The isolated clarity of vision available from the peaks of high theory reduces participation, engagement or agency to the carrying out of tasks decided on in advance by a disembodied spectator. A generalized theoretical rigour can thus threaten to mesh extremely well with the structure of bureaucratic institutional self-reproduction so as to reinforce the autonomy and mutual externality of our professionalized disciplines. This is not to say that this view of theory precludes interdisciplinary activity, but simply that it determines such activity in advance as a matter of external relations, grounded on analogy or shared methodology, and so also determines such activity as essentially abstract, cushioned against the shock of specific textual or visual encounters. Such generalized theory permits an interdisciplinarity that ignores the specificity of particular inquiries in favour of a unified field of 'cultural representations'. It argues, for example, that since 'everything is a text', everyone should be a textual semiotician. Against this, we would offer the possibility that it is precisely in the specificity of particular encounters with texts or objects that one finds oneself led, from within the heart of the discipline, beyond the terms in which it would enclose itself and into a multiplicity of contiguous associations which map new fields of inquiry in terms both intimate and alien.

If we stretch this wager to its maximum, we may find ourselves wanting to say, with Gilles Deleuze and Félix Guattari, that:

> a book also has no object. As an assemblage, a book has only itself, in connection with other assemblages and in relation to other bodies without organs. We will never ask what a book means, as signified or signifier; we will not look for anything to understand in it. We will ask what it functions with, in connection with what other things it does or does not transmit intensities, in which other multiplicities its own are inserted and metamorphosed, and with what bodies without organs it makes its own converge.[3]

A book will, then, not tell the truth; it will have effects and be worked upon. This would involve us in a kind of pragmatics, an insistence that what lies between the visual and the textual is not a border and so also that the work of theory is not that of the border guard, of regulating interactions. We might rather imagine what lies between vision and textuality as so many fault lines, masses exerting pressure on and shifting against one another at a particular location or set of locations in a complex, layered and folded landscape.

Deleuze and Guattari would urge us to set the book to work, not to prompt it to speak the truth, or indeed any truth at all. Reading will be a working of the fault, prolonging it through multiple vectors, and the book will not provide an image of the world, but work with a multiplicity of other surfaces or reading heads (analogous to tape heads). Introducing this book, our task would be not to tell you what it means but simply to propose some of the more obvious heads for reading it. We would thus position this book as functioning in what Deleuze and Guattari call 'a logic of the AND' that 'does away with foundations' so as to 'practice pragmatics' (A Thousand Plateaus, p. 25). To read is to add another AND, another circumstance, to set a text to work in yet another way. Writing it this way, *Vision AND Textuality*, we would argue that these bodies of knowledge, research and teaching are without organs, that they hide no essences, no final and secure inner form; vision is plugged into textuality, and vice versa, in multiple ways.[4] What counts is how we follow the lines of their intersection, how we pay attention to their circumstances. So we counsel you to do things with this book, without knowing what it is you will do.

Each of the chapters that follow works some piece of the system of faults that are the mutual entanglement of seeing and reading. Each works that stretch into new relations even as each is worked by the various further relations into which it is placed in this volume. No single issue runs through them all, and this introduction will not attempt to fix on their common denominator, rather, it will try to lay out some of the various sites in which these contributions encounter both their objects and one another. No single one of these scattered sites maps the whole; not every study touches on all of them, and we will not touch on all the issues the various contributors individually take as central. Nonetheless, we hope that our remarks will offer a useful background against which to imagine the various constellations these chapters form. And, of course, these remarks themselves cannot but enter into the play of constellations they also claim to ground.

REPRESENTATION

Ut Pictura Poesis and Beyond

If we begin – as we already have – with the question of representation, we are likely to want to retell a story about the long Western tradition of comparing the visual and the textual under the auspices of mimesis. The early chapters of this story would be devoted to the Horatian doctrine of *ut pictura poesis*, a doctrine that asserted the direct comparability of visual and textual imitation of the world.

In classical literary theory, this is a poetic question, a question about making something in accordance with an objective world that is implicitly understood to be a harmonious and stable system. Rhetoric, functioning as a system of rules and generic classifications analogous to the system of the world, allows the artist to present a world in accordance with both its actual form and the potential shape of its meaning; it is this orientation not only to actuality but also to possibility that gives poetry, especially drama, its privilege over history in Aristotle's account.

As the explicit guiding model for Classical and neo-Classical art, the notion of the 'speaking picture' bound painting and writing together as rhetorically structured renderings of the world and the objects within it, and likewise linked visual work and writing about it through the practice of description and criticism as the verbal reproduction of pictorial rhetoric. Poetry aims to paint a world upon the mind's eye, just as painting seeks to present the mute objects of the world in a framework that will make them speak. The mimetic analogy between painting and poetry is symmetrical with the mimetic analogy between life and art.[5]

However, this mimetic practice is a matter of making (*poiein*) according to the rules of rhetoric, rather than of illusion. Mimesis does not seek to delude an individual into taking an imitation as real but rhetorically to persuade a public to an action, to making a real. Painting and poetry share the task of providing the objects around which communities of understanding form and sustain themselves. It is important to remember that when Sir Philip Sidney calls the poem a 'speaking picture' he thinks of it as functioning like a rhetorical *exemplum*, rather than as an illustration of an absolute law.[6] A rhetorical *exemplum* is an example given to the memory (itself one of the five branches of rhetoric) rather than to subjective consciousness. An orator possesses a stock of such *exempla*, some of which are utterly contradictory, and applies them as it seems appropriate in the circumstances rather than according to a unified logic. In this respect they are not unlike proverbs. Hence it is perhaps more accurate to think of these 'speaking pictures' as emblems than as examples in the modern sense: they exist as objects, jumbled together in the memorial space of a *wunderkabinett* or treasure house.[7] This is very different from the way in which exemplary illustrations function in modernist thought: each example illustrates a universal law, holding down a unique place within the extended and non-contradictory museal space of rational historical understanding. To call this latter space museal is to refer to the way in which the ground plan of the modern museum is already a map of a particular account of art history, offering a unified account of development and a generalized system of classification.

As the public matter of the polis, the speech of the orator or the tragic actor does not claim to represent a world but to participate in it: more strongly, social life and action has or finds its being in such mimetic activities. In refusing language as a picture of reality in favour of language as the mimetic stuff of reality itself, Aristotle and his successors make no specific effort to deliver painting and sculpture from the particular negative position assigned them by Plato as paradigms of the treacherousness of imitation. Tragic drama is promoted as the paradigm of imitation, and the visual arts are left to gain whatever dignity they can by adhering to that model and all that follows from it: for example, a privileging of history painting over other genres and, more generally, the privileging of the clear exposition of essentially literary meaning over other possibilities. To the extent that modern art history has constituted itself by essential reference to Renaissance theory and practice, it continues this structure of privileging, as is perhaps most palpable in its strong orientation to iconography and iconology.[8]

In general, 'modernism' names the break with this tradition, the sundering of the rhetorical unity of the visual and textual in favour of the acknowledgment of a radical difference between the two modes. The terms of this break on both the literary and artistic sides are complex. On the literary side it seems fair to say that this break entails a turn against rhetoric and literary language more generally in favour of modes of expression deemed more immediate and more natural: a rejection of the overt materiality of rhetorical practice in favour of the (pictorial) illusion of presence. The stage, the painting and the poem become windows on to the artist's mind. Such a turn carries within it a perceived threat of the concomitant reduction of literature to sheer unmediated expression, and the play of turn and counter-turn thus put in motion has meant that the literary problem of modernism has unfolded always in relation to claims for and against romanticism.[9]

On the side of the visual arts, the same break appears to unfold at the limits of the Baroque as a new radicalism in the ongoing competition of colour and design. As this played out in the arguments that traversed the French Academy in the late seventeenth-century, the terms of rhetoric are harnessed to the work of colour in order to claim a non-textual specificity for painting, as if the task were to recover a sense of the rhetorical that refused not only Plato's condemnation but also Aristotle's literary recovery and domestication of it. The new model of rhetorical action and expressivity would no longer depend on matters of meaning and the decoding of meaning. Rhetoric would be freed from, and made prior to, sense: as colour would be freed from, or made prior to, design. To speak of 'rhetoric' in relation to the late seventeenth-century practice of imitation is thus not to speak of either illusion or of rule-bound public speech, but of a practice of 'colouring' language or pictorial images: an affective stylistics, as it were. The visual and the textual are tied together by a rhetoric that is understood in terms of neither literary nor painterly meaning, neither narrative nor design, but which aims instead at presentational expressivity.[10]

The separation of the visual from the textual no doubt gains its most explicit and historically significant form in Gotthold Lessing's 1767 *Laokoon* with its strong argument for the fundamental differences between the imitative modes proper to the visual and textual arts and, most particularly, the difference

between a visual orientation to the instant and a textual orientation to narrative. The painting is seen all at once, the text read over time. While Lessing continues to think of both the visual and the textual as essentially imitative of the world and also thinks of both as essentially language-like, simply shifting the terms in which language is understood from rhetoric to semiotics, his work opens the door to the increasingly metaphorical use of 'language' in relation to visual art.[11] This usage prepares the ground for the modern sense of a 'language' of painting that is wholly embodied in the act and stuff of painting, and thus radically unassimilable to the 'language of language' embodied in the work of literary art. It also gives rise to the recurrent modernist efforts to recover a proper sense for the metaphor of language, whether through the coded abstraction of a Kandinsky or through the more severe reduction of the painterly to the semiotic at work in Duchamp.[12]

The modernist dispersion of the classical unity of the arts is thus multiple and uneven. The very notions of the literal and rhetorical are reinvented differently within the separated arts, as are their relations to such key notions as time and meaning, word and figure, colour and design. The histories of modern art and art history in their engagements with and disengagements from the 'literary' (along with their acknowledgments and denials of the inner coherence of the visual), read in good measure as complex symptoms of this continuing work of reinvention. At this level, modernism appears as an ongoing struggle to find adequate terms of translation both within and among the arts, torn between an impulse towards reintegration and a drive towards increased specificity and particularity. The various paths opened towards medium specificity all bid to free mimesis from its dependence on representation of the world or its meanings. Each particular art now seems called upon to realize its self above all, and this task may lead it to transform the notion of representation or to break with it altogether. The subject that a painting imitates becomes no more than a pretext for its exploration of its own nature, just as poetry comes to take the world of which it speaks as merely the pretext for focusing on the particular problems inherent in speaking of that world, on the problems of poetry. Modernist criticism of both visual and literary art has given us a number of different phrasings of this new task. We may want, for example, to speak of a new achievement of 'self-consciousness', or of 'purity', or of an emancipation from nature, from the copyist's enslavement to his or her object.[13] And we may gloss this by saying that imitation remains, but has become reflexive: rather than imitating a world the modern artwork represents itself, imitates its own making. But we might equally want to say that the modern artwork represents nothing and that its achievement is simply to be the work that it is (and we may well be uncertain whether this is or is not the same as saying that it refers to itself).[14] In this second mood, we may come to think of the task of the avant-garde as the defeat of meaning. Yet even as we say this we may also recognize that this endeavour will always come, in time, to nothing: as, for example, the immediacy of Pollock's skeins of paint gives way to the classical form of their rhythm, the drips falling into meaning, becoming marks not of spontaneity but of a particular conception of freedom at a particular moment in a particular political history and struggle.[15]

The questions that open along this path remain with us, and current claims to postmodernity perhaps only repeat and sharpen them: what would it be to

move beyond representation? Would this be an achievement or an evasion? How do being and meaning come together or fall a part in things we recognize as works? How far is such recognition dependent on institutional circumstances and conditions, and what kinds of limits do these impose on our imaginations of autonomy?

AESTHETICS

The Refusal of Representation

A second narrative of the differentiation between vision and textuality draws upon many of the same facts as the one we have just sketched, but places its emphases and key terms very differently. Aesthetics differs from poetics because it understands art primarily in terms of the problems posed by its reception rather than its production. Questions of representation and its modalities thus give way to a primary concern with the distinctness and uniqueness of the art object. What makes this appear as a painting rather than a failed painting or mere decoration? What makes this appear as a poem rather than prose? What claims are exercised upon the reader or viewer that can only be exercised by this particular form? What effects exerted by a given work depend upon its material specificity as work rather than upon its meaning or the object it represents? Underlying this approach is the Kantian insistence on what one might, somewhat tendentiously, call the formal meaninglessness of the work of art. The more positive statement of this insistence is that what the work of art accomplishes is an experience of the deep fit between the general structure of the human mind and the objects it grasps, so that in experiencing beauty – a term and experience we now cannot bypass – we are struck with our fitness to the world we inhabit. The focus on mimesis is displaced by the sense of an appropriateness that has no reference outside itself. In ordinary language terms, the aesthetic judgment 'this is beautiful' implies 'this feels right' rather than 'this is accurate'. Quality is a feature of the experience of the art object independent of either its perfection (achieved by the observance of external rules in its making) or its descriptive accuracy. Thus, the field of objects picked out by aesthetics is not defined in the first instance by a relation, positive or negative, to representation. The emphasis on specificity of work and medium takes the modern divergence of visual and textual as the emergence of a core truth of art and of aesthetic experience, and so also takes that truth as one that must in some sense already underlie our experience even of those non-modern works that present themselves as oriented, first of all, to representation. In the field defined by representation, 'art' is at best a restricted region and, more often than not, one to which our access has been essentially falsely restricted by the imposed mystification of 'aesthetic value'. The aesthetic account, by contrast, takes it that the term 'art' picks out an experience and an order of value that is irreducible to the terms of representation in general. Evaluation, rather than cognition, is the activity proper to the reception of the work of art.

This means that judgment is an ineradicable dimension of art historical activity, that art history is fundamentally bound to criticism and has no

non-evaluative foundations. This position appears, on the one hand, to be at odds with the modern ambition of art history to attain the standing of science, and, on the other hand, to be the primary marker of art history's autonomy over and against its dissolution into a more general field. The question of the aesthetic thus implies the separation of two projects – the scientific study of cultural representations, and a critical discipline grounded in certain claims to experience – each of which can claim history as its terrain. This contrast between the cognitive study of representations and a specifically aesthetic judgment is also a distinction between two notions of 'theory': while science is guided by theory in its search for knowledge about objects and does not happen apart from it, aesthetic judgment is fundamentally at odds with theoretical understanding. That is, to say the experience we have described as one of being struck with our fitness to the world we inhabit is not an experience of cognitively understanding that world; aesthetic judgment is not an experience that enhances our agency or satisfies our desires. There is no intellectual or practical profit in it. One might be tempted to say that it has less to do with the facts of our existence than with its (emotional or grammatical) mood.

To speak of 'mood' is to invoke a peculiar term within the psychological lexicon, one that marks the unstable boundary between those emotions we claim as actively our own and those feelings to which we seem more passively submitted. Moods are, after all, something we suffer from rather than decide to have. Aesthetic judgment, like mood, stands at the boundary between action and passion, between things we in some sense do and something that is more nearly an underlying disposition; we may, for example, enjoy a film or not, and we may also attribute our ability or inability to do so to being in or out of 'the right mood', 'the mood for it'. The spatial markers in these idioms – 'in', 'out' – are perhaps useful indicators of the way in which moods belong to a particular individual while being nonetheless experienced, however obscurely, as exterior to that individual. One might consider here the difference between being 'angry' and being, or finding one's self, 'in anger'; the latter phrase invokes special circumstances that exceed individual psychology, such as Achilles before the walls of Troy.

The experience of beauty in its distinction from our other pleasures is perhaps to be imagined along these lines. There is a passivity to it, an independence from our particular agency and interests, and a sense of its having more to do with the conditions under which the world appears to us than with our particular relations to particular items in it. When we are 'in a good mood', it is not that we are explicitly judging the things we encounter as good: rather, the implicit, more or less 'lived' judgment of goodness seems to be a condition for things being encountered at all. One will be naturally hesitant to call this a 'judgment'. It seems too automatic, too little our own doing; and one can, of course, often enough find oneself in situations where one's mood and one's explicit judgment are at odds. But this also points towards the ways in which a mood is a sort of involuntary judgment (we would not feel the conflict were it not), and this is certainly what Kant means to argue about the experience of beauty: the judgment of beauty is integrally part of the experience of beauty and not a verdict offered upon it. According to Kant, we do not first approach an object cognitively (gain knowledge about it) and then, subsequently, evaluate it aesthetically. Rather, if we are to approach it aesthetically, then the ques-

tion of beauty arises in a way that forestalls cognition: beauty impresses us, impresses itself on us. It happens to us, and we are obligated to it, to own it or deny it. And if we do own it, we do not do so in our own individual names but simply in the name of the human capacity to be so struck. Here we pass beyond the analogy to mood: if I am out of sorts, I know it is merely me, but on Kant's account if I find something beautiful I am entitled to expect that anyone else will also find it beautiful. The pleasure I feel cannot be attributed to any interest that is merely mine but only to the absolute specificity of this encounter of mind and object in me, as my experience of it. In stressing the passivity of Kant's judgment of taste, we mean to underline the ways in which he presents the experience of beauty as of a certain kind of deliverance from the normal work of relating, intellectually or practically, to the world. Where our normal position is one of continuous effort to establish such relations to the world, with beauty we experience an object as if it already related to us, as if it were fitted in advance to the structure of our perception, setting our faculties into a state of harmonious freeplay in which we think nothing in particular.

Beauty is in this sense healing, offering an experiential guarantee of the possibility of overcoming the various gaps and fissures that mark Kant's accounts of knowledge and morality. More particularly, Kant's *Analytic of Taste* is a part of the *Critique of Judgment's* general attempt to guarantee that the moral agent described in the *Critique of Practical Reason* and the knowing subject described in the *Critique of Pure Reason* are and can be known to be the same. The *Critique of Judgment* moves us to address the question of whether reflective aesthetic judgment provides a bridge over the abyss that apparently divides the realms of knowledge and morality, or whether it provokes something more like an acknowledgment that the relation of knowledge to morality is abyssally divided? The stakes of this question are raised further by the third critique's inclusion, along with the judgment of beauty, of the judgment of the sublime.

The Kantian sublime is an experience of one's difference from, separation from, the natural world, and so also, on Kant's account, a discovery of one's autonomy, one's freedom from the empire of the world rather than of one's fitness to it. The experience of the sublime is an experience of what overwhelms us, of what cannot be taken in – and, nearly simultaneously, of our ability nonetheless to rise or stand above such things. The sublime presents an object that exceeds cognition, and the subject experiences a mixture of pleasure and pain: pain at the incapacity of the faculties to come to terms with this object and pleasure at the capacity of the faculties to recognize their own incapacity. One might imagine it as linked to the human ability to recognize something as 'too big': the capacity to make excess itself count and not simply exceed.[16]

For Kant, the two experiences of beauty and the sublime are both fundamentally experiences of nature: of flowers and sunsets, on the one hand, and of raging oceans or boundless skies, on the other. They are significantly different in important respects, perhaps most notably in beauty's being universal, since it attaches to the mere structure of rational cognition, and the sublime's being culturally and historically variable, since it is related to our variously developed capacities for cognition (if we pasture our cows on the Alps every day, we are not likely to be overwhelmed by them; if we are not prepared to hold certain ideas of freedom and equality, the French Revolution will be merely another political event).

The Kantian account of human art would appear, then, to be stretched between these two experiences: of nature as something we belong to and which enfolds us, and of nature as something that expels us and folds us back on ourselves. Art would be always held in tension between these poles of beauty and sublimity, necessarily a pure case of neither, and the experience of art would seem to draw on both the healing force of beauty and the disjunctive self-discovery entailed by the sublime, sketching out these modes of sheer presence and self-presence without handing itself fully over to either.

It is perhaps a hallmark of modernism in visual and literary art and criticism that it has wanted to settle this tension one way or another, and most often in the direction of Kant's notion of beauty, thus taking or making the work as the very paradigm of radical presence and identity, the thing that is fully what it is. Modernism seeks the presence of beauty, offering beauty as presence. And it may then be useful to note that the invocation of the postmodern, by contrast, tends to appeal to the sublime. To the extent that this postmodern invocation merely replaces the one settlement with the other, it would seem simply to reproduce the terms of modernism within a new register. Postmodernism so conceived becomes but one more distinct historical formation, a period in the history of artistic practice and modes of presence. But where this postmodern appeal to the sublime appears more nearly as the recovery of a suppressed but essential dimension of what we have known as modernism, and so also a new stipulation of the conditions under which modernism might be said to continue, postmodernism becomes a stranger category: neither quite the name of a period nor a style, but a way of pointing towards what undergirds such names or classifications and entails their ongoing transformation, their exposure to time.

Just as with representation, so with the aesthetic: we appear to find ourselves in a moment of crisis and uncertainty, torn by impulses that can find expression either in an assertion of the end of aesthetics as a central concern for history and criticism or in an assertion of its renewed pertinence. We may want to describe the present as a moment of passage beyond Kant, or as a passage within Kant from an aesthetics of the beautiful to an aesthetics, and perhaps politics, of the sublime, or as a passage into the complex play of the one in and against the other. But our questions in this region will, for the most part, no longer be about what a work means or represents; they will be about whether and how the notion of 'a work' can still count for us, about whether and how we can grasp such objects as at once autonomous and self-contained, and transgressive, or about whether and how we can understand what in a work might both draw us beyond ourselves and throw us back upon our own subjectivity and agency.

INSTITUTIONS II

Discipline and Dispersal

The modern university can appear to be predicated on the dispersion of the arts into their separate media, a dispersion that acknowledges the claims of the individual arts to autonomy both with respect to one another and with

respect to the broader fields of social and cultural practice against which they stand out. At the same time the university has also tended to resist understanding its institutional arrangements as founded on explicit judgments of value – we are in general increasingly uncomfortable with canons and Arnoldian criteria – and has instead promoted an understanding of its essential activity in terms of 'research': an understanding that allows little purchase for talk of 'the experience of beauty' and so on. It has thus tended to drive a wedge between criticism and history, ceding the work of criticism increasingly to journalism rather than the academy, albeit not without a residual tension between the two with which departments of literature and art history both continue to struggle.[17] This disciplinary pressure has also created a rather more diffuse gap between the terms in which a faculty understands its 'research' mission and those in which it tends to pose its teaching activity, a gap that is certainly one of the major sources of energy for the debates over value, canon and curriculum that have recently been so prominent both inside and outside the academy.

Our introduction has tended to pose this sustained institutional uneasiness as if the modern history of the humanities were, to a high degree, the history of a struggle between mimetic and aesthetic conceptions of the disciplines, a struggle in which a disciplinary impulse oriented to autonomy and separation is repeatedly doubled by an interdisciplinary impulse that means to reassert the convergence of interests between art historians and literary scholars. Unsurprisingly, this tension has not been confined to relations between the disciplines but has repeatedly emerged within them: the practice of the social history of art as well as the persistent re-emergence of concerns for the decorative and such like within art history are, like the emergence of 'cultural studies' and related fields within national literature departments, symptoms of a pressure within the disciplines themselves to transgress the existing boundaries. It is perhaps not the least of the oddities of such a situation that many of those who argue most strongly for the specificity of their discipline tend to buttress their arguments through an apparently self-contradictory appeal to the paradigms of the opposed discipline.

If we look, for example, at the formation of 'English' as a distinct disciplinary and departmental formation within the US university, we find it crucially linked to the New Critical understanding of its activity as the reading of texts in their literary, rather than historical, specificity; but we also find this argument repeatedly filled out in terms of apparently visual criteria: the poem becomes the 'well-wrought urn', the 'verbal icon'.[18] At the same time, the emergence of art history, under the aegis of Erwin Panofsky and his followers, turned on an analogy between painterly and literary meaning so deep that the study of painting not only finds its objects to be like texts, but in many cases ends by finding their meanings precisely in and as texts.

As contemporary theory has found its way into the university, it has necessarily entered into complex, sometimes obscure and self-defeating, negotiations with such disciplinary arrangements and divisions, sometimes seeming to weigh in on one side or the other of the struggle, sometimes claiming to displace or transform it. Inevitably, the very terms in which theory is grasped and taken up are reshaped by the existing structures of the various fields it enters, and its deep inclination towards the discovery of new questions and

new objects is turned, with varying degrees of clarity and success, towards old questions and old objects. That the distinction between 'old' and 'new' can only be relative is an important reminder both of the limits of theory's news and of the justice of our confusions; that radical novelty is necessarily unrecognizable is perhaps an index of theory's own avant-gardism, its own problematic aspiration to a status associated with art.

We have, for example, drawn in this introduction on Deleuze and Guattari in order to mark the 'and' that links 'vision' to 'textuality' in this volume's title, and in so doing we presumably mean, among other things, to fix a specific difference between the range of writings represented here and those that might have figured in a volume of the same title just a few years ago. That volume would have seen its work in terms of an 'inter-arts comparison', assuming separation and working to build bridges of analogy or interest where we have posited adjacencies and transformative flows.[19] This difference can itself be read variously. If we continue to follow Deleuze and Guattari in asserting that the art object no longer appears as object but rather as a constellation of processes, offering and offered to a series of reading heads (such that there is no convergence towards a fixity of form or apprehension but a constant divergence in which any given path is always to be marked as the leaving of others), we may be in some measure harnessing our justifications to a further reading of postmodernity. Such a postmodernism would understand itself as a resistance to an order of mass communication in which subjects appear as mere relays within a global network of diverse and incommensurate information flows. In the context of mass communication and reproduction of information, such interdisciplinary work does not simply aim to reunify and reintegrate a general idea of culture that technology has fractured and specialized, in the tradition of German Idealism:[20] rather, it poses itself between the twin poles of mass-cultural homogenization and disciplinary isolation to ask pragmatic questions about the uses and functions to which knowledges are put and the exclusions and blindnesses that ground the possibility of the production of knowledges not only in reference to specific disciplinary projects, but also in terms of a general regime of knowledge production.

For such a postmodernism, there is no appeal to theory apart from further acts of historical, political or aesthetic location. This is what it means to speak of the work of theory rather than of the results of research. Such acts of self-location or positioning are themselves moments variously of fixation or transformation, and we can ask of them, for example, how far and in what way they assume a certain separation from or adjacency to their objects. Is the 'past' they posit distant in a way that calls for the development of mediating apparatuses – bridges of sympathy, scholarship or point of view – or is it posed as proximate, as that from which our present and our presence to it depends? If we accept agency as an integral dimension of the writing of history, how do we see that agency flowing? Is the past that in which we intervene, or is it that which may yet intervene in us? And if we are not satisfied with this choice, how else can we have or be had by the past? What kind of issue is time for us as historians or as critics?

We have, in the immediately preceding sections, produced certain narratives that we hope usefully open up the interplay among the various contributions in this volume. These narratives are, presumably, active ways of shaping

and claiming a certain present, a present in which theory finds for its occupation a certain range of places and these, like all places, open on to certain prospects and occlude others. It is, for example, a prominent feature of our excursus on representation that it does not give much place to the notion of representation as accurate depiction, and that it accordingly downplays the neo-Classical turn that describes mimesis in terms of illusion, on the centrality of convincing the viewer that the representation in question reflects a world. In so doing, we lose, abandon or refuse a resource that works powerfully in certain other appropriations of theory: the availability of 'realism' as a central historical and intellectual norm against which other moments are to be measured, whether for better or for worse. To understand mimesis in terms of realist illusion, and then to denounce it, does allow one to produce satisfying grand narratives about the history of artistic practice, either as the search for accurate depiction or as a falsification which needs to be made to acknowledge its conventionalism. However, there are also certain gains in the abandonment of such narratives (and the descriptive dichotomy of truth and falsity by which they are structured): for example, we do something to prepare the thought that particular objects or periods figure in the writing of art history not as pictures – either accurate or inaccurate, either in just perspective or wilfully distorted – but as rhetorical *exempla*, as appeals to (the prospect of) our collectivity and our difference. To say this is to think of the social inscription of art not simply in terms of ideology or propaganda but as fundamentally the appeal to a certain pragmatic institution of a heterogeneous community.

If the opening of the disciplinary as a question in art history is our aim, does that mean that we will understand that question in relation to Realism, or mimetic illusion (and will that mean we take ourselves as 'modern')? Or will we ask that question not simply in terms of the kind of truth Realism seems to offer (or the abandonment of that truth) but as a question concerning acts of persuasion amid fields of circumstances and discursive mobilizations (and what will that make us)?

John Baldessari, Rembrandt van Rijn, the English pleasure garden – all the objects, periods and styles that emerge and vanish in these pages – are readable then as so many points of flight, so many gestures towards instituting one or another art history or literary history: so many ways of sighting, and siting, the work of the university as if 'departure from' could come to be a way of saying 'department of', as if the task now were to realize Art History as its own depart-ment.

POSTMODERNISM

The Ends of the Aesthetic

A phrase like 'depart-ment' of Art History inevitably prompts a certain thought of ending, of other phrases likes 'the death of art' or 'the end of the history of art'.[21] These phrases are in their turn connected with our own recurrent point of departure in these remarks. For us, as editors, the question at work across the various contributions in this volume is in large part whether

or not the current invocations of 'the postmodern' mark any deep transforma-
tion of this field, whether or not they open any new way to think the intersec-
tion of the visual and the textual. There is certainly no unanimity of opinion
among the contributors on the response to this question, but they do seem to
us united in a shared recognition that the discourses of both art history and lit-
erary study are undergoing a major shift, which they variously tie to recent
theoretical work in fields as diverse as semiotics, psychoanalysis, philosophy
and political critique. One aim in bringing such diverse approaches together,
then, is to make visible the ways in which what are sometimes called 'the new
art histories' are more or other than the simple transportation into the field of
painting and allied arts of theories developed primarily in the analysis of liter-
ature, and so also to make visible the ways in which the institutional stakes
are not reducible to simple issues of 'autonomy' or 'assimilation'.

 There is, of course, now a vast and far-from-unanimous literature on postmod-
ernism and postmodernity: it is here, it is not here; it is a good thing, it is a bad
thing; it is an occasion for despair, it is a moment of celebration; it is late capital-
ism, it is postcolonialism; it is a fall into mere simulation and repetition, it is a
step into powerfully liberatory parody; and so on.[22] Any attempt to do justice to
this welter of writings in the compass of a short introduction would clearly be
futile, but it does seem useful to suggest that the term 'postmodern' will come to
seem valuable or necessary only when one is persuaded that the terms that have
seemed capable of grasping one's history and circumstance have become ex-
hausted, and have ceased to be able to grasp what is there to be grasped.

 For those committed to one kind of representational account, 'postmod-
ernism' will, evidently, point to the exhaustion or inadequacy of representa-
tion as either an artistic process or a way of understanding art. The most
familiar form of this as a claim to postmodernity is the sense that there is no
longer – perhaps there never was – any world or self to be reflected in the
work of art, or to be looked out on through the painting, or to be looked into
and given expression by the artist. What there is – or what we can now show
there always was – in the absence of a world present for representation is an
ideological work of construction and placement that masquerades under the
presumed naturalness of representation. Such naturalness is now to be
undone everywhere in an ongoing critique authorized not by some imagined
truth prior to representation and against which any given representation
might be measured but by the practical, primarily political, exigencies of the
present: exigencies whose ultimate and explicitly impossible aim must be the
refusal of representation altogether.[23]

 For those committed to a more aestheticist account, 'postmodernism' will
point to an apparently different kind of exhaustion, as if what has come to an
end are not simply the formal possibilities embedded in abstraction but the
logic that underwrote the seriousness of those possibilities. On the Kantian
account that underlies the aestheticist impulse, this would mean that what is
no longer available – or what was perhaps never really available – is a certain
experience of attunement or of being at home among things. One mark of this
exhaustion would be an upsurge of interest in the sublime: the experience, as
Kant describes it, of a certain insuperable distance between us and the world,
a distance made explicit in those moments in which we find ourselves unable
to take things in except as exceeding our cognitive and perceptual means, thus

throwing us back on, or discovering for us, a capacity nonetheless to register what we cannot make present to ourselves. If the representationalist account can be said to stress a certain end to meaning, the aestheticist account can be said to stress an end of persuasive meaninglessness (often phrased in terms of a fall into fragmentation or an undoing of the unities of the self). There is an odd symmetry in the fates of these two accounts: repeatedly crossed in their initial narration, so also they now cross in their crisis. It has been and continues to be tempting to register this crossing through the assertion that the sublime marks a limit to representation.

Some critics of postmodernism have written of it in terms of a 'hysterical sublime', understood as the damaging loss of modernist critical consciousness. Here the terms of analysis are typically drawn from Marxism: once late capitalism hails the political subject as consumer rather than producer, ideology takes the form of sensory overload rather than of falsification. Critics such as Fredric Jameson and Terry Eagleton invoke the sublime to characterize an effect of domination in which the subject is swamped and seduced by commodities, rather than chained to the dark Satanic mills of early industrial capitalism.[24] In general, such criticisms of the sublime form part of a generalized suspicion of the aesthetic domain as conduit of ideological mystifications and the operator of reifications that is characteristic of Marxist-inspired cultural criticism.

Others, such as Jean-Luc Nancy and Jean-François Lyotard, have invoked a postmodern sublime as a way to refuse the possibility of a bridge between the aesthetic and the political. They have appealed to the sublime displacement of subjective cognition in an attempt to make claims about art and society that refuse the possibility of either a beautiful society or a socially determined art.[25] This understanding of the sublime follows Kant in drawing a rigorous distinction between determinate judgments that measure a thing against a concept or set of rules, and indeterminate or reflective judgments for which there are no standards external to the experience. The aesthetic exacts thought, and the sublime names the aesthetic as the questioning of fixed rules or criteria. The postmodernity of this questioning perhaps lies in its insistence on the tendency of all authentically aesthetic questions to become sublime ones.

In the first case, postmodernism is understood as a response to modernism, a new epoch and a new episteme; in the second it appears more nearly as the recovery of a suppressed but essential dimension of what we have known as modernism, and so also a new stipulation of the conditions under which modernism might be said to continue: not a new episteme but a rewriting of modernism in terms of what it has repressed by privileging the beautiful over the sublime. On this latter view, it will be more or less natural to imagine modernism as worked by a certain unconscious, a certain repression, that is now to be lifted or worked through in new ways. This task will belong to the historian as fully as to the artist or critic.[26]

The postmodern turn to the sublime, whether it is attacked as a hypermystification or upheld as the decentring of the modernist subject, brings together the visual and the textual once more under the aegis of a generalized aesthetics. Where the modernist focus on beautiful form had pushed towards a greater separation of the two modes, had driven poetry and painting to cleave more nearly to their own particularity as the outward index of quality,

postmodernism seems oriented to the shock of heterogeneity, and most espe-
cially to the presentation of modes of visual and textual co-presence that do
not offer themselves to synthetic appreciation. That is to say, the incommensu-
rability of visual and textual materials is not overcome in the act of under-
standing: apprehension of objects prolongs their heterogeneous co-presence.
This is not simply a stylistic feature in contemporary artworks such as those of
Barbara Kruger; it is also the problematic that underlies the attention given by
post-structuralist critics to all those things (such as frames and signatures) that
limit or disrupt the imaginations of aesthetic purity or medium specificity
across a wide historical range of artworks. This impulse towards dispersion
and difference gains still further expression through the siting of works such
that the interaction of objects and their cultural textualization threatens or
undoes the object's apparent visual unity. And again, the contemporary
production of site-specific works goes hand in hand with a general critical
problematization of the relation of text to context, of image to institutional
framework. The postmodern sublime can thus be understood as the *active
consequence* of foregrounding the simultaneous incommensurability and
intimacy of the visual and the textual.

To the extent that the postmodern invocation of the sublime points to a
general and necessary fissuring of the art object, it seems to invite us to reread
notions of 'art' and 'the aesthetic' beyond the terms of their modernist enclos-
ure and yet without simply dissolving them into the broader representational
field. We might, then, want to speak of this in terms of a working at the decon-
struction of the binary opposition between aesthetic autonomy and a general
history of cultural representation: a work that keeps open the aesthetic as a
question by refusing either to mystify art by claiming that art provides its own
answers itself or to argue that the answers to the question of art can be
exhaustively provided from elsewhere, from a general history of culture. Such a
work is, in Lyotard's terms, a way of thinking about the logical inconsistency of
the remark 'This is art', in which the specificity of the case must supply the very
rule of cognitive understanding that is in question.[27] It can thus lead us to ask
new questions of art as something whose relation to its cultural context is not
adequately registered in the choice between autonomous value and mere
mystification, and the cultural effect of which cannot be exhaustively described
in terms of cultural representation or social meaning.

BLINDNESS

The Distance of Interpretation

One might thus see, behind the current recollection of the sublime, a reopen-
ing of the question of interpretation not as a question of method, criteria or
validity but as a question about how it is that things are open to interpretation
in the first place. Panofskian art history and New Critical reading are strong
solutions to the questions of method and criteria, the first tending to answer
the question in terms of representation and the second looking towards an
aestheticist solution. Both tend to presume a certain self-evidence for their
objects, suppressing the prior question of the availability to or demand for

interpretation in favour of telling us how to interpret. Panofsky will tell us how to insert an object within a general history of meaning, and how to see through an object into the history of meaning to which it belongs; Brooks will tell us how to abstract the text from any dependence on representation so as to determine what it is. Both these passages, from apparently self-sufficient image to the historical field of language and from the historical field of language to self-sufficient image, symptomatically point towards what they repress in their attempts to model their specific objects on the objects of the other's field; as if what remains unimaginable to both is the prospect that an object could be at once an object and in language.

'Theory' is at least as messy a term as 'postmodernism', but here too it seems possible to venture at least one generalization: that the passage to theory is operated, above all, by one's assent to some form or other of the proposition that interpretation is primordial (we do not perceive any thing except by perceiving it *as* something). Contemporary theory offers two powerful proposals for grounding this 'as': in the priority of practice over theory, so that interpretation is understood in general as our grasping of something within an overarching context of practical activity and purposes, or in the priority of language over brute sensory perception. In the first case, I grasp this hammer as a 'to-hammer-with' and only subsequently develop a more theoretically distanced relationship to it (I call it a hammer, analyse what holds the head to the handle, and so on). In the second case, I can grasp the same hammer as 'a hammer' only because my language delivers it to me as the sign of a hammer, as other than 'a mallet' or 'an axe' or 'tongs', each of which contributes to mark its place in our language and to make it appear as a complex intersection of carpentry, music-making, the physiology of hearing, and so on (an intersection, and so an object, that exists only for the English 'hammer' and not for the French *marteau*).[28]

These two ways of understanding the primordiality of interpretation move in significantly different directions. If one's primary orientation is to the first of them, one's question of a text or picture will be, in the first instance, what purpose does it, or can it, serve? If one's orientation is primarily to the second, the question will be, to what system does it belong? The first aims at incorporating the object into a world of doing, the second at understanding its place in a system of places. Since both assert the primordiality of interpretation, neither can be imagined as moving to recover a meaning that lies outside of, or prior to, the act of interpretation itself; but each must instead present itself as entering into a movement, practical or linguistic, that is already under way at any and every moment of the object's emergence in time. Both, that is, conceive the object itself as essentially unfixed, its identity permanently open to futures of radical novelty (the rock may at any moment be grasped as hammer as it may also at any moment find itself made to figure in enunciating the foundations of, for example, a new church).

What binds these two practices of interpretation together is, on the one hand, a recognition of interpretation as an activity with no foundation outside itself (an activity that includes and does not simply repose upon – or is not simply imposed on – its object) and, on the other, a recognition of the work of interpretation as essentially one of articulation rather than nomination or generalization. Interpretation is, then, less a mode of knowing than it is of

demonstration, of putting to work: to read a poem is not to take in its meaning, in however sophisticated a fashion, but to enter into its effects, to show what it does (which includes, among other things, both meaning, now conceived as one of its ongoing effects, and showing, both in itself and in its interpretation, which would then not be, or not simply be, our act).

There is a great deal in this vision of interpretative articulation, unfolding or demonstration that looks powerfully capturable with the aid of the Saussurean view of language as a net of unmotivated and differential signifiers thrown over a universe of potential signifieds that are brought into actuality when we speak, pulling the lines of the net taut and harvesting a world. And yet there is also a problem with this Saussurean view that becomes perhaps most apparent when we look at Saussure's writing as itself structured by an interplay of the visual and the textual and notice how far it depends on a certain investment of the visual by the textual (as, for example, in his presentation of the theses we have just outlined through the image of a signifier 'tree' placed in relation to a signified image of a tree). This pictorial notation would have us imagine the signifier coming in some sense to stand for or represent either the tree or its image. This 'either … or' measures a slope down which Saussure's notion of the signifier slides towards the notion of the sign, a slide that is epidemic in contemporary theory and that returns the problem of interpretation to the field of representation through the tacit taking of the signifier or sign as a metaphor. The bar that is so often placed between signifier and signified in this familiar diagram now looks like a device for sep-arating the textual and the visual precisely in order to reassert the dominance of the former over the latter (a gesture whose flipside would be the Saussurean denunciation of writing as a mere picture of language rather than a part of its living substance).

Against this there is, it seems, every reason to reassert what is perhaps most fundamental to the argument that interpretation is primordial: the contention that the field of signification is inherently shifting. Meaning exists nowhere else than as it arises in the acts of interpretation that accompany and consti-tute the possibility of perception. If we are to continue to speak of 'representa-tion' in such a field, it cannot be by taking objects as standing for something absent, for a meaning of which they are the vehicles. Interpretation thus loses the prospect of closure or finality, of replacing the object with its meaning, of determining the object as having just been a metaphor for something else, all along. The interpretation is not a move behind or beyond the representation to its hidden meaning: it is rather a work of prolongation of the object, its exten-sion into other spaces, other contexts, and as such a prolongation it does not allow of any easy or final distinction between what is present in it or absent from it. If this is so, then the contrast between the aesthetic presence of an object and its representational work will no longer have any force for us. This would be a further way of defining the postmodern, as that moment when the competition between the claims of the aesthetic and the claims of representation comes to an end, not because one has defeated the other but because it is recognized that whatever was going on between them was not a contest at all. If we take interpretation as the metonymic prolongation of its object, then it appears that we will no longer be able readily to distinguish the critic, with his presumed eye to value apart from time, from the historian,

with her presumed defining temporal relation to her object. Rather, an inter-minable analysis relinquishes both the promise of immediacy and the comfort of critical distance. The interpreter stands at once in time and in intimate rela-tion to the object, and so does not stand outside its judgment. The phrase 'its judgment' is intentionally ambiguous, designed to force a recognition of that judgment as finally attributable neither to the observing critic or historian nor to the work itself. Rather, the judgment belongs to their relation, to the act of interpretation itself, and does not stand apart from it. It is a matter, then, of one's attachment to one's object. One might want to speak here of the way in which one finds oneself promised to that object and so put into play by taking up that promise, making one's self its subject; or one might choose to speak of one's desire for an object and of the ways in which no object can satisfy that desire, leading one into an endless movement of repetition and alteration.

How are we to read this situation? Does it renew the Kantian account of the way we are struck by beauty? Or are we to take our becoming subject in this way as a way of determining our political location in the face of a work? What kinds of understanding of our own positions as interpreters are open to us and what are closed? What kinds of interpretive action can we imagine our-selves engaged in?

At one limit, these questions return us once more to Deleuze and Guattari, and now we are entitled to ask how far, finally, their position registers a scep-ticism grounded not in the usual sense of an object's distance from or inacces-sibility to us but in a new sense of our radical intimacy with it, an intimacy that permits intensity but forbids reflection. Would such absolute relation be something to fear or to long for?

It is perhaps a complex pattern of fears and longings that finally underlies our negotiations with the visible and textual, as if what were at stake in finding some way to legislate their relation were a desire to rein in the terrify-ing prospect that lucidity itself might be a mode of blindness, our reflective distance from the world merely a manifestation of our indissoluble continuity with it, our interventions in it merely a moment of its working, our deepest judgments finally not our own. Such fears and longings are hardly unknown to the disciplines of the visual and the textual themselves, finding a certain expression in, for example, the constitutive tension within art history between vision as sight and touch, optic and haptic, or the tension in literary studies between text as voice and as writing.

INSTITUTIONS III

Does it Work?

We have suggested throughout this introduction that the modern university, especially in the USA, increasingly articulates itself around a diminished notion of objectivity. This is a notion that is compounded out of an uneasy blending of a residual sense of the university as a bearer or transmitter of cul-tural value with an ascendant sense of the university's fundamental orienta-tion to 'research', and of both with a rapidly growing sense of the university as a site for professional and pre-professional training. It is an easy enough

matter to pick out signs of what is still unsettled in this blend: debates over
the canon; demands that those seeking funding in the humanities do so by
casting their work into the moulds of 'methodology' and 'research outcome';
an increasing corporate presence on many campuses, in the forms both of
leased-out sections of the university and of its own foundation of corporations
internal to it. It is also easy enough to see the administrative regime that pre-
sides over this blend as a bureaucracy whose claim to legitimacy resides in its
expertise in 'education' rather than in educating.

'The humanities' in this university appear increasingly definable in terms of
their openness to invasion by the social sciences on one side and their 'educa-
tional' doubles on the other, both of which answer more compellingly to calls
for research than do the traditional humanities, whose only recourse increas-
ingly seems to be an insistence on their own professional viability: that is,
their own ability to reproduce themselves as evidenced by a continuing high
level of professional production. 'Objectivity' in such circumstances comes to
name at best something between a minimal sort of neutrality towards 'data'
and a commitment to the procedural formalisms embedded in the demand for
research; at worst, it comes simply to seem some other department's word.

'Theory' has, more or less from its beginning, been received as offering a
challenge to received institutions and modes of knowledge; it has in fact
shown itself to thrive within the contemporary university and has proved an
immensely powerful support for the professionalization of the humanities
within it. There is perhaps no fitter emblem of this than the enthusiasm and
alacrity with which the term 'theory' itself has been embraced, as if possession
of that talisman alone were enough to guarantee a future to fields that would
be groundless without it. And it has turned out to be a wonderfully flexible
tool, putting at one's disposal all the equipment necessary to articulate one's
work in terms of the required procedural formalisms while nonetheless
freeing one of the nagging question of objectivity by asserting a crucial
methodological place for subjectivity (suitably transformed by the protocols of
'theory').

The institutional outcomes so far have been predictable: 'theory' has served
as a way variously to give new gloss and shape to various departments, to
justify a myriad of new programmes in such areas as film studies, popular
culture, gender studies, and so on, and to underpin the emergence of new
transdisciplinary formations such as 'semiotics' and 'cultural studies'. None of
these is inherently bad; indeed they are important and valuable effects of the
transformations set in motion by theory, significant pieces of the difference it
has already made. But to the extent that they have allowed themselves to have
been caught up in the contemporary university logic of disciplinary
discreteness and professional performance, they fall short of the radical
transformation which theory once appeared to promise.

It is, of course, possible that the hope that theory's questioning of disciplin-
ary structures would bring about major institutional transformation was
excessive from the beginning. The wager of this introduction is, however, that
it was not and that it remains to be understood, let alone taken up or secured.
This is why we have worked in these pages to bring out those dimensions of
the book that follows which do in fact constitute a conversation about what it
is to have an object – to find one's self in that relation – rather than to present

the various contributions as so many exemplars of one or another new methodology. Each of the following responses to the question of vision and textuality assumes or implies a view about the nature and adequacy of the institutional boundaries we draw around ourselves, and about the nature and adequacy of our imaginations of both disciplinarity and interdisciplinarity; therefore we would have you read in them not simply the theories they deploy but the diverse institutional spaces they imply. How are we concretely to imagine the site or sites of this work's unfolding? What difference can it make?

On 31 October 1994, shortly after reading the final proofs for this collection, Bill Readings died in a plane crash. If we had jointly dedicated *Vision and Textuality* to the memory of Louis Marin, there are now other memories embedded within it and in need of acknowledgement.

Both the lecture series on vision and textuality at Syracuse University and this book exist primarily because of Bill's energy and determination; getting these things to happen was, as it always is, a matter of pushing and prodding, finding ways through and around obstacles, herding recalcitrant details of procedure and organization into some more or less single direction, and so on. Bill was good at that kind of thing; but for the contributors, as for many of those who attended the original lectures, what will be most memorable is Bill's way of making everything happen beyond its details – the way he conceived intellectual life less as something to be administered than as something to delight in, an ongoing occasion for celebration.

The semester the series took place, I was teaching at Bryn Mawr College, as was Bill's wife Diane, so my memories always begin with the two of us speeding north through the night with a bombe au chocolat or poached salmon, along with an unhappy Russian Blue, in the back seat. There was no knowing what we would find in Syracuse – one night Bill and one of the guests wound up demonstrating the finer points of cricket 2 a.m. in the living room; another morning saw the three of us and another of the visitors drawing endless variations of the semiotic square on paper bags over equally endless cups of coffee; and on yet another day Bill and both his guests discovered a common serious interest in wine and spent all day preparing the evening's selections. For others no doubt other moments will stand out, but they will all come back, one way or another, to the extraordinary skeins of talk and food and argument and humour and drink and music and stories from which Bill wove the marvellous fabric that was his – and our – intellectual life. Is it too much to say that this too is a vision of the institution of learning, a site of this work's unfolding? Or to hope that it might provide yet another model for how to make this book work?

November 1994 STEPHEN MELVILLE

Notes

1 B. Wallis (ed.), *Art After Modernism: Rethinking Representation* (New York: The New Museum of Contemporary Art, 1984); A.L. Rees and F. Borzello, eds, *The New Art History* (Atlantic Highlands, NJ: The Humanities Press, 1984); P. Brunette and D. Wills (eds), *Deconstruction and the Visual Arts: Arts, Media, Architecture*

(Cambridge: Cambridge University Press, 1993); N. Bryson, M. Holly and K. Moxey (eds), *Visual Theory: Painting and Interpretation* (New York: Harper Collins, 1991).

2 See Bill Readings, 'Be Excellent: Culture, the State and the Posthistorical University' in *Alphabet City*, 3 (Toronto: October 1993).

3 Gilles Deleuze and Félix Guattari, *A Thousand Plateaus: Capitalism and Schizophrenia*, trans. B. Massumi (Minneapolis, MN: University of Minnesota Press, 1987), p. 4.

4 For a different but related reading of this 'and' see M. Bal, *Reading Rembrandt: Beyond the Word\Image Opposition* (Cambridge: Cambridge University Press, 1991).

5 On these topics, see, among many other things, R. Lee, *Ut Pictura Poesis: the Humanistic Theory of Painting* (New York: Norton, 1967); M. Foucault, *The Order of Things: An Archaeology of the Human Sciences* (New York: Random House, 1970); and M. Baxandall, *Giotto and the Orators: Humanist Observers of Painting in Italy and the Discovery of Pictorial Composition, 1350–1450* (Oxford: Oxford University Press, 1971).

6 Sir Philip Sidney, *A Defence of Poetry*, ed. J.A. van Dorsten (Oxford: Oxford University Press, 1973), p. 25.

7 On the space of memory in the Renaissance, see F. Yates, *The Art of Memory* (London: Routledge & Kegan Paul, 1966).

8 For the resistance within the history of art to this orientation, see S. Alpers, *The Art of Describing: Dutch Art in the 17th Century* (Chicago, IL: University of Chicago Press, 1983).

9 See M.H. Abrams, *The Mirror and the Lamp: Romantic Theory and the Critical Tradition* (Oxford: Oxford University Press, 1953); one might also note the apparent elective affinity between deconstruction and romanticism evident in the work of the so-called Yale School (Harold Bloom, Geoffrey Hartman, Paul de Man and J. Hillis Miller).

10 See R. de Piles, *Cours de peintures par principes* (Paris: Jacqueline Chambon, 1990); T. Puttfarken, *Roger de Piles's Theory of Art* (New Haven, CT: Yale University Press, 1985); and J. Lichtenstein, *The Eloquence of Color: Rhetoric and Painting in the French Classical Age*, trans. E. McVarish (Berkeley, CA: University of California Press, 1993).

11 See G. Lessing, *Laokoon: An Essay on the Limits of Painting and Poetry*, trans. E.A. McCormick (Baltimore, MD: Johns Hopkins University Press, 1962) and D. Wellbery, *Lessing's Laocöon: Semiotics and Aesthetics in the Age of Reason* (Cambridge: Cambridge University Press, 1984).

12 For this particular contrast, see T. de Duve, *Pictorial Nominalism*, trans. Dana Polan (Minneapolis, MN: University of Minnesota Press, 1991).

13 In art criticism, this view is most strongly associated now with the criticism of Clement Greenberg; see J. O'Brian (ed.), *Clement Greenberg: The Collected Essays and Criticism, Vols. 1* (Chicago, IL: University of Chicago Press, 1986). A similar tendency towards autonomy and purity may also be found in the work of Cleanth Brooks in literary criticism; see, for example, *The Well Wrought Urn* (New York: Harcourt Brace Jovanovich, 1947).

14 Drawing this distinction is an important element of M. Fried's controversial argument in his widely reprinted 1967 essay, 'Art and Objecthood'.

15 For a general account of the question of the avant garde in modernism see Peter Bürger, *Theory of the Avant-Garde* (Minneapolis, MN, trans. M. Shaw: University of Minnesota Press, 1984). The particular problem of the reappropriation of critical artistic experimentations by the very system they propose to shock is concisely summarized by T.W. Adorno in 'Cultural Criticism and Society' in *Prisms*, trans. Samuel and Shierry Weber (Cambridge, MA: MIT Press, 1983) and explored in *The Culture Industry*, ed. J.M. Bernstein (London: Routledge, 1991). Within the frame-

work of an understanding of aesthetic practices as a negation or disruption of representational mimesis, Jean-François Lyotard has made an important case for a distinction between avant-garde experimentation and modernist innovation, which insists upon the force of the disruptive effect of *desaissisement* ('disseizure' or 'upsetting') that aesthetic experimentation can produce, regardless of its later potential recuperation. Hence he insists that the work of experimentation is a risky and rule-less business, that there are no advance formulae that can guarantee the radicality of avant-garde practices (see *The Inhuman*, trans. Geoff Bennington and Rachel Bowlby, Stanford, CA: Stanford University Press, 1991, and *Toward the Post-Modern*, eds Robert Harvey and Mark Roberts, New Jersey: Humanities Press, 1993). Another way of approaching this question would be through the work of Marcel Duchamp and Hans Haacke.

16 Immanuel Kant, *The Critique of Judgement*, trans. James Meredith (Oxford: Clarendon Press, 1978):

the feeling of the sublime is a pleasure that only arises indirectly, being brought about by the feeling of a momentary check to the vital forces followed at once by a discharge all the more powerful. (p. 91).

 The feeling of the sublime is, therefore, at once a feeling of displeasure, arising from the inadequacy of imagination in the aesthetic estimation of magnitude to attain to its estimation by reason, and a simultaneously awakened pleasure, arising from this very judgement of the inadequacy of the greatest faculty of sense being in accord with the ideas of reason, so far as the effort to attain to these is for us a law ... Therefore the inner perception of the inadequacy of every standard of sense to serve for the rational estimation of magnitude is a coming into accord with reason's laws, and a displeasure that makes us alive to the feeling of the supersensible side of our being, according to which it is final, and consequently a pleasure, to find every standard of sensibility falling short of the ideas of reason. (p. 106)

17 For a recent instance, see the editors' introduction and M. Baxandall's contribution to S. Kemal and I. Gaskell (eds), *The Language of Art History* (Cambridge: Cambridge University Press, 1991).

18 Thus, Cleanth Brooks in *The Well-Wrought Urn* (New York: Reynal & Hitchcock, 1947) appeals, as his title implies, to the immediacy and boundedness of visual form as the strong metaphors for the perfection that marks the poetic object's achievement of autonomy or self-consciousness. This is more explicitly theorized by William Wimsatt in *The Verbal Icon* (Lexington, University of Kentucky Press, 1934), where the twin fusions of form and content, poetic realization and authorial intention, which guarantee poetic achievement entail a passage to the visual as iconic form. The New Critical paradox is that the ground of poetic success or beauty, the fact of achievement of presence by which a poem comes to be nothing other than what it itself is, is expressed in terms of a visual rather than a literary metaphor. If a poem achieves autonomy at the point where it does not mean (represent anything other than itself) but simply is, it is somewhat contradictory that the metaphors for a poem's being itself come not from poetry but the visual arts: that the poem which 'is' a poem, repeatedly 'is' so as a visual object.

19 For some versions of such work, see W. Steiner, *The Colors of Rhetoric: Problems in the Relationship between Modern Literature and Painting* (Chicago, IL: University of Chicago Press, 1982) and *Pictures of Romance: Form against Context in Painting and Literature* (Chicago, IL: University of Chicago Press, 1988); H. Sayre, *The Object of Performance: The American Avant-Garde Since 1970.*(Chicago, IL: University of Chicago Press, 1989). One might also want to consider the importance to modernism of the critical activity of such poets as John Ashbery or Frank O'Hara.

20 For the argument concerning the need to reunify the mass of disciplinary knowledges that technological specialization has fragmented, see J. Schiller, *Letters on*

the Aesthetic Education of Man, trans. E.M. Wilkinson and L.A. Willoughby (Oxford: Clarendon Press, 1967).

21 See Hans Belting, *The End of the History of Art*, trans. C. Wood (Chicago, IL: University of Chicago Press, 1987), and Arthur Danto, *The Philosophic Disenfranchisement of Art* (New York: Columbia University Press, 1986).

22 On the arrival of postmodernism, see Linda Hutcheon, *A Poetics of Postmodernism* (London: Routledge, 1989); for a more complicated account of what it might mean for postmodernism to 'happen' see J.-F. Lyotard, *The Postmodern Explained*, trans. J. Pefanis (Minneapolis, MN: University of Minnesota Press, 1993) and *The Postmodern Condition*, trans. G. Bennington and Brian Massumi (Minneapolis, MN: University of Minnesota Press, 1984); for a denial that postmodernism has, or should, arrive, see J. Habermas, 'Modernity: An Incomplete Project' in *The Anti-Aesthetic*, ed. Hal Foster (Seattle, WA: Bay Press, 1983). The latter selection of essays also contains Frederic Jameson's association of postmodernism with late capitalism, 'Postmodernism, or the Cultural Logic of Late Capitalism'. The fact that anthologies abound on this topic is perhaps significant, and we signal a few. The Ur-texts of the debate may be found in *Modernism/Postmodernism*, ed. Peter Brooker (London: Longman, 1992). The political critique of postmodernism is widely explored in *Postmodernism and its Discontents*, ed. E. Ann Kaplan (London: Verso, 1988) and in more exclusively Jamesonian fashion in *Universal Abandon? The Politics of Postmodernism*, ed. Andrew Ross (Minneapolis, MN: University of Minnesota Press, 1988). A sustained attempt to engage with the impact of postmodernism upon the nature and practice of literary history is made in *Postmodernism Across the Ages: Essays for a Postmodernity that Wasn't Born Yesterday*, ed. Bill Readings and Bennet Schaber (Syracuse, NY: Syracuse University Press, 1993). The relation of postmodernism to feminism is dealt with in a variety of ways in *Feminism/Postmodernism*, ed. Linda J. Nicholson (London: Routledge, 1990).

23 For a strong and influential version of this position, see C. Owens, *Beyond Recognition: Representation, Power, and Culture* (Berkeley, CA: University of California Press, 1992).

24 The sources for these generalizations are multiple. See Frederic Jameson, 'Postmodernism, or the Cultural Logic of Late Capitalism' in *The Anti-Aesthetic*, and 'Regarding Postmodernism: A Conversation with Frederic Jameson' in *Universal Abandon?* For Eagleton, see *The Ideology of the Aesthetic* (Oxford: Basil Blackwell, 1990).

25 As Jean-Luc Nancy has remarked:

What [tradition] hands down to us under the name of the 'sublime' is not *an* aesthetic (and especially not any of the particular aesthetics of the grandiose, the monumental, or the ecstatic with which the sublime is often confused – not without some historical justification, it should be admitted – and which lead to the discreet handling, or even the tendentious suppression of this somewhat too weighty term). Tradition hands down the aesthetic as a question. (Jean Luc Nancy, preface to Courtine *et al.*, *Du Sublime* (Paris: Belin, 1988), p. 7).
See also J.-F. Lyotard, 'The Sublime and the Avant-Garde' in *The Inhuman*.

26 For an important effort at articulating such a view, see R. Krauss, *The Optical Unconscious* (Cambridge, MA: MIT Press, 1993).

27 See J.-F. Lyotard, 'On What Is "Art"', in *Toward the Postmodern*.

28 See M. Heidegger, *Being and Time*, trans. John Macquarrie and Edward Robinson (New York: Harper & Row, 1962), and F. de Saussure, *Course in General Linguistics*, trans. W. Baskin (New York: McGraw-Hill, 1966).

PART II

Chapter Two
Basic Concepts. Of Art History
Stephen Melville

For the past decade or more talk of both a 'crisis in the discipline'[1] and a 'new art history' has been a standard feature of art historical discussions. The senses assigned both these phrases have been highly various: for some 'the new art history' is a new or renewed social history of art;[2] for others, the phrase evokes a new semiotic ground for the discipline;[3] still others may hear in it a call for a post-structuralist art history, or for an art history that is self-consciously 'postmodern', or for an art history that returns to its own histori-cal roots, renewing or transforming them.[4] These various versions of 'the new art history' have equally various relations to what currently exists as art history: some conceive themselves as interventions in the discipline from its (political) outside, some as integrations of it into a larger field, and some as critical returns into its own conceptual apparatus. Seen from this perspective, the 'crisis in the discipline' amounts to a vast uncertainty about the specificity, limits, location and effect of the discipline of art history within the larger field of knowledge and cultural practice. It is not clear that the history of art has foundations it can call in some sense its own, not clear what is inside it and what outside, not clear what terms might best negotiate between any such insides and outsides or to what effect they might do so, and not clear what loyalty or betrayal is owed to such founding figures as Alois Riegl, Heinrich Wölfflin, Aby Warburg, Erwin Panofsky and Ernst Gombrich.[5] In brief, the history of art appears to want or need to be thought through again from the ground up. Where does one begin such a task?

In the winter of 1941 the German philosopher Martin Heidegger conducted a series of lectures under the title 'Basic Concepts', or '*Grundbegriffe*'.[6] The first lecture opens with the obvious question: 'Basic concepts – of what?' Noting that it is evidently in the nature of concepts to be *of* something, to represent something, 'whether for the investigation of art history or jurisprudence, for chemistry or mechanical engineering, or for any other 'subject area' or field of human practice', Heidegger suggests that 'perhaps the unsupplemented title "Basic Concepts" means this: that it does not treat of particular regions of beings, nor of the corresponding sciences that investigate them individually' (including, then, the science that is presumably Heidegger's own, philoso-phy). Basic concepts, as Heidegger conceives them, would lie beyond or

beneath – in any case, apart from – representation; they would open the world in some different way. So Heidegger asks his audience to hear the German term *Grundbegriffe* differently: not as 'basic concepts' but as something else, something Heidegger tries to make visible by rewriting his title as *Grund-Begriffe*, emphasizing the etymology of its components in a way that might lead us to translate it more nearly as 'ground-graspings'. Whereas 'basic concepts' are an attempt to characterize, to lay out in advance, a certain delimited terrain of objects and principles, the activity of ground-grasping aims at drawing our attention to the dual fact that we must already be standing somewhere in order even to begin delimiting the terrain lying so self-evidently before us, and that this place in which we stand must be prior to and different from any conceptualization we might develop of it as a part of our ongoing work of surveillance and delimitation. It is only because we have already been addressed by the world that we can respond to it by calling it into representation; it is only because we have already been 'struck' or 'stamped' by the world that we can, in our turn, offer to 'characterize' it.[7]

For Heidegger art is essential to the non-representational opening of the world, so the inclusion of 'art history' with chemistry and mechanical engineering (and, interestingly, jurisprudence) as typical of the kinds of knowledge that are organized by 'basic concepts', representations, marks it as a certain kind of betrayal: the fall into representation of the very thing that in fact underlies representation and justifies a critique of it. The art historian may imagine that his or her work offers some kind of humanistic alternative to relentless utilitarianism of mechanical engineering, but in Heidegger's eyes such apparent opposition counts for nothing:

> The whole world talks about the 'cultural' significance of the ancient Greeks. But no one who speaks like this has the slightest knowledge that, and how, an inception occurs there. Those who evince a somewhat belated enthusiasm for 'classical antiquity,' and likewise those who encourage and promote the 'humanistic *gymnasium*,' demonstrate a no more essential stance toward the incipient, so long as their efforts are devoted only to salvaging what has been hitherto; so long as they fall back upon an inherited and very questionably arranged cultural treasure, and in so doing consider themselves superior to the enthusiasts of the technological age.

This passage forces a distinction, implicit in the critique of disciplinary knowledge, between things that are historically prior, 'an inherited and very questionably arranged cultural treasure', and things that are ontologically early (what Heidegger calls the 'incipient'). In his central essay on art, 'The Origin of the Work of Art',[8] this distinction plays out as the difference between taking art as something that has an origin – perhaps in the world it represents, perhaps in some human need, perhaps in some cultural practice – and taking art as something that *is* an origin, something without which there would be no world to represent, no human needs to order and address, no culture which might then treasure it. Because what strikes and characterizes us does not belong to the realm of representation, it is absolutely 'early', its experience at odds with the demands imposed by the historical understanding and its ordering of time.

Heidegger is unquestionably one of the presiding figures behind the emergence of the range of primarily French writings that make up what is

commonly and loosely referred to as 'theory'. His pre-eminence hardly passes without question: even those one might want to count among his closest followers – writers like Jacques Derrida, Philippe Lacoue-Labarthe, Jean–Luc Nancy, or, within the very different context of psychoanalysis, Jacques Lacan – are unable to take up his work without questioning it radically, and for many others the reactionary strands in his thought and the possible relation of those strands to his political actions under the Nazi regime are enough to render his work intolerable and unreadable.[9]

Nonetheless, it is clear that Heidegger's radical antimodernism has significantly shaped the contemporary arguments about a possible 'postmodernism'; that his insistence on the primordiality of interpretation is one of the primary sources for the major role assigned to language and cultural construction across a wide range of contemporary work; that his tendency to see in representation a barrier against rather than a reliable means of access to the world is now widely shared, as is his suspicion of those notions that provide crucial support for the primacy of representation (most notably that of 'the subject' as autonomous and self-identical centre of value and expression); that Heidegger's declared suspicion of the humanities conceived as the recollection and passing onward of an 'inherited and very questionably arranged cultural treasure' is echoed by a number of recent critical and historical stances which otherwise seem to have little in common or in sympathy with this thought; and that his antagonism towards the aesthetic and art historical frames in which we have come to enclose the work and experience of art is far from unique in both modernist art and in recent art historical writing.

It is the last of these points that I want particularly to pursue here. Frames are a fact of pictures as we have come to know and value them, the means by which they make their entry into the museum and the means by which, once entered in that space, they negotiate the relations among themselves that are their history, art history. There is perhaps no finer place to see to the art historical work of the frame than the pages in which Erwin Panofsky knots together in and through a pair of hand-drawn frames on either side of a sketch leaf in the Bibliothèque de l'École des Beaux-Arts in Paris (1) the emergence of a 'specifically 'artistic' interest' around 1400; (2) the authorship of Cimabue; (3) the location of the leaf as the opening of Vasari's album-collection; (4) Vasari's own placement at the origins of art history, as – one might say – its framer; and (5) the placement of that origin between 'Northern' and 'Southern' trajectories. It is not too much to say that the tying of this knot is a founding of art history; untying such knots, exposing their structure, may well be one of the central tasks of a new art history.[10]

We are often inclined to take frames as in some sense the physical markers of the gap between the ordinary world in which we normally live and the 'planet of aesthetics', in Duchamp's phrase, to which we are presumably transported in our encounters with the works they contain. We may even come to feel that frames are the very means of that transportation, as if it were enough to frame an object or experience in order to make of it art.[11] And we may want to embrace this condition, as many late modern artists have; we may equally want to argue that one task of a socially alert art history would be to undo the aestheticizing imposition of the frame, returning the work to the field of mundane practices in which it actually functions.

It is evidently important about Heidegger's treatment of Van Gogh's *Old Boots With Laces* in 'The Origin of the Work of Art' that he does not pause before its frame but rushes into it, as if the recognition of any frame other than the one it makes for itself, from its own inner dynamic, would block the experience it offers, an experience he will not allow to be limited to the 'aesthetic' or to the merely 'art historical'. The painting matters precisely because it cannot be contained within its frame, just as it is, and matters because it is, unprecedented and unbound from its author.

With these last considerations of precedent and authorship the concern with framing evidently becomes metaphorical and enters into relations with any number of closely related and pictorially-derived metaphors of, for example, 'point of view' or of seeing something 'in the light of' something else. This system or cluster of metaphors is evidently deeply ingrained in our talk and imagination of knowledge; it was, for example, implicit in the image offered earlier of knowledge as surveillance and delimitation.[12] Within this imagination of knowledge, we may find ourselves wanting to pass beyond the imposed restrictions of frame and point of view towards a greater lucidity, our gaze unfixed from our historical contingency and finite embodiment. We may perhaps imagine such deliverance as a sort of ascent to a point of view that can claim universality; equally, we may imagine it as something to be achieved through the coordination of points of view that in themselves remain partial and limited. These would be ways of reaching for unsupplemented basic concepts.

Against such prospects, it can perhaps matter to us now that what Heidegger takes out of the word *Begriff*, concept, is its etymological rootedness in a different system of metaphors, a system that privileges grasping rather than seeing, that implicitly poses a painting, for example, as something that touches us ('strikes us'?) rather than as something beheld. It would then be tempting to say that Heidegger's dream is of a kind of blind knowing, one that precisely cannot command the terrain in which it finds itself and that cannot map its position in any terms more encompassing than those given in and as the situation itself. In the dark my world is only as big as the reach of my body and my memory; deprived of the stabilizing ineluctability of the visible, I retest the world and myself with every reach and step.

Lucidity and blindness, the passage beyond all frames and the passage into the frame to the point of loss: so many ends to the desire set in play by the frame.[13] It is no doubt not accidental that these ends reproduce the contrasting terms of opticality and tactility through which early modern art history attempted to track the formal vicissitudes of period and style. The work of art and the writing of its history alike are woven in and around the question of the frame, the desire to be unframed and the need to acknowledge the insistence of the frame. Art history and the history of art are permanently torn between the submission to representation and those 'basic concepts' that spring from it and a grasping of its ground as incipient, originary and presentational. That this may be true of all disciplined knowing simply means that the 'basic concepts' of any given field are inseparable from particular knowings of particular things, or that such concepts are supplemented, irreducibly *of*, and in that measure irreducibly critical: they are attached not simply to the work but to the inevitable framedness of that work, caught in the complex play of lucidity and oblivion opened there.

None of the contributions gathered together in this part mention Heidegger (although he is implicit in Tagg's appeals to Foucault and Derrida, and could figure strongly as a part of the background to the particular problematic of German history and memory Rogoff addresses), and it is certain that not all of their authors will be equally happy to see themselves introduced by reference to him. Nonetheless it seems fair to say that all of the next four chapters work to reimagine the framing of art history and to work through the consequences of acknowledging the inevitable situatedness of its practitioner, a figure who can no longer be taken simply as a beholder but who is also touched by, perhaps even grasped by, his or her object. For Michael Holly, acknowledging this means opening the prospect that what we normally take as art historical 'description' is perhaps better recognized as a performance or prolongation of the work it claims to more simply represent, as if within or beneath the historian's framing of the object lies its prior framing of him or her. The suggestion that 'in fact most of what we do is rewrite the past in the terms it has anticipated for us', as well as the concluding emphasis on the art historical beholder as him or herself beheld, exposed, pushes the role of interpretation beyond the narrow confines Panofsky would impose on it and into the region of the hermeneutics first elaborated by Heidegger and Hans-Georg Gadamer, and later complicated and contested by such writers as Michel Foucault and Jacques Derrida.

If Holly's concerns can seem to resonate with Heidegger's it is in part because, like him, she focuses on the way the historian is and is not in the picture, entered into its frame. Pollock and Rogoff move strongly in the inverse direction, breaking through the frame into its social and historical contiguities (into, then, the area of Heidegger's greatest mystification).

In Pollock's case this means, above all, a renewed attentiveness to the effects of vision. The politics of looking she explores here understands the apparent neutrality of sight as always also a moment of contact, of placement and potential contestation of that placement; opening up art history to what it has excluded or undervalued means discovering new positions of contact within it.

Rogoff's chapter engages a field in which the traditional contact of art with itself, its continuity, has been radically disrupted. This is a specific feature of post-war German art; it is also a feature of many of the general accounts that have been offered of both modernism and postmodernism. In this context, the play of vision and position that informs Pollock's contribution is refigured as a play of history and memory, the subject's belonging to and alienation from the past it frames.

Although it is not directly to Pollock's purpose, it is certainly worth stressing the difference between the reading of Van Gogh she sketches and the one towards which Heidegger gestures,[14] just as it will be worth recalling that Heidegger is also an actor in the political events that generate the problem of history and memory put into play for art history by the painters Rogoff discusses.

John Tagg's essay, despite its episodic structure and professions of modesty, is an ambitious effort to think through the structure of displacements at work in, for example,the passage from Holly to Pollock or Rogoff and back again. It is, one suspects, far from accidental that the occasion for these meditations is provided by photography, a technology which in many ways appears to

answer to our desire to see or have the world in all its unframed contingency. That just here, between edge and centre, we should find the problematic of the frame re-emerging in its full complexity may be taken to indicate not only, as Tagg has it, 'how far we … have to travel from a conception of art history as an array of methodologies', but also how that journey will necessarily find its end always at the limits of what remains a discipline, caught between basic concepts and the grasping of the ground; as if, then, there were no ground that were not itself permanently scattered and unstable.

Notes

1 See, for example, the special issue of *The Art Journal*, 42, 4 (Winter 1982) devoted to 'The Crisis in The Discipline'.

2 See, A.L. Rees and F. Borzello, *The New Art History* (Atlantic Highlands, NJ: The Humanities Press, 1988).

3 See, for example, N. Bryson and M. Bal, 'Semiotics and Art History', *The Art Bulletin*, June 1991.

4 This last tendency has drawn considerable impetus from M. Podro's *The Critical Historians of Art* (New Haven, CT: Yale University Press, 1982).

5 For important instances of renewed negotiations with the discipline's founders, see M. Iversen, *Alois Riegl: Art History and Theory* (Cambridge, MA: The MIT Press, 1993) and M. Olin, *Forms of Representation in Alois Riegl's Theory of Art* (University Park, PA: Pennsylvania State University Press, 1992); M. Brown, 'The Classic is the Baroque: On the Principle of Wölfflin's Art History', *Critical Inquiry*, 9 (December 1982); M. Holly, *Panofsky and the Foundations of Art History* (Ithaca, NY: Cornell University Press, 1984); Silvia Ferretti, *Cassirer, Panofsky, and Warburg: Symbol, Art, and History*, trans. R. Pierce (New Haven, CT: Yale University Press, 1989), and G. Didi-Huberman, *Devant l'image: Question posée aux fins d'une histoire de l'art* (Paris: Minuit, 1990)

6 M. Heidegger, *Basic Concepts*, trans. G. Aylesworth (Bloomington, IN: Indiana University Press, 1993). The quotations that follow are taken from the opening pages of the book.

7 For an interesting way of taking our interest in these terms, see P. Lacoue-Labarthe, *Typography: Mimesis, Philosophy, Politics* (Berkeley, CA: University of California Press, 1989).

8 M. Heidegger, 'The Origin of the Work of Art,' in *Poetry, Language and Thought*, trans. A. Hofstadter (New York: Harper & Row, 1971).

9 For overviews of recent controversies over Heidegger's politics, see T. Rockmore and J. Margolis (eds), *The Heidegger Case: On Philosophy and Politics* (Philadelphia: Temple University Press, 1992) and R. Wolin (ed.), *The Heidegger Controversy: A Critical Reader* (Cambridge, MA: The MIT Press, 1993). H. Ott's *Martin Heidegger: A Political Portrait*, trans. A. Blunden (New York: Basic Books, 1993) appears to be the most reliable biographical account.

10 See E. Panofsky, 'The First Page of Giorgio Vasari's 'Libro': A Study on the Gothic Style in the Judgment of the Italian Renaissance' in his *Meaning in the Visual Arts* (Garden City, NY: Doubleday, 1955). This text appears to belong to a cluster of relatively early writings in which Panofsky forges a determinative relationship between the discipline of art history and the terms of Renaissance art. Other texts in this cluster would include *Perspective as Symbolic Form*, 'The History of the Theory of Human Proportions', and most of his writings on Dürer. One might also note the distance taken from Heidegger on interpretation between the 1932 German essay 'Zum Problem der Beschreibung und Inhalsdeutung von Werken der bildenden Kunst', *Logos*, XXI, and its more famous revision as 'Iconology and Iconography' in *Studies in Iconology*; for a useful discussion, see Didi-Huberman, *Devant l'image*, pp. 120ff.

11	This intuition has been given strikingly different philosophical forms by Arthur Danto, most notably in *The Transfiguration of the Commonplace* (Cambridge: Cambridge University Press, 1981) and George Dickie, in *Art and the Aesthetic* (Ithaca, NY: Cornell University Press, 1974). For a developed view of their contrast, consult E. Rollins (ed.), *Arthur Danto and His Critics* (Oxford: Basil Blackwell,1993).

12	My 'The Temptation of New Perspectives', *October*, 52 (Spring 1990) explores this within the context of a rereading of disciplinary foundations. I address it in relation to Lacanian theorizing of 'the gaze' in 'In Light of the Other', *Whitewalls*, 23 (Fall 1989) and 'Division of the Gaze: On the Color and Tenor of Contemporary Theory' (forthcoming in T. Brennan (ed.), *Vision*).

13	On the topics of the frame and blindness, see J. Derrida, 'The Parergon' in *The Truth in Painting*, trans. G. Bennington and I. McLeod (Chicago, IL: University of Chicago Press, 1987), and *Memories of the Blind*, trans. P.-A. Brault and M. Nass (Chicago, IL: University of Chicago Press, 1993). One might also explore the workings of the title trope in Paul de Man's seminal *Blindness and Insight: Essays in the Rhetoric of Contemporary Criticism* (New York: Oxford University Press, 1971).

14	The differences here can be further articulated and complicated by taking account of the various engagements of Heidegger by F. Jameson in *Postmodernism, or The Cultural Logic of Late Capitalism* (Durham, NC: Duke University Press, 1991; M. Schapiro, 'The Still Life as Personal Object', in *The Reach of Mind: Essays in Memory of Kurt Goldstein* (New York: Springer, 1968) and J. Derrida, 'Restitutions of the Truth in Pointing', in *The Truth in Painting*.

Chapter Three

Beholding Art History: Vision, Place and Power

Griselda Pollock

THE POLITICS OF LOOKING

In his book *Painting as an Art*, published in 1987, Richard Wollheim draws attention to the peculiarity of art history.[1] Alone amongst those disciplines which deal with our cultural patrimony, the study of the visual arts stresses history over criticism, the common term for literature or music or dance studies. It is a point well worth noting. It might be said that some of the current debates which animate the field of art history pivot on the precise nature of the historical character of the visual arts. What is admissible as argument, evidence or concept, namely what social theory shapes the research or its conclusions is deeply contested. Part of the resistance from the conservative establishment against the revitalized Marxists and feminists of the second wave, the intense precisions of the structuralists and post-structuralists, the fantasies of the psychoanalyticals, is that their critical theories bring a lot of trouble into the field of vision. They make it difficult to look at art in the same old ways. The deployment of a variety of theories which interlace the visual arts with cultural sign systems or with discursive formations and ideological apparatuses are perceived by many a defender of tradition as introducing alien textualities into a virgin and pristine domain where, as with an attractive woman, all that is really required is some good hard looking.

Indeed, significantly for those of us with an overdeveloped Freudian bent, the intense desire to be allowed simply to look at art in this way itself demands analysis. Richard Wollheim's introduction exemplifies this explicitly. He states quite clearly that he knows what is now on offer as possible roads through art's histories. He politely refuses to be tempted and reasserts that the old ways of art history will suit him just fine. Paintings simply need dedicated scrutiny.

> For I came to recognise that it often took the first hour or so in front of a painting for stray associations or motivated misperceptions to settle down, and it was only then, with the same amount or more time to spend looking at it, that the picture could be relied upon to disclose itself as it was.[2]

My intention is not to disagree that paintings are complex and require prolonged and respectful analysis, but what is revealed by such attentiveness, according to Wollheim? Art History's necessary and defining figure, the artist, is the discovery of intense visual examination: 'To the experience, to the experience hard won of the painting, I then recruited the findings of psychology, and in particular the hypotheses of psychoanalysis, in order to grasp the intention of the artist as the picture revealed it'.[3]

Wollheim's determined defence of art experience as the 'effect of the intentional activity on the part of the artist', combining psychology and analysis of the painted object, gratifyingly confirms observations I made in 1980 when I identified the ideological work which art historical practice accomplished as the production of an artistic subject for and of works of art.[4] The subject – intending or driven – is the source of meaning; the cause of art and the real object of appreciative consumption become identification. What is seen when looking at a painting is, then, the trace which takes us back to that definable and cogent subjectivity for which the painting's visual form is only a sign. This subtle hermeneutic requires, of course, a special kind of spectator.

Wollheim's theory moves directly from artist to spectator whose claim to be able to discover the artistic subject lies in the universality of human nature which, 'expressed' in art, forms the bridge between artistic and spectating subjects. Wollheim presents himself through this position as a socialist. Within his socialist humanism, the production of the artist as subject disguises the actual process which folds the viewer/historian over the putative author, seemingly discerning his (sic) intentions and psyche while not admitting to the fact of reading which is necessarily taking place in front of a complex social text.[5] Universalist socialist humanism leads Wollheim close to the reader proposed by Roland Barthes. Wollheim's artist and viewer have 'no history, no biography'.[6] They do certainly have a psychology, or else what would there be for Wollheim to study?

I seem to be setting up a straight opposition of vision versus textuality. What Wollheim's practice introduces is much more political than that. Humanist, intentionalist, connoisseurial: this is excellent and familiar stuff. I would not deny that art historians need to look carefully at paintings or whatever their objects of study. I would not deny the operative contribution of the producer (although this is quite distinct from mythic notions of creativity: the relative contribution of producer is historically variable and gives rise accordingly to different myths and concepts about the artist and genius).[7] And, as a post – Barthesian historian I would give especial emphasis to the spectator as agent in the productive consumption of culture. All of these elements, however, need to be radically historicized. They need to be read under the mark of difference, not fictions of sameness. The appeal to a universal human nature is still an alibi for a domination and exclusion.

Methodological debates aside, the issue is a matter of politics. Wollheim indulges in fantasies of a universal human nature, an ideology of sameness which is only possible because of an uncritical acceptance of the authority of masculinity, whiteness and Europeanness when the most urgent struggles of our time involve throwing off their burden. Under the imperializing claims which Western notions of humanity have cloaked, the humanity of many of

2 Kirk Douglas as Vincent Van Gogh in *Lust for Life*, MGM Minnelli 1956;
Publicity Still, British Film Institute

the world's peoples, genders and religions have been denied with varying degrees of violence. Race, gender and class are the theoretical terms by which the very basis of Wollheim's and Western art history's assurances are being challenged worldwide. The question now is who is looking at what, at whom, with what effects in terms of power.

VISION AND POWER

It is by now a commonplace to link vision and power which has increasingly been seen as a historical and social relation articulated in and through a variety of practices from perspective to surveillance.[8] To look is an act of perception, but it is an interrogation and an assumption of a place which yields itself as a metaphor for knowledge to which Michel Foucault has given the term, 'The Eye of Power'.[9]

To treat issues historically is not merely a matter of Marxist methods or theories added to Eurocentric and sexist art studies. It involves critically locating that spectator, this spectator, the historical *and* the contemporary viewer in a history of power relations and effects.

Art history (momentarily assuming that we can generalize its many narratives and strategies) works consistently to preclude such an insight by textual constructions of a highly personalized and individuated world of vision. The figure of the artist embodies and guarantees this text (Illustration 2). In some crude way, art history offers itself to us as a history of visual objects which, like commodities in a fetishized capitalist world, appear before us with an independent set of relations. Art history comprehends these relations between objects through categories such as style, the chronological succession of movements, formal properties and iconographic schema. We have sophisticated our methods with semiotics to extend valuable but limited formalist readings. We have tried to link movements to historical epochs and social disruptions. But I suggest we need a more radical departure from art history's paradigms. Instead of art history's study of 'looked at objects', I wonder what happens if we consider a different historical object: not vision with its seeming autonomy, but a history of the politics of looking. One of the theoretical resources appropriate for such a project lies in a different psychoanalysis from that appealed to by Richard Wollheim. Social history of art retains Wollheim's intending agent in the typical formulation of its questions of art: why was this made, for whom was it made, what effects did it have on its first viewers? A different agenda is proposed when, with the insights of psychoanalysis, we ask: why were they looking? What were they looking at? What pleasures or anxieties in looking had to be managed? Who could look and who could not?

VISION AND THE IMAGINARY

Just as Althusser has said there is no ideology without a subject, so we might assume that there can be no vision without a subject. I want to suggest that the visual field is both implicated in the processes by which subjects are formed and works constantly at their undoing. Another modernist, Jacques Lacan, has offered a particular account of the psychic structures or registers within which human subjects are formed as sexed and speaking subjects, which gives a particular reading of vision and its entanglements. The Imaginary (the term is derived from the prominence of the imago in the mirror phase which gives rise to the imaginary register) forms part of a triad with the Symbolic and the Real in the Lacanian schema.[10] In his discussion of their relations in the work of Lacan, Frederic Jameson describes one of the effects of the imaginary mode.

Within the imaginary register of the institution of the subject, there is a sense of things seen without an observer, a condition we may all recall from recollections of dreams.

> A description of the Imaginary will, therefore, on the one hand, require us to come to terms with a uniquely determinate configuration of space – one not yet organized around the individuation of my own personal body, or differentiated hierarchically according to the perspective systems of my own central point of view – yet which none the less swarms with bodies and forms intuited in a different way, whose fundamental property is, it would seem to be visible without their visibility being the result of the act of any particular observer, to be as it were, already-seen, to carry their specularity upon themselves like a colour they wear or the texture of their surface.[11]

I am tempted to pose art history's recurrent fixation on the visual self-evidence, or even self-presence of the art object as evidence of the imaginary mode at work within cultural criticism. Art history enacts an imaginary fantasy. The Lacanian schema of subject formation is not a narrative of development through various phases. Like Freud's models, it provides something more akin to an archaeological model of the subject as a settlement of sedimented layers which collectively and simultaneously constitute subjectivity in process. Hypothetically we describe the subject's coming into existence as process taking place through time, initiated in infancy and early childhood. But it is more important to grasp the subject in a perpetual present, defining subjectivity oscillating between its various registers without any regard for historical time, past and present, real and fantastic. Thus we should expect movement between the poles of the Imaginary and the Symbolic in intellectual discourse and cultural practice just as much as in the individual subject's other activities. From this perspective I would suspect that art history fetishizes a visual object – art as a kind of pure vision – which seemingly holds its own specularity within it.

The job of a critical practice on art history is to refuse to be complicit with such imaginary displacements of point of view and both intertextuality and intersubjectivity. Yet it must equally avoid falling too much under the sway of the Symbolic. We might then fail to acknowledge the potency of imaginary structures in fashioning the pleasures and anxieties, the pursuit of and defences against vision, in visual art forms. Art must solicit a viewer and structurally propose a place for a viewer, even if that is as often a place from which to be viewed.[12] Paintings, like the mirror holding its delusory imago in Lacan's schema, can be grasped as a screen in which subjectivities are intimated in complex relays of looking.

Let me unscramble the paradox I have just hinted at. Vision presents itself to us as a simple, primary, self-evident category, yet, through psychoanalytical studies of that complex formation we call human subjectivity, the visual is always already invested with meanings, potencies and effects in the organization of the drives, the formation of psychic representatives, symbolization, fantasy and hence sexuality and the unconscious. Scopophilia and paranoia, voyeurism and exhibitionism; through these psychoanalytical formulations of the vicissitudes of looking, vision is both a metaphor for the very process of subjectivity and yielded up to us, after the effects of repression caused by

access to the Symbolic, as the trace of all those pre-Oedipal fantasies. Thus it acquires its self-evidence. This founding element, however, is for ever a component of our subjectivities and therefore our cultural products and experiences. Ideologically the tendency is raised up to a philosophical function when vision becomes for the Western philosophical tradition the guarantee of truth and a denial of the complexities of any kind of knowledge.[13]

Critical practices in and on art history have to take on board what cinema studies have already explored, the ways in which psychoanalysis has mapped *in potentia* the relations between subjectivity and meaning in the field of vision. Psychoanalysis has furthermore provided a rich and complex set of concepts – scopophilia, paranoia, exhibitionism, voyeurism, fetishism – to set against the humanist assumptions of a Cartesian subject as a fixed, central viewpoint looking at the world and thereby perceiving palpable knowledge: the image of both Wollheim's artist and art historian.

ART HISTORY AS SPECTACLE

I take it as read that art history is a discourse, a body of texts about art, not always written (for example, exhibitions; but even these are obviously accompanied by texts in the catalogue and on labels and they also create a spatial narrative through the semiotics of display). This volume tries to address directly the oddities of a mainly literary and always textualizing discourse dealing with a non-literary and apparently non-textual practice. Art history, however, is a more extensive practice than lecturing, publishing and journalism. There is its major performative activity through museums and exhibitions. The organization of the architectural spaces, the displays and the itineraries laid out for the visitor all constitute a discourse on another register. The museum or gallery is an elaborate orchestration of a viewing body in space and time, invited and constrained to look at objects. These become the mediating signs of a culture experienced as spectacle.[14] The viewer is reduced to a specifically modern combination of tourist and consumer. Recent social historical interpretations of the consolidation of later nineteenth-century consumer capitalism have also redefined modernist culture, especially its painting, as being both shaped by and the representation of the city become spectacle.[15] To be interpellated as 'an eye', the aim apparently of modernist art from Cézanne's famous comment on Monet to Greenberg's theory of pure opticality, is the end result of a complex series of strategies and social relations which work to suspend or remove from view both the processes and the subjects of artistic production. Such privileging of art as visual is one of the culturally registered effects of what Marx defined as the fetishistic structure of capitalism, and the Situationists argued was capital accumulated until it becomes an image. Art history, maturing as a professional discipline in the era of modernism to become an institutionalized text, was ideologically shaped in the specularities characteristic of that moment of capitalism in the later nineteenth century, which has only been theorized in these terms in the later, postmodern twentieth century when that regime came under multiple challenges from those excluded from enjoyment of the mastering look, or the affirming exchange of looking symptomatically revealed in Richard Wollheim's model.

LUST FOR LIFE: ART AS SPECTACLE

The trajectory of late nineteenth-century economy of the spectacle leads us directly to its specialized cultural apparatus, the cinema. By means of calculated moves to suspend the viewing subject and encourage complete identification with a looking machine (the camera/projector), cinema manages visual pleasure and terror. Immobilized for the film's duration in a darkened room, the spectators are invited to reinhabit those fantastic domains of infantile looking, oscillating between exhibitionism and voyeurism. From time to time popular cinema takes on a high art subject, typically, (like Wollheim), by means of searching for the psychological cause of art through biopics of artists.

Such was the case in 1955 when Vincente Minelli was invited to direct for MGM *Lust for Life*, a film version of Irving Stone's romanticized historical fiction about the life of Vincent Van Gogh, first published in 1935[16] (see Illustration 2). In the course of the story, the film has to find some means to represent the artistic process in terms specific to the cinematic machine. The most striking example occurs in the narrative sequence in which Van Gogh travels to Arles, arriving at night and finding some dingy hotel room. When he awakes the next morning, he throws open the shutters and sees before him a world drenched by sunshine, colour, and bursting with blossoms. The film sequence is significant. From a point within the room the camera tracks Van Gogh going to the window. In darkness we see shuttered windows which create suspense by promising something to see when they are drawn back. Van Gogh (Kirk Douglas) opens the windows, an action which makes Van Gogh the subjective point of view for what will be revealed. Then comes a shot of what he sees, but not in perspective. Instead blossoms fill the screen, forming a colourful trellis of shapes against an intense blue background. The space is as shallow as any proto-modernist painting should be. All-overness is prefigured or remembered. No possible indication of a point of view is provided; instead, by means of the camera's characterstic self-effacement, we see a world signifying its own, thus Imaginary, specularity. The unintelligibility of the shot, therefore, has to be narratively, (that is, in Symbolic terms) secured by a reverse shot of Van Gogh (Kirk Douglas) at the window, looking. But all the cardinal rules of cinema, eyeline matches and 1800 rules are broken.[17] Music accompanies an extended visual essay composed of shots created by tracking and panning and zooming camera work. Up and down these screens of blossoms we are taken in a way that bears the most tenuous narrative relation and no logical perceptual relation to any onlooker, Van Gogh (Kirk Douglas) or a cinema spectator. The camera's movements feed a fantasy of a total freedom of an eye, liberated from a body, and from a fixed position in space. It uncannily represents an infantile fantasy of total mastery through vision, scopophilia which occurs originally in the infant through an imaginary splitting between the more precocious visual apparatus – as it can from birth – and general physical immaturity and dependency of the baby.

While the rhythm of rising and falling camera movements persist in this scene from *Lust for Life*, the photographic journey around blossoming trees yields to explorations of the surfaces of *paintings* of blossoming orchards. Pure perception slides into painted art. The technological viewing mechanism of

the camera is the very condition for a screen display of sights which seem independent of an observer and, through its peculiar modes of representation as apparent registration, the photographic representation of trees and their manufactured painted representation become indistinguishable.

What is of course elided at all levels by the film is production, both its own and the production processes of art. Why is this so important to stress yet again? The photographic representation, subject to its own peculiar fetishistic structures, becomes a metaphor for art as pure, unmediated vision. Represented by filmic codes as non-representation, art is simply a man's vision. The film effaces the graphic and corporeal elements of visual art as labour and manufacture: the hand gestures, the physical work of painting, marking canvases, composing its surfaces by dabs of colour deposited by a working as well as a sighted body, itself a physical place and a psychic space. Painting as much as sculpting, etching, engraving or drawing is very much a manual activity. I do not mean to slide simply into a technicist or artisanal account. The fact I want to stress is that painting has a body, a place, which is the site and image of a subjective, psychic life.[18] Moreover with a body, made by a hand, working with both conscious and unconscious materials, art is more a form of inscription.[19] It is a form of writing; a close relation is often observed in children who are precocious in graphic skills between writing and drawing. Visual art is the product as much of a writing – markmaking – as of a seeing body. Marking, a labouring and thus a gendered, classed, socially located and culturally shaped body, a screen and a series of social relations of looking: my bundle of concerns is slowly emerging.

LUST FOR LIFE II: THE VOICE OF ART HISTORY

Van Gogh's paintings are always accompanied by sound, often music, but more significantly in this paradigmatic case a speaking voice. The voice is not that of Van Gogh (Kirk Douglas) for, at these points, he is the object of the gaze-direct or indirect as subject of his art. We know well that the acoustic element is as structural to film as the image. It brings into play the invocatory drives which are as important in the structures of identification as the imago. The voice we hear accompanying the montage of images of the artist at work is that of the artist's brother, Theo Van Gogh. In the narrative he is reading letters written to him by Vincent Van Gogh. Thus, structurally, we are presented with a splitting of the subject 'Van Gogh'. The artist is exclusively identified with vision and visualization. The rational, though often poetic and always explanatory words of the *Letters of Vincent Van Gogh*, which formed a parallel literary oeuvre to the painted one, are appropriated acoustically by brother Theo, (in historical reality a progressive art dealer and, ideologically in art history and this film, a surrogate for the art historian). Addressed by the artist, summoned to look and listen or read, the character of Theo enacts the space of art history. The speech of the artist, severed from him, voiced by the Other, functions as commentary verbally revealing what, on the visual track, is being visually experienced as the artist's subjective experience (the stuff of art history). The art historian becomes a disembodied voice: not

an active protagonist in the process of self-critical interpretation but a witness, and, as it were, a sympathetic relative. By the end of the film, the artist is dead and it is the brother who remains, revealing at last that he has been the effective, and ultimately authoritative, point of identification in the film for the spectator: a kindly , guiding, sympathetic, faithful figure of the brother.

Does not the mode of art history itself generally claim a special intimacy with art in order to authorize the textual frameworks it establishes to regulate access to and consumption of art? This paradoxical relation, already intimated in the strategies of Wollheim, is dramatized in *Lust for Life* through the fraternal relation of artistic genius and patient caretaker. The split between vision and textuality is represented as, on the one hand, potent disorder and excessive creativity (an overload of intentions and heightened visual susceptibility) and, on the other hand, as authoritative order and understanding which involves turning from vision to textuality. The particular attraction of the Van Gogh myth is its dramatization and thus narration of the processes, relations and fantasies of art history's voice acquiring power over vision.

Now that we are on the theme of murder and violence (what else happens in *Lust for Life* other than a murder with which the culture is invited to collaborate and then regret?) I would like to take a look at a single drawing by Van Gogh. It will be, and indeed has been, claimed that I am a doing a violence to Van Gogh by the way I deal with him. This stems not so much from laying upon these innocent images a weight of Marxist and feminist interpretations which intrude alien concerns imported from sociology and history and so forth; it results from asking people to look at an image differently, to look at it from a critical distance such as is achieved if one 'looks as a woman': that is to say, troping the dominant culture by looking against the grain of those assumptions necessary to participate in it.[20]

A drawing from August 1885, done in the Dutch province of Brabant, it is titled *Peasant Woman Stooping Seen from the Back and from the Side* (Illustration 3). It is part of a widely circulated series of images which, together with Sunflowers and Blossoms, signify the artist Van Gogh. In art history they are swiftly passed over with some cursory comment about the heroic dignity of labour and the authenticity of the earthy peasant. Reproductions of such images are sold by major poster companies and adorn private homes, dentists' waiting rooms, students' lodgings and school corridors. They are part of the myth of Van Gogh as humanitarian sympathizer with the plight and heroism of the labouring classes.

I look and I ask myself how was this drawing produced? What were its conditions of production and the conditions of visibility for this image? I see a drawing of a woman. She is seen from behind. She is bending over. Her skirt has ridden up to show her legs and ankles. The viewpoint is low. I can see up that skirt. I am presented with a large expanse of skirt draped over broad hips. I am looking at her buttocks.

How did this drawing get made? A Dutchman with some money asked a woman to come to his studio to model for his drawings. Why did she agree? He is a bourgeois; she is a working woman. He is a Protestant from the elite minority in the village. He is the son of the dominie (pastor). She is a Catholic from the impoverished majority of field and factory workers they employ. Few people in the village wanted to pose for the artist who lived in the

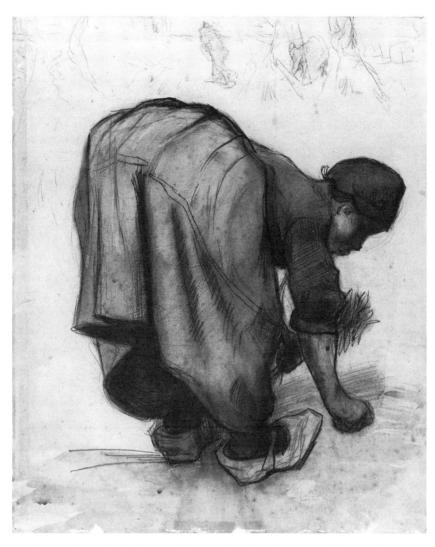

3 Vincent Van Gogh, *Peasant Woman Stooping Seen from Behind and from the Side*, 1885; Rijksmuseum Kroeller-Mueller

vicarage. They only did it, according to Van Gogh's letters, for the money. Why did they need money? The traditional peasant economy is one of subsistence: some land to yield sufficient crops to maintain the family and perhaps exchange for other necessities. Money comes in with capitalization. In its earliest forms capitalism lodged in and disrupted the rural economy. Some peasants with good land and luck became rich, like Courbet's father, Regis Courbet, who did well and moved to the local town and became a millowner, a bourgeois. Other peasants, with poor or little land but a need for money to

pay rent and taxes or buy what they did not produce, had to work for others. They became a rural proletariat. This was happening acutely in Brabant during the crisis of a prolonged agricultural depression and intense international competition in the 1880s.

The family from which Van Gogh got his models did not own land in the Nuenen commune. They worked for other people, seasonally especially at harvest time. But when they were thus employed they did not need Van Gogh's money. They were otherwise engaged. Van Gogh tried to follow them to the fields but his drawings and canvases got covered in dust, sand and flies. The people did not stand still. They were working. They were not models. These drawings are from people who were not employed because they were too old and too sick. The woman is poor. Unlike her sisters in the city where inadequate wages drove women to sell their bodies for sexual services, this woman sells her body to an artist. She exchanged the sight of her body posed as if working for the money she needed to live because she was not. The exchange between the artist and the model is therefore a social relation captivated in and articulating the developing socio-economic transformation of the Dutch countryside which was the very condition of Van Gogh's practice, the condition of existence and possibility for this drawing. Thus far social history will bring us.

Class is therefore an integral component of the looking here. So is gender power. The artist, the one with the money to buy the time to look at this body and draw it, is a man. He obliges the woman to bend over in front of him. It is not a position his mother or sisters ever adopted and never in front of a man and a stranger. Ladies' bodies did not bend. They were disciplined from an early age by metal and whalebone. The bourgeois feminine body functioned as integrated, as if manufactured whole: a sculpted landscape without any unnecessary reminders of component parts. Ladies have figures on which to display the codes of rhetorical femininity which involves a dress (that is, a single flowing line and no legs). Bodies were classed as well as gendered in this way, but herein lies the rub. Could working women be represented as women since working and the bodies with which they worked defied the codes of the feminine? Working-women's bodies are therefore defined in radical but complex difference.

Working-class women wore skirts and blouses which divided their bodies at the waist. Van Gogh repeatedly comments on this in his letters. Their skirts were shorter so as not to drag about in the dirt. Their feet were exposed and shod in heavy wooden clogs or else they went barefoot. Their hair was shorn or cropped and covered with dingy caps. These bodies flex and stretch, and their separated body parts became the focus for a dispersed eroticization and fetishism for the men of the bourgeoisie whose looking invested them as a fantastic landscape for a class-specific eroticism. We can trace these across many sites of representation. Bared forearms, arms with rolled-up sleeves, arms stretched and upraised opening out the chest and torso to emphasize its lack of constraint by corsetry, the fullness gently nestling beneath carefully rumpled linen, with ankles, feet, necks and also buttocks.

Van Gogh's drawings had a possible narrative context, but not a sufficient one to make the drawings speakable. Van Gogh's drawings of men and women engaged in typical agricultural tasks derived from Millet's *Labours of the Fields*. They were made to demonstrate skill in dealing with the figure and

claimed a place in the lineage of Millet. Van Rappard had challenged him by dismissing *The Potato Eaters* (1885, Amsterdam, Rijksmuseum: Vincent Van Gogh) several months before, for its lack of facility in articulating the working human body.[21] What is interesting in the resulting drawings Van Gogh produced to repudiate this criticism is the lack of any narrative, anecdote or generic format to distract the viewer from that moment of production: to manage the inclusion of the sexual subtext in such a way as to allow its viewers to consume it without ever having to address it. That is what the established protocols of realism and naturalism offered to the nineteenth-century salon visitor. Had Van Gogh undertaken the lengthy processes of ideological induction–academic training as an artist–by which such procedures for managing visual representation were internalized by academy- or art school-trained artists, he would have known what to do.

The drawn body to which we are allowed such intimate access is, at closer inspection, disturbing in its misconstruction. Massive, almost giantesque, it suffers moments of severe disproportion of certain parts. There is scarcely any head and the face is obliterated by shadow. A solid arm emerges jointless from the blouse, composed of an exposed and muscled forearm and a vast fist. It is difficult to describe what is happening between the head and the legs. Perhaps it is rather a matter of what is not happening in an area of intense graphic activity whose function is not descriptive.

All these oddities are compounded by the inconsistency of the viewpoints which travel around the body. The torso is too narrow and short for the massive area of the hips and buttocks which takes up almost half of the drawn figure. This suggests a viewpoint demanding some foreshortening. Yet the face and arms are seen in profile as if the artist is first placed at right angles to his model. The feet are seen from a side view, but the legs and ankles from behind. Finally the buttocks have been pulled round. The drawing inscribes a body–in which hand movements register the journey of a look over and around a body–but the hand movements also inscribe the desire to see, the fascination with certain areas, the psychic investments in selected zones. Finally the hand writes another, quite fictive or fantasized body which was never really there. This body, and only as a drawing, emerges from that intersection between a subject/body looking attentively at a model, not knowing how to translate that scrutiny into current codes and rhetorics, and the inscription on the paper of a body ultimately produced by us, the reading viewers, as the effect of that gap.

The drawing, then, is not a record of a perception (the ideological notion of what guarantees the artist's looking, which art historical scrutiny replicates). I suggest we can better understand it as a kind of screen in which a body is reassembled, a represented form emerges across which we can read its uneven patterns of investment and fantasy. It is not a record of a vision, but a visualization not so much *of something* as *for someone*. The paper is a fictive space, an unforeseen space in which unpredicted and unpredictable meanings are being produced in a form for a specific kind of recognition which should not be hypostasized as being essentially or exclusively visual. This field of meanings is only realized in an act of complex analysis by a viewer/reader who is, like the producing artist, an unstable subjectivity in process while processing the drawing. The drawing is, in Barthes's terms, a text: a place of multiple

processes, references, deference, quotations and memories. These are shaped and ordered unintentionally as well as purposively by the particular trajectory of the socio-psychic individual named Vincent Van Gogh but consumed by us as 'Van Gogh'.[22] But in order for this drawing to have currency, it had to make someone want to look at it. There must therefore be some convergence between the idiosyncratic – that is, an individual artist's work – and the common structures of subjectivity within a culture forming its classed and culturally specific genders and sexualities.

The dream is analogous to this process. It too is a visualization, remembered as a series of images which exists only in the telling, being spoken. But any dream is overdetermined in both content and form by the specifiable processes of conversions, displacement and substitutions by which Freud defined dream work.[23] The meanings are not in the manifest appearances, but the meanings are figured by the sequence of images, a *mise-en-scène* whose actual semiotics require subtle deciphering. This scopic field must be interpreted by thickening the thin line of visual representation with the materials, interests and wishes the representation so economically screens: that is, both projects and veils.

There are thus two senses in which an image can be understood as a screen. The first is the cinematic sense of a surface for representation, for projection. The second moves in the opposing direction for the screen is then an obstacle, veiling representation. In the paper from which this discussion of a drawing by Van Gogh derives, I try to suggest that this drawing puts into play at least two bodies.[24] Using codes of class in shape and point of view, one body is aggressively debased and rejected as aged, immodest, bestialized. Yet against that pressure, a monumental, maternal body swells to dominate and entrance a diminutive child. A pre-Oedipal fantasy and a post-castration anxiety aggression are part of the image's multiple registers of threat, pleasure, fantasy, fear and desire which are the symptoms of the uneven negotiation of the sacrificial process of bourgeois masculinity in this period.[25] This analysis, here much compressed, skirts close to Richard Wollheim's positioning of psychoanalysis as the means to determine what we see in a painting, or so it might appear. The crucial difference lies in the distinction between excavating a painting for its core, a unified and universal human subject represented by this individual, the named artist, and analysing the text for its complex inscription of historically specific and non-cogent, non-unified processes of subjectivity which are gendered, sexed, and classed and culturally defined. The fact that some can now look at such a drawing and find pleasure in it derives in part from what Freud, explaining why we are not bored by writers fundamentally retelling their dreams or describing their fantasies, identified as a surplus yield of formal or aesthetic pleasure.[26] But it must also imply the possibility of entering as spectator into the gendered and classed and raced psychic positions from which this drawing was produced, and which are inscribed as the conditions of its intelligibility. By taking a distance, because I refuse that position, I have been able to suggest that the violence of the representation is not just that enacted by the artist subject Van Gogh against his proletarian woman model: it is also the violence of the patriarchal ordering of masculinity to which Van Gogh as a historically produced masculinity was subjected, of which his work as cultural representation from within and of

that culture was symptomatic. In the increasingly desperate, repetitious culture of early modernism (that is, of the European bourgeoisie), the body of woman is endlessly refashioned as both its most detested and most desired sign.

VISION AND DIFFERENCE

A corollary of such a historico-psychic analysis of the structures of Western bourgeois masculinity is an investigation of its feminine positionalities. In 'Modernity and the Spaces of Femininity',[27] I examined the sexual politics of early European modernism by means of the metaphors of space and the look. From Cézanne's oft-quoted phrase about Monet only being an eye to Greenberg's fantasy of a pure spectator contemplating an art reduced to pure opticality, modernism has mythologized vision. My work on femininity and early modernism identified differential positions within modernity, for those placed as masculine or feminine social subjects. Modernism, the founding culture of modernity, has been read as the product of a specific moment of consumer capitalism's remaking of the city. The city of Paris in the later nineteenth century was not only the site for the economic and social processes of production and consumption, it was physically and mythically reshaped to function as an image for those processes. Fetishized and opaque, the city was the inscription of the social in space.[28] Representations of that social in space were thus images of images and chiefly orchestrated their pictorial space as both representations of and representations to the characteristic figure of that city, the masculine, erotic, covetous, *flâneur*. Gustave Caillebotte's *Man at a Window* (Illustration 4) stages the gender and class relations as a representation of a looking. A man stands on a balcony, the picture's viewer posited as behind and sharing the direction and content of his look out on to the almost deserted square below. A single figure crosses this space. It is a woman, in fashionable dress, but alone, unchaperoned, on the street. This is enough to open up the question of her marital, social and sexual status, and forms the subject of the picture. But it is *about* the look, its charge, its mystery and its excited fantasy fuelled by that ambiguous figure falling within the orbit of the man's gaze.

The city was a place and image for men, but it was both place and image imagined to be *of* women. The mother, wife or homely sister are the signs of the interior, the sphere of emotion, intimacy and familiarity in contrast to the risk and fluidity of the street. The sexually-used women of 'unfixed' class and working-class women are figured in that latter realm of masculine freedom, licence and fantasy.

Olympia (Illustration 14) by Manet is one of the canonical paintings of modernism. Could a woman have painted it? Could a woman have had access to such social spaces and their exchanges? How can a woman viewer relate to the viewing position it proposes, the spectatorship it assumes (even if the aim of the painting is precisely to discomfort the complacency of the art viewer)? Can a woman be offered imaginary possession by sight of a female body so that the modernist artist's strategy of negation and disruption can become effective?

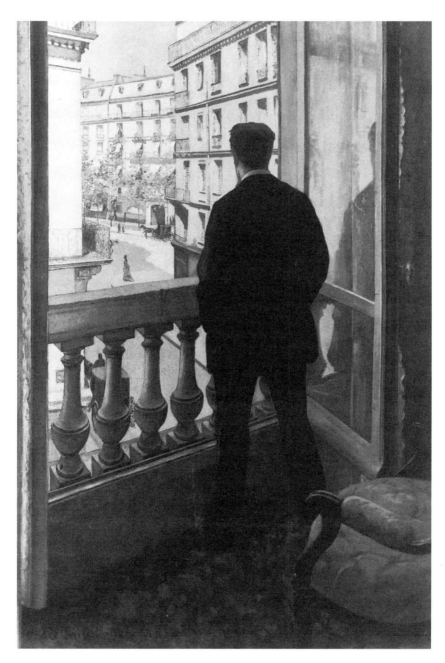

4 Gustave Caillebotte, *Man Looking out of a Window*, 1876; Private Collection

The answers invited by such rhetorical questions are clearly in the negative. Nonetheless, I suggest that the painting presumes a woman spectator. Without hypothesizing the presence of bourgeois ladies, mothers, wives, daughters and homely sisters in the social spaces of the salon, the shock of this painting remains partially unintelligible. The painting brings one of the social spaces of modernity (a fictitious courtesan's clearly staged bedroom) into the presence of another of bourgeois modernity's sites (the exhibition hall which, as the salon, was in fact compatible with the spaces of femininity). Bourgeois men could traverse these disparate sites of their own masculinity's enactment across rigorously demarcated femininities, or rather femininity and its antithesis. Their money bought them access and power in both. But the ideological opposition between the spaces of femininity (home, garden, opera and salon) and those of 'other *women*' (backstage at theatres, cafés, brothels, bars) constructed the hybrid category 'Woman'. The painting *Olympia* confounded the necessary distance between the opposing terms of lady and prostitute precisely because of who – namely ladies in the presence of men – were able to see it in the salon. But it also pictured an exchange of looks between a seller of sexual services and a client, signifying the commercial sexuality of the public realm which was supposed to be *invisible* and thus unimaginable to ladies.

Mary Cassatt represented women looking in public urban places. In *Woman in Black at the Opera* (Illustration 5), the dialectic of looking and being looked at is made the very subject of the work. The painting juxtaposes two looks within its space. By means of her status in the foreground and the pose of holding opera glasses to her eyes and projecting a steady gaze across the plane of the painting, this female figure is empowered. To look actively is often represented as the very sign of power.[29] The viewer's gaze is mirrored by that of the man in the background. It thus becomes potentially intrusive and certainly is denied its assumed freedom and authority. By explicitly being enjoined to a (masculine) point of view which is made an object of sight, imaginary possession of the woman is denied. To read this, there has also to be another spectating position, different from the represented man/mirrored masculine viewer. The painting constructs the potential of a feminine viewing position.[30] The way in which this relay of looks and spectatorships undercuts the masculinity of the conventional relations of viewing calls to mind the more explicit strategic contest with the power of that assumed masculine gaze in Barbara Kruger's *Your Gaze Hits the Side of My Face* (Illustration 6). The banner headlines plastered over the image utilize the invocatory force of language; they incite us to read and vocalize what we are encountering as graphic marks and visual signs. The possessive pronouns in the phrase work to make the viewing position a relational one which is critically the meaning of the image. The words spoken from the first person–my–do not quite attach to the averted female head of the imaged statue, but they establish a link, and thus create a gendered, feminine voice breaking the silence: the metaphor of Woman, signified by the statue, which is enjoined on women.[31] The head is averted, refusing the viewer's look and resisting it with a stoniness which generates a tactile association to suggest the hit of the text while evoking the pain of the assault of a gaze.

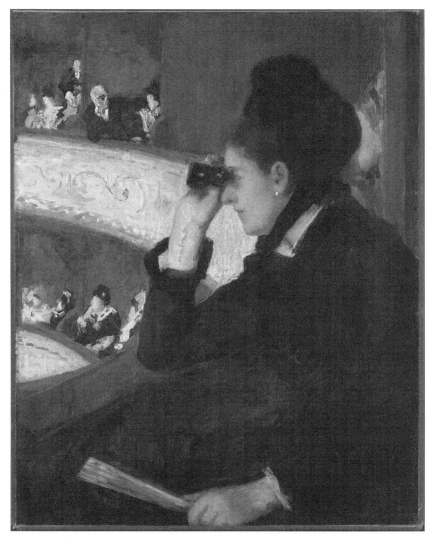

5 Mary Cassatt, *Woman in Black*, 1880; Museum of Fine Arts, Boston

These two artists, Cassatt and Kruger, span the historical moment we call modernism, both its emergence and its contested displacement. In it a specific masculine gaze was culturally placed to assault and, in Angela Carter's phrase about Picasso, cut women up. Even Cassatt and Kruger cannot dare fully to turn the female gaze back directly. Cassatt's contemporary, Degas, tried it and the pictures that came from a bizarre moment of compositional daring with which he experimented over many years are monuments to its dangers. Around 1866 Degas sketched a young woman, possibly his pregnant sister Marguerite, holding binoculars to her eyes (Illustration 7). The drawing may

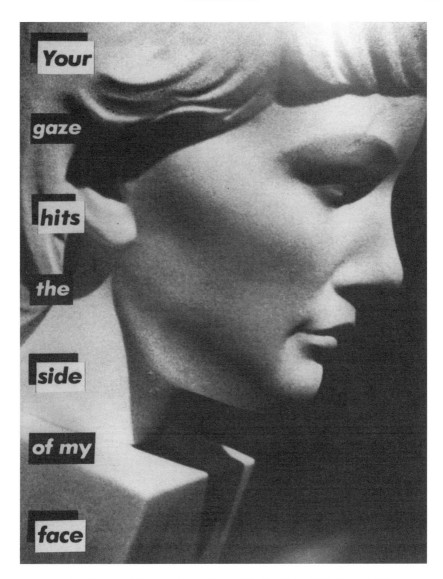

6 Barbara Kruger, *Your Gaze Hits the Side of My Face*, 1981

have been a preliminary move towards a picture of spectators at the race course. The woman looks out of the picture. The viewer is being looked at, scrutinized by a woman. This early version of a repeated theme concentrates on the head, yet the eyes are obscured by the binoculars. They are substitutes for eyes, machines to enhance the power of the gaze. Yet the way they are painted inscribes considerable anxiety and aggression. Is it too fanciful to think of some horrific act of violence gouging out the eyes, leaving only

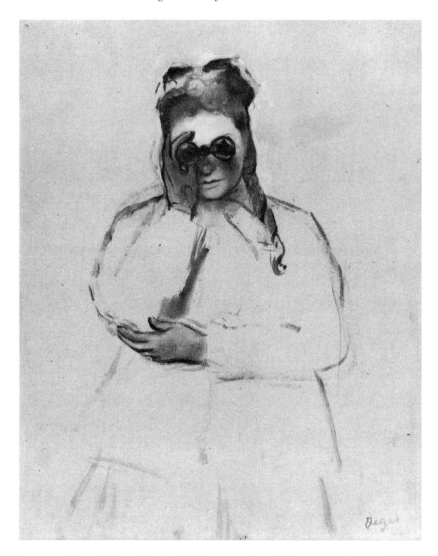

7 Edgar Degas, *Young Woman with Binoculars*, c. 1866; British Museum,
London

bloodied hollows? Is it further too ingenious to recall the fate of Oedipus and
Freud's association of blindness and castration? Probably; yet the image
creates a tension between the calculated gentleness of the pose with its elegant
gestures, and what the painter did when he came to lay paint on the paper, to
stand in for rather than to signify the gaze of this sisterly figure.[32]

How can women operate in such a culture as producers of art? How can
and did women of this modernist moment look? The way in which difference
structures the gaze to deconstruct a monolithic masculine gaze, and to suggest

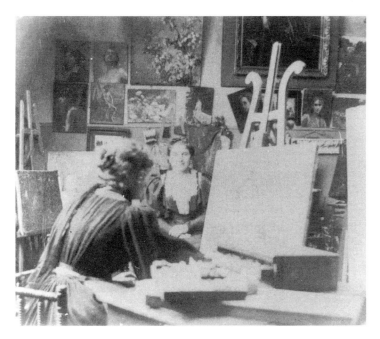

8 Anonymous, *Morisot's Studio*, c. 1890; Collection Sirot-Angel, Paris

there were historically and culturally other forms of looking, can be glimpsed in this photograph of Berthe Morisot in her studio with a model (Illustration 8). The photograph represents an exchange of looks happening in the process of artistic production. In place of exclusively subject/object positions, posited by the *flâneur's* gaze, looking is the site of intersubjective exchanges which are shaped by their spatial setting. There is an artist at work, and a woman sitting for her. The room is not large. It is a confined and cluttered space in which the artist cannot take a distance. The two figures could be in conversation or in a consultation were it not for the signs of her craft and the labelling of the sitters. The physical proximity underlines a social and psychological familiarity between women of the same class and social milieu or, if not, at least the same household. We know from other sources that women such as Morisot and Cassatt painted within their family or domestic circle. They rarely worked from strangers with whom their only relation was mediated by money. The circle within which the looks are exchanged provides the comfortable fabric of intimate and companionable relations. I hardly suppose that Picasso's *Demoiselles d'Avignon* (1907, New York Museum of Modern Art) could have been produced out of this space of representation within early modernism, or indeed any of Picasso's other more fearful mutilations of the female form.

 Luce Irigaray has argued that the specificity of feminine sexuality lies in a different relation to the look: 'Investment in the look is not as great in women

as in men. More than other senses it objectifies and masters. The moment the
look dominates the body loses its materiality'.[33] For Irigaray, the body does
not imply any essential biological difference which in and of itself is determ-
inant upon the psycho-social subject. The bodies of men and women in the
their morphological diversity provide material and semiotic resources for
the metaphoric function of the body in the Imaginary and Symbolic systems.
The specificity of the feminine body Irigaray is at pains to figure in discourse
will sustain a metaphor for a network of relations to the world through which
alone it will be possible to speak as women (that is, as something other than
Woman, which is in fact a synonym for not-man). The emphasis is therefore
away from the specular image, Woman, produced within a masculine domi-
nated psychic and cultural economy, to the possibility of women's discourses.
In the paintings by artists who were women in the early modernist moment, I
have remarked upon the specificity of the treatment of figures in space, the
proximity between the represented figures and the lack of distance for the
viewer from them. These features occurred precisely as the masculine tradi-
tion of modernism hypostasized a distancing, impersonal cult of vision in
which the whole world is reduced to a democracy of objectness before both an
interrogative and a fantasizing gaze.

In paintings by women a closeness to or of the body suggests that bodily
positions in space are signifiers of relations in the social spaces of femininity.
Nowhere is this more evident than in those many images which vividly repre-
sent moments of initial exploration of relatedness, namely representations of
the child and its adult caretaker. In art history such pictures are typically
called mother and child, and it is deemed natural that women should paint
such themes since they are extensions of the 'natural' physical difference
which makes them childbearers. But we know that it is culture alone which
demands that women be child*rearers*, that it is a social relation of immense
complexity and symbolic potency. Both adult and child are formed as subjects
in that labour process we call childcare. No more can we separate the labour-
ing body and the look in this instance than I suggested we could in the case of
Van Gogh's drawing of the peasant woman. What is it that allows the Van
Gogh drawing its wide appeal while the work of Casssatt and Morisot (which
explored the maternal look) or the infant female look had to await the vindica-
tions of feminism? Is it to do with spectatorship and sexual difference, articu-
lated through differential relations to *the body*, the maternal body? I would
like to suggest that for historical reasons laid out in my essay 'Modernity and
the Spaces of Femininity', the paintings of Morisot and Cassatt construct a
socio-psychic viewing position, a *feminine* viewing position. Those who cannot
occupy that position cannot see the images. They find them boring and call
them predictable. They refer them back to stereotypical categories of women's
art. As a result we find in regard to certain women artists a sort of art histori-
cal aphasia which results from a tedium of looking. That this is not a simple
question of men and women art historians but a matter of a historical work of
critical analysis and reconstruction is made clear by the review of the large
Berthe Morisot exhibit in Washington in 1987. Leila Kinney discerned an
impasse in writing about Morisot in a text by Tamar Garb and Kathleen
Adler.[34] Kinney argued that Garb and Adler had run into problems precisely
because they wanted to situate Morisot, the modernist of suburban

domesticity, in opposition to the model of the *flâneur* and city centre modernity. Kinney comments:

> The obstacle race becomes a labyrinth for its victim, leaving her little room to manoeuvre between barriers of constraint and mirrors of reflection. A way out might be found by taking into account one's own resistance, the resistance that today's feminist viewers feel to imagery like Morisot's. It is perhaps founded on their suspicion that it reinforces the patriarchal order, often in exquisite, deeply moving depictions of women's traditional role. In short we identify with the protagonist, but not with the imagery. The terms in which to respond to a woman painter who paints primarily images of women and children are not readily available.[35]

In my earlier discussion of Van Gogh's drawing I spoke of investment. Something of what is invested in that work is a relation to and horror felt for the mother: explored and humiliated, celebrated and defied by the act of looking and drawing. Here is its opposite in relation to the figuration of the woman as social mother: boredom, resistance, and indifference. Kinney represents that place where many women live, fantasize and experience some of their deepest, most violent and most tender moments as 'women's traditional role'. Why are images of women and children boring or uncomfortable? After all, it was an obsessive subject for many centuries in Christian art. Julia Kristeva has compellingly analysed the madonna of Bellini, showing what has been invested in the image by son/artists to make it so fascinating. Kristeva significantly maps the mother as a place, or space; a threshold from which language and signs emerge: 'motherhood is nothing more than such a luminous spatialization, the ultimate language of a jouissance at the far limits of repression, whence bodies, identities and signs are begotten'.[36]

INTERIM CONCLUSION

I hope I have suggested, however crudely, that there is a fundamental link between the regimes of sexual difference and the organization of the visual field. The archaeology of a text by Van Gogh yields, even for me in my revolt as a feminist, rich deposits to be critically but also sympathetically mined in the process of reading its visual textuality. To excavate the works of artists producing from a historically specific bourgeois and European feminine position – and now politically as 'women' as in 'the women's movement' – is more difficult. We have had to construct specific modes of spectatorship and reading to project femininity from the tedium its threatening nature has pressed upon its public currency in a phallocentric culture. We have had to devise new ways of looking. But then can what we see be represented on the existing screens of representation? Will it always seem veiled?

The contemporary artist, Mary Kelly, has posed the dilemma and produces startling ways of resolving the dialectics of sexuality and representation of difference. In *Post Partum Document* (1975–9) the mother/woman was simply not on view.[37] The process of which Kristeva writes from the son's point of view is examined from the intersubjective interlacing of female adult and child through a mixture of image, text, writing, drawing and objects.

Constructed across the multi-media installation is the fragmented discourse of the mother, which must of necessity signify in its formal enunciation also the discourse of the feminine unconscious. The piece concludes with a section on the child's acquisition of language, *Experimentation Mentis VI On the Insistence of the Letter*, which is composed of fifteen tablets or slates, each with three registers of marks (Illustration 9). The first traces the child's progress from the making of simple marks such as the 'x' or '+', to forming rounded shapes and

9 Mary Kelly, *On the Insistence of the Letter*, detail. *Post-Partum Document* 1979; Arts Council of Great Britain, London

finally their articulation into words which culminate in the writing of the child's name. The second combines the rhetoric of children's alphabet books and the mother's commentary on it, 'A is for apple' pointing to the 'coagulation of the signified' with the emergence of the letter which is thus tied to the logocentrism of language system, a system which privileges naming and leads through the proper name to the Name-of-the Father. The process of learning language moves slowly through marks, stories, rhymes and other semiotic rhythms to the final moment of assuming an identity in its order by writing and accepting a name. As art work, this process is represented as physically carved and photographically transferred inscriptions upon a writing slate reminiscent of both former schoolrooms and cultural icons like the Rosetta Stone (London, British Museum). Kelly suggests that writing itself is the anagram of the mother's body, both the screen on which it is written and the displaced substance of those curious shapes and forms we call the alphabet.

> Pre-writing emerges as postscript to the Oedipus Complex and as preface to the moment of latency. In so far as the child's researches are repressed by the Law and the Father, they are sublimated in the body of the *letter*; but it is the mother who first censors the look, who wipes the slate clean with her silence and prepares the site of inscription. For the mother, the child's text is a fetish object; it desires her. The polymorphous perversity of the letter explores the body beyond the limit of the look. The breast (e), the hook (r), the lack (c), the eye (i), the snake (s); forbidden anatomies, incestuous morphologies; the child's alphabet is an anagram of the mother's body.[38]

In work that is conceived at a historical point of critical contestation of modernism's investment in the look and its sublimation of the woman as its sign, be it figured or as the virgin surface of the to-be-inscribed canvas, Mary Kelly's project developed a form of representation which would bring the repressed to our attention. Like Cassatt or Morisot, aspects of the mother/child interaction, intersubjectivity, are central because they allow access to the processes of formation of subjectivity shaped by particular regimes of sexual difference. These subjectivities as cultural phenomena are enacted and reproduced through the work of culture, and in the case of art through invocation of the subject. But work such as Mary Kelly's refuses the limitations of fetishization of vision and the look, with its sexual regime of masculine gaze and feminine body, to explore the infinitely more complex, unstable and shifting territories of the subject which is, contrary to Richard Wollheim's readings, the legacy of psychoanalytical theory which has been taken up within poststructuralist feminism.

In an issue of *Wedge* magazine subtitled, 'Sexuality: Re:Positions', Kelly wrote:

> The field of vision is ordered by the function of images: at one level, quite simply by means of a path of light: but at another level, this function seems like a labyrinth. Since fascination in looking is founded on separation from what is seen, the field of vision is also, most appropriately, the field of desire.[39]

This text coincided with another major artistic project, titled *Interim*,[40] whose formal concerns allow us to recognize what I am tempted to call the

visuality of writing precisely because it refuses the division of vision and textuality (Illustration 10). Writing, as in *On the Insistence of the Letter*, is a site of inscription of the subject, a graphic process, a product of a body, if not in itself the making of a body, not just as description, but through the relation of the drives to the signifying process. The spectator, who finds herself reflected in the surfaces of certain pieces as much as 'reflected' in the imagery and stories, is also an aural viewer. She reads the texts and sees the images they evoke, and she is invoked to voice the words the artist's hand has traced. The interplay of text and image, as in this section from *Corpus: Appel Fig. 2*, confounds not merely the theoretical distinction between textuality and vision, but the historical premises on which it rests, the repressions of the body and the subject which both image and word necessarily and mutually inscribe, trace, speak and figure.

Commenting directly on the difficulty of inserting a woman as artist/art historian into this field of practice or analysis, Kelly notes the conflict women artists and writers inherit between the feminine position as object of the look and the masculine position as subject of the look. Kelly refers only to artists, but I think it can be extended to those who have to look at the works of artists. Kelly goes on to pose the central question: 'Here the problem of images of women can be reformulated as a different question: how is a radical, critical and pleasurable position of woman as spectator to be done?'[41]

In a sense, this is the question this chapter has been pursuing. Feminist interventions in and against art history involve precisely the production of a radical, critical position for looking at art, analyzing it and excavating its multiple registers. I have focused on the field of vision and suggested that it is, as Kelly argues, a field of desire. Perhaps I am, therefore, ending where I began, with Richard Wollheim's injunction to look hard at paintings and anticipate that their complexity will only emerge after intensive examination. But instead of the fiction of the artist as universal subject functioning as an unreflexive alibi for the spectator's desire, a feminist reformulation suggests the taking of responsibility for whose desires are invested in, or discovered in, the field of vision and in what systems these historically contingent desires are shaped as well as shaping. Kelly continues in terms which can serve as summary and conclusion to my attempt to push aside the apparently neutral and yet false opposition of textuality and vision and replace it with an acknowledgment of difference, hence power, in the interplay of vision and subject position or place.

> Desire is not caused by objects, but in the unconscious, according to the peculiar structure of fantasy. Desire is repetitious, it resists normalization, ignores biology, disperses the body. Certainly desire is not synonymous with images of desirable women; yet what does it mean to say that feminists have refused the 'image of the woman?' First this implies a refusal to reduce the concept of the image to one of resemblance, to figuration, or even to the general category of the iconic sign. It suggests that the image, organized in the space called the picture, can refer to a heterogeneous system of signs, indexical, symbolic, iconic. And thus that it is possible to invoke the non-specular, the sensory and the somatic in the visual field; to invoke especially the register of the invocatory drives (which according to Lacan are on

10 Mary Kelly, *Corpus: Appel*, detail. *Interim*, 1990; Collection of the Artist

the same level as the scopic drives, but closer to the unconscious) through writing.[42]

Notes

1 This study was originally prepared for a conference in 1989. I tried to use materials on which I was currently working as examples in order to explore the conference theme, *Vision and Textuality*, and my section *Beholding Art History*. In revising it for publication in 1993, I added several footnotes which reveal that I was then thinking about a number of issues which merited (and have since received) fuller treatment in separate publications. This study is not superseded by the fact. There is, I hope, a use in providing a theoretical overview of key issues, made sharper by being seen in a broader context, especially now when the claims made about individual paintings or cases can be supported by the detailed studies which my subsequent publications have provided. The article does propose an argument which has sustained the development of various projects around the deployment of psychoanalysis in feminist studies of the visual arts, focusing specifically on issues of spectatorship and subjectivity.

2 R. Wollheim, *Painting as an Art*, (London: Thames & Hudson, 1987), p. 8.

3 Ibid, p. 8.

4 G. Pollock, 'Artists, Mythologies and Media ...' *Screen*, 21, 3 (1980), 57-96.

5 Since this paper was first written, Mieke Bal's *Reading Rembrandt* (Cambridge: Cambridge University Press, 1993) has been published. Bal offers another model for intensive and sustained visual analysis of both the visual semiotics and the narrative textuality of paintings which stresses the active role of the spectator as producer or processor of meaning, taking responsibility for the necessary act of interpretation.

6 Roland Barthes, 'The Death of the Author', in *Image Music Text*, ed. S. Heath (London: Fontana Collins, 1977), p. 148.

7 Griselda Pollock, 'Agency and the Avant-Garde: Studies in Authorship and History by way of Van Gogh', *BLOCK*, 15 (1989), pp. 4–15.

8 M. Jay, 'In the Empire of the Gaze', in D.C. Hoy, (ed.), *Foucault A Critical Reader* (Oxford: Basil Blackwell, 1986).

9 Michel Foucault, 'The Eye of Power', in C. Gordon, (ed.), *Power Knowledge and Other Essays 1972–77*, (New York: Pantheon, 1980).

10 See J. Laplanche and J.B. Pontalis, *The Language of Psychoanalysis*, (London: Karnac Books, 1988).

11 Fredric Jameson, 'Imaginary and Symbolic in Lacan, Marxism, Psychoanalytic Criticism, and the Problem of the Subject', *Yale French Studies*, 55/56 (1977), pp. 354–5.

12 I am thinking of religious art of the medieval or Byzantine period, but also of later nineteenth-century paintings of women: see, for instance, my article on Rossetti in *Vision and Difference, Feminism, Femininity and Histories of Art*, (London: Routledge, 1988).

13 Yve Lomax, 'Some Stories which I Have Heard and Some Questions which I Have Asked', in *Three Perspectives on Photography*, ed. V. Burgin (London: Arts Council, 1979), pp. 52–5.

14 See analyses by Carol Duncan and Allan Wallach, 'MoMa: Ordeal and Triumph on 53rd Street', *Studio International*, 194, 988 (1978), pp. 48–59, and by F. Orton and G. Pollock, 'Les Données Bretonnantes: La Prairie de Representation', *Art History*, 3, 3 (1980), pp. 314–44.

15 The idea was originally advanced by M. Schapiro in 'The Nature of Abstract Art', *Marxist Quarterly*, 1937, and reprinted in M. Schapiro, *Modern Art* (London: Chatto & Windus, 1978). It was elaborated by T.J. Clark in *The Painting of Modern Life*:

Paris in the Art of Manet and his Followers (London: Thames & Hudson, and New York: Alfred Knopf, 1984).

16 I have analysed this film in my article 'Artists, Mythologies and Media ...', *Screen* 21, 3 (1980), pp. 57–97, and recently I offered an extended analysis of the film's representation of modernism in 'Crows, Blossoms and Lust for Death–Cinema and the Myth of Van Gogh as Modern Artist', in *The Mythology of Van Gogh*, ed. Kodera Tusaka (Amsterdam: John Benjamins, 1993), pp. 217–41.

17 See N. Burch, *Theory of Film Practice* (London, 1973) and S. Heath, 'Narrative Space', *Screen*, 17, 3 (1976).

18 For further discussion of this topic in relation to modernist and postmodernist debates about painting and femininity see G. Pollock, 'Feminism, Painting and History', in *Destabilising Theory: Contemporary Feminist Debates*, ed. M. Barrett and A. Phillips (Cambridge: Polity Press, 1992), pp. 138–76.

19 Inscription has a range of meanings upon which I am relying, such as carving names and verses on to memorial tablets, as well as being written into a register as in the German *einschreiben*.

20 See P. Kamuf, 'Writing like a Woman', in *Women and Language in Literature and Society*, ed. S. MacConnell-Ginet (New York: Praeger, 1980), pp. 284–99, and J. Culler, 'Reading as a Woman', *On Deconstruction: Theory and Criticism after Structuralism* (London: Routledge & Kegan Paul, 1983), pp. 43–64.

21 G. Pollock, 'Van Gogh and the Poor Slaves: Images of Rural Labour as Modern Art', *Art History*, 11, 3 (1988), pp. 408–532.

22 For fuller discussion of the import of Barthes and others on the theories of authorship in art history see G. Pollock, 'Agency and the Avant-Garde: Studies in Authorship and History by Way of Van Gogh', *BLOCK*, 15 (1989), pp. 5–15.

23 S. Freud, *The Interpretation of Dreams*, [1900] *Penguin Freud Library Vol.4* (Harmondsworth: Penguin Books, 1976).

24 G. Pollock, *Sexuality and Surveillance: Bourgeois Men and Working Women* (London: Routledge, 1994).

25 This argument is very compressed but I draw heavily upon the work of feminist historians who have analysed the class and gender effects of the social practices of childcare in nineteenth-century bourgeois households which lend historical density to Freud's analytical studies of the psychic 'cost' at which white bourgeois masculine subject positions are adopted.
See particularly Lee Davidoff, 'Class and Gender in Victorian England,' in J.L. Newton *et. al., Sex and Class in Women's History* (London: Routledge & Kegan Paul, 1983).

26 S. Freud, 'Creative Writers and Daydreaming' [1908] in *Art & Literature, Penguin Freud Library vol. 14* (Harmondsworth: Penguin Books, 1985).

27 G. Pollock, *Vision and Difference: Feminism, Femininity and Histories of Art* (London: Routledge, and New York: Methuen, 1988).

28 See D. Harvey, *Consciousness and Urban Experience* (Oxford: Basil Blackwell, 1985).

29 The point is made in the analysis of cinematic images of women wearing glasses by M.A. Doane, 'Film and the Masquerade: Theorising the Female Spectator', *Screen*, 23, 3–4 (1982), pp. 82–3.

30 I do not intend to go into lengthy theoretical explanations here about the nature of difference. I work from the position that while gender is socially constructed rather than innate, it is structured at the psycho-symbolic as well as economic, social, political and cultural levels. The term femininity therefore does not in any way imply a notion of innate or essential female characteristics or positions, but it does indicate both a social discourse on women's nature and sanctioned behaviours and a psychic formation giving rise to particular experiences and meanings, both of which are historically and culturally specific, and hence synchronically and diachronically variable and unstable. Femininity here also refers

to the specifically bourgeois regime of sexual difference which emerged in the modern era in the West.

31 Odilon Redon produced an image, female, profile, titled *Silence*, which Cora Kaplan discusses in 'Language and Gender' in her *Sea Changes: Essays on Feminism and Culture* (London: Verso, 1986).

32 This painting and its variants are discussed at length in my paper 'The Gaze as a Question of Difference', in *Dealing with Degas: Representations of Women and the Politics of Vision*, ed. R. Kendall and G. Pollock (London: Pandora, 1992).

33 L. Irigaray, 'Interview' in M.F. Hans and G. Lapouge (eds), *Les femmes, pornographie et l'érotisme*, (Paris, 1978), p. 50.

34 K. Adler and T. Garb, *Berthe Morisot* (Oxford: Phaidon Press, 1987).

35 L. Kinney, 'Berthe Morisot', *Art Journal*, Autumn 1988, p. 240.

36 J. Kristeva, 'Motherhood according to Bellini', in *Desire in Language: A Semiotic Approach to Art and Literature*, trans. L. Roudiez (Oxford: Basil Blackwell, 1980), p. 243.

37 The whole of this work is also available in book form: Mary Kelly, *Post-Partum Document* (London: Routlege & Kegan Paul, 1983).

38 Ibid, p. 188.

39 M. Kelly, 'Desiring Images: Imaging Desire', *Wedge*, 6 (1984), p. 5.

40 Mary Kelly, *Interim* (New York, Museum of Contemporary Art, 1990).

41 Ibid, pp. 8–9.

42 Ibid, p. 9.

Chapter Four
Past Looking
Michael Ann Holly

In 'The Burden of History', an essay which is by now over two decades old, Hayden White argues that one of the most important activities for all critically aware historians—confronted as they are with the positioning of their discipline somewhere between art and science – is to strive to make the presentation of their material consistent with 'the techniques of analysis and representation which *modern* science and *modern* art have offered for understanding the operations of consciousness and social process'. White is understandably reticent about providing examples, either imagined or paraphrased, but he does confidently assert that 'there have been no significant attempts at surrealistic, expressionistic, or existentialist historiography in this century ... for all of the vaunted "artistry" of the historians of modern times'. The result of this lack of historiographic experimentation 'has been the progressive antiquation of the "art" of historiography itself'.[1]

Could it indeed be the case that the issue of a historical text's compositional style (White's phrase) must be confronted by both writer and reader before either can assess whether the account meaningfully conveys something about the past? The Renaissance historian Peter Burke has further argued that any intellectually attuned historian should be explicitly engaged in a search for innovative forms in which to cast his or her narrative (since all the old ones are a bit impoverished), and he has recently suggested the deliberate adoption of cinematic techniques, such as flashbacks, cross-cutting and the alternation of scene and story.[2] Both historians' concentration on reconceiving the formal (I think I would prefer rhetorical) relationship of narrative to historical documents through categories of visual experience might encourage us to think about the efficacy of such a transformation for the practice of the history of art. Art historians do not join text to text, as for the most part historians and literary critics do, but text to visual object. Even though both modern and postmodern art are frequently defined by their relationship to manifestos, visual objects (as most art historians would be the first to claim), demand that their formal specificity be appropriately acknowledged before any sort of ancillary investigation can begin. Might this recognition encourage a certain willingness to experiment with the rhetorical composition of the art historical text in order to match the formal virtuosity and iconic ingenuity of the images about which it speaks? Or

does the fundamental incommensurability of structure between image and word, object of study and the study itself, hinder historiographic inventiveness in the discipline? Clearly, we need only look at recent issues of the standard art history journals to answer that peevish question. The hackneyed debate about whether history is an art or a science is, of course, particularly irksome to the practising historian of art. Faced with the work's physicality and marketability as an object in the world, she or he needs to identify its subject, its creator, its state of preservation, its antecedents, its patrons, its formal and iconographic relationship to other works created at the time and so on, and all such inquiries demand empirical expertise and verification.

Traditionally the word 'history' in the term 'art history' has denoted a positivistic pursuit. At the same historical moment when even historians of science have eschewed a reliance on facts as givens, all but a few historians of art have paraded a consistent refusal to recognize the dependency of the criteria and values they employ upon their own gendered, ideological and cultural situatedness as scholars. Hence the uncomfortable alliance between art critics and art historians. Until the advent of the 'new historicism', hardly anybody in literary criticism in the last few decades employed the term 'literary historian', but the distinction between criticism and history has always loomed large in the professional art historical consciousness. Historians are interested in facts; critics in impressions and judgments. Historians coolly analyse; critics are passionately engaged. Historians are exempt from ideological commitments; critics revel in their presence. And perhaps most important, historians deal with the art of the past, and critics with the art of the present. The rest of this study is intent upon contributing to the subversion of that distinction in the history of art, with the awareness that this would no longer be a timely issue in any other historical discipline.

I engage in this task because of my sense that critical attention to the *formal* or rhetorical resonances between objects and the histories of art that inscribe them might provide an answer for the kind of historiographic experimentation which Burke and White have obliquely urged upon the historical profession in general. To be fair, the history of art is not exclusively what it once was: the conservator of elite objects and the preservator of a certain canon of values. A variety of critical challenges to this traditional role have animated the discipline during the last two decades, from the revisionism of feminist and Marxist readings, to the interpretive paradigms of semiotics and psychoanalysis, and yet it certainly needs to be acknowledged that, for the most part, these challenges have originated outside the confines of art history proper. The metahistorical task of discovering some theme or issue shared by this plurality of re-visions need not necessarily prove unilluminating. The concentration on the 'gaze' as an interpretive principle cuts across a wide sampling of recent theoretical perspectives. Paintings are, after all, meant to be looked at, so it should come as no surprise that the investigation of who or what is presumed to be doing the looking is now viewed as a critically unsettling issue in post-structural writings on art. Despite the complexity and subtlety of the debate, however, so far the discussion about the gaze seems to me to have overlooked a special, one might even say a privileged, case of spectatorship: that of the historian whose account of works of art is itself being implicated in or anticipated by the structure of the objects it labours to illuminate.

Once upon a time, matters appeared to be more straightforward: take the long-lived paradigm of the interpretation of Renaissance painting as an example. The art historian – be he a Gombrich or a Panofsky, or even a more pedestrian writer of Renaissance surveys – was assumed to have taken up a certain prescribed position before the object, from which fixed aristocratic perspective he (probably) replicated in words for others what he clearly had been earlier trained to see: its allure, its formal structure, its iconographic programme and its resonance with other cultural artefacts (Illustration 11). There is no question that his was an imaginative and pleasurable enterprise, but its overarching virtue was its presumed objectivity, its commitment to a certain achieved standard of scholarship. The historian stood before the work in place of Alberti's positioned artist/observer, and the world of the painting panoramically unfolded before his aristocratic, male, monocular viewpoint.[3] The voyeuristic point of view appeared to be reassuringly unproblematic, and now its tortured passing has called into question the practice of the discipline as such.

In a 1986 essay in the *Journal of Aesthetics and Art Criticism*, David Carrier surveyed several recent works on the phenomenon of spectatorship. As he reviews it, there are four structural (he cautiously avoids the political) relationships to be established between the beholder (not necessarily a historian, but more of that momentarily) and the work of art: 'the spectator stands before a work; the spectator sees the work and the work looks back; the spectator is as if absorbed into the work; the work elides the spectator's presence'. The first, the Albertian model, is unilateral in its direction. When 'Gombrich, an Albertian, says, "I see the picture," he treats viewing as a one-way relation between the active spectator and the object of his perception.'[4] No matter how

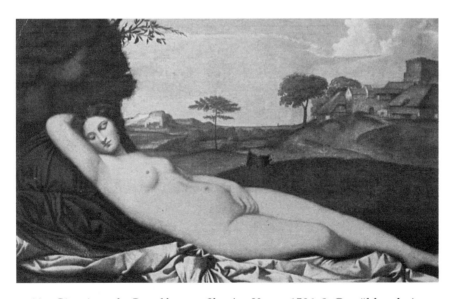

11 Giorgione da Castelfranco, *Sleeping Venus*, 1506–8; Gemäldegalerie,
Dresden

sophisticated a reading the historian of art may give to the painting, his initial posture before it appears to be an uncomplicated one. He views what is arrayed before him and confidently comes to some conclusions, just as Jacob Burckhardt did long ago in his 1855 guidebook, *Cicerone* (his description of Raphael's *School of Athens* – Illustration 12 – here serving as an example): 'the wonderfully beautiful hall, which forms the background, [is] not merely a picturesque idea, but a consciously intended symbol of the healthy harmony between the powers of the soul and the mind. In such a building one could not but feel happy. Raphael has translated the whole thought and learning of antiquity entirely into lively demonstration and earnest listening ... We *find in the picture* [my emphasis] a most excellent arrangement of the teachers, listeners, and spectators, easy movement in the space, richness without crowding, complete harmony of the picturesque and dramatic motives.'[5]

Foucault–or was it Velasquez?–considerably complicated the matter of spectatorship with *Las Meninas* (Illustration 13): 'We are looking at a picture in which the painter is in turn looking out at us. A mere confrontation, eyes catching one another's glance, direct looks superimposing themselves upon one another as they cross ... a matter of pure reciprocity ... The painter's gaze ... accepts as many models as there are spectators; in this precise but neutral place, the observer and the observed take part in a ceaseless exchange ... We do not know who we are, or what we are doing. Seen or seeing? ... We are observing ourselves being observed by the painter, and made visible to his eyes by the same light that enables us to see him.'[6] This oft-repeated scenario is now a classic example of the spectator's seeing the work at the same time that the work looks back, as is Manet's *Olympia* (Illustration 14) who so uninhibitedly acknowledges the virtual presence of the voyeur in her sumptuous bedroom.

For Carrier's third and fourth possibilities – the spectator as if absorbed into the work and the work's eliding the spectator's presence – the writing of Michael Fried comes directly to mind. In *Absorption and Theatricality*, Fried offers many examples of eighteenth-century French painters' preoccupations with Diderot's anti-theatrical effect: the articulation of the pretence that the beholder does not exist.[7] A genre painting by Chardin, for example (Illustration 15), is predicated upon the presence of characters so absorbed in each other's activities that they seem oblivious to the presence of any audience. The gazes exchanged are strictly internal ones. With the work of Courbet, even the position of the artist himself becomes intrinsic (Illustration 16). In painting after painting, Courbet strives 'to undo all distance ..., all separation between himself' and the representation upon which he is working. 'The heavy urgency of the painter-beholder's determination to achieve union with the painting before him and by so doing to annul every vestige of his own spectatorship' temptingly poses an erotics of desire in which, finally, there is no difference between image and image-maker.[8] The painter/beholder has become, in Fried's word, 'supererogatory'.

Where does this leave the critical historian? In all three of these 'non-Albertian' models – so-called by Carrier – the former unproblematical relation between perceiver and perceived is disrupted. Chronology aside, all three, even according to his cautiously apolitical analysis, are opposed to presenting the realm of the visible independently of the role of its spectator. Does

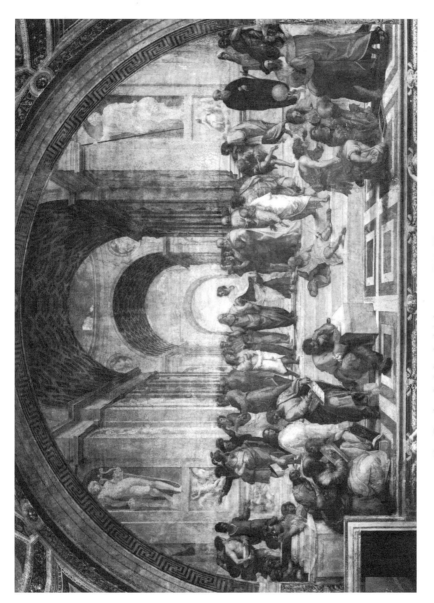

12 Raphael, *School of Athens, c.* 1509; Vatican, Rome

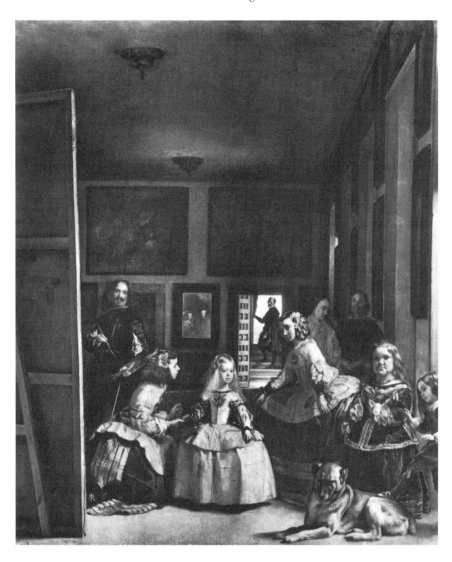

13 Diego Velasquez, *Las Meninas*, 1656; Museo del Prado, Madrid

that attribute mandate that the words written about these kinds of work must
be exercises in criticism rather than historical essays? More is on the line, obvi-
ously, than the simple identification of the direction or exchange of glances in
works of art. Above all, I would challenge Carrier's argument for its tenacious
clinging to some essentialist notion of 'perceptual purity'. As Bryson has
pointed out, what is at stake when we talk about the gaze is the 'discovery of a
politics of vision'. All of the things that we once assumed to be 'private,
secluded, and inward – perception, art, the perception of art' must be viewed
as socially constructed and constructing.[9]

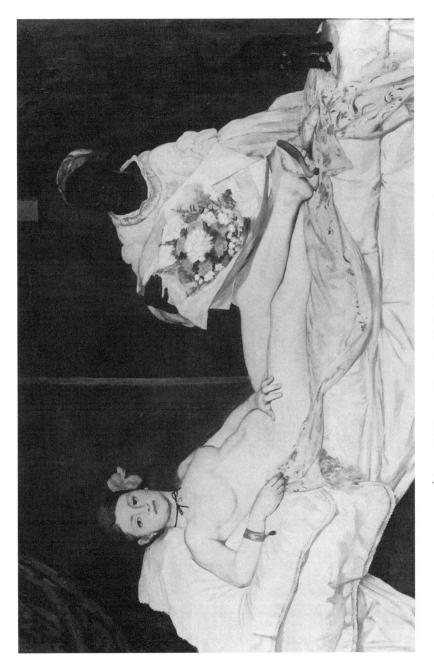

14 Édouard Manet, *Olympia*, 1863; Musée d'Orsay, Paris

74

15 Jean-Baptiste Siméon Chardin, *The Young Schoolmistress*, 1740; National Gallery, London

16 Gustave Courbet, *The Corn Sifters*, 1854; *Musée des Beaux-Arts, Nantes*

Here is where the special case of the commentator – be she a critic or a historian – becomes significant. The focus on the gaze has become a particularly crucial interpretive issue because of our late twentieth-century preoccupation with 'interventionist' commentary, that term applied to the variety of approaches (for example, feminism) in which the issue is less how history can serve art than how art can serve as a basis of cultural and social criticism.[10] One could almost say that the focus on the gaze has itself provoked the more ideologically charged gaze upon the focus of criticism.

As many postmodern critics have recognized, the confrontation with the complexities of vision, of seeing and being seen, has not been restricted to the domain of art criticism. In an essay in *The Four Fundamental Concepts of Psychoanalysis*, Jacques Lacan recounts a memorable story from his youth: 'I was in my early twenties ... and ... being a young intellectual, I wanted desperately to get away, see something different, throw myself into something practical, something physical, in the country say, or at the sea. One day, I was on a small boat, with a few people from a family of fishermen in a small port. One day ... as we were waiting for the moment to pull in the nets, an individual known as Petit-Jean ... pointed out to me something floating on the surface of the waves. It was a small can, a sardine can. It floated there in the sun ... And Petit-Jean said to me – '*you see that can? Do you see it? Well, it doesn't see you!*'[11] Lacan goes on to relate the unease he felt at the others' laughter. Self-conscious about not belonging on the little fishing boat along with 'those fellows who were earning their livings with great difficulty, in the struggle with what for them was a pitiless nature', he recognized all too terribly that he 'was rather out of place in the picture'. Much later, drawing the moral from his youthful experience, Lacan would write: 'I am not simply that punctiform being located at the geometral point from which the perspective is grasped. No doubt, in the depths of my eye, the picture is painted. The picture, certainly, is in my eye. But I am not in the picture.'[12]

Clearly, even in Lacan, it is still the Albertian model of spectatorship that haunts our history, our criticism. His almost homely focus on geometry, on punctiforms, on perspectival rays as the basis of exchange in seeing and being seen is itself transparently predicated upon an Albertian model of vision, so much so that it is difficult to visualize what he could be describing apart from that totalizing scheme of spatial construction. Perhaps it is the lack of fit between art and artefact that disturbs him. Unlike a sardine can, a Renaissance painting is designed to be seen; it is a crystallization of a certain deliberate viewing of the world. Alberti's *De Pictura* had effectively coordinated the problems of subject and object, seeing and being seen, in the term *compositio*. He even recommended that one of the foreground figures make some kind of gesture of invitation to the spectator outside (Illustration 17).[13] The illusion a painting in perspective produces is always a 'seductive' one.[14] Unlike the sardine tin, it implies the involvement of the spectator who is the absent focus, or even the unseen orchestrator, of the narrative. The story unfolds around her or his single viewpoint, and then vanishes at that distant point on the horizon where he or she can no longer see. In this sense, perspective construction invalidates the first category that Carrier designed it to exemplify. It is not just the case of a naive beholder standing there looking at a painting that does not look back. Only rusty sardine cans are intransigent.

17 Piero della Francesca, *The Flagellation of Christ*, c. 1450; Galleria Nazionale delle Marche, Pallazzo Ducale, Urbino

It is even less the case when that beholder of a Renaissance painting is a learned historian of the Renaissance, whose eyes have long been predisposed to exchanging glances with the past. Let me use Burckhardt as a brief example, so that I might more appreciatively complicate my earlier characterization of his descriptive words as 'unproblematic'. There is no time here to go into this nineteenth-century Swiss historian's idiosyncratic and long-lived vision of Italy in the fourteenth and fifteenth centuries. I hope it suffices to say that his 1860 *Civilization of the Renaissance* excludes nothing from its gaze.[15] Topics as apparently diverse as bloodthirsty tyrannicides and Petrarchan love sonnets are vividly, often imagistically, aligned side by side. Hayden White, in fact, has extolled Burckhardt for his willingness to experiment in his composition with avant-garde compositional techniques. Like his Impressionist contemporaries, White says, 'Burckhardt cuts into the historical record at different points and suggests different perspectives on it, omitting, ignoring, or distorting as his artistic purpose requires.'[16]

I would argue that the narrative composition of this text is derived not from the art of Burckhardt's contemporaries, as White claims, but from Renaissance principles of pictorial composition, by which I mean not only the inclusion of Alberti's prescribed variety and abundance of details, but also his articulation of a perspectival infrastructure. A committed connoisseur of Renaissance art, Burckhardt learned from the painters how to look, how to visualize, how to think historically. His text, formally analogous to a painting by Raphael (Illustration 18), makes everything appear in proportion, makes everything fit together and leaves nothing out of place. In both cases – that of text and image – the organon through which this panorama is systematized, this Albertian graph of space, is primarily dependent upon the gaze of an external viewer whose directed focus singularly legitimates the arrangement of the rich and abundant details of the optical field.

The perspective system originated by Alberti, in other words, might be construed not just as a painterly device that permits the artist to locate objects spatially in a certain manifest scheme of relationships, but also as a kind of cognitive map for the cultural historian whose directive is to relate events, attitudes and personalities in a coherent temporal architectonic. Burckhardt's essay is simultaneously an exercise in narrative (the story of ...) and a critique of narrative (the picture of ...). It is what it is also not: a diachronic plot but arrested upon a synchronic grid.[17] I have argued elsewhere that Renaissance paintings presented Burckhardt with a strategy for representing the Renaissance: that is, the works of art of the period compositionally prefigured their own historiographic response.[18]

What is the point of this nineteenth-century example? The issue is one of a productive correspondence of rhetorical ideologies between image and text. Representational practices which are encoded in works of art continue to be encoded in their commentaries. Perspective construction is particularly telling in that regard, for Renaissance art seems to conform so well to the ability to write coherently about it.

If it is indeed the case that in some subliminal way Renaissance paintings have formally predicted the shape of their most influential subsequent cultural histories in the German idealist tradition, then two important historiographic issues arise: (1) perhaps it has never been true that historians

18 Raphael, *Marriage of the Virgin*, 1504; Brera Gallery, Milan

of art or culture can easily escape the lure of casting their histories in the
shape of those objects they have set out to investigate; in other words, I am
suggesting that the historical artefacts, particularly visual ones, are themselves
always trying to systematize their own historical account (that is, as signs
literally engendering other signs); (2) if so, it follows that the historian, as a

special kind of spectator, is herself or himself always already anticipated or implicated in the formal logic of the works he or she describes. The author is never exclusively on the outside. Not literally inside the Renaissance, the historian's vision is nonetheless being emplotted in the Renaissance pictorial imagination,perhaps by the Albertian painting, according to Carrier, that supposedly does not look back. There are ways in which the syntactical ideology of the work of art 'sneaks into' the ideology of the art historian who is purportedly analysing it from afar. This predicament can, of course, lead to a replication of problems, particularly with respect to point of view: on the past, on the autonomy of artistic creation, on the relationship between the sexes, on the organization of knowledge, and so on.

In the *Philosophical Investigations*, Wittgenstein claims that language is always a question of usage; the language one employs testifies to a kind of physical understanding of knowing how to do something, of getting something 'right' without being able to say how.[19] If we think about it that way, then historical analysis can never be analysis in a pure sense. There is always some kind of game going on. Burckhardt, for example, enters into the formal apparatus or rules of Renaissance art in order to play, rather than analyse his scopic field with some kind of alien instrumentality. Analysis is not something that is superimposed upon the structure of the work of art, but is instead a continuation of the performance of the work in the terms of its own compositional schema, of its own expectations of what its ideal viewer should or should not be saying, of where such a viewer should come from, of where he or she should literally take his or her stand. When we write about painting, we cannot help but begin to perform a kind of Wittgensteinian game. It is not a matter of truth or falsehood at all. It is a case of signifiers playing with each other, although the calculus of relationships is always shifting, depending on who is writing about what.

My aim here is to question what it is we are doing as historians and critics when we talk about pictures. What predetermines the shape of our argument? What are the 'ligatures' [20] which hold our critical discourse in contact with the painting? And does the character of these questions differ from those being asked by literary critics? To be a bit reductive about it, much recent literary criticism seems intent on making manifest the intertextuality of all discourse, the domain of texts begetting other texts, thus valorizing criticism as a no less primary interpretive activity than the literature about which it writes. The original poem or novel serves only as a pre-text for the equally significant critical text. Criticism itself has been construed as a 'fully autonomous literary object'.[21] On the other hand, many art historians, like acolytes, still devotionally move about under the conviction that their labours are serving the sacred object, perhaps because the objecthood of their objects is so sacrosanct, often valued as it is in millions of dollars.[22] Or perhaps there is a more interesting distinction to be made, that arising from the predicament with which I began. In their texts, writers on art must acknowledge the presence of the visual 'other', and text in this case cannot be so felicitously linked to text. Two very different orders of spatial and temporal experience confront each other. A hierarchy of investigation seems implicit in the enterprise.

I am interested in the generic problem of the ways in which an historical period might syntactically 'prefigure' its own historiographic expression, and

I think the cultural histories of historians more than tangentially interested in a period's works of art, from Burckhardt to Gombrich, pose intriguing examples of that process at work. There does indeed sometimes appear to be a hermeneutic overlap between the materials of a historical age and its historiographic expression. I would like to explore the idea that certain rhetorical features of a period's consciousness, as visually embodied in its works of art, determine not just the array of things that can be said about it in the predictable ways, but also formally or perhaps semiologically legislate *how* these things are organized in the first place: the way they assume their relationships in the historian's composition.

It is a case of a later ideology reinstantiating an earlier formulation of its principles. I am most anxious to avoid the implication that because works of art might rhetorically prefigure the way we write about them, that what we end up saying has some 'truth value' to it in a positivistic sort of way. I am instead trying to undermine that which Paul de Man has called the 'binary polarity of classical banality in the history of metaphysics: the opposition of subject to object based on the spatial model of an "inside" to an "outside" world'.[23] Historians, particularly cultural historians who begin their study of the interconnectedness of an age by looking at its works of art, are not only the distant analytic observers on the other side of time that they so often wistfully claim to be. The moment they begin to plot their studies upon a formal substructure of relationships that resonates with the formal architectonic of the works that have courted their gaze in the first place, they have stepped over the gap of historical time. Outside has become inside. The language of art has invaded the historical imagination, has decentred the self and has mediated perception.[24]

In the *Philosophical Investigations*, Wittgenstein said that instead of feeling 'as if we had to *penetrate* phenomena', our investigation should be directed not towards phenomena, but, as one might say towards the *"possibilities"* of phenomena ... There is a way of grasping a rule which is not an *interpretation*, but which is exhibited in what we call '"obeying the rule."'[25]

This argument is not to deny the fact that very different histories of the Renaissance, say, have been and will be written; it is simply to make the claim that historical perspectives are in fact critical stances at the level of both story and structure. Different rules, of course, call out to different responses in different historians. Some histories 'match' their periods more adequately than others in terms of how they structure their arguments, but in doing so they also syntactically perpetuate its cultural and social mythologies. The understanding involved in writing about a work of art is based upon a *coincidence* of the formal ideology of that work or group of works with the compositional (also ideological) needs of the narrator. The work of art privileges its own ideal spectator (his gender, his class, his world view); to write convincingly (historically?) of it is to assume its particular point of view and replicate it because then an effective 'match' has been achieved. To speak critically of the work is to challenge that point of view and all its attendant historical implications. But, in either case, the work is still mandating the parameters of the discussion, still compositionally pre-fixing the point of view from which to begin.

Postmodernism has reminded us that historical time is far from linear and, if that is the case, critical text and originary monument cannot be felicitously

disjoined. As Craig Owens has pointed out, once upon a time the modernist agenda, with its various strategies of self-reference, managed to appear to suspend or bracket out the notion of mimesis. The fundamentally deconstructive impulse of the postmodernists will not permit such a revulsion to the idea of copy. Contemporary art may participate in mimesis in order to denounce it, but it also valorizes the return to the original and plays a game with it, at the same interpretive moment (Illustrations 19, 20). When this art speaks of itself, 'it is no longer to proclaim its autonomy, its self-sufficiency, its transcendence; rather, it is to narrate its own contingency, insufficiency, lack of transcendence'.[26] Heeding White's plea about making the presentation of historical material consistent with the 'techniques of analysis and representation which modern art [has] offered for understanding the operations of consciousness', a contemporary historical text (one that was critically self-aware) might acknowledge, openly, that it is acceptable to end up talking like the text you are talking about. In point of fact, what else could be going on?

Lacan suggests as much when he speaks of observation as the chiasmic process by which the subject becomes a part of the picture.[27] In interpretive praxis, there is clearly a 'double coding' at work which has nothing to do with 'truth value'.[28] The whole idea of knowledge in the West is predicated on the

19 Peter Blake, *The Meeting, or Have a Nice Day, Mr. Hockney*, 1981–3; Tate
Gallery, London

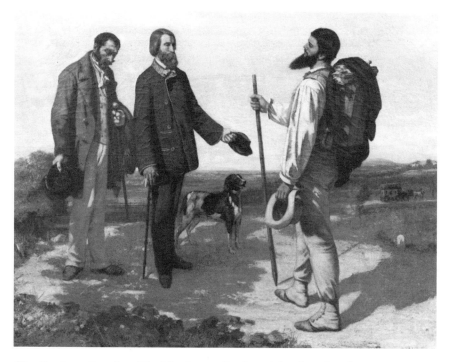

20 Gustave Courbet, *The Meeting, or Bonjour, Monsieur Courbet*, 1854; Musée
Fabre, Montpellier

notion of difference, on the idea that to observe something means to take up a
position on the outside, to be something other. But postmodernism has shown
us there is no other. We may be talking about an artefact, but we are also
talking about ourselves in the terms the artefact has delineated for us. In other
words, we cannot read the interpretation of paintings as history, pure and
simple, with the historian on one side of the divide, and the work on the other.
What the discussion about the gaze in works of art has taught us is that per-
ception always involves a circulation of positions, a process of movement back
and forth that will forever undermine the fixity of the two poles, inside and
outside. Herein lies the source of an historian's critical artistry. The trick is
making what forever will be a provisional metaphorical construction at least
partially consonant with that made visible in the reigning artistic metaphors
of the period. Indeed, that seems to be something of what Nietzsche,
Burckhardt's favourite student, had in mind in *The Use and Abuse of History*
when he claimed that historical 'composition' in its highest form will result in
'an artistically, but not a historically, true picture'.[29]

What conclusions, then, can be drawn about the historian as beholder? Is
there any such thing as 'history', or is all writing about art 'criticism'? We can
guess, of course, what Fried would answer, and probably Foucault as well.

That is why I see it as important to take on the purportedly straightforward Renaissance case of the Albertian relationship of painting and spectator (that is, that of the beholder as distant observer or as substitute for artist) and reconstruct the visible syntax through which it has mandated a prototypical historical response, from Burckhardt to Panofsky to Gombrich. Like all avowedly mimetic exercises, the texts of historians necessarily intertwine historical form with historical content, the 'medium of representation with what is represented'.[30] Understanding the historians' roles as spectators posed in certain grammatical relationships to the historical artefacts about which they write is crucial. Style in this sense may indeed be more determining than substance, and herein lies its danger. Perspective construction has provided us with an example. This particular rationalization of sight, once perfected in the fifteenth century, has ever since implied 'the notion that reality itself is pictorial'.[31] This system of visibility has been appropriated for something more crucial still than optical verisimilitude. I do not doubt that it is itself, in part, the originator of the modern historiographic interest in foregrounding and backgrounding, in hierarchy and coherence: of writing history as the discovery of a hidden order of things.

The very idea that a historical project has to produce an ordered vision from afar is especially apparent in Burckhardt's *Civilization of the Renaissance*. It is incumbent upon the cultural historian to reveal symmetries and relationships at work behind the chaos of historical appearance. Perspective provides a means of fixing the world (historical or historiographic) against the mutability of life.[32] It is a political vision replicated many times over. The cultural practices which translated themselves into representational practices have in turn organized the field for the production of meaning in Renaissance art history. Lately it has been the tendency to speak of works of art as reflections of certain ideologies, to decipher their latent political and social content but, as Althusser has reminded us, works of art also generate ideology; art reproduces ideology through the *forms* of its representations.[33] Critical history does not arise spontaneously: it is coupled with the objects about which it speaks. Historians, like most spectators, do not simply *perceive* order and significance in art, and the process is done for. 'The act of recognition that painting galvanises' (Bryson's claim) is 'a production, rather than a perception, of meaning.'[34] Ideology manifests itself in the shape of the argument, as well as in the argument itself. Embodying the gaze of the historical other, Renaissance works of art exert a tenacious grip on the Renaissance historiographic imagination. The visual mechanics of the process demand attention. In looking and writing about painting, we are in large part participating in the ground rules, fair or unfair, that it has laid down for us. Our discourse is empowered by the historical other, and in this sense, as we look, our gaze is literally embodied in the world of the Renaissance. The death of the artist has presaged the demise of the art historian.

Writing about painting is itself part of the painting. I am certainly prepared to admit that such a claim is itself simply a symptomatic restatement of the essential postmodern dilemma. Every image that arises now comes to us already emplotted in the context and history of earlier images. We have abandoned the modernist faith in the inexhaustibility of discovery

of representational forms; nowadays our aesthetic sensibility cannot get out from the under the weight of the visual past and the burden of the simulacrum.[35] When it comes to the writing of history, I am suggesting that in some way this has always been a predicament, recognized as such since Nietzsche called our attention to it. And therein lies the hidden terror of the discipline of art history, since sight is 'always constructed in relation to power, and powerlessness'.[36] In *Thus Spake Zarathustra*, Nietzsche satirized the will's inability to overcome the finality of time's 'it was'. The will, he said, '"cannot will backwards; ... it cannot break time and time's desire – that is the will's most lonely affliction."'[37] Even though the historian is frequently a voyeur to the past, his or her comparatively impassive gaze is being actively shaped by the vital presence of the visual scene upon which she or he is looking. We historians are not only 're-visioning' the objects; the objects are also revising us. Hence we might even go so far as to claim that in fact most of what we do is rewrite the past in the terms it has anticipated for us. Tradition, the past, has always already arrived there before us, the latecomers, mere epigoni, as Nietzsche called us;[38] we are always rehearsing scenes played out long ago by others. Consider how frequently the earlier twentieth-century works of Magritte are employed by late twentieth-century thinkers in need of characterizing the 'hysterical semiology' of contemporary thought, by means of which Baudrillard has said ' "everything wants to be exchanged."'[39] And it is particularly Magritte's puns with seeing and being seen that have helped to unsettle the modernist faith in progress and objectivity. In his *False Mirror* (Illustration 21), the floating orb (what Bataille has characterized as the cold-blooded 'pineal eye': the detached, dead, almost ahuman organ hovering vertiginously at the centre of modern thought) becomes a metaphor for the real terror of all sign-systems which are always 'self-referential, tautological, ... and solipsistic'.[40]

The object here viewed – the eye – abruptly changes its direction and circles back on its rival the other 'I', the spectator outside the painting. The object becomes the subject, and then the equation is reversed, only to be undone once again and yet again. Nothing inside or outside can escape the exchange. It is the ultimate extension of Alberti's perspectival order: 'a *logic* of representation which changes the viewer himself into a representation'.[41] This might be a problem only if we are terrified, and well we might be (since Foucault has warned us), of the power of surveillance, the tyranny of the gaze. Undoubtedly the fear of being watched rather than doing the watching accounts for the distinct anti-ocular discourse of twentieth-century French thought to which Martin Jay has called attention.[42] It might also account for art history's resistance to theories of representation that unsettle our secure and objective points of view as historians of art: it is more reassuring to regard paintings as sardine tins that do not look back.

On the one hand, this is an absurd characterization. The terrifying existential impact of Lacan's story hinges upon the ahuman quality of the artefact, the insouciance with which it randomly floats by on the surface of things, unheeding of human recognition, unmindful of human concern. Once crafted by human artifice, it has long since been cast upon the waves. Paintings from the past, on the other hand, and perhaps deceptively, seem to require familiarity

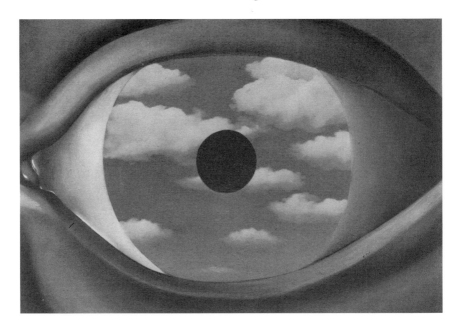

21 René Magritte, *The False Mirror*, 1928; Collection, The Museum of
Modern Art, New York

and care; or so say the mutually dependent institutions of museums and the history of art. Most members of the human sciences have long been predisposed to think of their relationship to the past as a curatorial one. And paintings, in particular, seem made to be attended to; they need to be sold, preserved, labelled, situated in a meaningful chronological narrative. But what if, in some sense, they are doing the tending? We all should recognize that historians bring modes of interpretation to objects of art, yet we do not often consider the rhetorical field of possibilities for detecting a similar process at work in the reverse direction. I do not mean to suggest any absolutes here; the active and interactive, even paradoxical, relationship that exists between artefact and its interpretation is a vital and chiasmic one. However, if the recent talk of spectatorship has any merits at all, it cannot help but provoke meditation on the role of the caretakers. If absorbed, if elided, if caught in a web of ceaseless reciprocity, then where do we locate our objective, our historical, points of view?

We have always known that objects of art have a numinous power about them. And yet, ironically, as art historians, we repress that power with a power play of our own: an attempt to explain or describe or capture that hypnotic hold through labels and schemes of our own devising. Nietzsche, Bataille, and Bryson among others, have reminded us that any talk of the gaze is in the first place a political issue. The person who does the looking is the person with the power. No doubt about it: looking is power, but so also is the ability to make somebody look (Illustration 22).

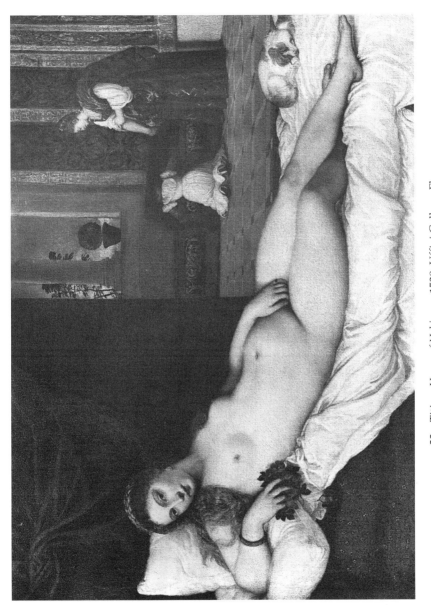

22 Titian, *Venus of Urbino, c.* 1538; Uffizi Gallery, Florence

["

21 Murray Krieger, *Arts on the Level: The Fall of the Elite Object* (Knoxville: University of Tennessee Press, 1981), p. 40. On this issue, see also Terry Eagleton, *The Function of Criticism: From the Spectator to Post-Structuralism* (London: Verso 1984), pp. 94–5.

22 Victor Burgin describes the 'regimes of simulacra which make up the "art world"' as 'those incestuously intimate dances in which critical discourse, money, and image continuously exchange masks': *The End of Art Theory: Criticism and Postmodernity* (Atlantic Highlands, N.J: Humanities Press International, 1986), p. 170.

23 Cited in Hal Foster, *Recodings: Art, Spectacle, Cultural Politics* (Port Townsend: Bay Press, 1985), p. 61 from P. de Man, *Allegories of Reading* (New Haven, CT: Yale University Press, 1979), p. 107.

24 Cf. Foster on expressionism, p. 62.

25 Wittgenstein, *Philosophical Investigations*, pp. 42, 81.

26 Craig Owens, 'The Allegorical Impulse: Toward a Theory of Postmodernism', *Art After Modernism*, ed. B. Wallis, p. 235.

27 Lacan, *Four Fundamental Concepts*, p. 96. See also p. 76 here and footnote 11.

28 See Charles Jencks, *What is Post-Modernism?* (London: Academy Editions, 1986).

29 Friedrich Nietzsche, *The Use and Abuse of History*, trans. Adrian Collins (Indianapolis: Bobbs-Merrill, 1957), p. 37.

30 Carrier, 'Art and its Spectators', p. 15.

31 Patrick Heelan, *Space-Perception and the Philosophy of Science* (Berkeley, CA: University of California, 1983), p. 102.

32 Holly, 'Burckhardt and the Ideology of the Past'.

33 Louis Althusser, 'Ideology and Ideological State Apparatuses (Notes toward an Investigation)', *Lenin and Philosophy and Other Essays* (London: New Left Books, 1971).

34 Bryson, *Vision and Painting*, p. xiii.

35 See Burgin, *The End of Art Theory*, pp. 167–70.

36 Bryson, 'The Gaze in the Expanded Field', p. 107.

37 Quoted in Arthur Kroker and David Cook, *The Postmodern Scene* (New York: St Martin's Press, 1986), p. 9.

38 Nietzsche, *The Use and Abuse of History*, p. 28.

39 Kroker and Cook, *The Postmodern Scene*, p. 79.

40 Quoted in ibid, p. 11 from *Visions of Excess*, and p. 33. The authors here cite Nietzsche's final postcard to Burckhardt, written before he descended into madness: ' "The unpleasant thing, and one that nags at my modesty, is that at root every name in history is I." '

41 Bryson, *Vision and Painting*, p. 106.

42 Martin Jay, 'In the Empire of the Gaze: Foucault and the Denigration of Vision in Twentieth Century French Thought', *Foucault: A Critical Reader*, ed. David Couzens Hoy (Oxford: Basil Blackwell, 1986)

Chapter Five
A Discourse
(With Shape of Reason Missing)
John Tagg

IMAGE

I begin with an image: an image of two crowds, in which I shall try to clear a space to make something visible; or perhaps I shall only be making visible that space itself, a space that is already there. The image is John Baldessari's; a 4 ft by $2\frac{1}{2}$ ft gelatin silver print made in 1984 (illustration 23) and first published on the cover of the Fall 1985 issue of *Journal*, in the context of a 'Special Feature' edited by Jeremy Gilbert-Rolfe and John Johnston on 'Multiplicity, Proliferation, Reconvention'.[1] Johnston you may know as a translator of Baudrillard, Deleuze and Foucault. Gilbert-Rolfe is a painter and critical theorist who, at the time, was teaching at the California Institute of the Arts, where Baldessari had also been on the faculty since 1970.

The focus of concern in Gilbert-Rolfe and Johnston's 'Feature' is that play of displacement which is at work within all languages and institutional structures, continually undoing the constraints they impose against proliferation and multiplicity, displacing the bounded space of sign and system into a network of heterogeneous connections and disseminating references. We may note in passing that Gilbert-Rolfe and Johnston make a point of listing Baldessari's cover work in their 'Table of Contents' and remark on it in their editorial essay, in relation to what they describe as that 'multiplicity which occurs through subtraction, or more exactly, ... the role of subtraction in the production of multiplicity'.[2] They write that: 'The title of the work of John Baldessari's [*sic*] reproduced here is *Two Crowds With Shape of Reason Missing* (1985), which in a sense [so they tell us] says it all. Difference here is heightened by what is announced as a reduction of difference, the withdrawal of identity from each crowd'.[3]

Clearly, we are engaging a complex theoretical apparatus and perhaps a host of associations has already begun to crowd Baldessari's image. But, for the moment, let me draw a line around this lucid thesis that the editors insert into the heart of Baldessari's picture, and add only that the work in fact appears twice in the *Journal* 'Feature': first, on the cover, as I have said, and

90

then, somewhat strangely, as a 'detail' placed like an illustration on the third page of an essay by Michel Feher on 'Mass, Crowd and Pack'.[4] On this page, Feher discusses Freud's concept of narcissism and its importance to the theory of the primal horde and that horde's ambivalent relation to its dominant leader. Only overleaf, not on page 47 but on page 48, does Feher go on to

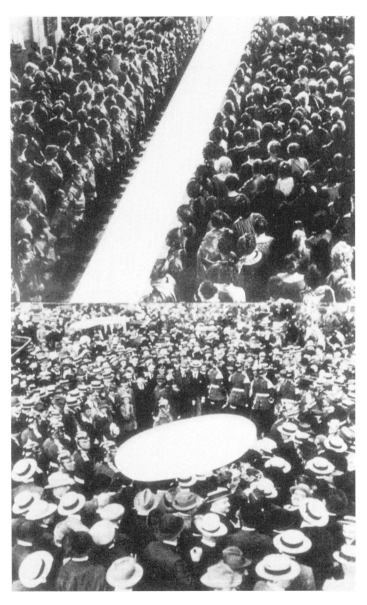

23 John Baldessari, *Two Crowds (With Shape of Reason Missing)*, 1984

contrast Freud's account with what he calls 'Elias Canetti's masterpiece', *Crowds and Power*: a book Baldessari is also reported to have been reading prior to 1986, perhaps as early as 1984, the year in which he made the first version of the work that the editors of 'Multiplicity, Proliferation, Reconvention' have cropped and pasted into Feher's text.[5]

So Feher and Canetti can be added to the crowd. And we might go further, if we recognized the lower half of Baldessari's image as an altered version of a well-known news photograph of the proclamation of war in Berlin, on 1 August 1914 (Fig. 24). We might note that, in his chapter on 'The Crowd in History', Canetti, too, represents this moment:

> On the outbreak of the First World War the whole German people became one open crowd. The enthusiasm of those days has often been described. Many people in other countries had been counting on the internationalism of the Social Democrats and were astounded at their failure to act. They forgot that the Social Democrats, too, bore within them this forest-army symbol of their nation; that they themselves had belonged to the closed crowd of the army and that, whilst in it, they had been under the command and influence of a highly disciplined and immensely effective crowd crystal, the Junker and officer caste. Their membership of a political party carried very little weight in comparison with this.
>
> But those first August days of 1914 were also the days in which National Socialism was begotten. Hitler himself is our authority for this. He later described how, at the outbreak of war, he fell on his knees and thanked God. It was his decisive experience, the one moment at which he himself honestly became part of a crowd. He never forgot it and his whole subsequent career was devoted to the re-creation of this moment, but *from outside*. Germany was to be again as it was then, conscious of its military striking power and exulting and united in it.[6]

We might immediately want to ring round the terms 'open crowd', 'closed crowd' and 'crowd crystal': terms which figure importantly in Canetti's elaborate typology and collective psychology of crowd formations; terms which may, in turn, be suggestive for Baldessari's choice of images.[7] The 'closed crowd', for Canetti, like the ceremonial congregation in the top half of Baldessari's picture, establishes itself by accepting its limitations, renouncing growth and putting its stress on permanence and stability.[8] But 'the open crowd' – like the crowd in Berlin, metonym for 'the whole German people' – is what Canetti calls 'the true crowd, the crowd abandoning itself freely to its natural urge for growth'.[9] It is a crowd that wants to grow, it wants density, and it wants direction; its constant fear of disintegration meaning that 'it will accept any goal' and will continue to exist 'so long as it has an unattained goal'.[10] Within such formations, 'crowd crystals' are 'the small, rigid groups of men, strictly delimited and of great constancy, which serve to precipitate crowds'.[11] The uniformed soldiers visible in each frame of Baldessari's image exemplify this type of grouping, which is, Canetti tells us, 'all limits': 'everyone belonging to it constitutes part of its boundary, whereas the closed crowd has its boundary imposed on it from outside, if only by the shape and size of the building where it meets'.[12]

There is clearly space for speculation here, and Baldessari himself was to return to the same ground in the following year, extending his thoughts to a further five images, titled *Crowds With Shape of Reason Missing*, which he published in 1986, again as a contribution to a theoretical anthology: the first issue of *Zone*, edited by Michel Feher and Sanford Kwinter, and devoted to the city.[13] I could go on: we are not at the end of it. Even so, let me cut off this discussion here so that we can find our way back along the route from where I began, with an image – *Two Crowds (With Shape of Reason Missing)* (with or without parentheses) – cutting it out and pasting it in place, opening in its interior the outline of an interpretation, probing its edges, even where they bleed, and giving it a frame, with all that hangs on it: the name of an artist, a title, a date, a location, a provenance of sorts, sources and influences, lines of derivation and anticipation, a whole personal history in the future anterior, as Althusser would have said.[14] All this is familiar enough: habits of art history. But what this might make us think is that, if such framing marks the beginning, then it began before I started to write and was in place or, better perhaps, described a place in which the work might find itself and be found. And if such a frame was always already there in advance, though with the shape of its reason missing, then what is ruled out is that this chapter had a proper beginning, an institution proper to itself. Let me draw a line and try to begin again.

FRAME

The crowds are everywhere, or so it seems. Filling every corner, or all but one, they press forward in rapt attention, concentrating their gaze, held back in each case only by two lines of soldiers in full ritual dress. Held back, that is, from the whiteness of a void, in which each crowd's desire is projected but its reason is repressed. Now an oblique line, now an ellipse, this void is, at once, a space the crowd creates and a space on which it converges; a space to which the crowd gives meaning and a space that is its reason for being.

Even Baldessari's knife, in paring away a layer of truth in the image and cutting the sutures that seem to stitch the viewer in, does no more than formalize what is already there in the source pictures as a white space of meaning – a clearing, a circle, an aisle – where the crowd closes on or opens to the spacing of a performance (Illustration. 24 and 25). In one place, the crowd must accommodate to the divisions and limits of a pre-existent architectural script. In the other, we seem to see the ancient shape of pure spontaneity, bound by no outer limit, with a vortex at its centre across which, as in an arena, the crowd is exhibited to itself in an intensifying spiral of self-identification. And if we are troubled by images of a crowd that has lost its reason, we can, on the other hand, see that the crowd supplies its own logic and its own architecture, more than a backdrop to history to set off the significant players, more than a context lacking focus, more than disorder wanting sense. If the crowd is called forth by the event, it also constitutes a necessary stage and indispensable setting as, in more or less violent passivity, it asserts its role of spectator as the condition of a spectacular event that, in

Baldessari's image, we can as yet only imagine: a performance of meaning in which some other may pronounce 'I do', perhaps, or 'I declare'.

'I do' and 'I declare': the pronouncements of marriage and war. We are in the classic space of the performative here, in which, according to John Austin, utterance and context saturate each other as meaning is enacted to produce an effect which cannot be said to have existed before or outside language.[15] To speak is to act, but only here, in this well-understood social setting, before the appropriate witnesses.

Writing on Austin's lectures on *How To Do Things With Words*, Jacques Derrida, however, rejects Austin's notion of the performative as a singular and original event of meaning in which the conscious intention of the speaker is unambiguously realized within the framework of a 'total context'.[16] For Derrida, the conventionality that determines meaning extends not just to the circumstance of the statement, but also to what he calls 'a certain intrinsic conventionality of that which constitutes the locution itself, that is, everything that might be quickly summarized under the problematic heading of the "arbitrariness of the sign"'.[17] This 'extends, aggravates, and radicalizes the difficulty', since it compels recognition that: 'Ritual is not an eventuality but, as iterability, is a structural characteristic of every mark'.[18] The opposition between singular, univocal statement-events and statements that do not have the same specific context dependence is not, therefore, to the point. The 'performative', too, is a coded or 'iterable' inscription, of which intention, consciousness, presence and meaning are not preconditions but can only be analysed as effects.[19]

It follows that what must also be displaced is the concept of or quest for an 'exhaustively determinable' context of meaning: a context for which a conscious intention must provide the determining focus.[20] Yet Derrida's point is not that the inscription Austin calls 'performative' is valid outside its context, but 'on the contrary that there are only contexts without any centre of absolute anchoring'.[21] It is not that there is no relative specificity of the effects of consciousness, of speech, of presence and of the performative: 'It is simply that these effects do not exclude what is generally opposed to them term by term, but on the contrary presuppose it in dissymmetrical fashion, as the general space of their possibility'.[22] There is no primal scene or last instance of meaning, only spacing and temporizing – a play of *différance* – that erodes all closures and opens an abyss in the midst of the performative act, deconstructing the presence of event and context.

For Michel Foucault, too, the discursive event – though event nonetheless – is neither discrete nor dissolved into the formless unity of contextualization, the intentionality of a subject, or some great external causal process. Instead, it is traced on what Foucault calls 'those diverse converging, and sometimes divergent, but never autonomous series that enable us to circumscribe the "locus" of an event, the limits to its fluidity and the conditions of its emergence'.[23] The event is not what fits a hole in a context, but neither does it carry its reason in itself. The fundamental notions to be brought to the analysis of the discursive event are no longer those of consciousness and continuity, but neither are they those of sign and structure. Foucault's conception of discourse is not, therefore, to be confused with the structuralist model of language as an available resource with the potential to generate all possible, and no

impossible, statements. All possible statements do not occur, while others continue to be reinscribed and to furnish criteria for policy and individual conduct, regardless of assessments of their value and use. It is this rarefaction of discursive events that interests Foucault: their 'rules of appearance' and 'conditions of appropriation and operation', which raise immediately the

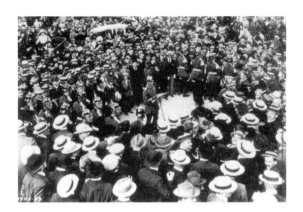

24 and 25 John Baldessari, *Two Crowds (With Shape of Reason Missing)*, 1984

question of power and focus attention on the strategic role of discursive systems, the domains of objects and forms of knowledge they make possible, and the administrative effects they engender.[24]

There is, then, at least this much in common with Austin's performative, that discourse for Foucault is not a purely linguistic phenomenon, for the elements of a discursive system may not be in words at all. (Confessional rituals, for example - whether in the church or in the analyst's office – involve not just certain kinds of speaking and hearing, but also specially designed spaces, particular techniques and bodily postures, and special kinds of priestly or psychoanalytical training. And we can readily see how this could be extended to the rituals of connoisseurship or art historical judgment, as to other scenes where it is the attentiveness of the eye that is in play, rather than that of the ear.) It is not, then, a matter of the history of ideas. The field of discourse is a field of material acts. 'Violent, discontinuous, querulous, disordered even and perilous',[25] as Foucault describes it, it is a field that takes shape under a set of incitements and constraints that operates to control, select, organize and redistribute the production of discourse and 'to evade its ponderous, awesome materiality'.[26]

In the inaugural lecture on 'The Discourse on Language', such incitements and constraints are divided by Foucault into the categories of 'exterior' and 'internal' rules:[27] on the one hand, rules of exclusion, prohibition, division and rejection, governing the hazards of the appearance of discourse; on the other hand, rules of identity, typology, origin and disciplinary formation, and rules of employment and subjection, distributing speakers among discourses and discourses to subjects. Foucault's stress on 'exteriority' and 'external conditions of existence',[28] as fundamental principles of the genealogy of discursive formations, may seem problematic here, reiterating a division of internal and external that he rejects in the traditional history of ideas. In effect, however, it functions as a rhetorical counter to notions of 'signification'[29] as the determinant effect of a deep and exhaustive structure, and it takes Foucault into a territory that he now defies his critics to call 'structuralism'.[30]

What is crucial in this new territory is the emerging theme that the production of discourse is inseparable from the action and generation of power effects. And, already, at the time of the lecture on 'The Discourse on Language', before the writing of *Discipline and Punish*, Foucault's conception of this relation of power and sense is not focused only on negation – on cutting out, rarefaction and the prohibition of certain objects, practices and performances of discourse. Equally, it seeks to follow the ways in which the operations of power on and in discourse are productive: productive of reason and truth; productive of textual hierarchies, unifying principles, and orders of discourse; productive of subjects and fellowships of discourse. Not only is the formation of a field of sense an effective formation of control, but control is effective as a formation of sense. It is a violence that is done to us and that we do to things.[31] But it is a field of violence that takes effect as an incessant, scattered and discontinuous production of discourse that would evade 'its character as an event'[32] or series of 'events' that always 'have their place'.[33]

Power and place: the terms of analysis of discourse have begun to pass from the rules of formation of statements, what governs them and the ways they govern each other, to a politics of sense; to an analysis of the 'discursive

régime'[34] which can no longer be confused with a formal paradigm and for which the appropriate model is not the linguistic system, but war and battle: 'relations of power, not relations of meaning'.[35] As in Derrida's analysis of the frame or *parergon*,[36] it no longer has any meaning, therefore, to ask whether the structures Foucault enumerates are 'inside' or 'outside': they *institute* discourse and their location eludes both an internalizing formalism and a sociologism of the external.

The convergence of views between Derrida and Foucault is striking here, despite the two philosophers' well-documented disagreements.[37] Inside and outside, event and context, work and setting, the structural and the empirical: these coupled terms – familiar to us as those that fix the polarities of an interminable methodological debate in art history – are radically displaced by Foucault's conceptualization of the discursive event and the discursive field. Yet the effects of these dualisms persist, with all that depends from the separations they inscribe, between the pure interiority of form and the determinant exteriority of context and 'social' history. To understand what supports this seemingly unsurmountable separation, we must look to the apparatus that keeps it so squarely in place: to the action of what Derrida calls the frame which, one can argue, is precisely an apparatus – a *dispositif* – in the fullest sense of Foucault's term.[38]

It is the frame, Derrida argues, that *'gives rise* to the work',[39] in that it produces the distinction between the internal and proper sense and the circumstances, which organizes all Western philosophical discourse on art and meaning.[40] Yet the frame also troubles the very division it brings into existence. Like the supplement, the frame is an adjunct that is neither inherent nor dispensable. Marking a limit between the intrinsic and the extrinsic, it is neither inside nor outside, neither above nor below. Its thickness and depth separate it both from the integral inside of the so-called work itself, and from the outside, from the wall or the space in which the work is sited, then, 'step by step, from the whole field of historical, economic, political inscription in which the drive to signature is produced'.[41] The frame thus stands out against the two grounds that it constitutes – the work and the setting – and yet, with respect to each of these, it always dissolves into the other.[42] This oscillation marks its presence and effaces its effect. The frame is all show and yet it escapes visibility, like the labia which, to the infibulating eye Freud gives the little boy, already present the desolate spectacle of 'nothing' to be seen, enframing the sight of pure difference.[43] The frame, too, is seen and not seen, disavowed, already at work in fixing the look and the givenness of difference, yet always denied or multiplied to infinity.

Across this denial, however, the work of the frame – this supposed adjunct to the work itself – returns, as, in Derrida's words: 'That which puts in place – the instances of the frame, the title, the signature, the legend, etc. – does not stop disturbing the *internal* order of discourse on painting, its works, its commerce, its evaluations, its surplus-values, its speculation, its law, and its hierarchies'.[44] The instability of difference always betrays itself. What is put at issue is the structure of the institution itself and:

> No 'theory', no 'practice', no 'theoretical practice' can intervene effectively in this field if it does not weigh up and bear on the frame, which is the

decisive structure of what is at stake, at the invisible limit to (between) the interiority of meaning (put under shelter by the whole hermeneuticist, semi-oticist, phenomenologicalist, and formalist tradition) *and* (to) all the empiricisms of the extrinsic which, incapable of either seeing or reading, miss the question completely.[45]

Note the terms here: 'formalist tradition' and 'empiricisms of the extrinsic'. Once more, the familiar polarities and unsettleable differences of art history are drawn out and reinscribed within the institution on which they hang. Once more, we find ourselves at a cut-off point, in a bounded space, up against the frame.

APPARATUS

Like the populous settings engraved by Fantuzzi that exemplify the frame in Derrida's text (Fig. 26), the crowd in Baldessari's image is both present and absent. Describing a void, it belongs to a whole surrounding apparatus of presentation. Yet, opening that space as a space of discourse, it is traced on the very constitution of what is presented as the event of meaning itself. This elusive limit between event and setting is scored out here by the cut of a knife that pointedly inverts the relation of image and mount. We see, however, that Baldessari has cut into his images more than once. The cut in each interior visibly frames a void that puts before us the question of the intrinsic and the extrinsic, event and setting, meaning and context. But Baldessari has also made a cut a second time, in a way that is obvious yet escapes us, cropping out unwanted meanings and spatial cues, to give each print the edge of authority and the finality of a frame. So, if we extend the logic of Baldessari's staging of the event of representation, what we have here are the shapes of two reasons for which the larger crowds are missing: the crowds that gather beyond the edges, beyond the crop-marks, beyond the viewfinder of the camera at the scene, beyond the limits of the film set or the street, beyond whatever frame. What crowds must we now imagine into which these pictures may be fitted as the shapes of reason?

Each cut marks a threshold: 'the decisive structure [as Derrida says] of what is at stake'.[46] It is the historical trace of an institution of knowledge, where the object of knowledge takes its place in an architecture of presentation, or places this architecture in question. It is the uncertain edge at which a proper attention – looking, listening, reading – is invoked and engaged, or frustrated (Illustrations 27 and 28). It is the never settled threshold at which a legitimized discourse is allowed to begin; like the discourse of art history, shall we say, mounting its precious or even delinquent objects in the white spaces of the modern museum, the university lecture hall or the pages of the publishing industry, and bringing to bear the full authority of its gaze.

Another crowd gathers around another void: a vacant white oblong waiting the projection of meaning, for which it has been prepared in advance. It is along its edges that a historical deconstruction might begin to operate with effect, on 'the decisive structure' of the institution itself, on the order of

externality and interiority it demarcates and on the laws, evaluations, structures of knowledge, forms of spectacle and types of commerce this order makes possible. What might be the outlines of such an operation? How might one begin to 'bear on the frame' in art history, the frame of art history?

The function of the frame, like that of the prepared ground, is, as Meyer Schapiro has told us, 'an advanced artifact' presupposing a long historical development.[47] Not until late in the second millennium BC did the variable elements of frame and ground come together to constitute that closure and smoothness through which the image, in the West, acquired what Schapiro calls 'a definite space of its own',[48] marking a 'fundamental change in art which is basic for our own imagery, even for the photograph, the film and the television screen'.[49] Yet, Schapiro argues, just as the cropped rectangular picture without frame or margin became a commonplace of photographic illustration that seemed to appeal to immediacy and the momentary gaze, so: 'The frame was dispensable when painting ceased to represent deep space and became more concerned with the expressive and formal qualities of the non-mimetic marks than with their elaboration into signs'.[50]

If Schapiro is right, then this would seem to be an end to it: the frame falls as artists strive to overthrow every convention in their restless search for that new idiom which is the mark of their freedom. (We might think of Jackson Pollock in Hans Namuth's photographs, if Baldessari had not been there before us and marked the space of the heroic artistic subject as another candid void.) But Schapiro is short of the mark, because his analysis is confined to the

26 Pages 64–65 of Jacques Derrida, 'Parergon', in *The Truth in Painting*, showing a plate of Antonio Fantuzzi, Ornamental *Panel with Empty Oval*, 1542–3

27–28 Discourse (With shape of Reason Missing)

frame as a non-mimetic element of the image-sign. But, for Derrida, the frame is not a semantic element of a historically developed signifying system, but the margin of certainty where the supposed interiority of such a system is set in place, at the price of disclosing that system's incompleteness to itself. Beyond this, what Schapiro also neglects is that, as part of the very process by which the authority of pictorial conventions and hierarchies of genre came to be weakened, the function of the frame had been absorbed into the wall and, more extensively, into the space of the gallery and then of the museum itself.[51]

Like the frame, the space of the museum encloses and displays. It cuts an inside from an outside, closing that inside on itself as pure interiority and surrounding it with value, of which the gilt of the frame is an embracing sign. What defines the museum as frame is thus the constitution of the space that constitutes art yet effaces itself in the visibility of its works. At the same time, as Jean-Claude Lebensztejn has shown, the museum can only make this cut by excluding what remains as other, its heterogeneity reduced to the status of non-art. 'Everything the museum excludes from its space [Lebensztejn writes] becomes, by this exclusion, an undefined murmur, a level of noise against which art defines its difference'.[52] 'Such, in the last instance, is the function of the museum. It gives art its proper status by separating it from the remainder and, by its integrative function, conceals the cut that gives it the status of art'.[53] Yet this remainder continues to taint the enclosure that guarantees the

pure, hygienic space of art. Within the museum, the reserve collection, closed as it is to the public and consigned to secondary status, marks the trace of this undisplayable surplus. And in the silent galleries themselves, the very wall that stands for the infinite void in which art is apparently self-enclosed and self-defined, also doubles as the *murmur*: the white noise of that unnameable production through whose exclusion, by the action of the frame, the wall and the space of the museum, art is defined (Fig. 29).

The canonicity of the museum collection is therefore haunted by a loss and the pure interiority of its art is always tarnished by the trace of its other. It is this loss that the museum would make good in the imaginary of what Stephen Bann has called the museum's 'poetics':[54] the figures of a desire to restore the wholeness of history in the ideal totality of the historicist construction or in the reconstitution of an enveloping illusion of authenticity. We may note that

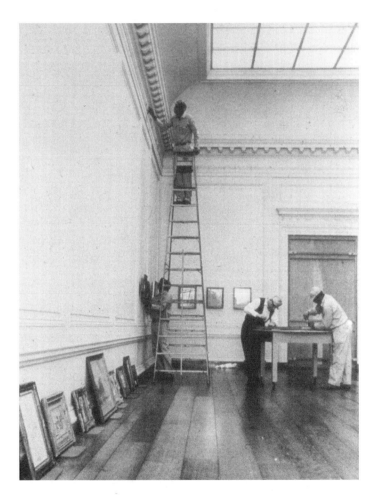

29 Installing the 25th Anniversary Exhibition at the
National Gallery of Art, Washington, DC, 1966

the rhetorical polarities of this 'poetics' hang, once again, on the oscillation of the frame across the spaces it divides and defines, from work to context. At one pole, the metonymic sequences of masterpieces, schools, nations and centuries, in which disjunct paradigmatic objects, each systematically isolated in its frame, are joined by the continuous wall in syntagmatic chains, from wall to wall and gallery to gallery (Fig. 30). At the other pole, synecdochic representations of an imaginary totality in which the frame, itself now a sign of periodicity, links the picture to a larger ensemble or syntagm of authenticity: a contextuality offered to experience, rather than a rationalist reconstruction of an ideal progression (Fig. 31). And between these poles – which are rarely present in their singular form – the narrative conflation of artist and oeuvre serves as a kind of relay (Fig. 32), presenting an ordered stylistic sequence, governed by evolutionary law, as a lived totality of which the index is the *signature*: that tear in the space of the enframed, which repeats itself countless times, in the label, in the catalogue, in the spin-offs of the marketing machine and in the lure of the name which draws us on through the sequential installation of the monographic show, from the street to the entrance and from room to room, to the exit that marks a death and the end of a series (Fig. 33).

In the signature is written the promise of authenticity and order, the presence of the author and the integrity of the oeuvre, singularity and exchangeability, the unique and the taxonomic combined.[55] But what is also inscribed is the promise of identification with an exemplary subject: a mirror for our selves. For the frame of the museum orders meaning and knowledge, pleasure

30 Installation view of *Kazimir Malevich 1878–1935*; National Gallery of Art, Washington, DC, 1990

31 Installation view of *The Treasure Houses of Britain: Five Hundred Years of Private Patronage and Art Collecting:* The Waterloo Gallery; National Gallery of Art, Washington, DC, 1985

32 Entrance to *Matisse: The Early Years in Nice 1916–1930*; National Gallery of Art, Washington, DC, 1990

33 Exhibition panel, *Kazimir Malevich 1878–1935*;
National Gallery of Art, Washington, DC, 1990

and perception, but also the structure of identification and subjection. The frame is a frame of differentiation that directs and delimits the field of visuality, setting in place a distance and separation that regulates desire and positions the subject – a subject whose enjoyment of the look is exercised only through submission to the authority of the Other: the gaze of the museum.[56]

Thus, if pleasure is in play in the museum, it is also at work. It is invoked to be organized. The museum orders subjectivities just as it does the objects it selectively displays. And this goes beyond the explicit moral mission, developed in the latter half of the nineteenth century, to join curatorship of Culture to a pedagogy that will displace 'idle curiosity' and cultivate the useful disposition of leisure – a mission in which each display case, frame and label would be, as George Goode wrote in 1893, 'a perpetual lecturer … constantly on duty in every large museum'.[57] It was not only on this level of consciously-articulated policy, however, that the museum effectively took shape as an apparatus of visual ordering and visual training, a space for the ordered production of knowledge and pleasure, where spectacle and discipline met.

Emerging across these two intersecting regimes of power, sense and vision, between the formations of spectacle and discipline, the museum, which took form as a sanctuary against the unceasing dispersal of space and time, was marked as the product of the double and conflictual drives of Western modernization. At one level, just as the museum in the West became, in a sense, a condition of everyday life through the 'ordering up of the world itself as an endless exhibition',[58] so, within its walls, too, it was fully invested in the new economy of spectacle, reproduction and accelerating exchange that transformed the operation of visuality in the capitalist states of Western Europe and in the colonialist culture they extended to the rest of the world. At the same time, the institution of the museum was equally and inseparably implicated in what Jonathan Crary has seen as those 'new forms by which vision itself became a kind of discipline or mode of work'.[59] As in the disciplinary reconfiguration of the hospital, factory, prison and school, which Foucault has described,[60] the museum instituted a new disposition of bodies and spaces that worked to procure a docile consumption in what might otherwise have been a dangerously contentious public space. Within this space, the museum set in place a new technology for managing attention, partitioning and cellularizing vision, fixing and isolating the observer and imposing a homogeneity on visual experience (Fig. 34). In its effects, it belonged with the development and marketing of a whole set of nineteenth-century optical and photographic products and devices, from the diorama to the stereoscope, and latterly the cinema. Such technologies shattered the structure of existing fields of vision. But this was the condition for their reframing or, as Deleuze and Guattari would say, their 're-territorialization' into new institutions, new hierarchies and new forms of exchange.[61]

The founding of art history as an academic discipline was also part of this re-territorialization. It, too, depended on the deployment of a new technology of vision, as much as it did on new modes of reproduction, circulation, indexing and storage, and on the creation of new public spaces for a culturally-mobilized urban population. Yet, the founders of modern art history, as Jonathan Crary has pointed out, excluded from their purview the very nineteenth-century art production whose making, consumption and effectiveness depended on the apparatuses of vision, display and reproduction that also made the academic practice of art history possible.[62] Only later were the categories and models developed in the analysis of the figurative art of antiquity and the Renaissance extended to the incorporation of more recent phases of artistic production. A conflict is clearly sensed. Yet, the paradox is

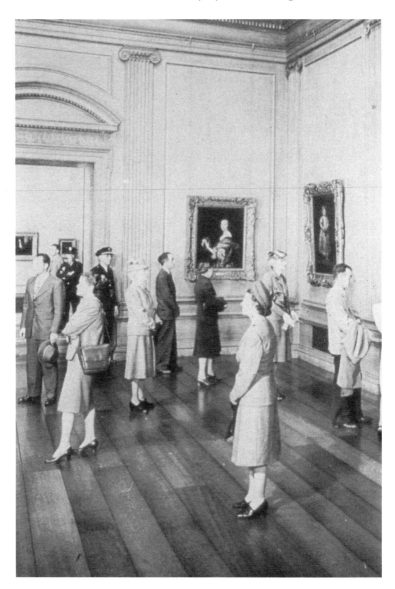

34 West Building, National Gallery of Art, Washington, DC , 1947

not, as Walter Benjamin would have it, that nineteenth-century art history faced technical developments that promised to destroy forever the aura or cult value that had hitherto surrounded the work of art.[63] But rather the reverse: that the technologies, which marked so profound a discontinuity in the history of vision, should themselves have furnished the apparatus to enframe 'art' as integral, coherent and structured internally by conventions whose authority and continuity could not be in doubt.

Once again, however, in tracing the 'rules of appearance' and 'conditions of appropriation' of academic art history, we are dealing with a multiple and overdetermined process. If art history emerged only through the discourses and technologies that shaped the museum, then it was equally caught up in the emergence of an educational apparatus whose strategic aims and techniques of training were, in turn, to rechannel their effects into the workings of the museum. What I am thinking of here goes far beyond the usual treasured histories and anecdotes of *émigré* scholars and university traditions. It is the shaping of art history within the social dispersion of practices of cultural self-improvement, within the deployment of aesthetic disciplines in the school system, and within the tertiary-level training not only of a cohort of expert technicians and cultural bureaucrats, but also of a *cadre* of 'critical minds' capable of serving as trainers and exemplars in a new system of visual attentiveness as a technique of self-regulation.

A model for such a history can be found in Ian Hunter's remarkable 'genealogy' of modern English criticism and literary education as 'a specialised sector of the apparatus of popular education'.[64] This apparatus itself was formed within the field of disciplinary techniques to which I have already referred. That is, it emerged in the dissemination of an unprecedented machinery of administration and regulation, which began to surface in Western Europe at the end of the eighteenth century and which, by the middle of the nineteenth century, had largely succeeded in reconstituting the everyday life of whole populations. The target of such administrative regulation was a new conception of the individual, whose health, moral conduct, criminal and sexual tendencies, and *culture* were constituted as the objects of new forms of governmental attention that aimed at reshaping the 'moral and physical' order of the populace, but were made operative through forms of individual conscientiousness and disciplinary self-regulation.[65]

It is within this field of local disciplinary tactics that the deployment of 'culture' in education has to be understood, for it was through this deployment that what Ian Hunter calls the 'aesthetico-ethical practice' of a minority caste[66] acquired a new function by its insertion into the morally-managed disciplinary environment of the public school. In the teaching of literature and criticism – and, by extension, in the teaching of art and art appreciation – an elite culture of the self was thus linked to the machinery of normalization and the corrective technologies of the public sphere, harnessing the ethical authority of the cultivated sensibility to an apparatus of governance through which the population internalized the disciplinary norms of 'social' life as the seemingly spontaneous and individual project of self-realization. What such training worked to produce was not lovers of literature or art, but a highly specific profile of cultural attributes necessary to the mobilization of a body of citizens or, as the British will have it, subjects. And, here, we might also remember that – as with the development of the museum – this educational strategy was and remained a national project, tying the teaching of language and literature, art and art history, into the differing forms of cultural articulation of the nationalist state.

In directing attention to the strategic effects of the museum apparatus, art history and its pedagogical practice, I would want to stress, however, that there is no need to conjure up a panoptic consciousness or a logic of ideology

and the class state. We are dealing, for the most part, with piecemeal historical changes and technical transformations, local programmatic imperatives that take hold on the individual and the population in multiple and dispersed ways. There is no single rationality and no single outcome: no nineteenth-century observer, as Jonathan Crary would still have it, despite his doubts,[67] and no unified or stabilized discipline of art history; though that is not to say there are not always traceable limits to the possible, thinkable or permissible mutations the field can undergo. However, we can very well think of art history, as Hunter does of English literary studies and criticism, as a complex of administrative, pedagogical, ethical and aesthetic techniques, invested in disciplinary technologies and articulated by supervisory goals that seek to exert specific effects on the constitution of a 'social' field. [68] We might also want to note, in passing, the corollary that, if it is not fruitful to speculate on art history as if it assumed a singular form, then neither is it useful to expect it to respond to any single theoretical or political diagnosis or intervention. There is not only one hammer to take to this frame.

END

These are no more than the tracings of outlines, no more than indications of possible directions; but they may be enough to show how far we would have to travel from a conception of art history as an array of methodologies, tractable to theoretical correction and ideology critique. Such indications describe a space of thinking made possible by the overlaying of the model of the apparatus and the model of the frame; that is, by the mutual pressures of Foucauldian genealogy and Derridean deconstruction. This may be surprising, especially since it implies an unfamiliar deconstruction, at least to those critics and proponents who have equated the insistence that everything is discourse or text with the unlikely belief that everything happens in books. (Some of the more fruitless stand-offs in recent art historical debates begin here. But the aim, on all sides, has mostly been a coup in the boardroom and business as usual.) Yet Derrida has been clear enough that:

> It is because deconstruction interferes with solid structures, 'material' institutions, and not only with discourses or signifying representations, that it is always distinct from an analysis or a 'critique'. And in order to be pertinent, deconstruction works as strictly as possible in that place where the supposedly 'internal' order of the philosophical is articulated by (internal *and* external) necessity with the institutional conditions and forms of teaching. To the point where the concept of institution itself would be subjected to the same deconstructive treatment.[69]

What follows for art history is not a form of conventional institutional history, but neither is it an endless meta-commentary, generating a universe of tertiary texts that float in a self-sufficient space without coordinates, detached from the realm of the social and political. The very terms of this commonplace accusation merely repeat the action of the frame that deconstruction puts at issue. In their very implied promise of another space of genuinely

political critique, necessarily 'outside' textuality, these terms effectively remove the institution from the reach of political judgment. The deconstruction of the oppositions of internal to external, work to commentary, the rhetorical to the literal, texts to action, discourse to politics, theory to practice, transforms the concept of the institution and changes the conceptual space in which the political is thought.[70] It displaces those politics that seek to ground themselves on criteria that cannot themselves be political, because they are presented as the state of things, the literal or the real. It insists on the necessity of political judgments and strategic choices between differing opinions, not on the basis of a decoding of their representation of social reality but on the basis of an argued calculation of their rhetorical strategies, their modes of linkage and their discursive effects.

If deconstruction of the institution of art history withdraws from 'social' critique, it does so, therefore, precisely in order to foreground the question of political and ethical practice; precisely in order to drive home the stakes of the discipline. But stakes are not interests. They are not what lies behind, so that this political practice cannot take the form of an unmasking. But neither can it stop at a mapping or traversal of the spaces, boundaries, closures, fractures and linkages of the institutional formation. To question art history's finalities is to open the question of its ends. And when it is open, the question of ends compels contesting voices to speak to the stakes on which they are banking and to which they would have art history tied.

So art history is always tied to the stake. It seems we must prepare ourselves, therefore, for pain and suffering. The space in the crowd threatens to be that of a martyrdom. But what of the instability of structures? And what of dissidence, deviance or resistance as pleasure and even joy?

Let us plunge into the crowd one final time, back into the crowd of Canetti, the title of whose book, *Masse und Macht*, might, more literally, be translated as *Masses and Power*. For Canetti, the crowd or mass does not conform to its image either in Marxism or in psychoanalysis, even in their structuralist variants. It is neither the collective subject and figure of the future, whose allotted task in vulgar Marxist teleologies is to actualize a necessary moment of the historicist dialectic; nor is it the regressive, infantile, primitive horde of psychoanalysis, bound by terror and guilt in submission to a masterful father-leader, on to whom the horde projects a common ego ideal. No more is it the subject of structuralist interpellation, in which Freud's narrative of identification is transferred to the structure of the Law and the Ideological State Apparatus. By contrast, Canetti's account, as Michel Feher reads it, 'does not consider mass in terms of revelation, regression, or submission, but in terms of the will for power'.[71] The crowd is not contained by submission to the systematics of destiny or authority, but is a contagious, turbulent pack – 'a true incarnation of a multiplicity disseminating effects'[72] – which breaks out whenever 'events' call it forth, when the systems that work to conjure its powers away have only the effect of focusing and exacerbating the crowd's disruptive drives.

This crowd does not therefore surge from 'in itself' to 'for itself', towards its own, as yet undisclosed, historical reason. This crowd is not slave to a void into which it has projected the fantasized power of its own imaginary figure. This crowd is a pack, beyond all reason and restraint; a force field without

shape that propagates the void only as the trace of its own internal limit, as unassignable drive turns into decline. This crowd is not, then, the model of a structuralist system; neither is it the docile subject of an omnipresent disciplinary power. It is dangerous and motile. It breaks all formal bounds. It erupts, like the crowd of white residents and servicemen in downtown Los Angeles who, over several nights in the June of 1943, savagely beat and stripped young Mexican American *pachucos* on the street in what, by a telling reversal, came to be dubbed the 'Zoot Suit Riots' (Fig. 35).

35 Wild Mob Looks for Zoot Suiters, *Los Angeles Times*, 1943; Jaico Zoot
Suiters. *Los Angeles Daily News, 1943*

This last image of the crowd framing the victims of racist policing in Los Angeles is more topical now than I had foreseen, though I do not have the time to develop the analysis of these events that I have made elsewhere.[73] My point is, however, that, if the crowd as a structure of closure is never predictable, stable or fixed, then neither is the event of meaning ever stripped bare or contained *en masse* and utterly exhausted by its frame. The violence in Los Angeles was fired by a suit of clothes that insisted on drawing attention to itself, flaunting its excess and perversion of the proper form.[74] The language of the Zoot Suit, the language of *caló*, the *mestizo* language of *pachucos* and *pachucas*, crossed over all borders. It evaded the spaces of separatism and segregation. It was mobile and inventive and disassembled the codes and protocols of Anglo and Mexican speech, dress and culture to release a play of identity and difference that fitted no known frame.

In the face of the regimes that frame and enclose our lives, this is, then, more than resistance as negation, more than inversion, more than the recoil of suffering, constraint and loss. It is the burden of lack lived as the exhilaration of incompletion; the pain of silence turned into exuberance beyond speech. I therefore offer the *pachuca* and *pachuco* as shapes of another reason for a deconstructive art history on which their strategy will not be lost. As Jean-François Lyotard has said, the way beyond capital's hegemony and the 'bloody impasses' of the great doctrinal systems lies not in the terror of legitimation through tradition or myth, which in the end amount to the same thing.[75] It comes:

> when human beings who thought they could use language as an instrument of communication learn through the feeling of pain which accompanies silence (and of pleasure which accompanies the invention of a new idiom), that they are summoned by language, not to augment to their profit the quantity of information communicable through existing idioms, but to recognize that what remains to be phrased exceeds what they can presently phrase, and that they must be allowed to institute idioms which do not yet exist.[76]

Perhaps there is even an echo of Meyer Schapiro in this: if we are to live, we are all constrained to strike against the frame.

Notes

This study was researched and written during my tenure as Ailsa Mellon Bruce Senior Fellow at the Center for Advanced Study in the Visual Arts, at the National Gallery of Art, Washington, DC. It was first presented at a colloquium in the Center in April 1991. I remain grateful to the Deans, Fellows and Staff of the Center for their comments, criticisms and support at this time, as I am to the editor of *Art History* for permission to reprint the version of the text that was subsequently published in *Art History*, 15, 3 (September 1992), pp. 72–94.

1 Jeremy Gilbert-Rolfe and John Johnston (eds), *Multiplicity, Proliferation, Reconvention*, a Special Feature for *Journal: A Contemporary Art Magazine*, 5, 42 (Autumn 1985), pp. 21–65.

2 Jeremy Gilbert-Rolfe and John Johnston, 'Multiplicity, Proliferation, Reconvention', in Gilbert-Rolfe and Johnston (eds), *Multiplicity, Proliferation, Reconvention*, p. 28.
3 Ibid.
4 Michel Feher, 'Mass, Crowd and Pack', in Gilbert-Rolfe and Johnston (eds), *Multiplicity, Proliferation, Reconvention*, pp. 45–9.
5 Ibid, p. 48. The reference to Baldessari's reading of Canetti is made in Coosje van Bruggen, *John Baldessari* (Los Angeles: Museum of Contemporary Art/New York: Rizzoli, 1990), p. 163.
6 Elias Canetti, *Crowds and Power*, trans. Carol Stewart (New York: Seabury Press, 1978), pp. 180–1.
7 See ibid, pp. 16–23, 73–4.
8 Ibid, p. 17.
9 Ibid, p. 20.
10 Ibid, p. 29.
11 Ibid, p. 73.
12 Ibid, p. 74.
13 John Baldessari, 'Crowds With Shape of Reason Missing', in Michel Feher and Sanford Kwinter (eds), *Zone*, 1/2 (New York: Urzone, 1986), pp. 32–9.
14 Cf. Louis Althusser, 'On the Young Marx', in *For Marx*, trans. Ben Brewster (London: Allen Lane, 1969), p. 63.
15 See J.L. Austin, *How To Do Things with Words* (New York: Oxford University Press, 1962).
16 Jacques Derrida, 'Signature Event Context', in *Margins of Philosophy*, trans. Alan Bass (Chicago, IL: University of Chicago Press, 1982), p. 322.
17 Ibid, p. 323.
18 Ibid, p. 324.
19 On 'iterable', see ibid, pp. 315 and 326. What follows from this concept for Derrida is that, 'above all, one then would be concerned with different types of marks or chains of marks, and not with an opposition between citational statements on the one hand, and singular and original statement-events on the other' (ibid, p. 326.)
20 Ibid, p. 327.
21 Ibid, p. 320.
22 Ibid, p. 327; the text says 'dyssemtrical fashion'.
23 Michel Foucault, 'The Discourse on Language', in *The Archaeology of Knowledge*, trans. A.M. Sheridan Smith (New York: Pantheon, 1972), p. 230. The original text was published as *L'Ordre du discours* (Paris: Editions Gallimard, 1971).
24 Foucault, *The Archaeology of Knowledge*, p. 120.
25 Foucault, 'The Discourse on Language', p. 229.
26 Ibid, p. 216.
27 Ibid, p. 220.
28 Ibid, p. 229.
29 Ibid, p. 230.
30 Ibid, p. 234.
31 Ibid, p. 229.
32 Ibid.
33 Ibid, p. 231.
34 Michel Foucault, 'Truth and Power', in *Power/Knowledge: Selected Interviews and Other Writings 1972–1977*, ed. Colin Gordon (New York: Pantheon, 1980), p. 113.
35 Ibid, p. 114.
36 Cf. Jacques Derrida, 'Passe-Partout' and 'Parergon', in *The Truth in Painting*, trans. Geoff Bennington and Ian McLeod (Chicago, IL and London: The University of Chicago Press, 1987), pp. 1–13 and 15–147.

37 Derrida's criticisms of Foucault's *Folie et déraison* and, specifically, of Foucault's reading of a passage from Descartes's First Meditation were first presented in a lecture at the Collège de Philosophie on 4 March 1963 and first published in the *Revue de métaphysique et de morale* (October–December 1963). Four years later, Derrida reprinted 'Cogito et histoire de la folie' in *Ecriture et la différence (Paris: Points-Seuil, 1967)*; see 'Cogito and the History of Madness', in *Writing and Difference*, trans. Alan Bass (Chicago, IL: University of Chicago Press, 1978), pp. 31–63. Foucault's response came only in 1971, in 'Mon Corps, ce papier, ce feu', first published in *Paideia* (September 1971) and reprinted at the end of the 1972 edition of *Histoire de la folie à l'âge classique* (Paris: Gallimard, 1972): see 'My Body, This Paper, This Fire', trans. Geoff Bennington, *Oxford Literary Review*, 4, 1 (1979), pp. 9–28.

38 Cf. Michel Foucault, *Discipline and Punish: The Birth of the Prison*, trans. Alan Sheridan (London: Allen Lane, 1977), e.g., Part Three, Chapter 3, 'Panopticism', pp. 195–228; and Part Four, Chapter 1, 'Complete and Austere Institutions', pp. 231–56.

39 Derrida, 'Passe-Partout', p. 9.

40 Derrida, 'Parergon', p. 45.

41 Ibid, p. 61.

42 Ibid.

43 Sigmund Freud, 'Some Psychological Consequences of the Anatomical Distinction between the Sexes, (1925)', in *Sexuality and the Psychology of Love*, ed. Philip Rieff (New York: Macmillan, 1963), p. 187.

44 Derrida, 'Passe-Partout', p. 9.

45 Derrida, 'Parergon', p. 61.

46 Ibid.

47 Meyer Schapiro, 'On Some Problems in the Semiotics of Visual Art: Field and Vehicle in Image-Signs', *Semiotica*, 1, 3 (1969), p. 223. See also pp. 226–7: 'Apparently it was late in the second millennium B.C. (if even then) before one thought of a continuous isolating frame around an image, a homogeneous enclosure like a city wall'.

48 Ibid, p. 224.

49 Ibid.

50 Ibid, p. 227.

51 See Jean-Claude Lebensztejn, 'L'Espace de l'art', in *Zigzag* (Paris: Flammarion, 1981), pp. 19–47, especially pp. 40–1. For a formalist analysis of the function of the gallery wall, see Brian O'Doherty, 'Inside the White Cube: Notes on Gallery Space. Part I', *Artforum*, 14, 7 (March 1976), pp. 24–30; 'Part II. The Eye and the Spectator', *Artforum*, 14, 8 (April 1976), pp. 26–34; 'Part III. Context as Content', *Artforum*, 15, 3 (November 1976), pp. 38–44.

52 Lebensztejn, 'L'Espace de l'art', p. 42.

53 Ibid, p. 45.

54 Stephen Bann, *The Clothing of Clio: A Study of the Representation of History in Nineteenth-Century Britain and France* (Cambridge: Cambridge University Press, 1984), Chapter 4, 'Poetics of the Museum: Lenoir and Du Sommerard', pp. 77–92.

55 See Derrida, 'Signature Event Context', pp. 327–9; 'Passe-Partout', p. 18; 'Parergon', p. 78; and 'Restitutions of the truth in pointing [*pointure*]', in *Truth in Painting*, pp. 279, 301, 365. See also Jean Baudrillard, 'Gesture and Signature: Semiurgy in Contemporary Art', Chapter four of *For A Critique of the Political Economy of the Sign*, trans. Charles Levin (St Louis, MO: Telos Press, 1981), pp. 102–11.

56 Cf., Kaja Silverman, 'Fassbinder and Lacan: A Reconsideration of Gaze, Look and Image', *camera obscura*, 19 (January 1989), pp. 55–84.

57 George Brown Goode (Assistant Secretary of the Smithsonian Institution in Charge of the National Museum), 'Report of the Assistant Secretary', *Report of the National Museum* (Washington, DC: National Museum, 1893), p. 23.

58 Timothy Mitchell, 'The World as Exhibition', *Comparative Studies in Society and History*, 31, 2 (1989), p. 218.

59 Jonathan Crary, *Techniques of the Observer: On Vision and Modernity in the Nineteenth Century* (Cambridge, Massachusetts and London: MIT Press/October Books, 1990), p. 18.

60 See especially Foucault, *Discipline and Punish*, and *Birth of the Clinic: An Archaeology of Medical Perception*, trans. A.M. Sheridan Smith (London: Tavistock, 1973).

61 Gilles Deleuze and Félix Guattari, *Anti-Oedipus: Capitalism and Schizophrenia*, trans. Mark Seem, Robert Hurley and Helen Lane (New York: Viking, 1978) and *A Thousand Plateaus: Capitalism and Schizophrenia*, trans. Brian Massumi (Minneapolis, MN: University of Minnesota Press, 1987).

62 Crary, *Techniques of the Observer*, pp. 21–3

63 Walter Benjamin, 'The Work of Art in the Age of Mechanical Reproduction', in *Illuminations*, ed. Hannah Arendt, trans. Harry Zohn (New York: Schocken Books, 1969), pp. 217–51.

64 Ian Hunter, *Culture and Government: The Emergence of Literary Education* (London: Macmillan, 1988), p. viii.

65 Cf. Foucault, *Discipline and Punish*, and *Power/Knowledge*.

66 Hunter, *Culture and Government*, pp. 3, 70, 153.

67 Crary, *Techniques of the Observer*, pp. 6–7.

68 Hunter, *Culture and Government*, pp. 153, 263.

69 Derrida, 'Parergon', pp. 19–20.

70 Cf. Bill Readings, 'The Deconstruction of Politics', in Lindsay Waters and Wlad Godzich (eds), *Reading De Man Reading* (Minneapolis, MN: The University of Minnesota Press, 1989), pp. 223–243.

71 Feher, 'Mass, Crowd and Pack', p. 49.

72 Ibid, p. 48.

73 See Marcos Sanchez-Tranquilino and John Tagg, 'The Pachuco's Flayed Hide: The Museum, Identity and *Buenas Garras*', in Richard Griswold del Castillo, Teresa McKenna and Yvonne Yarbro-Bejarano (eds), *Chicano Art: Resistance and Affirmation, 1965–1985* (Los Angeles, CA: UCLA Wight Art Gallery, 1991), pp. 97–108.

74 The relationship of *drapes* to *frame* might be pursued. Derrida's analysis of the frame departs from his reading of a passage in the first part of Kant's *Critique of Judgement*, on the analytic of the beautiful and judgments of taste, in which Derrida focuses on the anomalous position of *parerga* or ornamentations: those adjuncts that, in Kant's words, run the risk of being mere 'finery' and 'enter into the composition of the beautiful form' of the work itself only in so far as they also augment the delight of taste by means of their form. Kant's examples of such *parerga* are the framings of pictures, the colonnades of palaces and the *drapery* on statues. (Cf. Immanuel Kant, *The Critique of Judgement*, trans. James Creed Meredith (Oxford: Clarendon Press, 1952), p. 68; and Derrida, 'Parergon', op. cit., especially pp. 52–82.)

75 Jean-François Lyotard, *The Differend: Phrases in Dispute*, trans. George Van Den Abbeele (Minneapolis, MN: The University of Minnesota Press, 1988), section 262, p. 181.

76 Ibid, section 23, p. 13.

Chapter Six

The Aesthetics of Post-History: A German Perspective

Irit Rogoff

Ours is a grave dilemma, situated in the West at the end of a millennium. We stand in the shadow of numerous traumas of holocaust, genocide and erasure, and we are faced with a series of moral deliberations concerning the relation between memory, testimony, and the task of living out our histories in a vaguely responsible manner. Those who perpetrated crimes against the innocent in the names of political ideologies or political expediencies are now confronted with the need to remember as part of some form of reconciliation with history. At the same time, the victims, or what remains of them in altered forms, are simultaneously confronted with the spectre of their reinscription into history as a potential healing of the very trauma of their initial excision. It is the discourses of such notions of responsibility, the questions of whose convenience they serve and of what they ultimately mask and contain, which constitute our dilemma. I would like to engage with the way in which they have been problematized in the work of several German artists who have been producing work within the frameworks of postmodernity. The discourses of memory and commemoration within German cultural life entail questions regarding historical practice, responsibility and testimony which are linked to certain moralizing positions, all of which claim that to produce some concrete manifestation that marks loss, even in a negative form, is the appropriate response.

I would like to take issue with such moralizing discourses, though that does not mean that I would wish to dispense with the necessity of a morality. The issues I would like to take up result from a perception of such moralizing as an essentially comforting discourse which identifies right and wrong positions with great ease and rapidly suggests an appropriate gesture of response and reconciliation. These gestures serve to reproduce the binary structure which has for so long dominated Western modernist consciousness and in which trauma, manifested as loss, is forever addressed by processes of concrete objectification. Victims are faced with perpetrators, ruins with some form of (even partial) reconstruction, silence with narrativity, and erasure with reinscription.

We are all familiar with the history of Germany in the twentieth century, a history so spectacular that it has become the very index of Western horror. However, the invocation of horror functions in several ways and an attenuated and accountable historical reading would also dictate that we see the consequences of this history beyond legacies of guilt and burdens of remorse, beyond the endless, tortuous ways in which guilt becomes a saturation of banal sign systems. We must also mark the ways in which such invocations of spectacular history serve as a device for establishing a cohesion, a myth of nation and a unifying narrative in terms of which everything is interpreted. The responses to the political events of 1992–3 in Germany were a recent case in point. While thousands of racist German thugs brutalized foreigners, refugees and guest workers throughout the land, millions of other citizens demonstrated against such racism and xenophobia in the name of 'the good Germans'. Such a division between 'good' and 'bad' Germans can only resonate if read against the background of the spectacular histories and horrific legacies of National Socialism. Certainly the world's press received the events in such a spirit, and sensationalized them by invoking the old model of Fascism rather than viewing the events as the inevitable clash between the collapse of state Communism and the transitions taking place within late capitalism. The recuperation of such old models of understanding is one of the many ways by which the boundaries of national narratives are policed and reinforced. So the issue at hand is nationalism and its ubiquitous and insistent presence at the heart of cultural histories which attempt to deal with trauma as a relation between victims and perpetrators, as a legacy of guilt. What, then, is the fate of narratives of nation which are founded on notions of unique and discrete histories at moments of post-history, when a rapid succession of events serve to undo totalizing historico-political movements and identities? Ironically, it is my contention that nothing establishes the boundaries of nation better than so much of the visual, cultural work which is motivated by the desire to be anti-nationalist. In Homi Bhabha's words.

> To study the nation through its narrative address does not merely draw attention to its language and rhetoric; it also attempts to alter the conceptual object itself. If the problematic 'closure' of textuality questions the 'totalization' of national culture, then its positive value lies in displaying the wide dissemination through which we construct the field of meanings and symbols associated with national life.[1]

I must forewarn our readers that this effort at reading and undoing the cohesive narratives of German cultural legacies will be a long and circuitous journey. My aim is to avoid the concept of *Wende* (turning point) which has so dominated discussions of German culture in recent years, to avoid the concept of new beginnings and to see how a succession of linked visual art practices deal with the problematic of memory in the public sphere.

Since subject position is central to my analysis, I must declare that I am hardly a disinterested party in a discussion which attempts to loosen the national boundaries of particular given histories. I have long been interested in the process of attempting, to paraphrase Palestinian writer Anton Shammas, to 'unGerman German History'.[2] As an Israeli and a Jew it is clear to me that the events that took place in Germany in the 1920s, 1930s and 1940s were

equally central to the shaping of our culture in the Eastern Mediterranean in the 1950s, 1960s and 1970s, and in ways which extend far beyond simple demographic issues of immigration and cultural displacements. Therefore I offer the following thoughts in the name of exploring a broad intertextuality of historical trauma which has worked to inform all our cultures in odd and diverse ways and in opposition to a view of culture contained within a a singular national history. To this purpose I shall look at a series of works by German male artists, which touch on issues of the relations between history, memory and fantasy. (There is another essay waiting to be written, forming itself at the margins of this particular piece. This second essay has to do with the relative absence of women artists from the visual discourses of national memory and from the rituals of public commemoration. The essay-waiting-to-be-written would reflect on this absence as a critical one, in which women artists have chosen to fragment concepts of totalizing history and its concomitant memories, in the name of difference and through an insistence on multiple, concurrent histories which embrace the mundane quotidian and the obliquely subjective. The visual work of Rebecca Horn and the writings of Ingeborg Bachmann or Christa Wolf might serve as examples for such alternative explorations.)

For the moment, however, let us remain with the artists who have positioned themselves in the middle of a public discourse aimed at stimulating and activating a cultural imagination as a way of questioning how these political memories operate at the level of a cultural subconscious.

CONTEXTS

Since the end of the Second World War, West German cultural discourses have been dominated by the tensions inherent in the construction and reconstruction of successive and conflicting narratives of its own history. The present moment is characterized by the contradictory mode in which local historical narratives are framed by wider theoretical developments. On the one hand we find the *Historikerstreit*, the German historical debate, in which the neo-Conservative historians in Germany (Nolte, Hillgruber, Sturmer, Broszadt and Kokca) have sought to relativize the Fascist era by stressing those aspects in which other countries have undergone so called 'comparable experiences' (for example, totalitarianisms and genocides). The West German historian Wolfgang Mommsen has characterized the opposing views in this debate as primarily modes of and attitudes to relativization. Instead of bracketing Nazism out of German historical continuity, as does the school of historical thought and method which looks at German history as following in a *sonderweg*, a unique path, the neo-Conservative historians in Germany have sought to relativize it by stressing in what respects other countries have undergone comparable experiences. The opposing argument is put by the proponents of the *sonderweg* who have emerged from the post-1968 neo-Marxist schools of history, and who refuse the introduction of such notions of historical relativization and insist on looking at the Nazi state's activities as institutional continuities located within a specific development of German history. The political implications of this debate are immense, and the responses which the

West German philosopher Jürgen Habermas has made to neo-Conservative historians, charging them with the attempt at the construction of a usable past within present day Conservative politics, have illuminated their full complexity.[3] As West German economic prosperity has continued to develop in the relative calm of strife-free labour relations and official denial of increasing racial exploitation and stratification, as West German cultural practices have gained critical cachet and market clout, so the revisions of historical narratives have emerged with greater strength to frame and envelop these developments with greater comfort and ease. It is important to mention in this context that the *Historikerstreit* was not an esoteric debate among scholars, but a fully-fledged political campaign carried out by both factions within the national press and media which has continued for the best part of four years.

More recently the collapse of the Communist state of the German Democratic Republic and reunification with West Germany have once again served to rewrite dominant histories. The resultant economic destabilization of the Western part of the new nation and the economic disadvatange of the Eastern part have resulted in disillusionment, violence and an alarming swing to the political right, to a politics of law and order and economic stability haunted by ancient ghosts of the 1920s, of extreme chaos on the one hand and of an even more extreme terror of imposed order on the other.

However, the collapse of the GDR and the concomitant reunification have also brought Germany to an exceptionally interesting historical impasse. Every single event, every historical narrative, every biography, political movement or geographical site, is contested and disputed, pulled back and forth between competing historiographies. And these traditions are no longer upheld by state structures but by personal memories, by oral histories, by photograph albums and dream landscapes; these are sites of memory which cannot be effaced by the introduction of a new school curriculum, the denunciation of recent political leaders or the introduction of new manufacturing methods. The most spectacular of Western Europe's modern histories is at present also the most fragmented, a template of fractured nationalisms at an impasse.

At another level, the wider theoretical one, we inhabit the moment of post-history, that moment in late bourgeois development in which historical movement seems to be arrested despite many hyperaccelerated processes. The theoretical framework which has emerged from post-structuralist discussions of historical practice is at present at a stage which negates both the positions described above. It is both anti-Hegelian and anti-Marxist by definition since it is the rejection of the search for an overall theory of history. To complicate the picture even further, if that is possible, all of these historiographic debates as well as their theoretical frameworks have had substantial counterparts within the institutions and discourses of representation. Simultaneously with these political/historiographic debates, several museums devoted exclusively to the construction and display of German history are being opened (Frankfurt, Berlin, wings of museums in Osnabruck, Munich, Nuremberg and other cities) in the near future and heated public discussions have ensued concerned with precisely which version of history they are going to represent.[4] The emergence of Berlin as the resurrected capital of the new united Germany, the efforts to re-establish its national institutions and to re-write its awkward and interesting marginality as a triumphant spectacle of continuous history, continues to

erupt in stormy debates and protests. If there are processes to be charted within these post-historical waters, they are those of recuperation, a rhetoric of nostalgia put forward by a weak government and seemingly ignored by most of the embarrassed population.

Within visual culture, during the 1980s certain West German painting practices, operating under the generally inappropriate title of 'Neo-Expressionism', captured the popular imagination as *the* European school of history painting. For me the fascination with these works and their relation to their articulating context has been precisely the *absence* of any traditionally serious, conceptual or problematized discussion of history. Were they putting forward a world of sign and simulacra entirely divorced from any historical narrative? Were they discoursing on the impossibility of a discourse of history? Were the cynicism and irony apparent in every thematic and formal aspect of the work directly related to the sacrifice of a grounding narrative and its fragmentation into an endless array of free-floating signifiers? Increasingly it seems to me that, in the effort to find ways of approaching the unapproachable taboo of history within West German culture, an alternative discourse, (a discourse of collective memory) has been opened up. My comments, then, are an attempt to understand the shift from a discourse on history to an alternative discourse of memory and the visual representations of this emergent and politicized understanding of memory as seen in some of the work of Joseph Beuys and of Jorg Immendorf. The second part of this discussion examines some work by Jochen Gerz which takes on issues of uneasy viewing positions and pushes them to their very limits, to the point where they virtually disappear as concrete historical referents.

It is important, even within such a very brief discussion, to clarify that by memory I do not mean the notion of individuated, private recollection and neither do I view it, in this context, as a resource of the individuated psyche embedded in the unconscious, but rather as the concept has emerged through the debates on history and collective memory launched by Maurice Halbwachs, Phillipe Ariès, Herbert Marcuse and Michel Foucault over the past 60 years.

The main tenets of this debate and as much as I can reiterate here are Halbwachs's argument (formulated in the interwar years in a series of important books and brought to a premature end by his death in the Nazi death camps) that collective memory is related to deep social structures which shape all conscious human endeavour.[5] The social foundation of all processes of recollection, memories are formed out of the imagery of shared experience. By lifting memory out of the unconscious psyche and into a conscious and readily identifiable realm of social understanding, Halbwachs sought to weave individual recollections into the cultural fabric that gives them their broader design.[6] Equally, Halbwachs claims, memory is paradigmatic: it does not resurrect the past but rather it reconstructs it in a plurality of coherent, imaginative patterns. In fact Halbwach's theory of the adaptation of specific memories to the design of a general cultural scheme is close to Lévi-Strauss's later structuralist notion of *bricolage*; the same artefacts may be appropriated for unrelated purposes in different cultural milieux.

In the context of the present discussion, Phillipe Ariès' problematic (and far more conservative) contribution to this body of thought is that, for all of memory's vagaries, it is still our initial point of entry into the past. Memory

then proceeds to have its own history conditioned by its role as a *route* to historical understanding. Ariès sees the twentieth century as one in which counter-memory and the history of collective mentalities dominate. This is couched in a deeply conservative argument against the growing authority of the public, political world to which memory serves as a private counter-measure. While the politics of this argument is hardly scintillating, he does, however, offer some useful thoughts, primarily his discussion of the modern passion for public commemoration which he links to the anxiety wrought by modernity's ever-increasing temporality. This passion, he states, has led to a process in which history has begun to shape memory; translated into our parlance this can be read as an observation on representation's ability to construct meaning.[7]

'Images of the past', wrote Walter Benjamin, 'are the spoils of war carried on behind the winner's triumphal chariot'.[8] What then is to be said of the post-war German situation in which there were no triumphal factions? In fact the greater the historical distance, the greater the overall perception of loss: Socialism lost, Fascism lost, representative democracy lost, the entire gamut of German modernism has been lost and exists only within museumified mythical constructions that posit objects which have been wrenched out of their discursive spheres. Who then has the traditional privilege of constructing the dominant narrative of the past?

Within this increasingly apparent demise of traditionally perceived and overtly articulated triumphant ideologies, we are faced with another problem of disarticulation. The true victors, the dominant forces which structure Western society, patriarchy and capitalism, utterly refuse their own construction as subjects of discourse. While they define everything around them they themselves refuse definition and insist on their own standing as normative values and codes. Their strength lies in their resistance of articulation and therefore their evasion of visual codification. How do you visually signify patrimony or capitalism overtly? There are no sign systems such as Hitler's moustache, the swastika, or crematoria chimneys which work towards a kind of reductive pornography of Fascist evil. Long, elaborate and analytical projects (such as those of Hans Haacke or Hannah Darboven), provide close readings of particular processes but do not produce an easily readable or reproducible sign system. Furthermore, even if we had an overt and visible victorious faction, the moment is one of the implausibility of putting forward any coherent theory of history which would provide a master narrative in which these could be placed. Instead we are all much preoccupied with fragmenting that narrative into more representative narratives, and even more with problematizing our own positionality towards them.

INVOKING MEMORY AND INHABITING FALSE CONSCIOUSNESS

While memory is undoubtedly a form of entry into a discourse of history, it is not necessarily voluntary.[9] I would like to suggest that some of the early work of Joseph Beuys, in its conscious resistance to simplified forms of historical signification, touches off an involuntary collective memory. His point of entry,

along the lines of Ariès' argument, is a thematization of the tension between collective and individuated notions of 'The Wound'. As a case in point I would like to look at Beuys' 1955 entry for a public competition of a memorial for Auschwitz. Its components, blocks of tallow on a rusted electric plate, forms alluding to chimney stacks, electrodes and wires, maps of railroad tracks leading into the death camp, drawings of emaciated young women, rows of sausage-shaped matter alluding to waste and organic debris, repeated references to his declared desire to 'show your wound': all of these form an allusion, rather than a set of specific references, to concrete historical components.

'I do not feel', said Beuys in an interview,

> that these works were made to represent catastrophe, although the experience of catastrophe has contributed to my awareness. But my interest was not in illustrating it. Even when I used such titles as 'Concentration Camp Essen' this was not a description of the event but of the content and meaning of catastrophe. The human condition is Auschwitz and the principle of Auschwitz finds its perpetuation in our understanding of science and of political systems, in the delegation of responsibility to groups of specialists and in the silence of intellectuals and artists.[10]

Pathos aside, what strikes me as interesting about his analysis is the way in which it negotiates visual codification for two of Herbert Marcuse's most salient contributions to the history/memory debate: those in 'Counterrevolution and Revolt' which posit knowledge as recollection and science as rediscovery. The form of the Auschwitz piece provides its grounding in an alternative form of historical narrative. Unlike any conventional commemoration, this is not heroic, monumental, present or possessed of a coherent narrative; rather it is a testament to absence, being small, fragmented, humble and requiring a prolonged process of reading and reconstituting. In its understanding of the absence at the heart of the taboo – after all, what was being commemorated here, the technology and efficiency of mass murder? – it is a commemoration of what is no longer and what cannot be recuperated in direct historical narrative. Shoshana Felman's recent work on what she terms 'bearing witness' (the ability to site oneself outside of a paradigm in which a course of action took place and 'testify' as to its workings, the space between 'engaged activity' and critical judgment) will be brought into this discussion in relation to Gerz's more current deconstruction of Auschwitz as a phenomenon, but it also has relevance to Beuys' position in the West German cultural scene in the moment preceding the dramatic events of 1968. Echoing the end of *Erfahrung* (that formulation of the concept of *experience* which dominated German philosophy until the end of the 1930s) Beuys was able to touch off a notion of involuntary collective memory and lead it in the direction of language, thereby facilitating some entry, however inadequate, into the hitherto taboo notion of narratives of the past.

At this point I come to the part of my discussion with which I feel considerably ill at ease, particularly since I have repeatedly been accused of producing serious readings of what appears as the obviously cynical and exploitative art being produced by Jorg Immendorf at present and thereby of providing it with a legitimating narrative. I would like to make it clear that neither the artist nor his intentions are the subject of my discussion and are not of much

concern to me. Issues of artistic quality, of the authenticity of authorial voice and of ideological soundness seem to me to be redundant categories of analysis when applied to the attempt to understand visual culture as the disintegration of the unity of visual discourses.

While Beuys (Illustrations 36 and 37) became the cult priest of the revolution of consciousness in his later years, Immendorf seems to have always been determined to be as publicity seeking and media exploiting as he is allowed to be. I would, however, argue that in the case of Immendorf, the constant staging of the self and foregrounding of the heroic project of art is part of an articulation of the sphere of false consciousness in which he locates his work and our spectatorship. Trying to assess him by traditional criteria is contrary to trying to read him as a much wider manifestation of the postmodern politics of implosion and impasse. Having been through the gamut of post-1968 intellectual and political developments, Immendorf's work seems particularly apt for a discussion of the evacuation from, and assumption of, revised concepts of pictorial meaning; all the more so since the element of nostalgia is markedly absent from it.

Jorg Immendorf, student of Beuys and the most enduring figure of the 1968 rebellion at the Dusseldorf Art Academy, has over the past 20 years been through what Harald Szeeman has so aptly termed 'the long march of art'.

- founder of the counter-academy 'Lidl' inside the Dusseldorf Academy and dedicated to baby talk and baby art.
- theatrical revolutionary in the 1960s
- theoretical Maoist in the 1970s
- founder of Red Cell Art and other radical teaching programmes for secondary schools in the Ruhr area
- currently slightly punk, ageing star of Dusseldorf's international road show of art.[11]

This 'long march' combines within it the dualities of the regional, parochial and the international, of the factual historical and the critically theoretical, and thus seems a process of visual encoding which functions parallel to our own critical project.

As the events of 1968 and their spontaneous and optimistic populist impulses hardened in West Germany into the terrorism of the 1970s, framed on the one side by the hysterical right-wing reaction to the Baader-Meinhof tactics and on the other by Willy Brandt's *Ostpolitik* of national reconciliation, it became increasingly clear that the sphere of history was the only forum which could explicate such disparate and conflicting manifestations. While Immendorf painted the 30-odd canvasses known as *Café Deutschland*, the Federal Republic erupted in a series of publicly organized exhibition projects documenting the victims and opponents of Fascism and working under such dramatic titles as 'Art in Resistance', 'Art in Exile' and 'Art and Collaboration'. At the same time as the literary establishment embraced the work of Heinrich Böll, Gunther Grass and Siegfried Lenz as the acceptable voices of the recent past, Christa Wolf offered literary narratives of history as memory and a huge film project, retrospectively named the 'New German Cinema' was embarked upon, at whose centre lay the attempt to examine the past as a sign system from which present day popular myths and responses were codified.

36 Joseph Beuys, *Bathtub* (*Show Your Wound*), 1960; *Wrapped Body*, 1971;
Private Collection

37 Joseph Beuys, *Auschwitz*, 1958; Stroher Collection, Hessisches Landesmuseum, Darmstadt

The series of paintings which Immendorf embarked upon in 1976 attempted to integrate every strand of the emergent discourses on Germany's past to counter the fundamental concept of a 'new beginning' linked to a specific post-war historical moment. His meeting during that year with R.H. Penck, the East German painter, in East Berlin, served to add another dimension to the political discourse he was constructing as well as to give it another artistic personification. From this point on almost all of the paintings incorporate into their space both past and present, both East and West; all foreground the 'artist', in the dual personification of Penck and Immendorf, as the linchpins of this historical discourse and all embrace a social, racial, political and gender plurality. Immendorf's discursive space of history in *Café Deutschland I* (Illustration 38) is located in a combination of the traditional alternative space of artistic activity, that of the café/cabaret/disco depicted as an intensely centrifugal and hallucinatory dive lit and coloured with a garishness which points to the artificiality of a dream space. At its centre we find Immendorf and Penck trying to traverse the division imposed by the Berlin Wall; Immendorf thrusts his hand through it while Penck is reflected in ghostly fashion in the chrome column behind his head next to an even ghastlier vision of the Brandenburg Gate, the emblem of yet another decisive historical moment. The figures themselves are framed by two columns of war emblems relating to the Fascist and Communist heritages

38 Jorg Immendorf, *Café Deutschland I*, 1978; Neue Gallery Ludwig
Collection, Aachen

but formulated in the timeless idiom of the totem pole; part myth and supersti-
tion, part historical data. In the background we find Immendorf on the dance
floor engaged in frenzied jiving under the emblems of a nationalist past (the
German eagle and the swastika), while his own image reflects the schizophrenia
of the legacy he has inherited by dressing as part Fascist officer and part Sixties
revolutionary. He appears for the third time in this painting in the depths of the
bar where, clad in a leather jacket, he embraces a naked woman. Here again we
find a duality inscribed into the image which is equally a representation of
sexual freedom as well as a condemnation of sexual consumption as a
pornographic market practice.

Thus we are confronted with a dyadic pictorial discourse of perpetual inter-
nal contradiction which represents a society engaged in endless critical ideo-
logical conflicts while intellectually negating the possibility of a prevailing
ideology. Here I would like to return to Dietmar Camper's previously quoted
notion of an aesthetics of post-history. 'The imagery within such an aesthetic',
writes Camper,

> is neither in the service of societal metaphors nor is it engaged in the metamor-
> phoses of myth. Instead of this traditional form of anchoring they are in fact
> travelling through an empty space. At a certain point in the existence of these
> appearances, a saturation point, a specific truth of the time suddenly emerges.
> In that sense the aesthetic of post history is not an intention but an effect.[12]

This checking of attitudes, a saturation of the work with opposing sign
systems, within the discursive space of painting is continued in another
version of the *Café Deutschland* series entitled *Let's Go to the 38th Party
Conference* (Illustration 39), which works to reinstate the full spectrum of polit-
ical ideologies within this discursive space of capital-cum-history. These are
represented by the figures of Lenin, Trotsky, Stalin and Hitler, the readership
of *Pravda* confronting those who wished to ride the flying horses of mythology
which are dropping down to earth everywhere in the painting; the materialist
tendencies versus the mythologized symbols. These are, however, political
emblems which he evokes via easily recognized, almost clichéd, coded refer-
ences. To them are added reflections on the reception of history by the great
unrepresented population; the cloth-capped worker, the leather-clad thug and
the spiky-haired punk waitress. All of these are incorporated together into one
space which constitutes the collective memory of the present culture. Are they
simply functioning as visual illustrations of the opposing factions in the
Historikerstreit or has their production as a spectacle turned them into the
pornographic *tableaux vivants* of certain dramatic historical moments?

The artistic modes which Immendorf practises in the making of these works
also reflect attempts to integrate conflicting opposites into a working relation-
ship. The size of the paintings, for example, all of them between two and three
metres square, makes an emphatic reference to traditional history painting
while at the same time referring to the particular brand of Socialist Realism
which was being evolved in East Germany. On the other hand, the simplified
forms of the actual painting incorporate the lessons of clarity, legibility and
accessibility gleaned from advertising and the media, and consequently
confirm a commitment to the modernist project and its aspirations. Neither
does Immendorf attempt to represent his efforts at accommodating several

39 Jorg Immendorf, *Let's go to the 38th Party Conference*, 1983; Ulli Knecht
Collection, Stuttgart

different histories within one frantic space as in any way successful. In works
such as the one discussed above he and Penck inhabit the foreground of the
painting, crawling on the floor, felled by art. For all of their painterly and nar-
rative bravura these paintings succeed in maintaining a speculative quality
since they do not make claims on behalf of preferred accounts or the feasibility
of historical coherence. In fact one senses that Immendorf is inscribing a
similar dichotomy into the actual representational idiom he is employing,
since both the supposedly regressive act of reference to the past in which he
indulges himself as well as the operatic quality with which he does so are
negated by the fact that he has no theory of history to present through this
construct. Similarly there is a deeply ironic subtext to the overtly political/his-
torical one in which he speculates on the holy status of culture and the import-
ance attributed to its desecration. The jiving, writhing, assaulting and
assaulted figures he portrays are placed in the opulent splendour of a theatri-
cal set, thereby rendering the act of cultural presentation an empty gesture.
This is accentuated by Immendorf's self-representation as an artist whose
vision is obscured, the blurred double vision of the artist who has no social or
cultural vision. It is obvious that the flying horses, the heraldic emblems of
recent history and the ghostly and distorting deep purple glow of the painting

are invoking the spectre of Wagnerism. Even the dead bodies of the protagon-
ists in the foreground are reminiscent of a dramatic/operatic convention. It is
similarly clear that this spectre is not being utilized for its aura of splendour
but precisely for the seduction of gesture inherent in the attempt to package
and present a cultural project.

By placing the emblems and personifications of conflicting political ideolo-
gies within one discursive space Immendorf simply proclaims his insistence
that they are coexisting constitutive factors within present-day realities, and that
neither choice nor exclusion are truly possible. By placing them ironically
within the frantic and lavish environments he creates, he also expresses his own
grave doubts concerning the tendency to invest culture with healing properties.

I am equally interested in the fact that these works identify the obsession
with narratives of collective identity as a form of collective narcissism, and
signify this through the numerous mirrors and reflective surfaces which are
worked into the pictorial space. Often these mirrors parody the slightly
Baroque conventions of narcissistic pornographic practices, with their opulent
mirror reflections of sexual titillation or copulation. However, they also signal
the state of hovering just outside the prevailing discourse, not as an outside
presence but as a distantiation achieved through being a reflection rather than
a reality. Narcissistic, mythologized and sexualized, the past becomes a fetish
and the compulsive business of constructing endless and conflicting historical
narratives emerges as a process of fetishization. The past thus exists outside
any conventional ideological framework as a field of signs which constitute a
narrative of fascination rather than an argument for comprehension.

Returning to the original site of my argument, it seems to me that we can
locate here a counter-discourse of visual culture, a discourse which works
against the grain of the historians' debates (which are argued from clearly
identifiable right- and left-wing positions). This counter-discourse operates at
two main levels: it codifies a rejection of the attempt to reconcile the displace-
ments of the past, and it posits identity as continuously negotiated and contin-
gent on precisely such displacements. Each identity is constructed through
viewing the other – Fascist and bolshevist, East and West, right and left – and
the actual business of identity construction gets done in the cracks which
mark repeated displacements, the inter-discursive spaces.

Second, it identifies the serious business of historicizing as a subjective and
fascinated form of fetishizing which of necessity includes categories of desire
and sexuality and in which history becomes that impossible object of desire.
The recognition of this desire on the part of the spectator is the cue we have
been waiting for within visual culture to exit the closed arena of German
national discourses I have been mapping out and to establish their links to
other histories and other subjectivities.

'THAT OBSCURE OBJECT OF DESIRE'

I have recently spent a long period in Germany; throughout the agitated and
traumatic political winter of 1993 I sat through numerous discussions which
attempted to gain a deeper understanding of the meanings and workings of
anti-Semitism within German history. These discussions were undoubtedly

prompted by contemporary waves of nationalism and racism and the fears they arouse in those who live in the shadow of a somewhat older nationalism and racism and of their horrific consequences. While all of this is entirely understandable, what I actually heard was something quite different; these were, to my ears, discourses of guilt and of closure which once again claimed a central role for perpetrators and allowed the victims neither voice nor, more importantly, an arena of contemporary claims. German guilt, Germans' desire for a missing part of their culture – an absence they locate in the physically missing Jews – serves the purpose of freezing the victims into some form of historical unity, of timelessness and of closure. Victims of Fascism did not live out their victimization in an identical and universal way. Issues of class, race, gender, cultural heritage and geographical location inflected victimization into 'differentiated victimizations'. More seriously that moment of historical victimization, cataclysmic and horror-laden as it is, is not a moment of closure and finality. There are continuations of those lives and ramifications to those ruptures all over the world in the lives of the exiled and immigrated, the returned and the dislocated, and certainly in the lives and the cultures inhabited by their children and grandchildren. If one begins to think of the myriad of momentous traumas which were in various ways a reverberation of the combined forces of both the internal and external politics of German and related fascisms, then the list grows longer every day. This trauma perpetuated many satellite traumas: of the gypsies whose social structures and geographical allegiances were shattered, of male homosexuality whose cultural legitimacy was set back by almost half a century, of women across the world whose perceived roles changed through war and suffering only to regress dramatically again in peacetime, of German Jewish refugees being interned by the British for fear of a fifth column within Britain, of Japanese Americans being interned and consequently resettled by US authorities for similar fears of treason, of Jews arriving in Palestine only to be shipped back to camps in Europe by the British Mandatory power in Palestine. These are only the disruptions of which we have some general idea and there are many more throughout the Indian subcontinent, Africa and Latin America which are only slowly surfacing and integrating with the Western narratives. The argument I would like to make against historical closure, and monumental commemoration is a form of historical closure, is that it is a view of offence and responsibility from the point of view of the perpetrators that is so enclosed by its sense of guilt that it continues to deny the differences, specificities and subjectivities of those who experienced it. Even more urgent is the desire of the heirs to those original historical moments to cease being positioned as victims, a position entirely devoid of agency, and to be recognized as living out their cultures in ways which accept trauma and dislocation as the point of departure for complex and altered cultural formations.

Thus it is imperative for us to think the numerous heritages of European fascisms as a kind of global intertextuality, which in turn functions at the level of psychoanalytically conceived human subjectivities who experience these developments at the level of absence, loss and desire. It seems to me that at this time of decolonization taking place throughout the world around us, we must read emergent cultures across traditionally acknowledged

cultures and admit the degree to which they are mutually imbricated in one another.

Simultaneously, if we could find ways to address the sense of loss and of fascination felt on both sides of each of these traumatic disjunctures, if we could understand the ways in which the absences which are felt on all sides are reformulated into phantasmic cultural desires, then we might have the tools to place ourselves *within* an active commemorative practice, rather than as spectators of historical rituals.

Rather than put forward a series of abstract statements, which would probably only serve the purpose of providing a counter-morality anyway, I would like to try to structure an argument that adapts the practice which Jochen Gerz and his collaborators have put into use,[13] a practice in which the structures and modes of representation, the institutional aims, the subjective desires of the audience and the conventions of avant-garde art all become the subject of inquiry and thus displace the moralizing narrative which the work of art is expected to put forward. This legacy of conceptual art of the 1960s and 1970s has more recently been reinforced with postmodernism's 'incredulity towards meta-narratives' (in the words of Lyotard) and with the insistence of psychoanalysis on human subjectivity as a history in and of its own. At the historical moment of such erosions of boundaries and fusions as those between critical cultural theory and art practice take place, it is possible for me to cease looking at Gerz's work as in any way reflective of the histories and problematic of the contemporary culture he inhabits and to engage with it as a cultural intervention which mobilizes both ideological and culturally critical issues; this is not a commentary and certainly not a prescriptive statement, but a small chink, aligned with many other small chinks, in the armour of Western modernism's seamless and unconscious cultural positivism. Thus in engaging with the work I shall attempt to emulate its form in prying loose the various components which make up the supposed need and the supposed practice of historical commemoration, and I will try to dislodge them from the cultural and moral values which have been imposed on them in the name of comforting moralizing discourses which assume that any form of remembering, of bringing the past into the present, is in itself a responsible action. I would like these components to point elsewhere, away from historical meta-narratives and away from the closure brought about by the falsities of absolution and redemption which animate the work of historical commemoration. Rather it is the work of mourning, the structures of human subjectivity as the desire for closure and the active construction of invisibility as a self-consciously critical cultural commentary which I hope to put into play.

Traditionally the task of commemoration has always been perceived as the replacement of an absence with a presence. The myriad of public monuments to the dead of wars and the victims of other disasters, to the marking of someone's concept of the great moments in their own history, have operated upon the belief that such a replacement is indeed possible. Furthermore it has also been founded on the notion of a 'universal positioned viewer', one who is a full, equal and acquiescent participant in the historical narrative to which the monument or other commemorative act refers.

What is it that the work of historical commemoration wishes to achieve? I would say that above all else it wishes to render the invisible visible, to effect

a form of historical reconciliation and to attempt the satisfaction of a desire for
a concrete material presence as a tangible manifestation of some process of re-
demption which is taking place.

In fact critical discourses have been mobilizing against such notions of re-
placement for several generations. In a recent piece which both historicizes
the discussion and characterizes what he calls the 'counter-monuments' of the
1980s, James Young recounts a variety of high modernist arguments against
the concept of the monument as expression of a commemorative practice. He
begins with a classic voice of the modernist matrix, Lewis Mumford, who in
the mid-1930s spoke against monument's 'false sense of continuity'; false that
is, to modernism's overriding desire for constant renewal and change. Next he
invokes the German historian Martin Broszat, who states that monuments do
not remember events as much as they bury them beneath layers of national
myths and explanations; they 'coarsen' historical understanding through cul-
tural reification. Finally we are presented with French historian Pierre Nora's
well known work on *Lieux de Memoire* (sites of memory), which warns that
monuments take over the burden of memory thus enabling a form of 'active
forgetting'.[14]

Taking up all of these critical issues are the 'counter-monuments' of the
1980s, as James Young characterizes them, including such sites as Maya Lin's
Vietnam Veterans' memorial in Washington, DC, Daniel Liebeskind's pro-
jected plan for a Holocaust memorial museum in Berlin, Jochen and Esther
Gerz's own sinking column in Hamburg, Denis Adams's various 'Architecture
of Amnesia' projects dotted throughout Europe or Horst Hoheisel's inverted
fountain in Kassel. The Gerzes' 'Monument against Fascism' (Illustration 40) is
one of the best examples of counter-commemorative activity at present. This
was devised as a response to the impossibly overbearing and globalizing invi-
tation by a juried competition held by the city of Hamburg to erect a monu-
ment which would galvanize a form of universal anti-Fascism. The Gerzes'
response was an attempt to problematize a series of questions concerning
commemoration as a cultural impulse and its mistaken assumptions that it is
possible to dictate or elicit a set of righteous responses from the viewing
public. That traditional relationship between the object and the viewer is akin
to a social contract in which both parties agree on the nature and the conse-
quences of the trauma being commemorated, while the monumental object
becomes the currency of exchange within this contractual relation. The project
finally realized by the Gerzes attempted to undo this narrative at several
levels. A vast hollow metal column was erected and covered with a thin layer
of soft lead so that the piece itself defied any form of allegorical function or
narrative inscription. Instead it presented the viewing public with an available
surface on which they could inscribe their names against Fascism. Thus it is in
essence their own responses to the dichotomy between Fascism and human
rights that make up the allegorical work rather than some unified account
agreed upon by the artist, the culture and the state.

This shift in the conventions of commemoration serves to introduce a subtle
differentiation since it poses the question of 'Whose Fascism?' rather than as-
suming one coherent and global account of Fascism which can in turn be ab-
solved and exonerated through a series of ritual actions. Furthermore it
negates the very concept of commemoration in its refusal to 'museumify' the

past and contain it within a historical location.[15] Instead this project remakes the relation with Fascism through its encounters with the viewers in the present and allows them the opportunity of differentiating the narratives of Fascism as a living legacy rather than a concluded and distant historical event. When a graffito appears on its surface which claims that 'Erich loves Kristen',

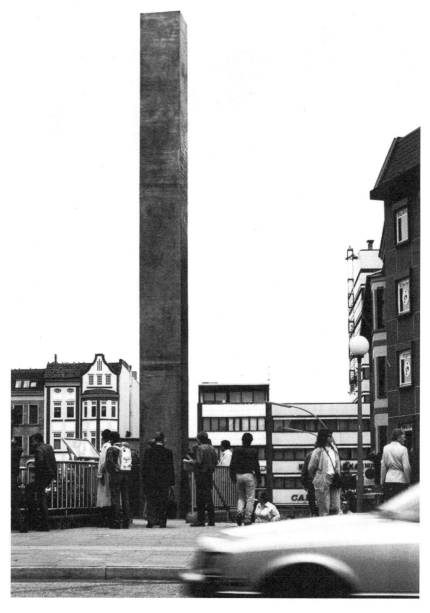

40 Jochen Gerz, *Monument Against Fascism;* Hamburg; Collection of the Artist

it is not necessarily a trivialization of the enormity of the political legacy but perhaps a manifestation of banality, of the oversaturation of the culture or possibly of the anxiety of those who come into contact and are faced with the need to respond without having a discourse of response. However we may understand this response, we need to see that it is a form of active engagement rather than the expected one of pious genuflection.

Finally the piece defies its own monumental materiality. Once a year it is lowered further into the ground by 1.40 metres and it will eventually disappear from sight altogether. The sinking of the piece serves the purpose of making fresh writing space available to the public and enhancing the centrality of contingency to the project as a whole.

What this and other counter-monuments begin to do is at one level a dismantling of the binary relation between presence and absence as a simple, positivist correspondence. Instead of a substitution, an actual thematization of the absence takes place in the forms of gaps or gashes in the case of Maya Lin's Vietnam Veterans' memorial which slashes into the earth, discontinuities in the surface narrative of the building as in Liebeskind's deconstructionist plan for the Berlin Holocaust Museum, a slow process of withdrawal from the arena of concrete commemoration as in the case of the Gerzes' sinking column in Hamburg or the actual inversion of a free-standing obelisk below ground level, as in Horst Hoheisel's inverted fountain in Kassel.

As Young's detailed discussion of these publicly contested works states, having dispensed with the easy formulation of absence/presence the arena is cleared for a more complex discussion of the subject of memory itself. 'In a Sisyphian replay', he says, 'memory is strenuously rolled nearly to the top of consciousness only to clatter back down in arguments and political bickering whence it starts the climb all over again. Germany's ongoing *Denkmal–Arbeit* simultaneously displaces and constitutes the object of memory.'[16]

The displacing of memory which takes place here is within the previously all-defining national/cultural narratives of history and its reconstitution through the empowering of mobilized spectators who make and remake the fabric of memory through processes which alert them to a possibility for remembering or marking, rather than providing them with a narrative structure for memory. In describing a work by Norbert Radermacher in the Neuköln section of Berlin where a text is projected on a section of a street on which previously stood an enforced labour camp and later a satellite for the women's camp at Sachsenhausen, Young says that the ever-changing memorial which is subject to times of day and climactic changes 'remind[s] us that all such sites depend for their memory on the passersby who initiate it – however involuntarily". He also suggests 'that the site alone cannot remember, that it is the projection of memory by visitors into a space that makes it into a memorial'.[17] Thus what we find here is a shift from the confrontation of the viewer with a visually embodied narrative structure of which he or she is the spectator to the activity of commemoration as the site upon which a form of memory production is triggered. Nevertheless I would argue that we are still, albeit in a far more attenuated and speculative way, within a trajectory of a presence/absence, since all of the activity of eliciting a response from the viewer still hinges on the existence of some form of presence which triggers off re-memory. Though these presences may be partial, self-negating, vanishing,

transparent or self-destructing, although they are enormously self-conscious about both the form and process of commemorative activity, nevertheless they begin this work through staging it, in and around and through a concrete entity.

I would like to depart slightly from this trajectory and outline another which is situated in its vicinity but perhaps at a slightly oblique angle. The trajectory I have in mind deals with the slow process by which 'thingness' is evacuated from the activity of commemoration and we are left with the process, not the form, of mourning work and with speculations concerning our desire for 'that obscure object'.

Over the past 20 years the work of Jochen Gerz and his collaborators has subjected these issues of commemoration to a profound problematization. An early project which suggested a mode of inquiry into the desire for commemoration was *EXIT/Dachau Project* (Illustration 41) in which some issues concerning the relation between history and commemoration through exhibition practices were explored. This installation formulates its inquiry in a form almost opposite to that of Beuys' earlier Auschwitz memorial. It negates the material experience and posits instead a structure for its contemporary reception. Rather than represent the actual extermination camp, Gerz produced a critical representation of the museum which is now in essence the sole purpose of the camp, a site which is dedicated to remembering itself. Since history can never be recreated and can only be re-presented, it is the means and systems of representation which determine the historical narrative which circulates through culture. In this early project Gerz began speculating on whether the horror of the extermination camps can actually be represented. The question does not arise as an emotional response which assumes that the scale of the horror prevents any attempt to deal with it or that the language of cultural description has been so contaminated through the practices of this horror that it is barred from any counter-use, and neither does it follow on from Adorno's belief that 'The aesthetic principle of stylization makes an unthinkable fate appear to have some meaning; it is transfigured, something of its horror is removed... some works are even absorbed as contributions to clearing up the past'.[18] Rather the work demands from an artistic practice a self conscious de-aestheticization which recognizes that it is systems of representation which imprison meanings and neutralize historical events. The camps had been, above all else, about extermination and the construction of an invisibility, but they had operated through a specific authoritative mode of marshalling and regulating. People were systematically herded together, transported, classified, marshalled into separate areas, given rules and regulations by which to exist, given a meagre amount of information concerning their location and the movement allowed them which was disseminated by basic signs, the final aim of which was a form of ultimate 'EXIT' of no return.

The museum which commemorates the camp, which supposedly reflects on all of this, is shown by Gerz in his project to function along not dissimilar guidelines in which the public is marshalled, classified and meagrely informed through a sign system of authoritative regulation which equally ends with an exit. Thus the camp and the 'camp as museum' are systems which are imbricated in one another. In the installation of the project another system,

41 Jochen Gerz, *EXIT\Dachau Project*, 1972–4; Collection of the Artist

one of the study of information by orderly desks lit with weak lamps, was added to the system of exhibition. His project was therefore primarily concerned with these systems: the information, interdiction and signage which were set up to marshall and contain the facts and representations of those who had been marshalled and contained and finally annihilated. Thus what is achieved is a recognition that this re-presentation is little more than a translation of one system into another while furthering little consciousness of the language of representation or of the viewer's position within such a system. This work begins in shifting the discourse, at a structuralist level, through the recognition that it is the systems of representation that establish and re-establish the processes and meanings.

This process of voiding the concrete materiality at the centre of the commemoration work has taken a new and radical turn in the present work: the Saarbrücken Invisible Monument ('*2146 Stones – Monument Against Fascism*', ongoing work: Illustration 42). Working with a class at the Saarbrücken Art Academy, the participants researched all of the Jewish cemeteries and burial grounds which had existed within Germany prior to 1939. Gerz's premise had been that 'Where there are people there are burial spaces, where there are cemeteries and no people that is almost a mathematical metaphor for saying that something is pathologically disturbed.' Since most of the cemeteries had been destroyed during the Nazi period, information had to be painstakingly re-collected. At present some 2167 cemeteries have been identified. Once the information had been collected it, plus the date of the contemporary activity, was secretly engraved on the underside of cobblestones dug up and immediately replaced from the courtyard of the Saarbrücker Schloss, the local eighteenth-century castle which had always been the seat of regional power and authority, which had served as Gestapo headquarters during the Second

World War and which is now the site of both the local government and the regional history museum. After the considerable political furore which erupted once the completed project was made public knowledge, the regional parliament had no choice but to grant the site the status of an art work and to rename the courtyard as 'The Square of the Invisible Monument'. The prevailing discomfort and unease which have dominated German culture and politics over the past 50 years is aptly represented in this site on which the local bureaucracy walks to work each morning, stepping on the secretly engraved cobblestones.

However, the radical break which I would claim for a move such as one being made within this work is far greater than a strategy for discomfiting politicians. This absolute voiding of concrete reference within the work performs the work of mourning as process. 'In what does the work mourning performs consist?' asks Freud in his germinal essay of 1917, 'Mourning and Melancholia'.

> The loved object no longer exists, and it proceeds to demand that all libido shall be withdrawn from its attachments to that object. This demand arouses understandable opposition – it is a matter of general observation that people never willingly abandon a libidinal position, not even, indeed, when a substitute is already beckoning to them. This opposition can be so intense that turning away from reality takes place and a clinging to the object through the medium of a hallucinatory wishful psychosis.[19]

The adherence to the concrete referent, similar to that which Freud calls the loved object, has manifested itself in both the desire for and the actual practice of holocaust commemoration which has taken place so intensively in Germany. Within the site at Saarbrücken Castle, which comes at the end of a series of projects which have increasingly aimed at evacuating the referent as a concrete object outside the self, this work is taking one step further in the process of mourning.

At this point I feel that other strands need to be added to the argument; we must remember that the materials of the commemoration work done here are cemeteries. These cemeteries are in themselves about bearing witness to the dead; who was there, when, of whom, and soon. The presumably mostly peaceful deaths of the cemetery are overlaid by the violence of their demolition and sutured on to the violence of the later annihilation: a layering occurs in which death invokes death and absence invokes absence. Thus we understand the demolition of the cemeteries which was part of a process of erasure, and the hidden and visually inaccessible information about them, as part of a much larger discourse of invisibility. In her brilliant reading of Claude Lanzman's film *SHOAH*, itself part of a larger project on witness bearing and testimony, Shoshana Felman says:

> The essence of the Nazi scheme is to make itself – and to make the Jews – essentially invisible. Not merely by killing them, not merely by confining them to 'camouflaged' invisible death camps but by reducing even the materiality of the dead bodies to smoke and ashes, and by reducing, furthermore, the radical opacity of the *sight* of the dead people as well as the linguistic referentiality and literality of the word 'corpse' to the

42 Jochen Gerz, Two image of Saarbrücken *2146 Stones – Memorial Against Racism;* Collection of the Artist

transparency of a pure form and to the pure rhetorical metaphoricity of a mere *figure*: a disembodied verbal substitute which signifies abstractly the linguistic law of infinite exchangeability and substitutionality. The dead bodies are thus rendered invisible and voided of substance and specificity, by being treated in the Nazi jargon as *figuren*: that which all at once cannot be seen and cannot be seen through.[20]

Thus the production of invisibility is part of the historical materials being invoked and must itself be seen as part of cause, event and commentary. As Freud says: 'Just as mourning impels the ego to give up the object by declaring the object to be dead and offering the ego inducement of continuing to live, so does each single struggle of ambivalence – loosen the fixation of the libido to the object by disparaging it, denigrating it and even as it were, killing it'.[21]

The production of invisibility and the achievement of erasure are at the centre of the original scene and the constant urge to revisit it. The voiding and evacuation of the concrete referent which are at the heart of the Saarbrücken project once again focus on process rather than on historical event or narrative. Thus a space is opened up, a blank space under whose surface something lurks. In actual fact we know that what is concealed underneath the surface is concrete information: Jewish cemeteries, names, numbers and dates. But the blank normative surface engages our fantasy because it achieves the invisibility of the original project; our horror is not aroused by facts, concrete referents, but living out ourselves the condition of complete invisibility, an utter blankness. In a conversation we recently had about the Saarbrücken project, Gerz brought up an analogy, the site of an accident on a busy street in Paris. Pedestrians, compelled by curiosity and anxiety, gravitate close to the scene of the accident and are confronted by a policeman who commands *'Circulez, il n'y a rien à voir'* ('Move on, there is nothing to see'), another instance of authority's ability to produce invisibility. The anxiety and curiosity which compels pedestrians on the street towards a concrete manifestation of an accident, the ultimate fear of the pedestrians, is in itself a manifestation of desire for what remains concealed from them; the site of their own fear.

If the task of commemoration is in part one of attaining redemption then its language is one of resolution. There is an entire vocabulary which stands in for our desire for such resolution: to heal, to make amends, to work through, to commemorate, to pay respects, to lay to rest. The blank surface of the Saarbrücken work resists all that: it elicits our desire for wholeness, completion and resolution and sustains it as desire. It turns the tables on the problematic and faces the viewer with the fact that it is his/her desire, that which by definition cannot be satisfied, which is the subject of the activity of commemoration. Philosopher Debra Bergoffen, in making an argument on perspectivism without nihilism in Nietzsche's writings, says that her argument is grounded in an understanding of human subjectivity as desire.

As desire the human subject is the lack seeking to overcome itself as lack; the finitude seeking immortality; the limited in quest of the unlimited; the singular seeking the absolute. To understand desire as central to the human experience is not to suggest that humanity is teleologically oriented towards its object of fulfillment but rather to indicate that in naming our objects of desire we are attempting to fix what cannot be fixed in the hope of

transcending the condition of our existence. That is, if to be human is to be desire, then no named object can arrest the dynamic of desire that is the human being.[22]

Thus what was historically meant to be concealed remains invisible and what becomes apparent is Lacan's notion that something becomes an object of desire when it takes the place of what, by its very nature, remains concealed from the subject.

To evolve a commemoration project which attempts to deal with revisiting the site of memory without resolution is to take part in what Freud described as the work of mourning. Equally it is to acknowledge desire, our immediate desire, as the animating force behind such activity and as our only opportunity to participate actively in it. When the commemoration activity of national traumas can be dealt with at the level of individual subjectivities they might also cease to be mutually exclusive. Recently I heard a friend deliver a paper on the contemporary attempt at culturally living out the legacy of Japanese internment and resettlement in the USA during the Second World War. I thought of living out the legacy of the displacement of European Jews to the Eastern Mediterranean. The facts are quite different, the blame has long since been settled and the offence ascribed, but that is hardly the point. At issue is the effort to sustain the memories at the level of desire, to live out the dislocations with some semblance of reflexivity, to allow ourselves finally to acknowledge nostalgia as a potent critical and political tool rather than a sentimental yearning, and to forge a culture in which the collective commemorations can be read across one another rather than vie with one another in competition of whose represents the greater offence. Once again my fantasy is drawn towards that blank cobblestone surface in Saarbrücken with its undertow of archaeologically layered invisibilities and the possibility it finally affords me of writing my own form of commemoration.

Notes

1 Homi K. Bhabha, 'Introduction', *Nation and Narration* (London: Routledge, 1990), p. 3.
2 Anton Shammas, in *Critical Fictions* (ed. Philomena Mariani), Dia Center for the Arts, 7 (Port Townsend, WA: Bay Press, 1991), p. 77.
3 Charles Meier, *The Unmasterable Past* (Cambridge, MA: Harvard U.P., 1989) and *New German Critique*, Special Issue on the *Historikerstreit*, Summer 1988.
4 Deutsche Historische Museum, Berlin, Round Table Discussion, Berlin Senate, 1986.
5 *La Mémoire Collective* (Paris, 1945); *Les Cadres Sociaux de la Mémoire* (Paris, 1925).
6 Patrick Hutton (History Dept, University of Vermont, Burlington, VE), 'Collective Memory and Collective Mentalities – The Halbwachs–Arias Connection', paper delivered at Center for European Studies, Harvard University, by permission of the author, p. 5.
7 Ibid, pp. 18–25.
8 Walter Benjamin, 'Theses on the Philosophy of History', in *Illuminations* (New York: Harcort, Brace & World, 1969).
9 Paolo Jedlowski, 'Modernisation and Memory', unpublished manuscript, with kind permission of the author.
10 Quoted in Caroline Tisdall, *Joseph Beuys* (New York: Solomon R. Guggenheim Museum, 1979), p. 23.

11 For documentation of Immendorf's work see catalogues of Kunsthaus Zurich, 1983, Braunschweig Museum, 1985, and Oxford Museum of Modern Art, 1985.

12 Dietmar Camper, 'The Transformation of Bodies by the Imagination: On the Arrogance of the Mind Towards Time', in *German American BiNational Catalogue*, Kunsthalle Dusseldorf and Institute of Contemporary Arts, Boston, Cologne: Dullant Buchueslag, 1989.

13 This part of the present essay was developed as a collaboration with Jochen Gerz for a publication documenting his most recent public project; '2146 Stones – *Monument Against Racism*' Saarbrücken Museum of Modern Art, Hatje Verlag, Stuttgart, May 1993.

14 James E. Young, 'The Counter Monument: Memory against Itself in Germany Today', in *Critical Inquiry*, 18 (Winter 1992), pp. 267–93.

15 I am using Adorno's formulation of 'museal' to describe objects to which the viewer no longer has a vital relationship and which are in the process of dying, as it appears in 'The Valéry–Proust Museum' in *Prisms*.

16 Young, 'The Counter Monument', p. 269.

17 Ibid, p. 286.

18 Theodor Adorno, 'Commitment', in *The Essential Frankfurt School Reader*, ed. A. Arato and E. Gebhardt (New York: Urizen Books, 1982), p. 313.

19 Sigmund Freud, 'Mourning and Melancholia', 1917, pp. 244–5. German edition in Sigmund Freud, *Gesammelte Werke*, vol. 10, pp. 428–46.

20 Shoshana Felman, 'In an Era of Testimony – Claude Lanzman's SHOAH', in *Yale French Studies*, 79, pp. 39–82. See also Felman's somewhat extended argument co-authored with Dori Laub, '*Testimony – Crises of Witnessing in Literature, Psychoanalysis and History*' (New York and London: Routledge, 1992).

21 Freud, *Mourning and Melancholia*, p. 257.

22 Debra B. Bergoffen, 'Nietzsche's Madman – Perspectivism without Nihilism', in Clayton Koelb (ed.), *Nietzsche as Post Modern – Essays Pro and Contra* (New York: State University of New York Press, 1990), p. 58.

PART III

Chapter Seven
How Obvious is Art? Kitsch and the Semiotician
Bill Readings

In introducing the four chapters that we have grouped as chiefly semiotic, perhaps by virtue of the pre-eminence of some of their authors as practitioners of the semiotic method, I want to focus on this question of the relation of semiotics to art history. The semiotic analysis of paintings rests upon a number of propositions, but primarily on a textualization of the artwork in the interests of a general semiology. To state the matter as baldly as possible, the painting is understood as a constellation of signifiers, whose function is understood in terms of the structuralist description of language. Signifying elements are determined syntagmatically in terms of their interrelations (internal syntax) and paradigmatically in relation to generic conventions (iconology is redefined as a code) or wider social meanings (the cultural lexicon). Aspects such as foregrounding or the play of light are held to function analogously to the processes of narrative focalization, and the semantic content of particular images is determined in relation to a network of oppositions (the meaning of a black neck-band is fixed by opposition both to other colours within the painting and to a wider social code). The sign replaces the symbol or the icon as the mode of meaning in painting. Neither does semiotics rest at the level of immanent analysis of specific works, for it can understand artworks as constellations of signifiers that themselves circulate as signifiers within the discourses of art, so that Mieke Bal writes 'Rembrandt' to remind us that the name of Rembrandt is itself a sign whose meaning is determined by its position within the structure of names that makes up the discourse of Western art, with a connotative as well as a denotative function. In fact, one is struck by the sense in which the semiotic analysis of painting, for all that it depends upon a primary *textualization*, seems to have even greater explanatory power than literary semiotics, for its revelation of a representational structure at work contrasts the more vividly with the apparent immediacy with which a painting gives itself to be seen. Semiotics gains its force from the readiness with which we forget that a tree in a painting is a sign of a tree, that the colour red is in fact 'red', a choice of one colour-combination from among a strictly limited set of colours on a palette rather than an autonomous presence. In painting, 'red' will always mean the absence of other colours from the palette.

However, what remains to be determined is why the propositions of semiotics have raised such furore in both art history and textual studies. This question seems significant for the present volume precisely since the semiotic analogy between the functioning of language and the visual arts addresses with singular directness our concern for the intersection of textuality and vision. Indeed, detractors might claim that semiotics is a mere subordination of vision to textuality.

The injustice of such an accusation will become clear to readers of the work of Marin, Bal, Bryson and Foster presented here. Any tendency to mechanistic reductionism is kept at bay by an attention to the specificity of the painterly signifier. In preceding chapters, we have been worrying at the edges of art history. Our turn towards textuality has understood itself as restoring or bringing to light interpretive practices and conceptual apparatuses that the apparent obviousness, the sheer visibility, of painting and photography renders transparent and hence invisible. In some cases, we may identify a semiotic impulse in this process itself: in the work of Griselda Pollock, for example, where an Althusserian account of ideology is mapped on to an insistence that aesthetic objects manipulate signifiers in a semantic field, where the social determination and ideological impact of art is revealed as precisely its occluded semiotic import. Indeed, if the visual arts do seem obvious or immediate, the semiotic mode of analysis can precisely claim a certain innovative force of revelation: displaying the cultural significance of art to which we have hitherto been blind. If, on the other hand, we acknowledge that art history has never, as a discipline, been able to assume the obviousness of its object, then semiotics comes to seem more internal to and continuous with art historical tradition than its more radical proponents might wish. Divesting semiotics of its status as outsider in this way does not seem to me to mitigate its interest since we end up by rewriting art history as somewhat more radical in its address to the question of art than connoisseurs would wish.

The understanding of art as sign seems, coldly considered, to be a singularly modest proposal. Art history's abiding interest in iconography may require some revision if the symbol were to be replaced by an attention to the unmotivated and differential nature of the sign. Our claims for meaning in art would lose none of their urgency for gaining a new insistence on comprehensibility rather than timeless continuity: what is at stake is rather a revision than an utter abandonment of the notion of tradition. Semiotically speaking, we will emphasize the constant revision of the tradition within semantic networks rather than its imperviousness to change. However, the very unmotivated quality that Saussure ascribes to the sign will demand an ever-greater engagement with the impact of tradition in constituting the system of signs in relation to which meaning becomes possible. Likewise, the funeral rites for the artist and the work will coldly furnish forth the necessaries for a celebration of sign-system and textuality as the organizing centre of art-historical discourse. There will still be plenty to say about painting, possibly even more than remains to be said within the traditional discourses of artistic endeavour, painterly influence and historical attribution.

In this context, semiotics must be understood as exacerbating an anxiety that is structural to art history itself; hence proceed both its force and its modesty. In reading the artwork as a collocation of elements taken from

elsewhere, whose meaning is an effect of the combination of their paradigmatic selection from pre-existing visual language and their syntagmatic arrangements, semiotics locates the artwork where modernism had identified all that was inimical to the practice of art: as kitsch, in Clement Greenberg's definition. According to Greenberg, kitsch uses as its raw material 'the debased and academized simulcra of genuine culture' in a mechanical and formulaic operation.[1] If the semiotic historian of art insists that the sign is visible as a culturally coded element articulated in the syntagmatic ensemble of a painting as text, this would seem to be a kind of transvaluation of Greenberg's jeremiad, in which kitsch is accused of 'borrowing' the elements of 'a fully matured cultural tradition' so that it may 'convert ... them into a system'.[2]

If painting is located in a semantic field whence meaning arises differentially and by combination, then innovation is necessarily subjected to adaptation, the message to the code. In this sense, a painting made of signifiers is like a statue of Elvis made of sea-shells. It is common to attribute the furore raised over semiotics in art history to political conspiracy, motivated by reaction against the threat of semiotics to the bourgeois institutions of art history and their guardian deity, the male artist. Certainly, semiotic analysis discards a priori any possibility of art as the guarantor of transcendental values, since signs can only have meaning within the quasi-linguistic structuration that allows them to function. Yet the threat of semiotics does not menace the art institution simply from without: Mieke Bal does not take the analogy of Barthes' *S/Z* literally, and it is not critics carrying semiotics textbooks that enter museums to slash and fracture Rembrandt canvases. Yet, in a sense, her manipulations do just this, in a way that reveals something internal to art history's practices.

That semiotics should show art history its long encounter with kitsch and violence proceeds from the semiotic acknowledgments of the understanding of the artwork in terms of its adaptability to comprehension, and of art historical description as composed of elements alien to painting (even the technicalities of painterliness become signs of 'painting' in a language finally external to paint). There can be no propriety in painting. And yet, in another sense, a sense that semiotics is always struggling to realize, painting is nothing other than the search for its propriety (as Greenberg might agree). In the very specificity of its search for a language of painting, semiotics does not simply say what the proper meaning of paintings is: it evokes the essential nature of the question of impropriety and propriety for painting, the question of the obviousness of art. Rather than subjugating the visible to the readable, semiotic readings (should) testify to the extent to which the necessary availablity of the visible for reading, the very fact that we want to talk about the visual arts at all, in any way, breaches the autonomy and propriety that we are wont to attribute to them. This anxiety is not new: semiotics makes it harder to ignore the fact that it is proper to the visual arts that we breach their propriety in speaking of them. In this sense, attention to textuality renders vision opaque, an opacity that allows us to see (by virtue of its resistance to perception) the mediated quality of perception itself. Nothing more (is) obvious.

What is certain, however, is that with the semiotic turn comes both a recentring and a certain destabilization of our understanding of vision and its

obviousness. Mediation now marks the essential nature of perception, as vision and textuality are fused under the common aegis of the sign. However, mediation is not itself entirely obvious or visible: signs cannot simply be read. Thus Mieke Bal's chapter is an essay in a 'textual semiotics' whose explanatory power to decode is disrupted by a sense of its own textuality, or visibility. Marin insists upon the speaking subject 'itself' as a figural topos, refusing to situate the artist as a transcendent presence behind or above the signifying web. Likewise, Norman Bryson's contribution must be read in the context of his championing of a structuralism that has already relinquished the pretension to scientificity in favour of an engagement with discursive specificity. In his reading of the imaginary museum of Philostratus, he traces the textual organization of space as a necessary precondition for the possibility of vision. The relation of world and image is negotiated in a semiotic space that is eminently textual. And this is where Hal Foster's study of the armouring of the body seems to open a revision of the semiotic project: as the point at which the semiotic hardening of the body into an articulated series of surfaces does not simply fuse the real and the represented, and does not simply mean that all that is real is a representation and vice versa. On the contrary, the politics of art intervene, and point towards the next section of this book, precisely at this site of non-equivalence. To put this another way, one might say that the semiotic project encounters its politics at the point where one gives up on the Baudrillardian understanding of the simulacrum: that is, at the point where the non-equivalence between the textual and the worldly demands a politics, and denies that one can arrive at the politics of the real by simply decoding it as a representation. The real is semiotically invested, certainly; it must be read. But, as Bryson's tripartite mapping of world (things), word and image suggests, and as Foster's reading of Bellmer illustrates, the textualization of the visual is not the answer to political questions, but the beginning of political negotiation.

Notes

1 Clement Greenberg, 'Avant-garde and kitsch', in *Perceptions and Judgments, 1939–44* (Collected Essays and Criticism, vol. I), ed. John O'Brien (Chicago, IL: University of Chicago Press, 1986) p. 12.
2 Ibid, p. 12.

Chapter Eight
Reading the Gaze: The Construction of Gender in 'Rembrandt'
Mieke Bal

Two groups of figures represented in 'Rembrandt'[1]: nude, often mature, women and blind old men; two viewing positions distinguished in modern theory: the gaze and the glance; two gendered positions distinguished by Western culture: women as objects of looking, men as subjects of looking; two gendered feelings distinguished by psychoanalysis: fear and envy; two arts, two media, two semiotic systems distinguished by Western academia: textuality and vision; two ways of processing these: reading and looking; two paradigms of interpretation: the verbal one, based on Jakobsonian ideal, mutual communication, and the visual one, based on one-sided, objectifying voyeurism; is there life beyond binary thinking?

In this chapter, I will try to cut across these oppositions, moving from one pole to the other, from one set to the other, from one gender, art, medium, viewing position to the other; I will suspend current hierarchies, and establish connections wherever I can. I start from two assumptions. The first assumption is that the construction of gender in 'Rembrandt' is not necessarily stereotyped, or monolithic. In other words, I wish to be open to the possibility that these constructions may be informed by oscillation, if not contradiction. The second assumption is that academic disciplinary practice is not necessarily adequate for the understanding and analysis of art, especially the propositional content of art. In other words, I wish to propose that we *read* the *gaze*, in a non-metaphorical sense.

BEYOND THE WORD–IMAGE OPPOSITION

When we think of communication, we think of language in the first place. Verbal communication is the most obvious form of communication. Other forms of communication are often referred to as specific languages: body-language, animal language, sign language. Language has become the model of communication, and it has been linguistics that developed the models for analysing communication which have become predominant, and remain so in

147

spite of decisive criticism. The standard view of communication is Jakobson's model which, as you all know, runs as follows.[2] A message, say the text, an utterance, an image, is sent by a sender or speaker, to a receiver, reader, listener or viewer. In order to be understandable this message must refer to the reality which sender and receiver share (at least in part). This reality is called the context. Furthermore, the message must be transmitted through a material channel, the medium, to which the receiver has access, and be set in a code to which the receiver must possess the key.

In addition to all kinds of problems of internal logic, this model can only account for ideal, totally successful communication, wherein the message arrives unharmed at its destination and is decoded according to the intention of the sender. The receiver is totally passive, a container rather than a subject,[3] and the sender is omnipotent. We all know, of course, that reality is not so idyllic, and that messages hardly ever arrive complete and undamaged. Neither is the sender ever completely aware of all aspects of his or her message. Moreover, the receiver is not passive. Whereas the sender takes into account what she or he assumes the receiver wishes or is able to hear, read, or see, the receiver approaches the message from within her or his own context and preoccupations. All this must sound boringly obvious to you. Yet most of art history and much of literary interpretation still aims at 'restoring' this ideal communication by retrieving the original intention and context. Why would that flagrant contradiction between theoretical persuasion and critical practice persist and pass unnoticed? One reason can be detected when we consider what it is that is thus obliterated.

Perhaps the most important aspect that this model relativizes, to the point of obscuring it, is manipulation. The sender does more than transmit a clear message; the package contains other, subliminal and unconscious messages. Symmetrically, the receiver manipulates the sender, by being whom she or he is and by the affective, political and intellectual relationship between receiver and sender. Manipulation is not only an instance of (ideological) agency, but also of the historical embeddedness of that agency. Rather than the assumed (but in fact projected), authorial intention, the interaction between work and audience should be the object of a genuine *historical* inquiry. These aspects do not pass unnoticed but, by virtue of the dominance of the Jakobsonian model, these aspects of actual communication are seen as merely deviant disturbances, as 'noise'. The provenance of this idealized view is not indifferent to this state of affairs. The linguistic background of the model is partly responsible for the repression or marginalization of, in particular, the importance of power and manipulation in communication. Yet attempts to use this or related linguistic communication models like Benveniste's (see *Problems in General Linguistics*, translated by Mary Elizabeth Meek, Coral Gables: University of Miami Press, 1970) for the analysis of visual art are nevertheless promising, because at least they impose the acknowledgment in principle of a receiver. Louis Marin's Benvenistian pictorial linguistics, for example, has become rightly famous.[4] The most pertinent aspect of this use is the insistence on the situation of communication, the distinction I–you versus s/he. The concept of deixis, also taken up by Bryson in *Vision and Painting* (1983), allows the critic to acknowledge that when a sender sends out a message, there is a receiver there, on the spot; yet the place of this receiver remains

theoretical, and passive. The underlying analogy between language and painting is taken too much for granted. As a consequence, the sender-orientedness of the model is not really challenged, even if, or because, it is unproblematically reversed in statements about viewing. An example is Sharon Willis's statement (see note 19): 'Any speech event, then, constitutes an implicit mapping of positions with respect to a context. The same is basically true for the look' (p. 92). The problem is not only that this analogy obscures the difference between the relations language and painting entertain with propositional content, but also that the traditional discrepancy between sender (speech event) and receiver (look) is not worked through, and therefore sender-privileging is able to creep in through the back door.

However, the Jakobsonian model is no longer the only available one . Recent interest in visuality, in particular in film theory, has provided an alternative model. Feminist inquiries into the power relations that obtain in the domain of visual culture emphasize these. Thus an alternative model is taking shape that represents visual communication as a not quite symmetrical counter-part of the linguistic idealistic model. This alternative model is based on the notion of voyeurism. While the linguistic model tends to obscure power in, and failure of, communication, the visual model tends to reduce looking to power only, to an absolute subject–object relation, wherein the viewer/receiver has total power and the object of the look does not even participate in the communication. This model is in fact based on non-communication.[5]

The absolute opposition between these two predominant models makes one suspicious. Which interests could be served by the ongoing predominance of the linguistic model? And could visuality be perceived as so threatening that its communicative aspects do not even surface? In keeping with recent attempts to overcome this absolute opposition, I will try in this study to stay away from Jakobson's unidirectional sender-oriented ideal communication, without simply replacing it by voyeurism, which is equally unilateral, receiver-oriented and non-communicative. A serious examination of the possible connections between the two is imperative for the development of a non-idealized and non-censoring view of painting. Such a mediation may be offered by recent work in visual analysis.

THE GLANCE AND THE GAZE

Rembrandt's nudes have provoked many comments, from his era to the present day.[6] One reaction has been criticism of his 'realism', a realism which resulted in the representation of the ugly aspects of bodies, like stretch-marks and the imprints of garters.[7] The following passage from a contemporary comment clearly shows what is at stake:

When he [Rembrandt] a naked woman, as it sometimes happened,
Would paint, chose no Greek Venus as a model,
But sooner a washerwoman, or a peat-treader from a barn,
Calling his error imitation of Nature,
Everything else invention. Sagging breasts,

Wrenched hands, even the pinch of the sausages [the mark of the pinches]
Of the stays of the stomach, or the garter on the leg ...

What was considered excessive realism has also been considered aggressive
realism: a misogynistic representation of what men find repulsive in women.
On the other hand, the beauty of some of the nudes, in particular the *Danae*, has
been celebrated. In these two reactions we see the typical conflation of repre-
sentation and object which comes with the eroticization of viewing. If the body
constructed for the mind's eye is considered lustful to look at, the painting is
praised; if that body is found ugly, the painting or drawing is criticized.

The problem with these two series of reactions is that, in terms of viewing,
they are basically the same. The work of representation itself is ignored, so
that the work of art disappears behind its object. This attitude involves a
specific status for the act of viewing. What is *not* seen, according to this
criticism, is a 'real' woman, or anything as close as possible to a real woman,
who is in charge of providing beauty. What is *not* seen is that which is
perceived: the work. Thus seeing and perception are radically separated.
What is lacking in these reactions is an awareness of the act of reading. Thus
both the receiver and the object disappear, and we are back into the
Jakobsonian model.

In Norman Bryson's terms these reactions verbalize the gaze, the look that
a-historicizes and disembodies itself and objectifies (takes hold of) the
contemplated object.[8] Bryson distinguishes the gaze from the glance; it is
the involved look where the viewer, aware of and bodily participating in the
process of looking, engages in interaction and does not need, therefore, to
deny the work of representation, including its most material aspects like
brush-, pen- or pencil-work. The point of this mode of looking is that the
awareness of one's own engagement in the act of looking entails the aware-
ness that what one sees is a representation, not an objective reality. And, of
course, this mode of looking does not fit the linguistic model of communica-
tion too smoothly.

This distinction, whose usefulness I will end up advocating here, suffers
from three problems. In Bryson's own work, it is not always clear where he
locates the terms of this distinction: in the work or in the act of viewing.
Discussing Chinese and Japanese calligraphy he seems to place them in the
work, and they refer to the traces of the work of representation, the brush-
stroke (*Vision and Painting*, pp. 89–95); these works exist as traces of enunci-
ation which is a sender-activity. But elsewhere (for example, the
Annunciation of the Master of the Barberini Panels: see *Vision and Painting*,
pp. 101–3) the terms refer to modes of seeing,[9] which is receiver-activity. In
terms of the Benvenistian variant of the model, whose enunciation is it?
I would like to test the usefulness of these terms for the discussion of the
construction of gender, limiting their meaning to the viewing attitudes
proposed and encouraged, but not enforced, by the work. The traces of enun-
ciation which encourage the glance are marks of the work that constitutes
the work: sender and message cannot be distinguished. The gaze is, then, the
attitude that conflates model and figure, encouraged by 'transparent' realism
effacing the traces of the work of representation, while the glance is the
attitude that emphasizes the viewer's own position *as* viewer, encouraged by

the traces of the work of representation which propose, for reflection, that the representation is focused in specific ways. The two modes of looking can be alternated before the same work and even combined within the same looking-event, yet they are not an entirely arbitrary option: the work's structure appeals to either mode or not.

The second problem is the binary structure of the distinction itself, which tends to support the very dichotomistic tendency I would like to undermine. I will circumvent that problem by refusing categorical assignations of either mode of looking to any particular work. The distinction has to be relative, dialectic and mobile.

A third problem is the infelicity of both terms themselves. The disadvantage of the term *gaze* is the popularity of its use in Lacan, where it has come to mean the social formation of a generalized visual discourse equivalent to language.[10] This meaning is not unrelated to the use in the present distinction, but it is much less precise. In both cases the gaze is a mode of domination, but its gender profile is much more specific in the use of the concept at stake here. I will solve this problem by limiting the use of the concept to this particular sense.

The disadvantage of the term *glance* is an inherent contradiction. Although it can imply self-consciousness, the traditional meaning of the glance does not imply the kind of self-conscious pause, the Habermasian self-reflection the concept refers to here, but rather a flight from such an activity. In fact, it has these two – quite different – meanings at the same time, and although there is much interest in keeping these two together, for simplicity's sake I will solve this problem by specifying the concept in the Habermasian direction.

To return to the first problem, the status of viewing positions in relation to the work, we need to avoid fallacious self-fulfilling and self-repetitive conflations of representation and actual viewing as exemplified in the reactions to Rembrandt's female nudes. I assume that in representational art, figurations of viewing positions are not indifferent, or imperative. The actual viewer is addressed by these positions which, according to their attractiveness, are offered for identification or the refusal thereof. According to present insights in reader-response theory it seems plausible to me to suppose that, although no simple one-to-one relation between represented viewing position and actual viewing can be assumed, a representation of viewing does interact with actual viewing, in ways to be analysed further.[11]

As soon as we address Rembrandt's nudes from the position of the glance – which we can but do not have to do, yet which in some cases we are, and in others not, encouraged to do – we are hit in the face by, to begin with, the insistence with which the many drawings and sketches of the so-called 'ugly' female body relate to the representation of looking itself. Indeed, the 'ugliness' itself may not so much be generated by an excessive concern for realism (as Pels sarcastically suggests), or by misogyny (as others tend to think) but, on the contrary, by an emphatic concern with representation. This concern need not be placed with the sender – even though Rembrandt's self-awareness is well known (see Alpers, *Rembrandt's Enterprise*) – but can be *read* in the works that are its traces. I will illustrate this hypothesis by comparing three drawings of female nudes, all three of which are 'ugly': that is, neither idealized nor Venus-like.

THE GLANCE AGAINST VOYEURISM

The paradox of drawings like that shown in Illustration 43 is the representation, hence the exposure, of a body as not exposed for looking. This drawing would most certainly be classified as one of the ugly nudes. What is 'ugly' about the represented body is, however, not the body itself but its attitude. The whole body expresses unwillingness to be seen, an unavailability for eroticism and lack of exhibitionist efforts, yet it is represented for us to see. But what exactly are we supposed to see: what is being represented?

The work of representation is precisely to make this unavailability for seeing itself visible. The effort, the traces of which constitute the drawing, is towards lowering the shoulders, letting the belly protrude, underlining by the proximity of breasts to belly that the former are not ornamental but part of the mass of flesh that this body in intimate relaxation chooses to be. Pels would call these breasts 'sagging'. The sketchy background is no more than what it is: background, a surface that screens off the space of the woman. It signals the intimacy of her position and represents the screen which should also shut her off at the other side, the viewer's side. The curtain on the left should fall and let the woman be alone.

Turning one's head away is a conventional sign of the reluctance to be seen. Paradoxically again, the woman in this drawing turns her head away *towards* the viewer, only to lower her eyes. Thus the refusal to look back is thematized by this conspicuous gesture. Everything in this drawing explicitly discourages erotic response. This is not to say that an erotic response is impossible. It certainly is possible, but on different terms: on the terms of the glance, not of the gaze. One can respond erotically to this representation in different, contrasting ways. One can either respond through the awareness of the viewer's intrusion, and by coming to terms with the unwillingness of the figure to be watched – in other words, by *working through*, and thus overcoming, one's position as voyeur[12] – or one can respond by enjoying the woman's exposure despite her reluctance. I think that even an act of viewing of the latter kind is not very easy, as the figure's reluctance has in any case to be dealt with, and thus the awareness of a focused representation is inevitable.

In the following drawing (Illustration 44), at first apparently in the same category as Illustration 43, the representation of this reluctance is dramatically different. Again, the female figure is not exposed for viewing. She is engaged in herself, and her body expresses relaxation and indifference to its visual effect. The position of her legs, for example, is not only not at all gracious, but is doubly uninviting: it closes off what the peeper would want – and fear – to see, and the legs are engaged in a self-contained movement which signifies their unavailability. Again, the effort of the work is towards emphasizing this unavailability, as the strong line from the left hand to the foot suggests. The head is turned away again, but this time not in the direction of the viewer but away from him/her. Unlike the passive, interiorized look of the preceding drawing, however, this figure does actively look, but not at the viewer. Ignoring the viewer, she is busy looking at herself. The left edge of the figure narrativizes the drawing and brings the female figure to life. If the preceding figure was represented in its utter narrative passivity, this one is represented as active. The refusal of the first figure is replaced by the indifference of the second.

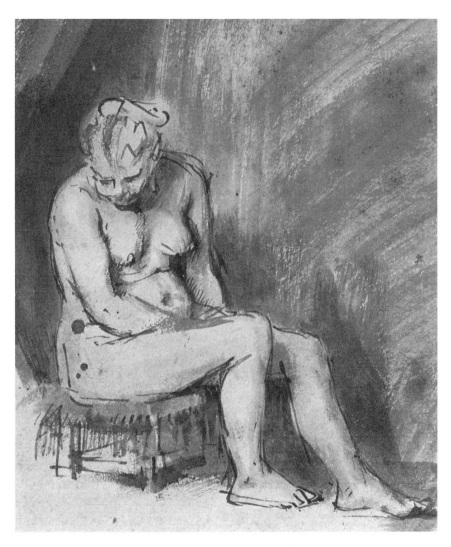

43 Rembrandt, *Female Nude Seated, c.* 1654–6 (Benesch 1122); The Art
Institute of Chicago

This difference also changes the position of the viewer. The absence of any
indication of exposure of the body, of any exhibitionism, does not preclude
voyeurism as strongly as did the other sketch, but neither does this lack of ex-
hibitionism encourage it. The indifference confronts the viewer with his/her
own choice: to watch or not to watch; to watch the indifference or to watch the
body; to watch the work or to watch the object. The very fact that the option
between glance and gaze is emphatically proposed to the viewer is in itself an
obstacle to the smooth, self-effacing gaze. This is the paradox of self-reflexive

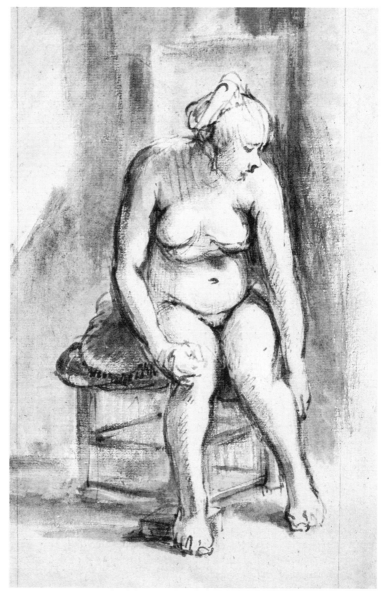

44 Rembrandt, *Female Nude Seated*, *c.* 1660–1 (Benesch 1142);
Rijksprentenkabinet, Amsterdam

art. Similarly, some postmodern novels paradoxically *enforce* the *freedom* to read realistically or self-reflexively.

With the third of this series (Illustration 45), we come closer to traditional nudes. The woman, rising from her seat, holding a veil that does not veil her body, and looking towards the viewer as if surprised by the latter's intrusion, is the rhetorical signifier of erotic provocation. The figure establishes a continuity between herself and the viewer. The drawing's narrativity, the figure's pretension of movement, is consequently weak compared to that in Illustration 44. The woman in Illustration 45 looks outside the image, without signs of distress or anguish, and the token act of taking up a cloth for covering

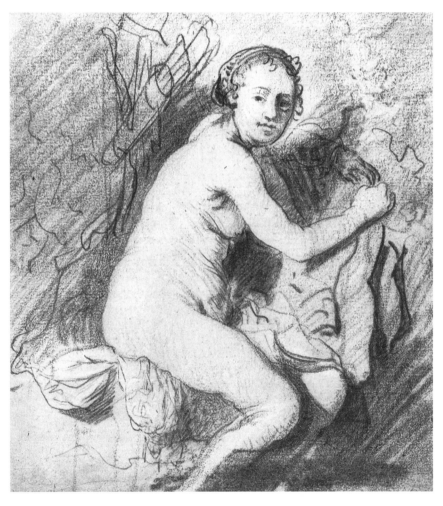

45 Rembrandt, *Female Nude Seated, c.* 1630–1 (Benesch 21);
British Museum, London

her body is the pretext for the arm to be stretched out, for the breast to be shown, and for the shoulder to be raised. Although the body is neither more nor less 'ugly' than the two others, this relation between it and the viewer is now completely different. Stretch marks, a weak, protruding belly, and a thigh that is no more smooth, are equally represented. But this body is not warding off the possible visual–erotic initiative of 'whom it may concern'.

Even here, we cannot claim that the work stands fully in the eroticizing tradition. Traces of the work of representation remain, which disturb the perfect objectification of realism welcomed by the gaze. The lines of armpit, breast and thigh deny what the attitude and look suggest and emphasize the representation itself. The strange lines on the upper left thigh belong to the cloth; yet they also seem to suggest disturbance in their position as guardians of the body's entrance. And although the figure looks in the direction of the viewer, her eyes are just not clear enough to be caught. These works are sketches, and thus are even less made for public viewing than etchings are. Because they are sometimes preparations but more often exercises for paintings or independent exercises, they bear a close relation to the artist-and-his-work as we know him/it: to 'Rembrandt'. In a sense, they *are* this work, and they can therefore never fall entirely under the gaze.[13] But studying them, here, is a way to retrace the steps of the work of representation and to remain in continuity with the representing subject. It is, so to speak, a way to keep in touch. Let us take a brief look at another drawing, which is considered to be a preparatory drawing for the early painting of *Susanna surprised by the Elders*, in the Mauritshuis, The Hague.

This drawing (Illustration 46) does not belong to the 'ugly' nudes; the body is far removed from the mature and rather fleshy bodies of the three other drawings. It is hardly a nude at all. The drawing shows the effort of representing the moment of getting up from a seat. The effort of the work is in the tension in the figure's back. The artist has succeeded in representing a unique moment in a 'still' medium, thus challenging the common opposition between visual and verbal art.

The same performance shows in the head of the figure. The head is not turned towards the viewer; it is caught in the very moment of turning. Again the work of drawing goes into this important difference between a situation and an event as the different lines around and on the neck show. Comparing this head to that in Illustration 45, the difference is striking. The same can be said about the eyes. In Illustration 45, the eyes are not looking directly at the viewer but resting more vaguely somewhere between fictional onlooker and outside spectator; the sharp eyes in this drawing address the viewer directly and instantaneously, emphatically briefly. To read these images as theoretical statements, these two pairs of eyes stand to each other as representations of the gaze and the glance.

The eyes, in this drawing, are apostrophic, active and positioned in time. They protect the body – here already protected by the clothes – against the eyes of the viewer who, after being thus addressed, can only raise his hat and walk by, blushing. The viewer of Illustration 45 can take his time and look on as long as it pleases him. Unlike the term 'glance' suggests, this does not mean that the actual viewing time for the two drawings is different; on the contrary, Illustration 46 is much more interesting and will ask for more viewing time. But the viewing, however long it takes, is positioned on a time scale. The

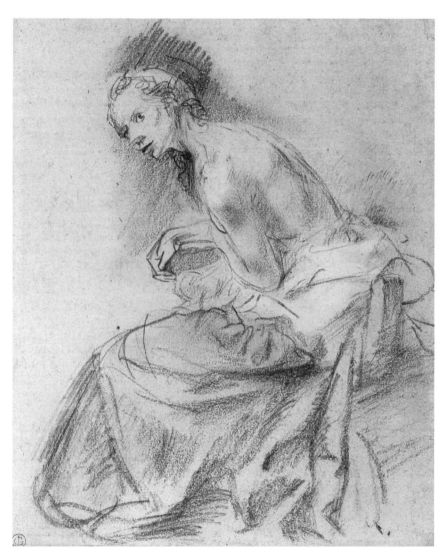

46 Rembrandt, *Woman Standing Up* (Susanna?), no date (Benesch 590);
Kupferstichkabinett, Berlin

viewer who watches Illustration 46 for ten minutes will realize all those
minutes that he is being indiscreet and unwanted. Even the briefest look at
Illustration 45, in contrast, will take the stature of a gaze: outside time,
undisturbed, the viewer can 'take in', usurp (Bryson would say, *prendre sous
garde*) the represented body. Even if the actual viewing time is shorter, the
viewing of the image before the mind's eye is longer. The viewer takes it with
him as a fixed icon.

THE FOCALIZER: THE FIGURATION OF THE VIEWER

We are now equipped to assess the status of the viewer as *reader*. What is specifically readerly about the glance-work as I have outlined it so far? I will try to answer that question by proposing a specific use for the term *focalizer*, which refers to the subject of point of view in narrative theory. The focalizer is an agent in the work who represents vision, and thereby offers positions of viewing to the real viewer. As such, it is a possible mediator between the two poles of the linguistic communication model, and between the two opposed models of language and voyeurism. Reading a work through an analysis of the focalization that marks its representation is a double mediation. Such a reading mediates between sender and receiver by pausing at the sites of available viewing positions, enforcing the real viewer's freedom to choose, and hence to act. And it mediates between discourse and image, because the narrativization of the viewing process it entails inserts the mobility, the instability and the time-consuming process of reading sequentially. As we will see, reading the focalizer involves undermining the gaze, and blocking voyeurism.

Between narrative focalizer and erotic voyeur, the viewer's position can shift from the one to the other in variable degrees. Of these two aspects of the position, that of focalizer relates to narrative and that of voyeur to the gaze; in this section, we will try to see how these two interact. In order to avoid terminological confusion, methodological eclecticism and ideological miasm, it is imperative to assess the *visual* status of the narrative focalizer.

The concept of *focalization* has a quite elaborate and specific bearing on the analysis of narrative discourse, and as such it refers to both *narrative* as a genre and *discourse* as a semiotic system.[14] In fact, it relates two aspects, the narrative represented and its representation, in that it refers to the steering perspective of the events or fabula that is verbalized in the text by the narrator or voice. Although its basis in the notion of perspective *seems* to make its transposition to visual art plausible, I would not like to suggest that such an unproblematic transposition is my goal. For the gap we have to bridge first is the one that separates the 'mind's eye', and what is or is not visual about what it sees, from the 'real eye', whose visuality is neither more self-evident than, nor identical to, the former.

In order to make the concept operational for visual art, the following points of comparison are pertinent.

1. In narrative discourse, focalization is the direct *content* of the linguistic signifiers. In visual art, it is the direct content of visual signifiers like lines, dots, light and dark, and composition. In both cases, focalization *is already an interpretation*, a subjectivized content. What we see, before our eyes or before our mind's eye, is an already interpreted image that only the mind's eye is able to see.

2. In narrative there is an external focalizer, in principle identifiable with the narrator, from which it is distinguished in function, not in identity. This external focalizer can embed an internal, diegetic one.[15] For the analysis of narrative, this relation of embedding is crucial. In visual art, the same distinction between external and internal focalizer holds, but is not always easy to point out. In this etching of Joseph and Potiphar's wife

(Illustration 47), the external focalizer, with whose view the spectator is asked to identify but from which the latter is technically distinguished, *embeds* the internal one, the Joseph-focalizer. Hence, they do not meet on the same level and, to a certain extent, the focalization of Joseph is entirely contingent upon the fantasy of this external focalizer, which I have elsewhere identified with Potiphar.

3. In narrative, the fabula or diegesis is considered to be *mediated*, or even produced, by the focalizers. Similarly, in the case of visual art, the use of the concept implies the claim that the *event* represented has the status of the focalized object produced by focalizers. In the case of a diegetic focalizer, the 'reality'-status of the different objects represented is variable and contingent upon their relation to the focalizer.

4. As a consequence of this last point, the same object or event can receive different interpretations according to different focalizers. The way in which these different interpretations are suggested to the reader are medium-bound, but the principle of meaning-production is the same for verbal and visual art. In *Madame Bovary*, the heroine's eyes are variably dark, black, blue or grey, according to the internal focalizer with whom we watch her. The words conveying these incompatible descriptions do not themselves betray the

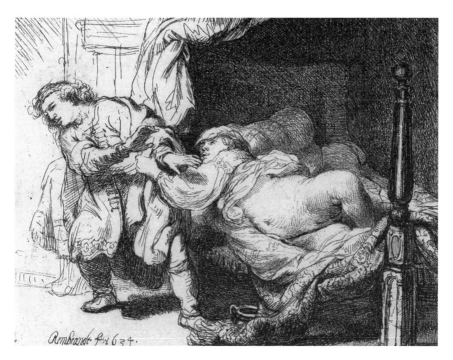

47 Rembrandt, *Joseph and Potiphar's Wife*, 1634; Teyler Museum, Haarlem

difference between them. Only the hypothesis of different focalizers, substantiatable in a textual analysis, can account for these differences. In the Joseph etching, one object, the woman's body, is represented in two different, incompatible ways, according to the two different focalizers, one of whom was internal (Joseph) and one hinging between internal (Potiphar) and external. Again, the lines composing the body do not themselves betray the difficulty – the body could have been simply 'ugly' – but the hypothesis of two different focalizers showed the rabbit-or-duck problem underlying this 'ugliness'.[16]

5. In narrative discourse, the identification of the external focalizer with an internal one can produce a discursive conflation called Free Indirect Discourse.[17] The identification between the external focalizer in visual images with an internal focalizer represented in the image can similarly give rise to such a conflation. The conflation is, then, to be situated on the level of the representational work itself, the 'text'. Such a conflation strengthens the appeal to identification.

The dynamics of focalization are at work in every visual work that contains traces of the representational work performed by the artist as seen and interpreted by the viewer, since it is precisely in those traces that the work is narrativized. To begin with an apparent counter-example, in the drawing of Judith killing Holophernes (Illustration 48), the internal focalizer is represented as failing the act. The soldiers who are supposed to spy on Judith look in the other direction. What is represented emphatically here is the absence of the onlooker: the guards who should *see* the threat to Holophernes. It is certainly not by chance that the drawing's theme is exactly the opposite of that of Susanna and the Elders, the story of illegitimate looking so popular in Western art. Here, the rapist[18] aggression comes from a woman, and the viewer is *not* invited to share in it. In contrast, the viewer is asked to look away. In other words, the onlooker in both cases is addressed as sharing the male interest: fright, in the *Judith*; pleasure, in the *Susannas*. Of the three 'ugly' nudes I have analysed above, the first one, Illustration 43, is not narrative on the level of the fabula; no narrative action seems to be implied. Yet the strong resistance to the viewer and the emphasis on the representation of that resistance make the drawing narrative in precisely this sense: the position of the external focalizer, with which the viewer can easily identify, is implicated in the representation of what becomes an active resistance to exposure. In the second drawing, Illustration 44, narrativization took place on all three levels of narrative discourse: on the level of the 'text', narrativization was located in the emphatic representation of the 'activity of indifference'; on the level of the focalization, in the implications of both access to viewing and self-reflection on viewing; and on the level of the fabula, in the figure's internal focalization, directed 'elsewhere', refusing to meet the external focalizer's eye. In the third, Illustration 45, the easy, yet not entirely convincing, encounter between external and internal focalizer left nothing to focalize; the only action is erased by the 'event' of that encounter. The traces of the 'text' are partly erased for the benefit of the external focalizer and, as a result, the event is not understood as a diegetic event.

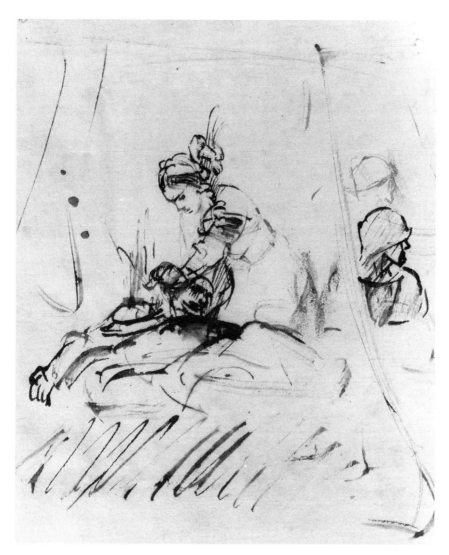

48 Rembrandt, *Judith Beheading Holophernes, c.* 1652 (Benesch 897); Meso di
Capodimonte, Naples

In Illustration 46, in contrast, the same action – rising up – leads to an event
of internal focalization so strong that it undermines the external one. This
is comparable with narrative stories where the 'point of view' (read as
'focalization') of a character produces so strong an illusion that the external
focalizer seems absent, although this is technically impossible. James's *What
Maisie Knew* is the classic example, a favourite of literary theorists, but, as
often happens, more often evoked than actually analysed.

These brief accounts illustrate how narrativization of the image can either
support or counter voyeurism, in interaction with a viewer who is or is not

sensitive to the dynamics of narrativization.[19] In different terms, these remarks can also suggest that in variable degrees the glance, as a viewer position proposed by these works, can undercut the gaze.[20]

GENDERING THE GLANCE

In *The Toilet of Bathsheba*, in the Metropolitan Museum of Art in New York (Illustration 49), we see a naked woman, according to the biblical story of II Samuel 11, being prepared for royal rape. The *story* includes a scene of voyeurism: King David, standing idle on the roof of his palace, sees the naked Bathsheba taking a bath, and his lust is kindled. Although the rooftop can be seen in the background of the painting, the voyeur himself is not visible. The nakedness of the woman, emphasized by the passivity of her pose, is the real subject-matter of this painting. The two women who help her prepare her toilet only enhance the importance of her display: she is being made ready to be a perfect object, first of the gaze, then of the rape for which the gaze is a

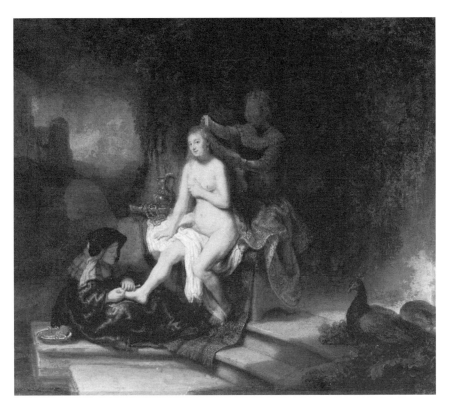

49 Rembrandt, *The Toilet of Bathsheba*, 1643 (Bredius 513); Metropolitan Museum of Art, New York

preparation, or at least a substitute. She has one hand on her breast, but this gesture has no meaning other than to attract attention to her nakedness itself. This woman also looks at the viewer, but this look is not related to any internal focalizer-position. Hence, it works for voyeurism and is as acquiescent as the look of the woman in Illustration 45.

In contrast, the naked woman in the *Danae* in the Hermitage in Leningrad looks away from the viewer (Illustration 50). This painting is not only a generally acclaimed masterpiece, but it is also an obvious counter-example to the charge of misogynistic realism, of 'ugliness'. Not only does the figure look away from the viewer but, more importantly, the look of the figure is narratively embedded in a structure of focalization that changes the voyeurism generated by the display of her body. I will use this work to argue for a non-binary view of gender in Rembrandt.

In fact, at first sight the painting comes close to voyeurism; it thematizes it. The woman is represented as naked in her most private space, on her bed. But her nakedness does not make her passive. Where Bathsheba was represented in her emphatic passivity, this woman derives power from her nakedness. Her beauty, desired by both the lover Zeus and the viewer, is not an object to be

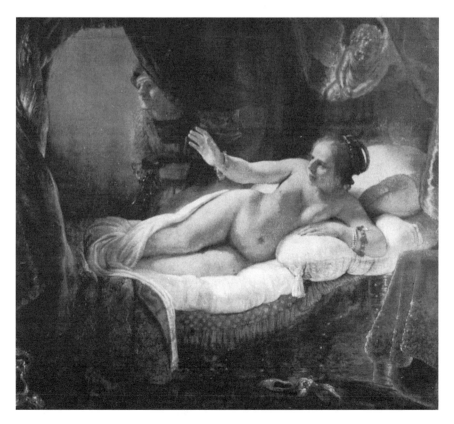

50 Rembrandt, *Danae*, 1636 (Bredius 474); Hermitage, Saint Petersburg

taken in. She disposes of it herself. The structure of focalization in this painting raises the question of the intertextual relations between verbal pre-text and painterly text which underlie the word/image opposition. It allows us to assess the two ways to narrativize a painting that tend to be conflated in criticism: by projecting a pre-text and by constructing a text.

Let us look at some details. The shower of gold in which Zeus is supposed to approach the woman takes the form of a sheen. But this sheen, the border of light, so crucially Rembrandtish, dissolves into futility. For, in spite of deceptive appearances, it is not Zeus's gold that illuminates this woman; her light is disseminated throughout all the corners of the space. Zeus's sheen coincides with the limit of the space in which the woman is enclosed – the sheen delimits her private space and thus emphasizes the form of the opening in which the woman's feet disappear – her opening.[21] The sheen emphasizes the opening, but it does not produce it; the sheen does not *count*. Thus the pre-textual story and *its* internal focalizer are undermined. The hand the woman raises directs us. In the story, this hand welcomes Zeus who descends in a shower of gold, hardly visible in the upper left-hand corner. But in combination with the look of the servant behind the curtain, an internal focalizer, the hand sends away the voyeuristic gaze. The implied onlooker is forced to follow the narrative structure of focalization and look with the servant, with the woman, somewhere else. Had the internal focalizer not been represented, then the gesture would have been deprived of its narrative status and become empty, a pretext for a better look at her body. The powerful arm which makes us aware of this woman's self-disposal certainly does not preclude the viewing of her body, but it does encourage awareness of that act of viewing: from the gaze to the glance.

Switching to the story, told in the present, of the situation of viewing: the viewer, who is *also* supposed to come in and be welcomed – as voyeur, allowed to see the female body on display – is equally deprived of his identity, as his eyes hit his mirror image in the two represented onlookers: in narratological terms, the delegated focalizers. These two, the putto and the servant, form an insistent triangle with the female body as its base, paralleling and reversing the triangle of the exit-vagina?-curtain. The putto, iconographing-in the pre-text as the 'symbol' of forbidden sexuality iconed by his tied hands, also offers a possibility of viewing, but an immature, childish one. He is not looking at the woman's body although he wrings his hands in despair over this lack, but at the bonds on his hands, which thus prohibit both touching *and* looking.

This is not a coincidence. According to Freud, looking is a 'natural' extension of touching[22] while, according to the opponents of pornography, touching is an inevitable extension of looking. This tension, which produces the present state of an important feminist debate, cannot be resolved because both positions rest on incompatible premises. This tension is simply there as a cultural contradiction, textualizing the *Danae*. Exasperated by the interdiction, the putto is visually self-enclosed. The servant, whose intent look cannot but direct the viewer's look, is engaged in looking *elsewhere*. This figure looks towards the limit between outside and inside, the frame of the situation of voyeurism as well as of the pre-textual episode. The face of this 'officially' female figure seems strangely masculine; moreover, a strong similarity, not

only with the artist's face but also with the beret which he so often dons in his self-portraits, is hard to overlook. The figure thus represents the conflation of genders and of sender (the artist) and receiver (the viewer). This seems significant for a figure who is in charge of representing looking between the gaze and the glance. S/he literally holds the key to an opening, but *which* opening is left to the visual narrative to decide. S/he looks, not at the body but at the place the powerful arm of the woman sends his/her eyes to: outside the bedroom.

These two stories – the textual, verbal pre-text and the story of the visual present – collude in the work's textuality. They are in tension, but not in contradiction. They produce a new story, the text of the *Danae*: Zeus, invisible as he/it is, thus becomes the pre-text the woman uses to get rid of the indiscrete viewer. The woman who at first sight seemed to be on display – as spectacle, in a static, visual reading – takes over and dominates both viewer and lover. Her sex, prefigured by the slippers and magnified by the opening of the curtain at the other end of the diagonal of viewing, is central in the framed text. Her sex is turned toward the viewer, but it can be seen by neither viewer nor lover, because the viewer is sent away while the lover comes from the other side/sight. The viewer again receives the 'freedom' to choose a mode of looking flung into his/her face. Each mode comes with a price.

BLINDNESS AS INSIGHT

The position of the viewer has thus flipped to the other side as well. Far from representing the construction of a female object for the voyeuristic gaze, then, what the *Danae* stands for is the construction of a masculine viewer whose visual potency is extremely problematic. While the ideal communication of a transparent message – female beauty – is disturbed by the woman's counter-action which specifies the status and possession of that beauty, the opposite model – voyeurism and the subordination of the passive female object it entails – has been disturbed by the same token. The painting, if about anything, is about manipulating and blocking, demonstrating and disturbing, both visual communication and the distribution of power between the genders.

This leads to the other group of works, of which I cannot show you much here: works representing blind old men. Indeed, Rembrandt sketched, etched and painted so many blind men that we cannot but see here a leitmotiv, if not an obsession. Of the biblical stories Rembrandt represented, his works on stories of voyeurism – Susanna, Bathsheba – are outnumbered by works on the story of Tobias, a young initiate who cured his old father's blindness, and equalled by works on the story of Samson, the hero who was violently blinded. The former story is represented about 55 times in what is presently left of Rembrandt's works.

Skipping the interesting case of the Tobias story, in which Rembrandt proposed the formation of gender mainly through the ambivalent relationship between son and father, it is especially the story of Samson which must detain us here. The *Blinding of Samson* can, for more than one reason, be considered the site where the two preoccupations, with women and with blindness, meet and illuminate each other. One reason is the pre-textual one: Samson's

blinding was due to an attractive woman, and we might assume that looking at female beauty is punished by blinding (a straightforward Oedipal castration motif). A more interesting, specific reason is a formal similarity between the crucial painting of the female nude – *Danae* – and the crucial Samson painting, now in Frankfurt[23] (Illustration 51).

The *Danae* can be read as being about seeing, about the transgression of the taboo on access to the woman's body, and about the interdiction to see. Seeing in this work a 'most succulent female nude' (Schwartz, 1985) is ignoring the work's narrative, which bars the viewer's sight by the powerful arm of the woman, used as an index referring the viewer elsewhere. This power is as insulting as contemporary critics have found Manet's *Olympia*'s gaze to be. But the work is not only about the interdiction to see, just as the *Samson* is precisely about that: the similarities go further. The structure and composition itself is identical to that of the *Samson*. Although the *Danae* is an attractive and to some extent sensuous work wherein the reclining body of the woman in the cave formed by the curtains yields self-confidence and power, it cannot be denied that the *Samson*, almost contemporaneous with the *Danae*, is structured in substantially the same way: a body reclining in a cave formed by curtains. Where Samson lifts his right foot, Danae lifts her right hand, forming a similar line, displaying *force*. And the ostentatious changes hardly obscure the identifications.

In order to give these similarities more depth we must emphasize the maturity of the woman in the *Danae* who hardly suggests the young virgin of the mythical pre-text, of the 'official' story of female initiation; the presence of the blind child in the putto who is represented *en abyme*, thus doubly fixed to immobility; and the strangely male features of the 'offically' female servant: dressed as a woman, s/he has the face of an elderly man. The painting focuses on the woman, the mother-figure, and thereby alone escapes simplified Oedipalism. In Oedipal terms the *Samson*, on the other hand, shows the son-figure, now grown up, the proud, invincible hero, in the reclining position, identified with the mother in the force emanating from his foot, structurally identified with her arm. For the rest he seems utterly different: victimized, blinded: deprived, like the viewer in the *Danae*, of seeing the mother. In that respect he continues the servant of the *Danae*.

The sexual aspects of the painting are of a different order. While the *Danae*, problematizing facile gender-identities, constructed gender only to undermine it by narrativizing vision, the *Samson* uses the same compositional structure and the same theme – vision – to construct gender against aggression. Take the soldiers, for example. By definition and by virtue of the pre-text, they *are* aggressive, but their aggression is not unproblematic. They are aggressive, let us say, to the same extent as the woman in the *Danae* is on display as a nude. Their aggression is genderized, we might also say, to the extent that the weapon of the soldier at the left *means*, by its form and direction, the penis. How else would we interpret the *round* point of this most visible of weapons? This soldier does not wear the harness and helmet of the others, but looks, in fact, quite like a 'normal' young man. Yet the colour of his dress is red, the colour of blood as of passion. And he *looks*. He looks and thus establishes a line of focalization which leads from his eyes via the weapon/penis to Samson's eyes. There, the look stops short, because Samson, precisely, is being

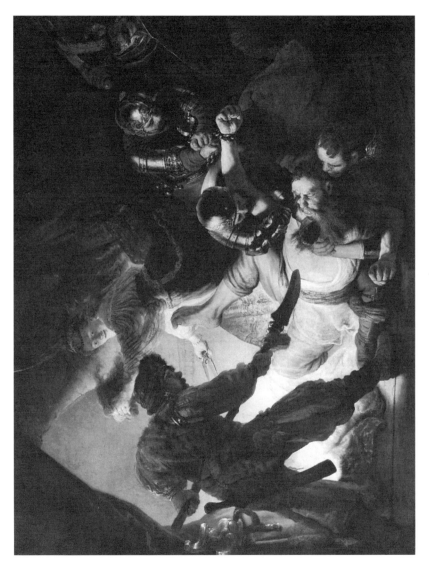

51

deprived of his eyes. We can now see how the concept of focalization is more useful than the limited concept of line of sight. While sight stops short, focalization continues. In this line, sight is replaced by violence, and the force of this violence directs us further, via the forcefully kicking foot to the woman standing in the back.

If we take the left-hand soldier as an internal focalizer, the focalization is genderized as male. The position of the weapon in relation to Samson's opened legs is not without sexual overtones either. Neither is, in a totally different proportion, the position of the body in relation to the cave itself. Sexual penetration is thus represented on various levels and with various means, and far be it from me to suggest that the representation proposes it as pleasant. We cannot maintain either, I am afraid, that Samson is constructed as unproblematically male.

The similarity with the overtly erotic *Danae* foregrounds the sexual aspects of the *Samson*, while the obvious opposition in mood is meaningful in its turn. The sexual aspects signify another level of meaning where they 'conceal and reveal' the relation between aggression and sexuality: the representation of sexuality as frightening, as terrible, and as *work*. The soldiers who do the blinding not only handle their phallic weapons relentlessly; they labour. This is hard work.

If we can thus see aggressive and sexual impulses represented in this work, and imbricated in one another at that, there is a third level of meaning where the two meet and explain each other. The shifter between the two distinct but related isotopies is the structural element that makes the painting deeply ambiguous, in the psychoanalytic and in the semiotic sense. Samson lifts his foot in order to kick Delilah. It is this element that is similar to the arm of the powerful woman of the *Danae*. It resembles two things at once, but in order to see what I want to point out, one needs to see in two manners at once, allowing two totally different compositions to operate.

Let us look once more at the lines, the composition of the painting. On one level, the cave signified by the curtains signifies in turn a gigantic womb. Although this is not systematically the case in 'Rembrandt', it is not the first time that we encounter this possibility.[24] If the cave is a womb, then Samson could even be read as a baby who is in this very moment and before our very eyes being born. Being born is a painful experience: it is represented as struggling his way out. His foot pushes the mother aside in order to push himself out of the mother's body, to pave his way towards being. Thus viewed, the foot is that of a baby labouring to distinguish himself from the mother's body: a view of primary narcissism in turn symbolized in a birth scene.[25]

Now let us take the same foot as an element in a different proportion, wherein the cave is a room again. Let us face it: Samson is also represented as a woman, who is being raped or/and giving birth. He is reclining, held/bound by a midwife – the man lying underneath him, a less than realistic image of fighting – and his spread legs are about to let the baby through – pushing it out. In this perspective the cramped foot represents the effort of the suffering woman giving birth, an undeniably painful experience.

What about focalization in this framework? The double composition is held together precisely by focalization: by the lines proposed by the figures who look, and what they look at. Both the figure of the woman and the position of

the foot are key elements in the construction of focalization. The work is about looking in more than one sense. The intensive looks of Delilah and the soldiers are quite meaningful in both these interpretations. Delilah's look represents in the one view the displaced metaphor of the woman to whom the gigantic womb belongs: a token woman, so to speak. That metaphor is metonymically suggested and supported by the blue colour of her dress which mingles with the bluish background of the curtain and the sea-like, dream-like world outside. In the second interpretation she is also a midwife, one who, filled with concern for the suffering 'woman', nevertheless fulfils her practical duties, one of which is proposing a way of looking.

It requires a discursive a priori input from the pre-text to see in this woman's looks anything like aggression. Her look, instead, is remarkably un-aggressive. In her hand she holds a pair of scissors; scissors serve to cut off not only hair, but also umbilical cords. The scissors point backwards, but her bulging eyes look back, at us. Thus the line of sight that started at the first fo-calizer at the left, and that was continued problematically by the force that re-placed Samson's sight, ends with the viewer. In between are the blinded eyes and the forcefully pushing foot. But this line of sight is not the only one. This is a multifocalized painting, and the sense of overcrowdedness, compared to the balanced *Danae*, stems from the overwhelming representation of vision, rather than from the sheer number of figures.

The soldier at the right, with bulging eyes and open mouth, is clearly im-pressed by what his eyes see, just like the viewer whom he represents. This representational function is doubly signified. This soldier locks the viewer within a frame of vision, by the similitude between his eyes and Delilah's, with whose face his face rhymes, and by the ambiguity of the direction of his eyes, which seem to look at the horrible act he is witnessing, but not quite so. His eyes hesitate, just overlooking Samson's face in the move from there to the viewer. The soldier with the phallic weapon does not look aggressively any more than the other figures, but rather seems concerned. The second soldier on the right looks at the left-hand man, rather than at the fallen hero. His look, emphasized by the light, is a typical example of the stealthy, quick, self-conscious and anxious glance. Four looks, none of which shows either aggres-sion or pleasure, while the three other figures (whose eyes we do not see), are engaged in forceful labour: what are we to make of such a representation?

We can now see how the *Samson* is responding to, or offering the other side/sight of, the *Danae*. The female body offered for voyeuristic non-commu-nication took over, and made visual communication the thematic centre of the self-awareness the work promoted. In Jakobsonian terms, the message short-circuited the sender's attempt to dominate the viewer at the expense of the female figure. The *Samson* makes the woman and the man change places, putting the ambiguous servant in the foreground, and the woman in the back.

The woman who dominated vision by delegating the servant to direct our look now takes the place of this servant. She directs our look, not away from the beautiful body but away from the frightening body. The ambiguous servant who looked so much like a man, and like the artist, while representing not-being-able-to-see, now represents total blindness and total effort, while re-maining sexually ambiguous. The posture of Samson's body, especially his foot, identifies him with the mother he is struggling against, with the female

who directs the eye, and with the artist who, as a maker of visual art, nonetheless distrusts vision.[26]

Collapsing the *Danae* and the *Samson*, we can now see that the woman and the man have changed places, and how and why. The servant was already being blinded, the taboo on vision already being established. Imagine the accents to be displaced on to the next episode: the woman in the *Danae* disappears from sight, and the servant, now completely blind, takes her place. It is for not resisting the temptation to look that Samson is condemned to become central, to be put on display in his turn. Like the woman in the *Danae*, he tries to defend himself against that horror. But his defence seems to miss its target, for it is directed away from the viewer. It is not entirely futile, however, for if it cannot protect the figure from the viewer, it definitely spoils the pleasure of looking.[27] But who said that visual art is for pleasure?

The two models, the linguistic model of total, ideal and sender-oriented communication, as well as the visual model of total subjection, break down under scrutiny of Rembrandt's work. In fact, they break each other down. The voyeurism of the gaze is countered by glance-appealing work, and thus the works draw the receiver in, leaving the sender behind. The two opposed ideologies cancel each other out. This mutual subversion implicates gender-categories (not that these disappear; on the contrary). Aegina wins where Samson loses, and it is *as* woman and man that they do. But as soon as one tries to approach either figure with gender-stereotypes, they do not fit the categories. The same holds for the opposition between word and image. In order to work, to be effective, the gaze must be *read*: it must be given propositional content, be processed in time and be related to the verbal pre-text without being confined to it. But as soon as we think we are reading, the visuality of the image *and* its thematic centrality impose themselves blatantly. But who said the two media can be distinguished, conflated or hierarchized?

Notes

1 The quotation marks surrounding the name 'Rembrandt' are meant to signify the concept of authorship at stake here. I consider all works traditionally attributed to Rembrandt to constitute the oeuvre 'Rembrandt' which has a specific meaning as a cultural construct. 'Rembrandt', indeed, stands for 'High Art' for our culture; paradoxically, then, 'Rembrandt' is a construct of popular culture. The concentration, in this chapter, on works belonging to 'Rembrandt' should not, therefore, be seen as a recuperation on the idea of the genius, but as an account of cultural dealings with (readings of) what the members of that culture collectively consider to be art.

2 See Roman Jakobson, 'Linguistics and Poetics', in T.A. Sebeok (ed.), *Style in Language* (Cambridge, MA: MIT Press, 1960).

3 The French word *recipient* means both receiver and container.

4 See L. Marin, 'The Iconic Text and the Theory of Enunciation: Luca Signorelli at Loreto (Circa 1479–1484)', *New Literary History*, XIV, 3 (1983), pp. 253–96 , and 'Towards a Theory of Reading in the Visual Arts: Poussin's *The Arcadian Shepherds*', in Norman Bryson (ed.), *Calligram: Essays in the New Art History from France* (Cambridge: Cambridge University Press, 1988), pp. 63–90.

5 The seminal article here is Laura Mulvey, 'Visual Pleasure and Narrative Cinema', *Screen* 16, 3 (1975), pp. 6–18 , which started a whole new trend in film studies.

6 See for contemporary responses, J.A. Emmens, *Rembrandt en de regels van de kunst* (Amsterdam: Van Oorschot, 1968); S. Alpers, *Rembrandt's Enterprise. The Studio and*

the Market (Chicago, IL: The University of Chicago Press, 1988), pp. 137–8, gives a translation of a text by Pels (Dutch edition by Maria A. Schenkeveld-van der Dussen, *A. Pels: Gebruik en Misbruik des tooneels* (Culenborg: Tjeenk Willink/ Noorduijn, 1978) which is typical.

7 The notion of realism here refers to insistence on one side of the dialectic of ideal and type as discussed by E. Gombrich, 'Ideal and Type in Italian Renaissance Painting', in *New Light on Old Masters* (Oxford: Phaidon, 1986), pp. 89–124.

8 Bryson *Vision and Painting. The Logic of the Gaze* (London: Macmillan, 1983), pp. 93–4, relates the term to the French *regard*, which he decomposes into re- (= repetitively) and -gard (*prendre sous garde*, taking hold of).

9 The terms are based on a Lacanian theory of looking; see J. Lacan, *The Four Fundamental Concepts of Psycho-Analysis*, edited by J.-A. Miller and trans. A. Sheridan (Harmondsworth: Penguin, 1979), pp. 65–119. Also Jacqueline Rose, *Sexuality in the Field of Vision* (London: Verso, 1986).

10 Bryson discusses the Lacanian concept of the gaze elsewhere: see *Calligram*.

11 In a book written in Dutch, *Bij wijze van lezen. Verleiding en verzet van Willem Brakmans lezer* (Muiderberg: Coutinho 1988), Ernst Van Alphen discusses the main streams in reader-response theory as criticized by J. Culler in *On Deconstruction. Theory and Criticism After Structuralism* (Ithaca, NY: Cornell University Press, 1983). The author is satisfied with Culler's conclusions concerning the aporia entailed by both positions' compulsion to grant more importance to the factor – text or reader – they initially deny any stability, but not satisfied with the powerlessness those conclusions entail. Van Alphen then proposes to abandon the idea that we are always talking about one concept of meaning. Instead, he distinguishes between what he calls 'two moments of meaning' (p. 235) which are not congruous with each other. A summary of these thoughts appeared in English in the Italian journal *VS/Versus*, in a special issue on the reader ('The Complicity of the Reader', *VS/Versus*, 1989, pp. 52–3, 121–32).

12 In other words, the position of the viewer is represented, included in the image, in order to preclude the easy and uncommitted gaze. This is one possible way of countering the disturbing aspects of pornographic films. See Ellis, 'Photography/ Pornography, Art/Pornography', *Screen* 20, 1 (Spring 1980), pp. 81–108.

13 Even today, the trace of this relation remains in that drawings are seldom on exhibition. They can only be viewed by special permission, often under surveillance of a member of the museum staff. The viewer is then in turn being viewed. This reproduces the position proposed to undermine the porno effect for the pornographic viewer.

14 The concept was first proposed by Gerard Genette in 1972 (*Narrative Discourse: An Essay in Method*, translated by Jane E. Lewin, Ithaca, NY and London: Cornell University Press, 1980) and it was meant to distinguish narrative *voice* (who speaks?) from *vision* (who sees?). Genette did not give the concept the systematic stature it deserved because he failed to ground it in a systematic theory of narrative. I have tried to solve that problem (*Narratology. Introduction to the Theory of Narrative*, translated by Christine van Boheemen, Toronto: University of Toronto Press, 1985), an attempt which generated an incredible amount of response; too much, indeed, to hold the theoretical aspects of my proposal accountable for it. The critical, hence feminist, potential of my amendments became clear much later, and I now think it is that potential which gave rise to such strong reactions. I elaborated that aspect of the theory later (*Femmes imaginaires. L'ancien Testament au risque d'une narratologie critique*, Utrecht: Hes Publishers, Montreal: HMH Hurturbise, Paris: Nizet, 1986) in the framework of my feminist analyses of biblical love-stories. In that French book, I reworked the discussion with Genette and related it to ideological issues. This reworking appeared in English in a different context (*On Story-Telling: Essays in Narratology*, edited by David Jobling, Sonoma, CA: Polebridge Press, 1991).

15 The term *diegetic* is derived from *diegesis*, an alternative term for *fabula*. Both fabula
 and diegesis refer in this terminology to the – presupposed but non-existent –
 sequence of events that, in modified form, is represented in the story. 'Diegetic'
 comes in handy where fabula does not allow for an adjectival form.

16 The concept of focalization is much more specific and therefore, useful than that of
 'centrally imagining' and its derivative, the 'internal spectator', proposed by
 Richard Wollheim, *Painting as an Art. The A.W. Mellon Lectures in the Fine Arts, 1984*
 (Princeton, NJ: Princeton University Press, 1987, pp. 101–86).

17 The literature on Free Indirect Discourse is abundant. See B. McHale, 'Free
 Indirect Discourse: A Survey of Recent Accounts', *PTL* 3, 2 (1978), pp. 249–87, for
 a useful summary. A. Banfield, *Unspeakable Sentences: Narration and Representation
 in the Language of Fiction* (Boston, MA: Routledge & Kegan Paul, 1982) proposes a
 linguistic theory which raised many criticisms but which is, in my opinion, the
 best account of the phenomenon to date. Banfield ignores the concept of focaliza-
 tion, however, which leads sometimes to stretching the realm of 'pure' linguistics
 a bit far.

18 The murders of heroes by female characters in the Bible tend to be represented in
 sexual imagery. Yael's manner of killing Sisera in Judges 4 and 5 comes close to a
 reversed rape, and I have argued elsewhere (*Murder and Difference. Gender, Genre
 and Scholarship on Sisera's Death*, translated by Matthew Gumpert, Bloomington,
 IN: Indiana University Press, 1988) that it is indeed a revenge for the rape and
 murder of young women in the book of Judges.

19 S. Willis, 'Lettre sur les taches aveugles: à l'usage de celles qui voient', *L'Esprit
 créateur*, XXIV, 1 (1984), pp. 85–98, suggests that in Diderot narrativization is a
 device in the service of the ideology that suppresses the female subject. The term
 narrativization, however, refers there to the projection of a priori constructed
 narratives on an image that is thereby recuperated and displaced.

20 These two suggestions do not overlap. As recent feminist films have demon-
 strated, the gaze can be undercut by a redirection of internal focalization as well as
 by a blocking of it. The first strategy is used in Karen Arthur's *Lady Beware* (1987)
 where the man's focalization of the store windows is alternated by the woman's
 focalization of the same, thus opposing to his erotic interpretation a postmodern
 play with signifiers. The second strategy is used in Marleen Gorris's *Broken Mirrors*
 (1984) where internal focalization is first proposed and then cut off, so that the
 traditional parade of women, maintained on the level of the fabula, is undermined
 on the level of focalization. This example shows clearly that focalization is
 constitutive of meaning itself, not a dispensable comment; the event of the parade
 still takes place, but there is no parade.

21 Curtains, the ploy of theatricality, cannot be taken for granted; they often, but not
 always, function as the delineation of a gigantic vagina in 'Rembrandt'. Other
 works where this is obvious are the *Blinding of Samson* in Frankfurt and the etching
 Joseph and Potiphar's Wife.

22 'The perversions', in *Three Essays on the Theory of Sexuality (1905)* (Standard
 Edition, vol. VII, pp. 125–243). For Freud, voyeurism is healthy if it actually leads
 to intercourse, so that it can be seen as foreplay; it is perverse if it does not. At first
 sight, this seems a shocking invitation to rape; but it is, on the contrary, a naive
 misunderstanding of voyeurism. Looking is not voyeurism; only forbidden
 looking, in secrecy, is voyeuristic. It is the latter mode of looking which implies
 guilt and illegitimacy, and shifts easily to forbidden touching: to rape. The story of
 Susanna and the Elders exemplifies this mechanism. See my 'The Representation
 of Vision: Focalization and Voyeurism', in *Reading Rembrandt: Beyond the Word –
 Image Opposition* (New York: Cambridge University Press, 1991).

23 There are also historical reasons, concerning a gift to a patron, which would lead
 us too far here. Let me just point out that Gary Schwartz, reluctant to accept that

Rembrandt offered the *Samson, a* work so consistently ugly, to his dissatisfied patron Huygens, proposes that he gave the *Danae* instead. This trade is amazing in a study so polemically opposed to idealization. I discuss the case in my *Reading Rembrandt* (pp. 333–5).

24 I have argued elsewhere (ibid, pp. 118–28) that this structure can also be seen in the Joseph etching.

25 For primary narcissism in terms of the separation from the mother, see J. Kristeva, *Powers of Horror. An Essay on Abjection*, translated by Leon S. Roudiez, (New York: Columbia University Press, 1982).

26 In psychoanalytic terms, we can interpret the aspects of doubling, of struggle, as representations of the struggle that comes with sexual ambiguity. The frightening coincidence of two frightening experiences turns sexuality into something horrifying, and the more so because it is an inevitable experience. The two experiences on which this conflict is based are that of the violence that the too-fearful human being sees in male sexuality, and the imprisonment, the suffocating enclosure feared in female sexuality: the fear to do harm and the fear to suffer harm. The latter fear stems from the association between sexual penetration and birth, the association with the mother's body. According to Kristeva's view of primary narcissism (see note 25 above) this association between sexuality and the omnipotence of the mother causes a struggle of life and death in which the existence or the destruction of the emerging subject is at stake.

27 Seen in this way, the scene is not so much a reworking of the biblical story in which Samson is subdued by the Philistines. True, the scene where he sleeps on Delilah's knees does have overtones of the child – mother scene, especially when read visually. But in the story there is a later scene to which this painting proleptically alludes. The final scene of the story and its most directly visual one is the destruction of the temple, which is Samson's death and greatest performance. In that scene, he is standing between two columns – gigantic thighs, we can venture – and pushes these aside, or, in the terms of this interpretation, forces the too-narrow opening, thus destroying the birthgiving mother and making her superfluous, but in the same move destroying himself.

Chapter Nine
Philostratus and the Imaginary Museum
Norman Bryson

The *Imagines* of the Elder Philostratus must count as one of the great ruins of antiquity.[1] From the Renaissance until the time of the excavations at Pompeii and Herculaneum, the *Imagines*, together with the surviving fragments preserved in Rome, constituted virtually all that could be known in Europe concerning classical painting. Even today, when so much more of that painting has been brought to light, the *Imagines* remains a unique resource. It is our most extensive account of what a Roman picture gallery, a Roman catalogue of pictures, and the Roman viewing of pictures may have been like. Philostratus claims to base his account in actuality. In the Proem he assures his reader that his 60-odd verbal descriptions are rendered after original paintings (*pinakes*) housed in a single collection in Neapolis (Naples).

> I was lodging outside the walls [of Neapolis] in a suburb facing the sea, where there was a portico built on four, I think, or possibly five terraces, open to the east wind and looking out on the Tyrrhenian sea. It was resplendent with all the marbles favoured by luxury, but it was particularly splendid by reason of the panel-paintings set within the walls, paintings which I thought had been collected with real judgment, for they exhibited the skill of very many painters.[2]

Philostratus has been asked by the son of his host to speak about the paintings, and he agrees. The text that follows presents itself as the record of his discourses, delivered before an audience of young men 'eager to learn', in the presence of the pictures themselves.

Part of the fascination of the text for the Renaissance and modern reader has been the promise contained in the idea of resurrection: from its pages might be constructed an entire gallery of the lost paintings of antiquity, together with the context of their reception by a living audience. Though the paintings at Pompeii and Herculaneum antedate Philostratus by two centuries, the discoveries in Campania and their publication from the mid-eighteenth century seem to have intensified this Atlantis-like aspect of the *Imagines*, and in the nineteenth century attempts were undertaken to correlate

Philostratus' text with the images unearthed by excavation. One consequence of such efforts was that the descriptions were found by some scholars not to correspond, or not to correspond closely enough, with the Campanian paintings. A debate accordingly developed from the second half of the nineteenth century and into the twentieth century in which the question of the authenticity of the descriptions became the leading question. Were they reliable, or had Philostratus invented the entire gallery out of nothing as a virtuoso exercise in *ekphrasis*? Discussion became polarized, with figures such as Welcker, Brunn and Wickhoff on the side of authenticity, opposing Caylus, Friedrichs, Matz and Robert.[3] Scholarship in English played a lesser role in the debate, with the great exception of Karl Lehmann's article 'The *Imagines* of the Elder Philostratus', published in *Art Bulletin*, in 1941.[4] Coming almost at the close of the 'authenticity' debate, Lehmann's article advanced what is perhaps the most vigorous and ingenious case ever mounted in defence of the view that the *Imagines* was based on an actual picture collection from the late second century or early third century CE.

Lehmann begins with Goethe's essay '*Philostrats Gemälde*', written in 1818.[5] Goethe had maintained that the present order of the 60-odd elements in the *Imagines* is confused and confusing. Accordingly he re-arranged them under nine separate headings: (1) Heroic and Tragic Subjects; (2) Love and Wooing; (3) Birth and Education; (4) Deeds of Herakles; (5) Athletic Contests; (6) Hunters and Hunting; (7) Poetry, Song and Dance; (8) Landscapes; and (9) Still Life. Lehmann takes Goethe's thematic re-ordering, which aimed at a clearer editorial sequence, and puts it to use within the debate on the authenticity of Philostratus' pictures. Working entirely from the existing, and apparently confused, sequence, Lehmann argues that it is possible to account for both the coherence of thematic groupings within the *Imagines* and the seeming incoherences of sequence also present in the text by mapping the *Imagines* against an *architectural* order.

Some examples will help to clarify Lehmann's processes of reasoning. In the second book of the *Imagines* occur six consecutive pictures illustrating the adventures of Herakles. Lehmann points out that it is inconceivable that this grouping could be accidental.[6] Apart from a fleeting appearance in the picture of the Argonauts (II.15), Herakles features nowhere else in the 60-odd descriptions. And yet the sequence of the Herakles pictures is strange. The first (II.20) portrays the contest between Herakles and Atlas; the scene takes place in north-western Africa. The second (II.21) shows the fight between Herakles and Antaios; now the scene is Libya. The next depicts Herakles, again in north Africa, sleeping and attacked by the Pygmies (II.22). Obviously these three (II.20–2) are concerned with Herakles' African adventures. Then follows a picture representing the Madness of Herakles, and now a temporal series can be inferred: after completing the last of the twelve Labours, Herakles voyaged along the coast of Africa, encountering on the way Antaios and later the Pygmies, before his return home and attack of insanity. This sequence accounts clearly for numbers II.20–3, four of the six Herakles episodes. But the two remaining pictures (II.24 and II.25) do not fit this scheme at all. II.24 deals with Herakles and Theiodamas. In the myth, the episode can be located in two different regions, Thessaly and Rhodes. Philostratus reads the landcape of II.24 as Rhodian. To Lehmann, this sounds odd for if the painter had

intended the landscape as that of Rhodes, the picture should properly have been placed between the African adventures and Herakles' final homecoming. Lehmann's resolution of the anomaly is to claim that Philostratus was wrong to interpret the landscape as that of Rhodes. In fact the mountains in the picture must be those of Thessaly, which is where Herakles's Labours *begin*.

Picture II.24 thus inaugurates the narrative sequence. The next picture in the *Imagines* shows one of the Labours (the taming of the horses of Diomedes). Though it comes last in the series, in terms of a continuous chronicle it follows II.24 and precedes the later episodes of II.20–3. What has happened is that the *Imagines* has run through a continuous story, but starting and ending at the 'wrong' points. The sequence *should* be: the commencement of Herakles' adventures in Thessaly; Herakles and the horses of Diomedes; Herakles and Atlas; then Herakles' return voyage, including the episodes with Antaios and with the Pygmies, in North Africa; finally Herakles' homecoming and madness. If Philostratus' account were cut and re-sequenced it would make up a single story. How has this flaw in the presentation come about?

It is here that Lehmann advances the hypothesis of the Room. If the sequence is laid out as a continuous chronicle, its six component episodes can be thought of as forming a band of pictures inset into the walls of a single chamber. The hypothesis of the Room then permits Lehmann to advance the corollary idea, of the Doorway. That the *Imagines* confusingly recounts the Herakles episodes in the order 3/4/5/6/1/2 can be explained if Philostratus is imagined entering the room through a doorway placed between the second and third pictures (II.25, 'The Horses of Diomedes' and II.20, 'Atlas'). Philostratus passes through the door, turns to one side, and begins his text in the middle of the Herakles legend (Illustration 52).

Observing the 'correct' narrative sequence is evidently less important to him than describing the pictures as he finds them *in situ*, set into the walls. If the existence of room and doorway is accepted, the break in sequence can be read as an architectural caesura, not a textual glitch. (In Lehmann's reading, all textual discontinuites will be projected as architectural registers: disunity in the text is to be resolved into the unity of the building; the text's openings, interruptions and incompleteness will be transformed, through a specific ekphrastic operation, into the wholeness of an image, an edifice, a museum.)

Having tested the hypotheses of the room and the doorway and finding them secure, Lehmann now proceeds to block in the walls of his *musée imaginaire* from dado to cornice.[7] For it turns out that sometimes, within an evidently coherent sequence, such as that of Herakles, there appear quite unrelated pictures, pictures that interrupt the sequence for no apparent reason. Such cases can be resolved by hypothesizing a *second* tier of pictures, placed above the first, towards the ceiling.[8] The opening pictures of Book II, Lehmann maintains, form a continuous series of episodes to do with love. To the group as a whole he gives the name 'Room of Aphrodite'.[9] Love's power features in the opening scene, showing girls in a procession for Aphrodite (II.1); it continues in the stories of Hippolytus refusing to love Phaedra (II.4), in the love of Critheis and Meles (II.8), in the suicide of Pantheia (II.9), and the death of Cassandra (II.10). Yet this catalogue of love's woes is interrupted by pictures quite unconnected with love: Cheiron educating Achilles (II.2) and

52 The Room of Herakles

Female Centaurs (II.3). Cheiron goes with Female Centaurs, but not with the Aphrodite series. Yet the interruption can be resolved if these pictures are imagined as a pair, placed above the 'main' scene. This upper tier can now establish its own band and its own independent life. 'The Education of Achilles' (II.2) and 'Female Centaurs' (II.3) can absorb a third scene from the life of Achilles, where he mourns the death of Antilochus (II.7). The picture of the youthful Antilochus can then attract as its cornice partner a picture of Arrhidikos (II.6: the feature held in common is that both show the corpses of young men); while the idea of Antilochus as a young Olympian victor can draw to itself the story of the birth of Pindar, 'the famous bard of such victories' (II.12). And, since Pan was present at Pindar's birth, Pan's presence with nymphs in an adjacent picture (II.11) can also be explained.

Lehmann does not stop with the room. To enclose the whole of the text, he must build an edifice, a stoa. How is it to be lit? The walls require windows,

and windows turn out to be doubly useful: they provide light for the pictures, and they fill up space when there seem not to be enough pictures to go round. Consider, for instance, the Room of Dionysus (Illustration 53).[10]

In Lehmann's analysis this comprises a lower-level tier devoted to six Dionysian subjects, and an upper tier with eleven miscellaneous scenes. Obviously there is a difficulty here. How could walls which, in their lower tier, show only six scenes, leave space for *eleven* scenes above? Evidently, the upper pictures should be imagined as smaller in scale: small enough that on Wall II as many as five scenes (II.18–24) may fit above two below.[11] Still, it makes for a long wall, and one which has only two pictures on its lower level. But if a *low window* is added (between II.18 and II.19), the emptiness of the wall's lower section is filled. Lehmann's museum is now rapidly acquiring

53 The Room of Dionysos

detail. The question arises of the layout of room to room. Goethe had proposed nine divisions, but Lehmann arrives at five, the number corresponding to Philostratus' recollection of the 'four, I think, or possibly five terraces'. Now the final architectural touches are ready. At the end of each of the two books, Lehmann argues, stand still lifes: these mark, then, the exits of the text, the porticoes of the building. The room size remains remarkably unchanging, but this would not be surprising if the building is thought of as a stoa composed of separate terraces. In terrace architecture the principal variable is not room size but the placement and size of windows, which, Lehmann further suggests, are adapted to the seasons. This makes for four seasonal dining halls: an *aestivum*, given over to pictures of rivers; an *autumnale*, dominated by stories of Dionysus; a *triclinium vernale*, set aside for Aphrodite; and a hibernale with scenes of the primitive, Saturnine world. Finally, the whole ensemble, 'resplendent with all the marbles favoured by luxury', is turned to the West; the sun casts its changing seasonal light on the different chambers of the house, before setting in the Tyrrhenian sea.

It would be possible to object to Lehmann's reconstruction on a number of counts. His case rests on an unargued premise that Philostratus never omits any pictures from the collection he is supposed to describe; Philostratus is denied any powers of selection over the works he discusses. Moreover, there is a further unargued assumption that the text of the *Imagines* survives as a perfect avatar of its first edition. In fact, textual corruption is not something that could easily show up in Lehmann's analysis. Whatever changes of sequence that might have befallen the text in its transmission from the third century would inevitably take the form of architectural syntax, as doors, windows, cornices, dados, porticoes or terraces. It could also be said that, at many places, the criterion defining what constitutes the semantic centre of a group seems strained.[12] It is hard to conceive of Cassandra with Agamemnon (II.10), or the victory of Rhodogune and the Persians (II.5) as types of love.

However, to quarrel with Lehmann's argument in this fashion would be to miss what is most enduringly interesting about his commentary. The central claim of his essay is that both the coherence of thematic groupings in the *Imagines*, and the seeming disturbances of sequence that also occur, can both be explained by projecting the text as architectonic form. Lehmann's primary reading strategies involve heavy use of the tropes of metaphor and metonymy. It is metonymic liaison that provides some of Lehmann's most convincing sequences (for instance, the reconfiguration of the Herakles pictures in the form of a continuous band, or *fabula*). The patterns deriving from metaphor are able to embrace even more extensive segments of the text. A term such as 'love', being elastic (to say the least), is able to unite scenes even as disparate as a singing procession of maidens, the deaths of Cassandra and Agamemnon, and the suicide of Pantheia. So far, Lehmann's groupings resemble those of Goethe, or perhaps of any editor or reader seeking to give order to a gnomic and fragmentary text. What is interesting is the way that with Lehmann the tropes of metonymy and metaphor do not remain editorial or textual operations but are figured in terms that are visual and volumetric.

Metonymy projects as the gaze of a beholder who, standing at the centre of the room, traces a continuous narrative frieze across the tiers; or as the pathway of the spectator's body moving from room to room, up and down staircases and across terraces, and finally out of the building at its exits, Xenia I and Xenia II (I.36 and II.26). Metaphor projects as the repetition of enclosing frames, whereby the unity suggested by shared semantic features ('love', 'primitive world') is concretized as the singleness and unbrokenness of mural space. Now, these particular tropes run singular risks of uncurtailability. Once a common feature such as 'love' is unleashed, it is hard to see what story may not, one way or another, be subsumed into the resulting series. Similarly, once the idea of chronological series comes into play, it becomes in principle possible to order all 60-odd descriptions into overlapping temporal groups. But the potential of both metaphor and metonymy for unlimited expansion across the whole corpus of the *Imagines* is held in check by the spatial boundaries of dado and cornice, window and door, terrace and staircase. Architecture emerges as the containment and pacification of textual energies which, without that binding influence from matter fixed in space, would soon run across the text from end to end.

What governs both metaphor and metonymy is another textual operation: visualization. The text as a whole is envisaged as a luxurious Neapolitan building. This response to the *Imagines* is Lehmann's distinctive ekphrastic operation. His work with Philostratus' text results in a crossing from text to image. Lehmann reacts to each round of textual difficulty within the *Imagines* by creating a new building feature. First, the room, whose walls soon present dados, cornices and doorways; they are lit by windows of varying size and position; the rooms are tiered as the terraces of a stoa; finally, like any good architect, Lehmann considers his building in relation to the seasons, and the orientation of the site. He is faced with a text filled with hiatuses and inconsistencies. Under pressure from the text's internal stress lines he produces, step by step, an architecture of containment. What emerges within the text as difficulty and disruption is projected in the visual domain as plenitude and unity. The text's moments of incoherence and disruption produce an architecture of massive and stable blocks.

It is in this doubling of the broken text as an unbroken image, rather than in his deductive reasoning, that Lehmann enacts a reading of the *Imagines* which, I want to suggest, is entirely sensitive to the contours and topology of Philostratus' writing. At the same time, this sensitivity is consigned by Lehmann to the unconscious of his text. To help locate that other, submerged reading of the *Imagines*, one can begin by noticing that, successful though Lehmann finds his own analysis to be, by his own admission there remains a group of pictures that fall quite outside the boundary of his analysis. Reviewing his work from its end, Lehmann reckons that he has been able to account for all 36 sections of Book I, and the first 26 of Book II, yet eight 'miscellaneous' cases remain.[13] Accordingly, Lehmann expels the entire group from his definition of the *Imagines*. He concludes that, lacking in the relations he has been proposing, the peccant images are in fact later additions, grafted on 'either before the real publication or else for a second edition'.[14] Bearing in mind what Derrida calls the 'logic of the supplement', by pressing on what Lehmann rejects one may come to see the principles of exclusion by which his interpretation is structured.

That supplement to the *Imagines*, so far from standing beyond its pale, may
delineate that which Lehmann's reading must constantly repress in order to
sustain itself; and, as part of this, what may be the features of the *Imagines*
which are the hardest for commentary in general to reach.

One would wish to examine in detail all eight 'supplementary' items
(II.27–34). Here just the first two in the group will be considered, and espe-
cially 'Looms'. The selection is in some sense justified by Lehmann's own
gesture of exclusion. His system has been working well; it has brought order
to all the previous pictures in both books, however bizarre or dislocated they
may have initially appeared. Yet after Xenia II (Book II.26), the system breaks
down entirely. In spatial terms, Lehmann's (re)construction of the stoa is now
complete. With the placing of the second still life, Philostratus writes
'The End'. The reader passes out of the portico – out of Lehmann's text-as-
architecture – into the outer, disorderly world. Interestingly, the face which
the world presents is exactly that of a broken building filled with debris:

> Now this doorway belongs to a house by no means prosperous; you will
> say it has been abandoned by its master, and the court within seems
> deserted, nor do the columns still support its roof, for they have settled and
> collapsed. No, it is inhabited by spiders only, for this creature loves to
> weave its web in quiet. ('Looms', pp. 19–25)

Lehmann's inspired solution to his text's difficulties – its doubling as a perfect
building ensemble – confronts at its exit the spectacle of a ruination at once
textual and architectural. What the figure of the building had particularly
enabled was the transfer of all the problems of the text back into the space
supposed to stand behind it: the terraced spaces of the villa. The moment
when Lehmann declares the 'true' text of *Imagines* to have ended is that of an
edifice collapsing.

Lehmann's entire reading turns on a suppression of the text's being as
written representation; his gradual construction of the stoa, with all of its
floors mapped and its pictures securely placed in tiers within chambers,
depends on a reading of the *Imagines* in terms of transparency before a pre-
existing referent. Concerning Philostratus' work within language, and of the
pictures' work with their represented scenes, Lehmann's account says
nothing. In pointing this out, the aim is not, in fact, to criticize or fault
Lehmann's interpretation. One of the principal desires of the descriptions in
the *Imagines* is exactly to cease being words on the page, to come alive in the
form of an image, to pass from the opacity of words to the luminous scenes
behind the words. Frequently met with, in the *Imagines*, is a textual moment at
which the description at last feels its own language to dissolve into the light of
the scene it opens upon. This is the Philostratian 'Look!':

> Now the painter has been successful in these respects also: that he has
> wrought the spider itself in so painstaking a fashion, has matched its spots
> with fidelity to nature and has painted its repulsive fuzzy surface and its
> savage nature – all this is the mark of the good craftsman and one skilled in
> depicting the truth. For look! here is a cord forming a square. ('Looms',
> pp. 33–6)

The painter's attention to truth has realized the spider in all its repulsive detail. Having traced that 'fidelity to nature' with a pen no less observant than the painter's, Philostratus earns the right for his own words also to be recognized as fully backed by truth. After his exclaimed 'For look!', the description at last reaches the moment of lift-off.

Three related labours come together in a single disclosure and presence: the work of the spider, building its web strand by strand; the work of the painter, tracing each of the threads stroke by stroke; the work of the ekphrasist, tracing the two previous sets line by line.[15] At 'look!' the words, the paint and the spider's web merge in a moment of visionary presence. Out of the diverse tissue woven by the spider, the painter and the writer comes a living image: 'the weavers travel across [their webs], drawing tight such of the threads as have become loose'. In this visionary space there is no separating the individual strands of image, text or web. The ekphrasis itself draws tight any threads that come away, pulling them back into the unitary image that is at the same time a web, a picture and a text. With part of itself, the ekphrasis seeks to shed the opacities it possesses by virtue of being made of words with only an arbitrary connection to things. It seeks to fuse the words into something beyond words, an image, a picture; and then to fuse that picture with what is real, in a web that is no longer lexical but pictorial, and no longer pictorial but alive.

Lehmann's desire for a text of the *Imagines* that will dissolve first into the pictures of a collection, and then into the architectural ensemble that houses them, is uncannily true to this aspect of Philostratus' text. Yet it embodies only part of that text's energies. Though in the passage just quoted the separate registers of weaving, of picturing, and of describing all come together in radiant fusion at Philostratus' 'For look!' elsewhere the 'Looms' description presents these registers as separable, separate and out of phase.

In fact, 'Looms' opens with a picture of – representation. The first, and seemingly gratuitous, picture in the description shows Penelope's loom, complete with its shuttle, warp, threads and lint. What opens the ekphrasis, then, is an image describing the fabrication of images, the representational means by which Penelope creates her tapestry. The image is made (and, with Penelope, unmade), within the apparatus of representation. The ekphrasis begins by emphasizing representation not as something which vanishes before its referent, but which stays stubbornly visible and in place, as material technique.

Similarly, 'Looms' foregrounds its own apparatus of representation, language. Penelope is presented not only as the site of work with images, but of work with words. She is the creation of Homer, and it is with Homer's lines that Philostratus builds his own picture of her: 'Penelope herself sheds tears so hot that Homer melts the snow with them'. This is a highly self-conscious reference to *Odyssey*, 19.204: 'Her tears flowed and her face melted as the snow melts on the lofty mountains ... and as it melts the streams of the rivers flow full: so her fair cheeks melted as they wept'. In the same way, Philostratus makes a point of telling his reader that the fine threads (on which the spiders drop from the roof and then climb up again) are taken from Hesiod.[16] At these points in the text the words exactly fail to dissolve, either into pictures (Penelope) or into things (spiders). They remain the embedded lines of Homer

and of Hesiod, woven into a text which refuses to assimilate them as its own or to dissolve them before a referent in pictures or in the world.

Just as the text insists on its own opacities, its ineradicable wordiness, so it points to ways in which nature itself will not be absorbed into the supposedly higher realm of human representation and culture. The place of the spiders is presented as the annihilation of human work. Where roofs and columns collapse, the spiders thrive. Human observers may compare the spiders with Penelope, and apply to their webs the terms of architectural or geometric measurement (*tetraplasios*), but the webs take over where human creation comes to its end. Interestingly, the spiders in 'Looms' are imagined not only as they appear in the picture. The description also includes a scene which exceeds that picture: 'the flat (nests) are good to summer in, and the hollow sort ... is useful in winter'. This is a typically Philostrastian aside, a digression to other times and places, suggested by the picture but not actually present within it. The picture shows only that moment when the spiders race across their web; it does not show them in these other seasons, when in summer spiders choose the flat webs and in the winter the hollow ones. 'Looms' points to another life of spiders which the scene, in other words, implies but does not state; to a world of ruins, silences and spider-life that goes on whether or not there are people around to see it. Nature takes over from culture; culture in fact collapses, its columns broken, but the spiders silently persist, away from the human labours of building, weaving, painting and describing.

Against Lehmann's maps of the architectural referent one might posit another topology of things, pictures and words, not as these come together in the ensemble of a resurrected museum but as they fail to connect, in a fracture or ruin of representation. The *Imagines* work with three different 'substances': words, things and images. With part of itself, Philostratus' act of description works to blur these three in visionary merger (Illustration on 54). In the heat of this fusion, words turn into images, or images melt into real things: 'For look!' (4). But such excitement and animation is only one of the *Imagines'* many possibilities. There are others, less ecstatic. Words come unstuck from things: they hark back, not to things in the world but to other words, by Homer or Hesiod (3). Or images pull away from the task of representation: they are shown as products of material technique, threads, weft, lint, looms (1). Or the world pulls away from its representation in art and language (2): the courtyard appears as deserted, 'abandoned by its master', a place where the visual order imposed by human cultivation collapses and the primary enclosure of human space – columns, roof, shelter – gives way to the openness of nature.

It is appropriate that 'Looms' opens with Penelope, a figure standing both for the capacity of art to provide marvellous pictures of the world, and for the unravelling of art back into mere threads and lint. The ekphrasis is in fact in continuous circulation across all of the interstices between the world, the word, and the image (spaces 1–7). At times ('For look!') it seems that art, concealing art, makes the dead matter of letters and brush-strokes come alive. But this is only one phase in the ekphrastic process. Equally important are the moments when the ekphrasis 'fails': when words revert to being words, tapestries revert to thread, and architecture to rubble.

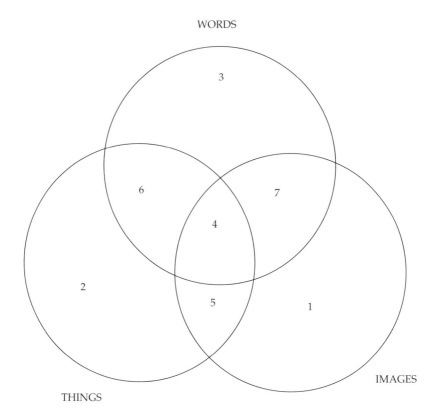

WORDS

THINGS

IMAGES

54 Diagram of overlapping areas in the *Imagines*

One reason that Lehmann's reading banishes 'Looms' from the *Imagines* may perhaps be the description's eminent failure: instead of giving way to a luminous and ostensible referent – the enthusiasm that enables Philostratus to say 'Look! the spiders' and Lehmann to say 'Look! the stoa' – 'Looms' darkens the picture, making it a place of shadows, dust and broken architecture. Spatially, it figures itself as a ruined courtyard. Textually, it traverses not only the place of ekphrastic excitement where words turn into pictures and pictures turn into things, but all the negative ekphrastic spaces where words remain words, or form hybrids with pictures, and pictures revert to their constituent elements, threads gathering lint on a loom. That Philostratus intends this effect of negativity, and intends it as a figure for his own ekphrastic enterprise, is confirmed by the pairing which 'Looms' (II.28) forms with its preceding picture, 'The Birth of Athena' (II.27).

The link, of course, is Arachne.[17] As Ovid tells the tale, Arachne is a human weaver who challenges the skill of the divine weaver, Minerva, and is punished for her hubris when Minerva turns her into a spider. At the contest, both weavers set up their looms: 'The web is bound upon the beam. The reed

separates the threads of the warp, the woof is threaded through them by the sharp shuttles which their busy fingers ply … the notched teeth of the hammering stay beats it into place'.[18]

Minerva pictures the twelve heavenly gods on majestic thrones. At the four corners of her tapestry are set miniature scenes of presumptuous mortals.[19] Arachne counters this imagery of the gods punishing humans for hubris with scenes of the gods, and especially Jupiter,[20] violating human females. Appalled by Arachne's work, Minerva hits her three times with a shuttle, then robs her of human form: 'Forthwith her hair, touched by the poison, fell off, and with it both nose and ears; and the head shrank up; her whole body also was small; the slender fingers cling to her side as legs; the rest was belly.'[21]

For many interpreters of the Arachne fable, the official moral – a cautionary tale against hubris – contains a second level, a topos of reflection upon the capacities and limitations of art. For Velasquez, the competition concerns not only weavers but painters. At the rear of the inner stage in *The Fable of Arachne* is shown Titian's painting *The Rape of Europa*, and Velasquez presents his own craft in parallel to the art of weaving; placed somewhere, perhaps, between Arachne and Minerva, between the genre painting of the foreground and Titian's history painting in the middle distance (Illustration 55). In the reading of Leonard Barkan, this capacity of the Arachne topos to act as art's self-reflexive commentary on art is already present in Ovid's text: 'It requires no great leap of the imagination to see in Arachne's tapestry all the elements of

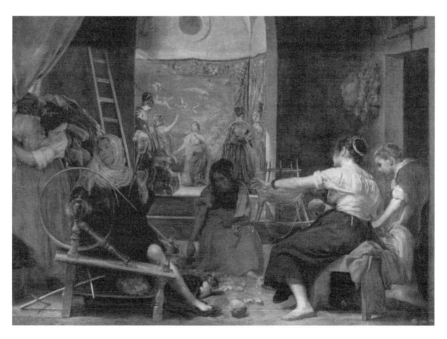

55 Diego Velasquez, *The Fable of Arachne*, 1644–8; Museo del Prado, Madrid

Ovid's own poetry in the *Metamorphoses'*. Just as Arachne tells the stories of the loves of the gods and the metamorphoses of their victims, so does Ovid.[22] Like Velasquez, Ovid positions his own work somewhere between the disorderly profusion of metamorphoses that issue from Arachne's loom, and the august, theologically correct, carefully framed tapestries that come from the loom of Minerva.

That Philostratus intends 'Looms' to unfold in the space of this Arachne topos is confirmed by a number of details. The Birth of Athena, the first subject of Minerva's tapestry, immediately precedes the text of 'Looms' in Philostratus' gallery. In Ovid, the contest of Arachne and Minerva is visualized as a spectrum of iridescent colours : 'As when after a storm of rain the sun's rays strike through, and a rainbow with its huge curve stains the wide sky, though a thousand different colours shine in it, the eye cannot detect the change from each one to the next; so appear the adjacent colours'.[23]

This is precisely the metaphor Philostratus uses to describe the armour of Athene as the goddess emerges fully armed from the head of Zeus: 'As for the material of her panoply, no-one could guess it, for as many as are the colours of the rainbow, which changes its light now to one hue and now to another, so many are the colours of her armour'.[24] Taking Philostratus' two descriptions in sequence, one can say that 'Looms' applies to the competition between Minerva and Arachne the figure of *bathos*. It is a comic transformation of Ovid's contest, scaled down, with Penelope in the place of Minerva and spiders in the place of Arachne.

Philostratus begins where Ovid left off, with Arachne's metamorphosis: 'the rest was belly' is expanded into the spider's 'repulsive fuzzy surface and its savage nature', and the spider's grisly meal. Where Ovid uses the Arachne fable as a means to comment on his own project in the *Metamorphoses*, placing his book somewhere between divine artistry and human craft, in his own comically deflated retelling of the fable Philostratus places his own project, the *Imagines*, somewhere between the higher artists (Homer, Hesiod, Ovid, and so on) and the beasts. Ovid and Velasquez use the topos heroically, to project magnified images of their own art as, at worst, highly accomplished, and at best, as bordering on the supernatural. But Philostratus inverts the rhetoric, in a comic desublimation or parody.

Let us touch again on the Philostratian exclamation, 'Look!' The moment when a picture seems to come alive is encountered again and again in the *Imagines*. In Xenia I Philostratus remarks that the painted grapes 'are good to eat and full of winey juice' (I.31). In Xenia II he invites the reader to reach out and take a loaf from the painted basket (II.26). In 'Narcissus' he says he cannot tell 'whether a real bee has been deceived by the painted flower or whether we are to be deceived into thinking that a painted bee is real' (I. 23). At the core of the *Imagines* is the promise that, at certain moments, words and pictures collaborate to produce a hyperreal, sensuously intense experience that goes beyond the limits of both pictures and words. It is not simply that words are supplemented by pictures and pictures by words. To read the *Imagines* that way is to model it on the example of the illustrated book. The logic of the text is in fact closer, once again, to that of Derrida's supplement. What words lack (because they are only words, characters on the page, marks without light), images can fill with a presence which is based on that lack,

which grows from it, and turns it into light. What images lack (because they are frozen in time, mere pigments on a surface, threads on a loom), words can supply with narration and movement. This strange, hallucinatory power of ekphrasis calls on the capacities of words and pictures to describe the world, but goes beyond their several powers into a visionary moment when 'Look!' becomes the only appropriate response. The exclamation directs the reader not towards the text, or its image, but past them both into another space where presence is alive to all the senses at once (sight, hearing, touch, taste).

Yet compared with Ovid (or Velasquez), Philostratus' text is clearly self-mocking and self-defeating. Its lines move out into all the negative ekphrastic spaces where the radiant fusions of 'Look!' are exactly unforthcoming. Instead of Arachne, the spider; instead of the loves of the gods in tapestry, an insect meal on a web. Accompanying the project of inciting the reader to envision is Philostratus' awareness that with every ekphrasis, at some point the lines and strokes always separate and unravel. The text presents itself as hollowed out by its own rhetorical self-awareness and as haunted by an inescapably secondary or belated relation to pictures. In the Proem the author dramatizes himself as a painter *manqué*:

> Now the story of the men who have mastery in the science of painting, and the states and kings that have been passionately devoted to it, has been told by other writers, notably Aristodemus of Caria, whom I visited for four years in order to study painting … In the present discussions, however … we propose to describe examples of painting in the form of addresses which have been composed for the young.[25]

Four years of study with Aristodemus have led not to a career in painting but only in criticism. In the scenography of the text, Philostratus is always old, and lesser than the young. The son of his host must summon him before he speaks. Spatially he is at the perimeter, beyond the city walls, a Greek wandering in Italy. Secondary in relation to painting, his pictures are also belated in time; not the work of 'men who have won mastery in the science of painting' discussed by Pliny, but of painters who are never, in fact, given names.

To this negative dimension of the *Imagines*, Lehmann appears remarkably insensitive. In his hands the *Imagines* are to come alive; he will infuse them with his own visionary energy, resurrecting the fragments of the text into a luminous stoa whose every corner he can visualize. His work with the *Imagines* is in a sense part of the 'Pompeian' tradition which, from Winckelmann to Bulwer-Lytton to Hollywood, aims to conjure living flesh from the ashes. In terms of its own rhetoric, Lehmann's is a heroic reading. The example of 'the great Goethe'[26] guides his enterprise.[27] Filling out what remained only tentative in Goethe's essay, he perceives an order in the *Imagines* which not even their author realized. The *Imagines* have to be wrested from Philostratus' hands. Philostratus misreads the mountains of Thessaly as the mountains of Rhodes: 'Philostratus takes no advantage of these connections and does not mention them'.[28] 'Although Philostratus was perfectly able to see immediately many of the implications of single pictures, he did not discuss the cyclic idea. He was not interested in it'.[29] As Lehmann's analysis gains momentum,

Philostratus tends to get referred to as 'the lecturer': 'Like many orators and letter writers and teachers before and after him, he decided to publish these lectures as a model of his technique and style in handling such a task'[30]; 'He paraphrased rather than described the paintings and pointed out the emotional values and psychological associations of each picture. His emphasis in *this course in the appreciation of art was one-sided, as has been that of every professor of this kind after him*' (emphases added).[31] Lehmann himself is not, of course, a lecturer or professor of this kind.

If Philostratus mocks his own secondariness, Lehmann expels secondariness from his text in the person of the outmoded professsor who only 'appreciates' and who cannot see what Lehmann sees, the hyper-realistic image of a gallery with all its rooms envisioned simultaneously and in detail. But these abject personifications, 'the lecturer' and 'the professor', are not the only bearers of anxiety in his reading or its only scapegoats. The *Imagines* need to be reconstructed, Lehmann maintains, because without them the third century is 'the dark century in the history of ancient painting', the era of a 'great crisis of ancient art in which the foundations for the development of later western art were laid'.[32] Here are Lehmann's words for the threat his reconstruction is to dispel:

> In a period for which a lower-middle-class tomb in Rome, like that of the Aurelii, is used as a cornerstone for the history of painting, and for which the discovery of the frescoes of a Jewish synagogue in Mesopotamia tends to revolutionize the entire picture of the history of ancient painting, we cannot afford to shelve these descriptions as negligible.[33]

Is it too much to find in these words a threat to a cherished image of antiquity, an image that *must* be protected?

Art history emerges here in one of its dubious heroizing guises, as the custodian of culture working against a background of crisis and collapse. Quite naturally, the custodians must live in a great house, 'resplendent with all the marbles favoured by luxury, but ... particularly splendid by reason of the panel-paintings set in the walls'. The force required to protect the custodians is that of the museum, *circa* 1941. It is a modernist exhibition space: stripped down, diagrammatic, programmatic, yet still (at the end of the reconstruction) conceived as a house of the great, with four dining chambers for the four seasons. Better than most museums, with their difficult diplomatic balance between the needs of scholars and of patrons, this museum is wholly designed by the art historian. The scholarship that builds this space is, to judge by the footnotes, an exclusively German affair. Furthermore, the account endorses the protocols of a certain strand in the German art history of its time. 'We shall always regret where *formal problems* are concerned the limitations of a description which aimed *not to describe but to interpret* what the audience saw' (emphases added). Painting is to be approached formally, not hermeneutically, and interpretation, now a negative term, is to be confined to an outpost of iconography, the identification of subjects and programme cycles.

Lehmann's own hermeneutic operation presents itself as the opposite of interpretive work. It proceeds by excluding all those images which appear to Lehmann to be editorial additions grafted on to the main text, supposedly

anomalous products of writing and publication, mere word-pictures unbacked by actual referents. It prunes away the rhetorical elaborations of 'the lecturer' and bypasses the pictures themselves in order to reach the solid masonry behind them, as though representation itself, verbal or pictorial, were a barrier to be torn down. This process is presented as a series of purifications. The text contaminated for publication is returned to its pristine state. The visual field is purged of its verbal dimension in a double movement from text to architecture and from art criticism to archaeology. Antiquity's dark age is banished. Its cultural mainstream is protected against distortion by inferior and marginal groups. Art history triumphs over 'art appreciation'. The end product of these procedures is the vision of a purified architectural form, whose authority is confirmed by a tradition of national scholarship and national culture, exiled to America and written up in English, yet still in direct contact with the author of *Philostrats gemälde* and with the Greco–Roman past.

Through rhetorical operations such as these, Lehmann's ekphrasis becomes, in a sense, a technique of the subject. It is surely much more than an archaeological reconstruction. Like Auerbach's *Mimesis*, written in Istanbul during the Second World War, it mobilizes the energies of cultural resistance to its own 'dark century'. It invests those energies in an incandescent visualization that configures the beleaguered subject as a unified building. It would, I think, be wrong to find fault with Lehmann's reading at the level it appears to operate, of sleuth-like deduction and rationality. Expelled by the text's rational procedures, rhetoric returns as the text's unconscious. At this buried or subterranean level, the reading actually moves much closer into the *Imagines* than it is able to admit.

Philostratus himself presents the art of painting not as a copy of the world but as an *internalization* of the world. In I.9 he warns his audience not to be impressed by a work's mimetic realism: in that case, he says, 'we should praise an insignificant feature of the painting and one that has solely to do with imitation (*mimesis*); but we should not be praising its intelligence or the sense of decorum it shows, though these, I believe, are the most important elements of art'.[34] Just as painting shows the world as it has already passed into the subjectivity of the painter, so the beholder should not dwell on the external matter of *mimesis* but should internalize the image, drawing it inside the subject. On its own the audience can see pictures, and judge *mimesis*, perfectly well; what the audience does not yet know are the techniques for absorbing the pictures into the mind. It is precisely for instruction in this assimilation of pictures to subjectivity that the audience has come to hear Philostratus speak.

It is in this aspect of internalization that the *Imagines* reveal rhetoric itself as a technology or discipline of the self.[35] The author of the *Ad Herennium* names *memoria* as the fourth part of rhetoric.[36] In order to memorize a lengthy speech, the orator should visualize the successive topics of his discourse as images arranged in consecutive places within architectural space. In the words of Frances Yates, 'Who is that man moving slowly in the lonely building, stopping at intervals with an intent face? He is a rhetoric student forming a set of memory *loci*'.[37] Architecture's role in rhetoric is as the supplier of milieux within which intense visualizations are to occur.[38] As Cicero says, the images should be 'active, sharply defined, and unusual, having the power of speedily encountering and penetrating the psyche' (*quae occurrere celeriterque percutere*

animum possint).[39] The speech unfolds as the rhetorician walks in his mind past walls, each memory-place hung with a vivid image, through rooms, doorways, stairways, porticos and terraces: 'The first notion is placed, as it were, in the forecourt; the second, let us say, in the atrium; the remainder are placed in order round the impluvium, and committed not only to bedrooms and parlours, but even to statues and the like'.[40]

The stability and dependability of this internal architecture is vital for the control of the self over its material. To forget the existence of a particular room is to leave out a whole stage of the argument; to misremember the sequence of images is to garble the presentation of the case.

> Places are chosen, and marked out with the utmost possible variety, as a spacious house divided into a number of rooms. Everything of note therein is diligently imprinted on the mind, in order that thought may be able to run through all the parts without let or hindrance. The first task is to secure that there shall be no difficulty in running through these, for that memory must be most firmly fixed which helps another memory.[41]

Here architecture not only stands for the control of the self; it is the actual, material means by which the self exercises its control over its words and its world.

If Lehmann's unitary and massively stable architecture stands for, and defends, the unity of a beleaguered cultural subject, his reading rejoins Philostratus' rhetoric as an operation whose means is imaginary buildings and whose goal is mastery over self and over representation. Ekphrasis here is a technique for consolidating the subject in terms of personal and professional control. While on the surface of his text Lehmann disavows heremeneutic art history and expels 'the lecturer', at other levels of his text Lehmann is Philostratus' shadow-partner or secret sharer. Lehmann's entry into the culture of late antiquity is through a shape-shifting in which he performs the architectural *ars memorativa* of a third-century orator.

Yet he does so in terms very different from those supplied in the *Imagines*. The kind of subject proposed and assumed by Philostratus' text is much less driven by the urge towards unitary self-possession. The *Imagines*' subject exists in a universe where things, images and words may frequently converge but do not consistently fuse together in the ardour of imaginary vision. The descriptions show the subject in transit across the interstices where world, pictures and language overlap. Especially interesting to Philostratus are the hybrid or chiasmic zones where different registers cross over.

Let us return, for the last time, to 'Looms'. Penelope's loom exists at the place where images and the things of the world cross over. The loom is a thing that makes images, yet we do not see the images it makes, only the things – warp, threads, shuttle – with which it works. Again, when the weavers travel across the web, or eat their squirming prey, they are seen as living, moving creatures; but at the same time the reader knows they are only a static picture. Elsewhere, the text moves to the place where the things of the world cross over into words. The author tells us that the spiders' 'cables' are almost too fine to discern. What brings them into view are in fact Hesiod's lines about spiders descending and ascending their threads. The word makes the thing exist. Or a single word in

Greek – *arachne* – is able to generate two utterly different beings, spiders and the weaver who challenged Minerva. The characters of 'Looms' are, so to speak, engendered by an ekphrastic pun. Words and things change places. At other times, the text crosses the place where words and image blend. Homer's text turns into a picture, then back again into Homer's words. The line between what is verbal and visual cannot be drawn.[42]

The subject of the *Imagines* is in constant motion and dispersal across this complex terrain of world, image and text. When the outward pictures enter the subject and are assimilated to the self's interior, they scatter across an intricately divided and fluid space. The images of Philostratus exist as *refractions* in 'a multi-dimensional space in which a variety of voices, none of them original, blend and clash'.[43] The subject who performs this internalization is in perpetual motion. The moments when, at the Philostratian 'Look!', the various registers join in visionary fusion do not last long. Almost at once the visions separate out into their component strands, unravelling as fast as they came together. And they lead on to the *next* image, more than 60 times. The unravelling of one image clears the space for the coming together of the next one. Or, better, the unravelling of each image calls into being, summons, the next. It is in that perpetual, Penelope-like emergence and falling away of images that the subject is spun by the text: not as a central storehouse or gallery, more as a motion or desire.

Lehmann's subject is in a sense the opposite of this. In Lehmann's case, internalizing Philostratus' text means seeking a way to arrest the motions of the text and to capture and immobilize its energies in a final, culminating form. Into the stability of the building that is to end the text as motion and desire are poured all the author's figures for the command of the subject: massive masonry, the prestige of the museum, purified form, Goethe, national culture, ethnic centrality, professionalism and positive knowledge. Which should make Lehmann Philostratus' most inappropriate reader, were it not for the brilliance and the yearning of his own visualization.

Among other things, Lehmann's reading exemplifies some of the paradoxes inherent in the tradition of positivist scholarship to which it belongs. It is this aspect that raises his reconstruction above the category of historical oddity, to adumbrate some of the vicissitudes of positive knowledge in more general terms. First, Lehmann's relation to the literary, to textuality and intertextuality, is remarkably strained and contradictory. The architectural order he proposes for the *Imagines* is itself *bibliographic*: Lehmann needs texts to enable his reconstruction to take place; in order to build his version of Philostratus' villa he must resort to the library; what he says, for instance, concerning the typology of rooms, their orientation and relation to the seasons, is directly dependent on Vitruvius. Yet at the same time his analysis must bypass textuality in order to dissolve the texts into architectural form. Necessary at certain moments of the analysis, at others textuality becomes an obstacle to be scornfully removed. Inherently untrustworthy beside the actuality (the positivism) of the archaeological *find*, texts are aligned in his interpretation with ideas of parasitism and mediocrity, figured here by the 'lecturer' or 'professor'. The reading works both to banish textual corruption completely (which cannot easily show up in the analysis, since hiatuses in the text are translated at once into architectural syntax), and to build the necessity for

textual corruption into his case (as when Lehmann axes the last eight descriptions as 'later additions'). Textuality features in this mode of analysis primarily under the sign of repression. Where it is able to grow transparent before the three-dimensional architectural and archaeological order, it can be admitted. Where textuality fails to become translucent before reference it must be expelled, even if the effort to do so becomes massive, involving the whole battery of figures for the command of the subject.

Second, this effort to repress textuality runs counter to many of the most conspicuous features of Philostratus' ekphrastic writing, especially its interest in exploring the 'negative' ekphrastic spaces in which the reader, so far from experiencing a dissolution of writing before the luminous referent (the Philostratian 'Look!'), apprehends the text as a sophisticated web of allusions, parodies, puns and tonal plays. Lehmann's quest for the stable masonry of the referent seems altogether blind to the many ways in which Philostratus' writing plays to the *sophia* (knowledge) of the reader, as one who can see bizarre connections, who can understand hidden mythic narratives within imagery (Arachne, Minerva), who can play the visual equivalent of the elaborate verbal dexterity that characterizes Hellenistic poetry. When Philostratus says that the web the spiders make is 'exceedingly fine' (*hyperleptos*), he is doing more than asking us to visualize something hard to see; he is using a key term from Hellenistic poetics, *leptos*, meaning witty, fine, clever, small-scale or sophisticated, and doing so as an invitation or a warning to the reader that his own writing, too, is all of these things. It is a warning that Lehmann, perhaps wisely, does not heed: for once ekphrasis is thought of as a form of writing that involves much more than a simple visualization of a text, it leaves behind the one certainty that ekphrasis seemed to hold out to the archaeologist – its promise of presence, of resurrection – and becomes something else, a mode of writing whose complexity we are perhaps only beginning to discern, and in relation to which the idea of visualization begins to appear as a simplification, at best.

Finally, the scrupulous rationality of Lehmann's interpretive method, with its emphasis on what can be deduced and demonstrated as positive knowledge and as architectural form, renders it strangely unaware of its own aspect of textuality, of the ways in which it is itself a working with words in which the words carry more associations, motivations and affect than the writer is able to hear or control. Working within a highly instrumental and reduced picture-theory of language, Lehmann's analysis radically underestimates the capacity of words to exceed their allotted functions of argumentation, demonstration and proof. Opening on to other investments and other scenes than that simply of archaeology and reconstruction, Lehmann's text speaks its own unconscious, and it is in that energetic and overdetermined underside of his text that his deepest engagement with Philostratus may be found. What he writes is, perhaps, the dream-work of positivism, not the forensics of archaeology, but its own buried poetics.

Notes

1 I am grateful to the members of the Laurence Seminar, held in the Department of
 Classics at Cambridge in May 1991, for their help in formulating the ideas
 presented in this essay; and especially to Simon Goldhill, Jas Elsner and Stephen

Bann for their very welcome observations and suggestions. I am also grateful to
Simon Goldhill, Robin Osborne, and the Syndics of Cambridge University Press
for permission to reprint this essay.

2 English translations are from the Loeb edition, ed. T.E. Page, E. Capps and W.H.D.
 Rouse (London and New York: William Heinemann and G.P. Putnam's, 1931).
3 For a history of the debate, see the following editions: *Philostratorum Imagines et
 Callistrati Statuae*, ed. F. Jacobs and F.T. Welcker (Leipzig, 1825); *Flavii Philostrati
 quae supersunt*, ed. C.L. Kayser (1844); *Philostrati Maioris Imagines*, ed. O. Benndorf
 and C. Schenkel (Leipzig, 1893). Also: K.N. Nemitz, *De Philostratorum imaginibus*,
 dissertation (Bratislava, 1875), pp. 1ff.; E. Bertrand, *Philostrate* (Paris, 1882), pp.
 67ff.; F. Steinmann, *Neue Studien zu den Gemaldebeschreibungen des alteren
 Philostratus*, dissertation (Zurich, Basle, 1914), pp. 1ff.
4 Karl Lehmann-Hartleben, 'The *Imagines* of the Elder Philostratus', *Art Bulletin*,
 XXIII (1941), pp. 16–44; henceforth referred to as 'Lehmann'.
5 Ed. Cotta, Vol. XXVI (1868), pp. 276ff.
6 Lehmann, pp. 21–4.
7 'Obviously he describes pictures that were topographically united, but without
 regard to the ideological and formal relation which had dictated their
 combination'; Lehmann, p. 20.
8 'Indeed, the only explanation of the relationships and the lack of order is that
 Philostratus saw real pictures which were, to a certain extent, arranged on the
 upper and lower parts of walls'; Lehmann, p. 20.
9 Lehmann, pp. 31–3.
10 Lehmann, pp. 33–6.
11 In fact the *Imagines* do not supply indications concerning the dimensions of any in-
 dividual work.
12 It should also be noted that Lehmann's groupings occasionally require him to
 rewrite the given titles of pictures.
13 'These last eight pictures of the second book show a remarkable absence of any
 such relation and connection as we have found everywhere else'; Lehmann, p. 37.
14 Lehmann, pp. 39–40.
15 The image of weaving is frequently used of writing; see, for example, Catullus 64,
 in which the marriage couch of Peleus and Thetis is covered with a tapestry 'vestis
 … variata figuris', 'vestis decorata figuris', where 'figura' is also a literary term
 for Catullus' own poetic rhetoric. Perhaps the crucial sites of configuring
 language, image and weaving are words such as *graphein*, meaning write/
 draw/design (in thread), *huphainein* (the weaving of tricks and plots) and *textum*
 ('woven thing').
16 *Op. et Dies*, 777.
17 The presence of Arachne in 'Looms' has been argued since the Renaissance. See,
 for example, the gloss on 'Les toiles' in Blaise de Vignière's edition (1610), p. 524.
 Lehmann, too, suggests that the two pictures (II.27 and II.28) both refer to the
 Arachne story (Lehmann, p. 39).
18 Ovid, *Metamorphoses*, VI, 53–5.
19 Minerva depicts Rhodope and Haemus, who dared to call themselves gods, now
 turned to mountains; the Pygmaean queen who challenged Juno, now turned into
 a crane; Antigone, turned by the angered Juno into a stork; Cinyras, whose
 daughters are turned to stone.
20 Arachne's tapestry shows Europa abducted by the bull; Asterie carried off by the
 eagle; Leda pursued by the swan; Jupiter disguised as Amphitryon; Danae.
21 *Metamorphoses*, VI, 140–5.
22 Leonard Barkan, *The Gods Made Flesh: Metamorphosis and the Pursuit of Paganism*
 (New Haven, CT and London: Yale University Press, 1986), p. 4.
23 Metamorphoses, VI, 63–6.

24 II.27, 15–19.

25 *Imagines*, Proem.

26 Lehmann, p. 16.

27 In the first paragraph of Lehmann's article, Goethe is found to be disappointed by Pompeii and Herculaneum, mere 'Middletowns' as Goethe/Lehmann put it, from whose 'limited atmosphere' they jointly turn away towards the *Imagines*. References to Goethe recur at several points in the essay: 'Strangely enough, no-one, with the exception of Goethe, has ever called attention to the problem of the general order of the paintings in the two books of Philostratus' (p. 19). Yet Goethe's re-arrangement of the *Imagines* is also, as Lehmann puts it, 'cavalier'; his own essay builds more systematically on Goethe's insights.

28 Lehmann, p. 25.

29 Lehmann, p. 30.

30 Lehmann, pp. 41–2.

31 Lehmann, p. 41.

32 Lehmann, pp. 17–8.

33 Lehmann, p. 17.

34 *Imagines*, I.9, 18–22; Loeb translation slightly modified.

35 On 'techniques of the self', see M. Foucault, *Le souci de soi* (Paris: Gallimard, 1984).

36 In *Ad Herennium* the five parts of rhetoric are: *inventio, dispositio, elocutio, memoria,* and *pronuntiatio*.

37 Frances Yates, *The Art of Memory* (Chicago, IL: University of Chicago Press, 1966), p. 8.

38 On architecture's relation to the art of memory, see the discussion by J. Elsner in *Art and the Roman Viewer: The Transformation of Art from the Pagan World to Christianity*, Chapter 2, section v (forthcoming).

39 *Ad Herennium*, II, lxxxvii, 358; trans. H. Caplan (Loeb edition); cited in Yates, *The Art of Memory*, p. 18.

40 Quintilian, *Institutio oratoria*, XI, ii, 17–22; trans. H.E. Butler; cited in Yates, *The Art of Memory*, p. 22.

41 Quintilian, *Institutio oratoria*, XI, ii, 17–22.

42 The diagram is not satisfactory; for instance its lines imply fixity, when the whole point is to suggest fluidity and continuum. But I hope the reader will follow at least the diagram's gist: that the *Imagines* constantly shuttles between words, images and things: (5) is the area of merger between things and images, (6) is the hybrid area of word/objects, (7) is the area of blur between word and image: perhaps the principal ekphrastic space, the space of the word *graphein*.

43 R. Barthes, from 'The Death of the Author', in *Image-Music-Text*, essays selected and translated by Stephen Heath (New York: Hill & Wang, 1977), pp. 145–6.

Chapter Ten
Topic and Figures of Enunciation:[1]
It is Myself that I Paint
Louis Marin

To the Reader[2]

[A] It is here a book of good faith, reader. It warns you, right from the outset, that I here envisaged no end other than a domestic and private one. Here I in no way considered your interests, nor did I look to my own glory. Such a project lies beyond my powers. I have destined my book to serve as a certain comfort to my parents and friends: having lost me (which, indeed, they soon will) they will find here not a trace of my condition or humors, and thus will cherish more wholeheartedly and vividly the knowledge that they have had of me. Had it been a matter of seeking the world's favor, I would have adorned myself better, just as I would have presented myself in a more studied manner. I wish to be seen here in all of my simplicity, quite natural and ordinary, without effort nor artifice: for it is myself that I paint. Insofar as respect for the public will allow, my flaws will be readily legible here as will be my artless shape. For had I found myself amidst those nations that are said yet to live under the gentle freedom of the first laws of nature, I assure you that I would more than gladly have painted myself here in my entirety, and completely naked at that. Thus, dear reader, I am myself the subject of my book: it is not reasonable that you should squander your leisure on a subject so frivolous and vain. Adieu, then, say I, Montaigne, on this first day in March 1580.

Thus reads the preface to the reader written by Montaigne on the occasion of the publication of the first edition of the *Essays* in March 1580. In the Pierre Villey edition (published by the Presses Universitaires de France) it amounts to sixteen lines, printed in italics which, grey against the white of the page, fill in a rectangular area that itself is preceded by a title, 'To the Reader', and by a capital 'A', placed in brackets. The function of this [A] is to indicate that 'as far as the essential features are concerned, the corresponding text dates from either the 1580 or the 1583 edition'.

195

'Sites of enunciation' will be our heuristic term for those points that, within this area, are characterized by instances of deixis: that is, by a use of language that involves a reference to the writing agent. Thus we shall pay particular attention to certain adverbs, personal, demonstrative or possessive pronouns, verb endings, and so on. These sites constitute a network, a pattern, that articulates the written surface, by providing it with the particular consistency (the coherence and cohesiveness) of a singular text. 'Topic' will be our term for the network that embraces the sites of written enunciation. By means of the title ('To the Reader'), the implicit writer or writerly instance (*instance ecrivante*) explicitly addresses this set of textual elements to us. From this set, our reading selects a certain series which, by deploying a number of different names, designates the contents of what, more specifically, is addressed to us by this very instance. Inscribed within the compact block of written characters, and displayed on its surface to our reading gaze, we find figures of the text as a whole, words and utterances that are as if embroidered on the tightly woven fabric of the text. On the one hand, then, we have sites and a topic of the writerly enunciation. On the other, figures of the written text. What we mean is that these figures themselves belong to the very text in which they appear. Thus, in a sense, these contents are ensnared by the text's enunciative thread, just as they also stand as figures for the process of weaving, as well as for the fabric that it produces. They designate this finished textual piece, called '(Preface) To the Reader' variously. As a result, these figures immediately proffer to the reading eye not only (semantic) contents, but the contents of the contents of the text: they are figures for the reflexion of the text on itself, figures for the folds constituting yet another network that, no less figuratively, may be called the text's drape.

The terms that articulate these figures also distribute them according to a dual motif, that of the visual (the visible, the image, the painting, the portrait), and that of writing (reading, the text and the book). What we have here is a dual motif that, in its very duality, is attached to itself in a manner so natural and immediate as to give us pause. Indeed, it would appear that the seam (to use one of Montaigne's own terms) connecting writing to painting has been rendered indiscernible in the (pre-)liminary text composed by Montaigne upon the completion of the first two books of his *Essays*, just shortly before he embarked on a journey through Europe and Italy. Or rather, it is as though the efficacy of writing finds its motivation in the logic of secrecy, the idea being to ensure the illegibility and invisibility of what in the language of mending and darning is called a 'finedrawn mend'. Let us, however, read and interpret this dual fold, in an attempt to make manifest once more the 'seam' that, in the text, unites what is visual and what is written:

It is here a book of good faith, reader.

I wish to be seen here in all of my simplicity, quite natural and ordinary, without effort or artifice: for it is myself that I paint.

[M]y flaws will be readily legible here as will be my artless shape.

I assure you that I would more than gladly have painted myself here in my entirety, and completely naked at that.

Thus, dear reader, I am myself the subject of my book.

Thus a kind of dual drape may be said to cloak and embrace what is but one and the same subject. The visual (painting and representation) and writing (reading and the book): these are the two fabrics that engulf the writing and painting subject. In writing with images, and in painting with words, this subject is disclosed in the topic of its sites. The name given to this subject comes to occupy a central site: I, in all of the transparency and opacity of my form and matter, at once plural and singular, have written myself so as to be seen, painted myself so as to be read. We discern the transparency and opacity accompanying the representation of the self by means of texts and images. It is in the fold created by this process that we find an autoportrait comprised of signs, characters, sentences, sketches, and outlines.

Now I would like to turn to a painting (Illustration 56) by Albrecht Dürer (1471–1528) which tells the story of the martyrdom of ten thousand. Executed in oil on a panel, this work has been remounted on canvas, measures 39 × 34.04 centimetres, and may be found in the holdings of the Kunsthistorisches Museum of Vienna. It is a painting cluttered with figures, with dismembered and tortured bodies, executioners, soldiers and their leaders, a crowd so thick that the gaze is momentarily disturbed. Only subsequently does the eye focus in on any one point, recording the details of one of the many scenes of torture. Draped from left to right there is a first and terrifying garland: two crosses adorned with hung bodies, yet another on the ground awaiting the tortured individual crowned with thorns; a soldier dressed in red and green prepares to decapitate a kneeling and blindfolded man; on the ground lies a beheaded body, its mouth agape and eyes turned to the sky; with massive blows, a soldier dressed in blue pulverizes the skull of a dying man, executing in this manner the injunctions issued by a white-turbaned leader who points his index finger at the victim as he gives his orders; and, on the right, at the same level as the crosses, our gaze remarks the bearded King of Persia, Shapur, who boasts a white turban and gilded clothes. Astride a horse and sceptre in hand, the king surveys the entire scene. On the far right, we note a child playing with a small dog. Taking the first level as its starting point, the eye resumes its trajectory. Fascinated by the figures depicting suffering and torture, it settles on the crown of naked bodies that sits on the garland just described. The details of this crown read as follows: spurred by the whips of the soldiers, a column of martyrs brave a steep road that climbs around a cliff of layered rock where trees find a precarious footing; the column reappears on the highest plateau between the two crags; here the bodies are thrown off the edge, prodded by thorns and spears; here the soldiers complete their labours, lapidating and dismembering the bodies with the blows of axes, piercing them with arrows. The crown comes full circle.

Between the crown and the garland, between the whiteness of the naked bodies and the red, blue and pink of uniforms and stately dress, against the background of the greens, greys and earth browns of rocks, grass and trees, in this space alive with murder and horror, the reader's eye, attracted by the strokes of black colouring a cloak, focuses on a particular spot that somehow seems absent from the story of the massacre. An individual observes the massacre from a point that is at the crossroads of the martyrs' paths, a site that,

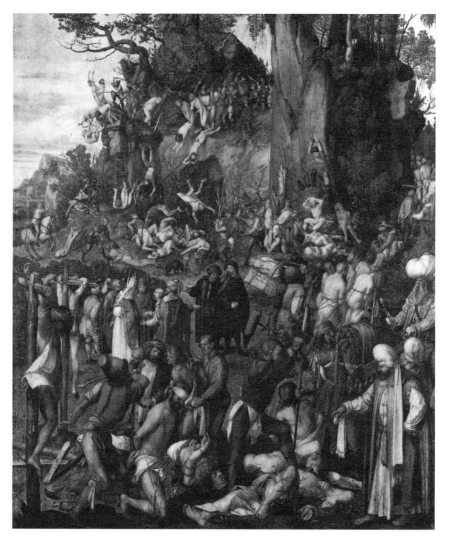

56 Albrecht Dürer, *The Martyrdom of the Ten Thousand Christians*, 1598;
Kunsthistorisches Museum, Vienna

in fact, is only determined as such by its exclusion from all the other sites that
accommodate the telling of the story. It is the point where the broad strokes
animating the surface and depth of the painting cross, a site in space that is
represented by the painting, yet excluded from the sequence of sites that allows
the story to develop. From this site an individual returns the gaze of the reading
eye; an individual holding a stick to which has been atttached a large sheet of
paper or unfolded parchment. This is how the words inscribed on this surface
read: 'Iste faciebat anno domini 1508 Albertus Dürer Aleman'. In the right-hand
corner of the piece of paper we read 'AD', the monogram of Albrecht Dürer.

Excluded from the sequences of sites in which the episodes of the story are deployed, and yet included in the represented space in which the story is told, the site in question is precisely where the instance of 'painting' assumes shape. Here emerges the autoportrait of the painter who carries the signs and the name that designate this very same instance.

Numerous figures on the signboard and in the representation serve to develop the narrative sequences that we see and read, allowing them to constitute a narrative topography. And amidst these sequences, all of which are co-present within the order of sites accommodating the figures, there is a site beyond all sites, and perhaps it is the particularity of its situation that makes it the site of all sites. This site is made into a figure in the form of a gaze directed to the eye that is its source, and in the form of the letters of a name. Here is the site where the instance of a pictural enunciation, a topological instance, is figured, giving itself a name and concentrating itself there. What is designated there is less a fold or folding of the contents contained within the space of the painting, less a topic of enunciative positions within these contents, than a 'hole', a rift or distance, a u-topos in the construction of the topography of the story, and in the organization of the topic of the narrative. This u-topos recalls the text of Montaigne discussed above, for, although quite differently, this u-topos does allow us, as spectators, to witness the overdetermination of the visual (the visible, the image, the painting) by writing (characters, the sentence, the name). Here it is not so much a matter of the weaving of the dual motif of the visual and the textual in and through the text. Instead we note the superimposition of the character and name in and through the visual, through its space, sites and figures.

What does it mean to paint oneself? What does it mean to write (about) oneself? In what follows these two questions will be played off against each other, just as they will also be made to work in tandem. More precisely, we are interested in the crossing over of what is read first in a text and then seen in an image, in the exchange between the two semiotic substances and forms of expression and content, between the two media of enunciation and visual representation: the imagistic, the written and linguistic. What does it mean to show oneself (to make oneself visible) so as to be read? What does it mean to proffer oneself for reading (to write the self) so as to be seen? In Montaigne's '(Preface) to the Reader', unlike Dürer's 'Martyrdom of Ten Thousand', the slippages between the terms of the visual and the textual are too apparent to be considered nothing more than an expression of the discourse's metaphorical values. Our attempt to bring visual representation and written representation into dynamic interaction – not just painting, but the painting of the self, not just writing, but the writing of the self – gives rise to a theoretical and methodological occasion allowing us to grasp with greater rigour and precision the manner in which these two sets of signifiers function. What is more, this theoretical opportunity is itself inscribed within a particular historical conjuncture. Situated at a certain moment within the history of thought, literature, the arts and modernity, Montaigne's '(Preface) to the Reader' and Dürer's painting provide an introduction to some crucial issues of which they are also the most explicit of illustrations. This is the case because what is in

question here is not only the reflexive dimension of representation, but the emergence within it of the Self, the identification of the subject (of representation) as an ego, the conquest by this subject of a personal and social individuality, of a singularity as painter and writer.

'It is myself that I paint … I am myself the subject of my book': these phrases disclose an important site of enunciation, that of the writing of the self in the form of a signature. Situated at the centre, as well as towards the end of the text, Montaigne's two statements are the most basic moments within a topic that can be grasped only in terms of the dynamics of succesive enunciation. Not only do they reveal the parallel between painting and the book, but that of form and matter ('I wish to be seen here in all of my simplicity [= simple form], quite natural, and ordinary, without effort nor artifice'). In these phrases we also discover the parallels between the two relations between 'I' and 'Myself' (*moi*), relations hierarchized by their position within the text, and by the discourse that produces them. In the first case, 'it is myself [*moi*] that I paint', the 'Myself' appears as a 'that' or 'what' which quite clearly polarizes the activity of an 'I' who alone is constituted by the activity of self-portraiture posited by the appearance of what serves as its object: 'It is myself that I paint'. In the second case, 'I am myself the subject of my book', the 'I' figures first in order to state its identity with the self as a proper name; 'I am myself', yet this identification of 'I' and 'self' (and all of the complex processes that it presupposes) is brought about by the writing of a book in which the 'I' is situated as its own property; a property, 'my book', of which the 'I' is the author. In the final analysis, the utterance 'I am myself' is possible only in the form of a book, in the writing of an 'I' who informs, gives form to the subject matter: 'I am myself, I am my book.' Later, upon his return from Italy, Montaigne will explore this fluid process of identity formation in an admirably clear essay entitled 'on rep[a]enting' which figures in Book III: 'Others shape the individual; I cite him and represent a given inchoate good which, were I to make him over again, I would really make quite differently. Henceforth Meshuy is constructed. Yet although the traits of my painting may change and diversify themselves, they do not confuse'.

It is not 'I' who, at the moment of what painters precisely call repenting (the title of the essay), reworks the traits of the self-portrait in a gesture aimed at their modification: it is the portrait itself that changes, becomes different. A page later, Montaigne gives expression to this identification of the book and of the self by means of the painting and writing subject, the 'I': 'Here we, my book and I, are in the smoothest of harmonies. Elsewhere it is possible to recommend or detract from the work quite independently of the worker. Not so here; whosoever insults the one, also insults the other'.

Self-portrait, the writing of the self: Montaigne's project is inaugural in that it is the most extreme and the most radical form of the self's signature, of the writing of the self, of the deployment of the topic of its opacity in the very transparency of its written (or painted) representation. All the markers of possession, and of the appropriation of the written object emerge from the tensions inscribed within the 'I' (who is the subject of the writerly enunciation). The same may be said of the literary apparatuses which, in presenting

the book and in representing its representation, present the author and writer, thereby attributing a name to this individual. From such tensions may also be derived all the forms involving the construction of protocols dictating the reading of the book; these protocols, in interpellating the reader, signal the author and construct, between sketch and self-portrait, the topic of the representation of the self as writer. From beginning to end, the 1580 '(Preface) To the Reader' is a product of the efficacy of such apparatuses.

The piece that may be termed liminal (as regards the order of reading) prefaces the first two books of the *Essays*. Yet in the order of writing it follows upon them as a kind of conclusion. I see this prefatory text as serving a very precise function. In it is situated an entire network of markers indicating certain modalities of enunciation and reception, as well as the apparatuses and topics governing the presentation of the textual representation as it is constituted by the two books in question, governing the textual representation of the Self that is the explicit objective, in the '(Preface) To the Reader', of the written enterprise of the *Essays*.

Four utterances mark this presentation of representation: first, the opening sentence: 'It is here a book of good faith, reader'; second, the crucial phrase in the middle: 'it is myself that I paint'; third, the words which almost conclude the passage: 'reader, I am myself the subject of my book'; finally, the concluding and formulaic remark: 'Adieu, then, say I, from Montaigne, on this first day in March 1580'. These four sentences sketch the main threads of the operative system of enunciation and reception. They articulate its topics and effect the systematic declension of an 'I', declension being used here in the grammatical sense of the term. This process begins with the unmarked, yet implicit positioning of the 'I' during the moment of address, in the to 'you' reader, and it concludes with the act of naming that accompanies the 'place-name' evoked within the context of a calendrical, chronological and historical temporality: 'say I, from Montaigne, on this first day in March 1580'. The process in question is complicated, and a full description would have to account for all of the following elements: the relation between the two uses of the nominative, 'I', and 'I here envisaged no end other than a domestic and private one'; their articulation with the accusative, 'me', with the genitive forms, *ma, mon, mes* (complements of the nominative form), and with the '*moi*' that appears first in a genitive form ('the knowledge that they have had of me'), and subsequently in its fully articulated position, in the two utterances already discussed above. Indeed we have in mind here the phrases constitutive of a personal identity acquired through self-portraiture and writing: 'It is I that I paint', 'I am myself the subject of my book'. In other words, in and through reading, the '(Preface) To the Reader' allows us to witness the emergence of the representation of the Self in its written, printed and published figure and form: the book and the name that gives it its socio-historical name and identity, 'Montaigne'.

The production of the self and of Montaigne made possible by the declension of a subject in and through representation, the book, serves as a starting point for two other articulations of the topic: the one pertaining to deixis and demonstratives, the other to verb tenses.

Let us first examine the verb tenses: of the four phrases extracted from the '(Preface) To the Reader' as particularly crucial moments within the enunciative topic, the first three are in the present tense ('It is here a book of good

faith, reader'; 'it is myself that I paint'; 'I am myself the subject'). The fourth sentence, however, has no explicit verbal form and simply effects a connection between calendrical and chronological time, and the present topic, the latter being itself a matter of the temporal coincidence between the act of enunciation and the uttered event.

In their being present, in and through the presence of their being present, these four sentences serve as a frame. More precisely, between the first and second phrase a past tense is dominant, situating in this manner the past of the writing of the *Essays* in relation to the present moment instantiated in the '(Preface) To the Reader'. In this blanket of the past, a conditional modalization takes shape: 'Had it been a matter of seeking the world's favor, I would have adorned myself better, just as I would have presented myself in a more studied manner'. What is being alluded to here is a possible writing, one that the author allegedly rejected or refused.

As a result of the space between them, the second and third sentence open up a textual space in which a future, pertaining to reading, is inscribed: 'My flaws will be readily legible'. Then there is yet another conditional: 'For had I found myself amidst those nations that are said yet to live under the gentle freedom of the first laws of nature, I assure you that I would more than gladly have painted myself here'. Following immediately upon the use of the future tense, the conditional suggests the potential reading of a virtual self-portrait, of the figurability or of the fictive self-portrait of the self as 'savage': 'I would more than gladly have painted myself here in my entirety, and completely naked at that'. In other words, beginning with the present tense of the uttered utterance, the first temporal articulation of the topic unfolds the past of the process of writing, the intentions and possibilities contained within it. The second one explores the future based upon reading, upon its exigencies and virtualities. Indeed the apparatuses of the presentation of representation, the topic of the textual processes constitutive of the identification of 'I' and 'Self' are at play, at stake, in this temporal dialectic of writing and reading, of the writing utterance and the reading reception. There is play in and around the present, play in the 'net' of writing produced in the present (tense).

The second articulation of the topic is the one made possible by a particular use of deictic expressions. Indeed, the text begins with a very forceful gesture of pointing: 'It is here a book of good faith, reader'. The series of '(t)heres' (*y*) that ensue all refer back to this '*ici*', just as they designate the book of essays: 'I (t)here envisaged ...'; '[T]here I in no way ...'; 'they will find [t]here ...;' 'I wish to be seen (t)here ...'; 'my flaws will be readily legible (t)here ...'; 'I would more than gladly have painted myself (t)here ... is here (a book)' designates an external object, a volume existing in space or, more precisely, a site in space occupied by an object, a book: 'it is here' designates the book in a gesture of presentation and pointing which is effected by the 'I' who is situated, *hic et nunc*, in the presence of the object identified by this same 'I' for the benefit of the reader who is to be interpellated.

At the same time, we are dealing here with an utterance that is somewhat paradoxical in that it is written in the very book for which it serves as a deictic: it is a kind of reflexive demonstrative. However, this auto-indication or self-reference is more complicated yet. It is true that the sentence is written in the book (on the first page after the title), but it is also a preface to the

reader in his or her capacity as someone who has not yet started to read the book: it is written on the threshold, on the margins of the book, in the work, and yet outside the work, on its very borders. In this regard it is a cataphoretic deictic that points to what will follow: an auto-indication that refers to what is inside the frame and which, by the same token, positions the 'I', in its gesture of pointing and presentation, on the edges of this very same frame. Following this line of reasoning, the 'I' is implicitly posited as being but the frame (the ex-ergon) of the book, the apparatus of presentation and representation. That this is definitely the case may be remarked already in the second sentence: 'It [this book here] warns you, right from the outset, that I here envisaged ...'. The 'I', who is implicitly posited as frame or threshold, here surrenders its enunciative voice to the book. From the outset, right from the start, on the threshold of reading, the book speaks in order to warn the reader of the intentions entertained by an 'I' in a process of writing made book. Our approach leads us to make a certain inference and elicits at least one remark.

First, the inference: it is here a book of good faith, reader. It is myself that I paint, I am myself the subject of my book. By lining up the three utterances, and in noting the parallels between the first two (it is here a book, it is myself that I paint) we discover, in the dynamics of speaking (particular to the presentation of representation), a certain displacement of the subject from its liminal (preliminary and implied) position where it played the role of a framing device. Previously on the margins of the text, the subject comes to occupy the position of the subject represented as a self. As a result, the subject is situated within the frame (it is myself that I paint), in the very position allowing for the identification of self and book (I am myself the subject of my book).

Second, the remark that perhaps is of even greater consequence. Let us recall the opening of 'Essay 28' in Book I, an essay devoted to friendship:

> Considering the direction that I have of the work of a painter, he asked me to follow him in it. He chose the most beautiful spot, the center of each wall, in order to place there a painting elaborated with the greatest of competence; and the emptiness around it, he filled with grotesques which are odd paintings, having variety and strangeness as their only grace. Also, in truth, is not what is here [cf. it is here a book of good faith] but grotesques and monstrous bodies pieced together from different limbs, without clear forms, having but fortuity as their order, development, and proportion? *Desinit in piscem mulier formosa superne.* I accompany my painter up until this second point, but I stop short at the next and best part: for my competence does not extend so far as to allow me to undertake a rich painting, polished and formed according to art. I took it upon myself to borrow one by Etienne de la Boétie which would do honour to the rest of this work. It is a discourse to which he gave the name *Volontary Servitude.*

About four years, then, before the composition of the '(Preface) To the Reader', Montaigne envisaged the entire enterprise of writing the *Essays* as a kind of framing gesture. If not a portrait of somebody else, the *Essays* were at the very least conceived as a book about a friend, about the other in himself, about himself in and through someone else. In a sense, then, the project involved the construction of an opaque mirror image. We all know what

finally happened: the 'Against One' ('Le Contr'un') was replaced by 29 sonnets by la Boétie, and these were ultimately excluded from the posthumous edition of the *Essays*. The contingent reasons for this rejection aside, it is indeed as though the writing of the *Essays* consisted of a 'monstrous' proliferation of a frame. It suggests a multiplication and dissemination of the apparatuses of presentation, to the point where they invade the space reserved for representation, becoming in the final analysis representation itself. There is a kind of migration of the subject from the position of the frame to that of the subject represented as a 'self' in the text. Yet the self that thus stands in for and displaces the portrait of the friend ('because it was he, because it was I') is nothing but a portrait's frame turned self-portrait, a self-portrait that will never be anything but its own frame: what we have here is the radical opacification of all representational transparency.

What does it mean to paint oneself in a text? This question we have tried to answer through an analysis of Montaigne's '(Preface) To the Reader'. Sites, topic, figures of enunciation: these are some of the terms that figure in our discussion. What does it mean to write the self in and through an image? Here we referred to 'The Martyrdom of Ten Thousand' by Dürer, discovering through our analysis the u-topos of the signature, a topological instance in the topography of a story.

Writing of self, self-portrait: name. It is not without good theoretical reason that the classical logicians purported to see, in the geographical map and in the painted portrait, the paradigm of representation in general. At that particular time in the history of thought, art and literature, it was the art of the visible, the artefact of the visual that seemed to them to offer the most explicit indication of the relation between meaning-making (signifiance) and the sign. And when these very same logicians sought to grasp this relation with more precision, in the immediacy and necessity of the natural functioning of the sign, it was to the most primitive form of self-portraiture that they had recourse. They turned to the image of a man produced by means of the very artefact of reflexivity itself, the mirror:

> There are two kinds of signs. Natural ones that do not depend on the fantasy of men as does the image of a man who appears in a mirror ...There are others that exist only as a result of institutions ...Thus words are the institutional signs for thoughts, and written characters the institutional signs for words.

Here is a definition of a self-portrait: a representation (portrait) of the painter painted by him or herself. Yet the banality and obviousness of this definition makes it misleading. The term 'portrait' is used twice and simply connected to the word 'painter' and the reflexive form of the verb 'to paint'. It is true, theoretically speaking, that all self-portraits presuppose at least three, if not four elements: the painter in the position of model, the canvas that, stroke for stroke, accommodates the portrait and, finally, the image of the model reflected in a mirror and presented to the eye of the painting subject. It is not the model whom the painter paints when sketching the portrait of the prince, of a father or a mistress: rather, what is committed to canvas is but the

image of these individuals, as models, appearing in the opaque transparency of an area that extends over and beyond the virtual depths of reality. Three elements, if not four: that is how I put it. Indeed, we must add yet another form of ambivalence to this withdrawal that characterizes the model at the moment of his or her manifestation in and through reflexion: the painter is not just the model, what is to be painted, the subject of the painting, the object immobilized by a pose, by the stillness that authorizes the elaboration of a representation. The painter is also an individual who paints, who engages in the industrious activity that involves the sketching in of the portrait's salient features, the outlining of its contours, the use of coloured strokes. In short, he or she engages in the practice for which palette and brush are both the signs and instruments. The subject of the painting is at the same time the subject-painter. Perhaps, however, we should not refer to something like a simultaneity of time for it is a matter here of a back and forth, of a rhythm oscillating between a pause and a gesture, between stillness and movement; of a rhythm that, through scansion, replays the scission of gaze and eye, the reflexive scission of subject and object, the portrait of the painter as self in the interval occasioned by the withdrawal of the model into the image reflected in the mirror or that which takes its place.

Let us take up once more the issues raised by the so-called 'natural' self-portrait studied by the classical logicians. As we already know, it was to the image of a man reflected in a mirror that these individuals turned in their search for a (paradigmatic) example of the immediate representation of the self. Now, we note that the representation in question is at once an instance of the doubling of a presence: in and through representation the man represents himself. Yet a reduplication is also effected in and through the reflexion in which the man presents himself. What we have here is a doubling and a reflexion which quite inevitably lead to what Benveniste called the proper name of the 'I': Myself. Before the mirror, the man observes himself silently in his reflected image, 'It is Myself'. This process of identification may be deemed quasi-necessary, for without it we would enter a realm of magic, madness or fiction. 'Myself' is the name that the model attributes to the image. By the same token, 'Myself' becomes the figurative designation for the model as reflected in the image. The phrase 'it is Myself' names the mirror's image and refers this 'self' to the subject who, otherwise nameless, engages in self-contemplation: 'it is myself who paints myself: the image is the (my)self through which the "I" paints itself'.

It is also to this very same self that a name comes to be attached. A 'proper' name is written, writes itself, the name that, as the classical logicians said, is appropriate to the singular idea. The proper name is, in a certain respect, the particular face of the self, its portrait within the social community of names. For a long time now we have known of the emergence, within the domain of the visual, and at a given historical moment (in the twelfth and thirteenth centuries) of certain practices of inscription involving names that, in independent or monogram form, sometimes are those of the subjects of enunciation: '*X pinxit, faciebat*'. Sometimes it is the voice of the work itself that proffers the enunciation: '*X me faciebat*'. Frequently the signatures are hidden away – particularly in the nineteenth and twentieth century – in the bottom right-hand corner of the painting which ideally is conceived as the last stage in the

trajectory of a gaze that proceeds according to the rules governing the reading of a written page. With regard to the image, such signatures are heterogeneous elements, and thus their inscription inevitably introduces a certain confusion. In the topography of the image governed by the sequences of the story or the values of devotion, it is the site of this confusion that is 'properly' u-topic for it is in this very instance, at the moment of its visibility, that the image absents itself from the visual cohesion and narrative coherence of the story.

Painters have frequently been more sensitive to such disturbances than have been those who write about painting. In order to contain these u-topics within the space of the image, in order to control them within the topographical order, painters will typically make use of some object represented on the canvas. Thus the mark of the name may be inscribed upon a fragment of a block of marble, or on a sheet of parchment lost somewhere on the edge of the painting. They will even represent, here or there, with more or less coherence, artefacts of which the sole function is to be a vehicle for writing (I am thinking here of streamers, scrolls, and so on). A signature incorporated in this manner makes it possible to safeguard the visual homogeneity of the painting, for the written element that announces the name is a part of it only as a result of the represented object that serves as its basis, allowing it to be seen and read. Let us contrast this practice of incorporation to yet another strategy, quite common during the nineteenth century, which consists of the superimposition of the signature on to the space of the painting. More or less discretely traced within the represented space, the name, by virtue of its presence, serves to recall the material opacity of the representation. With a kind of all-too-brief remorse, the name underscores the fact that the painting presents itself first and foremost as a flat surface, and this in spite of the mimetic brilliance of the image occasioned by a historical painting or by a genre painting. Yet it is perhaps too simplistic a gesture to oppose the incorporation of the name amongst the other represented figures to that of its superimposition on the surface of the painting. Where, for example, within such an opposition, would we place the cartellino that Zurbaran, using a *trompe-l'oeil* that is the ultimate in mimesis and yet already a transgression of its rules, sticks on to the surface of the canvas of his *Immaculate Conception* which now hangs in the museum in Bordeaux? It would be possible to cite any number of problematic cases.: for example, the folded paper that Carpaccio leaves lying on the floor of Saint Augustine's studiolo (Illustration 57) and which reads as follows: '*Victor Carpatheus fingebat*'. Here the 'fictioning' signified by *fingere* seems to designate the *trompe-l'oeil* itself, a *trompe-l'oeil* that nonetheless escapes its own charms by means of the shadow projected on the floor of the studiolo, a shadow that confirms its irresistible inscription within the domain of the 'represented'.

What is at stake in the writing of the name? A mark of appropriation, it is true. Yet what it designates is more a creative than a possessive property. The name refers to the author: 'This painting is (by) me, X'. Thus all paintings tend to be the virtual self-portrait of their painter. Designated by the signature in the painting, it is as though the painter undergoes a process there whereby he or she takes or assumes shape or figure. Sometimes it happens that this figure finds the possibility of its appearance in the secret of a reflexion, in the discrete

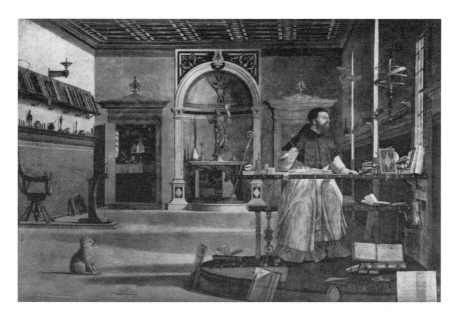

57 Vittore Carpaccio, *Sant' Agostino nello studiolo*, 1485?; Scuola di San
Giorgio degli Schiavoni, Venice

evanescence of a simulacrum, in the embossment of a pattern, in the swelling
of a crystal vase, or even in the mirror represented at the far end of the
painting's virtual space.

In this context we may usefully refer to the remarkable and standard
example of the full-length portrait, the one painted by Jan Van Eyck in 1434
which represents the Arnolfini couple (Illustration 58). In the background, on
the wall of the room in which the husband and wife pose, the painter signs his
name to the work. Yet this name is the subject of a narrative utterance which
displaces the signature towards the story of a past event, thereby introducing
the temporality of the present into the representation: 'Johannes van Eyck *fuit
hic*' ('Jan van Eyck was (present) here').

The painter stands witness to the scene that he paints, to the marriage, in
the past, of the models of his painting. Here, once upon a time, in the past,
here, now and forever, in the work, the painter assures his present. The
condition is, however, that he write his name above the convex mirror that
functions as a kind of 'sorceress', for beyond the images of the Arnolfini
couple seen from behind, the mirror shows a minuscule silhouette, hovering
between appearance and disappearance: the painter in red stockings and
some sort of turban of the same colour may be discerned in the virtual space
of the mirror's reflexion, a mirror that inscribes itself within the work as an
eye that, in the fictive space of the painted representation, captures its own
contemplation of external space. How, then, does the subject-painter reappear
as a 'self' in the painted narrative or in the holy image? How does the self
represent itself in the narrative or cultural scene of the painting?

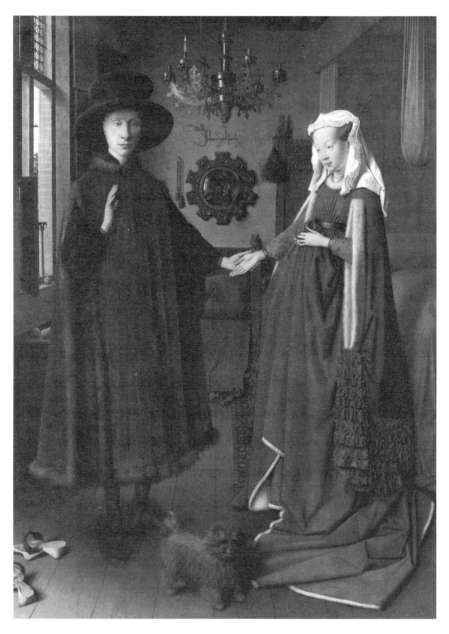

58 Jan van Eyck, *The Arnolfini Wedding*, 1434; National Gallery, London

First it will inscribe itself within the most grandiose and seductive scenes displayed in the historical paintings of the Quattrocento. Be it a matter of a Masaccio or a Botticelli, a Signorelli or a Raphael, it is not uncommon to find the figure of the painter represented as one of the participants amongst others in the narrative and represented action. A distracted gaze, the diversion of the look in the direction of the eye of the subject of representation (painter/spectator) denied by the represented subject; these are the signs by which the painterly figure is signalled as different. Numerous are the examples of the transition from a straightforward signature of the painter in the form of an image of the self to a complex and fully-fledged self-portrait, to the representation of a singular self with its history, its desires and goals, its ideas and beliefs. What, more precisely, are we to make of these figures of self-portraiture, caught in the wings of narrative, or on the margins of the map of representation? Are they simply iconic signatures?

The lovely 'Adoration of the Magi', painted by Botticelli between 1475 and 1478 (Illustration 59), presents the portraits of Cosimo de Medici the elder, and of Cosimo's sons, Julian and Giovanni, in the guise of the three kings. Closest to the right wing of the scene, the painter paints his own figure. Dressed in a yellow toga, the latter regards the spectator with an arrogant and defiant look. In this landscape of ruins, in the procession of the three kings (that is, amidst the servants of the Medicis), the painter is last. Yet in the painting he is first. Above him, perched on the crumbling wall, we find a peacock, the ocellated tail of which stands as an image for the celestial spheres. The ocellus is said to ward off the evil eye and, according to Saint Augustine, the peacock's flesh is incorruptible, a feature that leads him to see it as a symbol of immortality, just as the moulting of its feathers, each spring, becomes an allegory for the resurrection. In capturing his face and gaze, in accompanying his figure with the symbolic bird, Botticelli's representation of himself strains towards a twofold immortality, that of his work and that of the painter, its creator.

In the 'Crowning of the Virgin' (c. 1445) by Fra Filippo Lippi (Illustration 60), an angel arising from the lower right hand corner of the painting carries a banner inscribed with the words 'Is perfecit opus'. Now the question is, does this inscription, as has been frequently affirmed, indeed designate the painter as the kneeling and praying figure immediately below the Baptist who seems to bless him? Is this figure not more like Francesco di Antonio Maringhi, the individual who commissioned the work? And is it not precisely this uncertainty that makes it possible to forget the little monk who, in the left part of the scene, is situated in a position that is exactly symmetrical to that of the kneeling figure? Distracting the gaze away from the represented scene and towards the spectator, this monk is caught in what we, in an attempt to compare him with his praying counterpart, may call a melancholic attitude (the head upheld by the right hand), a strange kind of accidie. Is it possible to see this monk as a painter who has broken with the monastery?

It is true, as we have seen, that Dürer, in the 'Martyrdom of Ten Thousand', carries a staff with an inscribed parchment designating and naming him, through a use of the demonstrative form of the second person, as the subject of an imperfect verb that in turn suggests the enigmatic continuity of the process that creates the work: *'Iste faciebat anno Domini 1508 / Albertus Dürer*

210

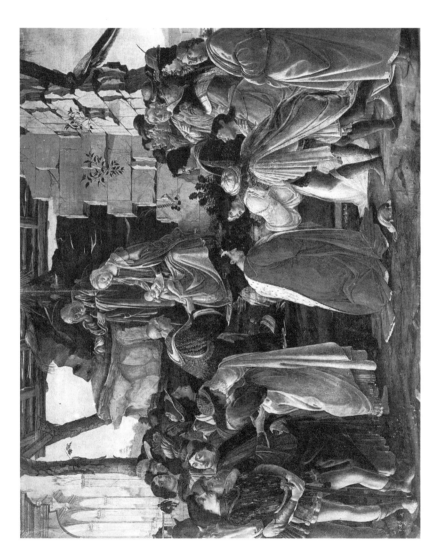

59 Sandro Botticelli, *Adoration of the Magi*, 1475; Uffizi Gallery, Florence

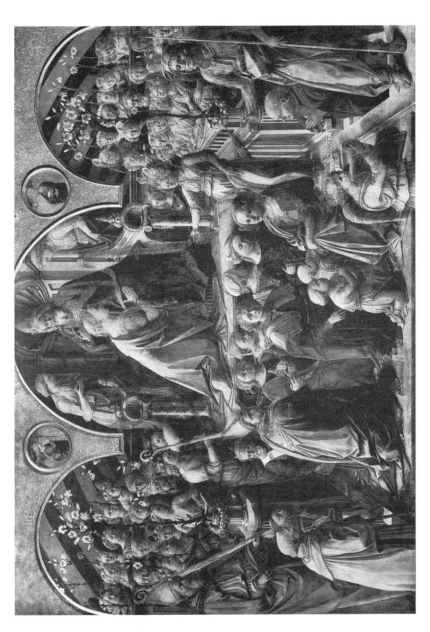

60 Fra Filippo Lippi, *Crowning of the Virgin*, c. 1445; Uffizi Gallery, Florence

Aleman.' Is this a signature in the form of an image, a signature that the monogram AD will sign a second time? No doubt. Yet is not the coat in which Dürer wraps himself the 'beautiful French coat bought in Venice'? Is it not true that Dürer has his friend Conrad Celtis accompany him on his intrusion into the painting, an intrusion that results in their occupying the most central of locations? For we recall that theirs is a site central both with respect to the general lay-out of the representation, and in relation to the core of represented actions. Is it not also true that Dürer looks at the spectator with a strange violence or enigmatic fear, while his companion points out to him the group that surrounds the bishop Achatius who, hands behind his back, awaits the terrible tortures that are being prepared for him? Aside from inscribing his signature in the form of a self-portrait, Dürer places himself in the very scene of martyrdom, in the position of the witness. He in turn occupies the site of the martyr, but as a martyr of ten thousand martyrs, a witness who would also be the pathetic commentator, the melancholic exegete of the atrocities represented in the painting, a kind of martyr of (the) painting. Hence the importance of the left-hand corner of the work. In the foreground the bodies of two thief-like figures hang suspended from and nailed to two upright crosses. On the ground lies a similar structure, ready to frame a third figure. And it is towards this cross that the butchers lead a 'Christ'. In the specificity of its narrative sequence, this crucifixion scene becomes the symbolic matrix for the entire massacre recounted by the painting, although only in inverted form. As noted by Panofsky (1943–87), the story of the martyrdom is condensed within the symbolic scene of an 'imitatio Christi' or a 'School of the Cross'. By being u-topic, the painter would serve the latter as both illustrator and pedagogue.

In both cases, the emotional and pathetic effects of the portrait of the painter and of his 'u-topic' are accentuated. And it is this emphasis that disturbs the narrative or mystical 'topography', as well as the 'objectivity' of the historical or devotional representation. It renders the latter's transparency opaque by means of a figure of subjectivity, a figure from which a singular self emerges whom the painter at times will invest with a dramatic violence stemming from the very depths of being. Thus when Cristoforo Allori paints the portrait of his formidable moorish mistress, he represents her as Judith, holding the severed head of the (forsaken) lover who thus appears as Holophernes. All of this in a 'primitive' scene that conjoins love and death. Similarly, Caravaggio paints his self-portrait as Goliath, placing the severed head in the hand of a young David carrying a phallic sword. On another occasion he travesties the self-portrait, representing himself as the bloody and screaming head of Medusa placed on, and painted on, the convex mirror of Perseus's buckle which, incidentally, proves to be the official buckle of the Duke of Tuscany.

In conclusion it remains for us to evoke the genre of works typically called self-portraits, those in which the painter represents him or herself as an autonomous and solitary figure. What we have here is the arrogance of a presence (in representation), the power of an appropriation of the self, of the identification of being as self; or alternatively, the fear of an existence that

eludes itself, defects and falls short, that finds itself at grips with time (that is, with death). It is clear that, in painting, the representation of the self by the self is made possible by the tension that is inscribed within representation as its very essence: 'With it the portrait carries absence and presence, pleasure and displeasure'. What Pascal writes about the portrait and the figure is quite certainly true of the representation of the self by a self. It involves a dialectic that is without synthesis, without ultimate reconciliation between two elements and processes: on the one hand, presence in its presence, a now that stands for all time as the essence of the self in its singular truth, but which, since eternity brings about changes, also constructs, from this very moment on, the definitive monument of the self, its tomb; and on the other, a moment of presence, the uncertain and problematic limit of an 'already more' and a 'not yet', the representation of which is the frivolous, disturbing and anguished attempt to grasp and fix, through an unstable figure, what already approaches in the distance, the troubling and troubled apparition of an image of the self in its momentous truth and sincere transcription, without repentance or desire, the image of the self in the process of disappearing. It is no longer a question here of the architectural monument of an essence, but of the movement of a momentarily suspended transition.

In his own inimitable way, Montaigne, the master of literary self-portraiture, allows his reader to consider both of the dimensions discussed above. On the one hand there is the tomb of the self: 'I have destined my book to serve as a certain comfort to my parents and friends: having lost me (which, indeed, they soon will) they will finde here not a trace of my condition or humors, and thus will cherish more wholeheartedly and vividly the knowledge that they have had of me'. And, on the other hand, there is Montaigne's attempt to grasp the transitional moment:

> It is a thorny enterprise, and much more so than it might appear, to try to follow the paths of so flighty a thing as our mind, to penetrate the profound opacities of its internal rules, to choose and impede so many of the minuscule ways in which it may be agitated. And it is a new and extraordinary kind of entertainment that withdraws us from the common occupations of the world ... cannot secure my object. It reels, unclear and staggering, naturally intoxicated. At this point, at the moment when I am amused by it, I take it as it is. I do not paint being. I paint its transition: not a transition from one age to another ... but from day to day, from minute to minute.

Emblematic of this double emphasis would be the confrontation, in a kind of face-to-face, of Rembrandt and Poussin. In a succession of self-portraits, the Dutch master scans his life, virtually from year to year. At each instance, a series of figures of the same and of the incessantly other 'self' called Rembrandt is engendered by the image perceived in the opaque reflexion of the mirror, and by the strokes of a brush. This series owes its existence as much to 'the profound opacities' of the internal folds of the self, as it does to 'the minuscule ways in which it may be agitated'. Moreover, it achieves unification only as a result of the gradual, yet irresistible, upsurging of an end, of the mortality that pervades life. The result? A figure that is plural yet identical to itself, that has been constructed out of all the possible relations between successive figures, an infinite figure, a virtual (in the two senses of

the word) figure. It is a matter of the presentation of a latent self who, as of yet, is but possible. Each and every self-portrait is but the extraction of a particular profile from this very bed of latency and possibility. Yet the figure created and constructed is also a figural virtue, a power of figuration, a capacity to acquire form in and through the efficacy of painting, a practice for which, in certain self-portraits, the brush and palette are the signs and images.

Poussin, himself a painter of history, jealously guarded his own face against painting, to the point of resisting, for many years, the reiterated requests of his client and friend, Chantelou. However, when in 1649–50 – the zenith of the century and of his life – he came to terms with the idea, he painted two self-portraits at once, in a kind of face-to-face that is an attempt to reveal the essential variation constitutive of the representation of the self. These portraits amount to a double mirror of painting, the interface of the two allowing us to make out the anaclastic image of the Self in its singular truth. Through two frontal representations, a double 'profile' is achieved. The first displays the image of the Master against the backdrop of a tomb on which are inscribed his name and titles, much in the manner of an epitaph engraved for all time. The second places the painter against a collection of frames, unpainted canvases, and finished works hidden behind those that remain to be executed. The temporality that sediments and concentrates itself here is that proper to the work of figurability, the work of the painter whose name is inscribed as the signature of a painting without figures, of a monochrome that remains to be painted.

Notes

1 Translated by Anne Mette Hjort. This article was originally published as 'Topique et figures de l'énonciation', *La Part de l'oeil*,1989, pp. 141–53 (translator's note).
2 The translations of extracts from Montaigne have been made as literal as possible in order to preserve the coherence of Marin's analysis (translator's note).

Chapter Eleven
Armour Fou
Hal Foster

In these pages I want to relate several works of Max Ernst and Hans Bellmer to a psychic apprehension of the body as *armour*, an apprehension I will consider tentatively in terms of fascism.[1] This chapter arises out of a silence following a lecture I heard several years ago, the first theory of surrealist photography read through such Bataillean concepts as the *informe* and the base.[2] Not only are formal conventions and idealist values subverted in these manipulated images by Brassaï and Kertész, Man Ray and Maurice Tabard, Raoul Ubac and Hans Bellmer; so too is the female body, a common ground of this subversion, often deformed, even violently so, in a way that no avant-gardist claim can quite justify. The apparent sadism of the photographs raised the spectre of surrealist misogyny, but it also pointed to an adjacent issue no less difficult: are these surrealist transgressions of the body related to actual transgressions of the body during the period from the mutilations of the First World War to the atrocities of the Nazi regime? If so, why are these fantasies visited upon the female body? Do they partake in a putatively fascist imaginary, a peculiarly damaged ego that seeks a sense of corporeal stability in the very act of aggression against other bodies somehow deemed feminine by this subject (Jews, Communists, homosexuals, 'the masses')?[3]

The first question was broached hesitantly after the lecture, and it startled many auditors in a way that went beyond the nasty *frisson* of any mention of fascism: suddenly the great anti-type of twentieth-century modernism was bluntly juxtaposed with one of its most privileged instances (at least of late). In its very absence this anti-type is crucial to the art-historical construction of modernism. Rarely is fascist art included, or fascist ideology mentioned, in narratives of twentieth-century art. (The fascist involvement of Italian futurism, for example, is usually just noted, and not really pursued.)[4] Indeed, the one instance that *is* often ritually cited, the notorious 1937 Nazi exhibition which condemned modernist art as 'degenerate', serves to purify such art politically as well as aesthetically. Thus, when 'Nazi' brushed against 'surrealist' that night, I wanted to deny such associations, and I doubt I was alone.[5] Bellmer, the most troublesome case, came immediately to mind, but had he not posed his *poupées* precisely as an *attack* on fascist father and state alike? Clearly the

215

question violated a critical taboo, and a nervous silence ensued: it was the sound of an interpretive breakdown.

I did not think about this silence for several years (such was the strength of *my* denial), at least not until I turned to representations of the mechanical-commodified body in dada and surrealism, mostly dysfunctional automatons and dismembered mannequins. Rarely do these caustic figures appear in mappings of modernism around the machine or the commodity, even though they are the dialectical complements of the mechanical-commodified body variously celebrated in constructivism, purism and the middle Bauhaus.[6] However, these figures, I came to see, may also oppose another type outside the common purview of modernist studies: the (proto)fascist ideal, forged in the aftermath of the First World War, of the male body become weapon, the Jungerian figure of the soldier-worker about which (proto)fascist authors wrote so obsessively in the 1920s and 1930s (Illustration 61).[7]

This tenuous connection led me to an early suite of Max Ernst collages in which the body, also usually gendered male, is treated appositely as either a ridiculous weapon or an impossible tool. Here, after the Bellmer dolls, was a different set of 'bachelor machines'[8] created amidst the Freikorps terror soon after the First World War, just as the *poupées* were produced amidst the Nazi militarization of society that led to the Second World War. To a degree the critical relation of dada and surrealism to fascism became encrypted for me in the autistic machines of Ernst and the sadomasochistic scenarios of Bellmer. I wanted to frame these works less as historical parentheses of this relation than as ambiguous explorations of the (proto)fascist obsession with the body as armour, and to see this armour as a prosthesis that served to shore up a disrupted body image or to support a ruined ego construction. In some way, I thought, the Ernst machines evoked this armouring in psychic and social terms, while the Bellmer dolls attacked it with the very force against which it was pledged: sexuality and desire represented (for this subject at least) by the feminine. The question was *how* to make these connections and, even more obscure at least to me, *why* I wanted to do so. The text that follows is thus provisional at best, and I present it only because I can now bear its fractured argument better than I can the restive silence that preceded it.[9]

Max Ernst was drafted into an artillery regiment of the German army in 1914 at the age of 23. Although soon transferred away from the front, he was wounded twice and so nicknamed 'Iron Head'. 'We young people came back from the war in a state of stupefaction', he would later remark.[10] 'Max Ernst died the 1st of August 1914. He resuscitated the 11th of November 1918.'[11] This account of the war in terms of shock is telling, as is the alienation of the first person by the third, for it is precisely in such terms of psychic disturbance as evoked by the war that I want to consider five or six of his early collages. This is to suggest not that Ernst was so disturbed, but that he deployed certain characteristics of such disturbance, familiar to him from pre-war studies in psychology at the University of Bonn, to critical ends.[12] Thus, when he 'resuscitated' from the war, he did so in a *quasi*-autistic guise as 'Dadamax' (short for Dadafex Maximus), machinic maker of machinic figures. At this time of strikes and street battles, Red councils and White terror, Ernst not only figured the body in

61 Joseph Thorak, *Comraderie*

mechanistic terms but also took the machine as a persona. In so doing he effec-
tively assumed the trauma of the military-industrial reconfiguration of the
body in order to delineate its psychophysical effects, and more, to deploy these
effects against the social order which produced them.[13]

Begun in the autumn of 1919, the collages in question were produced from
rough proofs that Ernst found at a Cologne printer.[14] Each work combines
diagrams of mostly mechanical systems with different devices, lines and
symbols to produce schematic figures, the reading of which is often keyed by
titular inscriptions.[15] Of course, to find meaning in these bizarre images may
be forced, especially as they tend to be read (if at all) as so much dada-non-
sense. Yet this nonsense is purposeful not only in its disruption of conven-
tional signification but also in its double imaging of a mechanistic body and a
schizophrenic representation,[16] for through this imaging the collages pose a
modern subject that is at once diagrammatic (so many abstract elements to be
redesigned) and dysfunctional (overcome by desiring production that serves
'to short-circuit social production, and to interfere with the reproductive
function of technical machines').[17]

The titles of two collages, *Le Mugissement des féroces soldats* (Illustration 62)
and *Trophée hypertrophique* (Illustration 63), point to a military-industrial
subject. In the first work the *mugissement* or roaring of the *féroces soldats*
suggests a loss of speech or reason, a becoming other of the 'ferocious
soldiers' (a trope that would soon be standard in surrealism for a becoming
unconscious). However, in the immediate post-war context, this roaring refers
to a becoming machine and/or weapon as well. And indeed the ferocious
soldiers, mechanically meshed as they are, evoke a kind of war machine run
amok and on automatic.

In *Trophée hypertrophique*, an even more disjunctive figure made up of
mechanical designs and calibrational devices, this becoming machine and/or
weapon is almost literal. Here the title, written like a legend in French,
German and English, seems to commemorate at least three of the four major
combatants of the war. Although the commemoration (war dead as *trophies*?)
is mordantly ironic (especially from an anti-chauvinist German veteran like
Ernst), this is precisely the first definition of 'trophy': 'Arms etc. of vanquished
enemy set up on field of battle or elsewhere to commemorate victory' (*Concise
OED*). In the trophy the body is displaced by arms; death renders it so much
armor. This play on the figure 'trophy' is deepened by the term 'hyper-
trophic'. Of a different Greek root from 'trophy' (*trophia* rather than *tropaion*),
'hypertrophy' concerns the 'enlargement (of organ etc.) due to excessive nutri-
tion'. 'Trophée hypertrophique', then, suggests not only that the war has
enlarged the number of soldier-trophies, and so nourished death excessively,
but also that it has armoured the (male) body, and so made of it precisely a
hypertrophic trophy.[18]

Why, we should ask here provisionally, does Ernst present such figures of the
military-industrial, and why in this manner of abject impersonality? As is well
known, dada intends a 'kynical' attack on the ideals of fine art and humanist in-
dividuality cherished by the 'cynical' classes that produced the war.[19] '[O]ur
rage had to find some expression somehow or other', Ernst would say in retro-
spect. 'This we did quite naturally through attacks on the foundations of the civ-
ilization responsible for the war'.[20] But the intent is not merely to shock this

62 Max Ernst, *Le Mugissement des féroces soldats*, 1919

63 Max Ernst, *Trophée hypertrophique*, 1919–20

civilization. 'Contrary to general belief', Ernst continues, 'Dada did not want to shock the bourgeoisie. They were already shocked enough'.[21] The intent is also to work over this trauma; the two operations cannot be separated. This hint is given, albeit obliquely, in *Le Mugissement*, where Ernst adds the inscription 'vous qui passez priez pour DaDa'. This note casts 'the roaring of the ferocious soldiers' in infernal terms ('vous qui passez ... '), and yet it also suggests that dada somehow treats this trauma, survives this hell (' ... priez pour DaDa'). This is hardly to deny that dada exploits the shock of the military-industrial for purposes of critical negation; it is only to insist that it also seeks to negotiate this shock: to 'prepare' (as Freud wrote grimly of the symptomatic nightmares of First World War shock victims) for a trauma that had already come.[22]

In any case, in *Le Mugissement* and *Trophée hypertrophique* a mechanizing of the (male) body is evoked, only to be subverted, at least symbolically. A similar strategy governs *Petite machine construite par lui-même* (Illustration 64), where such mechanizing is seen to penetrate the very beginnings of this body. Here the image is literally split: on the left is a drum figure with numbered slots, on the right a tripod personage, an animate camera or gun. Below is a text, in German and in French, the latter of which reads:

Petite machine construite par lui-même
il y mélange la salade de mer la sperme
de fer le périsperme amer de l'une côté
nous voyons l'évolution de l'autre l'ana-
tomie ca coute 2 sous plus cher.

Though allusively schizophrenic, this text actually describes the 'self-constructed small machine'. 'On the one side' (perhaps the left) is an 'anatomy' that 'mixes' within a 'bitter perisperm' both 'iron sperm' and 'sea salad' (*la salade de mer* also evokes through *mère*, 'maternal salad', and through *merde*, 'shitty mess').[23] This bachelor machine thus conflates, as in childhood theories of conception, the sexual and the scatological. Yet not only is the sexual-scatological used to mock the mechanical, but the mechanical is also seen to enter, even to replace, the sexual-scatological, in terms not just of the automatism of such acts but of the very substance of the species (for example, here sperm becomes iron).

In this way *Petite machine* points to a genetic mechanizing of the body, one which degenders it under the sign of the masculine.[24] So too *Petite machine* points to an historical armouring of the body, for the caption also alludes 'on the other side' (perhaps the right) to an 'evolution' of 'anatomy'. Here, under the shocks of massive industrial war and pervasive capitalist exchange ('ca coute 2 sous plus cher'), the (male) body has become an instrumental camera or gun. Paradoxically, however, this very instrumentality renders it dysfunctional as a body image, and this in turn points to the psychic dimension of the collage. For a certain autistic system is intimated: this armoured body, this 'self-constructed small machine', suggests a defensive shield, perhaps even a machinic substitute, for a damaged ego: one which, however, debilitates this ego all the more. (Ernst is not an 'I' here; the machine is signed 'Dadamax Ernst', again the third-person signature of an alienated subject.)[25] In effect, then, these armoured figures may allude not only to military-industrial shock

64 Max Ernst, *Petite machine construite par lui-même*, 1919

but also to the disturbed body image or ego construction attendant upon such shock.

The historical armouring of the male body is also nuanced in psychic terms in the last two collages to be mentioned here. *Ca me fait pisser* (Illustration 65) appears to be based on a diagram of an engine or pump, and the title suggests that the male body is little more than a mechanical or hydraulic penis. At the same time the figure resembles an elevation of a tower with a star, a *gratte-ciel*, and the words LE GRATTE-POPO are inscribed atop its second stage. This neologism is nicely ambiguous. On the one hand, it grounds the meanings of the image in its production (*gratter papier*, to scratch paper), which Ernst was wont to eroticize.[26] On the other hand, it confirms the phallic aspect of the figure as a scratcher not just of 'skin' (*peau*) but of 'ass' as well ('popo' is German slang). *Gratter*, moreover, means 'to cross out' as well as 'to scratch', and *popo* recalls 'papa' too. In this regard the phallic tower may be more than another monument to dada-scatology; it may also stand as a paternal figure, one which is implicitly challenged (crossed out) as well as desired (scratched). This suggests the tension between the 'positive' pole of a contentious identification with the father and the 'negative' pole of a persistent love for him that Freud came to see as intrinsic to the Oedipus complex.[27] Here, however, this tension, which fascinated Ernst more than any other dadaist or surrealist, appears less resolved than stalemated ('ca me fait pisser' suggests arousal, but only to piss, not to come). In short, this representation of a 'father-scraper' may point to an uneasy address to the paternal image, a suspended relation of scorn, even defilement of the symbolic order.

However playful, such puns also point to psychic pain. This is glimpsed too in *Adieu mon beau pays de Marie Laurencin* (Illustration 66), which seems to address the other side of the Oedipus complex. The figure resembles a schematic weapon, a missile-cum-tank, and yet its inscriptions, the titular mention of the artist Marie Laurencin as well as the additional phrase MAMAN TOUJOURS FJC-TICK, appear to gender it female. Many personal associations are possible here as elsewhere,[28] but might not the image be more profoundly autobiographical? That is, just as *Ca me fait pisser* might be an ambiguous representation of the paternal relation, might *Adieu mon beau pays* be an ambivalent imaging of the maternal body? If so, it is an almost Kleinian nightmare of stone organs and machine parts encased in a weapon-body, a projection which threatens the subject ('Hilfe! Hilfe!' and 'au secours!!!' are scribbled around the image) even as the subject also longs for it, this maternal body, as its 'beau pays'.

In a sense, then, a historical armouring of the body, as evoked in *Le Mugissement* and *Trophée hypertrophique*, is referred, in *Petite machine*, *Ca me fait pisser* and *Adieu mon beau pays*, to a psychic deforming of the subject. Apparently in each collage a dysfunctional machine is associated with a narcissistic disturbance, as if the first were an attempt to image the second and/or to 'rectify' it. However elliptically, these works may even juxtapose a *development* of a military-industrial type of body with a *regression* to a (pre)Oedipal (dis)organization of the drives. These meanings are obviously tentative and in tension – the first involving historical agencies in (proto)fascist Germany, the second traumatic events in psychic life – but it is of this tense connection that the Ernst collages may ask us to think. To do so

65 Max Ernst, *Ça me fait pisser*, 1919

here will involve two disconnected steps: first, to relate the collages to certain schizophrenic, even autistic, representations, and then to consider the social formation of the (proto)fascist subject from various psychoanalytical perspectives.[29]

66 Max Ernst, *Adieu mon beau pays de Marie Laurencin*, 1919

It is well known that Ernst studied 'the artistry of the mentally ill' and, for that matter, that the Nazis scorned it, especially in association with modernist art. His early collages converge with such representations in several respects: for example, not only a heteroglossic mixing of writing and drawing but also a contradictory imaging of bodies as often both disjunctive and mechanistic.[30] Such symptomatic signs were familiar to Ernst at the time of his machinic figures (that is, even before the 1922 publication of the classic Hans Prinzhorn text, *The Artistry of the Mentally Ill*); but his use of such visual cues goes beyond the stylistic.[31] In some sense Ernst intuited that this disturbed image-making articulated a disturbed ego construction, and that, if repositioned in a (proto)fascist milieu, it might be politically incisive precisely because it was psychologically incisive.[32]

Above I intimated that his post-war 'resuscitation' as Dadamax all but mimed an autistic defence, and that his 'self-constructed small machines' recalled autistic systems. This claim might be supported, at the level of representation, by reference to a famous case study of an autistic child that also centres on machinic figures. In 1967 the psychotherapist Bruno Bettelheim published an analysis of a boy named Joey whose autism was marked by certain characteristics also evident in the Ernst collages: for example, a type of speech neither oriented around an ego nor directed towards others, and a sense of the body as 'run by machines'.[33] These machines (Illustration 67), which Joey both constructed and represented, served not only to drive him

67 *Drawing of a machine devised by the autistic child Joey*, from Bruno
Bettelheim, *The Empty Fortress*, 1967

but also to protect him (that is, as a 'defensive armouring' against dangers from within and without, an armouring further required by his relative inability to distinguish between the two realms.This armouring placed Joey in a double bind, for he also needed periodic release from it, which came in the form of catastrophic 'explosions'. These explosions left him, in the depths of his autism, with the apprehension that he had no body at all, and thus that its waste was everywhere, that he lived in a 'world of mire'.[34] The machines, then, were attempts to abject this world, to re-establish his boundaries. Needless to say, they were hardly satisfactory, and 'his defensive armouring ended in total paralysis'.[35]

Bettelheim points to several sources of this autism which again resonate with the Ernst images:[36] a parental indifference to Joey as an infant, an inadequate cathexis of his body, and a resultant tendency to treat his functions as mechanical. Also involved were possible effects of a primal scene: that is, a vision of parental coitus witnessed, inferred and/or fabulated by the subject, around which questions of personal origin are teased out. Joey, Bettelheim speculates, may have defended against the threat of this scene through the substitution of machines for bodies, of machinic connections for sexual ones: a substitution from which he then would not be exempt.[37] In his images and texts Ernst often replayed exactly such a scene for its disruptive potential.[38] Indeed, very soon after his machinic figures come three collages, one of which (*La Chambre à coucher de max ernst*) appears to allude directly to a primal scene. More importantly here, the other two evoke this traumatic experience, only to relate it to military-industrial shock. In the first (untitled) work (Illustration 68), part of a female body is coupled with part of a biplane, while a wounded soldier is carried from the field; in the second (*Le Cygne est très paisible*), three putti displaced from a Nativity on to a triplane gaze upon a swan identified with a rape.[39] In both works images of peace and war, sex and death, are collided, and it is precisely in this collision, which appears to be temporal as well as spatial, that the trauma of these scenes is registered (as if in accordance with the Freudian formula of the *Nachträglichkeit* or 'deferred action' of trauma).

Finally, the putative emergence of Joey from his autism is also suggestive *vis-à-vis* the Ernst imaging of damaged subjectivity, for, in his 'symbolic re-experience of earliest infancy',[40] Joey is said to achieve subjecthood through a process of re-imaging. Indeed, his self-representations evolve only as his machines devolve in favour of other figures that he first acts out against, then trusts in and finally identifies with. In his work of the 1920s Ernst recapitulates a related process. After the 'perturbation' of his youth, he turns first to machinic figures suggestive of an autistic defence, then to images evocative of a primal scene, and finally to surrealist works more strictly Oedipal in theme. In so doing Ernst elaborates a practice of 'convulsive identity' around questions first of narcissistic disturbance and then of sexual difference, a practice governed first by an autistic persona 'Dadamax, self-constructed small machine' and then by a hybrid figure 'Loplop, the Superior of the Birds', who functions sometimes as an external superego (especially when identified with a castrative father).[41] Regarding the final moments of his 'hatching process' Joey says: 'I laid myself as an egg, hatched myself, and gave birth to me'.[42] In the final moments of his self-analysis Ernst echoes this reconstructive

228

68 Max Ernst, *Untitled* (Airplane), 1920

fantasy: 'Now and then he consulted the eagle who had hatched the egg of his pre-natal life. You may find the bird's advices in his work'.[43]

Such associations, I know, are dangerous, but my purpose is hardly to conflate the autistic and the avant-gardist. It is rather to suggest that the Ernst collages evoke such disturbed representations in a way that reflects on the damaged construction of military-industrial subjects immediately after the First World War, in particular subjects prone to fascism. But how can this connection to (proto)fascist subjectivity be made?

For countless veterans the First World War was 'a narcissistic wound of the first order'.[44] In this regard it may not be coincidental that Freud turned to such disorders roughly around this time. I noted his reconsideration of trauma soon after the war in *Beyond the Pleasure Principle* (1920), prompted in part by the shock of soldiers subject to new military-industrial technologies.[45] More pertinent to the Ernst imaging of damaged subjectivity, however, is his conception of narcissism as developed in 'On Narcissism' (1914), published around the outset of hostilities. In this paper Freud posits this phase, after that of anarchic auto-erotism but before that of external attachment, as one in which the subject is its own libidinal object. At this point the ego tentatively emerges, in a way thus dependent on an image of the body, on a *cathexis* of this image. (Freud came to define the ego as 'first and foremost a bodily ego', 'the projection of a [corporeal] surface'.)[46] It follows, then, that if this image is disturbed or this cathexis is inadequate, the subject will not fill in, as it were, and its object relations will be disrupted (an important point to retain when we relate the Ernst images to the Theweleit account of the (proto)fascist subject as 'not fully born').

Lacan, of course, reformulated this Freudian conception in 'The Mirror Stage' (1936/49), wherein the infant of six to eighteen months is said to identify with an anticipatory image of bodily unity in a way that founds the ego precisely as imaginary. Importantly here, Lacan regards the anarchic phase of auto-erotism, which he relates to a fantasy of 'the body in pieces' (*le corps morcelé*), as a *retroactive* effect of this imaginary unity of the mirror stage.[47] Accordingly, if there is a breakdown of imaginary unity or a crisis in narcissistic identification, the subject feels threatened by this bodily 'chaos'. For Lacan this threat renders the ego not only paranoid but also aggressive, and this in turn compounds the aggressivity already immanent to its fragile foundation in the field of the other.[48] In this context it is important to remember that, just as Freud published his account of narcissism at the beginning of the war, Lacan developed his notion of the mirror stage not only in the milieu of surrealism but in a period dominated by fascism.[49]

In his account of the (proto)fascist subject Theweleit draws on ego psychology and object-relations theory more than on Freud and Lacan.[50] For him 'armour' is not part and parcel of any ego; rather, it appears almost in lieu of a formed ego, hypertrophic if you like.[51] Theweleit does not hesitate to think of this subject in terms developed for the psychotic child: the (proto)fascist is said to suffer from a 'basic fault' (Michael Balint) in which object relations are never resolved and individuation never completed (Margaret Mahler).[52] Unable fully to cathect his body image or even to bind his periphery, he is not formed, as it were, from the inside out.[53] Thus, when faced with stimuli that cannot be discharged, he feels threatened with dissolution, and other forms of

binding become urgent. 'The body did acquire boundaries', Theweleit writes, 'but they were drawn *from the outside*, by the disciplinary agencies of imperialist society' (hierarchical academy, military drill, actual battle and so on).[54] These (proto)fascist agencies bind through a special sense of the body 'delibidinized' through pain: the body as armor. According to Theweleit, this armor serves as an ego stopgap, one which inclines the subject to an extreme aggressivity, if not to an asocial autism.[55] Such aggressivity seems necessary to the (proto)fascist not only for self-definition but also for self-defence, and it is thus that he attacks Jews, Communists, homosexuals, proletarian women and 'the masses'. In doing so, however, this subject aims at his own desiring production, and finally it is this, for Theweleit, that he most fears and loathes: his own unconscious and sexuality, his own drives and desires, coded, like his social fantasms, as feminine.[56]

However, even as the (proto)fascist requires this armor, he also strives to be free of it; thus his great ambivalence regarding comminglings of all sorts (sexual, social, racial and so on). This contradictory demand is treated most effectively in war (whether national, as in the First World War, or civil, as in the Freikorps terror), for there the subject can be defined and defended in the very act of discord and discharge.[57] This in turn compounds the extraordinary mystique of war in (proto)fascist ideology as an 'inner experience'[58] in which both body and psyche become weapon. 'Was I now perhaps one with the weapon?' Ernst von Salomon, First World War soldier and Freikorps officer, writes, 'Was I not machine – cold metal?' (Illustration 69).[59]

For Theweleit this reconfiguration of body and psyche as weapon is fundamental to fascism, since it allows for desiring production to be both suppressed *and* expressed as 'murdering production'. Such armouring becomes programmatic in the fascist modernism of Ernst Jünger, the most important writer of the German interwar right, for whom 'technology is our uniform.'[60] Jünger urged that technology be 'intertwined with our nerves', and that the 'pain' of military-industrial experience be transformed into a 'second, colder consciousness'.[61] Such 'political algodicies of the solid block, strength-through-joy, iron front, shoulder-to-shoulder, steel-ego, reconstruction egotype'[62] became crucial to Nazi ideology: that is, once its *völkisch* anti-capitalism was muted in favour of a technical rationality recoded in terms of a national *Kultur* rather than a corrosive *Zivilisation*. In this recoding not only politics but also technology was aestheticized as 'the embodiment of will and beauty'.[63]

How might the Theweleit account of this ideology, problematic though it may be, illuminate the machinic figures of Ernst as well as the fragmented dolls of Bellmer, and vice versa?[64] On a first level, the Ernst machines are not just dysfunctional; they are corrosive of (proto)fascist 'will'. So too the Bellmer *poupées* do not simply belie sublimation; they shatter (proto)fascist 'beauty' with the effects of sexuality. Moreover, where (proto)fascist subjectivity exults in the 'metallization of the human body',[65] Ernst refers it to a damaged ego, and Bellmer exposes its sadistic ends. Finally, against a 'damming up' of the unconscious, for Theweleit the *sine qua non* of (proto)fascist subjectivity, both artists incite a flowing of desires and a mixing of boundaries (this is the very purpose of the Bellmer dolls). Clearly these appositions need to be refined, and one way to do so is to turn to the Bellmer *poupées*, the works which provoked these remarks in the first place.[66]

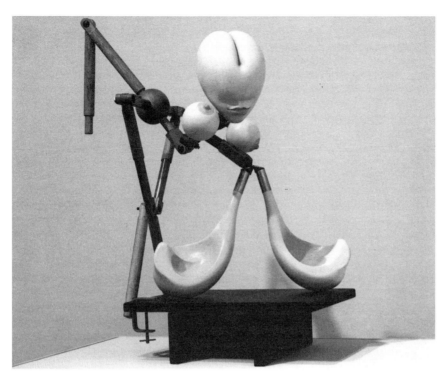

69 Hans Bellmer, *Machine-Gunneress in a state of grace*, 1937

While Ernst may only allude to (proto)fascism, Bellmer responds directly to Nazism.[67] Too young for the First World War, he rejected engineering, the profession dictated by his father, for publicity, which he also rejected when the Nazis came to power lest he abet them in any way. It was then that he turned to his *poupées*: again, as an attack on fascist father and state alike, an attack, however, played out on the compulsively (dis)articulated image of a young female body. How are we to reconcile these two data, the avowed politic and the evident sadism of the dolls?[68]

In *Die Puppe* (1934) Bellmer writes of his 'joy, exaltation and fear' before his fragmented first doll (Illustration 70).[69] This intense ambivalence is evidently of a fetishistic sort, as the second doll (begun in 1935), less anatomical, makes more manifest. Here Bellmer manipulates the *poupée* excessively: photographed in different positions, each new version is a 'construction *as* dismemberment' that simultaneously signifies castration (in the disconnection of body parts) and its fetishistic defence (in the multiplication of these parts as phallic substitutes).[70] This reading is not discouraged by Bellmer. In *Die Puppe* he speaks of the doll as a way to recover 'the enchanted garden' of childhood, a familiar trope for a pre-Oedipal moment before castration. Moreover, in a later text, *Petite Anatomie de l'inconscient physique, ou l'Anatomie de l'image* (1957), Bellmer locates desire specifically in the bodily detail, which is only

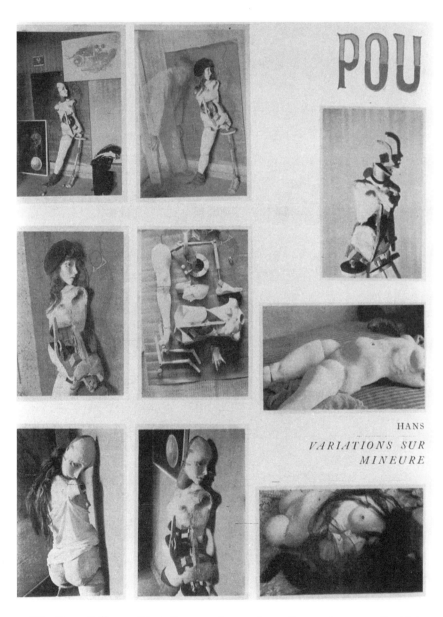

70 Hans Bellmer, 'Variations sur le montage d'une mineure articulée',
Minotaure, 6 (1934–5)

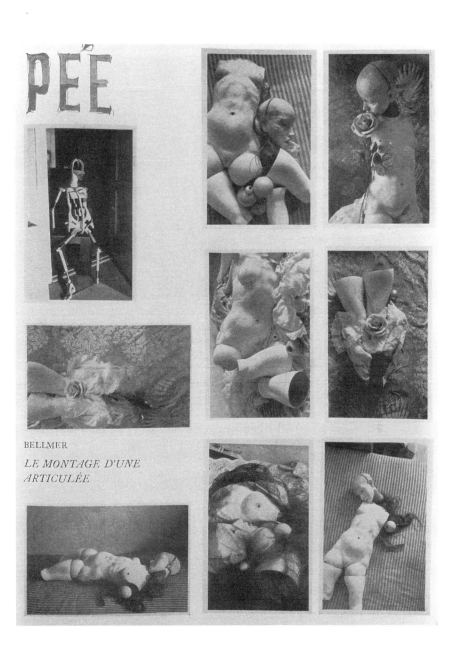

real, he argues, if desire makes it artificial: that is, if it is fetishized (sexually displaced and libidinally overvalued). Such is the 'monstrous dictionary of the image', he writes, 'a dictionary of analogues-antagonisms'.[71]

Yet the *poupées* involve more than fetishism. The very notion of a 'dictionary of the image' suggests a shifting of desire more than its fixing (as in the Freudian account of fetishism). So, too, the production of the dolls, especially the first, is revealed more than concealed (as in the Marxian account of fetishism); the photographs of the first *poupée* detail its construction explicitly. Moreover, the sex of this doll is not effaced or disguised; it is subjected to obsessive investigation. (Like little Hans, Bellmer manipulates the doll as if to ascertain the signs of difference and the mechanics of birth.) Finally, not only are the *poupées* broken up rather than made whole; they are also posed in fantasmatic scenes suggestive of rape rather than sightings of castration. In short, castration is not disavowed here; on the contrary, it is staged again and again. It often appears punished, as Freud writes, with 'horror at the mutilated creature or triumphant contempt for her'.[72] And yet is it strictly the fantasm of a castrative woman that is avenged in the dolls, or does the figure of a castrative father lurk behind?[73]

The *poupées* concern the sadistic as much as the fetishistic, though the two are hardly opposed here.[74] Again, the first doll attests less to an arresting of desire than to its shattering effects, and the second doll is 'a series of endless anagrams' that are aggressively manipulated.[75] This sadism is hardly hidden; Bellmer writes openly of his drive to master his 'victims', and to this end the dolls are often posed voyeuristically. In the second *poupée* (Illustration 71) this look masters through the various *mises-en-scène* of the doll, while in the first *poupée* (Illustration 72) it is even made internal to the doll: its interior is filled with miniature panoramas intended 'to pluck away the secret thoughts of the little girls'.[76] Involved here, then, is a patriarchal fantasy of control, not only over creation but over desire as such.

What exactly is this desire? And precisely how masterful is it? At least two points call out for consideration.[77] The first concerns the political implications of the apparent sadism of the *poupées*, and here two related remarks seem useful. The first comes from Benjamin, also in the midst of the fascism of the 1930s: 'Exposure of the mechanistic aspects of the organism is a persistent tendency of the sadist. One can say that the sadist sets out to substitute for the human organism the image of machinery'.[78] This formulation is in turn specified by Adorno and Horkheimer towards the end of the Second World War: '[The Nazis] see the body as a moving mechanism, with joints as its components and flesh to cushion the skeleton. They use the body and its parts as though they were already separated from it'.[79] In this light the sadism of the mechanistic dolls might be seen, at least in part, as second-degree: that is, as a reflexive sadism aimed as an exposé at the sadism of the fascist father.

Bellmer constructed his first *poupée* under the erotic inspiration of his young cousin, with the technical help of his brother and out of childhood things provided by his mother. In its very making, then, it constitutes an incestuous assault against the father. As his friend Jean Brun graphically stages it, this assault turns the very tools of his father, a stern engineer and a zealous Nazi, perversely upon him:

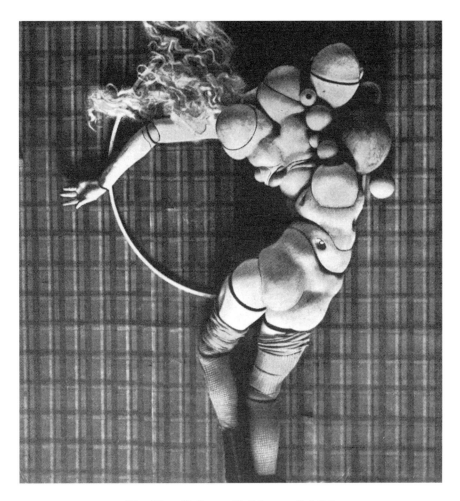

71 Hans Bellmer, *Doll* (second), 1935

The father is vanquished. He sees his son holding a hand-drill, securing a dolly's head between his brother's knees, and telling him: 'Hold on to her for me, I've got to pierce her nostrils'. Pallid, the father goes out, while the son eyes this daughter, now breathing as it is forbidden to do.[80]

Upon this transgression with the *poupées* Bellmer experiences 'a matchless pleasure', a *jouissance* that defies the phallic privilege of the father.[81] Here we may see the *perversion* of the dolls precisely as a *turning away* from the father, from his law. This notion is developed suggestively by Janine Chasseguet-Smirgel, for whom perversion involves a disavowal of the genital capacities of the father, a challenge to his law through an 'erosion of the double difference between the sexes and the generations'.[82] This erosion is enacted by Bellmer not only in his usurpation of the creative prerogative of the father but also, on

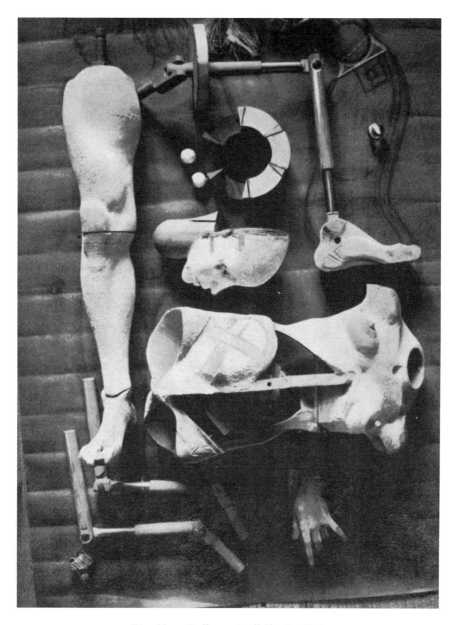

72 Hans Bellmer, *Doll* (first), 1934

the one hand, in his will to interpenetrate hermaphroditically with the female other and, on the other hand, in his scandalous seduction of the 'little girls'.[83] Moreover, throughout his oeuvre he positions the body in the dimension where this erosion of sexual and generational difference is said to be most extreme: 'the undifferentiated anal-sadistic dimension'.[84]

What does all this have to do with fascism? Like Ernst, Bellmer contests it even as he participates partly in it: that is, from within its construction of subjectivity. And he challenges it as seen from a range of perspectives. For example, he contests this subjectivity as theorized by Freud in *Group Psychology*: a subjectivity which, though it dreads the group leader as a primal father, also identifies with him, to the point that that 'this group ideal' comes to 'govern the ego in the place of the ego ideal'.[85] Bellmer is far from any such identification through idealization, but he also contests this subjectivity as differently theorized by Theweleit in *Male Fantasies*: this subjectivity which insists on bodily separation and persecutes all desiring production.[86] As opposed to such separation, Bellmer seeks a release from 'the outline of the self' through an interpenetration with its other. And, as opposed to such persecution, he aims for 'a physical unconscious', a fully libidinal body.[87] In short, against a fascist armouring of body and psyche his dolls are pledged to a surrealist *amour fou*.

Again, this *amour fou* is hardly free from aggressivity, as the mechanizing of the female body in the *poupées* suggests. This leads to my second point regarding the sadism of the dolls, now in relation to masochism. 'I wanted to help people', Bellmer would say in retrospect, 'come to terms with their instincts'.[88] Here we must take him at his word, for the *poupées* do appear to negotiate a struggle between psychosexual fusion and defusion. This struggle is fundamental to *amour fou*, to 'the innumerable *integrating and disintegrating* possibilities', as Bellmer puts it, 'according to which desire fashions the image of the desired'.[89] And within this struggle Bellmer reveals more clearly than any other surrealist the tension between binding and shattering tendencies and the play between sadistic and masochistic impulses. In his work the struggle crucial to surrealism between the erotic and the destructive, the one never pure of the other, is most blatantly played out, and most blatantly its theatre is the female body.[90]

For Freud there is a non-sexual drive to master the object which, when turned inwards, is sexualized for the subject. When turned outwards, this drive to master becomes sadistic. But there remains an aggressivity within the subject that the Freud of the death drive theory termed an 'original erotogenic masochism'.[91] It is this interrelation between sadism and masochism, sexuality and fantasy, life and death drives, that the *poupées* evoke, for, in his sadistic, scenes Bellmer leaves behind masochistic traces; in his destruction of the dolls he expresses a self-destructive impulse. In effect, he sets up an 'anatomy' of love, only to display the deathliness of sexuality–which the dispersed female body is made to represent. In this regard the dolls may go beyond (or is it inside?) sadistic mastery to the point where the masculine subject confronts its greatest fear: its own fragmentation, disintegration and dissolution. Perhaps this is why this subject seems not only to desire the (dis)articulated female body but also to identify with it, not only to master it sadistically but to become it masochistically as well. In one photograph of the first doll Bellmer appears not as its sovereign maker but as its ghostly double (Illustration 73).

With this point I want to return once more to fascist armouring. Again, for Theweleit this armouring is developed against the other of the fascist subject, whether seen as a weak, chaotic interior (his unconscious and sexuality, drives and desires) or a weak, anarchic exterior (Jews, Communists, homosexuals,

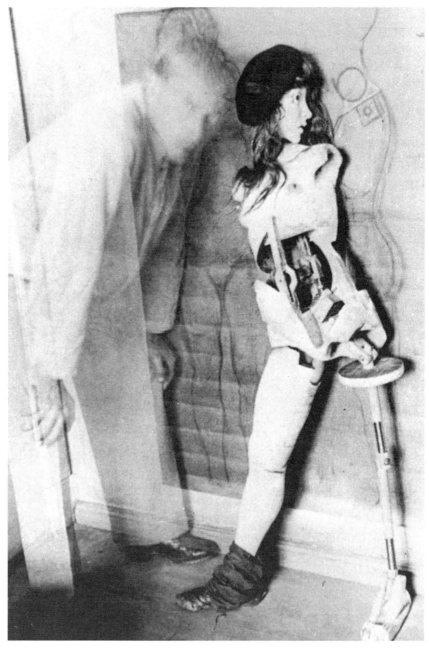

73 Hans Bellmer with *La Poupée*, 1934. From 'Variations sur le montage
 d'une mineu re articulée', *Minotaure*, 6

proletarian women, 'the masses'). Its purpose is to defend against the frag-
mentary and the fluid, the dispersed and the dissolute, as represented by the
feminine. This is a psychic key to the fascist imaginary, for this subject can
only be confirmed in violence against its other, this other that is also 'the
female self within'.[92] One way to develop this account might be to see this self
in terms of the masochistic aspect of the psyche (which Freud did describe,
problematically, as feminine). In this respect the fear of the feminine within
might also be the fear of this destructive or defusive drive within. And this
may be the place where the Bellmer dolls participate most deeply in the fascist
imaginary, only to expose it most effectively, for, in the *poupées*, this fear of the
destructive and the defusive is made manifest and reflexive, as is the attempt
to overcome it in violence against the feminine other; that is the scandal but
also the lesson of the dolls.[93]

I want to return to the beginning of my text – to the juxtaposition of surrealist
transgressions of female images with Nazi atrocities against actual bodies – in
order to contrive a moral at its end which, stated as crudely as possible, is that
representation should not be confused with reality. Here this moral concerns
both sexual politics and modernist studies. Charges of misogyny are often laid
against surrealism, and rightly so. However, some surrealist practices are
ambiguously reflexive about masculinist fantasies, not directly expressive of
them. I admit that the Bellmer images may produce misogynistic effects that
overwhelm his liberatory intentions; but this does not turn them into violent
acts against real bodies. Sometimes even sophisticated viewers overlook this
fact, in part because the reception of these images is no doubt inflected by
contemporary debates about pornography, the terms of which they place
under extreme tension.[94]

It is important to resist this referential collapse of image into act. The same
holds for a further conflation that may target Ernst as well as Bellmer: the
conflation of 'surrealist' and 'Nazi', of 'leftist' and 'fascist'. Clearly both artists
engage in a desublimation of aesthetic forms. Ernst replaces fine art with
printers' proofs, the human figure with dysfunctional machines, and Bellmer
shatters the classical nude into a (dis)articulated doll: perhaps the *nec plus
ultra* of the avant-gardist desublimation of this figure from Courbet and Manet
through Picasso and Kirchner. Ernst and Bellmer also practice desublimation
in a more strictly psychoanalytical sense: a psychic regression is intimated in
the Ernst figures, and an instinctual diffusion is displayed in the Bellmer
poupées. Posed against normative bourgeois identity, these images are thus
also posed against normative Oedipal subjectivity, and in this regard they
may well participate in the erosion of these structures under fascism. But if
they do, I have argued, they do so critically, 'kynically': they mime this fascist
(de)construction of subjectivity in order to expose it from within. The opposed
argument against this avant-gardist desublimation disallows the very poss-
ibility of such a critique.[95] Indeed, it rehearses a Lukácsian condemnation of
modernism *in toto* as so much psychopathology, a 'left fascism' in the hidden
service of reaction against all liberal institutions of individualism.[96] Today it is
important to question any automatic opposition of avant-garde and fascism,

but it is also imperative to resist any automatic identification of the two. There is a fundamentalist anti-modernism in the air, and it does not only blow from the right.[97]

Notes

1 This essay was originally published in *October*, 56 (Spring 1991); it appears here with some minor revisions and a different conclusion.

2 See Rosalind Krauss, 'Corpus Delicti', in Rosalind Krauss and Jane Livingston, (eds), *L'Amour fou: Photography & Surrealism* (New York: Abbeville Press, 1985).

3 This is essentially the argument of Klaus Theweleit in *Male Fantasies* (1977/78), 2 vols, trans. S. Conway, E. Carter, C. Turner (Minneapolis, MN: University of Minnesota Press, 1987/89). I draw on this provocative, problematic text at several points in this article.

4 In this regard literary studies of fascist modernisms are far more advanced than art-historical studies (why this is so is significant in its own right). This literature has grown enormously in recent years; two influential examples in English are Fredric Jameson, *Fables of Aggression: Wyndham Lewis, the Modernist as Fascist* (Berkeley, CA: University of California Press, 1979), and Alice Yeager Kaplan, *Reproductions of Banality: Fascism, Literature, and French Intellectual Life* (Minneapolis, MN: University of Minnesota Press, 1986). I am aware that even as I question the anti-typical function of fascism I mostly preserve it here.

5 I mean associations that can be culled from surrealist practices. Fascist sympathies were, of course, expressed programatically by some early associates (e.g., Drieu la Rochelle) and scandalously by some late members (e.g., Dali).

6 See my 'Exquisite Corpses' in Lucien Taylor (ed.), *Visualizing Theory* (New York: Routledge, 1993), and my *Compulsive Beauty* (Cambridge, MA: MIT Press, 1993).

7 Opposed ideologically, these figures, the dadaist – surrealist and the (proto)fascist, share a historical referent: the soldierly body of the First World War. In the (proto)fascist ideal this body is steeled, its psychic and physical mutilation disavowed. In dada, on the other hand, this body is often represented critically as such: as actually mutilated or as dysfunctionally machinic. Meanwhile, in surrealism, it returns uncannily, its mutilation displaced to the female body (e.g., dismembered mannequins, ruined torsos and the like), where its psychic state becomes manifest as castration.

8 The classic text is, of course, Michel Carrouges, *Les machines célibataires* (Paris, 1954), though Carrouges considers neither the Ernst nor the Bellmer works.

9 However, I am aware of at least one contemporary motive of this text: the sense that the figure of the armoured body pervades the imaginary of American culture. The militaristic posture of this figure has hardly disappeared; it is only repositioned along many faceted fronts where the individual body is shot through with the body politic: e.g., the Straight Body versus the AIDS Body, the Unmarked Body versus the Ethnic Body, the Pumped-up Body versus the Desiring Body, the Aerobic Body versus the Ageing Body, all perhaps governed by the opposition of Pure Body and Abject Body. Though sometimes parodic, even critical, the armoured figures of commercial culture symbolically treat fantasmatic threats to the normative social ego: visions of cities given over to drugged minorities (e.g., *Robocop*), of environments culturally invaded and genetically mutated (e.g., *Ninja Turtles*), and so on. In 1951 Lacan suggested that such armoured figures 'exteriorize the protective shell of [the] ego [of the heterosexual male], as well as the failure of his virility': 'Some Reflections on the Ego', *International Journal of Psychoanalysis*, 34 (1953). How much more complicated is the present complex where such shells are more developed, such virility more aggressive, and the technological devices at the disposal of this ego no longer exterior to the body (on the one hand) or

within its control (on the other)? With its deadly technophilic Orientalism the Gulf War was in part a continuation of this complex by other means.

10 Ernst in an interview with Patrick Waldberg, 'La Partie de Boules: Die Boules-Partie', in *Max Ernst in Selbstzeugnissen und Bilddokumenten* (Hamburg, 1969), p. 35, extracted in Diane Waldman, *Max Ernst: A Retrospective* (New York: Solomon R. Guggenheim Museum, 1991), p. 21.

11 Max Ernst, *Beyond Painting* (New York: Wittenborn & Schultz, 1948), p. 14. This art-treatise-cum-auto-analysis includes several texts, the earliest of which dates from 1927. Needless to say, this framing of the war contrasts sharply with its (proto)fascist celebration.

12 Ernst first read Freud in 1911, though it seems that his psychology courses were largely Wundtian in bias, i.e., sceptical of the Freudian unconscious. Also at this time Ernst became familiar with the Kraepelin classification of mental disorders in his *Textbook of Psychiatry* (1896). For his use of such material see Elizabeth R. Legge, *Max Ernst: The Psychoanalytic Sources* (Ann Arbor, MI: UMI Press, 1989), pp. 11–6.

13 Meanwhile, his fellow Cologne dadaist, a rich radical named Alfred Gruenwald, identified with the commodity via the pseudonym 'Baargeld' or 'ready money'.

14 Apparently there were many so produced, most of which are now lost. Although all but one discussed here are included in the Werner Spies catalogue of Ernst collages (*Max Ernst: Les collages*: Paris: Gallimard, 1984), these printers' proofs on paper altered with pencil, ink and/or gouache are not as materially various as most dadaist collages.

15 Though automatist in principle, the collages advance a mechanization of artistic procedure as well as of bodily image. This points to the dialectical relation in dada between the automatist and the mechanical, a relation that is further complicated in surrealism with the involvement of the unconscious.

16 Although my partially iconographic approach to the Ernst collages is perverse, its pertinence points to a problem in modernist art history: that practices like dada (or pop) often project iconographic themes even as they work to defy such meaning. I have intentionally bracketed the familiar art-historical associations of the Ernst collages to Duchamp and Picabia as well as to de Chirico; for these associations see Spies, *Max Ernst: Les collages*.

17 Gilles Deleuze and Félix Guattari, *Anti-Oedipus: Capitalism and Schizophrenia* (1972), trans. R. Hurley, M. Seem, H. Lane (New York: Viking Press, 1977), p. 31. The collages are thus bachelor machines in the sense elaborated in this text as well.

18 Collaterally, in a few wartime paintings Ernst suggests a mechanizing of landscape, and in a few 1920 collages a metallizing of organic forms. In one such collage, *Démonstration hydrométrique à tuer par la température*, he evidently refers such deathly processes to entropy, to the second law of thermodynamics. In the same year, 1920, Freud extrapolated from this law in his theory of the death drive in *Beyond the Pleasure Principle*. For technical and cultural elaborations of such energistic concepts, see Anson Rabinbach, *The Human Motor: Energy, Fatigue and the Origins of Modernity* (New York: Basic Books, 1990). In some ways the Ernst imaging of a military-industrial body plays critically on the fundamental redefinition of the worker detailed brilliantly by Rabinbach.

19 Peter Sloterdijk develops this distinction in his *Critique of Cynical Reason*, trans. Michael Eldred (Minneapolis, MN: University of Minnesota Press, 1987). There, in terms appropriate to the Ernst collages, he writes of the 'kynical irony' of 'a bashed ego' that performs 'resistance in the form of unresisting accommodation' (p. 441). In this light one might say that Ernst does to the modernist image in relation to reification what Baudelaire, according to Benjamin, does to the lyric poem in relation to the commodity.

20 Ernst in Waldman, *Max Ernst: A Retrospective*, p. 21.

21 Ibid. By now I have cut up this 1969 statement so much that I ought to reproduce
 it intact:

 Contrary to general belief, Dada did not want to shock the bourgeoisie. They
 were already shocked enough. No, Dada was a rebellious upsurge of vital
 energy and rage; it resulted from the absurdity, the whole immense *Schweinerei*
 of the imbecilic war. We young people came back from the war in a state of
 stupefaction, and our rage had to find expression somehow or other. This we
 did quite naturally through attacks on the foundations of the civilization
 responsible for the war.

22 See Freud, *Beyond the Pleasure Principle* (1920), trans. James Strachey (New York:
 W.W. Norton, 1961), pp. 6–7, 23–7. In a different way Walter Benjamin relates the
 Communist revolts of the time to the shock of the war: 'In the nights of annihila-
 tion of the last war the frame of mankind was shaken by a feeling that resembled
 the bliss of the epileptic. And the revolts that followed it were the first attempt of
 mankind to bring the new body under its control. The power of the proletariat is
 the measure of its convalescence'. See 'One-Way Street' (1928) in *Reflections*, trans.
 Edmund Jephcott (New York: Harcourt Brace Jovanovich, 1978), p. 94.
 Incidentally, this psychic work of the dadaist image would soon be fundamental
 to the surrealist image, at least as developed by Ernst precisely out of such
 collages as these. See my *Compulsive Beauty*.
23 The use of 'salad' here may be a derisive allusion to the Kraepelin dismissal of
 schizophrenic representation as 'word or picture salad'. 'Perisperm', meanwhile, is
 a tegument that covers some kinds of seeds.
24 Like some other bachelor machines (e.g., the Picabia *Girl Born without a Mother*,
 1916–17), this self-constructed small machine plays upon a patriarchal fantasy of
 technological creation outside the maternal body, a perverse family romance in
 which a machinic conjunction substitutes for a biological origin. This fantasy is a
 staple of twentieth-century modernisms across the political spectrum from
 Marinetti to Léger; indeed, it is difficult to distinguish a specifically fascist version.
 In this regard this remark on modern technology by the 'expressionist philoso-
 pher' Adrien Turel may only state explicitly what many other modernists think
 subconsciously: 'This technical prosthetic system, which is a typically masculine
 achievement, can only be compared with the prenatal, complete enclosure in the
 body of the mother' (from his 1934 *Technokratie, Autarkie, Genetokratie* quoted in
 Sloterdijk, *Critique*, p. 459).
25 Almost all the other collages, some of which also intimate autistic systems, are
 signed 'Max Ernst'. I return to the autistic aspect of the machinic figures below.
26 This points to a possible non-sociological reason why the fantasy of creation
 outside the mother is often figured in machinic terms.
27 Accounts of Oedipal conflict are commonplace in the literature on Ernst (cf. Legge,
 Max Ernst), indeed, on surrealism generally, but the literature entirely misses this
 crucial ambivalence.
28 For example, Marie Laurencin had tried to get Ernst a visa, without success. See
 Uwe Schneede, *Max Ernst* (London: Thames & Hudson, 1972), p. 21.
29 There are many psychoanalytical theories of (proto)fascist subjectivity, e.g., from
 Freud (*Group Psychology and the Analysis of the Ego*) and Reich (*The Mass Psychology
 of Fascism*) through the Frankfurt School (*The Authoritarian Personality*) to Deleuze
 and Guattari (*Anti-Oedipus*) and Theweleit (*Male Fantasies*). I am aware of the
 political dangers of such theories, as I am of their ideological incompatibilities.
 But no single account seems adequate to me (at least not in relation to the Ernst
 and the Bellmer works), though I do draw mostly on the Theweleit here.

30 In such representations boundaries are also treated paradoxically, sometimes totally ignored, sometimes excessively elaborated. Often this insistence on boundaries, prompted by anxiety about boundlessness, produces this very effect.

31 *Bildnerei der Geistenkranken* (1922) contains some 5000 works by some 450 artists, which Prinzhorn organized around six general categories: a need to express feelings, playfulness, ornamentation, a need for order, a compulsion to copy, and a tendency to visual-verbal systems. Although this text appeared after his collages, Ernst knew related work; he once planned to write a book on the subject. Moreover, as Sander Gilman has noted, the 'mythopoesis of mental illness ... dominated the German intellectual scene in the opening decades of the twentieth century'. See his 'Madness and Representation: Hans Prinzhorn's Study of Madness and Art in its Historical Context', in Stephen Prokopoff (ed.), *The Prinzhorn Collection* (Champaign-Urbana, IL: University of Illinois, 1984), p. 11, as well as his *Difference and Pathology: Stereotypes of Sexuality, Race and Madness*, (Ithaca, NY: Cornell University Press, 1985), pp. 217–38. Then as now the use of 'schizophrenia' as a cultural diagnostic bordered on cliché. On its dangers see Jacqueline Rose, 'Sexuality and Vision: Some Questions', in Hal Foster (ed.), *Vision and Visuality* (Seattle, WA: Bay Press, 1988).

32 It should be noted that some of the collages were circulated in the thousands in publications edited by Ernst and Gruenwald (the most important, *Der Ventilator*, was suspended by the British army of occupation after six numbers).

33 See Bruno Bettelheim, *The Empty Fortress: Infantile Autism and the Birth of the Self* (New York: The Free Press, 1967), pp. 233–339. Suspect though Bettleheim has become, I use this case history, distant though it is from the Ernst images, for a specific reason. Although machinic images are also found in the Prinzhorn collection, his formalism renders his text rather inattentive to the aspects of 'the art of the mentally ill' that interest me here. Moreover, Joey's representations occasionally resonate with Ernst's figures, just as Bettelheim's reading of this autistic child occasionally converges with Theweleit's account of the (proto)fascist subject.

34 Ibid, pp. 272–83. As we will see, Theweleit detects a related double bind, and a similar fear of 'mire', in his (proto)fascist subjects.

35 Ibid, p. 319.

36 As they do even more so with the Theweleit account.

37 See note 26.

38 In *Beyond Painting* Ernst presents the advent of most of his primary techniques (painting, collage and frottage) in terms of a primal scene. In a well-known passage on the collages he writes:

> One rainy day in 1919 ... I was struck by the obsession which held under my gaze the pages of an illustrated catalogue ... There I found brought together elements of figuration so remote that the sheer absurdity of that collection provoked a sudden intensification of the visionary faculties in me and brought forth an illusive succession of contradictory images ... peculiar to love memories and visions of half-sleep. (p. 14)

This association of an aesthetic discovery with the sexual-visual confusions of the primal scene underlies not only his definition of collage ('the coupling of two realities, irreconcilable in appearance, upon a place which apparently does not suit them': p. 13) but also his understanding of its purpose: like the primal scene collage is to disturb 'the principle of identity' (p. 19), even to 'abolish' the concept of 'author'. At some level it is this 'coupling' which the Ernst collages recapitulate, this trauma which his art as a whole works over, in form as well as in content. For more on his rewriting of 'convulsive beauty' as 'convulsive identity', see *Compulsive Beauty*.

39 The long title refers to Jupiter and Leda as well as to Lohengrin and Elsa.
40 Bettelheim, *Empty Fortress*, p. 294.
41 See Ernst, 'Some Data on the Youth of M.E. as told by himself', in *Beyond Painting*, pp. 26–9. Also see Werner Spies, *Max Ernst, Loplop: The Artist in the Third Person* (New York: George Braziller, 1983), pp. 79–80. Alternatively, perhaps, the early work is about the social deformation of the subject, about an inadequate ego construction, while the later work concerns the psychic disruption of the subject, a convulsed ego construction.
42 Bettelheim, *Empty Fortress*, p. 325. Freud uses the metaphor of a bird's egg to describe a closed psychological system in 'Formulations Regarding the Two Principles in Mental Functioning' (1911), as does Margaret Mahler in *On Human Symbiosis and the Vicissitudes of Individuation* (New York: International Universities Press, 1970), where her term 'hatching process' designates the slow separation from maternal symbiosis.
43 Ernst, *Beyond Painting*, p. 29.
44 Theweleit, *Male Fantasies*, vol. 2, p. 357. In 'Theories of Fascism' (1930), a review of an essay collection on the war edited by Ernst Jünger, Benjamin remarks that its loss came to be treated as 'the innermost essence' of Germany (especially as worked over in Spenglerian narratives of decline). See *New German Critique*, 17 (Spring 1979).
45 For Freud shock occurs on the piercing of 'the protective shield' (*Reizschutz*) of the body, an extruded layer of matter said to protect the organism against excessive stimuli. This quasi-physiological model, resurrected in *Beyond the Pleasure Principle*, resonates with my discussion of the armoured body, perhaps also with the Ernst imaging of an 'evolution' of 'anatomy' as a 'hypertrophic trophy' or 'bitter perisperm'. Indeed, Nobert Elias took up this model to think the development of a military-industrial body in *The Civilizing Process* (1939), trans. Edmund Jephcott (New York: Urizen Books, 1978). Concerned with armouring as a psychic phenomenon, Theweleit is ambivalent about this sociological account. On the one hand, he speaks of 'the technization of the body'; on the other hand, he argues that 'it has nothing to do with the development of machine technology' (*Male Fantasies*, vol. 2, pp. 202, 162).
46 Freud, *The Ego and the Id*, p. 16.
47 J. Lacan, 'The Mirror Stage as formative of the function of the I', *Ecrits*, trans. Alan Sheridan (New York: W.W. Norton, 1977), p. 15.
48 In his model narcissism is bound up dialectically with aggressivity: 'Aggressivity is the correlative tendency of a mode of identification that we call narcissistic' ('Aggressivity in Psychoanalysis', *Ecrits*, p. 16). On the one hand, the subject arrives at coordination, keeps the fragmented body at bay, through aggressivity; on the other hand, aggressivity recalls the very imagos of the fragmented body that threaten the subject. (Significantly *vis-à-vis* Bellmer, Lacan cites the example of dolls torn to pieces by children.) Such reflections lead him elsewhere to question the advantage of 'a strong ego'; see Lacan, 'Some Reflections on the Ego', p. 16.
49 For a little more on these connections see my 'Postmodernism in Parallax', *October*, 63 (Winter 1993).
50 *Contra* Freud, Theweleit questions whether the (proto)fascist subject ever achieves Oedipus, and *contra* Lacan he takes up the Deleuze–Guattari polemic against a conception of desire as founded in lack. Nevertheless, he is more indebted to both than he wishes to admit, just as he uses specific aspects of ego psychology (e.g., Margaret Mahler) even as he is generally critical of it.
51 'The armour of these men can be seen as constituting their ego' (*Male Fantasies*, vol. 2, p. 164). In the psychoanalytic literature Reich speaks of 'armouring' explicitly but also generally: for him it is fundamental to all character formation.

See *Character Analysis* (1933), trans. Vincent R. Carfagno (New York: Farrar, Straus & Giroux, 1972), pp. 43, 237. In 'The Mirror Stage' Lacan speaks of 'the armour of an alienating identity' (p. 4).

52

> I can think of no single psychoanalytic term developed with reference to the psychotic child that could not equally be applied to a behavioural trait of the "fascist" male. In both, object relations are equally impossible: both are distanced from the libidinal, human object world. Both have an "interior" that is chaoticized, saturated with aggression: both fear that their boundaries will disintegrate on contact with intense external vitality (*Male Fantasies*, vol. 2, p. 220)

This is dangerous – to see the fascist as psychotic, or (worse) vice-versa – more dangerous than the association of autistic and avant-gardist. It may repeat by reversal the charge of 'degenerate' levelled by the Nazis against modernism, and it remains within a system of the normal versus the pathological. And yet Theweleit asserts that this psychopathological type *is* 'the norm in Germany ..., far more "normal" and common than Oedipus' (*Male Fantasies*, vol. 2, p. 213).

53 See Mahler, *On Human Symbiosis*.

54 Theweleit, *Male Fantasies*, vol. 1, p. 418. In this regard etymological aspects of 'fascism' become suggestive: e.g., *fasces* (Latin) for rods or branches wrapped around an axe, *fascia* (English/French) for tissue binding muscles (see Kaplan, *Reproduction of Reality*, p. xxvii).

55 For Mahler autistic 'deanimation' is a defence against a dread of dissolution, a fear of engulfment, as is, for Theweleit, armoured aggressivity.

56 See, for example, Theweleit, *Male Fantasies*, vol. 1, p. 258, and vol. 2, pp. 74, 77, 403.

57 The Freikorps soldier 'rediscovers his boundaries only as a killer' (*Male Fantasies*, vol. 2, p. 38). Also see ibid, pp. 87, 192, 196–7, 208.

58 The phrase derives from Ernst Jünger, *Der Kampf als inneres Erlebnis* (1922).

59 Quoted in Theweleit, *Male Fantasies*, vol. 2, p. 179. Solomon was also an accessory to the murder of the prominent Jewish politician and financier Walter Rathenau. In Freikorps literature Theweleit notes a persistent version of the trope of man coupled with machine, the (machine) gun as whore, the sadism of which Bellmer exposes in his *Mitrailleuse en état de grâce* (1937).

60 Jünger quoted in Theweleit, *Male Fantasies*, vol. 2, p. 179. Jünger, it should be noted, was critical of the Nazis, from the aristocratic right.

61 Jünger, 'Photography and the "Second Consciousness" ', in Christopher Phillips (ed.), *Photography in the Modern Era* (New York: The Metropolitan Museum of Art, 1989), p. 207. In this text he actually advocates 'objectification': deadness recoded as vitality. This is also valued in the fascist modernism of Wyndham Lewis: 'Deadness is the first condition of art. The armoured hide of the hippopotamus, the shell of the tortoise, feathers and machinery ... With the statue its lines and masses are its soul, no restless inflammable ego is imagined for its interior: it has no inside: good art must have *no inside*: that is capital': *Tarr* (London: Calder & Boyars, 1968), pp. 279–80. Jameson glosses this modernism suggestively here: Lewis, he writes, 'stages something like a search for the ego, for the unifying principle of some autonomous, central subject, at the same time exploring the effects of the systematic dispersal of psychic unity by various historical agencies' (*Wyndham Lewis*, p. 97).

62 Sloterdijk, *Critique*, p. 468. 'Algodicy means a metaphysical interpretation of pain that gives it meaning' (p. 460). Although Sloterdijk does not cite Theweleit, he too regards the 'armouring of the ego against its suffering' as 'part of the Weimar zeitgeist' (ibid, pp. 467–8).

63 See Jeffrey Herf, *Reactionary Modernism: Technology, Culture, and Politics in Weimar and the Third Reich* (Cambridge: Cambridge University Press, 1984), p. 30, and

Anson Rabinbach, 'The Aesthetics of Production in the Third Reich', *Journal of Contemporary History*, 11 (1976), pp. 43–74.

64 There is a whole critical literature on *Male Fantasies*; let me mention just two points. The first concerns the (proto)fascist as 'not fully born'. Influenced by Mahler, Theweleit discounts regression as an explanation of the 'psychotic' traits of the (proto)fascist: 'His stabilizations derive from external sources; and when these disappear, he has no need of "regression". Instead, all the qualities otherwise concealed and dammed up inside him are suddenly released in their original form' (vol. 2, p. 259). But what then is sexual difference for this subject, and all that it subtends? On another level, how might this 'psychotic' designation relieve this subject of responsibility? This points to a double bind: criticized on the psychoanalytical front, Theweleit is also chastized for an overly psychoanalytical account: i.e., one which does not attend to economic determination or racist ideology (the anti-semitism of the Nazis, the *Tremendum* of Jewish oppression). However, his problematic is not fascism or Nazism *in toto* but rather its imaginary in certain German men of the 1920s.

65 The term is Marinetti's, as quoted by Walter Benjamin in 'The Work of Art in the Age of Mechanical Reproduction', *Illuminations*, trans. Harry Zohn (New York: Schocken Books, 1969), p. 241.

66 My delay signals the dilemma that to discuss this work is already to defend it, and it is very difficult to defend morally (that is, in terms of its disposition to its figured other). So why consider it at all? Because ethically – that is, in terms of its insight into a constituted self – it is incisive about certain aspects of both male (hetero)sexuality and fascist subjectivity.

67 For biographical information as well as critical analysis see in particular Peter Webb (with Robert Short), *Hans Bellmer* (London: Quartet Books 1985). Incidentally, Bellmer had ties to (Berlin) dada; at the Berlin Technical School of Art he met Grosz and Heartfield among others.

68 In this regard Bellmer makes explicit that the ground of Oedipal conflict is the female body.

69 *Die Puppe* (Karlsruhe: Th. Eckstein, 1934), the first publication of the first doll, contained ten photographs; eighteen photographs were then published in *Minotaure*, 6 (Winter 1934–35) under the title 'Variations sur le montage d'une mineure articulée'. I have mostly drawn on the French translation of *Die Puppe*, *La Poupée*, trans. Robert Valencay (Paris: Guy Lévis-Mano, 1936), n.p.

70 See Krauss, 'Corpus Delicti', p. 86; also see my 'L'Amour faux', *Art in America* (January 1986). Freud briefly discusses such multiplication in relation to the threat of castration in 'Medusa's Head' (1922).

71 Bellmer, *Petite Anatomie de l'inconscient physique, ou l'Anatomie de l'image* (Paris: Le Terrain Vague, 1957), n.p. This text was mostly written during the Second World War, part of which Bellmer spent interned, along with Ernst, as a German alien in France.

72 Freud, 'Some Psychical Consequences of the Anatomical Distinction Between the Sexes' (1925), in *On Sexuality*, ed. Angela Richards (Harmondsworth: Penguin Books, 1977), p. 336.

73 Bellmer was inspired to make the dolls in part by a 1932 Max Reinhardt production of Offenbach's *Tales of Hoffmann*. For Freud, who glosses Hoffmann's 'The Sandman' in 'The Uncanny' (1919), associations of castration and fetishism cluster around the doll Olympia (or in the operetta Coppelia), but behind her lurks Coppelius, the evil father figure. More generally in Freud, the threat of castration may be posed for the male subject by the female body, but it is only guaranteed, as it were, by the paternal figure.

74 The second doll appears more fetishistic-scopophilic, its structure one of ambivalence, a recognition-disavowal of castration; while the first doll

appears more sadistic-voyeuristic, concerned to reveal, even to persecute, such castration.

75 Bellmer, *Obliques* (Paris: Borderie, 1975), p. 109; also quoted in Christian Jelinski, *Les dessins de Hans Bellmer* (Paris: Denoël, 1966), p. 15. On this 'shattering' see the provocative argument in Leo Bersani, (ed.), *The Freudian Body: Psychoanalysis and Art* (New York: Columbia University Press, 1986), pp. 29–50.

76 Bellmer, *La Poupée*. An illustration in *Die Puppe* connects this mechanism directly to voyeurism, as does a reference in the text to a 'conscious gaze plundering their charms'. Paul Foss writes of the second doll: 'What is this "thing" or composite of things but the gaze pulled to pieces by the eyes, an open combinatory of spatial visions?': 'Eyes, Fetishism, and the Gaze', *Art & Text*, 20 (1986), p. 37. This remark holds for many of the drawings as well, especially as they tend to disjunctive superimpositions.

77 A third point concerns the nature of the sadomasochistic agreement. The sadist does not destroy his other; his part of the agreement is to preserve him or her: such is one stake at least of his mastery. Thus when Bellmer claims that the desires of his other are also figured in the dolls, we cannot merely dismiss it as an obscene rationalization. On this particular bond of love, see Jessica Benjamin, *The Bonds of Love: Psychoanalysis, Feminism and the Problem of Domination* (New York: Pantheon, 1988), pp. 51–84.

78 Benjamin, *Passagen-Werk* (Frankfurt am Main: Suhrkamp Verlag, 1982), V, p. 466. Contrast Bellmer: 'I want to reveal scandalously the interior that will always remain hidden and sensed behind the successive layers of a human structure and its lost unknowns' (*l'Anatomie de l'image*).

79 Theodor W. Adorno and Max Horkheimer, *Dialectic of Enlightenment* (1944), trans. John Cumming (New York: The Seabury Press, 1972), p. 235. 'Those who extolled the body above all else,' they add, 'the gymnasts and scouts, always had the closest affinity with killing, just as the lovers of nature are close to the hunter'. Adorno and Horkheimer also touch upon the masochistic aspect of this sadism.

80 Jean Brun, 'Désir et réalité dans l'oeuvre de Hans Bellmer', in *Obliques*, quoted in Jelenski, *Les desse ins*, p. 7. This reading is supported by a bitter prose-poem by Bellmer titled 'The Father', which attests to the subversive power of fantasy. But, again, the ground of this 'subversion', the female body, seems all but forgotten here.

81 From a 1964 letter to Herta Hausmann quoted in Webb, *Hans Bellmer*, p. 162.

82 Janine Chasseguet-Smirgel, *Creativity and Perversion* (New York: W.W. Norton, 1984), p. 2. This text includes a brief discussion of Bellmer (pp. 20–2) to which I am indebted. Bellmer: 'To an extent [the dolls] represented an attempt to reject the horrors of adult life as it was, in favour of a return to the wonders of childhood, but the eroticism was all-important, they became an erotic liberation for me' (quoted in Webb, *Hans Bellmer*, p. 34).

83 Bellmer: 'It is a question of the peculiar hermaphrodite interconnection between the male and the female principles in which the female structure predominates. What is always vital is that the image of the woman must have been "lived" (experienced) by the man in his own body before it can be "seen" by the man' (*l'Anatomie de l'image*).

84 Chasseguet-Smirgel, *Creativity*, p. 78.

85 Freud, *Group Psychology*, p. 59.

86 Again I have mixed theories. Theweleit is critical of the Freudian account of the fascist subject *vis-à-vis* paternal authority, intent as he is to explore its pre-Oedipal aspects. He is no less at odds (though here tacitly) with Chasseguet-Smirgel, who has her own theory of fascism as a 'fatherless universe' that permits a regressive fusion with the mother, with *Blut und Boden*. (On these points see the foreword to Theweleit, *Male Fantasies*, vol. 2, by Jessica Benjamin and Anson Rabinbach; also

see Benjamin, *The Bonds of Love*, pp. 144–55, which includes a critique of Chasseguet-Smirgel.) My own argument is also mixed. Can one follow a theory of the fascist subject in terms of perversion (as in Theweleit) on the one hand, and propose a critique of this subject also in terms of perversion (as in my reading of the *poupées*) on the other?

87 See *l'Anatomie de l'image*. There Bellmer discusses what his dolls and drawings perform: different displacements and superimpositions of male and female organs and limbs, sometimes in difficult articulations, sometimes in dangerous dissolutions. It is as if he seeks to be *horsexe* (in the sense of Catherine Millot). Bellmer: 'Man in that which I appear, I am woman in my physiological horizon, in my amorous vocation' (quoted in Webb, *Hans Bellmer*, p. 143).

88 Bellmer quoted in ibid, p. 38.

89 Bellmer in the exhibition catalogue for 'Le Surréalisme en 1947' at the Galerie Maeght, as quoted in Dawn Ades in *Dada and Surrealism Reviewed* (London: Hayward Gallery, 1978), p. 296 (italics added).

90 This may be one reason why Bellmer is marginal to the literature on surrealism: not because his work is eccentric to it but because its articulation of the sadomasochistic basis of sexuality is all too central. On this basis see Jean Laplanche, *Life and Death in Psychoanalysis*, trans. Jeffrey Mehlman (Baltimore, MD: The Johns Hopkins University Press, 1976), pp. 85–102, and Bersani, *The Freudian Body*, pp. 29–50. Laplanche traces three related routes through this tangled terrain depending on which moment in the Freudian corpus is privileged.

91 See Freud, 'The Economic Problem in Masochism' (1924). In the work of Kaja Silverman and others, an attention to masculinity has meant a focus on masochism.

92 J. Benjamin and A. Rabinbach, 'Foreword', in Theweleit, *Male Fantasies*, vol. 2, xix.

93 Bellmer: 'If the origin of my work is scandalous, it is because, for me, the world is a scandal' (quoted in Webb, *Hans Bellmer*, p. 42).

94 That is, the images may speak to the position that representations can be performative – that certain images can provoke certain actions like rape – *or* to the position that fantasy unfixes any essentialist anchorings of gendered subjectivity or spectatorship. No doubt reception of these images is further complicated by pervasive anxieties about child abuse.

95 For example, in 'Modern Art and Desublimation' Russell Berman argues that 'the historical demise of autonomous art contributes to the virulence of social aggression, especially to a recrudescent nationalism': *Modern Culture and Critical Theory* (Madison, WI: University of Wisconsin, 1989), p. 72.

96 I derive this term 'left fascism' from a paper of this title delivered by Richard Wolin at Cornell in the spring of 1993. Wolin condemns Bataille, those who associated with him (among whom one may number Bellmer), and those who were influenced by him (post-structuralists of all stripes), as so many 'left fascists'.

97 There is a parallel reaction against socialist, especially Soviet, avant-gardes. The Cold War hardly ended with the fall of the Berlin Wall which, in modernist studies at least, ushered in a renewed triumphalism. According to *this perestroika*, Russian constructivism is to be rescued from the Russian revolution, now revealed to be an historical error, and/or trashed as the precedent of Stalinist culture. (The epitome of this latter revisionism is Brois Groys's *The Total Art of Stalin*, Princeton, NJ: Princeton University Press, 1992.) The avant-gardist romanticism of the old extreme – to heroicize constructivism in easy opposition to Stalinism, or to purify modernism in easy opposition to fascism – is hardly improved by the anti-modernist *ressentiment* of this new extreme.

PART IV

Chapter Twelve
The Pen and the Eye: The Politics of the Gazing Body

Françoise Lucbert

I open this section, dedicated to the entanglement of vision and textuality as it affects the interaction between discourse and politics, with two quotations from two different genres of contemporary artistic production, both working on the reconciliation of the word and the image, respectively a movie referring to a founding textual tradition (the Bible) and a novel questioning the grounds of visual activity.

My first quotation is the exergue of *In Weiter Ferne, so nah!* (*Faraway, so Close!*), a recent movie by Wim Wenders. Wenders's story of the fallen angel Cassiel begins with a significant verse from the Bible: 'The light of the body is the eye' (Matthew, 6: 22, Authorized Version). The rest of the verse bears quotation, even if it is not mentioned by Wenders: 'If therefore thine eye be single, thy whole body shall be full of light'. The material light distributed in the body by the eye is compared to the spiritual light sparkling from the soul. In the metaphorical sense, the eye stands for the soul. A reading of the entire verse helps to explain the traditional conception of the eye as the reflection of someone's soul. In fact, as far back as *Genesis*, the eye as an organ implies a spiritual eye. When the snake tries to persuade Adam and Eve to eat the forbidden fruit, the devil argues that the apple can give them the power to establish the difference between good and evil: 'For God doth know that in the day ye eat thereof, then your eyes shall be opened, and ye shall be as gods, knowing good and evil' (Genesis, 3: 5). In such a view, vision – both as a phenomenological perception (sight) and as an 'inner vision' (insight) – would be the only trace of human life in Paradise. The eye is the light of the body because vision is a fragment of the divine light stolen from the gods by human beings before their fall on earth. We can notice that if, on one side, the Judaeo – Christian tradition definitively separated the soul from the body, it also conceived the human being as the site of the encounter between these two aspects. Even in the most Manichean conceptions of humanity, the soul always needs a body to become incarnate. How could such philosophers totally disregard their own bodies?

My second quotation comes from Paul Auster's *The Invention of Solitude*. The author comments on the perpetual interlacing of writing and seeing: 'For no word can be written without first having been seen, and before it finds its way to the page it must first have been part of the body, a physical presence that one has lived with in the same way one lives with one's heart, one's stomach, and one's brain'.[1] First and foremost, the activity of writing is deeply concerned with the activity of seeing. The physical activity of drawing characters on the flat surface of a page echoes the trajectory of the eye projected in the open, extended field of the visible. It is interesting to compare Auster's proposal with the traditional definition of vision. Since antiquity, vision has been associated with words. Ancient texts often confuse the activity of *seeing* and the activity of *speaking*; or, to be more precise, with the faculty of hearing divine oracles. In the Old Testament, the prophets literally see the Word (*Verbum*).[2] For example, Amos and Isaiah actually see the 'words concerning Israel' (Amos, 1:1; Isaiah, 2:1). Such visions are both experienced as images and sounds: at the same time, the prophets 'see' an apparition and 'hear' an oracle. In fact, Isaiah is able to visualize the burden of Babylon (Isaiah, 13:1) because God's *words make him see*, in both senses of the word. This apparent confusion between sight and hearing is very significant and, in my opinion, goes beyond the simple use of rhetorical figures. This type of *synaesthesia* haunts most of Western textuality, from philosophy to poetry, including art criticism, theatre, literature, and so on. The profound interweaving of gaze and discourse may partly come from the fact that the eye (as sight and as insight) and the ear (as hearing and as understanding[3]) are both located in one and the same human body. And we must admit that the Word could hardly have been made flesh if the body did not exist.

I chose these quotations because they allow me to situate the interaction of vision and textuality under the aegis of the body, and the three authors I introduce here – John Bender, Peter de Bolla and Thomas Crow – share this standpoint in their own work on the dialectic between vision and textuality. The eye glancing or gazing at the world and the hand holding the pen or the brush are actually sited in the body of the writer-viewer. But I chose these quotations because the fundamental point that should be stressed here is the relation between body, art and power. I define the 'gazing body' as a powerful biological and psychological individual inserted into a larger body: the social, historical and political one.

The three texts of the present section deal with complex issues touching on the relation between discourse and politics in art and/or literature. In contemporary criticism, the word 'politics' is often used by social historians of art. My few comments on the biblical conception of vision attempt to open the discussion about art and politics as widely as possible. I would not confine the political aspect of art to the *visual representation of political significations*. Even if revisionist art history reveals the limits of the formalist model and allows the multiplication and the reconciliation of many different methods (including feminist art history, psychoanalysis, the social history of art, Marxism, literary theory, structuralism, connoisseurship, and so on), it also has its own limits. Revisionist art history has the disadvantage of being primarily concerned with the representational dimension of art. For instance, Linda Nochlin's 'politics of vision'[4] shows how the works of artists such as Courbet, Pissarro, Degas and

Seurat deal with a specific socio-political situation. Titles such as *Representations of Women in Victorian Britain* or *Looking into Degas: Uneasy Images of Women and Modern Life*[5] are eloquent: art objects are in the first place considered as visual documents useful in the study of relations between art and society.[6] To my mind, the problem does not result from the choice of a particular corpus or methodology (I personally think that a feminist account is absolutely crucial in the practice of contemporary criticism[7]); but I am convinced that it is essential to rethink the interaction of art and power beyond the 'representational phallacy'. If we are mainly interested in the anecdotal content of art, how can we bring to light the real political dimensions of art and/or literature? Art is not solely a representation, an image of *something else*. As a discursive and aesthetic practice, it also has the power of intervening in society, and power has to be sought both inside and outside art practices.

The 'politics of the eye' presented here are concerned with the corporeal discipline which *represses* the eye as an organ. The question of the body (where, as Bataille argues, both the activity of seeing and the erotic pulsions are sited[8]) would thus provide the link between power and art productions. Since Plato, mind governs the eye and the body. The thematics of representation partly perpetuates the conception of visibility as a subjugated instrument. As Michel Foucault has demonstrated, the theory of similitude was grounded on an assumed correspondence between the world and the language: the assumption that the world *signifies* as language does.[9] Power and words are closely related because the triumph of rationality must inevitably go through the mediation of language, which is understood as the unique space where systematical and deductive thought can express itself. The historian Marcel Detienne argues that the invention of writing was very important for the development of cognitive activity.[10] The new standards of rationality established in Ancient Greece initiated a definitive epistemological rupture. Writing shaped human thought because it created new intellectual instruments consecrating the primacy of reason and introducing a critical regime that favoured intellectual activity. With the parallel unfolding of philosophy, geometry, medicine, geography, and so on, writing established the reign of abstraction. This epistemological rupture came in the first instance from the cleavage between subject and object. Rationalist philosophy established the supremacy of the subject: because of reason, the human being was in a position to exert an ascendancy over the sensible world (defined as the object of knowledge). The book, as the favoured witness to this rational grasp of the world, became the absolute model for knowledge. The metaphor of the world as a book to be read is very significant: it shows how the theory of representation repressed the sensible world and, consequently, the human senses.

The political history of the eye exposed by Bender, de Bolla and Crow takes into account the phenomenological sphere. Here, the term 'politics' embraces the hold of the mind on the body (Bender), the process of visual experience (de Bolla) and the repression of sexual desire (Crow). Furthermore, these three chapters allow us to consider the ethical and political dimensions of art and literature. Even if Bender declares his intellectual debt to Foucault, he thinks that the French philosopher's history of discourse left a number of fundamental questions unanswered, including the essential point of the link between

literature and the world. Therefore, he tries to understand 'how literary production has engaged in the ongoing process of cultural construction'.[11] In the opinion of Bender, Crow and de Bolla, it is impossible to separate art, culture and society: like the geometrical figures of a construction-set, political thought and narrative techniques fit into each other (Bender's note on Adorno and Horkheimer shows that we have to rethink the autonomization of the aesthetic sphere). We might initially assume that these three authors share this opinion with social historians of art, but all of them refuse to examine the complex interaction between art productions and the social context of such productions in terms of direct historical causality. They reject the theory of reflection: art and literature do not simply echo a certain social context. In this precise sense, novels, gardens and pictures are *vehicles of power*, rather than reflections of that power.

Bender and de Bolla define power in reference to the eighteenth-century moral and social theories in England. Bender shows how Godwin's novel 'textualizes' (and not only represents) a particular socio-political critique. The power is the 'impersonal violence' of a neutral and objective eye dissecting the reality. This eye would be the pen of the realist prose fiction writer using free indirect discourse. I specifically use the metaphor of the pen because its sharp-pointed shape looks like the 'metaphysical dissecting knife' mentioned by Bender. The pen, as the objective instrument of mind's power, would be an extension of God's eye. The omniscient power of logos submits the individual to an external authority. In the eighteenth century, moral theory and social order would thus take the place of the divine logos. It is interesting to compare Bender's and de Bolla's *'penetrating gaze'* with the Stoics' definition of logos as the manifestation of God's omniscience: in the opinion of the Stoics, logos was 'the divine principle penetrating the world and holding it together'.[12] If the pen symbolizes the activity of writing and drawing, it is also the expression of the reign of intelligible world over sensible world, which means that its gender politics are more complex than might at first appear. Even if de Bolla develops the nice concept of 'republic of visuality', we must admit that it is still difficult to reconcile the eye and the mind.[13] Would it be possible to invent a 'republic of the body' where every part of it would have an equal chance to express itself? In spite of the utopian features of such an unreasonable project, I think it is good to keep it in mind when reading the following pages because it has the advantage of considering a number of important questions too frequently neglected by academic studies.

Notes

1 Paul Auster, *The Invention of Solitude* (London and Boston, MA: Faber & Faber, 1982), p. 138.
2 See the articles 'Vision' and 'Word' in the *Encyclopedic Dictionary of the Bible*, a translation and adaptation of A. van den Bjorn's *Bijbels Woordenboek*, by Louis F. Hartman (Turnhout: Usines Brepols, 1963).
3 The French word *entendre* has the two senses.
4 Linda Nochlin, *The Politics of Vision. Essays on Nineteenth-Century Art and Society* (New York: Harper & Row, 1989).
5 Lynda Nead, *Myths of Sexuality: Representations of Women in Victorian Britain* (Oxford: Basil Blackwell, 1988); Eunice Lipton, *Looking into Degas: Uneasy Images of Women and Modern Life* (Berkeley, CA: University of California Press, 1986).

6 See the introduction to Linda Nochlin, *Women, Art and Power and Other Essays* (New York: Harper & Row, 1988).

7 For an exhaustive bibliography on feminist art history, see Thalia Gouma-Peterson and Patricia Matthew, 'The Feminist Critique of Art History', *The Art Bulletin*, LXIX, 3 (Sept. 1987), pp. 326–57.

8 See Georges Bataille, *The Story of the Eye* (New York: Urlzen Books, 1977).

9 Michel Foucault, *The Order of Things: An Archaeology of the Human Sciences* (New York: Pantheon Books, 1971).

10 See Marcel Detienne, 'L'écriture et les nouveaux objets intellectuels en Grèce', *Les savoirs de l'écriture en Grèce ancienne* (Paris: Presses Universitaires de France, 1988) pp. 7–26, esp. p. 10.

11 John Bender, *Imagining the Penitentiary. Fiction and Architecture of Mind in Eighteenth-Century England* (Chicago, IL and London: The University of Chicago Press, 1987), p. xv.

12 *Encyclopedic Dictionary of the Bible*, p. 1365.

13 See Maurice Merleau-Ponty, *L'oeil et l'esprit* (Paris: Gallimard, 1964), and *The Visible and the Invisible* (Evanston, IL: Northwestern University Press, 1968).

Chapter Thirteen

Impersonal Violence: The Penetrating Gaze and the Field of Narration in Caleb Williams

John Bender

My subject is the violence habituated within certain techniques of impersonal narration typical of realist prose fiction. I want to point to issues at once broad, complex, and by no means intuitively obvious. In developing them here, however, I shall concentrate mainly upon William Godwin's attempt, in his novel *Caleb Williams*, at a radical critique of the machinery of character and conscience as socially, legally and governmentally constructed during the Enlightenment: a critique ultimately overwhelmed from within by the technology it assailed.

But I shall begin again, this time with three quotations, the first from Jonathan Swift's Hack in 'A Digression on Madness'. Both Swift's dichotomy between ordinary vision and the scientific gaze and his metaphor fusing female skin and foppish clothing – his feminization of the body under the knife of scientistic inquiry – emerge as uncannily prophetic:

> The two Senses, to which all Objects first address themselves, are the Sight and the Touch; These never examine farther than the Colour, the Shape, the Size, and whatever other Qualities dwell, or are drawn by Art upon the Outward of Bodies; and then comes Reason officiously, with Tools for cutting, and opening, and mangling, and piercing, offering to demonstrate, that they are not of the same consistence quite thro' ... therefore, in order to save the Charges of all such expensive Anatomy for the Time to come; I do here think fit to inform the Reader, that in such Conclusions as these, Reason is certainly in the Right; and that in most Corporeal Beings, which have fallen under my Cognizance, the *Outside* hath been infinitely preferable to the *In*: Whereof I have been farther convinced from some late Experiments. Last Week I saw a Woman *flay'd*, and you will hardly believe, how much it altered her Person for the worse.

Yesterday I ordered the Carcass of a *Beau* to be stript in my Presence; when we were all amazed to find so many unsuspected Faults under one Suit of Clothes: Then I laid open his *Brain*, his *Heart*, and his *Spleen*; But, I plainly perceived at every Operation, that the farther we proceeded, we found the Defects encrease upon us in Number and Bulk: from all which, I justly formed this Conclusion to my self; That whatever Philosopher or Projector can find out an Art to sodder and patch up the Flaws and Imperfections of Nature, will deserve much better of Mankind, and teach us a more useful Science, than that so much in present Esteem, of widening and exposing them.[1]

Swift's contempt for deluded rationalist projectors leads him to prefigure, from an opposite political perspective, a counter-Enlightenment rebel such as William Blake, and to offer a satiric anticipation of Godwin's political idealism. Swift's Houyhnhnms in fact distilled for Godwin an ideal of society governed by orderly thought and practice: that is to say, a society inhabited by Godwin's peculiar brand of individually autonomous rationalism, by benevolence, and by honesty, rather than by institutions and contractual rights.[2]

This counter-Enlightenment current surfaces, too, in post-structuralist thinking, for example, in Jacques Derrida's appreciation of the thought of Emmanuel Levinas, entitled 'Violence and Metaphysics':

Incapable of respecting the Being and meaning of the other, phenomenology and ontology would be philosophies of violence ... [connected with] the ancient clandestine friendship between light and power, and the ancient complicity between theoretical objectivity and technico-political possession ... The heliological *metaphor* only turns away our glance, providing an alibi for the historical violence of light: a displacement of technico-political oppression in the direction of philosophical discourse.[3]

The metaphor of 'enlightenment', which we inherit from the eighteenth century, is one of those 'heliological metaphors' that conceals the impersonal violence involved in the scientistic framing of objects, in effacing mysterious otherness by infiltrating autonomous bodies with knowledge, by 'flaying' them with light's probing rays. When the form of knowledge known as realist narrative infiltrates the bodies and minds it represents, as it progressively does in the eighteenth-century novel, its 'technico-political possession' dominates and mutilates (symbolically dissects and even castrates) these bodies whether the instrument is the anatomical knife in the impartial hands of Reason that exposes flaws in the carcass of Swift's Beau or the penetrating gaze of clinical inquiry, or the novelistic depiction of consciousness. Caleb Williams is no more than a representative victim of enlightened inquiry analogous to the precisely specified female vagrants whose anatomized bodies are depicted in William Hunter's *Anatomy of the Human Gravid Uterus* (1774: Illustration 74 and 75) or the more generalized male figures dismembered for Gautier d'Agoty's *Myologie complette en couleur et grandeur naturelle* (1746–8: Illustration 76 and 77).

The third quotation comes from a preface that Godwin wrote nearly 40 years after *Caleb Williams's* publication. He thematizes the metaphor of dissection, also a favourite of his novelistic predecessors:

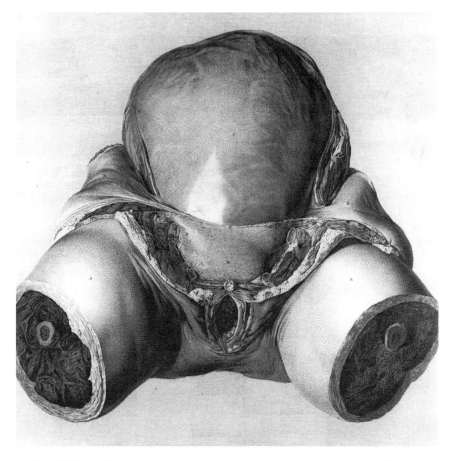

74 William Hunter, *Anatomy of the Human Gravid Uterus*, Tab. IV; The
Trustee of the Wellcome Trust, London

I began my narrative ... in the third person. But I speedily became dis-
satisfied. I then assumed the first person, making the hero of my tale his
own historian ... [This] was infinitely the best adapted ... to my vein of
delineation, where the thing in which my imagination revelled the most
freely, was the analysis of the private and internal operations of the mind,
employing my metaphysical dissecting knife in tracing and laying bare the
involutions of motive ... I rather amused myself with tracing a certain
similitude between the story ... and the tale of Bluebeard ... Falkland was
my Bluebeard, who had perpetrated atrocious crimes ... Caleb Williams
was the wife, who in spite of warning, persisted in his attempts to discover
the forbidden secret; and, when he had succeeded, struggled fruitlessly to
escape the consequences, as the wife of Bluebeard in washing the key of the
ensanguined chamber, who, as often as she cleared the stain of blood from
the one side, found it showing itself with frightful distinctness on the other.[4]

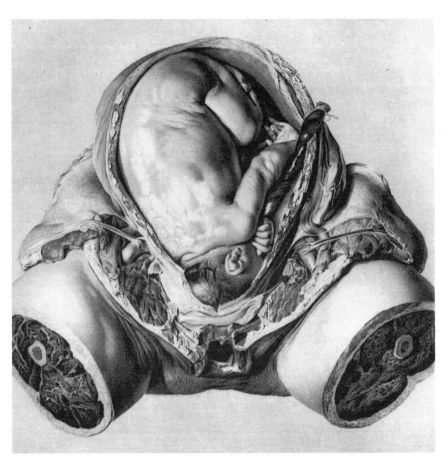

75 William Hunter, *Anatomy of the Human Gravid Uterus*, Tab. VI; The
Trustee of the Wellcome Trust, London

Later, I shall return to this belated preface by Godwin. For now, let me just
point out that he views his assumption of Caleb's first-person voice as a
metaphysical dissection and that he feminizes Caleb as the last in the sequence
of Bluebeard's murdered wives. The context of this passage includes
Godwin's review of the fictional analogues on which he depended and clearly
places Caleb in a long line of novelistic cadavers whose authors were, as
Godwin says, 'employed upon the same mine as myself, however different
was the vein they pursued: we were all of us engaged in exploring the
entrails of mind and motive' (p. 340). Hogarth already had conceived such
exploration as the literal dissection of criminal innards illustrated in the final
plate of his *Four Stages of Cruelty* (Illustration 78) and had visually likened the
process to a juridical trial, which is the scene of action more prevalent than
any other in *Caleb Williams*.[5]

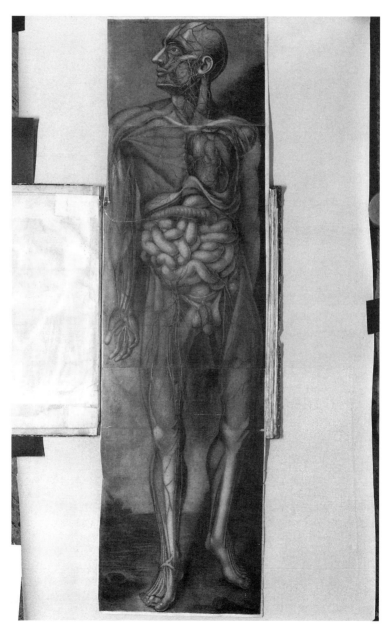

76 Gautier d'Agoty, *Myologie complette en couleur et grandeur naturelle*, Plate
4; The Trustee of the Wellcome Trust, London

77 Gautier d'Agoty, *Myologie complette en couleur et grandeur naturelle*, Plate
7; The Trustee of the Wellcome Trust, London

It is time to turn to certain framing propositions. A first set concerns the social
and psychological significance of the emergence of the third-person narrative
form known as *style indirect libre* (free indirect discourse), a technical
innovation historically specific to the later eighteenth century that enables the
presentation of consciousness through seemingly untrammeled, all-seeing,

78 William Hogarth, *The Four Stages of Cruelty*, Plate 4; by permission of the
Trustees of the British Museum

impersonal narration. As Dorrit Cohn says, free indirect discourse is a device
'for rendering a character's thought in his own idiom while maintaining the
third-person reference and the basic tense of narration'.[6] It is the characteristic
mechanism for securing the illusion of transparency that distinguishes the
realist novel from the later eighteenth century onwards. Transparency is the
convention that both author and beholder are absent from a representation,
the objects of which are rendered as if their externals were entirely perceptible
in a unified field of vision and their internality fully accessible. Flaubert

condensed the basic principle into a vivid formulation: 'The illusion (if there is one) comes ... from the *impersonality* of the work ... The artist in his work must be like God in his creation – invisible and all-powerful: he must be everywhere felt, but never seen'. Free indirect discourse disperses authoritative presence into the very third-person grammar and syntax through which the illusion of consciousness is created. The technique's emergence in narrative fiction correlates historically with the projection of impersonal authority in the penitentiary prison as epitomized by Jeremy Bentham's *Panopticon*. Bentham's idealized plan revealed that the operational fact of the penitentiary is what he called the 'principle of inspection', not the person of the inspector. The point is that the inspector-keeper is not really omniscient, or even really a person, but rather that the transparency of penitentiary architecture forces the prisoner to *imagine* him as such. Reformation hinges upon the conviction that omniscience enfolds being.[7]

Both free indirect discourse and Bentham's 'principle of inspection' correlate, further, with Adam Smith's identification of the sympathetic interchange of 'I' and 'other' as the fundamental psychic mechanism establishing conscience and character through the introjection of social norms as individual values. Thus, by a central irony, the sensation of sympathy founds an order of power. Smith, who named this internalized representation of the third person as the 'impartial spectator', himself sometimes employed narrative devices very similar to free indirect discourse. He presents his construction as a natural universal, whereas I view it as a description of the dominant behavioural ideology or social system of post-Enlightenment culture. Later, in my analysis of *Caleb Williams*, I will show how Godwin attempted to restage the very mechanisms of this ideology to expose it as a system of domination.[8]

Smith's contemporary, Goldsmith, allows us to see the embodiment of the 'impartial spectator' in literary culture, and to uncover the dispersed and secret assertions of omniscience in the seemingly private voice of the individual. *The Vicar of Wakefield*, although written during the 1760s in the first person and not self-evidently part of the prehistory of free indirect discourse, nonetheless reaches towards this technique. Certain passages in the novel can be understood as third-person narration reinscribed *as if* from the first-person perspective of the vicar.[9] The first-person subject emerges as a remarkably permeable web spun of individual sensation but *structured* by the impersonal geometry of socio-psychic organization. In hindsight, this fact has startling political implications for Goldsmith's case, since not merely his specific advocacy of penitentiary confinement but the dispersed, impersonal grounding of his narration cut across the grain of his articulate philosophy as a nostalgic country conservative with longings – *à la* Bolingbroke – for the concentration of authority in the highly individual person of a paternalistic king.

Godwin presents the obverse case: he is a utopian anarchist whose attack on personified authority in *Caleb Williams* is also staged within a field of narration that profoundly contradicts his enterprise. So compelling is the teleology of representation as configured in the realist novel that Godwin not only recast the ending of his story in conformity to its dynamic, but he proceeded thereafter to a wholesale rewriting of *Political Justice*. This rewriting and further

insertions in *Caleb Williams* indicate that the novel became a conflictual scene within which Godwin's initial belief in radically individualistic virtue could not maintain itself. His thought remained in the current of rational dissent, but was enveloped within a delineation of moral being that emerged as increasingly hegemonic from the 1760s onwards and that established a dialectic between a psychologized inner world of subjective reflection and an abstracted social order introjected through sympathetic identification with representative individuals. The gaze, and of course the spectatorship attendant upon it, are primary media within which this dialectic operates but the broader issues at stake concern the *vraisemblable* – the appearance of reality – within which post-Enlightenment culture constructs character and social relations.

Contemporary discussion of the gaze as a mechanism embraces ranges of generalization too vast and subtleties of distinction too refined for complete exposition here. But some opening to the topic is required by way of a second set of framing propositions. Especially relevant in this context are concerns about sexual domination brought forward in the work of Laura Mulvey and other feminist film theorists, and questions about the history of the gaze raised by Michel Foucault.[10] They have assisted in historicizing the gaze as an ideologically-laden cultural procedure that works to stabilize social forms by representing the political order as if it arose naturally from individual perception and psychology. This procedure establishes subjective character as a function acting at the conjuncture of a double or collateral gaze that stabilizes the Other within a fictionalized field of vision and knowledge, so as, finally and paradoxically, to introject its image as an impersonal gaze that fixes the subject within a moral, social and political order. This gaze is figured metaphorically and ideologically as a neutral, natural perspicuity that spontaneously opens objects in its field to analytic yet painless dissection.

Foucault has outlined a history of the medical gaze that moves from a clinical phase, focused on the description of symptomatic surface, to an anatomical phase that opens the body's interior to analytic pathology. Loosely but suggestively correlative would be Norman Bryson's contrast between Renaissance painting, where the gaze both predicates bodily surfaces in the field of vision and situates the viewer's body at the point of comprehension, and later European painting in which the gaze is disembodied and analytically sequenced.[11] Foucault's chapter title, 'Open Up a Few Corpses', like his discussion of Sade and the metaphorics of light in the conclusion to *The Birth of the Clinic*, points to the piercing quality of the gaze. As Bryson says, 'The *regard* attempts to extract the enduring form from fleeting process; its epithets tend towards a certain violence (penetrating, piercing, fixing), and its overall purpose seems to be the discovery of a second … surface standing behind the first, the mask of appearances' (p. 93). We recur, then, to the medical imagery Godwin himself used because it carries the correct (if usually submerged) implication that the gaze is an instrument that violently, albeit precisely, cuts open the body in the act of mapping its functions. This gaze is charged with sexual energy because it penetrates and wounds the body, which it characteristically genders female.

Film studies, the history of science, and speculative art history offer richly elaborated theories of the gaze. Comparatively novel, however, is my correla-

tion of contemporary ideas about the violence latent in the gaze with the eighteenth-century British school of benevolist moral thought – especially Adam Smith's – and with the narrative mode of free indirect discourse. The only current thinking I know about that explicitly links violence with sympathy appears in David Marshall's *The Surprising Effects of Sympathy* and in a few extraordinarily suggestive pages in Leo Bersani's and Ulysse Dutoit's *The Forms of Violence*. Bersani and Dutoit suggest, in the context of psychoanalysis rather than eighteenth-century moral theory, that 'there is a certain risk in all sympathetic projections: [namely, that] the pleasure which accompanies them promotes a secret attachment to scenes of suffering or violence' because any form of sympathetic identification with suffering must be considered to contain a 'trace of sexual pleasure, and that this pleasure is, inescapably, masochistic'. Psychoanalysis provides a more detailed account but, as Marshall suggests, the text of Smith's *Theory of Moral Sentiments* implies some linkage between the pleasures of sympathy and sado-masochistic identification.[12]

I need to insist, as I move to the main part of this chapter, that my aim is not to produce a single unified reading of *Caleb Williams*. Instead, I consider *Caleb Williams* as a fractured text, conflictual and dynamic at its very core, a text most usefully imagined as a residue of intellectual and representational struggle, rather than as the embodiment of a single set of purposive intentions or the outcome of a teleological development in thought.[13] This struggle involves contestants that the rules of criticism – despite the presence of a book like Ian Watt's *The Rise of the Novel* – have traditionally consigned to separate leagues: political thought and narrative technique. Godwin's criticism abounds in treatments of both but not in studies of their interaction. If we look at the two together, especially under the rubric of violence, we can see that the variously revised texts of Godwin's treatise and novel exhibit at least two sets of interrelated symptoms having to do first with Godwin's political critique and, second, with the narrative field he constructs.

Before specifically treating the textualization of these symptoms in *Caleb Williams*, I must offer a brief plot summary. With the hero, we enter a story long after many important events have transpired. Caleb, a bookish young man of humble birth, becomes upon his parents' death secretary to Falkland, a melancholy aristocrat of broad accomplishment who once relished society but now is reclusive. After an incident where Falkland threatens to trample Caleb when the secretary accidentally comes upon him moaning and hastily locking a mysterious trunk, the youth elicits the patron's story from his steward, Mr Collins. We encounter this long narrative in Caleb's third-person retelling, itself lodged within the novel's retrospective first-person account of actions beginning with Caleb's entry into Falkland's household.

The polished Falkland had innocently fallen a foul of his neighbour, Mr Tyrrel, a brutal country squire. After many perceived slights and real reprimands from Falkland, Tyrrel redirects his anger at his own dependent niece, the naive Emily Melville. He punishes Emily's admiration for Falkland by forcing her engagement to an odious fiancé and then, upon her flight, casting her into a debtor's prison for not paying her keep during her residence

in his house. Emily, of course, dies. Falkland's condemnation so infuriates Tyrrel that he beats him up before a county assembly. The same evening Tyrrel is secretly murdered. Falkland, having denied his guilt before an admiring public and having allowed a farmer and his son to be executed for the crime, retires into the solitary reflection that is disrupted by Caleb's arrival on the scene.

The curious Caleb, actuated by a magnetic sympathy and convinced of Falkland's deed, employs observation, innuendo and sly questioning to reach the firm conviction of 'guilty'. When a household fire presents the chance, Caleb breaks open that mysterious trunk and is apprehended by Falkland, who confesses to the terrified secretary after extorting an oath of secrecy and bondage. Caleb flees, and is apprehended and indicted for theft upon planted evidence. After twice escaping prison in the manner of Jack Sheppard, and then joining and fleeing a well-governed band of thieves, he feels himself under universal surveillance because his story has been widely circulated by folktale and criminal broadside. He undertakes a series of disguises before being captured in London by a seemingly omniscient agent named Gines. He breaks the oath of secrecy but no magistrate will countenance his accusation and he is returned to prison. Released, and seemingly free when Falkland declines to appear against him, Caleb begins a new life in Wales only to have it destroyed when Gines seeds the town with an old broadside. Debarred from exile and informed that Falkland intends England to be his lifelong prison, Caleb resolves to assail his patron with a full and circumstantial written narrative – that is with the novel we are reading – and to accuse Falkland once more on his home ground. A dramatic postscript concludes the action. I want to defer that, however, in order to discuss the symptoms mentioned above and to notice how Godwin's staging of the novel manifests them.[14]

The first range of symptoms has to do with Godwin's socio-political critique and indicates that he initially arranged *Caleb Williams* as a contention between two systems of moral and political order, both of which he hoped to discredit because both were working hegemonically in the society of his day to maintain corrupting institutional forms. Roughly speaking, Falkland and Caleb figure forth an opposition between the two: on the one hand, an aristocratic system preoccupied with class honour and actuated by shame; and on the other a contract system propelled by sympathy and actuated by guilt.[15] The previous year, in the 1793 version of *Political Justice*, Godwin had powerfully argued instead for a society in which all institutions would be supplanted by autonomous private judgment equally exercised by all members. What he called 'political justice' opposed party politics and questioned even republicanism, because he viewed all forms of government as giving 'substance and permanence to our errors'.[16] Rather, justice was for Godwin 'a rule of conduct originating in the connection of one percipient being with another' and politics was 'the adoption of any principle of morality and truth into the practice of a community'.[17] Godwin strives to maintain this utopian ideal as an alternative to any institutional formation.

Godwin founds individual judgment in the human capacity to make reasoned comparisons among perceptions, which refer themselves in turn to sensations. A virtuous community assists the process by transmitting its forms through practice, education, discussion and literature, but *not* through formal

institutions, which by their nature lend authority to error. He insists upon the role of education in training autonomous judgment, and upon communal discussion in calibrating it to specific situations, but rejects its maintenance through mechanisms of shame or guilt. Both the old system, based upon honour, and the newer one based upon sympathetic introjection are political in the worst sense because they personify judgment as an enforcing third person rather than founding it upon the analogous but independent percipience of individuals. The one holds this spectator externally, the other introjects and holds it internally, but both situate individual morality in the regard – in the gaze – of others rather than in one's own integrity. Both deny what Rousseau called *amour de soi*: that crystalline openness of self that he equates with true sentiment, and which, as Mark Philp says in his recent study of *Political Justice*, constitutes in Godwin's view the 'moral independence … required for genuine happiness and genuine concern for others'.[18]

I divide into two clusters the second range of symptoms: that is, the ones having to do with formal narrative features. They indicate that Godwin fundamentally undermined his project from the beginning because narration as he undertook it reproduced the constructions of character he was assailing and precluded any stable delineation of autonomous private judgment of the kind he idealized.

The first cluster of symptoms points to a fundamental contradiction in narrative practice: even though, as Godwin indicated in his 1832 preface, he abandoned his initial conduct of narration in the third person in order, as he says, to make 'the hero of my tale his own historian', the purpose, as Godwin says, was in fact to wield his 'metaphysical dissecting knife … in exploring the entrails of mind and motive' (pp. 339–40). In truth, not only is the nominally first-person account of fact in *Caleb Williams* shot through with knowledge about past events and motives that no single individual could possibly possess, but also the field of narration is fractured by sentences that render consciousness in encoded free indirect discourse of the kind I have elsewhere pointed out in Goldsmith. By 'encoded' I mean that the first-person form is maintained while the grammatical instance of communication – the speech act – is of the third person. Ann Banfield has argued that such discourse is historically produced and can take place only in written narration.[19] Godwin's entry into the grammar of omniscient presence, even or perhaps especially for purposes of fiction, replicates the very structure of domination he is assailing.

The second cluster of symptoms reveals that Godwin persistently frames his narration as a progression of images or tableaus that reproduce the violence of the gaze as a demand that the individual submit to external authority. Possibly because Godwin was straining to intensify conventional narration in order to propel his audience into awareness of a new kind of identity, or possibly because his virtually exclusive focus on two male characters throws the gender-laden phenomenology of realist narrative into prominence, he pushes towards the extreme instance of the European tendency (described by Bersani and Dutoit) 'to isolate and to immobilize the violent act as the most significant moment in … plot development'. In arguing that 'a coherent narrative depends on stabilized images; [and that] stabilized images stimulate the mimetic impulse', they observe that 'our views of the human capacity for empathetic representations of the world should therefore take

into account the possibility that a mimetic relation to violence necessarily includes a sexually induced fascination with violence'.[20]

I shall turn, then (working under the symptomatic rubrics just traced, and in the same order), to ways in which *Caleb Williams* both exhibits apprehensions about sympathetic identification and narrative violence and is captured by their spell.

Godwin obviously attacks the aristocratic code of honour, which always has been understood as his chief target, but the novel also works to indict the newer orthodoxy of sympathy. Caleb's transparent subjectivity makes plain that the sympathetic equation, no less than Falkland's aristocratic *amour propre*, holds up the opaque mask of appearance that Rousseau condemned as merely artificial social form. But Caleb's sympathy is no neutral or innocent alternative; it is an irrational and exploitative byproduct of political power, experienced as a real psychological state, though itself produced in masquerade. When he decides, as he says, to 'place myself as a watch upon my patron', he confesses to 'a strange sort of pleasure in it'. This pleasure is directly aroused by Caleb's fear of authority: 'To do what is forbidden always has its charms, because we have an indistinct apprehension of something arbitrary and tyrannical in the prohibition'. The more domineering the object, the more intense the 'enjoyment [and] the more the sensation was irresistible ... The more impenetrable Mr. Falkland was determined to be, the more uncontrolable was my curiosity' (pp. 107–8). This 'magnetical sympathy', as Caleb calls it (p. 112), propels him to the first climax of the action when Falkland, sitting as justice of the peace on a case analogous to his own, flees the scene, thus convincing the closely observant secretary of his patron's guilt. If Caleb's 'involuntary exclamations' and the feeling that his 'animal system had undergone a total revolution' were not sexually explicit enough, he cries 'I had had no previous conception ... that it was possible to love a murderer' (pp. 129–30). Once the fire and Caleb's burglary of Falkland's trunk have followed with a haste that smacks of allegory, he justifies his 'monstrous' act by claiming that 'there is something in it of unexplained and involuntary sympathy' (p. 133). A more scathing depiction of the sympathetic construction of character would be hard to imagine.

Now, let us move to specific instances of the two clusters of formal symptoms previously outlined, treating first the novel's actuation of plot through immobilized tableaus and then the technical forms of its narration. The first third of the novel, containing Caleb's retelling of Mr Collins's narrative, replicates in hyper-concentrated form Godwin's comprehensive organization of plot as a sequence of stablized tableaus, many of them violent. This narrative explicitly inspires Caleb's sympathetic identification and establishes it as the motive force of the main action. In fewer than 100 pages we encounter more than a dozen such tableaus: a duel narrowly averted during Falkland's grand tour of Italy; a stand-off between Falkland and Tyrrel at a country ball; a call upon Tyrrel meant by Falkland to substitute rational expostulation for the duel they seem headed towards (which visit ends with veiled mutual threats); Falkland's rescue of Emily from a fire during which he orders adjacent houses destroyed and can be seen to walk across a burning roof; Tyrrel's and the fiancé's threat of Emily's dispoilage in a forced marriage; her flight in the manner of Clarissa; her wasting illness, imprisonment and death;

Falkland's verbal assault on Tyrrel and, of course, their final altercation ending in Tyrrel's murder; a hearing on Falkland's arraignment; and the execution of innocent parties. Caleb's fictional mimesis of this history recapitulates for readers the profound sympathetic engagement the young man is said to have experienced upon hearing Mr Collins's version.

So compelling is the mechanism that establishes Caleb's destructive fascination with Falkland that it assumes control of the novel. In order to assure the reader's identification with his hero, Godwin establishes in this opening Collins/Caleb narration a paradigm of concentrated plot deployment that structures the balance of the work. He thus authorizes in *Caleb Williams* as a whole a pattern of identification that, in the early segments of the novel, he had used to unveil the awful dynamic of power underlying the sympathetic construction of character. Godwin's revisions show his defensive response to this fact. In the third edition, that of 1797, the interpolated fourth paragraph of Chapter 1 specifies Caleb as a person whose fascination with sequences of cause and effect propagated 'an invincible attachment to books of narrative and romance'. 'I panted', he says, 'for the unravelling of an adventure, with an anxiety, perhaps almost equal to that of the man whose future happiness or misery depended on its issue. I read, I devoured compositions of this sort. They took possession of my soul; and the effects they produced, were frequently discernible in my external appearance and my health' (p. 4). This paragraph attempts to reinscribe susceptibility to narrative as a pathological trait of Caleb's (not to mention as a vector of bodily penetration) and thus to exempt readers from any taint produced by their own engagement with Godwin's novel.

In the end, however, Godwin cannot novelistically produce a subject capable of sustaining the utopian autonomous private judgment he so forcefully advocated in the 1793 *Political Justice*. In many ways it appears that Godwin framed Caleb's third-person narration of Mr Collins's story within the larger first-person context of the novel to act out the illusion of mastery conferred by the false sense of first-person autonomy based upon sympathetic introjection. This mastery is a juridical illusion, because the very power it confers to construct one's own version of another subjectivity derives from the maintenance of an 'impartial spectator' within a permeable self.[21]

Interestingly, the two passages in Caleb's third-person retelling of the Collins story that come closest to free indirect discourse (and hence to sympathetic illusionism) both thematize a sense of powerlessness on the part of the entered subject. These are our only points of access in the novel to reflections by Tyrrel and Falkland, who otherwise remain opaque precisely because they mark one pole in an opposition with transparency that Godwin in general maintains. The first occurs when Tyrrel, thwarted by Emily's flight and condemned by Falkland for persecuting tenant farmers, 'recollected all the precautions he had used ... and cursed that blind and malicious power which delighted to cross his most deep laid schemes':

> To what purpose had heaven given him a feeling of injury and an instinct to resent, while he could in no case make his his resentment felt? It was only necessary to him to be the enemy of any person, to insure that person's being safe against the reach of misfortune. What insults, the most shocking

and repeated, had he received from this paltry girl! And by whom was she now torn from his indignation? By that devil [Falkland] that haunted him at every moment, that crossed him at every step, that fixed at pleasure his arrows in his heart, and made mows and mockery at his insufferable tortures. (p. 80)

After these reflections, Tyrrel immediately proceeds to his destruction of Emily by imprisonment.

The other passage comes after Tyrrel's furious public assault on Falkland, whom he knocks to the ground and kicks. Falkland's reflections appear in the text as follows:

Every passion of [Falkland's] life was calculated to make him feel it ... acutely ... [His] mind was full of uproar ... He wished for annihilation, to lie down in eternal oblivion, in an insensibility, which compared with what he experienced was scarcely less enviable than beatitude itself. Horror, detestation, revenge, inexpressible longings to shake off the evil, and a persuasion that in this case all effort was powerless, filled his soul even to bursting. (p. 96)

These passages might be read as ironically intended signs of Caleb's delusion that he can enter Falkland's, or any other, mind. But in fact, information Caleb could not possibly possess, and encoded episodes that verge on free indirect discourse, both covertly invade – even capture – the first-person account that makes up the balance of the novel.

Key instances of such encoded first/third-person introspection occur, for example, during Caleb's earlier and later episodes of imprisonment. I present them in simultaneous translation into quasi-free indirect discourse by inserting into Caleb's first-person narration brackets that contain the third-person pronouns:[22]

I [Caleb] recollected with astonishment my [his] puerile eagerness to be brought to the test and to have my [his] innocence examined. I [He] execrated it as the vilest and most insufferable pedantry. I [He] exclaimed in the bitterness of my [his] heart ... why should I [he] consign my [his] happiness to other men's arbitration? (p. 182)

Or again later,

My [His] resolution was not the calm sentiment of philosophy and reason. It was a gloomy and desperate purpose; the creature, not of hope, but of a mind austerely held to its design, that felt, as it were, satisfied with the naked effort, and prepared to give success or miscarriage to the winds. (p. 278)

The surprising consequence of Godwin's representational strategy is that his thought appears to have been overtaken in some considerable measure by the allied force of the grammar that governs his field of narration and the propulsion derived from a plot suspensefully and climactically structured into images stabilized by the gaze of covert omniscience. Both mechanisms engender sympathetic identification by replicating the violence upon which they are predicated.

In the dramatic postscript that concludes the first edition (1793), Godwin rewrote the original climax he had intended for the novel, enacting not his initial plan for Caleb's defeat and probable destruction by the malice of Falkland but showing, rather, the capacity of the young man's sympathetic identification with the anguish of his haughty patron to inspire both Falkland's confession and his spontaneous death. The remorse that instantly descends upon Caleb follows inevitably in the system of sympathetic representation, like guilt after an exultantly violent sexual fantasy. The new ending closes with the novel's most famous lines: 'I began these memoirs with the idea of vindicating my character. I have now no character that I wish to vindicate: but I will finish them that thy story [Falkland's] may be fully understood' (p. 326).

Just about everyone agrees that the revised ending makes for a more powerful narrative than the unpublished original, which leaves Caleb scribbling away like the ravingly incoherent Clarissa after her rape. In that ending, the feminizing logic of the gaze was overtly thematized but there was no magical reversal, no fixated tableau where, in the manner of Bluebeard's wife, the victim becomes keeper of the perpetrator's violence. But paradoxically, the most successful readings of the novel (those of Myers and Philp, for example) do not respond to Caleb's lines about lack of character. On my account, this gap in response occurs because these lines reassert the structural logic of the novel in face of the overwhelming triumph of its narrative momentum. But the fame of Caleb's final lines also speaks a truth: the dissonant truth that the novel's conceptual order lives in contradiction with its mode of representation.

On my analysis, then, *Caleb Williams* is best understood as the textual residue of a struggle to define the price paid for that moral progress which other critics attribute to Caleb. Myers argues, for example, that he learns to appreciate the essential humanity of sympathetic understanding, while Philp maintains that he gains the kind of autonomous private judgment Godwin values above all else. This moral progress, like the narrative that produces it, is typically experienced as *real* when in fact it is merely *realistic* and, in truth, deeply fractured. *Caleb Williams* reveals the idea of moral progress to be historically specific and ideologically laden: a product of a certain kind of violently fixated narrative structuration implicit in sympathetic spectatorship.

No doubt one could construct a linear reading that found Caleb, as first-person narrator, to be distorting the real meaning of sympathetic identification. Certainly the first published version of 1793 left open the possibility of a radical reading that would leave Caleb in the delusionary state of *believing* that he at last had reached the highest ideal of humankind in his sympathetic union with Falkland, while in fact recording the truth that he has no character at all. Such a reading of the 1797 version, profoundly contradictory as it remains, is far more difficult to support. Godwin's strenuous efforts in the revised editions of 1796 and 1797 to incorporate passages towards the end of the novel that extol the impartial spectator and that found the idea of humanity itself on sympathic identification make it quite clear that he is trying *ex post facto* to clarify the novel and to redeem it from the fractious struggle of its original production. What had been Caleb's investment in the new orthodoxy has become Godwin's investment. Godwin,

as Mark Philp shows, clearly changed his mind in the course of his novel's initial composition. The remarkable fact is that he responded so powerfully to the narrative logic of sympathetic introjection that he also entirely rewrote *Political Justice* for its second and third editions to bring it, much more closely than before, into conformity with that main line of British moral thought from which he had so carefully established a distance in 1793. Disquisitions on sympathy and the impartial spectator figure importantly among these additions.

I close by returning, however briefly, to the body. The stringent economy of a short essay allows only a passing glance at the myriad ways in which Falkland and Caleb each employ the gaze as an instrument to waste away the body of the other. Falkland fades into a corpse well before his death and Caleb, after his long flight, must literally be strip-searched by Gines in order to be identified. At one point Caleb, dreaming that Falkland has sent an assassin, awakes to behold the 'Amazonian' hag who cooks for the band of robbers that is hiding him. She wields a butcher's cleaver that sinks into the bedpost in an attempt to halve his skull. Her 'glance' no less than her strength all but over-whelm him and, when he prevails in the struggle, she threatens to dash his entrails into his eyes (p. 231). This same economy permits no more than mention of Godwin's addition in 1796 of a new third paragraph in Chapter 1 concerning the strength and flexibility of Caleb's youthful body, for the purpose, I believe, of counter-balancing the powerful feminization his field of narration had worked upon his hero.

Instead of accumulating further examples from the text, I turn in conclu-sion to a spellbinding recollection of the terrifying eighteenth-century machine placed on exhibit in London for five shillings per view during the year 1733 by the surgeon Abraham Chovet: it was a

> new figure of Anatomy which represents a woman chained down upon a table, suppos'd opened alive; wherein the circulation of the blood is made visible through glass veins and arteries; the circulation is also seen from the mother to the child, and from the child to the mother, with Histolick and Diastolick [*sic*] motion of the heart and the action of the lungs.

No such automaton remains but amazing wax anatomical models made famous by Felice Fontana and others of the Florentine school do survive in Florence, Vienna, London and elsewhere (Illustrations 79–83). Goethe and Sade were among the many eighteenth-century figures who visited them as part of the Grand Tour. Not only are they startlingly realistic but they are nar-rative figurations of the body, since their organs may be progressively dis-played by the removal of layers that reveal a succession of tableaus which mimic dissection. A number of these models display a seductive sexuality that is new to anatomic figures and that may be considered a symptom of the early modern gendering of the gaze as a tool of scientific inquiry.[23]

I have been suggesting that we ourselves may take for granted another kind of anatomizing that survives from the eighteenth century because to some degree we still live within its canon. I refer, of course, to realism as a cultural practice.

79 *Wax female figure with moveable parts*; The Trustee of the Wellcome Trust, London

80 *Wax female figure with moveable parts* (cont.); The Trustee of the Wellcome
Trust, London

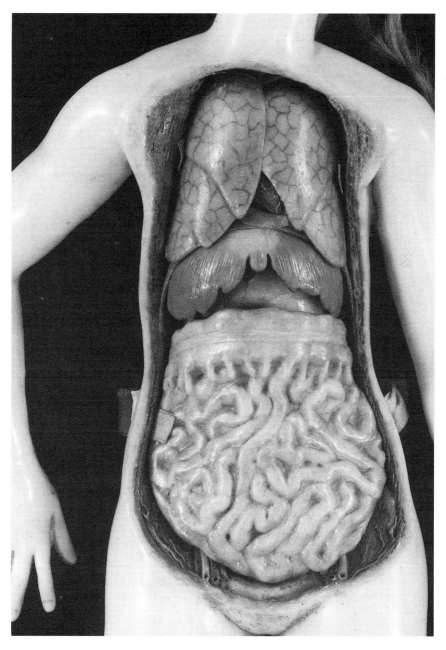

81 *Wax female figure with moveable parts* (cont.); The Trustee of the Wellcome
Trust, London

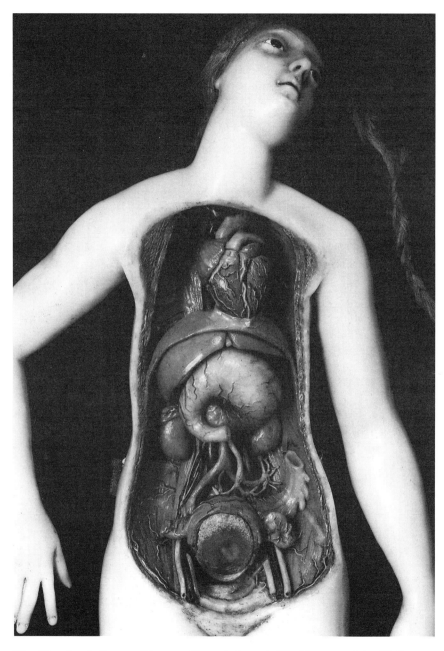

82 *Wax female figure with moveable parts* (cont.); The Trustee of the Wellcome
Trust, London

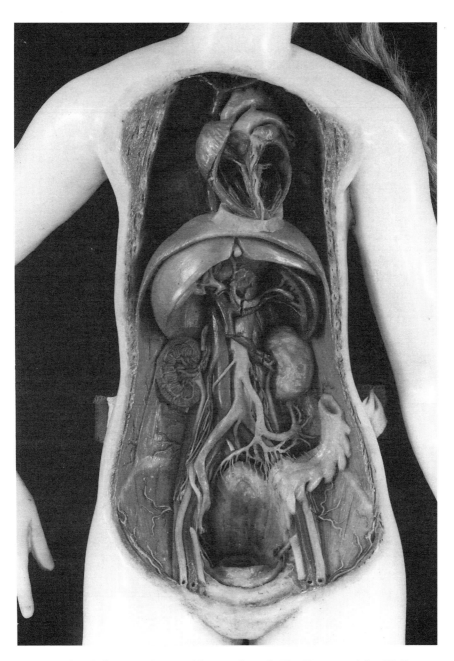

83 *Wax female figure with moveable parts* (cont.); The Trustee of the Wellcome Trust, London

Notes

1 Jonathan Swift, *A Tale of a Tub*, ed. A. C. Guthkelch and D. Nichol Smith, 2nd edn (Oxford: Clarendon Press, 1958), pp. 173–4.

2 See Don Locke, *A Fantasy of Reason: The Life and Thought of William Godwin* (London: Routledge & Kegan Paul, 1980), p. 8, and Peter Marshall, *William Godwin* (New Haven, CT: Yale University Press, 1984), p. 48. Both Blake and Godwin in their different ways anticipate Max Horkheimer's and Theodor Adorno's attack on the instrumental perversion of reason in their *Dialectic of Enlightenment*, trans. John Cumming (New York: Herder & Herder, 1972).

3 Jacques Derrida, *Writing and Difference*, trans. Alan Bass (Chicago, IL: University of Chicago Press, 1978), pp. 91–2. Other quotations from this essay might be added: 'Heidegger still would have questioned and reduced theoretism from within, and in the name of, a Greco–Platonic tradition under the surveillance of the agency of the glance and the metaphor of light. That is, by the spatial pair inside-outside ... which gives life to the opposition of subject and object' (p. 88); or again,

> After having spoken of taste, touch, and smell, Hegel ... writes in the *Aesthetics*: 'Sight, on the other hand, possesses a purely ideal relation to objects by means of light, a material which is at the same time immaterial, and which suffers on its part the objects to continue in their free self-subsistence.' ... This neutralization of desire is what makes sight excellent for Hegel. But for Levinas, this neutralization is also ... the first violence ... Violence, then, would be the solitude of a mute glance, of a face without speech, *the abstraction* of seeing. According to Levinas the glance *by itself*, contrary to what one may be led to believe, does not *respect* the other. (p. 99)

4 William Godwin, *Caleb Williams*, ed. David McCracken (Oxford: Oxford University Press, 1970), p. 339. All subsequent citations are to this edition and appear parenthetically in the text. Godwin's retrospective description of the composition of *Caleb Williams* appears in his preface to the 'Standard Novels' edition (1832) of his novel *Fleetwood*.

5 Ronald Paulson, *Hogarth's Graphic Works*, 3rd rev. edn (London: The Print Room, 1989), plates 190–190a and, for commentary, pp. 148–52. The corpse is not visibly castrated but in neither the preparatory drawing nor the final plate does the corpse appear with genitals. Sean Shesgreen refers to 'intimations of cannibalism' in the drawing. See Sean Shesgreen (ed.), *Engravings by Hogarth* (New York: Dover Publications, 1973), plate 80.

6 See Dorrit Cohn, *Transparent Minds: Narrative Modes for Presenting Consciousness in Fiction* (Princeton, NJ: Princeton University Press, 1978); Kate Hamburger, *The Logic of Literature*, trans. Marilynn J. Rose (Bloomington, IN: Indiana University Press, 1973); Roy Pascal, *The Dual Voice* (Manchester: Manchester University Press, 1977); and Ann Banfield, *Unspeakable Sentences: Narration and Representation in the Language of Fiction* (Boston, MA: Routledge & Kegan Paul, 1982). The quotation from Flaubert comes from *The Letters of Gustave Flaubert, 1830–1857*, ed. and trans. Francis Steegmuller, 2 vols (Cambridge, MA: Harvard University Press, 1980–2), vol. I, p. 230. Bakhtin/Voloshinov says of this technical narrative device:

> Some ... shift had to have occurred within socio-verbal intercourse ... for that essentially new manner of perceiving another person's words, which found expression in [free indirect discourse], to have been established ... The inner subjective personality with its own self-awareness does not exist as a material fact ... but it exists as an ideologeme ... *A word is not an expression of inner personality; rather, inner personality is an expressed or inwardly impelled word.*

Compressed from Mikhail M. Bakhtin and Valentin N. Voloshinov, *Marxism and the Philosophy of Language*, trans. Ladislav Matejka and I.R. Titunik (New York: Seminar Press, 1973), pp. 143 and 152–3.

7 On Bentham and the correlation with free indirect discourse, see John Bender, *Imagining the Penitentiary: Fiction and the Architecture of Mind in Eighteenth-Century England* (Chicago, IL: University of Chicago Press, 1987), Chapter 7.

8 On Smith and free indirect discourse, see Bender's *Imagining the Penitentiary*, Chapter 7.

9 See John Bender, 'Prison Reform and the Sentence of Narration in *The Vicar of Wakefield*', pp. 168–88 in Felicity Nussbaum and Laura Brown (eds.), *The New Eighteenth Century: Theory, Politics, English Literature* (New York and London: Methuen, 1987); on the reinscription of certain kinds of first-person narration as quasi-free indirect discourse, see especially pp. 184–5.

10 See Laura Mulvey, "Visual Pleasure and Narrative Cinema", and 'Afterthoughts on "Visual Pleasure and Narrative Cinema"', in Constance Penley (ed.), *Feminism and Film Theory* (New York: Routledge, 1988), pp. 57–68 and 69–79. For a convenient summary of theories of the 'gaze' in feminist film theory, see Tania Modleski, *The Women Who Knew Too Much: Hitchcock and Feminist Theory* (New York: Methuen: 1988), pp. 1–15. See also Constance Penley, *The Future of an Illusion: Film, Feminism, and Psychoanalysis* (Minneapolis, MN: University of Minnesota Press, 1989), pp. 41–54, and Mary Ann Doane, *The Desire to Desire: The Woman's Film of the 1940's* (Bloomington, IN: Indiana University Press, 1987), pp. 38–69. The main text by Michel Foucault is *The Birth of the Clinic: An Archaeology of Medical Perception*, trans. A.M. Sheridan Smith (New York: Vintage Books, 1975), especially Chapters 7 and 8.

Although rarely mentioned in recent discussions, the chapter on 'the gaze' (*le regard*) in Sartre's *Being and Nothingness* (Part 3, Ch. 1, Section 4) marked out much of the philosophical terrain. Jacques Lacan has been very influential, especially in film theory. See, for example, *The Four Fundamental Concepts of Psycho-Analysis*, ed. Jacques-Alain Miller and trans. Alan Sheridan (New York: W.W. Norton, 1973), pp. 67–105. For a current development of the Lacanian theory of the gaze, see Slavoj Zizek, 'Pornography, Nostalgia, Montage: A Triad of the Gaze', in *Looking Awry: an Introduction to Jacques Lacan Through Popular Culture* (Cambridge, MA: MIT Press, 1991), pp. 107–22.

11 See Foucault, *The Birth of the Clinic*, Chapters 7 and 8, and Norman Bryson, *Vision and Painting: The Logic of the Gaze* (New Haven, CT: Yale University Press, 1983). Svetlana Alpers, in *The Art of Describing* (Chicago, IL: University of Chicago Press, 1983), treats this opposition as a contrast between southern and northern European ways of seeing. For a discussion of the possibility of alternate gazes that do not participate in the violence and domination, see Edward Snow, 'Theorizing the Male Gaze: Some Problems', *Representations*, 25 (1989), pp. 30–41.

A point often submerged in discussions of the gaze is that its analytic and sequential character (in contrast to the 'glance' or the '*coup d'oeil*') makes it a narrative mode. Indeed, one of Foucault's central points is that the clinical gaze organizes its findings through linguistic description.

12 Leo Bersani and Ulysse Dutoit, *The Forms of Violence: Narrative in Assyrian Art and Modern Culture* (New York: Schocken, 1985), pp. 38 and 40–56. See also, by the same authors, 'Merde Alors', in Beverly Allen (ed.), *Pier Paolo Pasolini: The Poetics of Heresy* (Saratoga, CA: Anima Libri, 1982), pp. 82–95. I read David Marshall's *The Surprising Effects of Sympathy* (Chicago, IL: University of Chicago Press, 1988) after this chapter was written, but his argument linking violence to sympathy anticipates mine.

13 Every critic I have encountered on the novel attempts a unified reading, even those who, like Mitzi Meyers in a marvellous essay, 'Godwin's Changing Conception of *Caleb Williams*', *SER*, 12 (1972), pp. 591–628, and Mark Philp in his book on *Political Justice* (London: Duckworth, 1986) lay stress on the rapid shifts that occurred in Godwin's thought between 1793 and 1798, these five years include the original publication of both treatise and novel as well as considerable revision. Kenneth W. Graham takes up questions about the novel's unity and about the influence of *Caleb Williams* on the revision of *Political Justice in The Politics of Narrative: Ideology and Social Change in William Godwin's Caleb Williams* (New York: AMS Press, 1990), a book that appeared after this chapter was written.

14 In what follows, for the sake of economy, I interweave manifest facts and accepted interpretations of Godwin's views with my own inferences. Limits of space cause me to focus upon my main assertions rather than upon the textual evidence that underlies my understanding of the novel.

15 On Godwin's attitude towards contract-governed society see Ian Balfour, 'Promises, Promises: Social and Other Contracts in the English Jacobins (Godwin/Inchbald)', in David Clark and Donald Goellnicht (eds), *New Romanticisms* (Toronto: University of Toronto Press: forthcoming). See also, Leo Damrosch, *Fictions of Reality in the Age of Hume and Johnson* (Madison, WI: University of Wisconsin Press, 1989), Chapter 7. The contrast between shame and guilt as cultural orientations and modes of social control is compactly developed by Alvin W. Gouldner in *Enter Plato: Classical Greece and the Origins of Social Theory* (New York: Basic Books, 1965), pp. 81–7. See also, Bender, *Imagining the Penitentiary*, p. 221.

16 Godwin's *Political Justice* (1793), Book I, Ch. 4. See William Godwin, *Enquiry Concerning Political Justice and Its Influence on Morals and Happiness*, ed. F.E.L. Priestley, 3 vols (Toronto: University of Toronto Press, 1946), vol. 3, p. 247. This edition is cited hereafter as 'Priestley'.

17 Godwin's *Political Justice* (1793), Book I, Ch. 2 and Book I, Ch. 4. See Priestley, vol. 1, p. 126 and vol. 2, p. 239.

18 Philp, *Godwin's Political Justice*, p. 47.

19 Banfield, *Unspeakable Sentences*, especially pp. 180, 227, and 257. For examples of 'encoded' free indirect discourse, see the analysis below as well as Bender, 'Prison Reform and the Sentence of Narration in *The Vicar of Wakefield*,' pp. 183–5.

20 Bersani and Dutoit, *The Forms of Violence*, pp. 52 and 38. See also p. 41 on the idea that capacity to stir 'imaginative sympathy', often described (e.g., by E.H. Gombrich) as an innovation of Greek narrative art and associated with realism, aimed to excite audiences 'out of themselves and into new identities as a result of high narrative skills'.

21 *Caleb Williams* reveals this truth in numerous episodes that I cannot discuss here, but an elaborate paragraph about the standing as testimony in court of Caleb's version of the Collins narration makes it clear that such issues are alive in the text (106).

22 Roland Barthes proposes a similar test during a discussion of personal and apersonal narration as systems or codes independent of superficial linguistic markers: 'there are narratives or at least narrative episodes ... which though written in the third person nevertheless have as their true instance the first person'. He then proceeds to rewrite the third-person pronouns of such a text in the first person. Run in reverse, his test reveals how first-person narration can venture obliquely upon the representation of consciousness from the impersonal, all-penetrating perspective that free indirect discourse makes possible. See Roland Barthes, 'Introduction to the Structural Analysis of Narratives', in *Image-Music-Text*, ed. and trans. Stephen Heath (New York: Hill & Wang, 1977), pp. 112–13; reprinted in *A Barthes Reader*, ed. Susan Sontag (New York: Hill & Wang, 1982), pp. 283–4.

23 The description of Chovet's automaton is quoted in Thomas N. Haviland and Lawrence Charles Parish, 'A Brief Account of the Use of Wax Models in the Study of Medicine', *Journal of the History of Medicine*, 25 (1970), p. 62. On the Florentine models and the Grand Tour see Sander L. Gilman, *Sexuality, An Illustrated History* (New York: John Wiley, 1989), pp. 184–90. On the models more generally, see Ludmilla Jordanova, 'Gender, Generation and Science: William Hunter's Obstetrical Atlas', in W.F. Bynum and Roy Porter (eds), *William Hunter and the Eighteenth-Century Medical World* (Cambridge: Cambridge University Press, 1985), pp. 385–412; and 'Natural Facts: A Historical Perspective on Science and Sexuality', in Carol P. MacCormack and Marilyn Strathern (eds), *Nature, Culture, and Gender* (Cambridge: Cambridge University Press, 1980), pp. 42–69; also Barbara Maria Stafford, *Body Criticism: Imaging the Unseen in Enlightenment Art and Medicine* (Cambridge, MA: MIT Press, 1991), p. 21. On Fragonard, see Annie Le Brun, *Petits et Grands Théâtres du Marquis de Sade* (Paris: Paris Art Centre, 1989), pp. 69, 77, and 79. More terrifying, even, than Chovet's machine would have been are the 'models' constructed from dissected corpses between 1766 and 1771 by Honoré Fragonard at the École Vétérinaire in Alfort.

The present chapter is part of a work in progress that parallels the technical pratices of the later eighteenth-century novel with anatomical science, medical electricity, and other invasions of the body and nervous system during the period.

Chapter Fourteen

The Visibility of Visuality: Vauxhall Gardens and the Siting of the Viewer

Peter de Bolla

What price have we paid for the fantasy that there are free rights of access to the domain of the visual? That everyone with eyes to see can in fact stand on an equal footing in the republic of visuality. This fantasy has long been with us and its origins lie deep in our history of understanding the visual realm. This chapter will explore a signal moment in that history when the politics and erotics of the look take on special cadences within the cultural topography of eighteenth-century England.

The following remarks constitute an attempt to think through the implications of understanding visuality as a cultural construct. By this I mean to signal that vision is not entirely circumscribed by and through optics. The science which sets out to explain light, and how light falls upon the retinal surfaces of vision, neglects the cultural dimension to the subject's insertion within visuality. When we do attend to this we need to nuance the distinct but overlapping practices which constitute at any one historical moment the full enclosure of visuality. Some of these practices may well be historically insensitive, as one would suspect would be the case with the technical description of the faculty of sight, but others have clearly demonstrable connections to other cultural practices, and share in common ideologies which form and shape the contours of the concept 'subjectivity'. Thus, for example, the activity of looking at high art pictures, say in a gallery, has a specific historical carapace which is itself determined by other historically contingent ideologies and conceptual forms.

In the larger context of the book from which this present chapter is extracted I examine three distinct social, physical and cultural environments in which the activity of looking takes place. These three distinct but overlapping environments are the landscape garden, the country house and the exhibition of pictures. In all three I investigate the somatic tracings of a metaphorics of the eye in order to begin the task of describing the anatomy and grammar of a specifically eighteenth-century or enlightenment visuality. In large brush-strokes this argument contends that the social, cultural and

discursive constructions of the visual field (what I am here calling visuality) all determine singly or in combination and to varying extents the grammar of forms which constitute the *activity* of looking as well as the parameters within which an individual is to be understood as a viewer, spectator or looker. This subject in view, whose specific social, class and gender attributes are in part constructed in the sitedness of looking, is coerced into particular positions both within and in relation to the scopic field. It is these positions, which inhabit both the real and virtual spaces of the viewing scene, that will be the central focus of my argument since it is only by paying attention to the siting of the viewer that the anatomy and grammar of eighteenth-century visuality becomes visible.

I would like to argue at the furthest reach that these sitings are definitional of subjectivity no less than they are indicators of where the scopic is located. Perhaps another way of getting a fix on this project is to see it as an investigation of the socio-cultural semantic range of the term 'viewer'. I am suggesting that a viewer in mid-eighteenth-century England has, then, very precise contours: he or she is placed or positioned by the activity of looking, situated in relation to a social and cultural topography and thereby centred in specific social, economic and gendered descriptions of the individual. I argue below that it is the work of something I term the metaphorics of the eye to create these site specificities and to locate the body of the viewer in the enclosures of visuality, just as it is also the regulatory force of this metaphorics which controls the *activity* of looking itself. I want to stress this notion of the activity since looking, as I am going to argue, constitutes just one option within the range of possible insertions into visuality, there being other activities within the domain of the scopic that can be described by other terms such as gazing or glancing.

What I mean by the term metaphorics of the eye is the collection of figurative expressions generated within eighteenth-century discussions of specific forms of visual experience. These figurative expressions have a considerable range: in the viewing of landscape, for example, the eye is 'thrown' to a particular point, or sometimes it is 'drawn' towards an object in the landscape known as an 'eye-catcher'. This same eye is sometimes 'exhausted' or 'sated', sometimes 'hungry' or 'restless'. Eighteenth-century viewers were well acquainted with the notion of 'fatigue', for example, as the eye quickly becomes tired of too much visual stimulation, but they were equally familiar with the excitation of the eye.

The precise environment in which the activity takes place determines to some extent the metaphorics that constitute the anatomy of the look. Viewing the landscape park, for example, is not the same as inspecting the pictures in a country house. These different activities generate different modes and purposes for the eye and demand different somatic insertions within the spacings of the visual. And, to make the description yet more qualified, of course not all architectural spaces demand and constitute the same forms of viewing activity; not all gardens require identical modes of visual address. What we need here are precise examples in which the physical spaces of the particular environment are overlaid upon the virtual spacings of the scopic field, since it is precisely in the gap produced by the imaginary overlaying of these two spaces where the metaphorics of the eye does its figurative work.

The viewing activity, then, not only takes place within a specific physical environment, but it is also sited within the culturally dispersed enclosures of visuality itself: that is, within the virtual spaces created by cultural forms. Any experience of that visuality is, therefore, actively inseminated within those discourses of rank, class and gender which largely focus definitions of specific agents. My stress here is on the interactive quality of this insemination since I shall be arguing that the very fact of entry into the scopic regime is as much definitional of the viewer (and of the viewing activity) as particular affiliations to rank or class determine what form the activity might take and what kind of viewer one must be in order to participate in such activity. There is, then, an interaction between an individual who comes along to the viewing scene already in possession of a number of defining characteristics – say those constitutive of gender – and the specifically gender-inflected modes of particular insertions into the scopic regime. It is clear that this interaction may cause friction as much as it might reinforce already constituted definitions of the individual who comes into the viewing scene.

Whether the period itself understood this rather complex interplay of socio-cultural determinations of the practices of viewing is a question we will have to leave hanging for the time being. One way of approaching this difficulty is to call to mind Robert Adam's deliberations on the topic. Adam was, of course, the most influential architect and designer of the mid-century, and it is clear from both his writings and his practice that he understood the visual field as requiring or encouraging differing modes of address. Thus, in the designs for interior spaces he made in their thousands he took great pains to create embellished surfaces which did not tire the eye. It is for this reason that Adam interiors are relatively free of fresco composition and pictorial decoration since these tend to demand a form of viewing activity – which I shall term the studious gaze – that Adam thought inappropriate for the domestic interior. In its place Adam recommended the use of 'grotesques', the kind of stucco tracery that quickly became the hallmark of the Adam style. In designing the interiors of his clients' rooms in this way Adam was echoing very closely a generally disseminated awareness of the somatics of the viewing activity. Adam himself commented upon this in the preface to *The Works in Architecture*:

> the rage of painting became so prevalent in Italy, that … they covered every ceiling with large fresco compositions, which though extremely fine and well painted, were very much misplaced, and must necessarily, from the attitude in which they are beheld, tire the patience of every spectator. Great compositions should be placed so as to be viewed with ease. Grotesque ornaments and figures, in any situation, are perceived with the glance of an eye, and require little examination.[1]

What Adam is pointing out are two distinct ways of entering the enclosures of visuality: gazing or glancing. In the gaze the eye fixes on an object, most usually a painting, and in so doing it organizes the visual field; this penetrative gaze structures both the field of vision and the spectator's position within physical space. This activity of gazing requires a specific mode of address to the objects seen which can be described in shorthand as a readerly or semiotic practice: the gaze penetrates and organizes the visual field in order to arrive at

'meaning'. The glance is quite distinct as a viewing activity, requires a different mode of address and arrives at a different end point. In this mode the eye moves hurriedly across surfaces, delighting in variety, that cornerstone of mid-eighteenth-century aesthetics, and as it moves around the enclosure of the scopic field it feels itself to be located, sited within the virtual spacings of visuality through which it moves. Far from imposing its regime upon the visual it is inducted into the orderings of the scopic, and as it is so induced the viewing eye is itself subjected to those orderings. Consequently the gaze requires and imposes an orderliness in vision whereas the glance is ordered by and through the virtual spaces in which it moves. There is, however, a third form of viewing, which I shall term the look, that is a catoptric mode in which the eye requires self-reflection in order to register its own power to see, and recognize its instrumentality in visuality. This third mode can be thought of as an oscillation or pulsation between the gaze and the glance as the eye shuttles back and forth between penetration and reflection, depth and surface, and it is this look which will occupy the following discussion.

The full extent of these differences between modes of address to the scopic field can only be examined through recourse to specific instances of the viewing activity, but nevertheless it is helpful to pause here in order to reflect on why these differences and the corresponding metaphorics of the eye arise at the historical moment I am going on to investigate. This is to begin to note that our own age has recourse to an enabling metaphorics of the eye no less than the eighteenth century, since how else can we know the facts of vision? In the case of the eighteenth century, one of the reasons for the insistence on visuality as opposed to optics in my account so far is the opacity of the visual field for this period. What I mean by this is the extent to which things seen are rendered visible through varying degrees of transparency; in the enlightenment model of the individual and its sensory mechanism the media through which one makes out the objects of sight are more opaque than transparent. This is because optics as yet can explain the fact of vision only to the eye; it will take early nineteenth-century researches into the holistic phenomena of vision and visuality in order for the science of optics to begin explaining the fact of vision to the viewer as both mental construct and somatic presence.

What is lacking for the eighteenth century is a means by which one can move from the observable data of optics to the fully sensitive and sensitized mind/body of the observer. It is for this reason that visuality, the social thickness of the visual, takes a major role in constructing the facts of vision, or what is known in and through visuality, and why the ground of vision is not the body of the viewer, not the complex of nerves and retinal surfaces which constitute vision for modernity, but visuality itself. This is to say the facts of vision are not imaged as some 'truth' to be elicited from the corporeal evidence contained within the physical enclosure of the viewer, but from the evidence of the individual's insertion into visuality, into the virtual space of cultural forms. This insertion includes the somatic locations of a particular body in determinable real space – its specific posture, distance and address to the object held in view – as well as the imaginary sitings of specific ideologies of the individual, be they inflected by class or gender, within the virtual space of visuality. We may think of this in a pictorial fashion as if the body is always at odds with its own shadow, as if the fit between the corporeal substance and

projected outline constantly causes friction. However accurate this image might be it is nevertheless that friction which enables the viewer to recognize the catoptric glint of the enclosure of visuality, and which forces the registration of the social and cultural manifestations of self-identity as much as it causes embarrassment at the threat of auto-voyeurism. Recognition here takes self-regard into uncomfortable territory.

The viewer, then, is made aware of the corporeal by attending to how the imaginary body looks to others. We shall see in a moment just how this imaginary image is literalized in the spaces of Vauxhall, and how being the object of sight, being vision, for others works out in the eighteenth-century exhibitionary spacings of the pleasure garden. As we shall see, this comes down to conceiving of the activity of spectating in public as inextricably caught up with acts of voyeurism: spectating in public involves watching others in the activity of spectating.

There is more to be said about the contours of this spacing, its gender filiations and social registers, for example, as there is equally room for discussion about the economics of visuality created in and by such spacings. I think here of the problematic triangulation of the exchange of glances in the exhibition room, in which the viewer enters into a three-way circuit of gaze, glance and returned look as he both seduces and is seduced by the naked eye that appears to him in the plane of reflection. This plane – which might equally be the surface of the canvas or the bodily presentation of others in the trajected objectification of sight – is flexible enough to fulfil a variety of roles: the screen upon which distinct viewpoints are projected, the opaque transparent surface through which the look of others and of the eye is made out, or the voyeuristic pin-hole opening to another visual spacing upon which the viewer can only wantonly gaze as he marks his exclusion from the there of the view. But I will leave these complexities pregnantly suspended in order to move quickly to my material example: Vauxhall Gardens in London.

There are a number of reasons for taking this London pleasure garden as my example. The first is that, as we shall see, the garden was crammed full of paintings. Not only were there paintings all over the garden, but the actual experience of visiting this pleasure ground was, as I shall argue, precisely one in which the activity of looking was made visible. In point of fact the decorative work carried out in the garden is exactly coincident with the first 'exhibitions' of paintings in England which were mounted at the Foundling hospital from 1739 on. In point of fact the decade between the mid-1740s and mid-1750s witnessed an explosion in the number and frequency of exhibitions for contemporary art. These displays were not necessarily confined to temporary exhibition spaces: many country houses – for example, Houghton and Holkham in Norfolk, or Kedlestone in Derbyshire – were built expressly to display art collections. These houses were visited, entrance fees often charged and guide books written, all of which contributed towards what we might mistakenly think of as our own distinctively 'modern' form of tourism.

There were, however, no full-scale and regular public exhibitions of contemporary paintings until 1760, when the first temporary display of British art took place in a room on the Strand. A year later, in 1761, the society of artists began a regular yearly show at Spring Gardens, which were immensely

popular as social spaces right from the beginning. It is within this context that I want to examine Vauxhall since it undoubtedly served as the location for the first experience of the public display of high art images for thousands of eighteenth-century viewers.

THE VISIBILITY OF VISUALITY

A pleasure garden had been established at Vauxhall by the early 1660s when records tell us that the New Spring Gardens opened. The Old Spring Gardens existed simultaneously for a short while but were quite quickly supplanted by the new gardens. Throughout the last decades of the seventeenth century the gardens were a popular location for outdoor recreation, and by the beginning of the next century they had become, according to Addison, 'a kind of Mahometan paradise'.[2] Vauxhall really came into its own in 1728 when Jonathan Tyers obtained the lease of the Gardens. He became proprietor in 1752, and from this time on he was devoted to increasing the popularity of the pleasure grounds, famously employing the talents of his friend Hogarth to mount a grand *ridotto al fresco* and to decorate the pavilions in the garden. Tyers died in 1767 and the gardens passed on to his sons, one of whom (Jonathan Junior) continued to manage them until his death in 1792.

The garden was situated on the south bank of the Thames and was about 12 acres in extent and laid out in a number of gravel walks lined by trees. At the centre of the garden was a wood of about 8 acres, first known by the name Il Penseroso, and later more simply as the grove. Many walks intersected with this wood, in the middle of which stood a temple containing inscriptions. The gardens were almost continuously altered in very small ways season by season, in order to continue or refresh the attraction of the garden.

We know that by the mid-decades of the century the supper boxes had been decorated with painted scenes, many of them depicting leisure-time pursuits, and that also by around this date very large *trompe l'oeil* paintings were placed at the ends of the grand walks. Painting, in other words, was an integral feature of the garden: for example, parallel to the grand walk, which was itself terminated by a painted representation of a gothic obelisk, ran the south walk which also terminated in a large painting, in this instance of the ruins of Palmyra. A third avenue, the grand cross walk, also contained a representation of ruins. The orchestra located at the northernmost edges of the wood was surrounded by the semi-circular sweep of supper boxes, cubicles in which visitors took their refreshment, most of which were decorated with paintings by Francis Hayman. The principal building in the gardens was the Rotunda, 70 ft in diameter, containing an orchestra, and running off this room another long room known as the saloon or Picture Room. All in all, by mid-century there were around about 115 pictures throughout the garden and its buildings. What I mean to point out, then, is that a visit to these pleasure gardens was, by the mid-1740s, already one in which paintings were displayed and in some manner to be viewed. In the following section I shall attempt to convey a sense of what such visits were like.

THE TOUR OF SPRING GARDENS

The following description is taken from *The Ambulator*, a contemporary guide book to London. Before entering the Mahometan paradise we must pause at the entrance and pay one shilling, precisely the same amount as for the Royal Academy summer exhibition but less than the amount charged by a number of rival auctioneer-sponsored exhibitions of paintings mounted in the early 1760s. The *Ambulator* describes the entrance in the following manner:

> The first scene that salutes the eye, is a noble gravel-walk, about nine hundred feet in length, planted on each side with a row of stately elm and other trees, which form a fine vista terminated by a landscape of the country, a beautiful lawn of meadow ground, and a grand gothic obelisk, all which so forcibly strike the imagination, that a mind scarce tinctured with any sensibility of order and grandeur, cannot but feel inexpressible pleasure in viewing it.[3]

At once we are within the discursive territory of the theatre – a 'scene salutes the eye' – and this will foreground the following discussion since it is precisely a spacing of the spectacle that we are going to witness. This spacing, in which the viewer is constantly suspended between two distinct positions, actor and spectator, tells us a great deal about the framings of this particular viewing activity: here vision is imbricated within the witnessing of a theatrical event in which we participate and at which we spectate, thereby making us into spectactors. This comes with its attendant problems, as we shall see, most especially in relation to the ability or willingness on the part of the spectactor to cathect the seductions of voyeurism, discussed below.

The theatrical spacing that greets our entry into the garden is also a feature of landscape experiences in which various elements of the view are understood as 'screens' or 'side screens' directing the viewer's eye, and thereby determining the thrownness of the eye. This first scene, then, is a 'noble' one, a class indicator we can hardly fail to notice, which is reinforced by the planting of elms, usually associated with farming but here qualifed as 'stately'. More significant, however, is the sense that one is walking into a picture, precisely a landscape in the high art renditions of a Poussin or Claude. The natural, here, is concocted, created by man for his pleasure.

Once the eye has registered these indices to the 'natural' it is able to continue its trajectory towards the vista which terminates the view, a large painted depiction of – the landscape. It is clear from contemporary engravings of this garden that its perimeter was far from being enclosed by tightly cramped dwellings. In point of fact, all the views out of the garden would have been to open countryside. It is, then, of some importance that in the place of the 'real' extension of the garden into a landscape we find a *representation* of such a landscape. Here, immediately, the grounding of representational space is brought into the enclosure of visuality: the viewer's entry into the scopic field must negotiate *ab initio* the folds and frames of representational spaces and surfaces. This, at a glance, brings to the foreground the tension between surface and depth, between the somatic surfaces presented to the optical realm – retinal surfaces – and the experiential virtual space of perspectival depth perception. Surface – retina or canvas – is played out against depth –

the three dimensional projection of perspectival representations – in ways that
analogically mirror the alternations between spectator and actor in theatrical
space. The result of this, as I hope to show, is a spectacle in which we witness
the entrance of visuality into the domain of the visible: that is to say, what the
spectactor is going to see, and be seen seeing, in Vauxhall Gardens is visuality
itself. As we learn from the *Ambulator*: we 'cannot but feel inexpressible
pleasure in viewing' (p. 195) this scene, and part of what follows will be the
investigation of the particular modes of and resonances to that 'pleasure in
viewing'.

 In the first place we must take some delight in recognizing that the scopic
field is potentially eidotropic, deliberately striving to deceive the eye. Most of
the pleasure the eye derives from this is in suspending optical veracity in
order to delight in the play of scopic fantasy. In doing this we feel ourselves
become a part of a social domain in which visual error, where perception is
deception, founds the basis for collective empathy; we are a part of this social
experience in so far as we allow our eyes to be deceived just as, in the political
terms of republican civic humanism, we are free in so far as we give up a part
of our freedom to and on behalf of the state. Thus the primary entrance into
visuality – the social terrain upon which vision is itself mapped – is effected
via our common suspension of the demand for optical truth. The eye is
thrown to a flat surface upon which a representation of the countryside stands
between the viewer and the real countryside, stands in the place of (that is,
precisely re-presents) what the representational surface itself bars or blocks
from vision. Furthermore, this deception only works if we project into that
surface the virtual space of perspectival depth; in other words, it only works if
we imagine the surface to dissolve its singular materiality of flatness into the
receding depth of imaginary three-dimensional space. The playful necessity of
this can be illustrated by the grand walk which, as I have already mentioned,
terminated with a gothic obelisk. This painted surface, the *Ambulator* tells us,
'is to appearance a stately pyramid, with a small ascent by a flight of steps,
and its base decorated with festoons of flowers; but it is only a number of
boards fastened together, and erected upright, which are covered with
canvases painted in so masterly a manner, that it deceives the most discerning
eye' (p. 195).

 Even being armed with the knowledge that the eye is going to be deceived
will not prevent the deception: this is why it makes no difference if the guide
book warns us in advance since the visual experience is all-subsuming. What I
mean to point out here is that the eye can only function within visuality; the
'truth' of the scopic regime is not some hypothetical neutral science of optics,
beams of light and a sensitized receptive bodily surface, but on the contrary a
contingent truth implicated in and by our entry into the theatrical spacings of
the spectator outlined above. Indeed, this is the payment extracted from us as
we disembark from the south side of the Thames and walk through the
entrance which is the peep hole giving on to the spacings of the spectacle.
Consequently it does not matter that the mind knows what the eye does not
since the evidence of the eye is completely constrained and determined by the
enclosure of visuality; the eye both registers and determines its 'truth'. If we
refuse to enter this scopic regime it will only give us grief and will in fact
destroy what the eye naturally seeks out: its pleasure. This is in fact made

abundantly clear to us at this point in the tour through the garden since the obelisk contains upon its flat surfaces a message, which comes in the form of the decorated base where we see a number of chained slaves and above them the following inscription: *Spectator fastidiosus sibi molestus.*

This indicates the full measure of the stakes being played for; it is not merely a matter of entering into the playfully deceptive modalities of representational space, not merely a matter of going along with the pleasures of the eye, for what is at stake in the final analysis is the constitution, fabrication and enfranchisement of the viewer. It is a matter of not being blind to visuality, and therefore blind to being in the here of vision, being a viewer for others, and a matter of not resisting our induction into being in the place of pleasure: that is, of not being blind to what is over there in the spacings of the self-regarding subject, being a viewer for ourselves.

The inscription warns us, then, that we will harm ourselves if we refuse the purposiveness of the eye; warns us that a disdainful eye will inflict pain upon the viewer if it resists entry into the theatrical and illusory spacings of visuality that are constituted by the gardens. To embrace or espouse such a refusal or resistance is to be enchained, disenfranchised, without liberty and without self-regard. We must be both spectator and actor in this drama of vision, must be spectators if we are to be fully agents within the republic of visuality. If we do accept this, then, as I shall comment below, the liberating and enfranchising politics of looking are activated. This political dimension, in which both lower and upper social echelons might see each other in the activity of looking, presents problems at the psychic level even as it seems to embrace a form of democratic looking at the social level.

We are not yet done with the *Ambulator,* our exemplary spectactor, however, who continues to give us a description of the layout of the grounds, pausing to note the various other marvels of deception, chief among them being the cascade, 'the effect of which was brilliant, and the contrivance ingenious' (p. 196). This was a large transparency of a cascade of water which was hidden behind a curtain. At the appointed hour a bell was rung to alert the spectators that the curtain was to be drawn back. The *Ambulator* writes: 'It is wonderful to observe how the people of both sexes flock in rapid crowds to observe it, on the notice of the bell, about nine o'clock' (p. 196). Perhaps the Pavlovian registers to this ringing of the bell are too insistent for us, but there is nevertheless a kind of coercive feel to this communal fantasy deception, as well as a desire to be seen participating in this group activity. As the *Ambulator* remarks: 'Perhaps no better eye-trap is to be found anywhere' (p. 196).

Before we approach the largest building in the gardens, the Rotunda, which was described as early as 1750 in the guide to the gardens as a 'Temple of Pleasure', we should dwell a moment on another aspect to this entertainment remarked upon by our guide, the bringing together of the sexes in a common social practice: precisely the entrance into the republic of visuality in which both men and women are spectactor citizens. One example, which will also serve to anticipate our entrance into the Temple of Pleasure, comes from a 1750 guide 'in a letter to a noble lord':

> In a word, an intelligent Spectator, of a warm imagination, is so variously
> delighted here, that he need not envy the Transports felt by the ancient

Greeks in their ... Temples of Venus, these tasted by him being equal, if not superior; and unsullied by the Guilt of which the Votaries of that Goddess were often conscious.[4]

The author continues: 'here the Splendor is so great, as well as in the *Temple of Pleasure*, that the juvenile Part of both sexes may enjoy their darling Passion – the seeing others, and being seen by them'. (p. 13).

Seeing and being seen perhaps inevitably raise the spectre of an erotics of the scopic field; it is noteworthy that at the origin of the modern display of art this erotics was, pretty much, explicitly recognized. For what was it to be in the look if not to recognize the look of recognition? Indeed, it is this which made Vauxhall's reputation, this which seduced thousands of patrons, from the lords of the land to the footmen of their coaches, into the culture of self-display, the cultural spacings of visuality. The attractiveness of the gardens, then, was created through this heady mix of self-reflection and display, visual deception and the permeability of social ranking. This is made clear by Pierre Grosley's account of his visit to the Gardens in 1772, in which he remarks that 'the pleasures of Vauxhall and Ranelagh unite both sexes, and all ranks and conditions',[5] and by Goldsmith who comments on the sense of satisfaction generated by the activity of looking in these gardens:

The illuminations began before we arrived, and I must confess that upon entering the Gardens I found every sense overpaid with more than expected pleasure: the lights everywhere glimmering through the scarcely moving trees; the full-bodied concert bursting on the stillness of night; the natural concert of birds in the more retired part of the grove, vying with that which was formed by art; the company gaily dressed, looking satisfaction, and the tables spread with various delicacies, – all conspired to fill my imagination with the visionary happiness of the Arabian lawgiver, and lifted me into an ecstacy of admiration. 'Head of Confucius' cried I to my friend, 'this is fine! this unites rural with courtly magnificence'.

The legislation of public space in eighteenth-century England was constantly faced with the problem of maintaining the hierarchies of economic and social rank. It is for this reason that the mixing of rank and gender produced such a frisson of danger and also why it quickly became so popular. Here at Vauxhall, however, the guards are more fully down than in any comparable space, say Ranelagh, where charivari or masquerade disguised the full extent of the permeability of social rank. In such spaces particular customs and laws governed what might happen, how one might behave precisely for the duration of the entertainment: at its close everything returns 'to normal'. At Vauxhall, on the other hand, the project is far more disturbing, and I would like to suggest that it is so to the extent that the Gardens very aggressively bring into the spacings of the visible the activity of viewing, and thereby foreground the visibility of the construction of identity. In the masquerade high and low mingle together in the fantasized invisible space behind a mask; it precisely marks the distinction between what can be seen and what must not. All this is so different at Vauxhall, where the most intense pleasure is to be gained by witnessing oneself coming into the domain of visibility, and once we recognize this as an entry into the virtual spaces of the

socio-cultural then we begin to take the measure of how potentially politically disturbing this place is.

We need to get into the 'Temple of Pleasure' in order to see this at its most spectacularly visible, and we shall do this by following our guide first into the Prince of Wales's pavillion where we encounter four large paintings by Hayman, whose subjects are taken from the historical plays of Shakespeare. *The Ambulator* furnishes us with a description of these paintings taken from *Lear, Hamlet, Henry* V and *The Tempest* (a picture of Miranda reading) and then comments on the overall impression of the gardens: 'The groups of figures varying in age, dress, attitudes, & moving about on this occasion, cannot fail giving great vivacity to the numberless beauties of the place, and a particular pleasure to every contemplative spectator'. (p. 197).

So, once again, the registers here all point towards self-observing self, of the mutual *recognition* of being in the domain of looking, within visuality. Such self-reflexivity is even given representation in the picture which adorns the outside of the central pavilion: a picture that 'represents the entrance into Vauxhall, with a gentleman and lady coming to it' (p. 201). The social index conveyed by this representation is noteworthy since it suggests that to be within the enclosure of the garden one needs to be or aspire to a certain standing: to be fit company for royalty, for example. This sense of the viewer's admission into a visuality that has specific social and economic registers is clearly indicated by a newspaper account of 1787. Here, in the following extract, the politics of looking at and in this garden are made fully visible:

> Amongst the fashionable circle, were the Duke of Queensberry, with a large group of foreigners; but, speaking of this place, we are not anxious to say, the quantity of the company, which did not exceed a thousand, made up for the want of quality. The manners of the lower orders of the people have, by almost imperceptible degrees, been humanized by often mixing with their betters; and that national spirit of independance which is the admiration and astonishment of Europe, in a great measure takes birth from the equality it occasioned.[6]

So here is the political project of the siting of the viewer, and note that it is phrased in specifically nationalist terms, that old pride in the peculiarities of being British. That such a nationalist emphasis is present to the garden is made very explicit in the four paintings Tyers commissioned from Hayman, to be exhibited in the long gallery opening out from the rotunda. These very large canvasses were, in the words of the 1762 guide to the gardens, meant to 'celebrate ... some of the most glorious transactions of the present war'.[7] In 1761 the first of these pictures was hung in the picture room and it depicts the surrender of Montreal 'to the victorious arms of Great Britain, commanded by General Amherst' (p. 24). Hayman represented the moment of Amherst's magnanimous gesture of feeding his captives who had endured weeks of siege. The painting, like the other three, clearly invokes great moments from antiquity, but in case its audience was unable to identify its classical model there appears in the bottom left-hand corner a stone with the following words chiselled onto it: 'Power exerted, conquest obtained, mercy shown'.

Each of these canvasses measured a massive 12 by 15 feet and each has a clear triumphalist note to sound. The second painting to be completed, for example, depicts *The Triumph of Britannia*, an allegorical painting with Neptune in his chariot driving Britannia bearing a medallion portrait of George III across the waves. Below her are portraits of the victorious admirals. The last of the four paintings, *Britannia Distributing the Laurels*, has failed to come down to us in any form – finished painting, sketch or engraving – and can, therefore, only be 'seen' through the contemporary descriptions of it. There are, in fact, two lengthy newspaper accounts of the painting published shortly after it was first hung sometime before June 1764. I do not want to examine these accounts in any detail since they take us too far from the present argument, preferring instead to take away a small observation from the first of these accounts which begins:

> BRITANNIA, with her usual attributes, is seen distributing to the Heroes wreaths of laurel, which are supplied to her from the lap of Peace, who appears in the form of a most beautiful woman, with satisfaction and plenty so strongly depicted in her countenance, that she can be taken for no being but what she represents.[8]

It would seem that the self-regarding impulse is so strong in the spacings of this pleasure ground that the look which signals one's entry into that enclosure of visuality, the look of satisfaction, even ends up being represented to and for us in the pictorial embellishments to the garden. Perhaps of greater note in the account is the contention that this most beautiful woman 'can be taken for no being but what she represents', for here spelt out to us in the most emphatic way is the autotelic image, the self-reflection of recognition. We look with satisfaction and in doing so we also can be taken for nothing but what we represent. And here what we represent is the viewer, engaged in the activity of looking and being looked at.

Now, having seen these paintings we can at last enter the room in which we will find the most spectacular spacings of the look, the Rotunda. To recap briefly, at this point what I want to suggest is that the overall experience of these Gardens is one in which the visual is constantly brought before our eye. And, as I have argued, this serves to bring into the domain of the visible visuality itself. Furthermore, this specific terrain of visuality is one in which the beholder constantly sees self-reflection in the form of others engaged in the activity of looking; the look is, in a way that will be made abundantly clear in a moment, entirely catoptric. This is recorded in all the guides and descriptions of the gardens which inform us that the place was so enticing to representation itself that not only were visitors constantly amused by the sight of other visitors, but that artists flocked to the gardens to paint these visitors looking on other visitors. As the 1762 guide book to the gardens informs us:

> A curious and contemplative spectator may at this time enjoy a particular pleasure in walking round the grove, and surveying the brilliant guests; the multitude of groups varying in figure, age, dress, attitude and the visible disparity of their humors might form an excellent school of painting, and so many of our lovely countrymen visit these blissful bowers, that were Zeuxis

again to attempt the picture of Venus, it is from hence, and not Greece, that he would borrow his image of perfect beauty. (p. 49)

The building we now enter stands slightly to the right of the entrance to the gardens and was known as the Rotunda, or Temple of Pleasure. It was constructed around 1750, and was extended by the long room known as the picture room by 1760. All the accounts of the garden move from the exterior to the interior, so in terms of sequence we are here following eighteenth-century descriptions. The room contained a large domed roof, known as the 'umbrella', under which could be seen a large glass chandelier. I now quote from the 1762 guide to the gardens:

In the middle of this chandelier is represented in plaister of Paris, the rape of Semele by Jupiter, and round the bottom of it is a number of small looking glasses curiously set: round the rotundo is a convenient seat. Above are sixteen white busts of eminent persons, ancient and modern, standing on carved brackets each between two white vases: a little higher are sixteen oval looking glasses, ornamented with pensile candlesticks, or a two-armed sconce; if the spectator stands in the centre which is under the great chandelier, he may see himself reflected in all these glasses. (pp. 21–2)

Here is the eidotrope made visible: It would be difficult to imagine a more overt description of the experience of coming into representation, of the entrance into the visual, the enfranchisement of the viewer within the republic of visuality. Everything here, from the self-reflection in the looking glasses wherever the gaze falls, to the eminent figures which form a retinal after-image upon which our self-reflected image is superimposed, contribute towards the viewer's induction into the visibility of visuality. This eidetic register is, of course, not necessarily a fully comfortable place to be, a sense given most obviously by the presence of the plaster of Paris representation of the 'rape of Semele by Jupiter'. Does this place us as the Dionysian offspring of that act, or as the perpetrator of it? Furthermore we might wonder if there is some kind of encoded warning here, since Semele, of course, was consumed at the moment her lover Zeus appeared to her naked eye in all his glory. At prescisely this point in the tour of the gardens, standing at the one absolutely prescribed point where to be in visuality is to be right here, the singularity of the entire scopic experience is revealed. It is in the ambiguity of the plaster of Paris representation that the full complexity of this singularity becomes apparent since the oscillation between penetrative gaze and recumbent glance is all too uncomfortable as the threat of recognition in voyeurism becomes almost too pressing: that is, the threat that self-recognition is equivalent to being a voyeur extracting pleasure from watching others look upon ourselves. Here the politics and erotics of the look become most unwilling bedfellows, but their pleasurable seductions are no less potent for that. The price one pays for enfranchising all who have eyes to see, for opening out the enclosure of visuality for those who can afford its shilling entrance fee, is the threat of a self-satisfied self-regarding culture becoming increasingly obsessed with the seductions of auto-voyeurism, totally self-absorbed with the pleasures of self. If this is a part of the legacy of an enlightenment culture of the visual, it is surely something to which we should bring a sceptical as well as an enlightened eye since, in the long term, we may not be able to afford such a price.

Notes

1 Robert and James Adam, *The Works in Architecture*, 3 vols (London, 1773–9), p. vi.
2 Joseph Addison, *The Spectator*, 383 (20 May 1712).
3 *The Ambulator, or The Stranger's Companion in a Tour round London*, 2nd edn, corr. and enlarged (London, 1782), p. 195.
4 [John Lockman], *A Sketch of the Spring Gardens, Vauxhall in a Letter to a noble Lord* (London, [1752]), pp. 12–13.
5 Pierre Grosely, *A Tour to London*, 2 vols (London, 1772), vol. 1, p. 155.
6 Warwick Wroth, Press cuttings collection in the Museum of London, 3 vols, vol. III, p. 38.
7 *A Description of Vaux-Hall Gardens. Being a Proper Companion and Guide for All who Visit that Place* (London, 1762), p. 24.
8 Wroth collection in the Museum of London, III, 7.

Chapter Fifteen
B/G
Thomas Crow

> It is deplorable in the 19th century, to go in search of images in Greek
> mythology: but I have never been so struck as I am with the powerful
> truth of these myths. (Balzac)[1]

In the literary academy today, there is perhaps only one famous painting from
the otherwise obscure corpus of late French neo-Classicism. The painting is
the *Sleep of Endymion*, by Anne-Louis Girodet-Trioson, and its present-day
fame arises from its use as the frontispiece to Roland Barthes's *S/Z*, perhaps
the most influential exercise in structuralist criticism.[2] As few will need to be
told, Barthes's book is devoted to an exhaustive analysis of one short (25-
page) novella by Balzac, *Sarrasine*. That story centres on the fatal infatuation of
a young French sculptor (Sarrasine) for the woman of his dreams, 'La
Zambinella', the great diva of the Roman musical stage in 1758. The drama of
the tale turns on the naive foreign artist's misunderstanding of local custom –
there were no women singers in the papal states – and his misrecognition of
Zambinella's gender status, that of castrated male. His enlightenment comes
too late to prevent his murder by the castrato's powerful protector, a sinister
Cardinal. But his obsession leaves behind an image of the false object of his
desire, a statue modelled from transports of memory in the solitude of his
studio. Expropriated by the Cardinal, the figure is subsequently copied on
canvas by Joseph-Marie Vien (the real painter who is made to figure in the
story as one of Sarrasine's companions) and given the title *Adonis*. The copy
was executed, Balzac states with a seemingly irrelevant precision, in 1791.

The story of Sarrasine's deadly misunderstanding is nested within another
narrative. The fictional teller of the tale is attempting to gain the sexual
acquiescence of a beautiful Mme de Rochefide in return for his revealing the
identity of the wizened, male enigma that the castrato has become 80 years
later. Their tacit bargain is sealed as they look on Vien's *Adonis* in the house of
Zambinella's family (who are now established in Paris with a fortune as mys-
terious as the identity of the frail old man they shelter):

> We stood for a moment in contemplation of this marvel, which seemed to
> have been painted by some supernatural brush ... The lamp hanging from

84 Anne Louis Girodet-Trioson, *The Sleep of Endymion*; Giroudon/Bridgeman Art Library

the ceiling in an alabaster vessel illuminated this canvas with a soft glow which enabled us to apprehend all the beauties of the painting.

'Does such a perfect creature exist?' she asked me, after having, with a soft smile of contentment, examined the exquisite grace of the contours, the pose, the colour, the hair; in short, the entire picture.

'He is too beautiful for a man', she added, after an examination such as she might have made of some rival.

Oh, how jealous I then felt: something in which a poet had vainly tried to make me believe, the jealousy of engravings, of pictures, wherein artists exaggerate human beauty according to the doctrine which leads them to exaggerate everything.[3]

The capture of his companion's desire in the painting goads the narrator to undercut this rival male: 'that great painter never saw the original', he tells her, 'and maybe you'd admire it less if you knew that this *académie* was copied from the statue of a woman'. His assault contains two contradictory assertions of the image's falseness: first, he denies that there is a real body to be desired behind its representation; then he asserts, shifting from the literalness of the first statement to an identification with the fantastic misrecognition of the sculptor, that there is such a body but that it is female. This disturbed response predictably angers Rochefide, leading the stammering narrator to concede that the image does possess a 'truth' after all; he is compelled to promise to tell it at their next meeting. Only by a full disclosure can he hope to eliminate the rival.[4] The history of Sarrasine then unfolds, concluding with the murder and the recovery of the statue. Still Rochefide fails to grasp the current identity of the castrato, and the narrator is forced to draw her attention back to the '*Adonis*' of Vien: it is 'the portrait in which you saw Zambinella at twenty, an instant after you saw him at one hundred ... Now you can readily see what interest Mme de Lanty has in hiding the source of a fortune which comes from –'. She cuts him off before the forbidden term can be uttered: 'You have given me a disgust for life and passions that will last a long time.'[5] The coming to light of the castrated body undoes the bargain, leaving only frustration and nausea in the teller and listener respectively. Her reaction echoes that of Sarrasine at his moment of painful awakening: 'Monster! You who can give life to nothing. For me, you have wiped women from the face of the earth'.[6]

The painting is fiction; there exists no such work by Vien. At the end of the story, however, Balzac supplies the concrete referent, the narrator explaining that the fictional canvas 'later served as model for Girodet's Endymion; you will have recognized the type in the *Adonis*'.[7] The text gave even greater prominence to the actual painting when it first appeared in the *Revue de Paris* of 1830.[8] The story was published in two instalments, and its first readers did not have to wait for the Girodet reference. The initial segment carried the title, 'The Two Portraits', and did without the pretended intervention of Vien. The fictional Adonis remained, but was simply 'owed to the talent of Girodet ... cherished by poets'.[9] When the Lanty family recovered the marble copy of Sarrasine's clay model in 1791, it was from Girodet that the Lanty family is said to have commissioned a rendering on canvas. The year 1791, not '*plus tard* (later)', was in fact the precise date of Girodet's *Endymion*, the making of

which Balzac fictionalized into two separate moments of representation and replication. In the final version of the story, published in the following year, Balzac found reasons to introduce yet another layer between real-world referent and the spell of the portrait. While Barthes nowhere mentions this revision in the text, the lengthening of the chain of replication has encouraged him to reduce the *Adonis – Endymion* to generic status, to see in it the debased product of a school, 'hark[ing] back to countless academic representations of Greek shepherds'.[10] Its contours, because they have been repeated to the point of exhaustion, are weak; because they are weak, they connote femininity; because feminine is the diametric opposite of masculine (strong), they connote a cancellation of gender: 'a terrifying essence of passivity, castration is paradoxically active: its nothingness contaminates everything it touches'.[11]

As *S/Z* retells *Sarrasine*, the painting is there in the story as a last-ditch substitute for the imaginary wholeness of the body that is lost to castration, the injury that comes to light not merely as the answer to a melodramatic mystery but as the repressed 'truth' of narrativity itself. It is an article of faith for Barthes that representation depends on absence rather than presence. The human body can be represented – and known – only as marked by the key signifier of sexual position, the phallus. But the entire symbolic order of human life depends on that signifier eluding conscious recognition. The reasoning comes from Freud via Jacques Lacan: the primordial interpretation by the infant of sexual difference as the possession or loss of the penis means that gender is initially understood as an injury, a subtraction from the wholeness of the perceived self. Successful socialization requires the repression of that interpretation, and, once installed in the unconscious, the castration fantasy is protected from correction. Symbolic difference between the sexes enters the mental life of the human subject via the castration fantasy; that primal submission to difference is the precondition for the subject's subsequent participation in all systems of symbolic exchange, from kinship and ritual to spoken language and literature.

From this acceptance of symbolic lack or absence in the unconscious domain of mental life comes the ability of the individual subject to put everything under a sign, to impose the arbitrary differences between linguistic signifiers on the plenitude of the world. Because the terrifying fantasy of pure difference, the all-or-nothing reduction of male to female, is barred from introspective consciousness, human beings are allowed the illusion that there is a reassuring presence behind every sign; words – and pictures – are taken to refer to things in the world in a natural way. Nineteenth-century fiction, in Barthes's view, puts a particular premium on making its highly artificial conventions of plot and character seem a natural expression of the way the world works. For this reason, the scandalous anecdote on which the story of Sarrasine turns becomes the scandal of naturalist representation as well. Once made explicit, the horror of castration brings the exchange of signs to an abrupt end. Lack, absence, non-being take over everything: for Sarrasine, women cease to exist; for Rochefide, all sustaining bonds of trust and love disintegrate. In this light, the painting of Zambinella can be no more than a

weak attempt to assert the impossible wholeness of the body – a body un-
marked by the void of castration – through an appeal to the putative immedi-
acy and instantaneity of vision.

Balzac's story, of course, does not break down; but Barthes finds it organ-
ized from beginning to end by rhetorical premonitions of the catastrophe it
must ultimately reveal. The unfolding narrative spares no possible antithesis
that might help bring the terrible awareness of lack under control.[12]
Collectively these make up what he calls the Voice of Symbol, a register that is
normally submerged by the redundant chatter of the realist text. The descrip-
tion of the *Adonis* painting he takes to be one signal instance of this voice
taking control; here it finds the means to do its work in the deceptively
common-place terminology of academic art. In the words chosen to evoke the
perfect male, states Barthes, 'everything connotes femininity'.[13] He can find
all he needs in the simple word *contours*: 'a word used only for the flaccid aca-
demic paintings of women or mythological ephebes'.[14] The subcode of art pro-
vides the clue that this male body is less than male (because castrated) and
therefore approaches the female, making the expressed desire of Rochefide
perversely capricious (the 'flaccid' image is insufficient to sustain it) or
homoerotic. The narrator remains the isolated bearer of uncontaminated
masculinity.

S/Z will always and rightfully occupy a pre-eminent place in the history of
modern criticism. It made the linguistics of Saussure, the anthropology
of Lévi-Strauss and the psychoanalysis of Lacan count in the reading of a
literary work in a way that was unprecedented in its comprehensiveness. It
managed at the same time respectable gestures towards Marxian notions of
ideology and the fetishism of the commodity. (It should be recognized that in
neither of these areas was it substantially original: its psychoanalytic core had
been almost entirely anticipated in a short professional article by Jean Reboul,
entitled 'Sarrasine or Castration Personified', which Barthes undoubtedly
knew but does not cite.[15]) The central achievement of *S/Z* was the application
of existing theory to create a method for reading prose that had the concentra-
tion once reserved for lyric poetry, a comprehensive mode of attention in
which no detail could be dismissed as minor or insignificant. In style, it was
unforced and animated with the excitement of discovery. The example of its
open-ended, multivocal form of reading has rightly been taken as one of the
central achievements of Barthes's formidable critical project and of the whole
structuralist movement in French intellectual history. Barthes's gesture was
liberating, but it was also one which observed, perhaps overscrupulously,
some of the limits on liberation characteristic of the left counter-culture of the
period. Reading his analysis from the perspective of 20 years, it seems
surprising that it passed – even in 1970 – without serious objection in the
literary-theoretical community. 'Castration' as an organizing concept gives up
nothing of the authority normally associated with the phallus, the positive
signifier of male power. It may be taken to mark the absolute quality of lack or
absence, but it is repeatedly evoked as the stopping point of a line of explana-
tion, the final answer. *'Beneath* La Zambinella ...', he states categorically, 'there
is the *nothing* of castration' ('il y a le *rien* de castration').[16]

It is at this point that Barthes, following in Reboul's footsteps, is most heavily invested in the psychoanalytic theory of Lacan; the governing power of castration in *Sarrasine* is the mirror of the authority of the phallus, as signifier of signifiers, in Lacan's account of the infant joining the symbolic order and becoming fully human. He makes much of the fact that the word 'castration' is never uttered in the text; any sentence that seems headed in that direction is somehow broken off before reaching the repressed term. Resistance to this interpretation is possible on the grounds that it ignores traditional, conscious rhetoric and at least one telling historical circumstance. The silence imposed on the scandalous word could readily have been an unsurprising instance of the ancient rhetorical device by which the force of an overwhelming idea is acknowledged by conspicuously leaving it unstated.[17] One could also cite the success of the novel *Fragoletta*, by Henri de Latouche, published just the year before in 1829, as obviating any need for more than a pointed allusion.[18] In the later 1820s, Balzac was extremely close to Latouche, an older, more experienced literary man who played a protective role towards the young artist through difficult economic and personal troubles.[19] In the latter's novel, also set in Italy, a brother and sister both fall in love with the same hermaphrodite. To build a plot around a castrato is simply to introduce the sexually ambiguous love object, a device with which his readers would have been familiar, by substituting what amounts to the negative reversal of Latouche's figure of doubled gender.

Second, this totalizing function of castration, as described in *S/Z*, requires for its signification that male and female connote all of their most stereotypical qualities. The castrated condition of the male body is signalled throughout by the 'feminine' qualities of weakness and passivity. Subsidiary characters cross gender lines, but are seen to do so by virtue of the same stereotypes: a display of power by a woman (as seen in Mme de Lanty, the mistress of the old castrato's household) makes her masculine; the display of nurturing or caring behaviour by a male (as seen in Sarrasine's teacher, Bouchardon) puts him among the women in the story's symbolic economy.

The bald use of these stereotypes is surprising in a mind of Barthes's subtlety. It might be argued in his defence that he is diagnosing the gender codes at work in Balzac's writing, those taken for granted in the early nineteenth century. Then the worst that might be said of *S/Z* is that it fails sufficiently to mark its distance from them; but nowhere is any critique of these essentialist sexual categories made explicit. In fact they are part of the means by which other features of 'bourgeois ideology', including realist narrative, are exposed as such. Barthes is wedded to the schema of binary opposition in the constitution of the sign. The forbidden sign of castration, which is seen to undo all fixed categories, depends for its existence on the fixed categories of male and female being preserved intact. His apodictic assertion of symbolic castration as the solution to the riddle of the text requires that this be the case.

Some telling objections thus apply to basic working assumptions about sexual difference made by Barthes and by that project of French literary theory for which he provided an eloquent voice. But the result need not be to rule that enterprise out of court as the product of unexamined patriarchal reflexes, however much it may be weakened by them. Barthes, in fact, at those

moments when he lets go of the phallus/castration master code, views language itself as the corrosive solvent of gender stereotypes: 'The body as whole, once reassembled to *speak* itself, must revert to the dust of words ... No one can *see* La Zambinella, an infinity of outlines drawn toward an impossible totality, because linguistic, because *written*'.[20] To attempt to speak the stereotype of feminine beauty, he seems to recognize, is unwittingly to subvert it.

The play on the verb *profiler* in that last passage (*profilée à l'infini comme un total impossible*) also suggests a far more productive formal reading of Girodet's *Endymion* than any Barthes himself can offer. It cues us to the ways in which the outline of the figure, while firm and complete at first glance, in fact refuses wholeness as we follow its linear course. The integration of the body with its surrounding atmosphere is an effect dependent on a continuously shifting play between clarity or obscurity of outline; the harder, highlighted areas are just hard enough to prevent the body submerging itself in the haze; the soft, shadowed ones just sufficient to prevent to the body coming free from its surrounding matrix.

Accompanying this play of line are unexpected reversals in the normal scale and relative presence of the body's parts: the features of the face are hardly present; they offer not so much a profile as a compression of the face into a narrow illuminated zone, contrasted with the large, almost grotesque area of neck in emphatic shadow, the pure, formalized play of presence and absence given unnatural stress through these unnatural transformations. This insistence on reversal extends to the accompanying eros figure, which is rendered in such a way that the edges of his body are drawn with light rather than with the dark tones that normally indicate the recession and disappearance of three-dimensional form; shadow moves from the edge of the body to its centre.

In addition there is the largest division of light and shade, the one that divides the body into its upper and lower zones. The desire of the goddess, reduced to moonlight, is displaced away from the privileged phallic location of male desire, allowing the question of Endymion's sexual identity to be placed in suspension. The sharp line of shadow cuts in a horizontal line directly across the swelling curve of the hip and just above the genital zone. The male eros, who stands in for the absent woman, opens the way to the moonlight with a look of malicious pleasure. His simultaneous provision and denial of light is the largest display of pure difference in the painting, generating less a castration of the male body than a perpetual displacement of its stability of sexual identity. It is that which organizes the separate qualities of the figure into a pervasive effect of androgyny. None of these features – the elongated and tapering legs, the ringlets of hair, the compressed Greek profile, the abandonment of consciousness – need be read as 'feminine' in and of itself.

If such an interpretation holds good, we would be applying an empirical corrective to one evident theoretical failing in *S/Z*. Barthes himself, rather myopically, can see the complex chiaroscuro of the painting only as 'blurred' and finds the painting and a photograph of it to be more or less equivalent, part of the same '*répliques des corps*'.[21] In a rather charming admission of his indifference to the material specificity of the painting, he offers a very Parisian vignette: 'Retracing the line of codes, we are entitled to go to the Bulloz

establishment in the rue Bonaparte and ask to be shown the box (most likely filed under "mythological subjects") in which we will discover the castrato's photograph'.[22] It would, nevertheless, be a mark of the residual power of *S/Z*'s example if it could foster a visual analysis of the *Endymion* that both avoids reliance on notions of essential sexual types and pays attention to the specific signifying features of Girodet's canvas. But it would follow that such an analysis, while dependent on *S/Z* as a text, could not proceed from any deliberate intention on the part of its author. It must therefore proceed from some record of attention to Girodet and his picture that *S/Z* has unwittingly caught in its net. It is an orthodoxy of recent literary theory that nostalgia for concrete reference implies reductiveness in interpretation, but it is possible that much of the stereotyping and premature totalization present in *S/Z* can be mitigated by our assuming that Balzac's text does have a dominant referent in the real world, and that that referent is Girodet.

It is vital of course to be clear at the outset that making *Sarrasine* 'about' Girodet is not to reduce its echoing polyphony of voices to the biography of one knowable historical being. Balzac's directions of encounter with Girodet's life and example were various, and much of that heterogeneity is preserved in the story. We might break them down into two principal facets: (1) the aura that surrounded Girodet's name in the art world of the 1820s and the close identification of the *Endymion* with its maker; and (2) Girodet's own writing of his life in vivid texts that Balzac had immediately to hand. Biography in this instance was itself multiform and textual before and as Balzac encountered it. He made a story out of it for his contemporaries in a way that shares something with Barthes's making another story out of *Sarrasine* for us.

We can begin to describe the encounter at the level of the novelist's own behaviour. In 1819, on the chance that Girodet was going to put the painting on public display, he requested a friend to make special arrangements so that he might see it.[23] (To do so, he was willing to risk breaking his promise to his family that he maintain a clandestine existence in Paris while they subsidized the 'idleness' of his fledgling literary career. He asked for a ticket on a lightly-attended day: 'I will go in the morning when no one will see me'.) When he was searching to establish a 'sublime' tone for the tragedy of Cromwell on which he labored during that year, he dreamed of capturing that of 'Girodet en peinture'.[24] Among the many citations of painters' names that appear in his work, Girodet is the only modern artist mentioned as frequently as Leonardo, Raphael, Titian, Rubens and Rembrandt.[25] By evoking the *Endymion*, Balzac was invoking the modern artist he seems most to have admired.

This personal commitment to Girodet, if seen only at the level of individual enthusiasm, does not necessarily prove a great deal by itself. One could object in Barthes's defence that the logic of the codes may override any wish of the author that the painting in the story be read as a persuasive vision of sublime beauty. But Girodet's aura demonstrably affected others at the time, including the readers Balzac would have had most immediately in mind. For us to gauge the feelings of the artist's admirers in 1830, it is first of all important to separate literary Romanticism from what is taken today to have been its direct counterpart in painting: that is, the challenge to classical drawing and

composition in the name of colour, gesture and emotional spontaneity. This is certainly the unstated antithesis in Barthes's characterization of the academic style as an ageing and played-out convention that marks the young body with its decrepit impotence. Supporters of the Romantics in literature, however, can reverse our received ideas of the opposition between youth and age in the painting of the period.[26] One such was Léonor Mérimée, former painter and doting father of the leading romantic writer Prosper. In 1829 he mocked the desire of Horace Vernet, 'le chef de nos romantiques', to go to Rome at the age of 40 in order to acquire a more solid grounding in the classical tradition. Precise and disciplined drawing, he states, could only be acquired 'in earliest youth'. A broad, open execution, on the analogy with the handling of paint in late Rembrandt or Titian, was the style of old men. The connection was inevitable: all artists 'enlarge their manner while advancing in age and are comparatively less finished'.[27] For Mérimée, it was the self-styled Romantics in art who were prematurely aged because they had failed to seize and develop the special aptitudes of youth.[28]

An organ of liberal sentiment such as the *Revue encyclopédique* went further, and linked the counter-classical style to an aesthetic fostered by the Holy Alliance, the foreign conquerors of France in 1815: 'Ever since Wellington defeated us at Waterloo, it has somehow followed necessarily that the painters of London are superior to the painters of Paris, and the pupils that David misled have received counsel on the proper path from the steps of Lawrence and Constable'.[29]

What threatened France was nothing less than 'a counter-Revolution in the arts', the reimposition of a corrupt old order. At the same time, however, the arts 'in retreat' remained a last pocket of resistance. So it was more important than ever to sustain the modes of painting that had supported France at the peak of her strength in arms and politics, and to refuse the 'murky doctrines' fostered by the gloating conquerors, who sought to include the fine arts in 'the holocaust that they have made of all our glories'. The fashion for the novelties of the Romantics was thus doing the work of the nation's enemies. Will the young painters of France, asks this text, 'allow themselves to be intimidated by the fear of struggling unsuccessfully against degeneration of taste, of remaining unknown while laboriously doing good work, instead of shining brilliantly by improvising bad?'

To anyone familiar with the ardently liberal and patriotic art criticism of the 1780s and early 1790s, this language will be completely familiar, the foreign Holy Alliance being substituted for the wealthy and privileged under the French *Ancien Régime*, the Romantic painterly style for the Rococo. Girodet had openly subscribed to that line during his formative years, and in the 1820s his name had come again to stand for the youthful strength of French art that was in danger of being lost.

This came out most dramatically in the extraordinary reactions to his death in 1824. The critic Etienne Delécluze recorded a long and vivid account of the emotional throng that made up his funeral cortège, where the most striking expression of grief came from Antoine-Jean Gros,[30] companion of Grodet in David's studio, renowned for his monumental canvases of Napoleonic victories. He walked, Delécluze relates, like a man in a trance, tears streaming. As the pallbearers began to slip on the icy, treacherous slope approaching the

grave, he suddenly came to life, shouting, 'This way! This way! The path will be better'. He then took charge of guiding the body down the incline, pointing with his laurel, while many in the procession found themselves, in the gathering darkness, slipping and falling in disordered confusion. When the appointed eulogists had finished, the spectators were surprised when Gros

> advanced to the edge of the pit, tears in his eyes and laurel in his hand, and made known his desire to speak. Everyone fell silent and in a speech frequently interrupted by sobs and giving himself over to fits of emotion, he spoke of the school of David as the only true one and of the eternal regrets that the death of a man such as Girodet must incite, a man who was the only painter whose talent and authority could have been the counterbalance needed to stop the slide of the French school down the slope to its ruin. Gradually his excitement mounted; he spoke vehemently against those who abuse deceitful facility and care nothing for study, valuing only passing fame and easy wealth.

These remarks echo his regretful comments made in the undertaker's premises prior to the departure of the body: 'I blame myself for having been perhaps the first to set the bad example in failing to invest enough severity in my choice of subjects and the execution of my works'.[31]

Gros's astonishing *mea culpa* met with general applause, was duly reported in the press and became a motif for others.[32] No one, however, was under any illusions that the Girodet of the 1820s was or would have been capable of leading a regeneration of French classicism. His productivity as a painter had virtually ceased for more than a decade; his behaviour was infuriatingly erratic and irascible; though beloved by his students, none had gone on to significant independent careers. But the painful contrast between the ageing artist and his younger self seems to have made him, in death, once again the shining success of the 1790s. The tenor of Gros's outburst make plain that it was a shared lost youth that was being mourned, and that the ageless memory of the young Girodet was needed as its object.

More sentimental tributes made the lost young artist one with his signature painting of eternal youth. This is an example, composed by the Marquis de Valori:

> Ah, if my sorrow has some charms, Muse, for the shade of a friend, recall the hour when beneath our tears, our Apelles fell into sleep. Was not this the hour when Diana on a mountain, far from profane eyes, shown most amorously and came, penetrating the shadowy night with a mysterious vapour, to caress a peaceful lover.[33]

The emotional catharsis of the funeral was followed by a heated competition for relics. L.-F. Bertin, the powerful editor of the *Journal des Débats*, wrote a private report on the studio auction to an old painter contemporary of Girodet.[34] He complained of being repeatedly forced out of the bidding against leading collectors and artists on the order of Gérard and Gros. Of paramount importance was the authentic hand of the artist. 'All the debris of the studio ... and his living quarters went for 220,000 francs', while the old masters in Girodet's collection often brought less than he had paid for them: 'In general, anything that was not by him sold badly'.[35] In the same year, 1825,

a published catalogue appeared that attempted to document all of the artist's autograph work, whether finished, unfinished or preparatory.[36] This effort to define and summarize his artistic identity was followed closely by one that would encompass Girodet's life and intellect as well. P.-A. Coupin, editor and art critic of the *Revue encyclopédique*, was also the brother of one of Girodet's pupils. From the artist's extensive literary estate, he fashioned a two-volume *Oeuvres posthumes*, published in 1829.[37] It is difficult to think of a precedent for such a comprehensive tribute to the total life and testament of a recently-living artist (it would be a half-century before David would receive the same treatment in print[38]). Coupin's collection presents every aspect of the life and work as of equal importance: intemperate youth is on the same level as seasoned middle age; embarrassing eccentricities reveal themselves in the company of dignified public poses.

Its contents predictably include the official intellectual record, including the formal academic lectures of an artistic elder statesman; but these texts were balanced by scores of letters from his student years in the 1790s, a correspondence that is marked throughout by immediate experience, by turns practical, quirky, passionate, perverse, self-obsessed and soberly analytical. A third element, which dominates the first volume, is an extended narrative poem entitled 'Le Peintre' that Girodet had composed around 1820 but never published. In the interests of completeness, the draft of an unfinished predecessor poem from years earlier, 'Les Veillées', was included as well. Alongside these major components are his translations from ancient Greek poetry, jottings on painting subjects never undertaken, and a range of other miscellany. Coupin introduced the volumes with an extended anecdotal biography, to which he added a revision of the 1825 catalogue.

The lesson of Coupin's textual reliquary is that the fascination exerted by the artist's work now proceeds from every word and event in his biography. The weakest verse and most banal theorizing are worth lingering over because they proceed from the exceptional and indivisible temperament of the artist. The biography and the work are equally the summation of a unique creative personality. This conflation of person and painting is no longer reserved for quasi-legendary figures like Raphael and Poussin, but can convincingly be applied to the celebration of a contemporary artist. Our century, in its veneration of Picasso or Pollock, makes this assumption routinely, but it is new for the nineteenth century. Part and parcel of this attitude is the insertion of the historical attitude into living culture. As historians want to examine everything, Coupin's volumes represent an effort to provide an unedited compendium of what he assumes posterity will want to know. He himself will not make the selection, but in this self-effacement is the confidence that the historical importance of his object will be beyond question and must be so taken by his contemporaries.

The sum of all this is to indicate that Girodet had as richly coded an individual identity in the Paris of 1830 as any modern artist could have possessed. One of the first writers to respond wholeheartedly to Coupin's gift was not a historian but, unsurprisingly given the date of its publication, Balzac in *Sarrasine*. Sources for the story's description of the Roman milieu and the custom of castrati singers have been traced to the memoirs of Casanova and eighteenth-century travellers' accounts; certain details of the artistic life of the period have been located in Diderot's *Salons*.[39] But Balzac's most immediate

point of departure was the record contained in Girodet's youthful letters. From Girodet came features of Sarrasine's fictive life that are anachronistic for a student artist of 1758: possessing one's own studio away from academic supervision was unknown; likewise having the independent resources necessary to frequent the theatre. But Girodet, who came from a wealthy family and who conspicuously rejected the pedagogical discipline of the French Academy, did possess these things. The information about his socially ambitious mode of life emerges largely from his wheedling requests for money. When his guardian protested at the expense, pointing out that art students did not live in this fashion in the time of Louis XV, Girodet replied that 'times have changed and painting too. Merciful God! I don't want to give the appearance in my works of a contemporary of Carle Van Loo'.[40] But a contemporary of Van Loo (1705–65) is precisely what Balzac made him into. In his letters, further, he evoked a Rome of novelistic romance, full of primitive passions, violence and intrigue, a city where a pretty woman will, as likely as not, lead you to a brigand's knife.[41]

From Girodet's account of his student days, Balzac was thus using dramatic effects of both an intended and unintended kind. Girodet plays up the atmosphere of danger in his deliberate efforts to dramatize the risks and difficulties of his existence (conditions which underscored his heroicizing notion of the artistic vocation). At the same time, what he did not have to overstate was the real menace of Catholic zealots who saw the French students as representatives of a blasphemous, heretical Revolution. The evocation of his intense period of labour over the *Endymion* is of the same two kinds. There is an exaggerated, almost paranoid secrecy about his progress and falsely modest claims for the breathtaking originality of statement that he indeed felt he had achieved: 'The desire to do something that is new and that does not carry the scent of the worker has perhaps led me to reach beyond my strengths, but I mean to avoid copying anyone'[42] At the same time, there is the occasional genuine expression of despair at the momentarily overwhelming task before him (which was no less than reinventing the genre of the male nude) and the painful description of one embarrassing episode which graphically illustrated the hidden hazards of his ambition: so that the painting would look forever as if it had just left the easel of its youthful maker, he mixed a large measure of olive oil in with the surface layer of pigment. The painting was to go on show in the student exhibition beginning 25 August; in July he wrote despairingly to Gérard that the surface was never going to dry. He had to scrape it off and in a few weeks produce the seamless surface that the other-worldly effect of the painting demanded.[43]

In the end, what is remarkable is that his fevered determination to astonish actually worked. The results were there to be seen in 1830 in the state collection at the Luxembourg Palace, as they are today in the Louvre: the skin of the painting inseparable from the nocturnal *sfumato* in which Endymion is embedded, as innocent of disruption as the fictional flesh of the Adonis/Endymion. When Balzac speaks of 'some supernatural brush' that created the *Adonis*, he is evoking less a bookish conceit than the complex two-sidedness of Girodet's painting: there is its uncanny physical surface, virtually free from any evidence of correction or second thoughts, and there is the actual agony and self-doubt known to lie behind this effect. And both aspects were in plain

public view: the painting in the state collection of modern art, the human story in the pages of the published correspondence. *Sarrasine* separates them into its two interlocking narratives, the former embodied in the timeless beauty of the painted figure that presides over the present-day intrigue, the latter in the dark secret of past history.

The anguish of creative doubt had all but consumed Girodet in his final major painting in which he had attempted to repeat the radiant impact of the *Endymion*. Its patron was Giovanni Battista Sommariva, an Italian residing in Paris since 1806. Though known under various titles, including Marquis de Sommariva, he had begun his career as a barber's assistant in northern Italy. Subsequently trained as a lawyer, he moved to Milan in 1796 just at the moment when the victorious General Bonaparte had arrived and begun his organization of a French puppet republic in the region. By the turn of the century, he was Napoleon's surrogate in Milan and in that capacity amassed an enormous fortune, a showplace villa on Lake Como and a commensurate number of bitter enemies. Even before his definitive fall from power, Sommariva set out to rehabilitate his unsavoury *parvenu*'s reputation by enlightened patronage of art. He first transformed his Italian villa into a shrine to classicizing art, and then – after disgrace in Italy – transferred his collection to an imposing Parisian townhouse. His proudest possession among these was a sculpture of the penitent Magdelene by Antonio Canova, in which the sensuality of the revealed body is reclaimed for orthodox piety only by the artist's classical economy of means. For its installation, Sommariva had a special shrine constructed where it was surrounded by violet furnishings and lit by a single alabaster lamp.[44]

The most prominent champion of classicizing art thus shared with the fictional Lantys a shady Italian past and mysterious fortune; like them, Sommariva chose to present his prize work of art under spectral illumination in a setting of sumptuous isolation. And it was he who drew Girodet into a futile effort to recreate the power of his youthful *Endymion*, commissioning him in 1812 to paint one of the central myths of artistic creation, the story of the sculptor Pygmalion who falls in love with his own creation and successfully entreats Aphrodite to bring the statue to life. True to his previous instincts, the artist sought to introduce an effect of stunning originality which would go beyond all previous approaches to the subject: the marble statue with which the sculptor has fallen hopelessly in love would be captured at the precise instant when an electric spark of life coursed through previously inanimate matter.[45] In thematic terms, the story is a direct reversal of the Endymion myth: there a divine being is smitten by love for a mortal and robs him of consciousness while giving him an unchanging, eternal beauty (like a work of art); here a mortal is smitten by a work of art, an image of undying beauty, and causes its divine transformation into mortal flesh and human awareness.

The making of the painting, however, brought on an altogether unwelcome reversal of the astonishing sureness and facility that had graced Girodet's youthful masterwork, transforming its theme of the ultimate creative act into a bitterly ironic commentary on the artist's declining powers. Having received the commission in 1812, Girodet was not able to display it in public until 1819. Working largely at night, isolated from daytime visitors, he was said to have

entirely effaced the painting three times during the six or so years that it rested on his easel.[46] The protracted production became itself the subject of art: Girodet's student F.-L. Dejuinne exhibited a picture in the Salon of 1822 showing his master at work on the *Pygmalion* (Illustration 85). He works at night under a lamp, with the top corner of the canvas overlapping the bottom corner of a replica of the *Endymion*. Through a skylight, the moon is visible in just the position implied by the fall of light in the latter painting. Dejuinne,

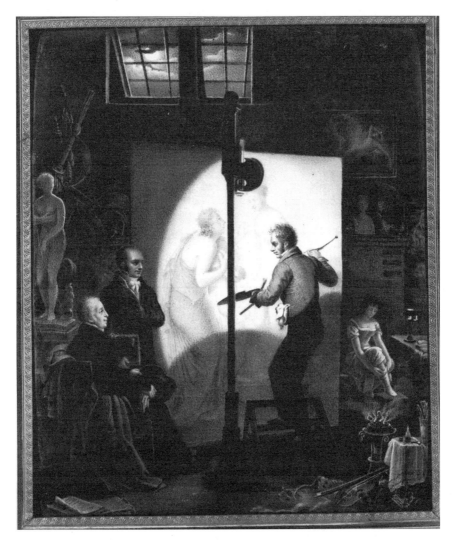

85 Adèle Chavassieu, *Girodet painting Pygmalion and Galatea*, copy after lost painting by F.L. Dejuinne; Civiche Raccolte d'Arte, Castello Sforzesco, Milan; Deposito Pinacoteca di Brera

doubtless with the blessing of Girodet and of Sommariva (who appears in and paid for the picture), makes the two paintings of myth into one continuous sequence, historically and conceptually. What is more, as Balzac transformed the Lanty boudoir into a space of mythic apparition, the studio is made to seem itself a site of divine metamorphosis. The same moon that takes possession of Endymion's body casts its light over the room; the smoking censer that appears in the *Pygmalion* as the vehicle of the sculptor's prayers is visible, likewise smoking, on the studio floor. A cast-aside violin with a broken string suggests that he has seized his brushes only after having reached a peak of inspiration. To one side of the easel is a replica of the Medici Venus, on which Girodet based his Galatea; on the other, and directly below the *Endymion*, a female model is either dressing or undressing. The painter is posed in such a way that he seems to embrace the nude figure on the canvas, which combines the two flanking extremes of dead marble and living, erotic woman.

Dejuinne's painting is an effort to redeem Girodet's struggle as promising a happy conclusion and a fitting companion to the Endymion. Balzac entertains no such illusions; his conflation of myth with the contemporary moment of Restoration Paris works to a markedly different effect from Dejuinne's uncomplicated (if dense) celebration of Girodet's creative powers. The world of myth is discovered in the up-to-the-minute world of the living, as both the secret history of the living and the tomb of a terrible beauty that it no longer possesses. 'I can give you', says the narrator to Rochefide at the end of the story, 'a fine example of the progress made by the civilization of today. Such unhappy creatures are no longer made.'[47] To understand this remark as referring to Girodet as well as to castrated male sopranos is to catch all the irony of the remark and thus save it from lame banality.

The purpose here, if it needs to be stated again, is not to equate fiction and biography or to subordinate imaginative synthesis to historical data. The fundamental structuralist assumption that there is no anchoring referent outside the network of codes is taken as given. But there is plenty of room for argument over the nature of the codes at work in *Sarrasine*. The dominant codings that traverse the fictional painting of Adonis do not connote sameness and weak repetition, but instead an exaggerated singularity and the force of youthful strength. These qualities in the image are the cause of the flaring jealousy in the fictional narrator, the jealousy that traps him into his futile bargain. In light of the immediacy and power of the *Endymion* reference, Balzac's belated substitution of Vien for Girodet makes sense as an effort to defend the fragile fictional world of the story against an overdependence on the factual. The greater distancing of the *Adonis* from the *Endymion* in turn more effectively channels the reader's knowledge of the latter into the service of the narrative. The spectral moonlight that was the most strikingly original features of Girodet's canvas is projected, in the form of the softly glowing alabaster vessel, into the fictional setting where the painting hangs and into the characters' very act of perceiving ('a soft glow ... enabled us to apprehend all the beauties of the painting'[48]). Entering from a hot, crowded and noisy party, the couple suddenly find, under the momentary spell of the painting, a secluded refuge under the sky like the bower that shelters Endymion during his encounter with the passionate moon goddess. 'How cool and fresh', says Rochefide, speaking of the blue silk covering the walls of this 'boudoir'.[49] The

body receives its transforming illumination from outside the painting; the light of the 'moon' is the means by which the woman can grasp (*saisir*) the form of the beautiful boy, which leaves its frame and assumes for a moment a presence in three-dimensional space almost as palpable as that of the 'cadaverous ... human wreckage' in which she will ultimately be asked to see its model. By vicarious experience of the effect of light and the act of inadvertent discovery, the reader participates in the transformation of Adonis into Endymion. It is all the stronger for that discovery being confirmed at the end of the story rather than dictated at the start.

When Balzac came to write his modern myth in 1830, the larger agony of maintaining the classical ideal in art was there to be seen in the exhaustion of the school of David during the 1820s and the evident lack of any persuasive replacement for it. Balzac chose to handle this by creating a tale that conflates the myth of Pygmalion with those of Adonis and Narcissus. All of those myths, in celebrating ideal beauty, reckon its ultimate cost to be sterility and death. What *Sarrasine* accomplishes is to fold Girodet's ambitions and career into the mythic world where he set his paintings. The outcome is a meditation – translated to the register of sexual desire – on the historical situation in which a set of beliefs about painting was passing away, bringing on its own death through a narcissistic fixation on a vanished moment of past perfection. The very look of the resulting painting supports Balzac's allegory of failure. Where the *Endymion* still carries extraordinary power by virtue of the seamless, uninflected surface of paint in which the illusion is embedded, the surface of the *Pygmalion* is clotted and uneven, bearing witness to indecision and obsessive, dissatisfied reworking (its protracted gestation surely lies behind Balzac's *The Unknown Masterpiece* of 1831, the story of the fictional master, Frenhofer, who futilely attempts to give the painted image of woman the ultimate illusion of life, effacing a magnificent likeness through obsessively dissatisfied reworking).

This reading of *Sarrasine* as an open-ended 'handling' of the complexities of lived experience and historical memory is less satisfying perhaps than the tidier answer offered by the psychoanalytic understanding of castration and signification. It may be less satisfying too than the categorical non-answer offered by Barthes's deconstructionist critics, where the censorship of the term for the lost phallus becomes the text signalling its unsayable difference from itself.[51] But Balzac, writing with a fund of knowledge shared by his audience but unknown to these modern-day interpreters, seems always ahead of the reigning theoretical constructs of our time. The sheer accumulation of historical markers is so thick as to leave little room for the yawning absence so dear to recent criticism. The value of that criticism now seems more heuristic than ultimately explanatory, its importance steadily diminishing as the actual matter of the story comes to light.

Notes

1 Balzac, *Lettres à l'étrangère* (Paris: Calmaun-Levy, 1899), I, p. 203.
2 Roland Barthes, *S/Z* (Paris: Editions du Seuil 1970); English edition, *S/Z*, trans. R. Miller (New York, 1972). The myth of Endymion has a number of variants; in some the hero is a grand and mature figure, son of Zeus and king of Elis; his eternal sleep comes either as punishment for his love of Hera or as a gift from

Zeus because Endymion could not bear the prospect of growing old. In another his connection to the moon begins in astronomical observations. (Later in life Girodet would contribute an entry to a mythological dictionary discussing the multiple aspects of the myth: François Noël, *Dictionnaire de la fable* (Paris: Le Normant, 1803), I, pp. 475–6). In 1791, however, Girodet chose as a primary source a text of later antiquity which both flattered his erudition and allowed him the greatest freedom of interpretation. It comes from Lucian's *Dialogues of the Gods*, the satire of mythology by the sceptical Greek writer of the second century ad (Loeb Classical Library, Cambridge, MA, VII, pp. 328–31). The source was first identified by George Levitine in 'Girodet – Trioson: An Iconographical Study', Ph.D. dissertation, Harvard University, 1953; published New York, 1974, pp. 126–7. In one short passage, Aphrodite mockingly chides Selene for her uncharacteristic infatuation with the mortal boy, describing her as the victim of her mischievous son Eros: 'What's this I hear you're up to, Mistress Moon? They say that every time you get over Caria, you stop your team and gaze at Endymion sleeping out of doors in hunter's fashion, and sometimes even leave your course and go down to him'.

Girodet renders the obsessive Selene as a fall of immaterial moonlight, whose passage is facilitated by the smilingly malign Eros disguised as Zephyr the wind. His treatment of her beloved follows directly from the description Lucian renders in her voice:

> I think he's good-looking, Aphrodite, especially when he sleeps with his cloak under him on the rock, with his javelins just slipping out of his left hand as he holds them, and his right hand bent upwards round his head and framing his face makes a charming picture, while he's relaxed in sleep and breathing in the sweetest way imaginable. Then I creep down quietly on tip-toe, so as not to waken him and give him a fright, and then – but you can guess; there's no need to tell you what happens next. You must remember I'm dying of love.

3 *Sarrasine* (reprinted in Barthes), p. 237; translation p. 232 (I have generally used the Miller translation, modifying it in places).
4 *Sarrasine*, pp. 237–9; translation, pp. 232–4.
5 *Sarrasine*, p. 257; translation, p. 253.
6 *Sarrasine*, p. 256; translation, p. 252.
7 *Sarrasine*, p. 257; translation, p. 253.
8 *Revue de Paris*, XX (1830), pp. 150–67, 227–52.
9 *Revue de Paris*, XX (1830), p. 164.
10 Barthes, *S/Z*, p. 76; translation, p. 69.
11 Barthes, *S/Z*, p. 77; translation, pp. 70–1.
12 Much of this, it should be noted, had already been observed by Jean Reboul in his article, 'Sarrasine ou La Castration personnifiée', *La Psychanalyse*, I (1956), pp. 92–3.
13 Barthes, *S/Z*, p. 76; translation, p. 70.
14 Ibid.
15 Reboul, 'Sarrasine', pp. 91–6. Having passed in silence over Reboul's priority, *S/Z* obviously cannot address the substantial divergence in its interpretation of the character of Sarrasine's insertion in the Symbolic order (compare Barthes, *S/Z*, pp. 220–2, translation 214–16, to Reboul, 'Sarrasine', p. 95).
16 Barthes, *S/Z*, p. 129; translation, p. 122.
17 The grief of Agamemnon at his daughter's sacrifice was most eloquently expressed in the painting of Timanthes, both Cicero and Quintilian observed, by covering his face with a veil. See Cicero, *Orator*, XXII. 74; Quintilian, *Institutio oratoria*, II. 13.13.
18 *Fragoletta ou Naples et Rome en 1799* places the story in the setting of the brutal repression by the English and the local Bourbons of the Neopolitan republic.

Balzac reviewed the book when it appeared (*Mercure du XIXe siècle* (June 1829), in Balzac, *Oeuvres complètes: oeuvres diverses*, eds M. Bouteron and H. Longnon (Paris, 1956), I, pp. 203–5), concentrating entirely on the political drama, saying of its author, 'He had Voltaire and Lord Byron in his soul'. He returned to the book in a later short essay, 'Du roman historique et de Fragoletta' (*Mercure du XIXe siècle* (January 1831), pp. 205–7), in which he described the romantic plot in this way (p. 207):

> Imagine before you this inexpressible being, who has no complete sex and in whose heart contend a woman's timidity and a man's energy, who loves the sister and is loved by the brother, and can return nothing to either one. See all the qualities of woman gathered in this captivating Eugénie and all those of man in this noble Hauteville; place between them this startling and gracious Adriani as the transition between the two types; lavishly throw passion over these three figures and torture their three hearts with combinations never even conceived anywhere before; then, finding no balm for their inutterable sufferings, raise this unhappiness to its peak; imagine one last, insupportable sacrifice; finally wrench our every sensibility and you will have created a masterpiece: you will have created *Fragoletta*.

19 See Frédéric Ségu, *H. de Latouche, un républicain romantique*, (Paris: Societé d'edition 'Les Belles Lettres', 1931), pp. 376ff.
20 Barthes, *S/Z*, p. 121; translation, p. 114.
21 Barthes, *S/Z*, p. 77; translation, p. 71.
22 Ibid.
23 Honoré de Balzac, *Correspondance*, ed. R. Pierrot (Paris: Garnier fréres, 1960), I, p. 46.
24 Ibid, p. 39.
25 See Pierre Laubriet, *L'Intelligence de l'art chez Balzac* (Paris: Didier, 1958), p. 398.
26 The *Revue de Paris*, where *Sarrasine* first appeared, published romantic writers while remaining friendly to classicism in the visual arts. In the same year that it published Sarrasine, it treated its subscribers to a sympathetic reminiscence of David's exile in Brussels (M. Baron, 'Les Exilés de Bruxelles', XIX, pp. 22–5, a review lamenting the sad state of contemporary painting in comparison to the great days of the Republic and Empire (Charles Rabu, 'Musée du Luxembourg: Tableaux de l'Empire', XX, pp. 53–6), and a long essay on artistic competitions by Raoul-Rochette, who had been a eulogist at Girodet's grave side ('Du concours en fait d'ouvrages d'art et de travaux publics', XX, pp. 177–92, XXI, pp. 14–24).
27 'Letters to Fabre, (29 January 1829)', *Nouvelle Revue rétrospective*, V (1896), p. 423.
28 Mérimée went on to say (ibid., p. 423):

> If an artist knowing how to draw and paint like Girodet had neglected correction to preoccupy himself with color, and if he had presented to the public grand sketches, brilliant in color and arresting in effect, there is no doubt that he would have gained a success that would have led the French school down this path to perdition and that our young artists would no longer want to learn to imitate *la belle nature*.

29 J.R.A., 'Quelques Vues sur l'École de David, et sur les principes de la peinture historique', *Revue encyclopédique*, XXXIV (June 1827), pp. 580, 591, 593.
30 E.J. Delécluze, *Le Journal de Delécluze*, ed. R. Baschet (Paris, 1948), pp. 50–64.
31 Ibid, p. 62.
32 See in particular *La Semaine: Gazette littéraire*, December 1824, pp. 334–5.
33 Marquis de Valori, *Sur la Mort de Girodet, Ode, Dédié à ses élèves*, n.p., n.d.
34 13 April 1825, 'Letters to Fabre', pp. 42ff.

35 Gérard was so chagrined that one of his own sketches made a comparatively poor showing, reports Bertin (ibid), that he put it about in the press that its buyer had turned around and sold it at a much higher price.

36 Alexis-Nicolas Pérignon, *Catalogue des tableaux, esquisses, dessins et croquis de M. Girodet-Trioson* (Paris, 1825).

37 The contract between Coupin and Jules Renouard, the publisher of Girodet's *Oeuvres posthumes* (Paris, 1829) is preserved in the departmental archives of Yvelines, Versailles, dossier J2072: Coupin signed a receipt for the papers on 10 March 1826, stating that the papers belonged to Renouard, and the latter counter-signed the same document on 12 October 1828, stating that the papers had been returned. I am grateful to Alain Pougetoux and Philippe Bordes for pointing out the location of these documents.

38 J.L.J. David, *Le Peintre Louis David 1748–1825: Souvenirs et documents inédits* (Paris, 1880).

39 See Henri David, 'Balzac italianisant autour de Sarrasine', *Revue de la littérature contemporaine*, (1933), pp. 457–68; Jean Seznec, 'Diderot et Sarrasine', *Diderot Studies*, 4 (1963), pp. 238–9; Helen Borowitz, *The Impact of French Art on Literature* (Newark, Delaware: University of Delaware Press, 1985), p. 118.

40 Girodet-Trioson, *Oeuvres posthumes*, II, p. 383.

41 See *Lettres adressées au baron François Gérard*, ed. H. Gérard (Paris, 1886), I, p. 152.

42 Girodet-Trioson, *Oeuvres posthumes*, II, p. 387; see also pp. 392, 396.

43 *Lettres addressés au baron François Gérard*, p. 178.

44 See Francis Haskell, 'An Italian Patron of French Neo-Classic Art', *Past and Present in Art and Taste* (New Haven, CT and London: Yale University Press, 1987), pp. 44–64.

45 See *Description du tableau du Pygmalion et Galatée exposé au salon par M. Girodet, suivi de l'entretien de Sa Majesté Louis XVIII avec Monsieur Girodet lors de la présentation de son tableau* (Paris, 1819); C.P Landon, *Annales du musée*, II (1819), pp. 11–12.

46 See Quatremère de Quincy, 'Éloge historique de M. Girodet, peintre', *Recueil de notices historiques* (Paris, 1834), pp. 328–9.

47 *Sarrasine*, p. 258; translation, p. 254.

48 *Sarrasine*, p. 237; translation, p. 231.

49 Ibid.

51 See Barbara Johnson, *The Critical Difference* (Baltimore, MD: Johns Hopkins University Press, 1980) pp. 3–12.

PART V

Chapter Sixteen
Vision Procured
Bennet Schaber

As she came into the room, she had seen her pale face reflected in a
mirror hanging opposite the door; but it was not herself that she saw
but her father with a death's head. (Breuer, 'Anna O.')

Your looks are laughable, unphotographable; But you're my favorite
work of art.(Rogers and Hart, 'My Funny Valentine')

As I write this chapter I am looking across my table at a full-page
advertisement for discounted cameras. In the land of perfected democracy
and free enterprise, vision has itself become democratic, although its cost is no
doubt that it finds itself reduced to a form of property on a massive scale.
These cameras range in price from 50 to 500 dollars; and the buyer, whose
pretensions may run the gamut from simple recorder of family history to full-
blown artist, is encouraged to think of his or her own photographic activities
within the mode of entrepreneurial capital. In the same newspaper, for
example, there is also an article on the latest Van Gogh sold at auction for an
astronomically high price. This sum marks the limit – the paradox and
promise of which is that it is no limit at all – upon which even the simplest
camera, fully automatic, one-touch, and so on, focuses its sights. And the
entire page at which I now gaze is in fact set from about 30 photographs (of
cameras), revealing not an image of nature, a natural, true vision (although
the page is set in strict adherence to Cartesian space), but the verisimilar stage,
the fantasy upon which consumeristic desire plays its scenes. Before imagin-
ing myself seeing, I imagine myself buying, seeing myself buy: the double-
entry accounting system of the retinal chequebook.

The work of capital, then, as this (fantasmatic) page makes clear, even *en
abyme*, is no longer that of simple production but has shifted towards recording-
production. And what is recorded on this page is only the most recent
instantiation of a history of ideology in which that shift is itself recorded: prop-
erty no longer understood as something produced but as recorded, held in the
hands of the eyes or ears (gourmet cuisine signified by its photograph and
hence its photographability; music judged by the quality of its technical repro-
duction, by its fidelity, but to what, if not to its own technological possibilities).

Since one of the cameras offered for sale on this page is an Olympus, a simple association lets me imagine this page as something like the counterpart to Manet's *Olympia*, displaced by a host of monocular arguses staring straight out of the page at me. This page, however, is not nearly as unsettling as we suppose Manet's painting to be and to have been. Not because of the sheer banality of the advertisement; after all, the Manet might seem equally banal within the context of recent discussions of art history of which the present book is no doubt an example. What, then, is the relation of the camera advertisement's prostitution of vision to Manet's vision/painting of a prostitute? (Illustration 14)

I would contend that they both respond to the same question, a question implicitly posed by the chapter in this part: is a representation, a visual representation, the property of a subject? The advertisement responds with a resounding yes. Indeed, the photo of the camera, sitting atop its price, gives the very *ratio*, the reason, meaning and equivalent, of the relation of vision to its subject, to the one who sees and records that sight. The painting, however, would seem to answer not at all. It says nothing explicitly. One either assents to its own fable, in which case one must imagine entering the room with just the prospect set up by the painter, paying this woman what she asks in order that she relax her gaze, look away, and yield up to you your proper pleasure; or, one imagines buying the painting, hanging it, for example, in the master bedroom, so that it might preside, once again, over one's proper pleasure, only this time within one's own, proper fable. In both cases, the painting acts as a mirror, the reflective and impassive surface framing my own act in such a way that I seem to see myself within that very action. Hence the painting would have the power of securing for me, finally and at a cost, the relation of property between subject and representation precisely by making my implication in a (sexual) action the object of my own vision. The painting on the wall would obviate the need for a mirror on the ceiling.

One might say that the *Olympia*, far from being a 'real' representation of, for example, life in a brothel, or even of the body and appurtenances of one of its denizens, literally procures vision. Its status as mirror, opening up and framing a field of vision, unsettles and embarrasses – makes one anxious – precisely because it situates vision elsewhere, with an Other whose gaze is divided and registered as blackness: the black maid who looks at the naked woman, the black cat looking at the viewer. The viewer's gambit is the unification and taking possession of these two looks as one's own, proper vision. Within the *mise-en-scène* of the painting the viewer pays and becomes party to a monetary transaction, so that the Other might rent out the gaze allowing him or her to settle into the reflective abyss of his or her proper pleasure. In the language of the painting, the maid's smock picks up the colour of Olympia's body in order to suggest the clothing and closing of the Other's body so that the body of the desired object might unclothe and disclose itself. What remains of that Other is the blackness of Olympia's eyes, her gaze – now, finally – reflected in my own. In fact, the eyes of maid and cat alike reflect the tones of her flesh. And those flowers, they are presented to both Olympia and me as the myth of our mutual (rather than the Other's) *jouissance*.

The great scandal of the painting, then, would be its staging of the Other who comes, who enjoys, in my place. The wager of the painting is the question

it poses to me: how much am I willing to pay in order not to see (the Other) so that I might mis-take my own vision as a field of my own omnipotent pleasure? How much would I pay for the fantasy that desire offers itself up freely to my taking? The trick is played, as with all good tricks, with mirrors. The eyes of maid and cat reflect the body of Olympia. Olympia's eyes reflect my own. All lines of sight converge on me as the origin of their power and the destination of their pleasure. Except it is all a lie, staged and factitious; just another trick turned and returned within speculation itself.

It is, I think, precisely this function of *Olympia* as specular reflection, *méconnu* misrecognised, that has informed T.J. Clark's animadversions on Manet's painting.[1] *Olympia*'s failure to signify for the critics of the 1860s itself signifies, in Clark's reading, a shift within pictorial and social practices in which the painterly signs adhering to the nude and which situated desire as the property of a male spectator became so unhinged and disjointed that desire became the property of the naked woman herself, inscribed in and on her body.[2] Clark no doubt intends his reading of *Olympia* as a (Marxist) contribution to the social history of art. But what interests me for the purposes of this introduction is that reading's seemingly inevitable encounter with and passage through Freud. And it is, I take it, just this inevitability, this necessity of a psychoanalytic attention to the visual within a social history of art, that the chapter in this part can be said to attempt to flesh out, to speak in the mode of both Clark and *Olympia*.

> The nude has to indicate somehow the false facts of sexual life, and pre-eminently that woman lacks a phallus. This is the issue that lies behind Lemmonier's talk of showing and not showing what woman is. The nude, he says, 'hides nothing because there is nothing to hide.' That is no doubt what most male viewers wish to believe, but it regularly turns out that that *nothing* is what has to be hidden, and indicated by other conventions … the hand seemingly coinciding with the body, enacting the lack of the phallus and disguising it. In that sense – in that particular and atrocious detail – Olympia was certainly scandalous. Her hand enraged and exalted the critics as nothing else did, because it failed to enact the lack of the phallus … When the critics said it was shameless, flexed, in a state of contraction, dirty, and shaped like a toad, they toyed with various meanings, none of them obscure. The genitals are *in* the hand, toadlike; and the hand is tensed, hard-edged and definite; not an absence, not a thing which yields or includes and need not be noticed. 'When a little boy first catches sight of a girl's genital region, he begins by showing irresolution and lack of interest; he sees nothing or disavows what he has seen, he softens it down or looks about for expedients for bringing it into line with his expectations.' Freud's account of origins is not necessarily to be taken as the whole truth, but it states quite well the ordinary form of male inattention in art. And Olympia's hand demands to be looked at; it cannot be disavowed or brought into line with anyone's expectations …
> The hand is Olympia's whole body, disobeying the rules of the nude.[3]

The argument, in all its assuredness and clarity, comes down to this: Olympia's hand, her whole body in fact, calls fetishism to account, and precisely because it functions as a failed fetish, a fetish *manqué* so to speak.

The argument derives from Freud, whom Clark cites with some apparent nervousness, since the Freudian account 'is not necessarily to be taken as the whole truth'. Nevertheless it is in place precisely to confirm Clark's earlier assertion that in *Olympia* 'Desire itself, in a form which carried any conviction, was the property now – the deliberate production – of the female subject herself.'[4] 'Fail[ing] to enact the lack of the phallus', the fetish/hand would seem thereby to restore to woman the right to her own, proper genitals: to her own body. And this argument would be ultimately convincing had not Clark got Freud's argument precisely backwards.

What a fetish, according to Freud, must 'enact' is not 'that woman lacks a phallus' but that she has a penis. 'The fetish is a substitute for the penis', he writes, the disavowal (*Verleugnung*) of the absolute nature of sexual difference as difference.[5]

> In [the boy's] mind the woman *has* got a penis, in spite of everything; but this penis is no longer the same as it was before. Something else has taken its place, has been appointed its substitute, as it were, and now inherits the interest which was formerly directed to its predecessor. But this interest suffers an extraordinary increase as well, because the horror of castration has set up a memorial to itself in the creation of this substitute.[6]

The traditional nude begins from this fact but it hardly ends there. It is not the fetishist's art exactly; rather, in depicting the seemless surface of woman taking pleasure in herself, it creates the narcissistic screen laid over castration in order to support male pleasure and protect it from anxiety. In the voluptuous and closed circuit of the nude *hetero*-sexual desire is inscribed upon the surface of the same, the *homo*. Woman, therefore, becomes the phallus, her body memorializing an untroubled auto-eroticism before difference and castration.

The fetishist – and perhaps every man – assumes his castration through the denial of the other's (the other sex). And if Freud stresses the visual determinants of this scene it is because vision here becomes the phallic counterpart to the female body. The gaze in the picture becomes the phallic term uniting woman with herself and man with his desired object, all within the unified and unifying substance of vision and light. If *Olympia* can be said to disturb this scenario, it is not because her 'hand is ... her whole body' but precisely because it is not. It cannot be seen as a part taken for a whole – the fetishist's art of disavowal in which every part signifies a whole within a unified and uncastratable substance – but as absolute and determined part, appendage and appended. Desire is no longer in or on the body but appended to it. And the explicit signs of prostitution, of the *demi-monde*, noticed by all of the contemporary critics, stressed that it was not vision at all but only cash that could restore this hand to its proper relation to the body. The painting was, as they pointed out, 'unfinished': castrated.[7]

The painting, as is invariably said of it nowadays, is 'flattened'; although it might be better, in the present context, to say that it is robbed of the (third) dimension that might restore to it the depth and truth of vision and woman. A dimension *volée*, the phallus flown the coop, a purloined painting, perhaps. If the contemporary critics (whose responses Clark so brilliantly assembles and deciphers) were left with nothing but anxious and angry pens in their hands,

it was because in *Olympia* commodity fetishism had finally kept its appointment with its perverse cousin and within a critique of pictorial property and propriety. Its scandal was not that it turned them into Johns, that would not have been so bad, but into pimps for the art world. It asked and continues to ask just how far one is willing to go (or has already gone) in order to procure (for oneself, as property) the visibility of a representation.

That Manet's painting makes this demand on the terrain of sexual difference is what allows it to go one better than my camera advertisement. To even acknowledge its demand would have taken, for the viewer at the *Salon* of 1865, something of Freud's courage and acumen in the face of the hysterics who overwhelmed him nevertheless. According to Lacan:

> It is simply that Freud ... failed to formulate correctly what was the object both of the hysteric's desire and of the female homosexual's desire. This is why – in each case, in the case of Dora as well as in the famous case of the female homosexual – he allowed himself to be overwhelmed, and the treatment was broken off. With regard to his interpretation, he is himself too hesitant – a little too early, a little too late. Freud could not yet see – for lack of those structural reference-points that I hope to bring out for you – that the hysteric's desire – which is legible in the most obvious way in the case – is to sustain the desire of the father – and, in the case of Dora, to sustain it by procuring.[8]

What Freud 'could not yet see', but what Manet, not far in advance of Charcot, perhaps did (in an urban landscape where prostitution was the order of the day), were 'those structural reference-points'; and in this way his picture's 'flatness' or 'unfinishedness', its organization and dividing of gazes in shades of black and white – in short, its castration – suspended desire in the name of the Other. The Other, the Father, the Phallus; these were at stake in the picture; and they faltered, each in its own turn.

The hysteric invented psychoanalysis and undid medicine's claims on the analysis of desire. She (usually) did this by posing the question of the analyst's desire.[9] 'Name my desire', she demanded. 'Am I a man or a woman; and what is the sex of the one who dares to tell me?' The analyst's back was to the wall: she procured him dreams in just the same way she procured women for the father.[10] She became the analyst's analyst within the transference. Manet's picture did much of the same and provoked the same paternal rage and impatience. The hysteric would seem to peer in on (and out of) *Olympia* from its other side.

Manet's painting has been linked to the pornographic photographs of the Second Empire.[11] By the 1880s the hysteric would become the new object of photographic interest, and no less pornographic despite its medical trappings. The camera was meant, in a sense, to save reason and its visual supports from the threats posed by the public theatre of prostitution and the 'private theatre' of hysteria.[12] It should have restored – against that theatricality – the real to vision but, as Martin Jay points out, it definitively failed. The double(d) dare of prostitute and hysteric displaced the double(d) truth of vision and woman.

The scandal of *Olympia* is quite simply this: I cannot find my desire in the picture as mine. While the traditional nude brought forward a body to organize and procure vision as one's own, one's inalienable property, Manet's

nude brought forward vision as the property of an Other for whom one procured. In what I say about it my desire is not reflected on and by itself; instead, 'I am photo-graphed'.[13] And so too, and I think inevitably, was T.J. Clark.[14]

What I want my preceding comments to suggest, in their own inept way, is that in Manet's painting the unsaid and unseen, circulating in the streets of nineteenth-century Paris with the most perfect and easy fluidity, could all of a sudden take on mass, recline and embody themselves. A hole could open up within the space of the city and shatter its pretensions to its own verisimilitude. I would liken this hole to the hysterical symptom – the cough, paralysis, stutter, and so on – which does much the same thing upon the body itself. Psychoanalysis found in this symptom not the sign of something *per se*, but a signifier for someone (or better, for another signifier). The symptom paid homage in the real to the Other's desire, its hold upon and carving up of the passional body of the hysteric.[15]

This Other remains beyond the scope of a social history of art that fails to encounter psychoanalysis. And I take this to be the point (or point of departure) of the following chapter. Martin Jay, to whom I have already referred, returns us to psychoanalysis's opening act within the nineteenth century while realizing that it cannot be held in place there and made the property of a sociological dicourse. Its 'rejection of Charcot's faith in the theatrical representation of madness' seems to me both the object of his history and the place from which his writing begins. Rosalind Krauss's chapter, which I suppose belongs to the anti-ocularcentric tradition whose origins Jay sketches, argues that the radicalism of the avant-garde, in this case surrealism, cannot be grasped as radical from within a strictly social, formal or institutional history. 'We have to bring the readymade closer to the site of its real power to scandalize', she writes. And her call for a 'psychoanalytic of the readymade' is irreducible to the analysis of commodity fetishism from within political economy or to some form of institutional critique. Instead, she locates the critical, analytical and scandalous power of Ernst's collages – their seeming affront to both autonomous vision and perspectivalism – in their staging of a 'visual automaton', the saturation and pre-existence of a visual field that reintroduces a subject to the traumatic dimension of pure loss within the visual (castration and the death drive). I take this to be a continuation of Lacan's elaboration of primal repression within the visual field itself. That is, the subject is brought into being as the effect of an encounter with a signifier (of some other's desire), the S or *trait unaire*, that it can only register as a representation after the fact, retroactively, *après coup*. This encounter is a profoundly missed encounter, *rencontre manquée*, and institutes the subject not as what it is but as what it will have been (for an other), as *manque-à-être*.

The readymade, therefore, reintroduces art to its primal scene, to its own radical separation from the scene of its own genesis. The blank canvas, so dear to Greenbergian conceptions of modern art, is revealed not as an essence or origin but as a screen or skin through which bleeds a metonymic series of representations, the serial automatism of the desire or discourse of the Other (the unconscious) within the visual field. Hence Krauss can speak of surrealist painting and its cognate Lacanian schemata as the 'repressed' of modernist pictorial practice and visual theory.[16]

Krauss's emphasis on the primal scene, on the 'master's bedroom', suggests that the visual is always already traversed by sexuality (which would be its very condition in advance of being its constructed effect), a field resistant to any subjective mastery or appropriation by virtue of the passage it demands, in order to be encountered at all, through the other (sex). Her contribution conceivably leads in the direction of feminism, not so much as a critique of the masculine appropriation of the visual (the so-called 'male gaze') but as an insistence upon difference, sexual difference, as the unmasterable fact of the visual itself.

Victor Burgin's chapter ends by returning us to to the bedroom, only this time granted, by way of Breton's *Nadja*, the power to derealize, through its traumatic structure, the political space of the city. Whether or not the chapter's clinical context controls or unleashes that power I leave the reader to decide. Nevertheless, Burgin's attempt to articulate an archaic and corporeal spatialization with and against 'the proper space' of the city strikes me as incisive, if not wholly decisive. My only regret is that his encounter with Little Hans seems so profoundly missed. While concentrating on the ways Little Hans represents 'by means of his body the whole multifariousness of the outer world', he forgets that the child was himself something of a *flâneur*, albeit a phobic one. The phobic perhaps presents the city with its other scene, its obscene, the subject for whom the utopian, symbolic and political circulation of the city comes to a halt. When Lacan commented on this case he made use of a map of Vienna. If the city can be thought of as the smooth, metonymic (infinite because delimited and linked to itself as proper) surface of a set of signifiers, the phobic discovers in it the potholes and traffic jams of the real. Nevertheless, Burgin makes clear, as does the phobic or psychotic, the ways in which the unified political space of the city is compromised by the very desires which traverse it or even appropriate it. The city then, cannot exhaust its possible symbolizations because its utopian and planned spaces and circulations become divided and jammed when articulated with and against the corporeal and libidinal spaces and circulations of its inhabitants, their chance encounters and unforeseen groupings. In short, Burgin would seem to take the metaphor of the 'body politic' quite literally in order to trace there its arterial flows of traffic, blood and desire.

The social history of art, therefore, must reckon consistently with the chance and missed encounter between the utopian arrangement of social space and what, for lack of a better word, might be called its libidinal derangement. It would have to take account of the double and doubled structuration of the visual field: the ways in which a historically determined set of meanings organizes, secures and arranges visual representations for its subjects but also the ways in which it resonates with and against a more archaic and sexualized regime of signifiers through which objects must pass in order to occupy the visual field in the first place. The history of the pictorial sign, therefore, is charged with the double task of determining both its meaning (through the history of social signs) and its very visuality which, as the following chapter make clear, cannot be done through the simple delineation of formal, technical practices. The example of Manet is intended to show just this double scansion, the ways in which a social rhetoric of prostitution and procuring returns within painting as the question of desire within the visual field itself. Hence

my insistence on property as both social relation (financial transaction) and as relation to an Other (the unconscious) who misappropriates what I take to be my proper gaze.

A black cat sleeps in my bed each night; and so does a woman. No doubt what I find in Manet's painting (but is it really his?) partakes of something of a chance and readymade encounter with the fantasy of my own origins. But precisely because I encounter it as readymade, as pre-existing and saturating my field of vision, what the picture shows me instead is the origins of my fantasy, my interminable procuring of objects for the gaze of the Other, who signs the page upon which I write just before I manage to sign my proper name.

Notes

1 T.J. Clark, *The Painting of Modern Life* (New York: Knopf, 1985), pp. 79–146.
2 Ibid, p. 131.
3 Ibid, pp. 135–6.
4 Ibid, p. 131.
5 'Fetishism', in *The Standard Edition of the Complete Psychological Works*, ed. James Strachey (London: Hogarth Press and the Institute for Psycho-Analysis), XXI, p. 152.
6 Ibid, p. 154.
7 Clark, *The Painting*, p. 84 and *passim*.
8 Jacques Lacan, *The Four Fundamental Concepts of Psycho-analysis* (New York: Norton, 1978), p. 38.
9 The 'analyst's desire' is the term through which Lacan attempted to situate the transference within analytic practice. It can be seen already deciphered in the case of 'Anna O.' whose so-called hysterical pregnancy may be read as an interpretation of Breuer's desire. Ernest Jones, *The Life and Work of Sigmund Freud*, vol. I (New York: Basic, Books 1953), p. 224, reports that after terminating the case, Breuer took his wife to Italy where she became pregnant.
10 See Lacan, *Four Fundamental Concepts*, p. 37, for a discussion of the dreams presented to Freud by one of his patients.
11 See Chapter 18 by Martin Jay in the present volume.
12 'Private theater' was the term coined by Anna O. to describe her daydreams.
13 See Lacan, *Four Fundamental Concepts.*, p. 106:

> This is the function that is found at the heart of the institution of the subject in the visible. What determines me, at the most profound level, in the visible, is the gaze that is outside. It is through the gaze that I enter light and it is from the gaze that I receive its effects. Hence it comes about that the gaze is the instrument through which light is embodied and through which – if you will allow me to use a word, as I often do, in a fragmented form – I am photo-graphed.

14 The signs of this photo-graphy may be read in the displacement of Clark's denegation of Freud's 'whole truth' to the affirmation of Olympia's 'whole body' as they relate to his discussion (a missed encounter, no doubt) of 'disavowal'. In a note to this passage Clark writes: 'I am aware that my use of [Freud's] article is partial and unadventurous, but my treatment of the nude in art would have been even more limited without it' (p. 296, note 143). Hence the part returns to the whole in a discussion of the critic/historian's own limitations.
15 See Jacques Lacan, *Television* (New York, 1990), p. 6: '[Man] thinks as a consequence of the fact that a structure, that of language – the word implies it – a structure carves up his body, a structure that has nothing to do with anatomy. Witness the hysteric'.

16 The wager implied in Krauss's call for a 'psychoanalytic of the readymade' has already been taken up by Thierry de Duve in his *Pictorial Nominalism: On Marcel Duchamp's Passage from Painting to the Readymade* (Minneapolis, MN: University of Minnesota, 1991). Here too 'the Lacanian paradigm is isomorphic to the Duchampian formula' (p. 165) of the readymade. That is, de Duve traces Duchamp's passage from 'painter' to 'artist' as, in one crucial instance, the traversal of Cezanne through the name-of-the-sister, Suzanne, so that the very status of the Duchampian artist as *passeur* implies, acknowledges and abandons the *pas soeur* traversed in the very name of traversal itself. 'Pictorial Nominalism', then, names not only Duchamp's practice *per se*, but the work of the art historian who encounters the unconscious, structured like a language, within the visual field constituted, in Duchamp's words, as 'being given', by or to the Other.

Chapter Seventeen
In the Master's Bedroom
Rosalind Krauss

for Joel Fineman

The argument Peter Bürger makes in *Theory of the Avant-Garde* turns on the notion of institutional critique. If dada, surrealism, and the Russian avant-garde were truly radical, he maintains, this must be understood against the historical conditions that made that radicalism possible, conditions Bürger locates in the very autonomy modernism had so painfully won for aesthetic production. For if this autonomy liberated art, it did so, ironically, only into the jail of its own institutional incarceration, freeing art from that very field of social praxis that could supply it with seriousness or purpose. The independence which the institution of art now supported and maintained – an independence from the social field of the patron, the moral one of the receiver, the objective one of the referent – was the independence of a closed and self-immured system: it was the very picture of alienation and the very rootlessness of the commodity condition. The institutional form of this autonomy consolidated itself during the last decades of the nineteenth century and the opening ones of the twentieth. By the end of the First World War this institution with its dealers, its system of exhibitions, its thirst for artist-authors, its marketing of the new, had emerged as an observable entity. It was this institution, Bürger insists, that the historical avant-gardes attacked.[1]

Now the institution Bürger's argument explicitly addresses is that of the visual arts: the field of creative production within which commodification occurs most spectacularly and in relation to which the spatial implications of 'autonomy' are materialized through the specific analogues of the gallery, the studio, the transportable easel painting and the independent exhibition. And indeed his examples of the avant-garde's attack on the institutional form of art are almost all drawn from visual practice: examples such as collage, the readymade, the collectively or automatically produced object. But the avant-garde Bürger is theorizing is not a specifically visual one, for autonomy was sought earlier and more passionately in poetry than in painting; the techniques of chance, montage, and readymade are as available to literary as they are to visual practice; and many of the situations that Bürger ends up wanting to

discuss, such as Brecht's theatre, make it clear that his avant-garde is indeed diffuse, embracing all areas of cultural practice.

If, however, autonomy meant something to the specifically *visual* practitioners of the avant-garde, it had not only an institutional form that determined the shape and consequences of its practice, but also a cognitive one, locating the grounds of its particular independence within the very conditions of the field of apperception. The idea of an autonomous vision – freed from all obligations to the object, and from all idiosyncratic definitions of the subject – becoming an abstracted sensory stratum that could be made to appear in and of itself as a kind of Kantian category, this notion of visuality was a founding conception of modernist pictorial practice, beginning in Impressionism, developing in Neo-Impressionism, and maturing in both Fauvism and Cubism.

It was this visuality, hegemonic throughout modernist practice, that certain of those artists Bürger identifies with the avant-garde did indeed act against in the period following the First World War. It was this visuality, for instance, that shaped Marcel Duchamp's distain for the art he called 'retinal' and led to the peculiar practice of a mechanization of the visual to which he gave the name 'precision optics'.[2] It was this visuality that negatively set the terms of the early work of Giacometti as he sought in the conditions of the labyrinth and the necropolis an antidote to the weightless lucidity and rationality of modernist space and, in the guise of Georges Bataille's *acéphale*, the irrational, decapitated victim who has no access to modernism's imperious visual mastery.[3] It was this visuality that much of surrealism scorned, installing the limitless indeterminacy of the fetish in desire's place of honour as a way of rebuking the claims of reason always to be able to set before itself clear and distinct ideas.

It can be argued that this tide of anti-vision was carried along by technical devices such as the readymade, or montage or chance to which Bürger refers. But I think these devices were in turn underwritten by the logic of their attack and the nature of their target, which was not limited to the autonomy of institutional practice but included the presumed autonomy of the cognitive field. It is this logic that I want to examine in what follows.

The icons of modernist visuality present us over and over again with the erosion of that figure/ground distinction which is fundamental, I would have thought, to the very possibility of vision: vision occurring precisely in the dimension of difference, of separation, of bounded objects emerging as apart from, in opposition to, the ambience or ground within which they appear. But the logic of these icons is not to deny that these are, indeed, the terms of seeing objects in space. Rather the logic of the grid, say, or the colour-field painting, sets these perceptual terms in relation to something more fundamental, which it understands as the precondition for the very emergence of the object to vision, what we could call the structure of the visual field as such. It is according to this structure, for example, that the spatial ground or field, which is given to perception as something that occurs *behind* objects, must for cognitive space be the matrix of an absolute simultaneity; must occur, that is, fully marked by the perfect synchrony that rules within the cognitive modality of the visual. Similarly the figure, which perception locates in a space

external to the beholder, must be understood as something that cognition grasps in a state of pure immediacy, yielding an experience which knows in a flash that if these perceptions are seen as there, it is because they are seen by me; that it is my presence to my own representations that secures them, reflexively, as present to myself.

If we imagine the modernist logic beginning with the opposition between figure and ground that prevails for the perception of objects and is the basis for traditional painting, we can understand that it would want to think a structure that was self-evidently derived from this first opposition – and thus obviously operating within the domain of the visual – but a structure that would project as well the way this domain is subsumed by, recontained within, and transparent to, a higher order of immediacy that is cognitive. To make a map of this set of interconnections, we could, interestingly enough, produce a schema that would configure itself like the structuralists' Klein group, with its two axes – the complex and the neutral – being the logical extensions or expansions of one another, the transformation of an original binary pair into a quartenary field that both replicates the first binary and extends its implications (Illustration 86).[4] If the complex axis is set up as this original perceptual binary – *figure* versus *ground* – the neutral axis, a derivational rewriting of the first, would read *not-figure* versus *not-ground*. It is this involution of the original terms that then establishes a level of the structure which can be seen to reproduce the first opposition, only now, in its reflexive form.

In the Klein group the axial relations which are those of contrariety are duplicated by vertical relations of contradiction, through which each term, set along what is called a schematic axis, confronts its own inversion; but this same term is also connected diagonally – along the axes termed deixic – to that member of the group with which it is implicitly synonymous: *figure* in this case reduplicating itself as *not-ground*; or *ground* being deixically restated as *not-figure* (Illustration 87). What becomes clear from this mapping of terms is that when the background of perceptual space – with its former status as reserve or secondariness – is rejected by modernism, in favour of the absolute simultaneity that is understood as a precondition of vision, the logic of this inversion into *not-ground* invests this term with its deixic character, which is

86 Diagram of Klein group

87 Diagram of the relation of figure to ground (Klein group)

that of *figure*. In this form the not-ground becomes available to the modernist painter as the new order of 'figure': that is to say, a field or background that has risen to the surface of the work to become exactly coincident with its foreground, a field which is thus ingested by the work as figure.

Further, when the figure's apartness and externality is rejected by modernism in favour of a kind of unimpeachable immediacy, the condition of *not-figure* that expresses this takes on exactly the deixic character of *ground*, ground understood as that which sets all outsides in a necessary relation to an inside, asserting that if there is presence of something to me, it is because there is, first of all, self-presence. It is this logic of the *not-figure* that gives to the frame of the modernist picture its particular status as that boundary which is not likened to the natural, or empirical, limits of the perceptual field but is seen, instead, as the deductive result of the internal conditions of the painting analogized to a map of total self-containment and lucidity. (This very idea of the frame as absolute cognitive closure, marker of the conceptually complete, can of course be generalized to the structural schema itself, as a logic of operations that is meant to account for, and thereby to frame, its own self-containment.)

Now if modernism's 'vision as such' can be constructed along this neutral axis of the *not-ground* in opposition to the *not-figure*, it is because in this form it has become an opposition which maintains the terms of difference even while emptying out difference itself, so that a certain kind of folding back on one another occurs, establishing these terms as reflexively redoubled. And because of this redoubling, the beholder is entered on to this axis twice: first at the pole of the *not-ground*, where the place of the empirical viewer is marked by the way the empty mirror of the pictorial surface is set up as an analogue to the retinal surface of the eye opened on to its world; and second, at the opposite pole. There the *not-figure* marks the place of the Viewer as a kind of impersonal absolute, the point at which vision is entered into the schema both as a repertory of laws and as a conscious relationship to those laws which is that of the transcendental ego.

Modernist painting was not only sponsored by the logic of this structure but it also, as I have indicated, tried to reduplicate the structure's own condition as cognitive image at the level of the individual work of art. The

idea of a spatial scene which, through the painting's very appearance to its viewer, opens on to the preconditions that both must sponsor perception and to which it must be transparent, held generation after generation of modernists in thrall.

However, there are other scenes, historical ones, and I would like to pass to one of these. Yet, as I hope will become clear, even this scene suggests other registers in which it might be rewritten, for it is the setting of a peculiar encounter, one I am tempted to think of as surrealism's primal scene. André Breton describes this scene as the sudden appearance of a group of objects through which surrealism as a whole would understand something of both its identity and its destiny. The scene took place in early 1921. Breton explains:

> In fact Surrealism found what it had been looking for from the first in the 1920 collages [by Max Ernst], which introduced an entirely original scheme of visual structure yet at the same time corresponded exactly to the intentions of Lautréamont and Rimbaud in poetry. I well remember the day when I first set eyes on them: Tzara, Aragon, Soupault and myself all happened to be at Picabia's house at the very moment when these collages arrived from Cologne, and we were all filled immediately with unparalleled admiration. The external object had broken with its normal environment, and its component parts had, so to speak, emancipated themselves from it in such a way that they were now able to maintain entirely new relationships with other elements, escaping from the principle of reality but retaining all their importance on that plane.[5]

An ex-soldier who could not leave Germany legally, Max Ernst was absent both from this scene and its later replay when his collages were exhibited at the bookshop Au Sans Pareil, in early May. But the explosiveness of the effect of these works is easy enough to document. Breton's reaction took the form of needing to master and recontain their impact; and to this end he went that summer to the Tyrol to meet Ernst before going on to Vienna to pay a visit to Freud. Bringing with him his volume of Lautréamont, he insisted on reading the *Chants de Maldoror* for hours at a time at a disconcerted Ernst in an effort to reassert his own authority.

Paul Eluard, who had not been at Picabia's for the unpacking of the collages, only saw them at the opening of Ernst's exhibition, but his excitment reached a pitch that was even higher than the others'. 'Eluard was the most affected', his biographer tells us. 'He suddenly understood that a brother had just been given to him.'[6] Indeed, so strong was Eluard's experience that by the summer's end he did not wait to meet Breton in Vienna as planned, but hurried to the Tyrol to arrange to visit Ernst in Cologne as soon as the Freud pilgrimage was over. For him the encounter was to be a very powerful one indeed. The passion that was instantly set up between Eluard, Ernst and Gala Eluard inscribed itself not only on the bodies of all three but in the work of both men, and by the following September Ernst was to respond to an invitation from Eluard too strong to resist. Leaving Germany, his wife and son, and travelling on a fake passport to Paris, Ernst was to join a ménage with the Eluards that lasted $3\frac{1}{2}$ more years.

There is an extraordinary image by Ernst that commemorates this meeting. Called *La puberté proche*, and bearing the dedication 'à Gala', it is like the majority of the so-called collages of Ernst's exhibition in that it is in fact not a collage but an overpainting. That is, instead of employing the additive process of gluing disparate elements to a waiting, neutral page, the overpaintings work subtractively, by taking a commercially printed sheet and, with the aid of ink and gouache, opaquing-out various elements of the original to produce a new order of image. The presence of this sheet, as the matrix or substructure of what is subsequently seen in the image, was in fact a major part of what both Breton and Aragon remarked about the works at the time they first encountered them. Aragon's account, written in 1923, notes that 'Max Ernst borrows his elements above all from printed drawings, advertisements, dictionary images, popular images, newspaper images'.[7] And in his 1927 essay, 'Surrealism and Painting', Breton (looking back) agrees that Ernst proceeded 'from the inspiration that Apollinaire sought in catalogues'. But the term that Breton had originally used for this element is the far more suggestive word 'readymade' as, in his text for the 1921 exhibition at Au Sans Pareil, he notes that the collages are built on grounds constituted by 'the readymade images of objects', adding parenthetically, '(as in catalogue figures)'.[8] This notion of the readymade is something to which we will return.

In the case of *La Puberté proche* the undersheet is a commercial photograph in which a nude had appeared, lying stretched out upon a couch, her head supported by one elbow. Swivelling this underlying photograph through 90 degrees, Ernst suspends the newly pendant figure in the strangely material, velvety ether of the gouache which covers the surface of the photograph like a hardened skin. Upright and headless, the nude now appears from within this thickened field as having been transmuted into the very image of the phallus: as having become, that is, the object and subject of that unmistakeably Oedipal fantasy of both having and being the sex of the mother. And in the inscription with which Ernst frames this space, the froth of pleasure is invoked by the words, 'la grâce tenue de nos pléiades': as the idea of the Milky Way summons up the old iconography of the body's secretions writing themselves over the page of the heavens.

This suspended, weightless, phallic body-of-the-woman, both a part of her setting and at some kind of material remove from it, will be the thread on which the images of the collage-novel *Femme 100 Têtes* will, at the end of the decade, be strung together. Within the context of *Femme 100 Têtes* the location of this figure is unmistakeably established as set within a fantasy world which is that of childhood; built, that is, on archaic foundations.

In 'Looking Back at Surrealism' in 1954, Theodor Adorno does so while obviously holding between his hands a copy of one of Max Ernst's collage novels. Setting aside much of what orthodox surrealist theory claimed for the movement's production – that it was able to manifest the workings of dreams, that it was able to produce the actual symbols through which the unconscious does its thinking – Adorno locates the accomplishment of surrealism in its uncanny staging of the archaic in the midst of the depersonalized, rationalized and commodified world of modernism. The archaic he has in mind is not that of the Greeks but rather that of childhood; which is to say, the ontogenic fact, played out in the life cycle of everyone of us, that we have a history. The

timeless uniformity which is pressed into our surroundings cannot erase the memory in each of us that we were once children. The archaic is thus to be found in children's books and in those other types of illustrated material that speak to us from out of the near distant past, a past which ties us through that childhood we vaguely remember to the world of our parents. The effectiveness of surrealist images, their ability to produce the shock to which they aspire derives, Adorno says:

> partly literally and partly in spirit, from illustrations of the later 19th century, with which the parents of Max Ernst's generation were familiar ... One must therefore trace the affinity of surrealistic technique for psychoanalysis, not to a symbolism of the unconscious, but to the attempt to uncover childhood experiences by blasting them out. What surrealism adds to the pictorial rendering of the world of things is what we lost after childhood: when we were children those illustrations, already archaic, must have jumped out at us, just as the surrealistic pictures do now. The action of the montage supplies the subjective momentum, and seeks with unmistakable intention ... to produce perceptions as they must have once been. The giant egg out of which the monster of the last judgment can be hatched at any minute is so big because we were so small when we for the first time shuddered before an egg.[9]

It is undoubtedly Ernst's *Femme 100 Têtes* that Adorno is thumbing as he writes these lines, savouring this upsurge of the archaic in its concatenation of nineteenth-century source material: the line engravings of pages from the *Magasin Pittoresque*, the kitsch classicism of illustrations from *The Age of Fable or Beauty of Mythology*, the explanatory diagrams of *Physique Populaire*, the line-cuts of *La Nature*'s presentation of the miraculous world of science staged either in the parlour experiments of its feature 'La science amusante' or in the laboratories of late nineteenth-century medicine, or engineering, or optics.

When the package of Ernst's collages was unwrapped that day in Paris, Picabia, Breton maliciously reported, was sick with envy.[10] Looking now at most of these objects, in their somewhat frail whimsy, their rather fragile dada charm, it seems hard to understand this intensity. For the overpaintings, the majority of them cast on the pages of a catalogue of elementary and high-school teaching aids,[11] often deploy their added gouache planes of colour to project a shallow, stage-like space within which the images of beakers and retorts and cathode tubes can then be elaborated into the kind of mechanomorphic personages that Picabia himself had for some years perfected. The commercially-produced (and thus self-evidently readymade) object abounds in Picabia's work as the vehicle of portraiture, as in his *Ici, c'est ici Stieglitz* of 1915, or as the medium of a dada-based derision, as in *Infant Carborator* (1919).

Yet certain of these images go far beyond Picabia's notion of a mechanical being and, with a prescience that is amazing for 1920, seem to set up a paradigm for an idea of mechanical *seeing*: a notion of an automatist motor turning over within the very field of the visual. This idea, which operates at the centre of surrealism's critique of modernism, contests the schema of visual

self-evidence and reflexive immediacy, substituting for this a model based instead on the conditions of the readymade; these conditions produce an altogether different kind of scene from that of modernism's.

The model Ernst constructs is indeed, structured as a scene contained within a proscenium frame in a way that is like the cognitive image provided by the modernists' Klein Group. But it is there that the comparison with a modernist visual model stops. Found most clearly in an overpainting called *The Master's Bedroom* (with an inscription in both French and German that adds, 'It's worth spending a night there'), this paradigm generates a scene that is concerted to turn our very conception of space inside-out, thereby picturing automatism's relation to the visual not as a strange conflation of objects, and thus the creation of new images, but as a function of the structure of vision and its ceaseless return to the already-known.

Like its fellow-overpaintings, gouache is used in this work to cover over those parts of the underlying sheet that are to be suppressed and at the same time to project a new space in which the remaining objects – in this case animals and a few pieces of furniture – will take their places. As in the other cases also the quality of the gouache is somewhat skin-like, as though a film had congealed over the surface of the image. Unlike most of the others, however, the space projected by this surface is insistantly deep, organized indeed as a full-blown perspective. The objects assembled there are not the bizarre hybrids of the other collages, but the unexceptional depictions of whale, bear, sheep, snake, bed, table, chest, and so on, the elements left in reserve from a Lehrmittel sheet on which row upon row of such animals and objects originally displayed themselves within the abstracted and grid-like circumstances of what we could call the space of inventory. From the diagrammatic, wooden nature of the poses, from the juxaposition of the elements in rows, from their obliviousness to the demands of perspective diminution that would require the distant animals to be smaller than the near ones, and from the occasional bleed of the underlying parts of the inventory through the gouache skin, the flattened grid of the supporting sheet remains apparent across the newly wrought terms of the perspective. And it is this appearance that was, I believe, decisive for the surrealists' original experience of the image as revelatory because what is projected here is a visual field that is not a latency, an ever-renewed upsurge of the pure potentiality of the external, but instead a field that is already filled, already – to say the word – readymade.

The painter's blank canvas, the draftsman's white sheet, even if already organized by the lattice through which perspective will map the coordinates of external space, is nonetheless the index of a kind of fundamental blankness which is that of the visual field itself understood as a field of projection. It stands, that is, for what we assume to be the nature of vision's spontaneous opening on to the external world as a kind of limitless beyond, an ever-retreating horizon, a reserve assumed from the outset but never filled-in in advance. If, in traditional perspective, vanishing-point and viewing-point, horizon line and canvas surface, finally mirror one another in a complicitous reversibility, this is because they represent two funds of pure potentiality, two locations of the always-ever never-yet-filled: on the one hand, the horizon that vision probes and, on the other, the welling-up of the glance.

That the ground of *The Master's Bedroom* is not a latency but a container already filled, so that the gaze is experienced as being saturated from the very start; that the perspective projection is not felt as a transparency opening on to a world but as a skin, flesh-like, dense, and strangely separable from the objects it fixates; these features present us with a visual model which is at one and the same time the complete reversal of traditional perspective and the total refusal of its modernist alternative.

Now if, in trying to characterize the visual model that is adumbrated here, one is reminded of the particular apparatus that so fascinated Freud and about which he wrote in his 'Note on the Mystic Writing Pad', it is not of course to enter into anything like a game of sources. It is rather because the model of the *Wunderblock* (magic slate) helps to analyse the peculiar layering of experience that is put in place. The top sheet of the little device – the one that registers the impressions etched upon it – is in Freud's model analogous to the system he calls *Pcpt.-Cs.*, that is, the part of the mental apparatus that receives stimuli (either from the outside world or from within the organism itself) as a set of impressions which are not, however, permanent within this layer of the system. In the *Wunderblock* this top sheet holds the visible mark only as long as it is in contact with an underlying slab of wax to which it temporarily sticks under the pressure of the stylus; once the two surfaces are detached from one another, the marks vanish and the *Wunderblock* presents itself as a kind of slate wiped clean. But though they are no longer available to view, the lines that have been pressed on to it are in fact retained by the waxen support, forming within it a permanent network of traces. And this Freud analogizes to the mental operations of memory and thus to that part of his topological model given over to the Unconscious.

In *The Master's Bedroom* the *Wunderblock*'s waxen slab finds its analogue in the underlying sheet of the Lehrmittel page, in its inventory-like concatenation of objects, the stored-up contents of unconscious memory; while the apparatus's top sheet appears as the perspectival covering of the gouache overpainting, the skin-like materiality of which seems to be an index of the way this receptor surface is detachable from its ground. This implication of detachment and reattachment relates to a further point Freud makes about the structure of the *Wunderblock* and its capacity to model the very nature of sensory stimulation, which he describes as pulsatile or periodic in nature, 'the flickering-up and passing-away of consciousness in the process of perception'. This flicker or pulse, this connection and disconnection within the perceptual field, is based on Freud's theory 'that cathectic innervations are sent out and withdrawn in rapid periodic impulses from within into the completely pervious' perceptual system. 'It is as though', Freud writes, 'the unconscious stretches out feelers, through the medium of the sytem *Pcpt.-Cs.*, towards the external world and hastily withdraws them as soon as they have sampled the excitations coming from it'.[12] In *The Master's Bedroom* it is not that this pulsatile motion is illustrated (indeed the scene's peculiar stillness is a striking feature of the collage); rather, it is the sense of the gap, the detachment, the split which results from the pulse, that is rendered.

However, the pulse, the stillness, the visual apparatus projected within the spectacle itself as a detachable covering, and the contents of vision figured forth as originating in optical space only because they are readymade: all of

these elements are structural features of the scene around which *The Master's Bedroom* is obviously organized and through which it was able to speak with the kind of power it did to Breton, Eluard and Aragon in 1921. Ernst may have claimed this bedroom as his own, but he could have done so only through an obvious identification with Freud's patient, the Wolf Man, and thus by evoking the famous dream of the wolves and behind them the Wolf Man's primal scene. All of it is there, indeed: the absolute immobility of the animals; the window opposite the bed; the raising of a curtain on the scene in the form of the window opening by itself which is the dream's figure for the onset of vision in the opening of the child's eyes; and underneath it all the element of repetition, the anxiety brought on by the uncanniness of the experience, by the fact of an already-there that is returning, returning in the form of an object which can only represent loss, an object whose identity resides precisely in the fact that it is lost. As a screen for the primal scene the dream allows that first uncanniness – the castration misperceived across the plane of the parents' coitus – to reappear, and it does so in the upsurge of a new uncanniness, in which the lost object is summoned forth through the first of that long series of substitutions – wolf, butterfly, cut finger – that repeat the mark of the lost object not as found again, but as recurring through the very condition of absence.

Is it historically possible, we might ask, to load this little object, made by Ernst in 1920, with such a freight of psychoanalytic ideas, and specifically with a connection to this precise case history? Perhaps at this point a digression into a certain kind of art-historical detail might be appropriate.

That Ernst identified with the Wolf Man in various of his works is easy enough to document. The 1923 painting *Souvenir de Dieu*, which the artist himself described as depicting his father in the form of a kind of omnipotent god-head, projects him there, indeed, in the guise of a wolf.[13] And beginning in 1927 Ernst was to publish in *La Revolution Surréaliste* the first version of a story he was frequently to repeat throughout his life, in which through the agency of a screen memory of his father performing obscene motions in front of a wooden panel, Ernst was to place himself at the observation post of his very own primal scene, ending the account with a coy reference to his father's conduct on the occasion of his conception.[14]

However, Ernst's relation to the entire corpus of Freud's texts is extremely striking. Everywhere one turns it becomes clear that the artist, who had been a psychology student at the university of Bonn and through this an avid reader of Freud, mined the major works of psychoanalysis for material for his art. Whether we look at the overtness of the 1921 picture *Oedipus Rex* or the more covert reference made by the 1920 *Dada in Usum Delphini* to Freud's announcement in his *Introductory Lectures* that he would not refer to the genitalia in *usum delphini* (that is, in the manner of speaking to children) but call them instead by their names,[15] or if we regard the staging of the trapping-of-the-lizard scene from *Delusion and Dream* that Ernst painted as a monument to his love for Gala,[16] we find evidence of the range and precision of Ernst's knowledge of the psychoanalytic literature, and more instances of this can be cited: from the Schreber case, from Dora, from the phobia of Little Hans.

The most specific and far-reaching example of this identification with Freud's case histories, however, was Ernst's projection of himself into the Leonardo story. At a somewhat superficial level we find this in the 1926 picture *The Virgin Chastising the Infant Jesus before Three Witnesses (A.B., P.E. and the Artist)*, in which the shadow of a bird formed in the profile of the innumerable doves Ernst was to paint in the late 1920s is cast onto the garments of the Virgin in a miming of the Oskar Pfister diagram of the hidden vulture in *The Virgin and Saint Anne*, published in the 1919 edition of Freud's Leonardo essay.[17] At a kind of eagerly assumed totemic level it operates more generally in Ernst's assumption of Loplop, 'Bird-Superior', as his own alter-ego, identifying this creature, the subject of innumerable pictures, as 'my private phantom, attached to my person'.[18] At another, iconographic level, it controls Ernst's relation to the realm of natural history, whether in the early collages or in the cycle of *frottage* drawings which assimilate themselves to the character of Leonardo's sketchbook projects in both facture and scope. But at the level that interests us here, Ernst's connection to the Leonardo case turns on the very function of screen memory as the central element of Freud's analysis: screen memory, that is, not as a generator of content but as a condition of structuration, for it is not the bird itself but the bird as fundamental absence that plays so important a role in the structure Freud will put in place.

Leonardo's reference to the recollection he had of a bird's having visited him in his cradle and having beaten its tail between his lips is interpreted by Freud as a screen on to which is projected in disguised form the remembered remanants of the infantile arousal caused by an overaffectionate mother. That it should be a bird that is produced as the perceptual content of this memory Freud explains in a way that is parallel to the Wolf Man's wolf, or indeed the various objects presented in the screen memories of so many of his patients. These elements are provided to the subject readymade, Freud states; they are what the child picks up from the scraps of conversation around him, from images he happens to see in books, from the behaviour of animals both seen and recounted. They are the data uncovered in the research the child's own sexual curiosity is constantly driving him to perform and, once discoverd, retrojected on to the formless past in the guise of 'memory'. They are the completely factitious referents that come, after the fact, to attach themselves to the floating signifiers of what Freud had come to think of as not the primal scene, but the primal fantasy. In Freud's reconstruction of Leonardo's case, the bird derives from an old wives' tale, the mother's repeated story of an omen of her child's future greatness, and it is then reinforced as the specific memory object, Freud hypothesizes, by the information that vultures have no mates and are instead inseminated by the wind.[19] The screen memory is, then, an apparatus by means of which vision is retrojected, projected after-the-fact on to the fully saturated ground of the readymade.

The Leonardesque screen has long been understood as playing a central role in Ernst's subsequent practice. However, it is not a memory screen – or more precisely, a screen memory – that has been seen as at issue in this development, but rather a projective screen – Leonardo's famous spotted wall – conceived as the setting for a free play of imagination, the screen itself interpreted as a latency that permits the welling up of associations within the creative process. In his treatise, *Beyond Painting*, Ernst quotes at length

Breton's explanation of 'Leonardo's lesson, setting his students to copy in their pictures that which they saw taking shape in the spots on an old wall (each according to his own lights)'.[20] And this Ernst juxtaposes with his own account of his discovery of *frottage*, which begins, 'On the 10th of August, 1925, an insupportable visual obsession caused me to discover the technical means which have brought a clear realization of this lesson of Leonardo', a story that tells how a sudden fixation on the groves in the floorboards of his bedroom at a seaside inn led him to invent his own projective procedure.[21] The reference to Leonardo's projective screen is obviously intended here to give *frottage* a pedigree of unparalleled lustre.

In this account, however, Ernst then goes on to make a claim that is inexplicable as long as we conceive of the projective screen as a latency which, like the blank page of conventional painting, can be analogized to the ground of vision as traditionally conceived. That claim is that *frottage* and collage (or collage as Ernst practised it, saying 'ce n'est pas la colle qui fait le collage') are indistinguishable as procedures, making it no surprise that the circumstances that suggested each of them to him should have been nearly identical. 'The similarity of the two is such', he writes, 'that I can, without changing many words, use the terms employed earlier for the one, to relate how I made the discovery of the other'. And then his account for collage begins: 'One rainy day in 1919, finding myself in a village on the Rhine, I was struck by the obsession which held under my gaze the pages of an illustrated catalogue showing objects designed for anthropologic, microscopic, psychologic, mineralogic, and paleontologic demonstration'.[22]

Yet if this similarity is possible, it is only so because Ernst conflated the two screens – Leonardo's spotted wall and Freud's account of the vulture memory – understanding the vision configured in the one as structured by the mnemonic retroactivity of the other. And in this conflation it is the unconscious that is understood to be at work, with the two processes made to occupy the same perceptual stage due to what Freud describes as common to both dreams and hallucinations (namely a regression towards the visual). Thus the parent space for both collage and *frottage*, the single plane from which both were launched, is explained in *Beyond Painting* as the screen of Ernst's own rather carefully fabricated screen memory, the mahogany panel in his bedroom which he casts in the drama of a twilight-state daydream he claimed for himself in early childhood. This is the panel he imagines his father to be copulating with and on which is produced an inventory of images: 'menacing eye, long nose, great head of a bird with thick black hair, etc.'.

In what Freud calls vision's 'other scene' – the one towards which the unconscious regresses in the conditions of dreaming, fantasizing, hallucinating, or screen-memory – the operation of retroactivity is at work. This retroactivity, or *Nachträglichkeit*, or *après-coup*, is importantly a function of the readymade which, displaced backwards in time, seems to rise up on the horizon of the subject's vision as an originary perception. Freud describes this, for example, in relation to secondary revision, as that process of the dream-work which comes, *après-coup*, to construct a façade for the dream: the one we seem to

remember upon waking, the one that gathers the chaos of the dream representations together, creating the relative coherence of a narrative. This façade, Freud says, is a readymade, a narrative lying in wait to be affixed to the dream material, its readymade condition making its attachment possible in the very split-second of waking. Offering many examples of the way this works, Freud asks of one of them, 'Is it so highly improbable that [this] dream represents a phantasy which had been stored up ready-made in [the dreamer's] memory for many years and which was aroused – or I would rather say "alluded to" – at the moment at which he became aware of the stimulus which woke him?'[23] Secondary revision, however, is not the affixing of just any prefabricated plot-line to the surface of the dream. The relation between the narrative façade that secondary revision erects and the desire that functions at the dream's core is that these two in fact mirror one another. And further, that inner kernel is itself ready-made, a function of daydreams elaborated in infancy or puberty which 'form within the nexus of the dream thoughts'.[24] And as we know, in that infinite regress in which the referent is constantly displaced from its supposed causal connection to the fantasy's origin, those daydreams will also be described by Freud as readymade for the subject, lying in wait for him in the scraps he picks up from his parents and grandparents, the legends the family tells about itself and him, its favourite sayings, the myths about itself that it weaves out of the prefabricated material of social chit-chat and cultural aspirations; the romances, in short, which he takes from others and assumes as his own.[25]

Now, if the daydreamer is able to produce these second-hand scraps of excitement as his own, if they appear to him on the screen of his memory as his personal experience, this is due to that particular structure of visual perception that Lacan has termed the '*belong to me* aspect of representations'.[26] It is this phenomenological experience of something's being both outside himself and *his* that turns this bric-à-brac into the deictic markers of the subject's own being, the evidenciary signposts that appear to him the indices of his own history, his own identity, the touchstones of his most intimate connections to the real; which is all the more astonishing in that the readymades he will come to identify as 'his' are the markers erected after the fact to commemorate an event that never happened, an encounter whose traumatic effect on him arises from the very fact that he missed it. The sexuality of the child, Freud says, will always be traumatic, because it will always be a missed encounter; one for which he was always either too early, or too late.[27]

The traumatic event, the missed encounter (what Lacan comes to call the tuché, and sometimes the dustuchia), produces not excitement but loss, or rather excitement *as* loss, as a self-mutilation, as something fallen from the body.[28] The repetition automatism set in motion by this trauma will work thereafter to restore that unknown and unknowable thing, attempting to find it, that is, on the other side of the gap the trauma opened up in the field of the missed encounter. The structure of the trauma, then, is not just that it initiates a compulsion to repeat, but that it institutes the gap of the trauma itself – the missed encounter – as the always-already occupied meaning of that opening on to a spatial beyond that we think of as the determining character of vision. For it is from the other side of the perceptual divide that the signifier will come, the object capable of standing for what the subject has lost. It is this

object that the child sets out to find, supplying himself with an endless series of substitutes that present themselves to him, in the world beyond the gap.

To the reservoir or inventory of this series of stand-ins Lacan gives the name automaton to indicate the quality of uncanniness that surrounds the finding of each of these objects, the sense not only of anxiety the encounter produces but also its aura of happenstance, an encounter one was not prepared for, a meeting that always, one insists, takes place by chance.[29] But the term automaton also underscores the inexorability and order that rules this series, that creates the logic of the substitutions which will take place among it.[30] The automaton inaugurated on the site of that gap of the missed encounter will both mark that spot and attempt to fill it, to produce from its grab-bag of readymades the stop-gaps presumed by the subject to be made to the measure of his own desire.

In the question period following Lacan's session on 'Tuché and Automaton' he is asked why, in describing the formation of intelligence up to the age of three or four, he seems to have abandoned the notion of developmental stages – first oral, then anal, then Oedipal – and to have organized everything around the fear of castration. Lacan's answer is:

> The fear of castration is like a thread that perforates all the stages of development. It orientates the relations that are anterior to its actual appearance – weaning, toilet training, etc. It crystallizes each of these moments in a dialetic that has as its center a bad encounter. If the stages are consistent, it is in accordance with their possible registration in terms of bad encounters.[31]

In another, earlier seminar on the notion of 'object relations' as viewed from within a Freudian structure, he had spoken of the castrative status of weaning. 'What happens', he asks,

> when the mother no longer responds to the sollicitation [*sic*] of desire, when she responds according to her own will? She becomes real, she becomes powerful. All at once access to objects is modified: until then objects which were pure and simply objects of satisfaction, are now transformed into gifts coming from this source of power. We witness, in short, a reversal of position. From being symbolic the mother becomes real, and objects from being real, become symbolic.[32]

If we were to try to graph this relation (Illustration 88), we might start by characterizing the primal appearance of the object within the infant subject's perceptual field as the advent of something that separates itself out from a hitherto undifferentiated ground to become distinct as figure. That object, which is the mother's breast – and by extension the mother – becomes a figure, of course, by dint of its withdrawal from the field of the infant, by virtue, then, of setting him up no longer as the amorphous and all-inclusive subject of satisfaction but now as the subject of frustration and longing, the subject that is, of desire. The very moment which produces the visibility of the object brackets it, then, as an object submitted to the terms of absence. As such this 'figure' is conditioned by its own contradiction, which is that of not-figure. But the figure, as image, is also mirrored back to the infant perceiver, who

88 Diagram of castration-fear (Klein group)

understands it as the representation of not just any object, but of that object which is uniquely his, which was invented for his satisfaction and pleasure, which in being his marks him as a unique being, and in this character of 'belonging to him' reproduces itself deixically as part of his own identity, the 'not-ground' of his self-differentiation as ego. Rewritten in this way, the appearance of the object as the psychoanalytically construed function of separation begins to suggest a schema with which we are familiar.

The Klein Group, on to which modernism's structure of vision can be mapped, is also the support for Lacan's L-Schema (Illustration 89). That schema, as we know, sets the subject of the unconscious in contrast to its objects, which Lacan terms *objets petit a* (or objects of desire). From that initial contrast two derivations then occur, as the *objets petit a* are first doubled along the mirroring relationship of the deixic axis to structure the field of the subject's ego and then are configured in terms of that absence that projects them into the unconscious field, also to be termed the Symbolic and the locus of the Other.

Now, although the L-Schema derives from the Klein Group and thus shares with other extrapolations from it – like the modernist visual structure we explored before – that feature of cognitive immediacy and synchrony that is the privileged domain of structure, this schema is used by Lacan to configure something quite different as well. For one thing, the schema challenges the very transparency set up by the structuralist diagram itself, for it is a map of the conditions of opacity that rule in the midst of a seeming transparency, operating from within the centre of that very transparency both to make it available as the terms of vision but also to mark it simultaneously as 'misrecognition'. For another, the schema is meant to contest the idea of the structure as cognitive mastery, given through the table's diagramatic stasis or a-temporality. As a generator or producer of effects, the schema is constructed as a circuit rather than a table, a circuit set in motion by the trauma's production of the compulsion to repeat. Thus it is only that sequentiality and time taken up into the heart of the system that gives it its character as homeostatic and its appearance as a-temporal.

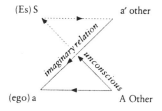

89 Jacques Lacan, L-Schema

Modifying the L-Schema to serve as the basis for our own problematic which is that of an automatist visuality, we would produce the following structure (Illustration 90). The figure, constituted by separation, is deixically redoubled as *not-ground*: as those parts of the subject's own body that are identified with the external object. But since that external object is given through its very condition as retreating or separating, those part-objects belonging to the subject are similarly parts lost to the subject, and for that reason written along the axis of castration. At the pole at the far end of that axis, the pole of the *not-figure*, the inventory of all those substitutes for the lost object pile up in a potentially endless series. The appearance of each of these figures, as it rises from behind the barrier of the missed encounter, out of the field of the unconscious and into that of perception, will strike the subject with surprise, and will seem to him the result of chance.

There are three things I hope to have shown by means of this demonstration. The first is the truly compelling nature of the two objects by Ernst that have functioned as its core: *The Master's Bedroom* and *La puberté proche*.

The second is the relationship between what we could call the graph of modernism, with its insistence on simultaneity and transparency (and its concomitant resistance to time and happenstance), and the schema of the visual automaton. The relationship I have in mind is not that they are opposed to one another, but that (as the Lacanian L-Schema already suggests) they map onto one another; and the nature of this mapping is that the second is the repressed of the first. The transparency of modernism's 'vision as such' is an effect of this convoluted structure, just as, for Lacan, the transparency of consciousness to itself that is the 'subjectivity effect' is indeed an effect of the relation to the unconscious. Seriality, repetition, the automaton: all these are the repressed of modernist visuality.

The third point can be no more than a suggestion here, but it is that the readymade, as a marker of the site of serial production, needs to be approached in relation to the repetitive mechanisms of consciousness and the unconscious, which is to say we need a psychoanalytic of the readymade. It is not enough to use it as a tool of analysis within the political economy, and address it solely in terms of commodity fetishism; neither is it satisfactory to

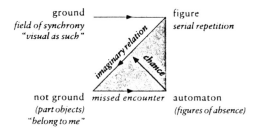

90 Diagram of the relation of figure to ground (L-Schema)

limit its discussion to its attack on the institutional closure of the aesthetic economy of the precious, artistically intended, object. We have to bring the readymade closer to the site of its real power to scandalize. And that site is 'the master's bedroom'.

Notes

1 Peter Bürger, *Theory of the Avant-Garde*, trans. Michael Shaw (Minneapolis, MN: Minnesota University Press, 1984), pp. 47–54.
2 I have explored this aspect of Duchamp's work in 'The Blink of an Eye', in *States of Theory*, ed. David Carroll (New York: Columbia University Press, 1989).
3 See my 'No More Play', *The Originality of the Avant-Garde and Other Modernist Myths* (Cambridge, MA: MIT Press, 1985).
4 For an analysis of the Klein Group, see Marc Barbut, 'On the Meaning of the Word "Structure" in Mathematics', *Introduction to Structuralism*, ed. Michael Lane (New York: Basic Books, 1970). See also A.J. Greimas, 'The Interaction of Semiotic Constraints', *On Meaning* (Minneapolis, MN: Minnesota University Press, 1987).
5 André Breton, 'Artistic Genesis and Perspective of Surrealism', 1941, in *Surrealism and Painting* (New York: Icon Editions, 1972), p. 64.
6 Luc Decaunes, *Paul Eluard* (Paris: Balland, 1982), p. 61.
7 Louis Aragon, 'Max Ernst, peintre des illusions', 1923, in *Les collages* (Paris: Hermann, 1965), p. 29.
8 André Breton, 'Max Ernst', 1920, in Max Ernst, *Beyond Painting* (New York: Wittenborn, Schultz), p. 177.
9 Theodor Adorno, 'Looking Back at Surrealism', in *The Idea of the Modern in Literature and the Arts*, ed. Irving Howe (New York: Horizon Press, 1967), p. 222.
10 Werner Spies, *Max Ernst Collagen – Inventar und Widerspruch* (Cologne: 1984), p. 81.
11 This was the 1914 *Kataloges der Kölner Lehrmittelanstalt*. See Dirk Teuber, 'Max Ernsts Lehrmittel', *Max Ernst in Köln* (Cologne: Kölnischer Kunstverein, 1980), pp. 206–40.
12 Sigmund Freud, 'A Note Upon the "Mystic Writing-Pad"', in *The Standard Edition of the Complete Psychological Works*, ed. James Strachey (London: Hogarth Press and the Institute for Psycho-Analysis), XIX, p. 231.
13 This connection is pointed out by Ernst himself in *Beyond Painting*, p. 28. See also Malcolm Gee, 'Max Ernst, God, and the Revolution by Night', *Arts*, LV (March 1981), p. 91.
14 Ernst, *Beyond Painting*, pp. 3–4.

15 In Lecture 10 he says, 'No science can be treated *in usum delphini*, or in a manner adapted to school-girls'. Sigmund Freud, *A General Introduction to Psychoanalysis* (New York: Perma Books, 1953), p. 161.
16 This connection is discussed by Werner Spies, 'Une poétique du collage', *Eluard et ses amis peintres* (Paris: Centre Georges Pompidou, 1982), p. 66.
17 See Werner Spies, *Max Ernst, Loplop: The Artist in the Third Person* (New York: George Braziller, 1983), pp. 101–9. Besides this connection, Spies discusses Ernst's identification with Leonardo in terms of his adoption of the bird as alter-ego and his embrace of the crumbling wall as a projective screen. He does not, however, consider the other meaning of 'screen image' that emerges from Freud's discussion.
18 Ernst, *Beyond Painting*, pp. 9–10.
19 Sigmund Freud, 'Leonardo da Vinci and a Memory of His Childhood', *Standard Edition*. The speculation that the bird fantasy was projected retrospectively on to a story about a bird visiting him in his cradle told to him by his mother was added in a footnote in 1919 (Chapter II).
20 Ernst, *Beyond Painting*, p. 11.
21 Ibid, p. 7.
22 Ibid, p. 14.
23 Sigmund Freud, *The Interpretation of Dreams*, trans. James Strachey (New York: Avon Library, 1965), pp. 533–4 (Chapter VI, Secondary Revision).
24 Ibid, p. 530.
25 Jean LaPlanche and J.-B. Pontalis, 'Fantasy and the Origins of Sexuality', *The International Journal of Psycho-Analysis*, XLIX (1968), pp. 10–11.
26 Jacques Lacan, *The Four Fundamental Concepts of Psycho-Analysis*, trans. Alan Sheridan (New York: W.W. Norton, 1977), p. 81.
27 Ibid, p. 69.
28 Ibid, p. 62.
29 Ibid, p. 58.
30 Ibid, p. 67.
31 Ibid, p. 64.
32 Jacques Lacan, 'La Relation d'objet et les structures freudiennes', *Bulletin de Psychologie*, X, 7 (1 April, 1957), p. 429.

Chapter Eighteen
Photo-unrealism:
The Contribution of the Camera to the Crisis of Ocularcentrism
Martin Jay

Let me begin by asking you to accept on faith a premise that I will not have the time to defend or even elaborate here, but which I have discussed elsewhere at length.[1] That premise is the hitherto unremarked existence of a pervasive and deeply-rooted rejection of the ocularcentric bias of Western culture on the part of a wide variety of French intellectuals in the twentieth century. Whereas our dominant philosophical, scientific and aesthetic traditions have generally celebrated the 'nobility of sight',[2] innumerable French thinkers from at least the time of Bergson have come increasingly to distrust its hegemonic role in modern epistemology, aesthetics and even social life. Beginning with a suspicion of the dominant scopic regime of the modern era, which combined Albertian perspectivalism with a Cartesian faith in the monocular gaze in the mind's eye at 'clear and distinct ideas', their critique often widened to embrace any variant of visual primacy, whether it be dependent on speculation, observation or revelatory illumination.

A wealth of examples from thinkers as disparate as Bataille and Sartre, Blanchot and Foucault, Metz and Irigaray, Levinas and Lyotard, Lacan and Derrida could be adduced to defend these generalizations, which I will have to ask you accept without demonstration for, rather than exhaust my time providing it, I want to devote it instead to what I think may well be part of the explanation for the widespread turn against ocularcentrism. I emphasize its partial nature, for there are certainly other considerations that must be introduced as well, such as the innovations in the nineteenth century's under-standing of the physiological basis of optics, the transformation in the visual landscape of the modern city, and even the impact of the First World War.

The factor I want to explore in this chapter, however, is not only a central element in the story, it is also a particularly fascinating one because its causal relationship to the denigration of vision will seem so intuitively paradoxical. What I want to argue is that the most remarkable technological extension of

the human capacity to see, at least since the microscope and telescope in the seventeenth century, helped ultimately to undermine confidence in the very sense whose powers it so extended; that is, the invention of the camera, which has so often been credited with producing a human environment saturated with images, a life-world of hyper-visual stimulation, also helped spawn a severe reaction on the level of critical discourse against that very outcome. This reaction in turn fed the widespread interrogation of ocularcentrism whose complex implications I have explored elsewhere.

A formidable literature has been devoted to documenting the development and history of photography, especially in France,[3] but only a rapid summary can be attempted here. When the inventions of Joseph-Nicéphore and Isadore Niepce, Louis-Jacques-Mandé Daguerre and William Henry Fox Talbot – who more or less simultaneously perfected methods to record images permanently in the 1830s[4] – became publicly known, the reaction in France as elsewhere was swift and vigorous. The *Gazette de France* reported on 6 January 1839, 'This discovery partakes of the prodigious. It upsets all scientific theories on light and optics, and it will revolutionize the art of drawing'.[5] Under the prodding of the distinguished astronomer and Republican member of the Chamber of Deputies, François Aragon, the French government granted pensions to Daguerre and Isadore Niepce (his father had died in 1833) in exchange for their relinquishing claims to private patents. The techniques of photography, officially presented at a meeting of the Academy of Sciences on 19 August, 1839, were thus immediately in the public domain.

The general reaction to the new optical miracle was overwhelmingly positive, producing in the 1840s what was called 'Daguerreotypemania'.[6] But among intellectuals, three issues soon emerged, which continue to spark debate even today. The first concerned the relation between photographs and optical truth or illusion. The second introduced the vexed question, is photography an art? It had as its corollary, what is the impact of photography on painting and vice versa? And the third addressed the impact on society of the new invention. In grappling with these issues, nineteenth-century thinkers helped prepare the way for the twentieth-century interrogation of vision in its wider senses.

Without a doubt the commonplace view of photography ever since its inception during the heyday of the Realist reaction to Romanticism is that it records a moment of reality as it actually appeared.[7] Daguerre's camera was immediately called a 'mirror' of the world, a metaphor frequently repeated to this day.[8] Many of the first photographers in France, such as Hippolyte Bayard, Victor Regnault and Charles Nègre, operated with a simple faith in the straightforward reproduction of the world; this earned them the sobriquet 'primitive', even if their works could be appreciated by later generations in other ways.[9]

So powerful has the assumption of photography's fidelity to the truth of visual experience been that no less an observer than the great film critic André Bazin could claim that 'for the first time an image of the world is formed automatically, without the creative intervention of man ... photography affects us like a phenomenon in nature'.[10] And even Roland Barthes could argue in his early essay on 'The Photographic Message' that 'certainly the image is not the reality but at least it is its perfect *analogon* and it is exactly this

analogical perfection which, to common sense, defines the photograph. Thus can be seen the special status of the photographic image: *it is a message without a code*.[11]

The larger context in which photography earned this reputation is aptly summarized by Noël Burch in his discussion of the origins of the cinema:

> The 19th century witnessed a series of stages in the thrusting progress of a vast aspiration which emerges as the quintessence of the bourgeois ideology of representation. From Daguerre's Diorama to Edison's first Kineto-phonograph, each state of the pre-history of the cinema was intended by its initiators – and seen by its publicists – as representatives of their class, as another step taken toward the 're-creation' of reality, toward a 'perfect illusion' of the perceptual world.[12]

In this progress, each new improvement in the technology, such as the stereo-scope or colour film, was seen as making up a deficiency in the previous ability to record what was 'really' there.

As a result of its rendering everlasting the image cast by a camera obscura it has often seemed, moreover, as if photography validated the perspectivalist scopic regime that was so often identified with vision itself after the Quattrocento.[13] The camera eye, as monocular as that of the peephole, produced a frozen, disincarnated gaze on a scene completely external to itself (an effect especially compelling before advances in film speed ended interminable sittings). As the 'pencil of nature', to use Fox Talbot's famous phrase, the camera provided what Ivins would call 'pictorial statements without syntax', direct images of the true surface *and* the three-dimensional depth of the perceived world.[14]

Such at least was the predominant belief when the invention first became known, some observers worrying that the little faces in the pictures were so real they could look back at them.[15] Even Baudelaire, whose keen hostility to the artistic pretensions of photography we will examine shortly, could acknowledge its alleged fidelity to nature.[16] But if photography and its improvements, like the three-dimensional stereoscope which came into prominence in the 1860s, could be praised for providing ever more faithful reproductions of the seen world, a subcurrent of scepticism also began to emerge.

The most prominent inventor of the camera had, after all, been known as a master of illusion. As Aaron Scharf notes,

> Well before his discovery Louis-Jacques-Mandé Daguerre had acquired a considerable reputation as a painter and inventor of illusionist effects in panoramas and, from 1816, as a designer of stage setting for the Paris opera. Almost at the same time as he invented the diorama, the most popular of all early nineteenth-century *trompe l'oeil* entertainments, Daguerre began to experiment with the photographic process.[17]

Significantly, his famous dioramas were called 'miracle rooms'[18] because of their displays of illusionistic virtuosity. Due to the physical imprinting of light waves on the plate of the camera, that materially causative link between object and visual sign which modern linguists have called 'indexicality',[19] it might

seem as if now the *oeil* was not *trompé* in Daguerre's new invention, but doubts nonetheless soon arose.

In the mid-1840s, photographers discovered that they could retouch their photos or even combine two to make a composite, techniques revealed to the astonished French public at the 1855 Universal Exposition by a Munich photographer named Hampfstängl.[20] Soon, it became the norm in portraits to help nature cosmetically rather than merely record it. Interestingly, some commentators cited the ability to combine images to defend the artistic potential of the new medium.[21] But it was also clear that the deceptive doctoring of 'true' resemblances of the surface of the world was an abiding possibility. Thus, in the so-called 'spirit photography' foisted on a gullible public by an American charlatan W.H. Mumler in the 1860s, ghostly presences were registered by double exposures. Only when amateur photographers with their mass-produced Kodaks in the 1880s achieved the same results by forgetting to advance their film was the hoax decisively undone. Yet, as late as the Dreyfus Affair, it was still necessary to warn the naive viewer against concocted images, as shown by the front-page article devoted to 'The Lies of Photography' in *Le Siècle* in 1899.[22]

Of still greater importance was the realization that even unretouched photos could be understood to provide something less than perfect verisimilitude, either of objects in three-dimensional space or of the human perception of them. As early as 1853, Francis Wey was commenting on the limitations of what he called 'heliography': 'first of all, the accuracy of perspective is only relative: we have corrected it, but we have not completely rectified it. Secondly, heliography deceives us with regard to the relationship among tones. It pales blue tints, pushes green and red toward black, and has difficulty capturing delicate shades of white'.[23]

Although it is difficult to reconstruct the precise stages of the ultimate disillusionment with the realist paradigm, which the examples of Bazin and the early Barthes show was never total, by the late twentieth century it was practically obliterated. A host of contemporary critics testify to its disappearance. Umberto Eco, consciously rejecting Barthes, confidently claims that 'everything which in images appears to us still as analogical, continuous, nonconcrete, motivated, natural, and therefore 'irrational', is simply something which, in our present state of knowledge and operational capacities, *we have not yet succeeded in* reducing to the discrete, the digital, the purely differential';[24] he then procedes to enumerate ten categories of codes that can be applied to the photographic message, which has no claim to being a simple reproduction of the 'real'.

Joel Snyder, no less hostile to the mimetic claims of the photographic image, summarizes the differences that separate it from the human experience of sight:

> To begin with, our vision is not formed within a rectangular boundary; it is, per Aristotle, unbounded. Second, even if we were to close one eye and place a rectangular frame of the same dimensions as the original negative at a distance from the eye equal to the focal length of the lens (the so-called distance point of perspective construction) and then look at the field represented in the picture, we would still not see what is shown in the

picture. The photograph shows everything in sharp delineation from edge to edge, while our vision, because our eyes are foveate, is sharp only at its 'center'. The picture is monochromatic, while most of us see in 'natural' color (and there are some critics who maintain that the picture would be less realistic if it were in color). Finally, the photograph shows objects in sharp focus in and across every plane, from the nearest to the farthest. We do not – because we cannot – see things this way.[25]

According to James E. Cutting,

> the eye has neither shutters nor exposure time, yet the visual system allows us to see a moving object clearly, whereas a still camera would register blur. In addition, the shape of the projection surfaces are different … the photograph, the canvas, and the sketch pad are flat; the retina conforms nearly to a section of a sphere.[26]

And Craig Owens adds the further objection that:

> the argument that the properties of the photographic image are derived not from the characteristics of the medium itself but from the structure of the real, registered mechanically on a light-sensitive surface, may describe the technical procedures of photography. But it does not account for the photograph's capacity to internally generate and organize meaning.[27]

Although it is doubtful that many nineteenth-century commentators were as clear as these writers on the distinctions between photographs and 'natural' visual experience, not everyone was seduced by the realist claims of its early proponents. Even if the dream of technical improvements leading to greater and greater verisimilitude never died, each new innovation seemed to raise as many questions as it laid to rest,[28] a process that was only intensified with the invention of the cinema. The photographic camera thus paradoxically played a key role in discrediting the camera obscura model of visual experience.

One suggestive interpretation of their unsettling effect concerns the rediscovery of a visual tradition at odds with the dominant modern scopic regime, that which Svetlana Alpers calls the Dutch 'art of describing'. It may not have been by chance that the rediscovery of Vermeer, Hals and their compatriots took place in the 1860s, shortly after the impact of the camera.[29] According to Alpers,

> many characteristics of photographs – those very characteristics that make them so real – are common also to the northern descriptive mode: fragmentariness; arbitrary frames; the immediacy that the first practitioners expressed by claiming that the photograph gave Nature the power to reproduce herself directly unaided by man. If we want historical precedence for the photographic image it is in the rich mixture of seeing, knowing, and picturing that manifested itself in seventeenth-century images.[30]

It is therefore the ghost of Kepler rather than those of Descartes or Alberti which hovers over the birth of the camera. The dead image on the retina that he had called a *pictura* was thus now given its mechanical fixation without the intervention of the rationalized space added by Cartesian perspectivalism.[31]

Regardless of whether photographs are more properly included in the northern rather than southern pictorial tradition, what is incontestable is their extraordinary expansion of the range of human visual experience. As

Benjamin noted, 'photography makes aware for the first time the optical unconscious, just as psychoanalysis discloses the instinctual unconscious'.[32] The layers of this unconscious were peeled away with new technical advances such as artifical illumination in the 1850s and stop action chronophotography in the 1870s and 1880s. The most celebrated developers of the latter were Edward Muybridge in Britain and Étienne-Jules Marey in France. By revealing aspects of movement hitherto undetectable by the unaided eye, they helped to denaturalize conventional visual experience. As Aaron Scharf notes,

> not only did the Muybridge photographs contradict many of the most accurate and up-to-date observations of artists, but phases of locomotion were revealed which lay beyond the visual threshold. The meaning of the term 'truth to nature' lost its force: what was true could not always be seen, and what could be seen was not always true.[33]

Yet another unsettling effect occurred when the increased speed of film allowed completely spontaneous moments of seeming evanescence to be caught forever. Here the implications were varied. One was the apparent robbing of life's flowing temporality by introducing a kind of visual rigor mortis, which forged a link between the camera and death; this link was noted as early as 1841 by Ralph Waldo Emerson and is still potent in recent French thought.[34] Although the so-called 'pictorialist' photographers of the late nineteenth century tried to reintroduce time in their images by softening their focus, the hard-edged violence of the snapshot seems more characteristic of the medium.

A further implication drawn from the freezing of evanescence was the calling into question of the fiction of a transcendental subject looking at the same scene through eternity. As John Berger has suggested,

> the camera isolated momentary appearances and in so doing destroyed the idea that images were timeless. Or, to put it another way, the camera showed that the notion of time passing was inseparable from the experience of the visual (except in paintings). What you saw depended upon where you were when. What you saw was relative to your position in time and space. It was no longer possible to imagine everything converging on the human eye as on the vanishing point of infinity.[35]

Or, put in Norman Bryson's terms, the camera helped restore the rights of the incarnated glance over the disincarnated gaze, and in so doing reintroduced an awareness of the deictic temporality of all seeing.[36]

It did so, however, by creating a temporality of pure presentness in which the historical becoming of narrative time was stripped away. As Siegfried Kracauer recognized in 1927, the spatializing impact of the photograph was a barrier to true memory, however much it may have seemed to be its aid. 'In the illustrated newspapers', he noted, 'the world is turned into a photographable present and the photographed present is completely eternalized. It seems to be snatched from death; in reality, it surrenders itself to it.'[37] Bergson's response to photography and the cinema anticipated this very criticism. As early as *Matter and Memory* in 1896, he identified the spatialization of time, the reduction of lived *durée* to a static image, with a snapshot.[38]

Thus in the long run, the invention of the camera may well have helped to undermine confidence in the authority of the eyes, which prepared the way for the interrogation of sight in twentieth-century French thought. As the film critic, Jean-Louis Comolli, put it,

> At the very same time that it is thus fascinated and gratified by the multiplicity of scopic instruments which lay a thousand views beneath its gaze, the human eye loses its immemorial privilege; the mechanical eye of the photographic machine now sees *in its place*, and in certain aspects with more sureness. The photograph stands as at once the triumph and the grave of the eye ... Decentered, in panic, thrown into confusion by all this new magic of the visible, the human eye finds itself affected with a series of limits and doubts.[39]

Rather than confirming the eye's ability to know nature and society, photography could have exactly the opposite effect. The pencil of nature could draw some remarkably unnatural things, as the later example of surrealist photography brilliantly demonstrated.[40] Photo-unrealism always shadowed the camera's celebrated ability to provide a truthful image of the real.

The second great controversy unleashed by the invention of the camera concerned the relationship between photography and art.[41] Here the questions were manifold, and often had legal as well as theoretical significance.[42] Were photographs really works of art, despite the seeming absence of an artistic hand in their production? If they were, was traditional painting now relieved of its time-honoured mission to render the world faithfully on canvas? If it still tried to register visual experience in some way or another, how did the optical unconscious revealed by photography affect that effort? And what, finally, was the effect of photographic reproductions of works of art in other media?

In an often cited statement made just as photography was made public for the first time, the painter Paul Delaroche proclaimed 'From this day on, painting is dead'.[43] In a literal sense, he was, of course, mistaken, although hoards of miniaturists were put out of business.[44] But there can be no question that painting was radically changed by the new medium. Many artists, from obscure portrait painters to masters like Delacroix and Ingres, eagerly used photos to help them in their work. Some were apparently affected by what they saw. Thus, for example, the harsh tonal divisions produced by artificial lighting have been seen as influencing Manet, and the blurred images of moving objects resulting from slow film have been credited with inspiring Corot's proto-Impressionism of the 1840s.[45] So, too, the flattening of space in Impressionism, which has sometimes been interpreted as reflecting the impact of the new interest in Japanese art, has also been derived from the breakdown of perspectivalism in photography.[46] Degas's ephemeral images of dancers or horses caught in motion have often been compared with the snapshots that became possible with the perfection of faster film. The later impact of Muybridge and Marey's dissection of movement has been noted on the heterogeneous 'fractured space' evident in certain of Manet's paintings, and even more so in those of Cézanne and Duchamp.[47] Even the brazen nudes starring out at the viewer in Manet's *Déjeuner sur l'herbe* and *Olympia* have sometimes been linked to the Second Empire's pornographic portraiture.[48]

What makes all of these putative influences so ironic is that the Impressionists themselves, indebted as they often were to the reigning positivist ideology of the era, generally claimed to be passive recorders of what they saw. Even Cézanne could protest that 'being a painter I attach myself first of all to visual sensation'.[49] A further irony lies in the fact that the same naturalist pretence of passive neutrality on the part of early exponents of the camera was precisely what led to its denunciation by artists hostile to the ideology of realistic mimesis. As early as three weeks after Daguerre addressed the French Academy of Science, a writer in *Le Charivari* contended that 'considered as art, the discovery of M. Daguerre is perfect silliness, but considered as the action of light on bodies, the discovery of M. Daguerre realizes an immense progress'.[50] Daumier later complained that 'photography imitates everything and expresses nothing. It is blind in the world of spirit'.[51] And the poet Lamartine called it 'this chance invention which will never be art, but only a plagiarism of nature through a lens'.[52]

Perhaps no one was as famously contemptuous of the artistic pretensions of photography as Baudelaire, who loudly lamented the triumph of naturalist idolatry in his Salon review of 1859.[53] Although granting to the new technology its scientific and and industrial uses, he fulminated mightily against its incursions into the realm of 'the impalpable and the imaginary'.[54] Of the vulgar masses' desire for the perfect reproduction of nature, he wrote, 'a revengeful God has given ear to the prayers of this multitude. Daguerre was his messiah ... A little later a thousand hungry eyes were bending over the peep-holes of the stereoscope, as though they were the attic-windows of the infinite'.[55] Although it is hard to disentangle Baudelaire's contempt for the masses from his distaste for their new toy, it is clear that he deeply distrusted the implications of photography for art. This attitude was so deeply ingrained that even later, when photographers self-consciously eschewed naturalism for artistic embellishments of the image, writers like Proust could still echo Baudelaire's suspicions.[56]

Such complaints were fundamentally misplaced in one important respect: the imaginative arts could never be annihilated by the camera because, as we have already noted, the latter's vision of reality was itself never straightforwardly mimetic or entirely indexical. In fact, as recent commentators like Heinrich Schwarz and Peter Galassi have convincingly shown, the predecessors of photography were not merely optical instruments like the camera obscura, but also certain traditions in painting itself.[57] The landscapes of Constable, for example, demonstrate a 'new and fundamentally modern pictorial syntax of immediate, synoptic perceptions and discontinuous, unexpected forms. It is the syntax of an art devoted to the singular and contingent rather than the universal and stable. It is also the syntax of photography'.[58] In other words, the photographic image can itself be understood as way-station between earlier non-Albertian art (perhaps best exemplified by the Dutch 'art of describing') and the definitive break with perspective in the Impressionist and post-Impressionist era.

In one final way, the Baudelairean disdain for the corrupting effect of photography on art was mistaken. The mass reproduction of paintings and other art works, begun by Adolphe Braun in 1862, anticipated, as many critics have noted, André Malraux's famous idea of the 'imaginary museum', in

which access to the art of the world was universalized.[59] One result was the stimulus to artistic experimentation produced by the photographic records of artefacts from exotic cultures, which supplemented the actual objects on display in the ethnographical museums that were established in the nineteenth century. Thus, the invention of the camera can be credited with helping educate Western eyes to new aesthetic possibilities.[60]

From another perspective, however, the extension of the range of Western aesthetic experience could be interpreted as an example of the dominating anthropological gaze at the 'other', trenchantly examined by recent critics such as Johannes Fabian and Stephen Tyler.[61] As early as the 1850s, what has been called 'photographic orientalism'[62] began with Maxime du Camp's series on Egypt, Nubia, Palestine and Syria, and Louis de Clercq's remarkable portraits of Jerusalem. Other reproduced images of exotic scenes, individuals or objects soon followed. Extending the World's Fair logic of gazing curiously at the other, the new technology abetted what one historian has called seeing 'the world as exhibition'.[63] Mass tourism based on the visual appropriation of exotic locales and the no less photogenic natives (or fauna) inhabiting them was not far behind.[64]

Another effect was evident in the sphere of esoteric Western art. The very aestheticization of 'primitive' artefacts meant removing them from their original context, functional, ritual or whatever, and appreciating only their abstract form. No account of the prehistory of modernism can ignore the impact of this revaluation of primitivism, which often drew on an older, Romantic belief in the power of 'innocent' vision, but its ambiguities have also become harder to ignore.[65]

If the photographic appropriation of the exotic 'other' did not, however, immediately trouble nineteenth-century sensibilities, neither did other social consequences of the new technology; at least at first. What, in fact, we have to ask, was the impact on society of this remarkable extension of our visual experience? On one level, the photographer might be understood as merely continuing visual practices already in place. Thus, for example, Susan Sontag has claimed that 'photography first comes into its own as an extension of the eye of the middle-class *flâneur*, whose sensibility was so accurately charted by Baudelaire. The photographer is an armed version of the solitary walker reconnoitering, stalking, cruising the urban inferno, the voyeuristic stroller who discovers the city as a landscape of voluptuous extremes'.[66] Like the naturalist novelist fascinated by the exotica of the 'lower depths', the photographer could both expose and revel in the hitherto hidden corners of 'picturesque' slums. The remarkable documentary potential of the new technology was immediately understood in comparison with the more costly and cumbersome procedures that it replaced. And, of course, photography could also be employed to extend the visual impact of advertising, which had already been revolutionized by lithography during the post-Napoleonic era.

However, more novel uses of the new medium were also possible. In 1854, an enterprising portraitist, A.A.E. Disdéri, invented the personal *carte de visite* by reducing the normal size of a picture and printing the negative cheaply a dozen times.[67] The innovation, which made Disdéri a rich man before he was bankrupted by intense competition from a multitude of new studios, had apparently egalitarian effects.[68] Everyone from the Emperor to the *filles de joie*

of the Second Empire's *demi-monde* sat for his camera. He thus anticipated the democratization of the camera which was only fully realized with the second wave of technological innovations begun by the American, George Eastman, and his Kodak in the 1880s. When the picture postcard came of age in the *belle epoque*, the visual pleasure of owning scenes of Paris and other sites of beauty was generalized as never before.[69]

There were also other, less benign implications of Disdéri's invention, for what began as a private calling card could soon become a public document, traded by collectors or used for licences, passports, wanted posters and other state-regulated forms of identification and surveillance. As John Tagg, writing from a Foucaultian perspective, has contended, the standardized image it fostered was a leading example of the disciplined and normalized subject produced by modern techniques of power: 'the body made object; divided and studied; enclosed in a cellular structure of space whose architecture is the file-index; made docile and forced to yield up its truth; separated and individuated; subjected and made subject. When accumulated, such images amount to a new representation of society'.[70] Anne McCauley finds equally sinister implications:

> The acceptance of the carte portrait as an item of exchange, a collectable, by the middle class and the subsequent adoption of the practice by the workers themselves represent the insidious transformation of the individual into a malleable commodity. Direct human intercourse was in a sense supplemented by the interaction with a machine-generated and therefore irrefutably exact alter-ego, a fabricated 'other'. The creation and popularization of the carte de visite during the Second Empire therefore represents an early step toward the simplification of complex personalities into immediately graspable and choreographed performers whose faces rather than actions win elections.[71]

No less ominous was the use of photos for police purposes, which began in earnest in the aftermath of the Paris Commune in 1871.[72] Combined with a questionable anthropology that pretended to be able to identify criminals and anarchists by their physiognomies, the techniques perfected by Alphonse Bertillon in the 1880s had political implications as well, which would continue to trouble such recent commentators as John Berger, Susan Sontag and John Tagg.[73] Moreover, in a population still largely semi-literate, political propaganda was also abetted by the skilful use of the new medium, which came into its own with the tendentious composite reconstructions of incidents during the Commune by Eugène Appert.[74] Later political movements, such as that supporting General Boulanger, expanded the demagogic use of photographic propaganda.

Still another exploitation of the camera's eye was its use to record alleged visual representations of insanity. First attempted by Hugh Welch Diamond at the Surrey Asylum in England, the technique came into its own with Albert Londe at Charcot's clinic, Salpêtrière, in the 1880s.[75] Here the older tradition of picturing the insane, which had been developed by artists as prominent as Le Brun in the seventeenth century and Géricault in the nineteenth, were quickly surpassed as the stop-action chronophotography of Marey was used to freeze every detail of the appearance of madness.[76] The result was what one

commentator has called 'the invention of hysteria', that quintessentially visual pathology enacted by women in the still ocularcentric world of Charcot's ampitheatre. Significantly, the introduction of psychoanalysis into France, which played such a crucial role in the development of the anti-ocularcentric discourse I want to trace, meant the explicit rejection of Charcot's faith in the theatrical representation of madness; the 'talking cure' needed no Albert Londe to depict the symptoms of the wounds it hoped to heal.

More 'normal' subjects of the dissecting photographic gaze could also have their movements broken down in ways that abetted their control. The innovations of Muybridge and Marey not only led to Duchamp's 'Nude Descending a Staircase', they also helped Frederick Winslow Taylor's rationalization of the work process through time and motion studies. His disciple, Frank B. Gilbreth, invented the 'cyclegraph' in which lights would be attached to parts of subjects' bodies and, by means of long time exposures, their movements could be charted and their inefficiencies remedied.[77]

A final social use of the camera, which might be seen as the realization of that *principe de survol* valorized by thinkers from Montequieu to Flaubert and then attacked by later ones such as Merleau-Ponty, is suggested by one of the exploits of perhaps the greatest photographer of the nineteenth century, Gaspard-Félix Tournachon, known as Nadar.[78] In 1856 Nadar, who had already descended into the earth to record the catacombs of Paris using artificial illumination, ascended into the sky to view it from above in a hot air balloon. The first aerial photographs were such a success that he commissioned the construction of a larger airship, known as *Le Géant*, in 1863. Although it cost him a fortune and had only mixed results because of technical difficulties, it marked the beginning of a tradition of high altitude surveillance of the works of humankind and nature that culminated in the celebrated pictures of earth by the American astronauts in 1968.

More immediate uses were recognized by the French government, which offered Nadar 50,000 francs to photograph troop movements during the conflict with Italy in 1859. This request Nadar refused but, during the Prussian siege of Paris in 1870, he was less reluctant to support the war effort. Along with the use of photography to make maps from the ground, which began in 1859, and the assignment of photographers to every army regiment (started on the suggestion of Disdéri in 1861), aerial photography showed the military potential of the new medium.

Nadar in his high-flying balloon was also the subject of a celebrated lithograph by Daumier published in 1863 in Étienne Carjat's newly founded *Le Boulevard*. Humorously captioned 'Nadar raising photography to the height of art', it pictures the photographer precariously perched in the swaying cabin of his balloon, his top hat caught by the wind, as he snaps a city of photography studios beneath him. As Heinrich Schwarz observes of its manifold implications:

> it deals with aerial photography, which, together with the intrusion of Japanese art, was to have a decisive influence upon the new optical approach – the bird's eye view – of the Impressionist painters; it satirizes an actual personality among the early French photographers and his passion for showmanship; it ridicules the rapid growth of the

photographic profession and in a sarcastic way raises the serious question whether photography should be considered an art or a purely mechanical procedure.[79]

Daumier's drawing might also be interpreted, I want to suggest in conclusion and with a little licence, as emblematic of the state of ocularcentrism itself in the late nineteenth century. The unmoving gaze from afar that the Enlightenment – exceptions like Diderot aside – could identify with dispassionate cognition was beginning to be shaken by the force of new cultural winds. The widespread dissemination of new visual experiences brought about by social as well as technological changes had introduced uncertainties about the truths and illusions conveyed by the eyes. Although the dominant ethos until the 1890s was still the observationally-oriented approach called positivism, with its literary correlate, naturalism, a new attitude was visible on the horizon. The hegemony of Cartesian perspectivalism was beginning to unravel, leading initially to explorations of alternative scopic regimes, and finally to a fully-fledged critique of vision in any of its forms in the twentieth century. Its first unmistakable signs can be discerned in the evolution of French painting from Impressionism to post-Impressionism, in the development of modernist literary theory and practice, and in the new philosophy of Henri Bergson. With these developments, we are already on the threshold of that denunciation of the spectacle, surveillance and the simulacrum which is so characteristic of contemporary French thought. The camera, I hope it has been convincingly shown, was unexpectedly instrumental in pushing us through to the other side.

Notes

1 Martin Jay, *Downcast Eyes: The Denigration of Vision in Twentieth-Century French Thought* (Berkeley, CA: University of California Press, 1993). This chapter is adapted from Chapter 3 of that book.
2 Hans Jonas, 'The Nobility of Sight', *The Phenomenon of Life: Toward a Philosophical Biology* (Chicago, IL: University of Chicago Press, 1982).
3 See, for example, Claude Nori, *French Photography: From Its Origins to the Present*, trans. Lydia Davis (New York: Pantheon 1979); Gisèle Freund, *Photography and Society*, trans. Richard Dunn *et al.* (Boston: D.R. Godine, 1980); Beaumont Newhall, *The History of Photography: From 1839 to the Present Day* (New York: MOMA, 1964); *Regards sur la photographie en France au XIXe siècle*, 180 chefs d'oeuvre de la Bibliothèque nationale (Paris, 1980).
4 The elder Niepce is usually credited with the first fixation of an image on a pewter plate turned sensitive to light by bitumen, which he accomplished in 1826, but it was not until Daguerre and the younger Niepce perfected it in the late 1830s that it was ready to be revealed. Talbot's great contribution was his invention of the negative, which allowed multiple prints to come from the same picture.
5 'The Fine Arts: A New Discovery', reprinted in Beaumont Newhall (ed.), *Photography: Essays and Images* (New York: MOMA, 1980), p. 17.
6 See the 1840 lithograph with this title by T.H. Maurisset, reprinted in Freund, *Photography and Society*, p. 27.
7 For a discussion of the Realist context of the initial reception of the new technology, see Victor Burgin, 'Introduction' to Victor Burgin (ed.), *Thinking Photography* (London: Macmillan, 1982), p. 10.

8 See Richard Rudisill, *Mirror Image* (Albuquerque, NM: University of New Mexico Press, 1971).

9 See the catalogue *French Primitive Photography*, intro. Minor White, commentaries by André Jammes and Robert Sobieszek (New York: Aperture, 1969).

10 André Bazin, 'The Ontology of the Photographic Image', in *What is Cinema?*, ed. and trans. Hugh Gray, foreword by Jean Renoir (Berkeley, CA: University of California Press, 1967), p. 13. Bazin, of course, extended his realist aesthetic to the cinema as well.

11 Roland Barthes, *Image – Music – Text*, trans. Stephen Heath (New York: Hill & Wang, 1977), p. 17.

12 Noël Burch, 'Charles Baudelaire versus Doctor Frankenstein', *Afterimage*, 8/9 (Spring 1981), p. 5. In *The World Viewed: Reflections on the Ontology of Film* (Cambridge, MA: Harvard University Press, 1979), Stanley Cavell adds that 'so far as photography satisfied a wish, it satisfied a wish not confined to painters, but the human wish, intensifying in the West since the Reformation, to escape subjectivity and metaphysical isolation – a wish for the power to reach this world, having for so long tried, at last hopelessly, to manifest fidelity to another' (p. 21).

13 For examples of this assumption, see William M. Ivins, Jr, *Prints and Visual Communication* (Cambridge, MA: Harvard University Press, 1985) p. 138; Victor Burgin, 'Looking at Photographs', in Burgin, *Thinking Photography*, p. 146; and Steve Neale, *Cinema and Technology: Image, Sound, Colour* (London, 1985), p. 20ff.

14 Fox Talbot, *The Pencil of Nature* (London, 1844); Ivins, *Prints and Visual Communication*, Chapter VI. The syntax to which Ivins refers is the cross-hatching or dots used to render light and dark in traditional prints. For a similar analysis, which stresses the realism of screen half-tone prints of photographs in the mass media in the 1890s, see Estelle Jussim, *Visual Communication and the Graphic Arts: Photographic Technologies in the Nineteenth Century* (New York: R.M. Bowker Co., 1974), p. 288.

15 See the comment of the photographer Dauthendey, cited in Walter Benjamin, 'A Short History of Photography', *Screen* (Spring 1972), p. 8.

16 See Baudelaire's letter to his mother of 1865, where he encourages her to go to a studio, even if he worries that the photographer will catch all of her wrinkles and faults. Baudelaire, *Correspondance* (Paris: Gallimard, 1973), vol. 2, p. 554.

17 Aaron Scharf, *Art and Photography* (London: Allen Lane, 1983), p. 24.

18 Dolf Sternberger, *Panorama of the 19th Century*, trans. Joachim Neugroschel (Oxford, 1977), p. 9.

19 The term 'index' was introduced by C.S. Peirce to denote signs with a direct or 'motivated' link to a referent; he used the term 'symbol' to denote those that were entirely conventional and artificial, and 'icon' to mean those that resembled their referent. See his 'Logic as Semiotic: The theory of Signs', in *The Philosophy of Peirce: Selected Writings*, ed. J. Buckler (London: K. Paul, Trench, Trubner & Co., 1940), pp. 98–119. Historians of photography have often pointed to its indexical character, for example Rosalind Krauss in 'Tracing Nadar', p. 34, where she argues Nadar was aware of its importance. Krauss has developed the idea of indexicality to describe certain kinds of modernist art as well. See her 'Notes on the Index, Parts I and II', in *The Originality of the Avant-Garde and Other Modernist Myths* (Cambridge, MA: M.I.T. Press, 1985). Peirce himself saw photography as combining indexical with iconic features. See the discussion in Mitchell, *Iconology*, (Chicago, IL: University of Chicago Press, 1903) p. 56f.

20 Freund, *Photography and Society*, p. 64.

21 See the discussion in James Borcoman, 'Notes on the Early Use of Combination Printing', in Van Deren Coke (ed.), *One Hundred Years of Photographic History: Essays in Honor of Beaumont Newhall* (Albuquerque, NM: University of New Mexico Press, 1975).

22 'Les mensonges de la photographie', *Le Siècle*, 11 January 1899; reprinted in Norman L. Kleeblatt (ed.), *The Dreyfus Affair: Art, Truth and Justice* (Berkeley, CA: University of California Press, 1987), p. 212. The paper printed eighteen composite photographs of enemies in the Affair appearing to be friends.

23 Cited in Elisabeth Anne McCauley, *A.E.E. Disdéri and the Carte de Visite Portrait Photograph* (New Haven, CT: Yale University Press, 1985), p. 194.

24 Umberto Eco, 'Critique of the Image', in Burgin, *Thinking Photography*, p. 34.

25 Joel Snyder, 'Picturing Vision', *Critical Inquiry*, VI, 3 (Spring 1980), p. 505.

26 James E. Cutting, *Perception with an Eye for Motion* (Cambridge, MA: M.I.T. Press, 1986), p. 16–17.

27 Craig Owens, 'Photography *en abyme*', *October*, 5 (Summer 1978), p. 81.

28 The invention of the stereoscope, for example, could have a complicated effect on the assumption of the materially causative or indexical nature of the photographic image, for its three-dimensional effect was produced nowhere but in the mind. Moreover, as Jean Clair has noted, it thwarted the fetish of the permanent image with its commercial possibilities: '*Because it has no material reality it does not permit symbolic exchange*. As a virtual image, an immaterial imitation, a totally transparent, all-too-perfect delusion of reality, it does not permit one to trade the substance for the shadow, unlike the material document on paper': 'Opticeries', *October*, 5 (Summer, 1978), p. 103. He goes on to argue that Duchamp's anti-retinal art was indebted to his fascination with stereoscopic images and their descendents known as anaglyphs.

29 The link is suggested by Anne Hollander in 'Moving Pictures', *Raritan*, V, 3 (Winter 1986), p. 100.

30 Svetlana Alpers, *The Art of Describing: Dutch Art in the Seventeenth Century* (Chicago, IL: University of Chicago Press, 1983), p. 43–4. See also Carl Chiarenza, 'Notes on Aesthetic Relationships between Seventeenth-Century Dutch Painting and Nineteenth-Century Photography', in Van Deren Coke, *One Hundred Years of Photographic History*.

31 Perfect resemblance between objects and their mental representations was not an assumption of Descartes's optics. The soul, he insisted, saw, not the eye, and as such, it provided a natural geometry not mechanically sensed by the physical apparatus of sight. It was the absence of that natural geometry in photographic images that helped them to undermine Cartesian perspectivalism.

32 Benjamin, 'A Short History of Photography', p. 7.

33 Scharf, *Art and Photography*, p. 211. Thierry de Duve adds that 'with the onset of motion photography, artists who were immersed in the ideology of realism found themselves unable to express reality and obey the photograph's verdict at the same time. For Muybridge's snapshots of a galloping horse demonstrated what the animal's movements were, but did not convey the sensation of their motion.' 'Time Exposure and Snapshot: The Photograph as Paradox', *October*, 5 (Summer 1978), p. 115.

34 Ralph Waldo Emerson, *Journals of Ralph Waldo Emerson, 1841–1844*, ed. Edward Waldo Emerson and Waldo Emerson Forbes (Boston, MA: Houghton Mifflin Co., 1912), vol. 6, pp. 100–1. Perhaps the most poignant exploration of the link is Roland Barthes, *Camera Lucida; Reflections on Photography*, trans. Richard Howard (New York: Hill & Wang, 1981). See also Thierry de Duve, 'Time Exposure and Snapshot: The Photograph as Paradox'. As Steve Neale has noted, the invention of the cinema seemed to hold out hope for the revitalizing of the image, the reversal of the rigor mortis of the still photograph. See his discussion in *Cinema and Technology*, p. 40.

35 John Berger, *Ways of Seeing* (London, 1972), p. 18.

36 Norman Bryson, *Vision and Painting: The Logic of the Gaze* (New Haven, CT: Yale University Press, 1983), Chapter 5. Deixis, the recognition of the contingent here

and now of every visual act, is, he claims, repressed in the dominant Western pictorial tradition. Roger Scruton notes that the main difference between the photograph and the painted portrait lies in the attempt of the latter to capture a representative version of the sitter over time, not a momentary glimpse of him or her. See his *The Aesthetic Understanding: Essays in the Philosophy of Art and Culture* (London: Methuen 1983), p. 110. Unlike Bryson, he uses this argument to deny artistic status to photography, which he sees as a causal rather than intentional medium.

37 Siegfried Kracauer, 'Die Photographie', in *Das Ornament der Masse: Essays* (Frankfurt, 1963), p. 35.

38 Henri Bergson, *Matter and Memory*, trans. N.M. Paul and W.S. Palmer (New York: Humanities Press, 1978), p. 38. Later, in *Creative Evolution* of 1907, he would introduce the term 'cinematographic' to indicate a false sense of temporality produced by the combination of immobile sections of flux with an abstract, mechanical simulacrum of time.

39 Jean-Louis Comolli, 'Machines of the Visible', in Teresa de Lauretis and Stephen Heath (eds), *The Cinematic Apparatus* (New York: St Martin's Press, 1980), p. 123. For a similar analysis, see Neale, *Cinema and Technology*, p. 38.

40 For an analysis of its importance, see Krauss, *The Originality of the Avant-Garde*.

41 The best summary of the debate is in Scharf, *Art and Photography*. See also Paul C. Vitz and Arnold B. Glimcher, *Modern Art and Modern Science: The Parallel Analysis of Vision* (New York: Praeger, 1984).

42 In an important decision called 'Mayer and Pierson v. Thiebault, Betbeder and Schwabbé' in 1862, the French courts decided that photography was in fact an art in order to protect the copyright of the image. For a powerful exploration of the implications of this decision, see Bernard Edelman, *The Ownership of the Image. Elements of a Marxist Theory of Law*, trans. E. Kingdom (London: Routledge & Kegan Paul, 1979).

43 Cited and discussed in Gabriel Cromer, 'L'original de la note du peintre Paul Delaroche à Arago au sujet du Daguerréotype', *Bulletin de la Société Française de Photographie et de Cinématographie*, 3rd series, XVII (1930), p. 114f.

44 Freund, *Photography and Society*, p. 10.

45 Scharf, *Art and Photography*, pp.62 and 89.

46 Vitz and Glimcher, *Modern Art and Modern Science*, p. 50.

47 Ibid, pp. 118 and 123; Scharf, *Art and Photography*, p. 255.

48 McCauley, *A.A.E. Disdéri*, p. 172.

49 Cited from a conversation with Émile Bernard in Herschel B. Chipp, *Theories of Modern Art: A Source Book by Artists and Critics* (Berkeley, CA: University of California Press, 1968), p. 13.

50 Cited in Heinrich Schwarz, *Art and Photography: Forerunners and Influences*, ed. William E. Parker (Rochester: G.M. Smith, 1987), p. 141.

51 Cited in ibid, p. 140.

52 Cited in Freund, *Photography and Society*, p. 77. This remark was made in 1858; a short time later, Lamartine reversed himself after seeing the very expressive work of Antoine Samuel Adam-Salomon.

53 Baudelaire, 'Photography', in Newhall, *Photography: Essays and Images*, pp. 112–13.

54 Ibid, p. 113.

55 Ibid, p. 112.

56 For a discussion of the attempt to make photos look like everything from oil paintings to lithographs, see Freund, *Photography and Society*, p. 88. For Proust's critical reaction to the medium, see Susan Sontag, *On Photography* (New York: Farrar, Strauss & Giroux, 1978), p. 164.

57 Schwarz, *Art and Photography*; Peter Galassi, *Before Photography: Painting and the Invention of Photography* (New York: MOMA, 1981).

58 Galassi, *Before Photography*, p. 25. Krauss, however, cautions against accepting Galassi's argument when it comes to stereoscopic photos, like those of Timothy O'Sullivan, which sought to be perspectival. See *The Originality of the Avant-Garde*, p. 134f.

59 André Malraux, *The Voices of Silence* (Princeton, NJ: Princeton University Press, 1978).

60 Ivins, *Prints and Visual Communication*, p. 147. It also might be noted that exposure to images of different ethnic types could have a liberalizing effect. Thus, for example, McCauley claims that Lavater's physiognomic works allowed the appreciation of beauty in forms other than that mandated by the Hellenic model of Winckelmann: see her *A.A.E. Disdéri*, p. 168.

61 Johannes Fabian, *Time and the Other: How Anthropology Makes its Object* (New York: Columbia University Press, 1983); Stephen A. Tyler, 'The Vision Quest in the West or What the Mind's Eye Sees', *Journal of Anthropological Research*, 40, 1 (1984), pp. 23–40.

62 R. Sobieszek, 'Historical Commentary', *French Primitive Photography*, p. 5.

63 Timothy Mitchell, 'The World as Exhibition', *Comparative Studies in Society and History*, 31 (1989). See also his *Colonising Egypt* (Cambridge: Cambridge University Press, 1988). For another account of the visual appropriation of the exotic other, which emphasizes its gender dynamics, see Malek Alloula, *The Colonial Harem*, trans. Myrna and Wlad Godzich (Minneapolis, MN: University of Minnesota Press, 1986).

64 For a critique, see Kenneth Little, 'On Safari: The Visual Politics of a Tourist Representation', in *The Varieties of Sensory Experience: A Sourcebook in the Anthropology of the Senses*, ed. David Howes (Toronto: University of Toronto Press, 1991).

65 For a recent discussion of these ambiguities, see James Clifford, *The Predicament of Culture: Twentieth-Century Ethnography, Literature and Art* (Cambridge, MA: Harvard University Press, 1988), Chapter 9.

66 Sontag, *On Photography*, p. 55.

67 McCauley, *A.A.E. Disdéri*; see also Freund, *Photography and Society*, p. 55f.

68 The egalitarianism produced by the camera can be interpreted in positive or negative terms, depending on one's attitude towards the society it depicted. For those who stress the still class-riven structure of that society, photographic democraticization can be attacked as ideological. For an argument of this kind, see Neale, *Cinema and Technology*, p. 23. Similar worries appeared much earlier as well. For an interesting account of their various forms in the American context, see Neil Harris, 'Iconography and Intellectual History: The Half-Tone Effect', in John Higham and Paul K. Conkin, *New Directions in American Intellectual History* (Baltimore, MD: John Hopkins University Press, 1979).

69 For an account of the importance of the postcard, see Naomi Schor, '*Cartes Postales*: Representing Paris 1900', *Critical Inquiry*, 18, 2 (Winter 1992). Her argument is directed against the strongly Foucaultian reading of the camera in the work of John Tagg and others influenced by the antiocularcentric discourse.

70 John Tagg, *The Burden of Representation: Essays on Photographies and Histories* (London: Macmillan 1988), p. 76.

71 McCauley, *A.A.E. Disdéri*, p. 224.

72 Donald E. English, *Political Uses of Photography in the Third French Republic 1871-1914* (Ann Arbor, MI: UMI Research Press, 1984).

73 Berger, *About Looking*, p. 48f; Sontag, *On Photography*, p. 5; Tagg, *The Burden of Representation*, Chapter 3.

74 Nori, *French Photography*, p. 21.

75 See Sander L. Gilman (ed.), *The Face of Madness: Hugh W. Diamond and the Origins of Psychiatric Photography* (New York: Brunner/Mazel, 1976); Georges Didi-

Huberman, *Invention de l'hysterie: Charcot et l'iconographie photographique de la Salpêtrière* (Paris: Editions Macuta, 1982); and Elaine Showalter, *The Female Malady: Women, Madness and English Culture, 1830–1980* (New York: Pantheon, 1985)

76 For an account of the tradition of attempts to picture insanity, see Sander L. Gilman, *Seeing the Insane: A Cultural History of Psychiatric Illustration* (New York: John Wiley, 1982).

77 For a discussion, see Stephen Kern, *The Culture of Time and Space 1800–1918* (Cambridge, MA: Harvard University Press, 1983), p. 116.

78 Among the many studies of Nadar, see especially Jean Prinet and Antoinette Dilasser, *Nadar* (Paris: A. Colin, 1966); Nigel Gosling, *Nadar* (London: Secker & Warburg, 1976); Philippe Néagu *et al.*, *Nadar*, 2 vols (Paris, 1970); and Roger Greaves, *Nadar ou le paradox vital* (Paris, 1980).

79 Schwarz, *Art and Photography*, p. 141.

Chapter Nineteen

Chance Encounters:
Flâneur and Détraquée in Breton's
Nadja

Victor Burgin

[N]*ous sommes tous plus ou moins des psychotiques guéris* (Octave Mannoni, 'La Part du Jeu')

About two-thirds of the way through his book *Nadja*, Breton describes meeting Nadja in a restaurant. The clumsy behaviour of a waiter prompts her to tell an anecdote about an exchange she had, earlier in the day, with a ticket collector in a *Métro* station. Clutching a new ten-franc piece in her hand, Nadja asks the man who punches her ticket: 'Head or tails?' To which the man replies 'Tails' and adds, indicating perhaps a vocation as a psychoanalyst: 'You were wondering, Mademoiselle, if you would be seeing your friend just now.' No one would suppose that Nadja is going down the *Métro* for nothing but, as the ticket-collector discerned, she is not necessarily aware of what she hopes to find there. There is more to our wanderings in the city than urban planners take into account.

Freud said that when he put on his hat and went into the street he stopped being a psychoanalyst. On at least one occasion he demonstrated that analysts may be no better than the rest of us at knowing their own motives while out in the city; he writes:

As I was walking, one hot summer afternoon, through the deserted streets of a provincial town in Italy which was unknown to me, I found myself in a quarter of whose character I could not remain long in doubt. Nothing but painted women were to be seen at the windows of the small houses, and I hastened to leave the narrow street at the next turning. But after having wandered about for a time without enquiring my way, I suddenly found myself back in the same street, where my presence was now beginning to excite attention. I hurried away once more, only to arrive by another *détour* at the same place yet a third time. Now, however, a feeling overcame me which I can only describe as uncanny, and I was glad enough to find myself

back at the piazza I had left a short while before, without any further voyages of discovery.[1]

By his own account Freud's ignorance of his most apparent motives for returning to that street, motives which for him were 'blindingly obvious', was not shared by the street's inhabitants. Freud fails to see what is 'under his nose' because his nose is buried in his *plan*, his conscious goal and the diagram which will lead him there. He has temporarily forgotten what he himself taught us: there is always another side to this map, 'another place' in this topography.

In his book *The Practice of Everyday Life*, in the chapter titled 'Walking in the City', Michel de Certeau inaugurates a dual mapping of urban space. There is first what he calls the 'Concept city', 'founded by utopian and urbanistic discourse', whose first operation must be, 'The production of its *own* space (*un espace propre*)'. Certeau comments, 'rational organisation must thus repress all the physical, mental and political pollutions that would compromise it'.[2] However: 'Beneath the discourses that ideologise the city, the ruses and combinations of powers that have no readable identity proliferate; without points where one can take hold of them, without rational transparency, they are impossible to administer'. 'No readable identity', writes Certeau, but he nevertheless goes on to inaugurate a reading of walking in the city; moreover, one conducted in terms of linguistics. After a discussion of pedestrian displacements in terms of classical rhetoric, Certeau remarks – in agreement with such writers as Benveniste and Lacan – that such tropes characterize a 'symbolic order of the unconscious'. He observes, 'From this point of view, after having compared pedestrian processes to linguistic formations, we can bring them back down in the direction of oneiric figuration'[3] Certeau goes on to identify

> three distinct (but connected) functions of the relations between spatial and signifying practices … the *believable*, the *memorable*, and the *primitive*. They designate what 'authorizes' (or makes possible or credible) spatial appropriations, what is repeated in them (or is recalled in them) from a silent and withdrawn memory, and what is structured in them and continues to be signed by an in-fantile (*in-fans*) origin.[4]

I understand the word 'believable' here to designate those material-factual conditions which furnish the occasion, pretext, alibi or disguise for what would otherwise be illegitimate, 'merely subjective', constructions of reality. As for the 'memorable', Freud's discussion of the uncanny is only a special case of his more general observation that what appears to come to us from the outside is often the return of that which we ourselves have placed there: something drawn from a repository of suppressed or repressed memories or fantasies. All this is familiar enough. It is the final term in Certeau's trilogy of 'relations between spatial and signifying practices' – the 'primitive', that which is 'signed by an in-fantile (*in-fans*) origin' – which calls for a clarification which Certeau does not provide. Certeau concludes his essay on 'walking in the city' with these words:

> The childhood experience that determines spatial practices later develops its effects, proliferates, floods private and public spaces, undoes their readable

surfaces, and creates within the planned city a 'metaphorical' or mobile city, like the one Kandinsky dreamed of: 'a great city built according to all the rules of architecture and then suddenly shaken by a force that defies all calculation.'[5]

He says no more on the subject, but what *are* these 'infantile determinants' of our experiences and practices in and of the city?

Writing of certain instances of the experience of the uncanny, Freud remarks: 'They are a harking-back to particular phases in the evolution of the self-regarding feeling, a regression to a time when the ego had not yet marked itself off sharply from the external world and from other people'.[6] The space of this time, 'primitive' to us all, was later mapped in some detail by Melanie Klein, of whom Lacan has written:

> Through her we know the function of the imaginary primordial enclosure formed by the *imago* of the mother's body; through her we have the cartography, drawn by the children's own hands, of the mother's internal empire, the historical atlas of the intestinal divisions in which the *imagos* of the father and brothers (real or virtual), in which the voracious aggression of the subject himself, dispute their deleterious dominance over her sacred regions.[7]

It is often observed that much as Freud discovered the child in the adult, so Klein found the infant in the child; as is well-known, her 'royal road' to this discovery was the analysis of play. Klein wrote that she approached the play of the child 'in a way similar to Freud's interpretation of dreams'. In her therapeutic technique the child's play takes on the function served by the verbal associations of the adult patient; consistently with Freud she cautions that, 'we have to consider each child's use of symbols ... in relation to the whole situation which is presented in the analysis; mere generalized translations of symbols are meaningless'.[8] Klein's interpretations were not based simply on the child's manipulations of its toys, they concerned the totality of the field of the child's play: the consulting room, and its furniture, within which the child displaced its body just as it deployed its toys. Klein came to view the spatialization of this theatre of play as the exteriorization, 'projection', of an internal world, a world of relations between 'objects'. Much of Klein's work is concerned with the description of internal objects, bound up with the somatic origins of fantasy.[9] We are familiar with such expressions as 'a lump in the throat', or 'butterflies in the stomach'; we are also accustomed to hear that hunger 'gnaws' at the stomach, or fear 'grips' the heart. In these examples from ordinary language, bodily sensations are identified with actual entities, endowed with an agency of their own, either benevolent or malevolent. There may also be times when we feel 'empty inside'. As adults we employ such metaphors without abandoning our knowledge of actual physiology. The infant has no such knowledge. The infant's primitive understanding of its own bodily feeling is its only reality. What we call 'milk' the infant (what we call 'the' infant) may experience, after feeding, as a benevolent object which emanates bliss. This object is destined to fade. Hunger will take its place, and this is a malevolent agency, bringing destruction of the 'good object', and pain. At this primitive level, the 'object' is the fantasmatic

representation of the phenomenological form of the infant's earliest experience. In the Kleinian description, the infant's reality is a battle-ground of and for such objects.

The subsequent formation of a bounding body-ego, to which the much-discussed 'mirror stage' contributes, does not put an end to the movements of projection, introjection and identification described by Klein; they are rather transposed into different registers and extensively subjected to repression. Upon a world understood in terms of the fantasmatic mother's body there is imposed a world whose salient features are projected from the corporeal envelope of the newly formed subject. Sándor Ferenczi observed:

> The derisive remark was once made against psycho-analysis that, according to this doctrine, the unconscious sees a penis in every convex object and a vagina or anus in every concave one. I find that this sentence well characterises the facts. The child's mind (and the tendency of the unconscious in adults that survives from it) is at first concerned exclusively with its own body, and later on chiefly with the satisfying of his instincts, with the pleasurable satisfactions that sucking, eating, contact with the genital regions, and the functions of excretion procure for him; what wonder, then, if also his attention is arrested above all by those objects and processes of the outer world that on the ground of ever so distant a resemblance remind him of his dearest experiences … Thus arise those intimate connections, which remain throughout life, between the human body and the objective world that we call *symbolic*. On the one hand the child in this stage sees in the world nothing but images of his corporeality, on the other he learns to represent by means of his body the whole multifariousness of the outer world.[10]

For example, when 'Little Hans' saw some water being let out of a railway engine he responded with, 'Oh look, the engine's widdling. Where's it got its widdler?' Freud completes the anecdote: 'After a little while he added in reflective tones: "A dog and a horse have widdlers; a table and a chair haven't". He had thus got hold of an essential characteristic for differentiating between animate and inanimate objects'.[11]

Such distinctions, founding the real world – the 'normal' – are learned, which is to say they may fail to be learned, or may be learned badly. Prior to such distinctions, spacing, there are only identifications, fusion. Spatial metaphors necessarily accompany the 'object' metaphors which abound in everyday language: for example, we may feel 'one' with someone, be 'on their side' in a dispute, and worry when, even though physically close to us, they appear 'distant'. Paul Schilder has given a schematic description of the continuum between normal and pathological space:

> There is the space as a phylogenetic inheritance which is comparitively stabilized, which is the basis of our actions and orientations. It is the space of the perception ego. We live our personal lives in relation to love objects, in our personal conflicts, and this is the space which is less systematized, in which the relations change, in which the emotions pull objects nearer and push them further away. When the emotional life regresses very far the perception ego-space loses more and more of its importance. In this

regressive space identifications and projections change the space and its value continually. This is the Id space which finds a very far-going expression in schizophrenic experiences. It is the space of magic.[12]

The space of magic: it is supposed that in the infant's early experience it is as if it summons the breast into being; unconscious survivals of this state into adult life may contribute to obsessional neurosis. Freud writes:

I have adopted the term 'omnipotence of thoughts' from a highly intelligent man who suffered from obsessional ideas ... He had coined the phrase as an explanation of all the strange and uncanny events by which he, like others afflicted with the same illness, seemed to be pursued. If he thought of someone, he would be sure to meet that very person immediately afterwards, as though by magic.[13]

Obsessively, a distraught Breton is tormented by thoughts of Nadja. He desperately feels the need to see her, but has no rendezvous with her until the following day. He goes out in a taxi, and,

Suddenly, while I am paying no attention whatever to the people on the street, some sudden vividness on the left-hand sidewalk, at the corner of Saint-Georges, makes me almost mechanically knock on the window. It is as if Nadja had just passed by. I run, completely at random, in one of the three directions she might have taken. And as a matter of fact it is Nadja ... This is the second consecutive day that I have met her: it is apparent that she is at my mercy.[14]

The normal infantile space of magic recedes ('once upon a time, long ago and far away') as the ego forms out of the nucleus of early object relations: a precarious process. In her paper of 1946, 'Notes on some schizoid mechanisms', Klein remarks, 'the early ego largely lacks cohesion, and a tendency towards integration alternates with a tendency towards disintegration, a falling to bits'.[15] The 'cracks in the structure' which may result may lead to subsequent crises of delimitation of ego/object boundaries, to 'psychosis'. Early object identifications are, as Edith Jacobson expresses it:

founded on primitive mechanisms of introjection or projection corresponding to fusions of self and object images which disregard the realistic differences between the self and the object. They will find expression in illusory fantasies of the child that he is part of the object or can become the object by pretending to be or behaving as if he were it. Temporary and reversible in small children, such ideas in psychotics may turn into fixated, delusional convictions.[16]

Laplanche and Pontalis write: 'Fundamentally, psychoanalysis sees the common denominator of the psychoses as lying in a primary disturbance of the libidinal relation to reality; the majority of manifest symptoms, and particularly delusional constructions, are accordingly treated as secondary attempts to restore links with objects'.[17] In psychosis, the internal and external world are poorly differentiated, or not differentiated at all; for example, whereas in 'normal' life we may encounter a person, *A*, who 'reminds us of' another person, *B*, the schizophrenic patient may simply substitute the latter

for the former; or, again, he or she may experience the internal representations of 'fantasy' as actual representations of external reality.[18] We should remember that psychoanalysis systematically insists that there are no fixed boundaries betwen 'normal' and pathological realities. The precondition of the pathological is in early 'normal' experience; it is in this sense that we may understand Mannoni's remark that, 'we are all more or less healed psychotics'[19]; to which we may add that there is never anything more than this 'more or less'.

To the 'psychoses' belong those forms of mental disturbance which everday language names 'madness'. Towards the end of *Nadja*, Breton writes: 'I was told, several months ago, that Nadja was mad ... she had had to be committed to the Vaucluse sanitarium'.[20] The first published fragment from Breton's *Nadja* appeared in the penultimate issue of *La Révolution Surréaliste*. In this same issue, in an article illustrated with Régnard's photographs of 'Augustine' from the *Iconographie photographique de la Salpêtrière*,[21] Breton and Aragon celebrate 'The Fiftieth Anniversary of Hysteria', which they find to be 'the greatest poetic discovery of the end of the nineteenth century', and, 'in every respect ... a supreme means of expression'.[22] The intentionally ironic indifference of these two psychiatrically trained poets to the diagnostic niceties of their former profession is evident; nevertheless they might more consistently have reserved their approbation for the psychoses rather than the neuroses.[23] According to Lacan, writing in another surrealist journal, *Minotaure*, paranoic deliriums

> need no interpretation whatsoever to express by their themes alone, and marvellously well, these instinctive and social complexes which psychoanalysis has the greatest difficulty in bringing to light in neurotics. It is no less remarkable that the murderous reactions of these patients very frequently emerge at a neuralgic point of the social tensions with which they are historically contemporary.[24]

History was very shortly to provide Lacan with an exemplary case of such violence: his subsequent study of paranoia to appear in *Minotaure* was dedicated to 'The Crime of the Papin Sisters'. Léa and Christine Papin were domestic servants who, for six years, in the words of Paul Eluard and Benjamin Péret, 'endured, with the most perfect submission, commands, demands, insults', until the day they, 'literally massacred their employers, tearing out their eyes and crushing their heads'.[25] About the same time that the awed comments of Eluard and Péret appeared in *Le Surréalisme au Service de la Révolution*, the surrealists had published a pamphlet in support of the patricide of Violette Nozière. Much earlier, the inaugural issue of *La Révolution Surréaliste* had featured a 'mug shot' photograph of the anarchist Germaine Berton, surrounded by portrait photographs of all the surrealist group (a guard of honour to which a picture of Freud has, for the occasion, been conscripted). Berton had assassinated the royalist Marius Plateau, editor of the extreme right-wing journal, *L'Action Française*. The assembled photographs are accompanied by a fragment from Baudelaire: 'Woman is the being who throws the greatest shadow or the greatest light on our dreams'. The dream is of violent revolution. Eluard and Péret had spoken of the Papin sisters' hatred, 'this very sweet alcohol which consoles in secret for it promises, sooner or

later, to add physical force to its violence'.[26] These particular women – clinically paranoiac or not – were seen as exemplifying the production of legitimate violence at three key 'neuralgic points' of social tension: in the case of Nozière, the family; in the case of the Papin sisters, the work-place; and in the case of Berton, politics.

Breton's description of his first, pedestrian, encounter with Nadja indicates precisely what he was out looking for:

> Last October fourth, toward the end of one of those idle, gloomy afternoons I know so well how to spend, I happened to be in the Rue Lafayette: after stopping a few minutes at the stall outside the *Humanité* bookstore and buying Trotsky's latest work, I continued aimlessly in the direction of the Opéra. The offices and workshops were beginning to empty out from top to bottom of the buildings, doors were closing, people on the sidewalk were shaking hands, and already there were more people in the street now. I unconsciously watched their faces, their clothes, their way of walking. No, it was not yet these who would be ready to create the Revolution. I had just crossed an intersection whose name I don't know, in front of a church. Suddenly, perhaps still ten feet away, I saw a young, poorly dressed woman walking toward me'[27]

Nadja, for Breton – for a time – is to be the locus of the transformation of everyday life, as if the social revolution absent from the France of 1928 could be acted out on the stage of sexuality. Breton is out looking for an explosive, Nadja is looking for a container. Breton celebrates the affirmative 'being in the world' of the Nadja who 'enjoyed being nowhere but in the streets, the only region of valid experience for her'.[28] But Nadja seems to have little sense of her own independent existence *without* the streets, and the encounters they offer. Breton writes, 'She uses a new image to make me understand how she lives: it's like the morning when she bathes and her body withdraws while she stares at the surface of the bath water. "I am the thought on the bath in the room without mirrors"'.[29] Schilder reports some of the utterances of his patients: 'I am not sure whether this room is one or more'; 'You can't go out of this house, there is no other world'; 'I do not know where I am. I feel that I am in the space between. That frightens me'.[30]

It as if Nadja is in the street to find those scattered objects she cannot contain when alone: an anxious search. Breton writes:

> Here on the right, is a low window that overlooks the moat, and she cannot take her eyes off it. It is in front of this window which looks so forlorn that we must wait, she knows that much. It is from here that everything can come. It is here that everything begins. She holds onto the railing with both hands so that I will not pull her away.[31]

Or again, 'Nadja cannot endure the sight of a mosaic strip extending from the counter across the floor, and we must leave the bar only a moment after we have come in'.[32] Lacan observes, 'the perceptual field [of the paranoid subject] is imprinted with an immanent and imminent "personal signification"'.[33] Breton muses, 'Perhaps life needs to be deciphered like a cryptogram'. Aragon, in his own book about the city streets, *Le Paysan de Paris*, writes:

Where the most ambiguous activities of the living are pursued, the inanimate may sometimes catch a reflection of their most secret motives: our cities are thus peopled with unrecognised sphinxes, which will not stop the musing passer-by and ask him mortal questions. But if in his wisdom he can guess them, then let him question them, and it will still be his own depths which, thanks to these faceless monsters, he will once again plumb.[34]

What is most familiar in that to which Aragon alludes is discussed by Freud in such papers as 'The Uncanny', or his paper on *'fausse reconnaissance'*. Fundamentally, 'What is involved is an actual repression of some content of thought and a return of this repressed content',[35] which may additionally involve, 'the identity being displaced from the really common element on to the locality'.[36] Breton misrecognizes Nadja's illness because it is centred perfectly upon that which surrealism was in the process of celebrating: the encounter with the enigmatic in the everyday. However, the accompanying affect in Nadja's encounter with the enigmatic is qualitatively and quantitatively different from that in the encounter with the 'uncanny' (which the French equivalent of 'uncanny' spells out as *'l'inquiétante étrangeté'*). Nadja's experience is of a world in which the two terms of Breton's simile are collapsed into an identity: for her, life *is* a cryptogram. It is precisely in *this* that her relation to the streets is 'infantile'.

Jean Laplanche has identified the early and inescapable encounter of the subject with 'primal seduction', the term he gives to 'that fundamental situation where the adult presents the infant with signifiers, non-verbal as well as verbal, and even behavioural, impregnated with unconscious sexual significations'.[37] It is these that Laplanche calls 'enigmatic signifiers': the child senses that such signifiers are addressed to it, and yet has no means of understanding their meaning; its attempts at mastery of the enigma, at symbolization, provoke anxiety and leave unconscious residues. Such estrangement in the libidinal relation with the object is an inescapable condition of entry into the adult world, and we may expect to find its trace in any subsequent relation with the object, even the most 'normal'. About a quarter of the way into *Nadja* Breton devotes some ten pages, and four photographs, to a description of his desultory visits to the theatre: to the *Théâtre Moderne*, with its bar like 'a living room at the bottom of a lake'; and to the *Théâtre des Deux Masques*, where he witnesses a 'Grand Guignol' drama, *Les Détraquées*, 'which remains ... the only dramatic work that I choose to recall'. The plot of *Les Détraquées*, in Breton's four-page summary, seems to turn about the encounter of a child with perverse (here, female) adult sexuality. I say 'seems to concern' as we are made to share Breton's own uncertainty: 'The lack of adequate indications as to what happens after the balloon falls and the ambiguity about precisely what Solange and her partner are a prey to ... is still what puzzles me *par excellence*'.[38] Breton immediately follows his account of *Les Détraquées* with a partial description of a dream which 'includes a reference to certain episodes of *Les Détraquées*', and which Breton found 'remarkable' in that it 'emphasized only the painful, repugnant, not to say cruel aspect of the considerations I had embarked upon' (included in the dream is an insect-like creature which attempts to choke Breton, who experiences 'an inexpressible disgust'). It is also within the space of these pages about his visits to the theatre that Breton

confesses 'I have always, beyond belief, hoped to meet, at night and in a wood, a beautiful naked woman or rather, since such a wish once expressed means nothing, I regret, beyond belief, not having met her'. He then recalls the occasion when, 'in the side aisles of the "Electric Palace," a naked woman ... strolled, dead white, from row to row', an occurrence he admits was unextraordinary, 'since this section of the "Electric" was the most commonplace sort of illicit sexual rendez-vous'.[39] I suspect that these scenes re-figure, transcribe, symbolize each other and contain each other just as the *Théâtre Moderne* is contained as a scene within the theatrical space of *Nadja*, which is a maze of façades. For *Nadja*, Breton commissioned photographers to take pictures of that which he might otherwise have felt obliged to describe. Images of places and things, including the drawings which Nadja made for Breton, are deployed throughout the book like so many decorated curtains, rising and falling between scenes with the turn of a page, or like so many theatrical 'flats'. We may recall that one of the origins of perspective is in the art of scenography. Breton's city is a stage for the encounter with the marvellous in the everyday. Breton is actor-director and general manager. Brilliant illusions are conjured on this stage, but they are imposed on a space whose coordinates are fundamentally Cartesian, whose geometries are Euclidean. In this, Breton's space is different from that of Nadja's, and there is a sense in which, throughout the book, they are never in the same place, and never meet.

Accompanying the celebration of the 'anniversary of hysteria', and the fragment of *Nadja*, in the penultimate issue of *La Révolution Surréaliste* is the transcript of an extended discussion (amongst the surrealists themselves) of sexuality. Intervening in the exchange, in response to his own question, 'Does love necessarily have to be reciprocal?', Breton states: 'It is necessarily reciprocal. For a long time I thought the contrary, but I have recently changed my mind'. Breton was elsewhere to voice his regret that he had not been able to love Nadja as she had loved him, which is to say that he was not fully able to participate in a world which the surrealists had so far eulogized only from a safe distance: that of the *détraquée*. Towards the close of the book Breton reflects that Nadja was 'born to serve human emancipation ... in its simplest revolutionary form', which includes, 'thrusting one's head, then an arm, out of the jail ... thus shattered ... of logic, that is, out of the most hateful of prisons'. He concedes that this is 'dangerous', adding, 'It is from this last enterprise, perhaps, that I should have restrained her'.[40] Breton did, however, exercise *self*-restraint, placing his own boundaries on *l'amour fou* and hence, implicitly, on surrealist revolution.[41] To speak more accurately, Nadja *introduced* Breton to his own limits and limitations. Breton reports that while speeding back from Versailles by car, at night, Nadja had:

> pressed her foot down on mine on the accelerator, tried to cover my eyes with her hands in the oblivion of an interminable kiss, desiring to extinguish us, doubtless forever, save to each other, so that we should collide at full speed with the splendid trees along the road. What a test of life indeed! Unecessary to add that I did not yield to this desire.[42]

Speaking of the Papin sisters, Lacan remarks: 'One has heard in the course of the debates the astonishing affirmation that it was impossible that two beings should both be struck, together, by the same madness ... This is a completely

false affirmation. Joint deliriums [*les délires à deux*] are amongst the most ancient of known forms of psychosis'.[43] Breton regrets that, 'Whatever desire or even illusion I may have had to the contrary, perhaps I have not been adequate to what she offered me'. But what was offered was that dark side of the drive whose only objects are fragments, and whose aims are destructive. Laplanche observes that pride of place amongst the 'enigmatic signifiers' is reserved for what Freud called the 'primal scene', where (the scene now dramatically lit by Klein), 'the parents are united in an eternal coitus which combines *jouissance* with death, excluding the baby from all capacity to participate, and therefore to symbolize'.[44] Breton returns from his walk only to pose the question of the city again in its most unanswerable terms:

It is not for me to ponder what is happening to the 'shape of a city,' even of the true city distracted and abstracted from the one I live in by the force of an element which is to my mind what air is supposed to be to life. Without regret, at this moment I see it change and even disappear. It slides, it burns, it sinks into the shudder of weeds along its barricades, into the dream of curtains in its bedrooms, where a man and woman indifferently continue making love.[45]

Notes

1 Sigmund Freud, 'The "Uncanny"', *The Standard Edition of the Complete Psychological Works of Sigmund Freud*, ed. James Strachey (*SE*) (London: Hogarth Press), XVII, p. 237.
2 Michel de Certeau, *The Practice of Everyday Life* (Berkeley, CA: University of California, 1988), p. 94. The term *'propre'*, to which the translator alerts us here, means not only 'own' but 'clean', and 'that which is proper'. The term 'pollution' which closely follows confirms that Certeau may be alluding to Julia Kristeva's *Pouvoirs de l'horreur: Essai sur l'abjection* (trans. *Powers of Horror, An Essay on Abjection*; New York: Columbia University Press, 1982) and/or to the book which so substantially contributes to Kristeva's argument, Mary Douglas's *Purity and Danger* (London: Routledge & Kegan Paul, 1966). For a discussion of 'abjection' in relation to space and vision, see my 'Geometry and Abjection', *AA files*, 15 (Summer 1987); and in Andrew Benjamin and John Fletcher (eds), *Abjection, Melancholia and Love: The Work of Julia Kristeva* (London: Routledge, 1989).
3 Certeau, *The Practice of Everyday Life*, p. 103.
4 Ibid, p. 105.
5 Ibid, p. 110.
6 Freud, 'The "Uncanny"', p. 236.
7 Jacques Lacan, 'Aggressivity in Psychoanalysis', in *Ecrits: A Selection* (New York: W.W. Norton, 1977), pp. 20–1.
8 Melanie Klein, 'Notes on some schizoid mechanisms', in Juliet Mitchell (ed.), *The Selected Melanie Klein* (New York: Free Press, 1955), p. 51.
9 See Jean Laplanche and Jean-Bertrand Pontalis, 'Fantasy and the Origins of Sexuality', in Victor Burgin, James Donald and Cora Kaplan (eds), *Formations of Fantasy* (London: Methuen, 1986).
10 Sándor Ferenczi, 'Stages in the Development of the Sense of Reality' (1913), in *First Contributions to Psycho-Analysis* (New York: Brunner/Mazel, 1980), pp. 227–8.
11 Sigmund Freud, 'Analysis of a Phobia in a Five-Year-Old Boy' (1909), *SE*, X, p. 9.
12 Paul Schilder, 'Psycho-Analysis of Space', *International Journal of Psycho-Analysis*, 16 (1935), p. 278.

13 Sigmund Freud, *Totem and Taboo, SE*, XIII, pp. 85–6; the man to whom Freud refers is the 'Rat Man' (see *SE*, pp. 233ff.).
14 André Breton, *Nadja* (New York: Grove Press, 1960), p. 91.
15 Melanie Klein, 'Notes on some schizoid mechanisms', in Mitchell, *The Selected Melanie Klein*, p. 179.
16 Edith Jacobson, *The Self and the Object World* (New York: International Universities Press, 1964), p. 47.
17 J. Laplanche and J.-B. Pontalis, *The Language of Psycho-Analysis* (London: Hogarth Press, 1973), p. 370.
18 See Harold F. Searles, 'The Sources of the Anxiety in Paranoid Schizophrenia' (1961), in *Collected Papers on Schizophrenia and Related Subjects* (New York: IUP, 1965).
19 Octave Mannoni, 'La Part du Jeu', *L'Arc*, 69 (Special issue on Donald W. Winnicott).
20 Breton, *Nadja*, p. 136.
21 See Georges Didi-Huberman, *Invention de L'Hystérie: Charcot et l'Iconographie Photographique de la Salpêtrière* (Paris: Macula, 1982).
22 *La Révolution Surréaliste*, 11 (15 March 1928), p. 22.
23 Laplanche and Pontalis point out that Freud, at an early stage in his work, did entertain the idea of an hysterical *psychosis*. See Laplanche and Pontalis, *The Language of Psycho-analysis*, p. 195.
24 Jacques Lacan, 'Le Problème du Style et la Conception Psychiatrique des Formes Paranoïaques de l'expérience', *Minotaure*, 1 (1 June 1933), p. 69.
25 *Le Surréalisme au Service de la Révolution*, 5 (1933), p. 28.
26 Ibid, p. 28.
27 Breton, *Nadja*, pp. 63–4.
28 Ibid, p. 113.
29 Ibid, p. 101.
30 Schilder, 'Psycho-Analysis of Space', p. 282. Harold Searles speaks of 'the draining off into the outer world, through projection, of much affect and ideation which belong to [the schizophrenic's] self'. (See Searles, *Collected Papers*, p. 467.)
31 Breton, *Nadja*, p. 85.
32 Ibid, p. 89.
33 Lacan, 'Le Problème du Style', p. 69.
34 Louis Aragon, *Le Paysan de Paris* (Paris: Gallimard, 1978); quoted in Peter Collier, 'Surrealist city narrative: Breton and Aragon', in E. Timms and D. Kelley, *Unreal City* (Manchester: Manchester University Press, 1985), p. 221.
35 Sigmund Freud, 'The "Uncanny"', *SE*, XVII, p. 249.
36 Sigmund Freud, 'Fausse Reconnaissance (Déja Raconté) in Psycho-Analytic Treatment', *SE*, XIII, p. 204.
37 Jean Laplanche, *Nouveaux fondements pour la psychanalyse* (Paris: Presses Universitaires de France, 1987), p. 125 (trans. in *New Foundations for Psychoanalysis*, Oxford: Basil Blackwell, 1989, p. 126: my translation differs).
38 Breton, *Nadja*, p. 50.
39 Ibid, p. 39.
40 Ibid, p. 143.
41 Laclau and Mouffe have imported Lacan's notion of *points de capiton*, 'buttoning down' the otherwise endless sliding of meaning in discourse, into a discussion of the social order. They remark that 'a discourse incapable of generating any fixity of meaning is the discourse of the psychotic'; by implication, a society that would be totally 'free' would be a psychotic society. (See Ernesto Laclau and Chantal Mouffe, *Hegemony and Socialist* Strategy (London: Verso, 1985), p. 113. Lacan similarly admits the necessity of the law as 'anchorage' in his article on the Papin

sisters, where he remarks, 'the adage "to understand is to forgive" is subordinate to the limits of each human community … beyond these limits, to understand (or to believe that one understands) is to condemn': Jacques Lacan, 'Motifs du Crime Paranoïaque (Le Crime des Soeurs Papin)', *Minotaure*, 3 (15 December, 1933), p. 27.

42 Breton, *Nadja*, p. 152, n.

43 Lacan, 'Motifs du Crime Paranoïaque', p. 27.

44 Laplanche, *Nouveaux fondements*, p. 126 (trans., p. 127).

45 Breton, *Nadja*, p. 154.

Index

absence
condition of, 335–6
of the missing Jews, 121, 129–30, 136
as symbolic lack, 299–300, 339–40
thematisation of, 133, 311
see also presence
Absorption and Theatricality (Fried), 70
act
commemorative, 130–1
creative, 308
of description, 183
of enunciation, 201–2
of interpretation, 21–2
of looking, 41, 59, 150–2
performative, 94–6
of reading, 150
regressive, 127
Action Française, L', 366
Adam, Robert, 284
Adams, Denis, 131
Addison, Joseph, 287
Adieu mon beau pays de Marie Laurencin (Ernst),
223, **225**
Adler, Kathleen, 58
Adoration of the Magi (Botticelli), 209, **210**
Adorno, Theodor, 134, 234, 254, 331–2
aesthetics, 11–14, 19–20, 344
vs de–aesthetization, 134
eighteenth–century, 285
of post history, 126
see also experience, judgment
Age of Fable, The or Beauty of Mythology, 332
agency
contemporary intellectual, 4, 6
ideological, 148
and subjectivity, 14
in writing of history, 16
aggression
and sexuality, 166–9, 237
in the subject, 229, 363
see also anxiety
Alberti, Leon Battista, 69, 76, 78, 85, 348
Allori, Cristoforo, 212
Alpers, Svetlana, 348
Althusser, Louis, 41, 84, 93
Ambulator, The, 288–90, 292
Amherst, Jeffrey (general), 292
*amour fou, surr*ealist concept of, 237, 369

Analytic of Taste (Kant), 13
Anatomy of the Human Gravid Uterus (Hunter), 257,
258–9
AND
logic of the (in Deleuze and Guattari), 7
androgyny, 302
Annunciation (Master of the Barbarini Panels),
150
anthropology, 300, 353
antiquity
archeology of, 188–9, 190, 192
classical, 32
ruins of, 174
anti–Semitism
in German history, 128
anxiety, 133, 188, 368
and aggression, 50, 55
of creative doubt, 307–8
and curiosity, 138
of Modernity, 120
post castration, 50, 320
structural, 144–5
and the uncanny, 335, 339
aphasia
art historical, 58
Apollinaire, Guillaume, 331
appareance
and disappearance, 207
mask of, 268
momentary, 349
rules of, 95, 107
of reality (*vraisemblable*), 264
Appert, Eugène, 353
appropriation
conditions of, 95, 107
mark of, 200, 206
power of, 212
spatial, 362
visual, 352
Aragon, François, 345
Aragon, Louis, 330–1, 335, 366–8
archeology, *see* antiquity
architecture
caesura in, 176, 184
as control of the self, 190
as order, 175, 179, 191–2
penitentiary, 263
in rhetoric, 189

373